If I Survive

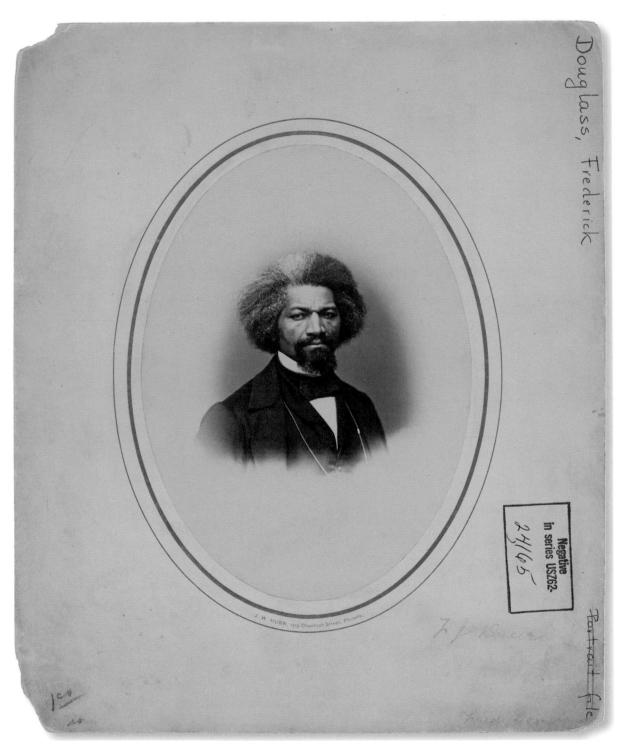

Figure 1: John White Hurn, *Frederick Douglass*, 1862. (Prints and Photographs
Division, Library of Congress, Washington, DC.)

If I Survive

*Frederick Douglass and Family
in the Walter O. Evans Collection*

A 200 YEAR ANNIVERSARY

Celeste-Marie Bernier and Andrew Taylor

EDINBURGH
University Press

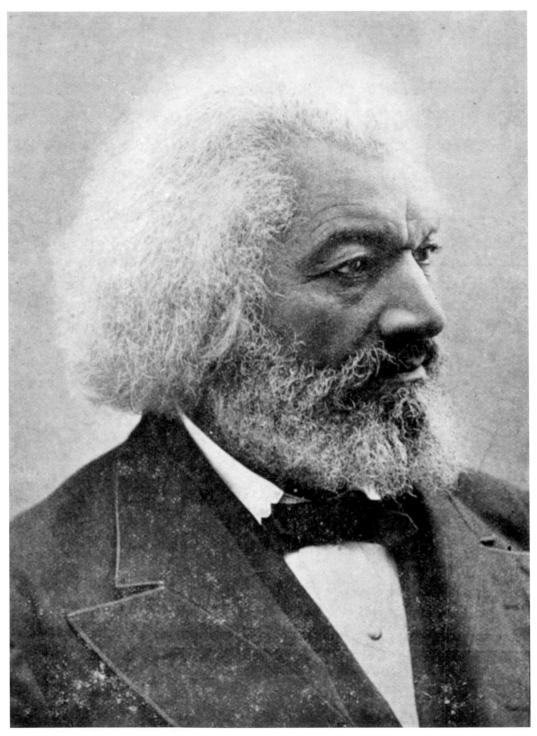

Figure 2: Anon., *Frederick Douglass*, n.d. Reproduced John W. Thompson, *Authentic History of the Douglass Monument*. (Rochester: Rochester Herald Press, 1903, 16. Collection of the Rochester Public Library Local History Division, Central Library of Rochester and Monroe County, Rochester, NY.)

A slaveholder never appears to me so completely an agent of hell,
as when I think of and look upon my dear children.

—Frederick Douglass, 1848

My poor mother, like many other slave-women, had *many children*,
but NO FAMILY!

—Frederick Douglass, 1855

I feel that we children have shared in a measure,
your sacrifices for the good of the Cause.

—Frederick Douglass Jr., 1883

The family worked on ~~and~~ only encouraged by the thought that they were working
for the cause in which their father and mother were interested—
namely the emancipation of the slave.

—Lewis Henry Douglass, 1905

We were a happy family in this work for the enslaved of our race.

—Charles Remond Douglass, 1920

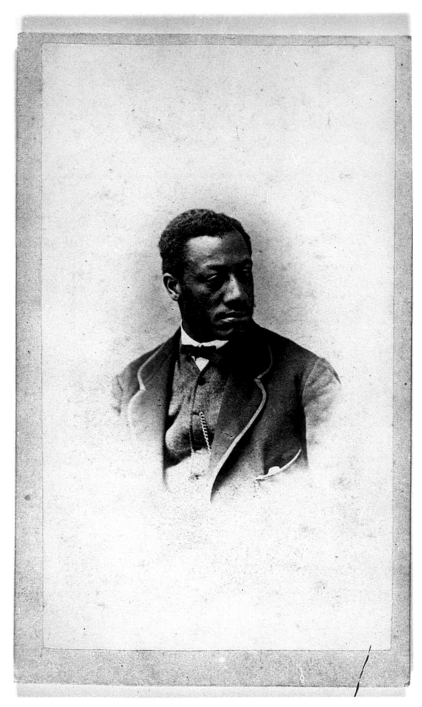

Figure 3: Anon., *Lewis Henry Douglass*, n.d. (Prints and Photographs Division, Moorland-Spingarn Research Center, Howard University, Washington, DC.)

Edinburgh University Press is one of the leading university presses
in the UK. We publish academic books and journals in our selected
subject areas across the humanities and social sciences, combining
cutting-edge scholarship with high editorial and production values
to produce academic works of lasting importance. For more
information visit our website: edinburghuniversitypress.com

Edinburgh University Press Ltd
The Tun—Holyrood Road, 12(2f) Jackson's Entry, Edinburgh EH8 8PJ

Typeset in Goudy Old Style and New Caledonia
by Biblichor Ltd, Edinburgh, and
printed and bound in Italy by Rotolito S.p.A.

A CIP record for this book is available from the British Library

ISBN 978 1 4744 3972 5 (hardback)
ISBN 978 1 4744 3973 2 (webready PDF)
ISBN 978 1 4744 2928 3 (paperback)
ISBN 978 1 4744 3974 9 (epub)

Contents

PART III: "Men of Color, To Arms!"

PART IV: The "Incontestable Voice of History" in Frederick Douglass's Manuscripts

PART V: "I Glory in Your Spirit"

PART VI: "I was Born"

PART VII: Narrative of the Life of Frederick Douglass, An American Slave and Free Man, as told by Charles Remond Douglass

PART VIII: Frederick Douglass and Family
in Photographs and Prints

If not called for in days, return to

To be kept for Haley Douglass

1-13

personal
(Haley L. Frederick)
March 13
1893

Hon. Frederick Douglass
Cedar Hill,
Anacostia
D.C.

UNITED STATES POSTAGE
TWO CENTS

List of Illustrations

Foreword

Robert S. Levine

On the occasion of the 200th anniversary of the birth of Frederick Douglass, Celeste-Marie Bernier and Andrew Taylor have presented us with a gift: *If I Survive: Frederick Douglass and Family in the Walter O. Evans Collection*, a veritable treasure-trove of documents and manuscripts by and about Douglass and his family. Virtually all of the materials in this volume are being published for the first time. Bernier and Taylor have done heroic work in selecting, annotating, and introducing these new materials, which mainly come from the Walter O. Evans collection in Savannah, Georgia. That collection, which many of us are learning about for the first time, is one of the world's outstanding archives of African American art, literature, and historical materials. Bernier and Taylor tell us more about the little-known but hugely important Evans in their introductory materials. Suffice it to say here that Evans is to be congratulated and thanked for his devotion over many decades to the project of collecting African American paintings, books, letters, photographs, and numerous other materials that might otherwise have been neglected or even lost to posterity. This volume draws selectively from the Evans collection, giving us access to heretofore unpublished writings by Douglass and members of his family, along with access to rare photographs of the Douglasses as well as extended family members and friends, many of whom have yet to be identified. At this bicentennial moment, *If I Survive* calls on us to rethink our understanding of the extended Douglass family and of Douglass himself.

We tend to regard Douglass as the iconic, almost transcendent nineteenth-century African American leader who rises above family, friends, and associates to do his cultural work. Consider, for example, how he is introduced in his three major autobiographies. The white abolitionist William Lloyd Garrison, the

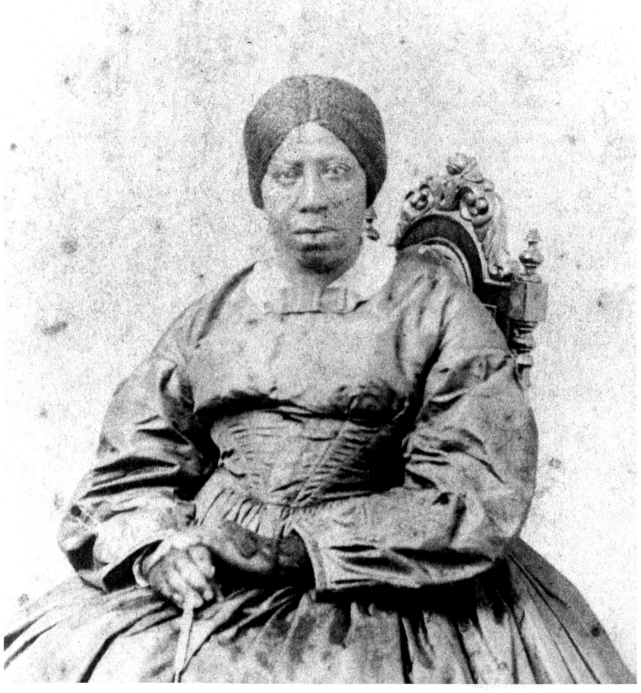

Figure 4: Anon., *Anna Murray Douglass*, n.d. (National Park Service, Frederick Douglass National Historic Site, Washington, DC.)

publisher of Douglass's first and still most famous autobiography, the 1845 *Narrative of the Life of Frederick Douglass, An American Slave*, declares about the first time he encountered Douglass at an antislavery meeting in Nantucket: "There stood one, in physical proportion and stature commanding and exact—in intellect richly endowed—in natural eloquence a prodigy—in soul manifestly 'created but a little lower than the angels.'" The black abolitionist, essayist, and medical practitioner James McCune Smith asserts in his introduction to the 1855 *My Bondage and My Freedom* that Douglass possesses "an unfaltering energy and determination to obtain what his soul pronounced desirable; a majestic self-hood; determined courage; a deep and agonizing sympathy with his embruted, crushed and bleeding slaves, and an extraordinary depth of passion." The black jurist George L. Ruffin offers an even more glowing tribute to Douglass in his preface to the 1881/1892 *Life and Times of Frederick Douglass*: "Up to this time the most remarkable contribution that this country has given to the world is the Author and subject of this book, now being introduced to the public—Frederick Douglass. . . . Our Pantheon contains many that are illustrious and worthy, but Douglass is unlike the others, he is *sui generis*. For every other great character we can bring forward, Europe can produce another equally as great; when we bring forward Douglass, he cannot be matched."[1] This rhetoric of "little lower than the angels," "majestic self-hood," and "*sui generis*" works to create the picture of an almost god-like black male leader who maybe doesn't have to eat, drink, or sleep in order to undertake his next great deed. Douglass probably enjoyed the way that he is depicted in these prefaces (two of which he commissioned), and it has to be said that in his autobiographies Douglass tended to further underscore his status as the representative black leader (or, to put this differently, that the prefaces emerged from perceptive readings of what Douglass sought to accomplish in terms of self-representation in his autobiographies). Perhaps Douglass believed that white America needed to be confronted with such an exemplary black leader in order to concede that blacks had capabilities equal to whites, or perhaps he simply liked being described in such heroic terms. His critics, after all, tended to talk about his insufferable ego.[2]

But now consider one of the most fascinating documents in *If I Survive*: the manuscript draft of Douglass's third son (and fourth child), Charles Remond Douglass (1844–1920), chronicling the Douglass family history. In this circa 1917 manuscript, Charles offers a very different picture of his father from what we see

1 Douglass, *Narrative*, 34; Douglass, *My Bondage and My Freedom*, 11, Douglass, *Life and Times*, 3.
2 For example, the antislavery activist and publisher Richard Webb, Douglass's host in Dublin in late 1845, remarked about Douglass: "F. Douglass was a very short time in my house, before I found him to be absurdly haughty, self-possessed, and prone to take offense" (R. D. Webb to Maria Weston Chapman, letter of 16 May, 1846, in Taylor, *British and American Abolitionists*, 260).

in the prefaces to the autobiographies. Rather than working mostly by himself, the Douglass of this manuscript is grounded in and dependent upon his family. For instance, Charles describes the young Douglass making his way from slavery in Baltimore to freedom in New Bedford with the help of his wife, Anna Murray, who, perhaps mainly out of Douglass's desire for privacy, has virtually no place in Douglass's autobiographies. After Douglass published his 1845 *Narrative* and subsequently sailed to Britain to avoid fugitive slave hunters, Anna, Charles discloses in his manuscript, took up shoe-binding in order to support their four children during the nearly two years that Douglass remained abroad. When Douglass returned to the United States and established the family's new home in Rochester, he started up his newspaper, the *North Star*, which in Douglass's 1855 and 1881/1892 autobiographies is presented as mainly the work of the indefatigable black leader, but which is here presented as a family affair. As Charles writes, "To maintain this paper every effort was put forth by every member of the family to keep it alive." The children may have been young, but they were collaborators: "My brothers and sister were taken from school one day in each week to attend to the folding and mailing of the paper. . . . We were a happy family in this work."

According to Charles Remond, that happy family continues to assist Douglass with his antislavery and antiracist activities. We learn that during the time when Douglass was most closely involved with John Brown's plotting, Charles himself served as an "errand boy" in passing messages back and forth between his father and Brown. (In an equally fascinating manuscript selection in this volume, Frederick Douglass Jr. [1842–92], Douglass's second son, says that he, too, helped with posting and receiving letters between Douglass and Brown.) Charles further suggests in his account of the John Brown years that his younger sister, Annie (1849–60), died of grief at the execution of Brown. Between the death of Annie and Douglass's hasty departure to Britain, after the attack on Harpers Ferry, to escape from Virginia authorities, Charles asserts that, "We became a dismembered family." But the family came together in their embrace of the Civil War as a war of emancipation, especially after Lincoln decided to admit black troops to the Union Army (the very policy Douglass had personally urged Lincoln to adopt).[3] Charles reports (with some exaggeration) that, "I had the honor of being the first to enroll at Rochester for the 54 Mass Inf[antry]," and Frederick Jr. pridefully reports in his family biography that, "I helped raise the 54th and 55th Massachusetts regiments of infantry." In the aftermath of the war, to follow Charles's family chronicle to its conclusion, Douglass initially hit the road as a lyceum speaker while Anna held the family together for the man who continued

3 On Douglass's meetings with Abraham Lincoln during the Civil War, see Levine, *The Lives of Frederick Douglass*, ch. 4.

to depend on family. We see an example of such dependence during the early 1870s, when Douglass took on the editorship of the *New Era* and appointed his son Frederick Jr. to act as the paper's business manager. Meanwhile, as always, Anna was there for Douglass. As Charles attests near the end of his chronicle, Anna "was the head of the house. She was the banker, the baker, and general manager of the home." Thus he can say about her what Douglass mostly fails to say in his autobiographies: that his mother "toiled side by side with my father from the day he escaped bondage until her death in 1882."

Douglass would never deny the importance of Anna Murray to his public and private life, and in fact he offers some acknowledgment of her copartnership in his final autobiography (Figure 4).[4] Moreover, when we reread *My Bondage and My Freedom* and *Life and Times* through the lens of the family papers in this volume, we begin to discern in the interstices of Douglass's autobiographical narratives his larger indebtedness to the family and friends who assisted him in his antislavery and antiracist labors. Still, what comes across in the various letters, essays, and other writings in *If I Survive* is that Douglass sought to maintain some separation (at least in public) between his public and private lives. But maintaining such separation was especially difficult for African Americans, who, because of the racial apartheid of white supremacist culture, were always on stage as black people. Douglass may have desired privacy for his family, but he had to go public to fight to get his children into public schools and eventually to help his sons challenge racist printers' unions. In short, as we see in this volume, Douglass confronted many of the problems that more ordinary African Americans had to deal with on a daily basis. From that perspective, this collection of Douglass family materials, while it casts new light on Douglass, is not simply about Douglass and it is not simply about Douglass and his extended family. It is also about the African American experience before, during, and after the Civil War. As exceptional as Douglass and his family were, they could not escape from the racism that had an impact on all blacks, famous or not, during the nineteenth century (and beyond).

Nowhere do we see more clearly just how hurtful whites' racism was to black life during this period than in the moving love letters between Douglass's first son, Lewis Henry Douglass (1841–1908), and Helen Amelia Loguen (1843–1936), the daughter of the dynamic abolitionists Jermain Wesley Loguen and Caroline E. Storum Loguen. Their letters, among the highlights of this volume, portray love between African Americans in the context of the challenges facing northern blacks in the racist United States. It is the kind of story that we don't often have access to. And it is a story shadowed by Frederick Douglass, who, for a change, is at the margins and not at the center of events concerning the Douglass family.

4 See Douglass, *Life and Times*, Second Part, ch. 2.

As we learn from the letters in this volume, Lewis Henry and Helen Amelia's romance began in 1859, right before the Civil War. In one of his initial letters to Amelia, Lewis invites her to visit his famous family. In response, Amelia remarks that she, too, is from a distinguished family of freedom fighters, referring to a family member who had "assisted your father on a certain occasion from Baltimore." In this letter, she also refers to the Jerry rescue—the famous 1851 rescue of a fugitive slave in upstate New York which took place when she was eight years old. The rescue made an indelible impression on Amelia, as Douglass's abolitionist work no doubt made an indelible impression on his children. But mainly Amelia and Lewis write about their love for each other, with Amelia remarking in one letter to Lewis: "Morning. I had a splendid little visit with you in my dreams last night." By December 1861, Lewis declares his desire to marry her, but six months later he's still at home with his family, not quite sure what to do following the outbreak of the Civil War. But he eventually has a purpose as a result of his father's campaign to allow blacks to fight in the Union Army. In a letter of March 1863, Lewis writes Amelia that (at least in part because of the success of his father's efforts) he's at Camp Meigs in Massachusetts and has become a member of the 54th Massachusetts Volunteers, who would go on to achieve fame at the battle of Fort Wagner. He tells Amelia that he and his fellow black soldiers are singing John Brown songs and that he's enlisted for three years (clearly, the end of the war was nowhere in sight). In a key letter of May 1863, Lewis subsequently writes Amelia about a visit from his famous father, who is presented as just another father concerned about the well-being of his son: "Father was down Thursday to see us, and will be down next week again, he was much pleased at my looking so well compared with my thin visage when I was home. We were the recipients of a box of niceties from home last week, to which we did ample justice, as you no doubt surmise." In the same letter to Amelia, Lewis remarks on a gift he had recently sent her: "I am glad you like 'David Copperfield,' how beautifully are family relations described." (Dickens was one of Douglass's favorite authors; he passed along his love of Dickens to at least one son.[5]) But the large thrust of Lewis's letter is to convey his sense of the political urgency of the war, and he does so in precisely the terms his father would have set forth: "Remember that if I fall that it is in the cause of humanity, that I am striking a blow for the welfare of the most abused and despised race on the face of the earth[,] that in the resolution of this strife rests the question of our elevation, of our degradation, our happiness or our misery." Douglass couldn't have put the goals of the Civil War any better than that.

5 On Douglass's love of Dickens, see McHenry, *Forgotten Readers*, 124–6.

I linger with the letters between Lewis Henry and Helen Amelia because they provide a complementary vision of what Douglass himself was up to during the Civil War, and also because they point to the intersection between the public and private Douglass. The letters, it should be said, have the dramatic feel of an epistolary novel, exposing the reader to the unfolding story of the difficulties facing Lewis, Amelia, and many other free blacks during and after the Civil War. Lewis speaks to those difficulties in a letter of September 1864, when he writes Amelia that he's glad they haven't yet married because he's still trying to figure out his place in society. "I have been so unsettled," he confesses, "that I have nearly lost my identity." Even after the successful outcome of the Civil War, he's still not entirely sure of his vocation, though in many respects he continues to seem his father's son. He reports to Amelia on his activities at black state conventions while he attempts to further develop his skills as a printer. But given the racism of white printers' unions, he has trouble finding employment. Douglass offers Lewis his moral support, writing him in July 1869 that he is "deeply gratified by every well aimed blow you deal the selfishness and meanness which seeks to humble, degrade and starve you." That same year Lewis and Amelia are finally ready to marry, and in July 1869 Douglass pays a visit to Amelia to celebrate the occasion. As Lewis reports to Amelia, his father delighted in the visit and was "descanting quite fully on your many good points." Lewis and Amelia marry on October 6, 1869, but Lewis continues to experience what he terms in a December 1870 letter to Amelia "senseless prejudice emanating from cowardly hate." The love story between Lewis and Amelia may have ended happily in marriage after a ten-year courtship, but they continue to face hardships, and Douglass would remain one of their big supporters. As we see in this volume, Douglass also offered his support to his son Frederick Jr., who, like Lewis, found it difficult to gain employment as a printer. In a letter of August 1876, Douglass complains to Judge Edmonds of Washington, DC, about his racist refusal "to give any of the printing to my son Frederick." Sad to say, Douglass's efforts to improve the lot of his children would remain a lifelong struggle.

Overall, *If I Survive* offers new perspectives, sometimes painful, on Douglass's more private concerns about his family. That said, the volume includes manuscripts of some of Douglass's most significant public speeches and essays of the post-Civil War period, such as his "Eulogy for Wm. Lloyd Garrison" (1879) and his notes on "The Exodus from the South" (1879). The volume also includes Douglass's long piece on William the Silent (William Prince of Orange of the Netherlands) as revised in 1876. This little-known lecture/essay shows Douglass's profound interest in history, along with his transnational imagination, as he uses his reflections on the sixteenth-century Dutch fighting for their civil and religious liberty against Spain as a way of addressing the American Revolution, John

Brown, and the current struggle for black rights in the United States. In the figure of William the Silent, Douglass, in an act of imaginative self-projection, also conveys his sense of the power of the self-reliant, heroic individual to bring about social change. But in the overall volume, particularly in the little-known letters between Douglass and his family, we see that the self-reliant Douglass was not so self-reliant after all. To take an important example: When Douglass in his position as US Minister Resident and Consul General to Haiti came under pressure from the US government in the early 1890s for supporting Haiti's resistance to the establishment of a US naval base there, Douglass offered eloquent defenses of his thinking in the *North American Review* and in the 1892 edition of *Life and Times*. He sounds boldly self-confident and self-assured in these defenses. But what we see in this volume is his anxiety about being misrepresented, as he privately turns to his family for support. In a letter to Lewis Henry of March 1891, he makes clear that he has not resigned and intends to hold onto his job. In the same letter, he asks about Helen Amelia's health and conveys his concerns about his wife's rheumatic fever. These are touching personal moments that look forward to the family letters he would write when he returned to the United States later that year. In an 1893 exchange between Douglass and one of his grandsons, for example, Haley George Douglass thanks his grandfather for the gift of a flute, and Douglass praises the boy for his politeness while offering the hope that he will grow up to be a "wise and good man."

But perhaps the most poignant letter in the entire volume is Douglass's letter to Charles Remond from the Haitian Pavilion at the 1893 Chicago World's Columbian Exposition. Though Douglass eventually lost his diplomatic position in Haiti, he remained a friend of Haiti, and the government asked him to serve as the nation's representative at the Chicago exposition's Haitian pavilion. At the conclusion of the 1892 edition of *Life and Times*, Douglass claimed that being appointed to this post was one of the "crowning honors to my long career."[6] But we get a somewhat different perspective on his work at the pavilion in a letter to Charles of October 1893. He confides to "Charley": "I shall rejoice when I can again plant my feet on Cedar Hill. It seems hard to have such a home and enjoy it so little." Yearning for his magnificent home in Washington, DC, Douglass the family- and house-deprived man nevertheless goes on to tell his son that "I am certainly doing some good in the life I am living. I am holding up the standard for my people." What comes across in this letter is that Douglass near the end of his life understood that his work as a public person had come at a cost, keeping him at a relative distance from his beloved family. It's almost as if he's trying to convince himself in this letter of the continuing importance of the "severe cross"

6 Douglass, *Life and Times*, 457. On Douglass and Haiti, see Levine, *Dislocating Race and Nation*, ch. 4.

that he describes taking up at the end of his 1845 *Narrative*: "pleading the cause of my brethren."[7]

There is much more in *If I Survive* that I admire and am tempted to describe in this foreword. But a foreword should pave the way into a volume and leave a good deal to the reader. I will conclude, then, by underscoring that one of the great contributions of this volume is the way it presses us to consider Douglass in relation to other people, in this instance members of his close and extended family. There is no question that Douglass as an autobiographer was successful in portraying himself as the heroic, representative leader of his black "brethren." Arguably, he was almost too successful in these rhetorical efforts, so that in the autobiographies in particular we lose sight of his relations to members of his family, whom we see in this volume were vital activists both on their own and side-by-side with Douglass. Douglass's autobiographies generally situate him as a self-reliant individual in the midst of a culture that, from Benjamin Franklin to Ralph Waldo Emerson, and beyond, cultivated the myth of self-reliance as a pre-eminent virtue. But the greatest myth of all may well be that of self-reliance. Humans live in relation to other humans, and Douglass would have been the first to acknowledge that truism. After all, his antislavery and antiracism commitments, which were often collaborative, derived from his concerns about human suffering and his desire for equality across the color line. *If I Survive* casts a revealing light on Douglass's own myth of self-reliance, showing how enmeshed Douglass was with family and how enmeshed his family was with him. The Douglass that comes across in this volume is a more human figure; his reform projects gained their exigence from a profound sense of connection to people whom he tried to keep out of the public eye but who we now see were central to the public man.[8]

7 Douglass, *Narrative*, 151.
8 On Douglass in relation to women, particularly the women of his family, see Fought, *Women in the World of Frederick Douglass*. Ezra Greenspan and Celeste-Marie Bernier are both in the midst of projects about Douglass and his family.

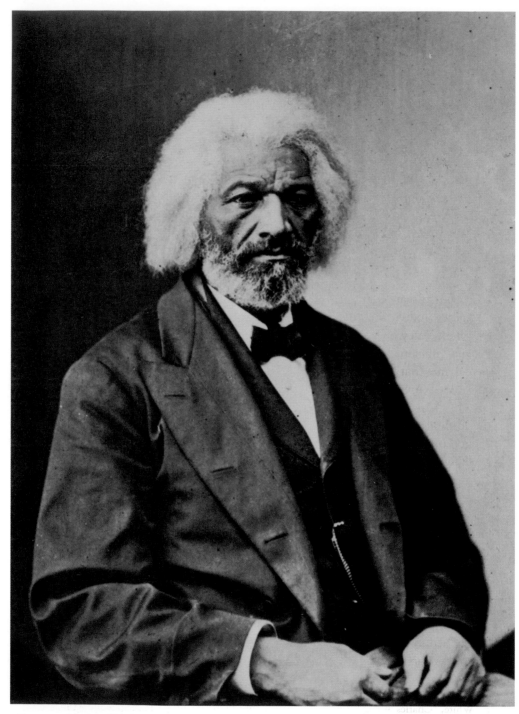

Figure 5: Mathew Brady, *Frederick Douglass*, c. 1877. (Walter O. Evans Collection, Savannah, GA.)

Preface

"My Only Way of Fighting"—Walter O. Evans and Collecting "400 years of Black History"

"I began to search for other books on Negroes, which led to Negro historical figures, individuals that played a role in the abolition of slavery, names like Denmark Vesey, who led a slave revolt. Nat Turner who also led a slave revolt. Harriet Tubman, Sojourner Truth, Booker T. Washington, Frederick Douglass, all were names that in later years I've become quite well read on."[1] So Charles White, an African American artist who was born into inner-city poverty in Chicago as early as 1918, readily confides regarding his hard-won search for Black heroes as the inspiration for his murals, paintings, and drawings. Coming of age against a backdrop of a long Civil Rights Movement and Black Power era, White was educated in a segregated school system in which white was right and Black lives did not matter. Working to carve out a space for artistic freedom in this white supremacist context, he was shocked to realize that the "book that was the standard book at that time for US history devoted only one line to the 400 years of black history."[2]

Still only a teenager in high school, White refused to capitulate to this unequal state of affairs by protesting the widespread invisibilization of pioneering Black freedom fighters in his US history class. As he recalls regarding the willful omission of legendary figures such as Frederick Douglass, Harriet Tubman, Sojourner Truth, and Nathaniel Turner, "I began to question why these names weren't mentioned in the standard US History which we all studied." He summarizes: "I remember the first day of class I had in my second year, I raised this question to

1 White, "Oral History Interview by Betty Hoag: March 9 1965," n.p.
2 White, "Charles White," 1968, 57. Unmicrofilmed Charles White Papers, Washington, DC, Smithsonian Archives of American Art.

the teacher and she told me to sit down." This high school educator's attempt to silence White had the opposite effect by providing the catalyst to his political, and subsequently artistic, resistance strategies. "I sat down and I sat out that whole class," he recalls. "I made up my mind I was going to sit out this whole class the rest of the term," he confides, freely admitting, "I was not going to participate in it until somebody gave me a satisfactory explanation of why it was so and if not why weren't they included." While he was offered no way out, as "[t]hey wouldn't let me drop US History," White staged his own act of revolutionary civil disobedience: "When the term paper came, I signed my name and turned it in blank. When she asked for oral recitation I would not raise my hand, she'd call on me and I would say, 'I don't know,' and sit down. This was my only way of fighting."[3] Over the decades, White demonstrated not one but many "ways of fighting" by assuming the role of visual historian, social commentator, and political activist across his murals, paintings, and drawings. Faced with the failures of written language as he had been forced to turn in his term paper "blank," he repeatedly turned to image-making. "Paint is the only weapon I have with which to fight what I resent," he urged.[4]

While Charles White's paintings and drawings bear witness to his determination to memorialize the lives and works of an array of Black revolutionaries and radicals living and dying over the centuries, there is one iconic figure to whom he repeatedly returns: an individual born into slavery in Talbot County, Maryland, in 1818 as Frederick Augustus Washington Bailey, only to be reborn into freedom in New York City on September 3, 1838 as Frederick Douglass. Over the decades, White produced a series of murals in which Douglass appears alongside other Black leaders, known and unknown, including *Five Great American Negroes* (1939–40), *The Contribution of the Negro to Democracy in America* (1943), and *Frederick Douglass Lives Again (The Ghost of Frederick Douglass)* (1949).[5] At the same time, Douglass is the repeated subject of White's solitary portraits. Prominent among these works are a lithograph he produced in 1951 and an etching he created in 1973, both simply titled *Frederick Douglass*, as well an oil on board work he apocryphally named *The System of the Slave— Frederick Douglass*, completed in 1974.[6]

3 White, "Interview by Betty Hoag," n.p.
4 Qtd. Barnwell, *Charles White*, 3.
5 These works are accessible online: *Five Great American Negroes*: <http://www.charleswhite-imagesofdignity.org/30.html>; *The Contribution of the Negro to Democracy in America*: <https://idealisticambitions.files.wordpress.com/2013/10/20131003-080035. jpg>; *Frederick Douglass Lives Again*: <http://www.widewalls.ch/artist/charles-wilbert-white/> (accessed January 14, 2018).
6 These works are accessible online at the digital David C. Driskell collection: <http://www. driskellcenter.umd.edu/White/White_Images/gallery1.php>; (accessed January 14, 2018).

According to Charles White, working in the twentieth century, Frederick Douglass's nineteenth-century activist legacy fulfilled a powerful function by inspiring his contemporary Black audiences to take a stand against racist injustice. White, like Douglass himself, saw no distinction between iconic and invisibilized Black freedom struggles by insisting on a continuum between public and private acts of protest. Growing up "very very poor," White poignantly concedes, "There is a woman seventy years old. . . . She's my mother. She's been a domestic worker since she was seven years old. . . . I paint about this woman."[7] For White, there was no difference in weight or purpose between the exalted activism of Douglass and the untold activism of his mother, who fought by every means necessary to survive. No exclusionary, hyper-masculine or mythic hero, White's Douglass is fallible, mortal, and inclusive.

In *Five Great American Negroes*, Douglass appears alongside celebrated figures such as Booker T. Washington, Sojourner Truth, Marian Anderson, and George Washington Carver. And yet, in stark contrast to Truth, who leads enslaved people to freedom, Washington, who exhorts an audience from the podium, Anderson, who sings, and Carver, who conducts scientific experiments, a white-haired and aged Douglass barely stands, bowed down, and with a sorrowful expression. Yet more revealingly, he does not appear alone. The visual antithesis of the legendary freedom fighter who is not only a household name but a household image, White's Douglass is burdened with the bent-over body of a traumatized young man. In a bold departure from White's imagining of Douglass according to a detailed physiognomy and elite attire in this mural, this unknown figure's face is concealed from view while his head rests in his hands: he is partially naked and clothed only in ragged pants.

No more hard-hitting visualization of Douglass's own personal conflict between his life as lived in slavery and his life as lived in freedom can be found than in White's memorialization. Here Frederick Douglass, the freeman, is literally burdened, and bound by rope, to the body of Frederick Bailey, the "slave."[8] As White realized only too well in his own day-to-day fight for survival against racist atrocities in the twentieth-century United States—which included being forced to the back of a segregated bus at gunpoint, and the lynchings of family members—Douglass escaped the fact of chattel slavery only to be confronted by the survival of the "spirit of slavery" in ongoing systems of economic, legal, social, political, and cultural disenfranchisement.[9] As we will

7 Qtd. Lovoos, "The Remarkable Draughtmanship of Charles White," 96; qtd. Barrett-White, *Reaches of the Heart*, 155.
8 Writing his first autobiography in 1845, Frederick Douglass chose a title that exposed slavery as a US institution: *Narrative of the Life of Frederick Douglass, an American Slave*.
9 Douglass, *Life and Times*, 363.

see, an exposure to these inequalities was not only to define Douglass's post-war radicalism but to traumatize the lives of his daughters and sons: Rosetta, Lewis Henry, Frederick Jr., Charles Remond, and Annie Douglass. They were all equally only too aware that they were born into a freedom that was in name only. While living their lives in the shadow of the "great" Frederick Douglass—now, as then, a mythological invention with very little bearing on Douglass the fallible mortal individual, let alone the political radical, experimental orator, literary author, philosopher, historian, and family man—they fought against every form of persecution in their lifelong quest for social justice. Theirs was an unceasing war against the white racist discriminatory forces that permeated every area of their lives. As voiced by Rosetta Douglass, they defied their incarceration within a new form of enslavement by sharing equally in her sense of despair: "I feel in bondage."[10]

Charles White's memorialization of Frederick Douglass, the free man, as burdened by the suffering of Frederick Bailey, the slave, in *Five Great American Negroes* visualizes Douglass's exposure to a physical and psychological wounding that showed no sign of abating during his own lifetime. Writing as early as 1845, less than a decade out of the "prison-house of bondage," he poignantly remembered his exposure to daily trauma.[11] "I was driven so hard, and whipped so often, that my soul was crushed and my spirits broken. I was a mere wreck," Douglass writes. He betrays his seeming disbelief: "I can scarcely realize how I ever passed through it without losing all my moral and intellectual energies."[12] And yet, while he succeeded in retaining his cerebral and emotional powers in the face of his exposure to a body-and-soul-destroying torment, he suffered from a repeated resurfacing of emotional and mental trauma.

Scarcely a year later, on May 16, 1846, Frederick Douglass sends a confidential letter to Ruth Cox, an escaped fugitive living in his own household, in which he lays bare his all-consuming depression. Nothing could be further from his self-creation as Douglass the public icon of super-heroic masculinity than this letter in which he writes as Bailey, a man still broken down by slavery and afflicted with psychological turmoil. He gives free rein to a gamut of emotions ranging from self-hatred to suicidal despair by confiding, "a few days ago—quite down at the mouth. I felt worse than 'get out!' My under lip hung like that of a motherless Colt. I looked so ugly that I hated to see myself in a glass. There was no living for me." Starkly contrasting to the aggrandized language for which Frederick Douglass the famed orator was celebrated, Frederick Bailey, the fallible individual writing to a

10 Rosetta Douglass Sprague to Frederick Douglass, Philadelphia, April 4, 1862.
11 Garrison, "Preface," *Narrative of the Life of Frederick Douglass*, iii.
12 Frederick Douglass to William Lloyd Garrison, Perth, Scotland, January 27, 1846.

woman he intimately referred to as his sister, sought solace in the colloquial language of the plantation in order to give vent to his despair. As he confides, "I was so snappish I would have kicked my grand 'dadda'! I was in a terrible mood—dats a fac! Ole missus is you got any ting for poor nigger to eat!!!"[13] For these reasons, it is necessary to approach Douglass's public declarations of self-liberation—including this celebrated example—with extreme caution: "You must not judge me now by what I then was—a change of circumstances has made a surprising change in me. Frederick Douglass, the freeman, is a very different person from Frederick Bailey, the slave. I feel myself almost a new man—freedom has given me new life."[14]

While Douglass "the freeman" was indeed "a very different person" to Bailey "the slave," the suffering experienced by Bailey "the slave" was to continue to define the many lives and loves of Douglass "the freeman." As Kenneth B. Morris Jr., Charles Remond Douglass's great-great grandson, powerfully writes, "The comment in this letter offers insight into the soul of a man whose humanity had been stripped away by the overseer's lash."[15] All white abolitionist claims to the contrary, and as Frederick Douglass and the thousands more who made it out of the house of bondage poignantly understood, the journey from slavery to freedom was no linear trajectory: the fight for their "humanity" remained a day-to-day struggle. Living a "new life" not as a "new man" but as *almost* a new man," Douglass escaped the physical reality of slavery only to re-experience the physical and psychological difficulties presented by the "guilty ghost" of the "old system."[16] As one "going to war without weapons" but refusing to surrender, as it was for Douglass in 1845 so it was for White a hundred years later: "The Negro fight for freedom, is the motivating impulse underlying all my works."[17]

At the same time that White produced *Five Great American Negroes*, he executed a delicately rendered pencil drawing in which he provides an intimate close-up of Douglass's physiognomy and which he simply titled *Frederick Douglass*, dated a year later in 1940 (Figure 6).

This portrait's striking resemblance to Douglass's face as portrayed in *Five Great American Negroes* suggests that this drawing may well have functioned as a study for his final mural. Douglass is not physically burdened with the body of his younger enslaved self in this monochrome work, but White invites his audience to reimagine his painful history by carefully delineating the furrowed forehead and saddened eyes that make up his sorrowful expression. While in his

13 Frederick Douglass to Ruth Cox, May 16, 1846, 124.
14 Frederick Douglass to William Lloyd Garrison, January 27, 1846.
15 Morris, "Afterword," in Stauffer, Trodd, and Bernier, *Picturing Frederick Douglass*, 224.
16 Frederick Douglass, n.t., n.d., n.p. Lewis Henry Douglass Scrapbook, Walter O. Evans Collection.
17 Qtd. Bernier, *African American Visual Arts*, 127.

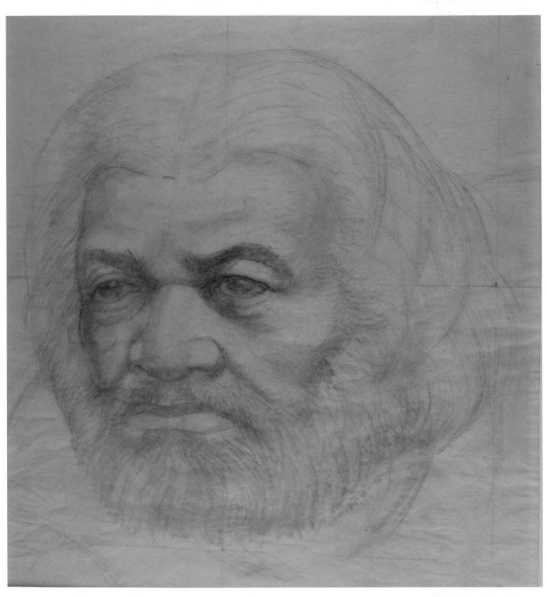

Figure 6: Charles Wilbert White, *Frederick Douglass*, 1940. (Pencil on paper, 14 x 11½ inches. Walter O. Evans Collection at the Savannah College of Art and Design Museum of Art, Savannah, GA.)

younger days Douglass had warred against the "caracature [sic] of my face" by assuming the traumatized "face of the fugitive slave," as an elder statesman and public icon he had lost none of his power to convey the suffering of Black people enslaved and free.[18] Across his postbellum portraits, he was equally dedicated to communicating his inconsolable sorrow at the daily losses of civil rights and the horrifying escalation of white vigilante violence enacted against African American women, children, and men.

Douglass's lifelong burden of bearing witness to the ongoing struggle not only to remember Black sacrifice but to endorse Black liberation strategies is powerfully to the fore in a studio photograph taken by renowned photographer Mathew Brady circa 1877 (Figure 5). A hard-hitting case in point, Douglass appears with a no less pained physiognomy at the same time that he chooses to show his muscular hands as a testament to his indomitable strength. While it is unlikely that this was the actual photograph White used as the basis for his drawing, Brady memorializes Douglass during the same era of his life, as readily conveyed by the similarities of his hair, facial hair, and lined physiognomy. Circulating as no grotesque stereotype across a visual archive that he himself commissioned and controlled, Douglass's dignified self-portraits represent his call to arms in an ongoing war of representation. "Negroes can never have impartial portraits at the hands of white artists," he insisted. He was in no doubt that, "It seems to us next to impossible for white men to take likenesses of black men, without most grossly exaggerating their distinctive features." As he confirmed, "the reason is obvious. Artists, like all other white persons, have adopted a theory respecting the distinctive features of Negro physiognomy."[19] Over the decades, Douglass's strategies of self-imaging and self-fashioning across his meticulously rendered daguerreotypes, cartes-de-visite, cabinet cards, and albumen prints lay bare his commitment to pioneering his own radical "theory" of Black representation, according to which he exposed the "gross exaggeration" of white artists for what it was: a visual lie.

Clearly, Charles White's conviction that images are weapons in the arsenal for the "Negro fight for freedom" is shared not only by Frederick Douglass—who wrote himself into existence at the same time that he dedicated his life to image-making in the service of Black equality—but by Walter O. Evans, a world-renowned collector, curator, and conservator of African American history, culture, and memory (Figure 7).

As the pre-eminent collector not only of paintings, sculptures, drawings, etchings, and lithographs but of manuscripts, letters, speeches, narratives, novels,

18 Douglass, "Letter to Sylvester Betts," January 28, 1883. Also see Bernier, "A Visual Call to Arms," 323–57.
19 Douglass, "A Tribute for the Negro," 380.

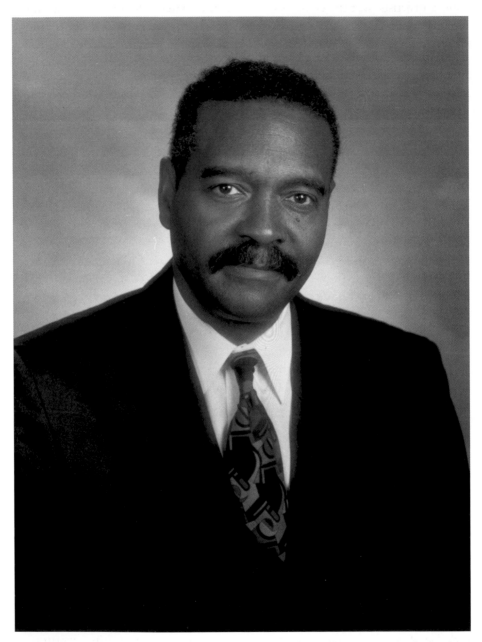

Figure 7: Anon., *Walter O. Evans*, n.d. (Walter O. Evans Collection, Savannah, GA.)

dramas, and poetry written, published, and disseminated by African American authors and artists over the centuries, Evans is the owner of White's drawing and of the copy of Brady's photograph. In a single private collection we encounter the works of a twentieth-century artist alongside those of a nineteenth-century freedom fighter. Inarguably, Walter O. Evans fuses Douglass's with White's "way of fighting" by assuming the role not only of the collector but of the conservator and preserver of "400 years" of Black histories, memories, stories, and lives. For Douglass, White, and Evans, words as well as images are weapons in the fight for social justice: a fight that has lost none of its force but is still more pressing in 2018, the two-hundred year anniversary of Douglass's birth.

Walter O. Evans as "Griot": A Collector, Conservator, and Curator of African American Art, Culture, History, and Memory

"Growing up in Savannah, Georgia, and Beaufort, South Carolina, did not afford me the opportunity to visit museums and galleries," Walter O. Evans confides: "Blacks simply were not allowed in these so-called public facilities." Coming of age in a mid/late twentieth-century US South, he was exposed to the discriminatory practices of segregation that bled through every area of civil, political, and cultural life. And yet he took solace in the fact that "I did, however, learn about African American writers, educators, and activists in the all-black elementary schools that I attended." In comparison to Charles White's white racist northern education, which was sorely lacking, Walter Evans's southern Black teachers immersed him in the lives and works of African American writers and artists. "I read about Langston Hughes, Paul Laurence Dunbar, Mary McLeod Bethune, Paul Robeson, Frederick Douglass, Booker T. Washington, Henry Ossawa Tanner, and many others," he recalls. Not only was he steeped in African American history and culture from a young age as a result of his Black-centric formal education, but he had the privilege of a resource that was much closer to home. As he confirms, "My family also taught me about these historical figures."[20]

Summarizing Evans's early biography from his birth in "Savannah, Georgia, in 1943," Shirley Woodson emphasizes that he was the "youngest of the five children of Willie Mae Rakestraw and Fred Benjamin Evans." As she declares, "Walter spent his boyhood days in Savannah and Beauford, towns where history and tradition were their life breath." As a result, he benefited from an in-depth knowledge of, and immediate access to, extended family relationships, histories,

20 Evans, "Reflections on Collecting," in Payne et al., *Walter O. Evans Collection of African American Art*, 19.

and memories. "The importance of family tradition and heritage in addition to a well founded education in the Evans family was in keeping with that of the southern African American community," Woodson observes, noting, "Evans began early on to assume a responsibility for knowledge of his ancestry and the meaning of his cultural heritage." As a subsequent world-leading collector, curator, and conservator of African American art, history, and culture, Walter Evans betrays his early indebtedness to the dual benefit of a Black-centered schooling and a family tradition dedicated to preserving and communicating oral histories. From an early age, Evans was equipped with all the cultural knowledge and psychological support he needed from within his community. As Woodson confirms, "This tightly woven fabric of cultural tradition, the social and psychological imperative to obtain freedom (within the land of the free) and the recognition of knowledge as a liberator was the backdrop of the African American south and duly prepared Evans for the tasks before him."[21]

Going north to Hartford, Connecticut, as a young adult, "where all of my teachers and most of my schoolmates were white," Walter Evans soon encountered a very different story and one which was much more similar to the invisibilization of Black culture encountered by Charles White. "People of African descent were not mentioned in history classes," he remembers. He was horrified but unsurprised to learn that, "With the exception of a paragraph in the American history textbook, which made the absurd claim that slaves were happy-go-lucky and content, blacks were simply omitted."[22] Walter Evans's ire betrays many similarities with Frederick Douglass's hard-hitting rejection of white racist ignorance centuries earlier. Writing in *Narrative of the Life of Frederick Douglass, an American Slave* in 1845, he had a ready explanation for any and all such fallacies surrounding the seemingly "happy-go-lucky" contentment of enslaved women, children, and men. As he explains, "slaves, when inquired of as to their condition and the character of their masters, almost universally say they are contented, and that their masters are kind," for the simple reason of survival: "The slaveholders have been known to send in spies among their slaves, to ascertain their views and feelings in regard to their condition." While living in slavery, Douglass freely admitted to his own complicity in this mythology: "I have been frequently asked, when a slave, if I had a kind master, and do not remember ever to have given a negative answer."[23]

On graduating from medical school as a surgeon, Walter Evans soon learned that the white racist ignorance that succeeded in writing African American

21 Woodson, "Curator's Notations on the Collector," 13.
22 Evans, "Reflections on Collecting," 20.
23 Douglass, *Narrative*, 19.

history out of US textbooks was the same racist ignorance that guaranteed the invisibility of African American art in mainstream galleries. "What moved me was that in all my visits to the museums of the world, I almost never saw any art by African-Americans," he admits, stating, "'If there were any, they didn't have any black figures in the paintings.'"[24] As confronted with this wholesale white-washing of Black art and artists from western art history, Evans's determination that "'my daughters'" would be able to "'see works with African-American images in them'" in their family home assumed a yet greater urgency.[25] As he explains, "'It was a conscious move on my part.'"[26] Working to rectify white mainstream gaps and omissions by taking on the role of the collector, as Judith H. Dobrzynski confirms, "In 1978, when the Detroit Institute of Art published a portfolio of 22 silk-screen prints by Jacob Lawrence called *The Legend of John Brown*, Evans bought the complete set."[27] Les Payne, a longtime friend and journalist, confirms, "With the purchase of the John Brown series—his first fine art purchase—Dr. Evans had framed the philosophy that would guide the early phase of his collecting."[28]

Evans's purchase of Jacob Lawrence's *John Brown* series testifies to the dual commitment to Black radical artistry and Black revolutionary activism that lie at the heart of his philosophy of collecting. His vision was shared by Jacob Lawrence, who readily admitted, "I was working with the Negro history theme," when creating these and other works. As Lawrence declared, he had been inspired to create his series commemorating white US freedom fighter John Brown's revolutionary actions in the fight for Black freedom at Harpers Ferry in 1859, by a determination to do justice to "people," Black and white, who were "involved in a struggle."[29] A commitment to memorializing the "struggle" no less motivated Frederick Douglass over a century earlier. Just two decades after this white freedom fighter's death, Douglass exposed his own shortcomings in order to celebrate John Brown's heroism. He had no qualms in conceding, "I could live for the slave, but he could die for him."[30] In his collections, Evans owns Lawrence's *John Brown* series alongside an original manuscript John Brown himself authored shortly before his death, in which he maps his family history.

"Into the late 1980s I collected a succession of paintings, sculptures, works on paper, books, manuscripts, and letters by African Americans," Evans confirms.[31]

24 Qtd. Payne, "Foreword," in *Walter O. Evans Collection of African American Art*, 9.
25 Qtd. Dobrzynski, "An Eye for American Art," 84.
26 Qtd. Payne, "Foreword," 10.
27 Qtd. Dobrzynski, "An Eye for American Art," 80.
28 Payne, "Foreword," 9.
29 Lawrence, "Oral History Interview," n.p.
30 Douglass, "John Brown," n.p.
31 Evans, "Reflections on Collecting," 20.

Inarguably, Evans's decision to collect Lawrence's *John Brown* series signaled his beginnings as a collector not only of art but of literature authored by African Americans, enslaved and free, and spanning historical and contemporary eras. "As an art collector and bibliophile," Woodson argues, "Walter Evans maintains a historical balance between art and letters." She emphasizes, "His curatorial approach to acquiring art and writing by African Americans has provided his collection with a discernible scholarship." A defining feature of Evans's "discernible scholarship" can be found in his commitment to collecting African American works inspired by and dedicated to the "struggle." As a result, he does justice, as Woodson argues, to "his sense of the necessity of visual and literary artistic expression as a reflection of our social history."[32] However much they differ in wide-ranging time periods, political contexts, and activist as well as artistic traditions, figures such as Frederick Douglass, John Brown, Charles White, and Jacob Lawrence, along with thousands more within his collection, betray a shared commitment to using visual or textual means to remember and recreate African American "social history."

"My introduction to collecting printed works (books, manuscripts, letters, documents) was quite another story," Walter Evans summarizes.[33] His determination to own histories, novels, narratives, letters, plays, and essays written by African American authors was motivated by his realization that, while he had "heard of" major Black literary figures, "I didn't read any books by African Americans in high school." At the outset, he was inspired by a determination to collect Black-authored literary works "for my daughters to read. Not to collect."[34] While "[i]n the beginning, I simply wanted first editions, autographed if possible," he soon broadened his scope to include a wide range of genres as well as manuscripts and scrapbooks in addition to published works. "I sought out the several dealers (mostly white) who specialized in black material. McBlain's, formerly in Des Moines, Iowa, but now based in Connecticut, was one of the most prominent," he explains.[35] As a result, as Les Payne emphasizes, "[i]n addition to art, Evans is also a world class bibliophile, specializing in the written works of African Americans." He confirms, "He is also fast gaining a reputation as one of the nation's leading private collectors of black literary memorabilia and correspondence."[36]

As of 2017, and since Les Payne made this statement nearly thirty years ago in 1991, there can be little doubt that Evans has now secured his reputation as the

32 Shirley Woodson, "Curator's Notations on the Collector," in Payne et al., *Walter O. Evans Collection of African American Art*, 13.
33 Evans, "Reflections on Collecting," 21.
34 Bernier, "Interview with Walter O. Evans."
35 Evans, "Reflections on Collecting," 21.
36 Payne, "Foreword," 10.

pre-eminent collector of "black literary memorabilia and correspondence." A labor of love, he has amassed a staggering collection of over 100,000 works. As Evans explains, while his collection began with a signed first edition of Paul Laurence Dunbar's collection *Folks from Dixie*, first published in 1898, it has since grown to include a multitude of authors that cover all genres and centuries of Black literary production. Among the writers in his collection can be counted the following: James Baldwin, Benjamin Banneker, Charles W. Chesnutt, Henri Christophe, Duke Ellington, Henry Highland Garnet, Langston Hughes, Jermain W. Loguen, Toussaint Louverture, David Walker, Phillis Wheatley, Malcolm X, Harriet E. Wilson, and Richard Wright. This handful of names is in no way an accurate reflection of the thousands of works of all forms, genres, dates, subjects, and contexts held in his collection.

"'Culture defines a people and art and is a significant part of that definition, like music and literature,'" Walter Evans declares.[37] "My wife Linda and I feel that by collecting African American art, literature and documents we, too, are helping to preserve this legacy."[38] Working not in isolation but with the endorsement of his wife, daughters, and granddaughters, he confirms, "My family has been extremely supportive of all aspects of my collecting efforts."[39] At the heart of Evans's and his family's collaborative vision is the hope that they will inspire others to start their own collections of African American art and literature. As he urges, "I hope that in some small way my collecting will encourage others to do the same, and to recognize the importance of preserving our cultural heritage, providing a legacy for those who come after us."[40] Over the decades, he remains unswerving in his determination to share knowledge and raise political and cultural consciousness. As he states, "my wife and I have established the Walter O. Evans Foundation for Art and Literature as a means of keeping the collection intact and ensuring that appreciation for and education about African American art and literature will be perpetuated."[41] Clearly, as Shirley Woodson argues, "In his collection of African American art, he has done so from a perspective of responsibility."[42] She celebrates the fact that, "He has responded to the visual arts as a griot, a keeper of the culture, and here he remains steadfast."[43] As not only a collector but a self-appointed "griot," Evans assumes the burden of conserving not only African American "visual arts" but African American literary production in

37 Ibid.
38 Evans, "Statement," n.p.
39 Evans, "Reflections on Collecting," 25.
40 Ibid. p. 25.
41 Ibid.
42 Woodson, "Curator's Notations on the Collector," 13.
43 Ibid.

order to educate, inspire, and galvanize social change for Black diasporic peoples across all generations.

Anecdotally, Evans admits, "Visitors come to my home and say, 'A black person painted that?' looking at a Duncanson or a Bannister," to which he is unequivocal in his response: "'Yes, I tell them, a black person painted that.'"[44] Such is no less Evans's vision for his literary collection, for which his response to any doubters would equally be, "Yes, I tell them, a black person wrote that." In a letter to white radical Gerrit Smith in 1851, Frederick Douglass himself betrayed a similar realization regarding the potentially transformative impact of feats of Black authorship for effecting social, political, moral, philosophical, and cultural change. Writing of his admiration for the proliferation of writings by Black authors in the mid-nineteenth century, Douglass was exultant. "The fact that Negroes are turning Book makers may possibly serve to remove the popular impression that they are fit only for Boot blackers," he declares. He was jubilant that, "although they may not *shine* in the former profession as they have long done in the latter, I am not with out [sic] hope that they will do themselves good by making the effort."[45]

Centuries apart, Walter Evans the contemporary collector, curator, and conservator of African American histories, narratives, and memories has his historical counterpart in Frederick Douglass, for whom any and all evidence of Black literary and artistic prowess was nothing short of revolutionary. Writing of his second autobiography, *My Bondage and My Freedom*, published in 1855, Douglass justified its publication in ways that reflect on his overall belief in the ameliorative power of Black literature in the unending fight against white racism. "I see, too, that there are special reasons why I should write my own biography, in preference to employing another to do it," he admits, stating in no uncertain terms: "Not only is slavery on trial, but unfortunately, the enslaved people are also on trial." For Douglass, as for Evans, the only way in which to annihilate white supremacist allegations that African Americans are "naturally, inferior; that they are so low in the scale of humanity, and so utterly stupid, that they are unconscious of their wrongs, and do not apprehend their rights," is to create and collect Black-authored, Black-imagined, and Black-disseminated works of literature and art.[46] According to their shared vision, it is not only by producing and commissioning but by amassing thousands of writings, paintings, sculptures, and drawings by African Americans that it becomes possible to begin to do justice to the missing "400 years" of Black US social, cultural, and political history.

44 Payne, "Foreword," 11.
45 Frederick Douglass to Gerrit Smith, January 21, 1851, 172.
46 Douglass, *My Bondage and My Freedom*, vii.

Frederick Douglass and Family in the Walter O. Evans Collection

"Among the materials in my collection is a large group of books, pamphlets, letters, and other written material relating to the great abolitionist Frederick Douglass," Walter Evans summarizes.[47] *If I Survive: Frederick Douglass and Family in the Walter O. Evans Collection* is the result of longstanding collaborations between Walter Evans and the authors. Working together to produce this volume, we are inspired by a shared commitment to bringing his collection of materials authored by Frederick Douglass and his family before a wider audience. As the inventory which we include in the bibliography at the end of this book confirms, the extent of the unpublished materials within the Walter O. Evans Frederick Douglass collection represents the largest and most significant private collection on this freedom fighter and his family members in existence.

By way of a very brief overview, the Walter O. Evans collection comprises the following: two editions of Douglass's autobiographies and one history of Benjamin Banneker, as bequeathed by Lewis Henry to his descendants and inscribed by Frederick Douglass to Frederick Douglass Jr.; six draft manuscripts comprising variations of Frederick Douglass's speeches, many of which are authored and/or annotated in his own hand; thirteen rare pamphlets publishing Douglass's speeches during his lifetime, many inscribed by Douglass or his family members; eight undated scrapbooks compiled by Lewis Henry, Charles Redmond, and Frederick Douglass Jr. and consisting of newspaper clippings (many from publications that have not survived) as well as handwritten letters, family histories, and drawings; one account book belonging to Frederick Douglass Jr. into which he pasted newspaper clippings, letters, and poems; thirteen unpublished typescripts of Douglass's public addresses and letters spanning the antebellum and post-war periods; forty-seven letters authored by Frederick, Lewis Henry, and Charles Remond Douglass, among many other correspondents, including Lewis Henry Douglass's wife, Helen Amelia Loguen; an autobiographical manuscript written by Frederick Douglass Jr.; a biography of Frederick Douglass Jr.'s wife, Virginia L. Hewlett Douglass, and a copy of one of her poems as written and reproduced by her husband following her death; Charles Remond Douglass's handwritten draft speech in which he retells the life of Frederick Douglass through the missing lens of his family's history; miscellaneous poems, letters, and condolences notes; over twenty photographic prints including daguerreotypes, cabinet cards, and cartes-de-visite; more than thirty letters and poems relating to the lives of Helen Amelia Loguen and the Loguen family. This Loguen archive—which we have recorded in the final part of this volume—includes potentially the sole surviving letter written by Amelia's mother,

47 Evans, "Reflections on Collecting," 21.

Caroline E. Storum Loguen, a leading conductor with her husband, Amelia's father, Jermain W. Loguen, on the Underground Railroad in Syracuse, New York.

To date, the Walter O. Evans Douglass and family collection has proved invaluable for a vast number of world-leading scholars including David Blight, Leigh Fought, Ezra Greenspan, John Stauffer, and Zoe Trodd. On the publication of this volume, it is to be hoped that the inclusion of the first annotated transcripts as well as the original facsimiles, complete with in-depth chronologies, detailed introductory essays, and an extensive bibliography, will make these materials much more widely accessible to international audiences. Working to widen knowledge of this collection yet further and to provide audiences with access to the original artifacts and archives, a series of US and UK exhibitions of the Walter O. Evans Douglass Collection will be held at the following institutions during 2018 and 2019: National Library of Scotland, Edinburgh, Scotland; Frederick Douglass National Historic Site, Washington, DC; Maryland State Archives and Banneker Douglass Museum, Annapolis, Maryland; Savannah Collage of Art and Design Museum of Art, Savannah. The research for this volume forms part of three larger ongoing research projects: *Struggle for Liberty: Frederick Douglass's Family Letters, Speeches, Essays, and Photographs*, comprising biographical chapters on Rosetta, Lewis Henry, Charles Remond, Frederick Jr., and Annie Douglass as well as annotated transcripts of their newly excavated 800+ writings and portraits; *For Your Eyes Only: The Private Letters of Frederick Douglass and Family*, consisting of the family's private writings; and *Living Parchments: Artistry and Authorship in the Life and Works of Frederick Douglass*, the first literary biography of Douglass's major and minor works, tracing the 7,000+ items held in the Library of Congress.[48]

Recognizing that the Frederick Douglass that is needed in a twenty-first century Black Lives Matter era is no infallible icon but a mortal individual, this volume cuts to the heart of Douglass's family relationships. While the many public lives of Frederick Douglass—as the representative "fugitive slave," autobiographer, orator, abolitionist, reformer, philosopher, and statesman—are and continue to be lionized worldwide, the aim of this book in which we publish the Walter O. Evans Douglass collection alongside essays, original facsimiles, and annotated transcripts is to shed light on the many lives of Douglass not only as public icon and renowned author and activist, but as private individual and family man. All of life can be found within these pages—romance, tragedy, hope, despair, love, life, war, protest, politics, art, and friendship—as the Douglass family worked together for a new dawn of freedom. The collection provides rare insights not only into a Frederick Douglass we have yet to encounter but into the lives and works of his sons, Lewis Henry, Frederick Jr., and Charles Remond, each

48 Bernier, *Struggle for Liberty*; Bernier, *For Your Eyes Only*; Bernier, *Living Parchments*.

of whom played a vital role in the freedom struggles of their father. As activists, educators, campaigners, civil rights protesters, newspaper editors, orators, essayists, and historians in their own right, Lewis Henry, Frederick Jr., and Charles Remond Douglass were no less unafraid than their father to sacrifice everything they had. They each fought for Black civic, cultural, political, and social liberty by every means necessary as they testified that there were not one but many "ways of fighting." No isolated endeavor undertaken by an exemplary icon, the fight for freedom was a family business to which all the Douglasses dedicated their lives.

For Frederick Douglass Jr., writing to his father in 1883, his own and his sisters' and brothers' contributions to the struggle was clear-cut. As he insists, "I feel that we children have shared in a measure, your sacrifices for the good of the Cause."[49] Lewis Henry Douglass was equally adamant that his own and his siblings' activism reflected the liberationist priorities not only of their legendary father, but of their repeatedly invisibilized mother: "The family worked on and only encouraged by the thought that they were working for the cause in which their father and mother were interested—namely the emancipation of the slave."[50] Celebrating his father's life during a public event organized for an anniversary of his birth and in the same year that he died in 1920, Charles Remond, Frederick Douglass's longest-surviving son, was jubilant: "We were a happy family in this work for the enslaved of our race."[51] While they were indeed a "happy family" in their collaborative efforts to liberate the "enslaved of our race," their surviving writings confirm that Frederick Douglass was not the only one who suffered as the collective fight for freedom took its emotional and physical toll. Rosetta, Lewis Henry, Frederick Jr., Charles Remond, and Annie Douglass all experienced bodily agonies, psychological afflictions, personal tragedies, emotional conflicts, and discriminatory barriers that leave no doubts regarding the enormity of their sacrifice.

As for Frederick Douglass himself—and here is where our book begins—the consciousness that slavery and its legacies had the power to destroy the lives of his children was an injustice that could in no way be borne. His realization regarding the vulnerability of his family provided the all-consuming motive that undergirded his unceasing fight against not only "my bondage" but "our bondage," as he fought not only to secure "my freedom" but "our freedom." As early as 1848, scarcely a decade out of slavery, Douglass was categorical in his conviction: "A slaveholder never appears to me so completely an agent of hell, as when I think of and look upon my dear children."[52]

49 Frederick Douglass Jr. to Frederick Douglass, July 26, 1883.
50 Lewis Henry Douglass, "Undated and untitled handwritten statement."
51 Charles Remond Douglass, "Some Incidents."
52 Frederick Douglass, "Letter to Thomas Auld," September 3, 1848.

Figure 8: Anon., *Rosetta Douglass Sprague*, n.d. (National Park Service: Frederick Douglass National Historic Site, Washington, DC.)

Family Tree

Frederick Douglass (1818–1895)

marries Anna Murray Douglass
Sept. 15 1838 (1813–1882)

marries Helen Pitts Douglass
Jan. 24 1888 (1838–1903)
No children

Rosetta Douglass (1839–1906)
marries Dec. 24, 1863
Nathan Sprague (1841–1907)

Lewis Henry Douglass
(1840–1908)
marries Oct. 7 1869
Helen Amelia Loguen
(1843–1936)

Frederick Douglass Jr.
(1842–1892)
marries Aug. 4 1869
Virginia L. Molyneaux Hewlett
(1849–1889)

Charles Remond Douglass
(1844–1920)
marries Sept. 27 1866
Mary Elizabeth Murphy
(c.1848–1878)

Annie Douglass
(1849–1860)

Annie Rosine Sprague
(1865–1893)

Harriet Bailey Sprague
(1866–1940)

Alice Louise Sprague
(1868–1875)

Estelle Irene Sprague
(1871–1930)

Fredericka Douglass Sprague
(1873–1943)

Herbert Douglass Sprague
(1875–1943)

Rosabelle Mary Sprague
(1877–1960)

No children
(1870–1886)

Frederick Aaron Dougas
(1870–1886)

Virginia Anna Douglass
(1871–1872)

Lewis Emmanuel Douglass
(1874–1875)

Maud Ardelle Douglass
(1877–1877)

Charles Paul Douglass
(1878–1895)

Gertrude Pearl Douglass
(1883–1887)

Robert Smalls Douglass
(1886–1887)

Laura Antoinette Haley
(1851–1928)
marries Dec. 30 1880

Haley George Douglass
(1881–1954)

Charles Frederick Douglass
(1867–1887)

Joseph Henry Douglass
(1869–1935)

Annie Elizabeth Douglass
(1871–1872)

Julia Ada Douglass
(1873–1887)

Mary Louise Douglass
(1874–1878)

Edward Arthur Douglass
(1877–1879)

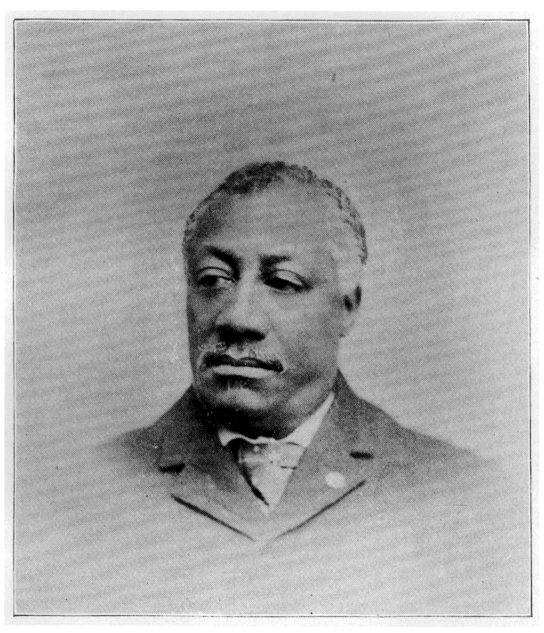

Figure 9: Anon., *Lewis Henry Douglass*, n.d. Reproduced James M. Gregory, *Frederick Douglass the Orator*. (Springfield, MA: Willey Company, 1893. Collection of the Rochester Public Library Local History Division, Central Library of Rochester and Monroe County, Rochester, NY.)

Acknowledgments

Both authors: We would like to express our heartfelt gratitude to Walter O. Evans and Linda Evans of the Walter O. Evans Foundation, without whom this book could not have been researched, written, or published. While the errors are entirely ours, *If I Survive* is solely made possible by Walter O. and Linda Evans's inspirational vision, breathtaking knowledge, and exemplary expertise. We have benefited from enriching and illuminating conversations with Walter and Linda Evans at every stage of the research and writing of this book. The Walter O. Evans Foundation is an inspirational organization dedicated to preserving, memorializing, and disseminating knowledge of African American history, culture, and art across all centuries and for audiences all over the world.

Working together on this book, our collaborations have extended to a series of UK and US exhibitions on Frederick Douglass and his family. These will be on view in 2018 and 2019 at the following institutions: in the UK, the National Library of Scotland, Edinburgh; in the US, the Frederick Douglass National Historic Site, Anacostia, Washington, DC; the Maryland State Archives Annapolis; the Savannah College of Art and Design Museum, Savannah, Georgia. We would like to express our heartfelt thanks to the following curatorial, educational, and directorial teams at each of these heritage sites, museums, and galleries: at the National Library of Scotland, Dora Petherbridge, Jackie Cromarty, Beverley Casebow, Christopher Fleet, Alison Metcalf, Ciara McDermott, Kenny Redpath, Sally Todd, Sarah Willmott, Gordon Yeoman; at the Frederick Douglass National Historic Site, Mike Antonioni and Ka'mal McClarin; at the Maryland State Archives, Catherine Arthur, Ryan Cox, Maya Davis, Christopher E. Haley, Emily Oland Squires; at the Savannah Contemporary Museum of Art and Design, Storm Janse van Rensburg and Geoffrey Taylor. This Frederick Douglass Family project, as it has developed across *If I Survive* and these national and international exhibitions, is deeply indebted to the transformative expertise of the following world-leading academic-activists at the Center for Black Studies Research, the University of

California Santa Barbara: Diane Fujino, Esther Lezra, George Lipsitz, Jeffrey Stewart, and Barbara Tomlinson. There is no question that George Lipsitz's powerful declaration regarding our responsibilities as researchers in deciding what a scholarship which "serves the cause of social justice" might look like has been with us every step of the way.

We would like to thank the following Frederick Douglass scholars for their groundbreaking expertise: John Blassingame, David Blight, Jeanine DeLombard, Joseph Douglass Jr., Leigh Fought, Henry Louis Gates Jr., Ezra Greenspan, Lee Jenkins, John R. McKivigan, John Muller, Hannah-Rose Murray, Rose O'Keefe, Alasdair Pettinger, Alan Rice, Fionnghuala Sweeney, John Stauffer, Zoe Trodd, and Robert K. Wallace. Without Zoe Trodd's wonderfully generous and kind introduction, we would never have had the privilege of meeting Walter O. and Linda Evans. Ever dear to our hearts is the inspirational activism and brilliant scholarship of Earnestine Jenkins, Bill E. Lawson, and Richard A. Lou. Their methodologies and practices have taught us new ways to think, write, and see. Finally, we would like to thank visionary scholars Kim F. Hall and Robert S. Levine, not only for their seminal writings, which have transformed the scholarly terrain on Douglass, but for the inspirational Foreword and Afterword that open and close this book.

For making *If I Survive* a reality, we are indebted to the exemplary team at Edinburgh University Press, including James Dale, Carla Hepburn, Gavin Peebles, and Adela Rauchova. Our editor, Michelle Houston, inspired us on with her belief in this book and with her lifelong commitment to the life and works of Frederick Douglass. We are also extremely grateful to our internal readers, internationally renowned scholars Rachel Farebrother and Simon Newman. Again, while the errors are all ours, we have worked hard to try and do justice to their brilliantly incisive reports and expert recommendations in finalizing this book. We would also like to thank our wonderfully generous and supportive colleagues at the University of Edinburgh for their vital contributions to *If I Survive* and the Douglass family project more generally: Janet Black, Paul Crosthwaite, David Farrier, Charlie Jeffrey, Anne Sofie Laegran, James Loxley, Dorothy Miell, Nisha Patel, and Jeremy Robbins. We were extremely grateful to receive a University of Edinburgh College of Humanities, Arts, and Social Sciences Knowledge Exchange and Impact Award, which made the publication of these original facsimiles possible. We are also indebted to the University of Edinburgh School of Languages, Literatures and Cultures Impact Fund for vital assistance in the production of this volume. We would like to express our heartfelt thanks to Judie Newman O.B.E., Emeritus Professor at the University of Nottingham. She shared generously from her vital expertise in orthography and genealogical research.

While we are deeply indebted to the Walter O. Evans Collection, we are grateful to the following institutions and organizations for permission to reproduce numerous Douglass family manuscripts, prints and photographs from their collections: Manuscripts and Prints and Photographs Divisions, Library of Congress, Washington, DC; Prints and Photographs Division, Moorland-Spingarn Research Center, Howard University, Washington, DC; National Park Service, Frederick Douglass National Historic Site, Washington, DC; Onandaga Historical Association Research Collection, Syracuse, New York; Rochester Public Library Local History Division, Central Library of Rochester and Monroe County, Rochester, New York. We are very grateful to Meaghan Alston at Moorland-Spingarn Research Center for her wonderful generosity and support of this project by supplying so many of the beautiful portraits we include here. Every effort has been made to trace the copyright holders, but if any have been inadvertently overlooked, the publisher will be pleased to make the necessary arrangements at the first opportunity.

CELESTE: I would like to thank the National Humanities Center for the Senior John Hope Franklin Fellowship, which made the completion of this book possible. I would like to express my profound debt of gratitude to the class of 2016–17 fellows for many inspirational conversations and for their wonderful friendship: Kim F. Hall, Grace Musila, Cynthia Talbot, Matthew Booker, Douglas Campbell, Mariana Dantas, Marlene Daut, Florence Dore, Laurent Dubois, Zsuzsanna Gulácsi, Mary E. Hegland, Benjamin Kahan, Nicola Marafiati, Richard Mizelle, Edith Sara, Tamara Sears, Nancy Wicker, Jakobi Williams, and Shellen Wu. The inspirational team—Brooke Andrade, Joel Elliott, Sarah Harris, Richad Newman, Joe Milillo, Don Solomon, Lois Whittington, and Felisha Wilson—all made this project possible. As always, this book on Mr. Douglass and his family is written for Richard Anderson and Catherine Nash: our conversations are a source of joy. This book is for Alan Frankland.

BOTH AUTHORS: This book on Frederick Douglass and his family comes to life from a series of conversations with another inspirational family from Maryland. We would like to dedicate this book not only to Kim F. Hall, the wonderful author of the Afterword, but to her mother, Vera P. Webb Hall, an activist and creator of breathtaking quilts, her father, Lawrence H. Hall, her brother, Reginald Lawrence Hall, and her family's lifelong friend, Charles Bowen. The opportunity to talk about the lives and works not only of Mr. Douglass himself but of Rosetta, Lewis Henry, Frederick Jr., Charles Remond, and Annie Douglass is a gift that never stops giving.

Lewis H. Douglass,

No. 609 F Street, N. W.,

WASHINGTON, D. C.

WASHINGTON. D.C.
DEC. 6
4 - PM
1894

DIC
22
1894
PUERTO PLATA

Mrs. H. Amelia Douglass
Care of Mrs. S. Marinda Fraser
Puerto Plata
San Domingo, W.I.

A Note on Texts and Editorial Practice

Working respectfully with the unpublished writings authored by Frederick Douglass and his sons, Lewis Henry, Frederick Jr., and Charles Remond Douglass, and held in the Walter O. Evans collection, we have endeavored to reproduce the text of the manuscript material in our transcripts with minimal editorial intervention. This has meant that we have not silently corrected any inconsistencies of grammar, punctuation, or expression. We indicate with [sic] words which have been misspelt, rather than correcting them. Where we are unable to read a word in the manuscript, this is indicated in the transcription by ___ [?]. As we are publishing the original facsimile pages alongside our edited transcriptions, we invite our readers to identify any and all words that have continued to elude us. As regards our edited transcriptions of these primary Douglass family materials, our annotations have been designed to be helpful to the reader rather than exhaustive, and to be explanatory rather than interventionist.

At the outset, we would like to signal a profound note of caution for our readers. Due to the fact that our archival research is still ongoing into the biographies of the children, women, and men who make up the wider Douglass family and friends circle, in many cases it has been impossible to name individuals referred to in these manuscripts with categorical confidence. As of 2018, our research into the Douglass family continues to fill those gaps.

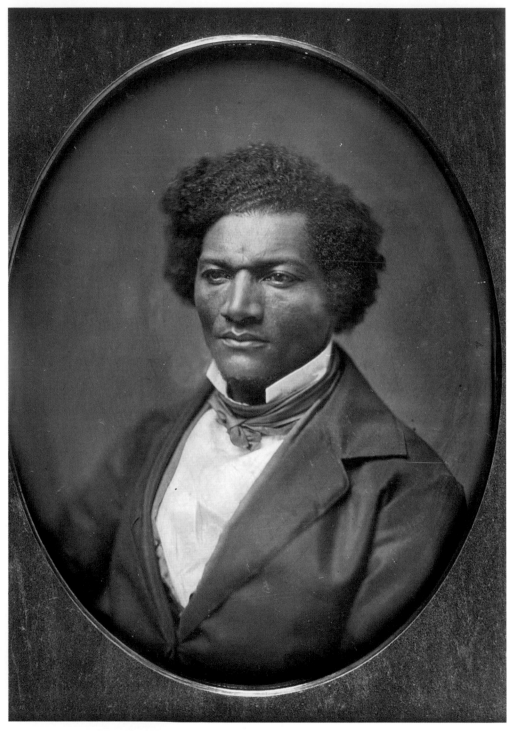

Figure 10: Anon., *Frederick Douglass*, 1843. (Onandaga Historical Association Research Collection, Syracuse, NY.)

Introduction

"We Labored with our Father"—The Told Story of Frederick Douglass is the Untold Story of His Family

"Just ten years ago this beautiful September morning, yon bright sun beheld me a slave—a poor degraded chattel—trembling at the sound of your voice, lamenting that I was a man, and wishing myself a brute."[1] So Frederick Douglass writes in a provocative letter entitled "To My Old Master" (Thomas Auld), which he published in the pages of his newspaper, *The North Star*, on September 8, 1848. While he exalts in his freedom from chatteldom a decade following his act of self-emancipation, he admits to the failure of any and all attempts to vocalize the suffering he then endured. He confides, "I have no words to describe to you the deep agony of soul which I experienced on that never-to-be-forgotten morning. I was like one going to war without weapons." While his anxieties defy literary expression, he waxes eloquent by taking great pleasure in informing Auld of his new life as an antislavery activist. Writing of his early recognition by renowned white abolitionists, he tells his "old master" that, "[a]fter remaining in New Bedford for three years, I met with Wm. Lloyd Garrison, a person of whom you have *possibly* heard, as he is pretty generally known among slaveholders. He put it into my head that I might make myself serviceable to the cause of the slave by devoting a portion of my time to telling my own sorrows, and those of other slaves which had come under my observation." Realizing only too well that Auld was already profoundly aware of his celebrated success, Douglass declares: "This was the commencement of a higher state of existence than any to which I had ever aspired." Ever artfully knowing that Auld would find himself lacking by the implied comparison between white northern and southern morality, Douglass

1 Frederick Douglass, "To My Old Master," September 3, 1848.

relishes in the fact that, "I was thrown into society the most pure, enlightened and benevolent that the country affords."[2]

Writing his "old master," Thomas Auld, on the ten-year anniversary of his life-changing moment of self-liberation, Douglass was keen to insist that his exaltation was not confined to his public renown as an antislavery activist but extended into his private life. "So far as my domestic affairs are concerned, I can boast of as comfortable a dwelling as your own," he confides, noting, "I have an industrious and neat companion, and four dear children—the oldest a girl of nine years, and three fine boys, the oldest eight, the next six, and the youngest four years old." Here Douglass deliberately suppresses the names of his wife, Anna Murray, and of his sons and daughters, Rosetta, Lewis Henry, Frederick Jr., and Charles Remond, for their safety. As a formerly enslaved individual whose own ancestors, as well as his brothers and sisters, were bought and sold on the auction block, Douglass recognized the incendiary nature of his "domestic affairs." He was painfully aware that the right to a family home constituted a violation of the legal practices of US slavery, according to which enslaved parents had no rights that white men were bound to respect. Adding insult to injury, Douglass takes great joy in flouting every belief Auld, as a white slave-trader, holds dear by informing him, "The three oldest are now going regularly to school—two can read and write, the other can spell with tolerable correctness words of two syllables."[3] As if it was not enough that Douglass and his wife and children were able to live together, they were also benefiting from an education. This was no mean feat in an era in which the Black woman, man, and child's right to literacy was typically obtained on pain of torture, imprisonment, and death in the US south and in the face of virulent prejudice and discrimination in the North.

Douglass's delight in informing Thomas Auld of his children's access to education was no doubt exacerbated by his own memory of being denied learning his "A.B.C." as an enslaved boy living in the household of his master's brother, Hugh Auld, in Baltimore. Burned into Douglass's memory was the fact that Hugh Auld "forbade Mrs. Auld to instruct me further, telling her, among other things, that it was unlawful, as well as unsafe, to teach a slave to read." Auld brooked no dissent by insisting, "A nigger should know nothing but to obey his master." Among the words that especially hit home for Douglass, as he later recalled, were Auld's warnings to his wife: "said he, 'if you teach that nigger (speaking of myself) how to read, there would be no keeping him. It would forever unfit him to be a slave.'" For Douglass, this epiphany was nothing less than revolutionary. As Douglass the intellectual philosophised, "I now understood what had been to me a most

2 Ibid.
3 Ibid.

perplexing difficulty—to wit, the white man's power to enslave the black man. It was a grand achievement, and I prized it highly. From that moment, I understood the pathway from slavery to freedom."[4] As Douglass writing in a public letter to Auld saw it, the joy that he was bringing up children who were "going regularly to school" and "unfit to be slaves" prophesied a new society in which the "pathway from slavery to freedom" was not only a dream but a reality. As he declared in "Blessings of Liberty and Education," a speech he delivered in Manassas, Virginia, toward the end of his life: "Education . . . means emancipation. It means light and liberty."[5]

"Dear fellows! they are all in comfortable beds, and are sound asleep, perfectly secured under my own roof," so Douglass jubilantly celebrates his children's freedom in his letter to Auld.[6] Not for his children was his own fate, which he poignantly recalls in his first autobiography: "I used to steal a bag which was used for carrying corn to the mill. I would crawl into this bag, and there sleep on the cold, damp, clay floor, with my head in and feet out." Douglass's exultation that his children sleep in "comfortable beds" is retributive justice for his own suffering for which he still carried the scars: "My feet have been so cracked with the frost, that the pen with which I am writing might be laid in the gashes."[7] He is equally triumphant in this public letter to his old master that his rights as a father are respected: "There are no slaveholders here to rend my heart by snatching them from my arms, or blast a proud mother's dearest hopes by tearing them from her bosom." Now living beyond the barbaric clutches of villainous slaveholders, he is full of "heart and hope" that "These dear children are ours—not to work up into rice, sugar, and tobacco, but to watch over, regard, and protect, and to rear them up in the nurture and admonition of the gospel—to train them up in the paths of wisdom and virtue, and as far as we can, to make them useful to the world and to themselves."[8]

And yet, the ideal picture that Douglass paints for himself and his children whom he delights in "training" so they can be "useful to the world" soon begins to shatter despite all his best efforts to hold it together. While writing as a loving father living in seeming freedom, he has no choice but to remember the tragedies experienced by families that were broken apart and destroyed by slavery. "Oh! sir, a slaveholder never appears to me so completely an agent of hell, as when I think of and look upon my dear children," he exclaims. He admits to a loss of self-possession when faced with this enormity: "It is then that my feelings rise above

4 Douglass, *Narrative*, 33.
5 Douglass, "Blessings of Liberty and Education," September 3, 1894.
6 Frederick Douglass, "To My Old Master," September 3, 1848.
7 Douglass, *Narrative*, 27.
8 Frederick Douglass, "To My Old Master," September 3, 1848.

my control." Overcome by emotion at even the thought of the plight his "dear children" would have suffered in slavery, he gives full vent to his traumatic memories. Douglass bears witness to his own and others' suffering by admitting, "I meant to have said more with respect to my own prosperity and happiness, but thoughts and feelings which this recital has quickened, unfits me to proceed further in that direction." He relies on distressing imagery to declare, "The grim horrors of slavery rise in all their ghastly terror before me, the wails of millions pierce my heart, and chill my blood."

No longer physically anchored and safe in his "comfortable dwelling," Douglass's "feelings" catapult him back to the plantation. "I remember the chain, the gag, the bloody whip, the deathlike gloom overshadowing the broke spirit of the fettered bondman, the appalling liability of his being torn away from wife and children and sold like a beast in the market," he writes. He forces Auld to concede the accuracy of his testimony by insisting, "Say not this is a picture of fancy. You well know that I wear stripes on my back inflicted by your direction." Incontestably, the physical violations that scarred Douglass's body during his struggles as a "fettered bondman" remained indivisible from the psychological wounds produced at the thought, let alone the reality, of "his being torn away from wife and children."[9]

For Frederick Douglass, the public antislavery activist and renowned orator, the ten-year anniversary of his emancipation was undoubtedly a cause for celebration. However, for Frederick Douglass, the private husband and father of five children—Annie Douglass was born a year later in 1849—and for whom the memories of Frederick Bailey "the slave" would repeatedly "rise before him," a life in freedom in a nation defined by chattel slavery was no freedom and no life at all.

Appearing on the 200-year anniversary of Frederick Douglass's birth, *If I Survive: Frederick Douglass and Family in the Walter O. Evans Collection* reproduces the original facsimiles and annotated transcriptions of over fifty manuscripts, letters, speeches, and essays written by Frederick Douglass and his sons, Lewis Henry, Frederick Jr., and Charles Remond Douglass. This book also provides full-color reproductions of their repeated appearances in the more than twenty portraits held in this private archive. The aim in sharing these unpublished materials with readers is to follow in the footsteps of Rosetta, Lewis Henry, Frederick Jr., and Charles Remond Douglass. They all assumed the role of family archivists, collectors, and historians during their father's lifetime and in the decades following his death. Their decision to tell the untold story of the Douglass family's collective activism over their autobiographies, speeches, letters, and essays represented a bold departure from the intentions of their father.

9 Ibid.

Writing Douglass on August 1, 1889, Frederic May Holland, one of his earliest biographers, petitioned him for some missing information. In the last stages of finalizing *Frederick Douglass: The Orator*, which first appeared in 1891 during Douglass's lifetime and in a revised edition in 1895, the year of his death, Holland asked Douglass to fill in particular gaps. As he informs him, "There are a number of dates which would be of great interest to the public, like those of the birth of your children."[10] Douglass immediately complies in a letter he writes two days later on August 3. For the benefit of Holland, he copies out the relevant dates as inscribed in the family Bible: "here they are from the family record. Rosetta June 24 1839. Lewis Henry October 9 1840. Frederick March 3 1842. Charles Remond Oct 21 1844. Annie March 22 1849." While he willingly supplies Holland with these "dates," he holds nothing back in expressing his disapproval. "I hardly see the need of giving the dates of the births of my children," Douglass declares. He admits to being utterly unconvinced regarding the relevance of this information by insisting, "I do not exactly see what light it can through [sic] upon my oratory, or upon my career as a public man."[11]

For Douglass, who had deliberately concealed the names of his children in the public letter he had written to Thomas Auld as early as 1848, the issue of separating his private from his public life was no less pressing in 1891. As he saw it, the lives of his children had no bearing or relevance to "my career as a public man." And yet, as the letters, manuscripts, essays, and speeches authored by Douglass's family and published alongside the research essays included in this volume reveal, nothing could be further from the case. Incontestably, Douglass's "career as a public man" was not only made possible by the activism of Anna Murray and Helen Pitts Douglass, his first and second wives, but by the groundbreaking accomplishments of Rosetta, Lewis Henry, Frederick Jr., Charles Remond, and Annie Douglass. Without the roles played by all the Douglass family as grassroots campaigners and Underground Railroad conductors; and by Rosetta as amanuensis, editor, proof-reader, household manager, domestic carer, food preparation specialist, secretary, school teacher, political advisor, and woman's rights activist; and by Lewis Henry, Frederick Jr., and Charles Remond Douglass, variously as Civil War combatants and recruiters, newspaper editors, printers, typesetters, delivery agents, civil rights campaigners, and electoral reform leaders, there would be no Frederick Douglass the "public man."

Writing Helen Amelia Loguen from the Civil War frontlines on July 20, 1863, and in the aftermath of the Battle of Fort Wagner two days earlier, Lewis Henry Douglass was at pains to reassure the woman who became the love of his life.

10 Frederic May Holland to Frederick Douglass, August 1, 1889. General Correspondence, Frederick Douglass Papers, Library of Congress.

11 Frederick Douglass to Frederic May Holland, August 3, 1889. General Correspondence, Frederick Douglass Papers, Library of Congress.

"Remember if I die I die in a good cause," he urges, conceding, "I wish we had a hundred thousand colored troops we would put an end to this war." "Should I fall in the next fight killed or wounded I hope to fall with my face to the foe," he confides, taking heart by promising, "If I survive I shall write you a long letter."[12] As Frederick Douglass fought to survive slavery, so Rosetta, Lewis Henry, Frederick Jr., Charles Remond, and Annie Douglass joined their father in the fight not only—in Lewis Henry and Charles Remond's case—to survive the Civil War and end slavery, but to survive a freedom that would be no freedom at all without the collaborative struggle of the entire Douglass family.

Rosetta Douglass Sprague, Lewis Henry Douglass, and Narrating the Lives of Frederick Douglass and his Family

"The story of Frederick Douglass's hopes and aspirations and longing desire for freedom has been told—you all know it," Rosetta Douglass Sprague informs her audiences in "My Mother As I Recall Her," a speech she delivers before the Anna Murray Douglass Union, a Black women's activist organization named in honor of her mother, only five years following her father's death in 1900 (Figures 8, 11, and 12).[13]

Working to raise awareness among her listeners of a story that had *not* been told and which they did not know, she was insistent that her father's liberation was a collaborative rather than a solitary effort. She declares: "It was a story made possible by the unswerving loyalty of Anna Murray, to whose memory this paper is written."[14] As Douglass Sprague affirms, it was Murray Douglass's "courage" that supplied "the mainspring that supported the career of Frederick Douglass."[15] In a lesson that is still to be learned for many twentieth- and twenty-first-century scholars who remain intent—all evidence to the contrary—on eulogizing Douglass as the lone "great man," she implodes any and all mythic constructions of her father as an isolated heroic icon. In so doing, she takes to task Douglass's own early strategies of self-imagining. Clearly, for Douglass's eldest daughter, the onus is not on telling the isolated "narrative of the life of Frederick Douglass," but the multiple narratives of the many lives of Frederick Douglass and his family.

12 Lewis Henry Douglass to Helen Amelia Douglass, July 20 [1863].
13 Douglass Sprague, *Anna Murray Douglass*, 6. This printed pamphlet is held in the Frederick Douglass Papers, Library of Congress. Their copy bears the handwritten inscription: "To Amelia Douglass—from J.H.D." These are most likely the initials of Joseph Henry Douglass, Lewis Henry and Amelia's nephew.
14 Ibid.
15 Ibid. 9.

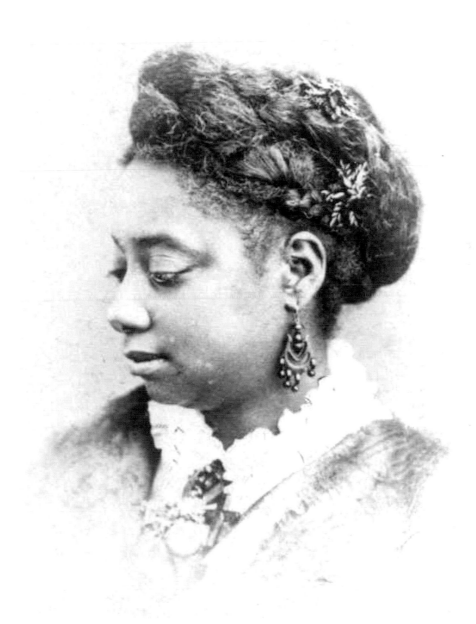

Figure 11: Anon., *Rosetta Douglass Sprague*, n.d. (National Park Service:
Frederick Douglass National Historic Site, Washington, DC.)

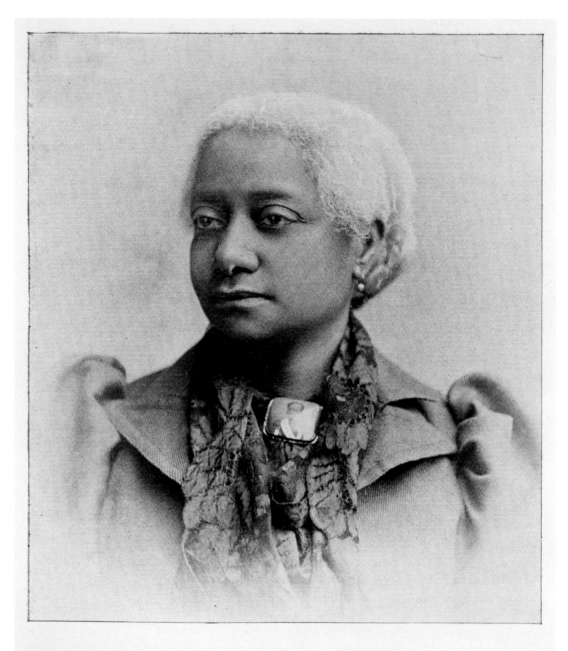

MRS. R. D. SPRAGUE,
Daughter of Frederick Douglass.

Figure 12: Anon., *Rosetta Douglass Sprague*, n.d. Reproduced James M. Gregory, *Frederick Douglass the Orator*. (Springfield, MA: Willey Company, 1893. Collection of the Rochester Public Library Local History Division, Central Library of Rochester and Monroe County, Rochester, NY.)

She establishes beyond all doubt that Douglass's freedom was made possible by her mother's labor as a "housekeeper." Living as the first freed individual in her family in Baltimore, she was "able to save the greater part of her earnings," which she was then "willing to share with the man she loved that he might gain the freedom he yearned to possess."[16] According to Douglass Sprague, it was Anna Murray Douglass's heroic act of self-sacrifice that secured her father's liberty.

In "My Mother As I Recall Her," Douglass Sprague summarizes her father's first years in freedom as a joint effort: "The early days in New Bedford were spent in daily toil, the wife at the wash board, the husband with saw, buck and axe."[17] She draws on firsthand accounts within the Douglass family to establish the veracity of her testimony by recalling, "I have frequently listened to the rehearsal of those early days of endeavor."[18] She celebrates Murray Douglass's importance not solely as a supporter of her husband but as an activist in her own right. "She was a recognized co-worker in the A.S. Societies of Lynn and Boston, and no circle was felt to be complete without her presence," she emphasizes.[19] Douglass Sprague insists on her mother's pioneering status as a northern-based freedom fighter by urging, "Being herself one of the first agents of the Underground Railroad she was an untiring worker along that line." While Murray Douglass financially aided one celebrated man in making his escape, as her daughter observes, she assisted many more whose names will never be known. As she affirms, and as many of her contemporaries, including other Underground Railroad operators, reiterated, "It was no unusual occurrence for mother to be called up at all hours of the night, cold or hot as the case may be, to prepare supper for a hungry lot of fleeing humanity."[20] As Booker T. Washington no less insisted: "Mr. Douglass, or Mrs. Douglass in her husband's absence, calling the boys, Lewis, Fred. and Charles, would have fires started in that part of the house where fugitives were hidden away, and at an opportune time they were taken to Charlotte, seven miles from Rochester, and placed aboard a Lake Ontario steamer for Canada."[21] While Frederic May Holland makes no mention of Anna Murray or Rosetta, as his focus is almost exclusively on Douglass's heroism as "an active agent of the Underground Railroad," he nevertheless admits to the role played by the sons: "When any new arrival took place, the little Douglass boys would go to and fro collecting funds, to pay the fare on the steamer across Lake Ontario."[22]

16 Ibid.
17 Ibid. 10.
18 Ibid.
19 Ibid. 13.
20 Ibid. 16.
21 Washington, *Frederick Douglass*, 160.
22 Holland, *Frederick Douglass*, 186.

As Rosetta Douglass Sprague, the revisionist historian, urges in "My Mother As I Recall Her," it is to Anna Murray Douglass rather than their father that Lewis Henry, Frederick Jr., and Charles Remond owed their careers as newspaper printers, editors, compositors, and typesetters. These professional skills were to play a key role in their lives and are the repeated focus of their letters and essays included in this collection. "During one of the summer vacations the question arose in father's mind as to how his sons should be employed, for them to run wild through the streets was out of the question," she remembers.[23] She pulls no punches regarding the white racist stranglehold presented by Northern prejudice in the 1850s by recalling, "[t]here was much hostile feeling against the colored boys." She notes that this hostility was a profound concern to her father. As "he would be from home most of the time" on his antislavery lecturing tours, "he felt anxious about them." The solution was the brainchild of Murray Douglass and Murray Douglass alone: "Mother came to the rescue with the suggestion that they be taken into the office and taught the case. They were little fellows and the thought had not occurred to father. He acted upon the suggestion and at the ages of eleven and nine they were perched upon blocks and given their first lesson in printer's ink, beside being employed to carry papers and mailing them."[24]

No longer vulnerable to racist attack on Rochester's city streets, Lewis Henry, Frederick Jr., and Charles Remond Douglass were instead apprenticed to the trade that was to become the lifeline within their professional careers and play a defining role in their grassroots activism. As Joseph L. Douglass Jr. confirms, "Journalism had become their first occupation and an enduring interest."[25] While they were to suffer from the discriminatory practices of white printers' unions, to which they were denied entry on racist grounds, they made history by working with their father to publish *The North Star*, *Frederick Douglass' Paper*, *Douglass' Monthly*, and *New National Era*. They also made major contributions to other leading African American journals such as *The Zion Standard and Weekly Review* and *The National Leader* by supplying editorials, political commentaries, and miscellaneous contributions. Working to insert themselves within a Black writerly tradition rooted in activism, they drew on their journalistic skills to publish countless letters of protest in which they took to task all forms of legal, political, social, and cultural discrimination facing African Americans in the national and regional press. The result of extensive research over the last few years, their protest writings run into the hundreds and appeared in the *Washington Bee*, *Washington Post*, *New York*

23 Douglass Sprague, *Anna Murray Douglass*, 17.
24 Ibid.
25 Joseph L. Douglass Jr., *Frederick Douglass*, 47.

Globe, Christian Recorder, Evening Star, Denver Daily, and *Rochester Democrat and Chronicle,* as well as many other publications.

Ultimately, Rosetta Douglass Sprague rejects any and all racist assumptions surrounding Anna Murray Douglass's refusal to learn to read by celebrating her exemplary gifts as a mother: "Unlettered tho' she was, there was a strength of character and of purpose that won for her the respect of the noblest and best." Frederick Douglass was undoubtedly his daughters' and sons' public inspiration, but it was Murray Douglass who was their private counselor, advisor, and guide. As her daughter observes, she played a vital role in the formation of their character: "She was a woman who strove to inculcate in the minds of her children the highest principles of morality and virtue both by precept and example."[26] While Douglass Sprague is at pains to recuperate key facts about her brothers' lives within this speech, her focus is ultimately on doing justice to her mother's invisibilized life. A few years later, Lewis Henry Douglass eulogized Anna Murray Douglass's heroism not as an end in itself but as a platform to memorialize his own and his sisters' and brothers' activism in the "struggle for the cause of liberty."

Lewis Henry Douglass tells the untold story not solely of his mother's but of his brothers' and sisters' contributions to the celebrated "story of Frederick Douglass" in an undated and untitled handwritten statement that he authored circa 1906.[27] Writing a response to an article debating his father's life's work that appeared in *Voice of the Negro* in 1905 but which he never published, he commends the author, Archibald Grimké, for his "glowing recital of the impression made by that truly great and remarkable man in his work of uplifting the people of his race."[28] And yet, he has a powerful criticism to make by conveying his deep sense of regret: "We can but sincerely wish that he would have been able to have gone all along the line of his work from the beginning of the first days of his labors and shown what were the distresses, the anxieties, and the hardships that he and his family had to undergo in the struggle for the cause of liberty."[29] Beginning in the same vein as his eldest sister, Rosetta Douglass Sprague, a few years earlier, he fought to visibilize the invisibilized freedom struggles of his mother. First and foremost among the "distresses, the anxieties, and the hardships" endured by the family, for Lewis Henry Douglass, is the story of "How the wife—the first Mrs. Douglass—worked early and late by the sunlight of day and the burning of the midnight oil at her duties of the household."

In contrast to his father, who cultivated real divides in his life, Lewis Henry Douglass remembers his mother as a civil rights campaigner who integrated her

26 Douglass Sprague, *Anna Murray Douglass,* 24.
27 Lewis Henry Douglass, "Undated and untitled handwritten statement."
28 Ibid. See Grimké, "Cedar Hill or the Famous Home of Frederick Douglass." General Correspondence, Frederick Douglass Papers, Library of Congress.
29 Lewis Henry Douglass, "Undated and untitled handwritten statement."

public life as an activist with her private life as a mother. He expresses his heart-felt admiration of her work as a laborer, reformer, and maternal inspiration by remembering how she was "at work binding shoes for the manufacturers of shoes in Lynn, Mass, and giving her attention and what she could share in money to aid in the cause of Abolition, and at the same time having four children while her husband was away." He lifts the curtain on the white racist inequalities that bled through every area of social and political life and from which they all suffered. As he concedes, "This was at a time when all was dark for the race with which Frederick Douglass was identified." Lewis Henry goes even further than Rosetta's emphasis on the dual reform efforts of their mother and father by mapping a history of collaborative family activism. He is insistent that the suffering belonged not to his father or even his mother alone. "No sunshine lit up the path the black man trod all was enmity, hatred and proscription," he avows. He admits to his own and his brothers' and sisters' exposure to daily struggles: "The children ~~had to partake~~ partook of the ill feelings manifested on the part of the so-called superior race and were bound down to the oppression that ruled in the dark days when pro-slavery was on deck and in command."[30]

As one of the sons whom his sister describes as "perched upon blocks and given their first lesson in printer's ink" at their mother's suggestion, Lewis Henry is ideally placed to inform his readers regarding the trials and tribulations of his father's antebellum newspaper, *The North Star* (later *Frederick Douglass' Paper*). "With what labor was it?" he asks, only to answer his own question by declaring, "Few ~~who~~ know how they work was done; how many sleepless nights and how many days were given up by his family his wife two sons and one daughter to succeed in the way of getting the paper to press ~~and~~ in mailing it and engaging in setting in type." As he recalls, he and his brothers and sisters were inspired by their parents' shared commitment to the work of Black liberation: "For years the family worked on ~~and~~ only encouraged by the thought that they were working for the cause in which their father and mother were interested—namely the emancipation of the slave." All adulations in favor of Frederick Douglass's indomitable courage notwithstanding, Lewis Henry does justice to the psychological burden placed on his own and his mother's, brothers', and sisters' lives by foregrounding the worries they endured for the sake of their father. As he remembered, "we labored with our father ~~in~~ when we have had fear for his safety as a constant companion and anxiety for his ~~safety~~ return to us from his work."[31] For Lewis, so it was for Rosetta: Frederick Douglass's sacrifice for the cause was a sacrifice endured by the entire family.

30 Ibid.
31 Ibid.

As the speeches, essays, letters, and autobiographies authored not only by Rosetta Douglass Sprague but by Lewis Henry, Frederick Jr., Charles Remond, and Frederick Douglass himself bear witness, the fight for the "emancipation of the slave," and for a newly liberated people for whom hard-won civil, political, physical, and legal freedoms were typically only a sham and a mockery, was a lifetime's work not solely for Frederick and Anna Murray Douglass but for their "dear children." While Frederick Douglass worked tirelessly as an antislavery campaigner, his daughters and sons supported his activism in equally indefatigable ways: by typesetting, proof-reading, printing, packing, delivering, and writing contributions for his newspaper; by transcribing and editing his speeches; by washing and pressing his linen; by hosting dinners and holding reform meetings; by advising him on political campaigns; by traveling with him on his lecture tours; by participating in conventions; by signing petitions; by liaising with a network of campaigners; by collaborating on numerous civil rights issues (electoral reform; women's rights; anti-lynching protests) among much more. No less importantly, they provided Frederick Douglass—who was to bear the psychological scars of Frederick Bailey, who had been cut off from his mother, denied a father, and estranged from his siblings by the institution of chattel slavery all his life—with the emotional strength to carry on.

Writing on April 29, 1847, on his return to Lynn, Massachusetts, from an eighteen-month visit to Ireland, Scotland, Wales, and England, Frederick Douglass wrote Anna Richardson, his English abolitionist friend, of his unbounded joy in being reunited with his family. "My three boys—Charles, Lewis, and Frederick, have grown rapidly, though not out of my knowledge," he declares. On his arrival at the train station in Lynn, he jubilantly confides, "When within about fifty yards of our house, I was met by my two bright-eyed boys, Lewis and Frederick, running and dancing with very joy to meet me." He refuses to give Richardson any more information, however, by insisting, "Here imagination must fill up the picture." By far the largest share of his delight arises from his sense of feeling needed by his family: "It is good to be at home; good to be among those whose welfare and happiness depend so much upon myself." "'Tis good to feel the tranquilising influence of home. Already I feel my heart improved," he urges.[32] Writing a letter to Scottish campaigners William and Robert Smeal, which he composes on the same day, Douglass includes a slight variation to this story. Here he foregrounds his reunion with his family as an emotional respite from his daily toil as an antislavery campaigner. "For once all cares of a public nature were cast aside, and my whole heart absorbed in grateful rapture," he proclaims.[33]

32 Frederick Douglass to Anna Richardson, Lynn, Massachusetts, April 29, 1847.
33 Frederick Douglass to William and Robert Smeal, April 29, 1847.

For Frederick Douglass, living his life under the public eye as a renowned orator, activist, and statesman, the opportunity to live in the private world of his family was a source of rejuvenation for "my whole heart." Frederick Douglass the free man's joy in the "tranquilising influence of home" could not be further from the suffering he endured as Frederick Bailey the "American slave." As he remembered of his domestic existence as an enslaved child, "My home was charmless; it was not home to me; on parting from it, I could not feel that I was leaving any thing which I could have enjoyed by staying." In contrast to Douglass's exultation in his close relationships with his sons, Bailey experienced only isolation: "My mother was dead, my grandmother lived far off, so that I seldom saw her. I had two sisters and one brother, that lived in the same house with me; but the early separation of us from our mother had well nigh blotted the fact of our relationship from our memories."[34] As the Walter O. Evans collection establishes, the intimate relationships between Fredrick Douglass and his sons Lewis Henry, Frederick Jr., and Charles Remond were to define their "memories." The successes or failures of their fight for survival depended upon the collective activism of a united family.

"Marks, Traces, Possibles, and Probabilities":
The Search for Frederick Douglass's Family

"Speaking of marks, traces, possibles, and probabilities we come before our readers," declares Frederick Douglass in *The Heroic Slave*, a novella he published in 1853.[35] Here he works to expose the racist biases of the white official "chattel records" which at best invisibilize and at worst distort the untold history of the "heroic slave" Madison Washington, one of the "immortal 19" who liberated over one hundred enslaved women, men, and children during a rebellion on board the *Creole* slave ship in 1841.[36] And yet his declaration has a wider applicability by offering a blueprint for the imaginative and creative work necessary for researchers to even begin to do justice to his immediate family members—Anna Murray Douglass (1813–82); Rosetta Douglass Sprague (1839–1906); Lewis Henry Douglass (1840–1908); Frederick Douglass Jr. (1842–92); Charles Remond Douglass (1844–1920); Annie Douglass (1849–60); Helen Pitts Douglass (1838–1903)—whose lives have no less been consigned to "chattel records."

Gaps in the historical record and the official archive guarantee that there are very real difficulties in even beginning to piece together the lifelong labors of

34 Douglass, *Narrative*, 28.
35 Douglass, *The Heroic Slave*, 176.
36 Ibid.

Anna Murray, Rosetta, Lewis Henry, Frederick Jr., Charles Remond and Annie Douglass as activists, reformers, historians, orators, literary writers, social commentators, and political theorists in their own right. A source of hope in the face of despair, the powerful socio-political analysis and literary accomplishments displayed by their writings and speeches—and as shown in the Walter O. Evans collection and in their published works elsewhere—lay bare their commitment to an inspirational array of reforms and activities in their lifelong determination to combat the survival of what Frederick Douglass interpreted as the "spirit of slavery."[37] As even a brief investigation into their 800+ writings confirms, no topic was off limits. They delivered speeches and wrote essays on a variety of subjects, including women's rights, discriminatory legislation, scientific racism, lynch law, prison reform, capital punishment, unfair housing, segregated schools, and prejudicial transportation networks. At the same time, they took a leading role by writing for and/or managing numerous African American newspapers. They also organized and held memberships of Black literary societies, professional sports leagues, Civil War veterans' organizations, and national reform movements, among much more. All these accomplishments notwithstanding, their lives and works have remained an absent-presence in the historical memory of Frederick Douglass.

In numerous biographical studies popularly appearing during his lifetime and immediately after his death, various authors examine the life and works of Frederick Douglass, typically by working with the primary materials supplied from the personal archives of his daughters and sons. Among these works are not only Frederic May Holland's *Frederick Douglass The Colored Orator* (1891, 1895) but Charles W. Chesnutt's *Frederick Douglass* (1899) and Booker T. Washington's *Frederick Douglass* (1906). However detailed they are regarding Douglass's own life, none of these early volumes investigate the biographical histories or writings of Douglass's sons and daughters, whose lives are repeatedly excluded from the public history of the "great man." One exception to this rule is James M. Gregory's *Frederick Douglass The Orator*, which he published in 1893. Prior to his death in 1892, Gregory had benefited from the support and expertise of Frederick Douglass Jr. in writing his biography. As a result, he breaks the silence surrounding Douglass's private life by providing a detailed examination of his daughters' and sons' lives at the same time that he reproduces a number of family portraits. All the rumors speculating that Douglass's relationships with his daughters and sons were deeply troubled notwithstanding, Gregory is at pains to celebrate a father's pride. He writes, "Frederick Douglass has followed with loving solicitude the career of his children, and has

37 Douglass, *Life and Times*, 363.

done all in his power to advance their interests and promote their happiness. Now in his advanced age he has reason to be satisfied with the success which has attended them."[38]

As of going to press in 2018, James Gregory's sensitive handling of the lives of the Douglass family remains the exception rather than the rule on into the decades of the twentieth and twenty-first centuries. Even a very brief survey of the scholarly field immediately confirms that many more exemplary scholarly works mapping Frederick Douglass's life and works have proliferated by pioneering historians and researchers but with the same results. Indeed, while numerous groundbreaking historians, biographers, and literary theorists incisively come to grips with key aspects that impacted upon Douglass's family members at various stages of their lives, there are as yet few book-length studies which investigate their biographies or works in depth, and none at all in which readers are given access to the speeches, essays, and letters they themselves authored. Benjamin Quarles's conviction, made as early as 1948, that "Douglass's love for his children outran his influence on them. None of them had his ambition or his devotion to a cause" is still a widely held view among scholars.[39] He takes this opinion yet further by speculating that Douglass "must have been depressed by the attitude of his offspring. As they grew older his children thought of him as the source from which all material blessings flowed."[40] According to Quarles's assessment, "Letters from Rosetta and Charles were invariably of a complaining or a begging nature."[41]

Rosetta Douglass Sprague and Charles Remond Douglass's letters do indeed provide hard-hitting evidence of their pecuniary struggles and their ongoing need for their father's financial support. Rosetta had severe money problems as a wife and mother, with little to no opprtunity for employment. She experienced daily struggles as she worked hard to bring up her children while living in a challenging marriage to her husband, Nathan Sprague, who, like her father, had been born into slavery (Figure 13).

Equally, while Charles was able to earn a living in various government offices, his ability to earn a wage was never secure. He suffered from exposure to the repeated exclusionary tactics of discriminatory white men, which invariably resulted in his loss of position and income. As a husband and father, he also experienced a series of personal tragedies in the premature deaths of four of his children—Annie Elizabeth, Julia Ada, Mary Louise, and Edward Douglass—and also that of his first wife, Mary Elizabeth Murphy. Frederick Douglass himself took

38 Gregory, *Frederick Douglass*, 206.
39 Quarles, *Frederick Douglass*, 109.
40 Ibid. 112.
41 Ibid.

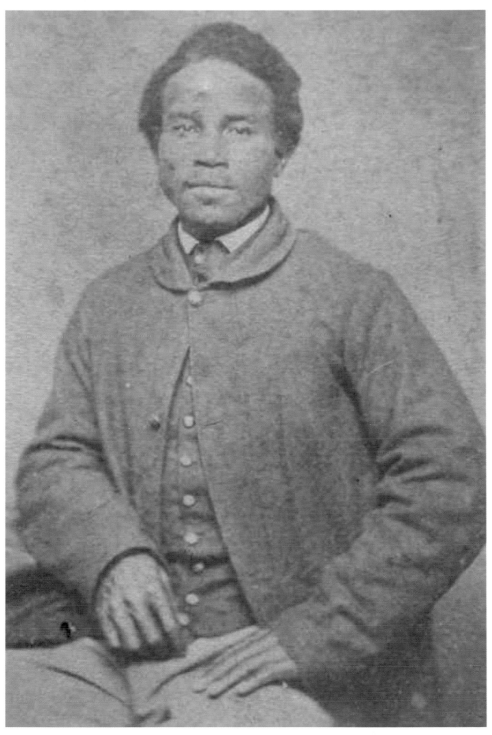

Figure 13: Anon., *Nathan Sprague*, n.d. (National Park Service:
Frederick Douglass National Historic Site, Washington, DC.)

a very different view to Quarles and subsequent commentators. He felt only compassion for the sufferings of his children, including his youngest son. As he writes Rosetta on March 22, 1890, "I share your wish that that [sic] Charley could be with me. Though I am no longer strong I might be able out of my weakness to give him some strength in the great affliction which has come to him."[42] Any and all assessments of the Douglass family relationships that do not rely on the letters, speeches, and essays they themselves authored risk downplaying the hardships faced by Rosetta, Lewis Henry, Frederick Jr., Charles Remond, and Annie Douglass. More damagingly still, these reductive accounts are responsible for generating misunderstandings which are still to be corrected. All oversimplified assumptions to the contrary, the Douglass family writings lay bare their lifelong fight to keep body and soul together in the face of very real economic, social, political, and cultural barriers.

Writing more recently, David Blight empathizes, "One can also feel the travail of a large Black family in the nineteenth century—the anguish of three sons (Lewis, Charles, and Frederick, Jr.) and one daughter (Rosetta)—products of a strained marriage—who struggled unsuccessfully to live up to the impossible model of their great father."[43] Blight does poignant justice to the "travail" endured by the Douglass family, for whom legal, political, and social persecution was a daily reality. Ultimately, as an in-depth investigation into the essays, speeches, and letters authored by Rosetta, Lewis Henry, Frederick Jr., Charles Remond, and Annie Douglass reveals, their struggles as formally trained and self-taught educators, typographers, printers, proof-readers, business correspondents, amanuenses, office managers, seamstresses, political commentators, historians, social analysts, philosophers, and domestic carers were testament to their successes against all odds. No less revealingly, Frederick Douglass's own letters to his daughters and sons in which he asks their political advice, seeks their emotional support, and confides personal decisions, confirm their indispensable emotional, intellectual, and practical contributions to the life of their "great father."

In undertaking the research for this volume, we are profoundly indebted to Joseph L. Douglass Jr. for his groundbreaking collective biography, *Frederick Douglass: A Family Biography: 1733–1936,* published in 2011. This represents an exemplary achievement toward which Douglass Jr.—himself a descendant of Douglass's brother Perry Downs, and personally acquainted with Charles Remond Douglass's son Haley George Douglass—worked exhaustively, and with

42 Frederick Douglass to Rosetta Douglass Sprague, Haiti, March 22, 1890. General Correspondence, Frederick Douglass Papers, Library of Congress.
43 Blight, "The Private Worlds," 165.

illuminating results, across a number of archives and secondary sources. It is an outstanding Douglass "family biography,"[44] meticulously researched and compellingly written, mapping the lives of each of Douglass's children in profound and revealing depth. This volume's unprecedented contribution to the study of Douglass and his family makes it all the more unfathomable that it has been largely ignored in Douglass scholarship, and that it is currently out of print. While Joseph Douglass Jr. passed away in 2015, his biography, though difficult to access, lives on. There can be no doubt that without the publication of his volume, *If I Survive* and *Struggle for Liberty*—much less our ongoing exhibitions on Douglass's family—could not have been written or curated. Joseph Douglass Jr. is in the vanguard of scholarship when he declares, "this endeavor is not intended to be a biography of the famous African American statesman. Rather, the sole intention herein is to reconstruct the development of the family of Douglass both in bondage and freedom."[45] Across his collective biography and numerous articles, he comes to grips with the intellectual and political necessity of interrogating Frederick Douglass's own repeated mythic focus on "my bondage and my freedom" in order to lay bare the Douglass family's collective fight against "our bondage" for "our freedom."

Numerous scholars are now following in Joseph L. Douglass's footsteps by taking these omissions to task and beginning to map the lives and works of his family.[46] John Muller draws on exhaustive archival research in his biography, *Frederick Douglass in Washington, D.C.: The Lion of Anacostia*, published in 2012. He includes detailed discussions of the military services, journalist activism, government work, and political activities of Lewis Henry, Frederick Jr., and Charles Remond Douglass. Even more recently, in 2013, Rose O'Keefe published her groundbreaking book *Frederick & Anna Douglass in Rochester New York: Their Home Was Open to All*. She pulls no punches regarding the difficulties besetting scholars: "Although researchers have devoted decades to cataloguing five thousand pieces of his public writings, speeches and travels in the marvelous series 'The Frederick Douglass Papers', details about the family are much harder to come by."[47]

Recognizing that the lives and works of the Douglass family continue to suffer from marginalization at best and invisibilization at worst, Leigh Fought's collective biography *Women in the World of Frederick Douglass* (2017) represents a

44 Joseph Douglass Jr., *Frederick Douglass*, vii.
45 Ibid.
46 David Blight, *Frederick Douglass: Prophet of Freedom* (New York: Simon & Schuster, 2018), includes extensive discussion of his family as drawn from the Walter O. Evans collection. Ezra Greenspan is also working with the archive to research his collective biography of Douglass's family.
47 O'Keefe, *Frederick & Anna Douglass*, 11.

seminal contribution to the field. She draws on decades of archival research—including extensive consultation of the Walter O. Evans Douglass and family collection—to right the wrongs of scholarly inaccuracies and put flesh onto the bones concerning the missing genealogies of female family members during Douglass's life in slavery. Across her volume, she excavates and examines the lives of Anna Murray Douglass and Helen Pitts Douglass as well as that of Rosetta Douglass Sprague. She also includes pioneering research in which she traces the lives and works of Julia Griffiths and Ottilie Assing, two foreign-born white women who played influential roles in Douglass's lives as business managers, editors, translators, and fundraisers. As Fought emphasizes, "family was of paramount importance to Douglass and a necessary component of his politics."[48] She underscores Douglass's daughters' and sons' struggles with heavy emotional and psychological burdens by emphasizing that they "carried with them the obligation of internalizing and projecting the image of obedient and resourceful offspring who would help improve the lot of African Americans."[49] "The Douglasses' public performance of an upstanding middle-class black family created a private space in which they could live without prejudice or judgment," she observes.[50] At the same time that Frederick, Anna Murray, Rosetta, Lewis Henry, Frederick Jr., Charles Remond, and Annie Douglass all generated intimate relationships by carving out a "private space" as defined by the absence of "prejudice or judgment," the physical and psychological struggles they experienced in undertaking the "public performance of an upstanding middle-class black family" took their toll.

While there are currently no books that include facsimile reproductions of works authored by the Douglass family, a handful of scholars have reproduced isolated letters and speeches. As early as 1926, Carter G. Woodson published four letters that Helen Amelia Loguen and Lewis Henry Douglass wrote to one another in 1862 and 1863, as held in his private collection in the *Journal of Negro History*.[51] Nearly three decades later, in 1953, Joseph Borome printed a letter written by Frederick Douglass to Lewis Henry Douglass from Paris in 1886.[52] In 1955, Benjamin Quarles pioneeringly published over a dozen letters Douglass authored to Rosetta Douglass and Nathan Sprague during his tenure as US Minister to Haiti.[53] And yet, Quarles reproduced none of Rosetta or Nathan Sprague's correspondence due to the fact that his sole focus was on Douglass's letters alone.

48 Fought, *Women in the World*, 4.
49 Ibid. 6.
50 Ibid. 7.
51 See Woodson, "Letters of Negroes," 87–112.
52 Borome, "Some Additional Light," 217.
53 Quarles, "Frederick Douglass: Letters," 75–81.

According to his editorial practice, he chose to publish transcriptions of the letters as characterized by deliberate "deletions of family matters."[54] Quarles's decision to exclude this content presents very real difficulties for researchers on the grounds that very few of these letters survive in the public archives. As a result, their record of "family matters" has been forever lost. Thirty years later, Dorothy Sterling published her seminal collection, *We Are Your Sisters: Black Women in the Nineteenth Century*, in 1985. Breaking new ground, she not only reproduces a few paragraphs from Rosetta Douglass Sprague's speech, "My Mother As I Recall Her," but two letters written by Anna and dictated to an amanuensis, as well as three letters Rosetta herself composed and addressed to her father.[55]

At the same time that the appearance of the Douglass family writings in these various publications represents a vital resource for researchers, the single most important edited collection to date is Mark Anthony Cooper Sr.'s volume, *Dear Father: A Collection of Letters to Frederick Douglass from his children 1859–1894*, which appeared over twenty-five years ago in 1990. Working with the private family correspondence held in *The Frederick Douglass Papers* at the Library of Congress and in a volume that, like Joseph Douglass Jr.'s, is now out of print, he reproduces over 120 letters written by Rosetta, Lewis Henry, Frederick Jr., and Charles Remond Douglass. Recognizing that "we have always looked at Douglass the Orator, Publisher, Abolitionist, and Civil Rights Activist," Cooper Sr. was motivated to edit this collection on the grounds that "here was a fresh perspective of the man that can be found in his children's letters to him."[56] Succeeding where other scholars have failed, he recognizes the significance of the letters in "depicting the devotion of Frederick Douglass's children" by applauding this epistolary archive as "a portrait in words about family love."[57] "When you peel back all those layers of who Frederick Douglass was, you understand that this former slave, first and foremost, was a great father to his children," he observes. "These letters make it evident that he had taken time to give his children a strong foundation to make it in a world that was cruel to black people." Cooper Sr.'s careful study of their contents leads him to conclude that "[t]hey each had their own trials and struggles as young blacks trying to make it in a society after the Civil War."[58]

In a first for contemporary scholarship, Cooper Sr. memorializes the Douglass family "trials and struggles" that are otherwise repeatedly under-emphasized and even denied by the majority of researchers. No more sensitive analysis of Douglass's

54 Ibid. 75.
55 Rpt. Sterling (ed.), *We Are Your Sisters*, 133–44.
56 Cooper, *Dear Father*, 3.
57 Ibid. n.p.
58 Ibid. 4.

role as a father can be found than in Cooper Sr.'s discussion of his lifelong dedication to equipping "his children" with "a strong foundation to make it in a world" so that they would be able to withstand daily exposure to racist persecutions and injustices. Here Cooper Sr. takes us back to Douglass's own words uttered only a decade out of slavery and with which we began this introduction. As Douglass freely admitted of his aims for his children, he sought "to watch over, regard, and protect, and to rear them up in the nurture and admonition of the gospel." Over his lifetime, Douglass unfailingly betrayed his heartfelt determination "to train them up in the paths of wisdom and virtue, and as far as we can, to make them useful to the world and to themselves."[59]

No "Quagmire of a Slave Past": Researching Black Families and a Call to Scholarly Arms

While the lives of the Douglass family appear and disappear within official archives as "marks, traces, possibles and probabilities," scholarly investigations into African American families in slavery and freedom are longstanding.[60] Two decades ago, Paula Giddings was jubilant that radical developments in emerging scholarship "refuted past notions of the black family being hopelessly trapped, like Tar Baby, in the quagmire of a slave past."[61] She was heartened by a new wave of researchers who were liberated from socially determinist constructions in favor of "looking at the African-American family through the lens of what it has done, against all odds, to sustain its coherence."[62] As she emphasizes, a focus on the triumphs of Black families rather than the tragedies that traumatize their daily existence "brings one to a very different conclusion than looking at it as merely a deficit model."[63] Giddings' rejection of a "deficit model" in favor of a framework defined by what the "African American family has done" is directly applicable to the analysis of Douglass and his daughters and sons for this volume. In *If I Survive*, we dispense with any and all reductive dismissals of Douglass's family's lives in favor of developing an alternative scholarly apparatus according to which their speeches, writings, and essays are placed up front and center. As richly layered and illuminating source material, this primary archive is the catalyst to any and all debates of the importance of the Douglass family by enabling in-depth, nuanced, and thoughtful discussions of their social, political, and cultural activism.

59 Frederick Douglass, "Letter to Thomas Auld," September 3, 1848.
60 See works by Moore, Gatewood, and Ball in the bibliography.
61 Giddings, Foreword, 11.
62 Ibid.
63 Ibid.

Giddings' insistence that the lives of Black families only become accessible via an "alternative conceptual framework, a framework informed by not just sociology but history" represents a call to scholarly arms that is vital to any and all investigations into Douglass's daughters' and sons' individual and collective biographies.[64] The adoption of a historical rather than a socially determinist lens makes it newly possible to situate their activism and writings within their wider political and cultural contexts. In this book, we share her determination to endorse a "framework that does not see the black family in aberrant isolation to be measured by an imagined white middle-class norm, but rather as a product of society that both shapes and is shaped by it."[65] Working to dispense with the racist stranglehold exerted by an "imagined white middle-class norm" that commits only depredations against Black lives, it is necessary to adopt a Black-centric model according to which Black families are no longer sites of lack or inferiority but of complexity, innovation, and resourcefulness. This new frame-work makes it possible to begin to do justice to the ways in which each of Douglass's daughters and sons worked by every means necessary to defeat the persecutory forces of a white supremacist ideology that bled into all areas of Black lives in a post-emancipation era.

As Andrew Billingsley summarizes, "African-American families are both weak and strong but their strengths are by far more powerful and contain the seeds of their survival and rejuvenation."[66] He rejects any and all tendencies to oversim-plify or sensationalize the forces circumscribing Black families by maintaining that, "For scholars and others who argue whether it was slavery or contemporary racism that cripples African-American families, we argue that it is both and more."[67] More especially, he speaks to the daily struggles facing the Douglass family by being under no illusion that, "while all African-American families are not in a state of crisis, the many who do suffer inordinately are not so much in crisis as they are engulfed by a set of crisis conditions, most of which emanate from society itself."[68]

Incontestably, Rosetta, Lewis Henry, Frederick Jr., Charles Remond, and Annie Douglass were all made to "suffer inordinately" by the "crisis conditions" generated by a nineteenth-century racist US society. While Rosetta suffered destitution in trying to make ends meet as her husband, Nathan Sprague, was barred from any and all employment opportunities, Lewis Henry struggled to earn a living as a printer while being denied membership of the national typographical

64 Ibid. 14.
65 Ibid.
66 Billingsley, *Climbing Jacob's Ladder*, 17.
67 Ibid. 18.
68 Ibid. 22.

union. Similarly, Frederick Jr. and Charles Remond were repeatedly without work as they suffered from discrimination in their various positions as federal government employees. No less poignantly, in the months before her premature death at just ten years old, Annie, the Douglasses' youngest daughter, was at a loss to understand white America's capacity for injustice when confronted with the execution of her beloved friend John Brown. For these reasons, Andrew Billingsley's conviction that "one cannot understand contemporary patterns of African-American family life without placing them in their broad historical, societal, and cultural context" undergirds the methodology in this book.[69] Walter R. Allen pulls no punches regarding the limitations in current scholarship by emphasizing, "Theorists of the black family are still in pursuit of adequate theoretical frameworks for the study of black families."[70] While research into Black family structures more generally remains ongoing, the search for an all-encompassing, respectful, knowledgable, and empathetic approach to the Douglass family, let alone their all but neglected writings, is far from over.

A Written Versus an Unwritten History:
Authorship, Activism, and Artistry in the Frederick Douglass Family Scrapbooks

At the heart of the Walter O. Evans and Douglass family collection, and in addition to the signed books, letters, and manuscripts, are eight scrapbooks—an invaluable and illuminating as well as a complex and contradictory archive. Research is still very much ongoing into these volumes. In practical terms, they betray enormous differences in size, paper, and type. Preliminary findings confirm that only one of the scrapbooks is purpose-made, while all the others were compiled from reappropriated and recycled pre-printed railway passenger lists, newspaper subscription lists, and personal account books. For readers leafing through these scrapbooks, the pre-printed matter connected to the book's original purpose competes for their attention. None of these volumes are accompanied by specific dates. Working across an extended time period, they include newspaper clippings and handwritten entries that cover all the decades from the Civil War until and even beyond Douglass's death in 1895. In terms of authorship, the internal evidence presented by the almost exclusive focus on their own and their father's lives and works—as well as repeated insertions in their handwriting—confirms that these scrapbooks were almost certainly the exclusive labors of Douglass's sons, Lewis Henry, Frederick Jr., and Charles Remond Douglass.

69 Ibid. 22.
70 Allen, "The Search," 117.

According to our investigations so far, it is as yet very difficult to establish which son created which scrapbook and whether they were produced as the result of solitary or collaborative efforts. Shedding some light on these issues for researchers, a handful of these volumes are prefaced by handwritten notes signed and dated by Lewis Henry Douglass. One such note is dated August 2, 1907, a year before he died, and reads as follows: "This Scrap Book is valuable for it shows in part the action of a committee of Colored people who visited the Capitol of the Nation as a delegated body in the winter of 1866. Frederick Douglass indited [sic] the reply to the President of which George T. Downing sought to claim credit. I wrote the reply according to my father's dictation and not a word came from any body else. This book is to be given to Haley G. Douglass at my death. There are several other scraps that do not not [sic] pertain to the above Scrap Book included in these pages." Here Douglass's eldest son protects his father's legacy by ensuring that his words are not plagiarized in the pages of history. At the same time, he issues an instruction which guarantees the preservation of this scrapbook within the Douglass family by ensuring that it is handed down to his nephew, Haley George Douglass, Charles Remond's son. A treasure trove of materials, this scrapbook not only includes the handwritten copy of the "reply to the President"—as written by Lewis Henry Douglass according to Douglass's "dictation"—but numerous letters that read as a who's who of Black and white liberators: Henry Highland Garnet, Martin Delaney, John F. Cook, and John G. Whittier among them.

Yet more revealingly, and as per all the scrapbooks in the collection, this volume provides a vital aid to researchers via the compiler's decision to paste newspaper clippings of articles that were written by Frederick Douglass himself and by his sons onto these pages. These materials are indispensable on two accounts. First, the Douglass sons glued in clippings from historical newspapers—including short runs of African American periodicals—that have not survived. In these cases, their scrapbooks provide the only extant copies of these otherwise impossible-to-find writings. As a result, the full extent of Douglass's family members' published writings can only be mapped by consulting these scrapbooks. Second, Rosetta, Lewis Henry, Frederick Jr., and Charles Remond Douglass repeatedly published articles for the press anonymously. Thanks to the captions provided by Frederick Jr. and Lewis Henry Douglass—to date, these are the only individuals whose handwriting can be identified in these scrapbooks—they not only provide information on the newspaper and date in which their articles were published, but they reveal the identity of the author. This is a lifeline for researchers; to cite just one among many examples, how else would we know that the pen-name "Justice" belonged to Rosetta Douglass Sprague, except for Frederick Douglass Jr.'s handwritten caption? Given that this scrapbook in particular was originally a

purpose-built school register in which Lewis Henry Douglass recorded attendance for his classes in 1862—his students' names appear and disappear between the pasted-in clippings—it would seem very likely that he compiled this scrapbook himself. At this early stage, however, very little can be determined with any certainty regarding verification of the identities of the creators of these volumes.

"This Scrap Book I wish to have taken care of and which I give to my nephew Haley G. Douglass," Lewis Henry Douglass again instructs in a handwritten note he pastes on the cover of another undated scrapbook. At the same time that he issues a clear directive—"This book will be given on my death to Haley G. Douglass Lewis H. Douglass August 2 1907 Washington D.C."—he provides a summary of this scrapbook's contents by stating: "It contains the history of my going in the government printing office and several other matters." As per his declaration that "not a word came from any body else" concerning his father's sole authored but collaboratively signed "reply to the president" included in the other scrapbook, here Lewis Henry Douglass's observation that this volume tells "the history of my going in the printing office" confirms he was not only writing for a private audience, but for a public readership. While they were family-made, family-preserved, and for family members' circulation, Lewis Henry was under no illusion that these scrapbooks were ultimately public property. Working to insert his own "history" alongside that of his father, he uses this scrapbook as a platform on which to tell the life of Frederick Douglass not in isolation but in the immediate context of the "distresses, the anxieties, and the hardships that he and his family had to undergo in the struggle for the cause of liberty."[71]

As another non-purpose-made scrapbook, this volume comes to life from the pages of a pre-printed ledger for the Central Overland California and Pike's Peak Express Company. This time, it is lists of handwritten passengers'—rather than students'—names, as they undertake the journey from Denver to Central City in 1861, that are clearly visible. How Lewis Henry Douglass, or very likely Frederick Jr.—whose handwriting appears across the majority of these scrapbooks—obtained this pre-printed ledger is still unclear: did either son obtain it while employed by this railway company during their time living in Denver? If so, this period of their professional lives has still to be uncovered. While the newspaper clippings pasted into this volume's pages are indeed dominated by letters and articles that tell the fraught history of Lewis Henry Douglass's career as a printer, this scrapbook also includes irrecoverable ephemera. Among these items are a ticket stub "admitting Lewis H. Douglass of the 'National Era'" to the stage door entrance of the National Republican Convention held in Philadelphia in 1872. Clearly, these scrapbooks represent an unparalleled resource for coming to grips

71 Lewis Henry Douglass, "Untitled and undated handwritten statement."

with the "marks, traces, possibles and probabilities" of the Douglass family lives by providing researchers with the necessary fragments with which to piece together their hidden histories.

In a bold departure from the undated and untitled scrapbooks that are accompanied by Lewis Henry Douglass's notes, the vast majority of these volumes are numbered in Frederick Douglass Jr.'s handwriting. Very likely, they were originally his property and his creation. The internal evidence provided by his distinctive handwriting, in which he supplies captions, letters, poems, songs, and personal commentaries on private and public events, bolsters this view. The survival of these numerous volumes alongside the scrapbooks that were almost certainly compiled by Lewis Henry suggests that, at his premature death in 1890, his eldest brother assumed responsibility for their preservation as he recognized their social, political, and cultural value as a record of the Black civil rights struggle in a post-emancipation era. A tour de force of erudite political analysis and philosophical reflection as combined with poignant revelations of intimate details of the Douglass family life, Frederick Douglass Jr. merges the personal with the political throughout these scrapbooks. He includes handwritten family biographies in which he records not only the births but the deaths of his mother, wife, and children. He painstakingly summarizes the nature of their last illnesses and writes down not only the month, year, and day but the very hour and minute that they passed on. Revealingly, this grief-stricken content—the vast majority of these deaths are tragically premature—does not appear in isolation but alongside his incisive political commentaries, in which he reflects on presidential campaigns, civil rights legislation, and his own activism.

Frederick Jr.'s decision to identify the author for each of the numerous newspaper clippings he pastes into these pages is nothing less than revolutionary for our understanding of the focus, forms, and extent of the Douglass family canon of writings. He also leaves the researcher with more clues to interpret his history by himself writing his autobiography and inserting letters in these scrapbooks as he counters Joseph Douglass Jr.'s claim that "Frederick Junior left the faintest footprint of all of the children."[72] Just as the numerous scrapbooks held in the Frederick Douglass Papers at the Library of Congress—and very likely the efforts of Helen Pitts Douglass and Rosetta Douglass Sprague—require further scholarly analysis, so it is the case that these volumes held in the Walter O. Evans collection await in-depth investigation.

Writing as early as July 31, 1886, in the pages of the *New York Freeman*, Gertrude E. H. B. Mossell, an African American journalist, author, and activist, issued a warning to Black audiences regarding the dangers of forgetting the past. "The aged

72 Joseph Douglass Jr., *Frederick Douglass*, 158.

ones who bore the burden and heat of slavery and prejudice; the ones who were pioneer laborers in the work of opening the school church and railroad facilities to us, are fast passing away," she declares, insisting, "How many beautiful lessons, how much valuable information might be gathered from them." Waging a one-woman war against the disappearance of this "vast treasure house of future life and thought," she issues a heartfelt appeal by instructing current and future generations to "[k]eep this unwritten history." More especially, she writes of the urgency of not forgetting the life of one "old soldier of the cross" in particular. "As I clipped from two late papers' articles speaking of Frederick Douglass," Mossell explains, she experienced an epiphany: "I thought how valuable and interesting would be a scrap book composed of newspaper clippings speaking of this one colored man." "A book could be filled with them, and what grand lessons his speeches, the comments upon them, his quiet talks, the influence they had upon others, would teach," she speculates, only to despair, "perhaps I am the only one who has thought of it, and now it is too late to make anything like a complete collection."[73]

Little did Mossell know that she had no grounds for sorrow. At the time of her writing in 1886, her call had already been answered by Douglass's own family members. Creating not one but multiple scrapbooks, they refused to focus on Douglass as "one colored man," however. Rather, they betrayed a shared determination to record what they saw as their father's "written history" alongside their own "unwritten history." For the Douglass family, the "grand lessons" of their father offered a blueprint not for singular but for collective activism. Working hard to provide future generations with everything they needed, Lewis Henry, Frederick Jr. and Charles Remond Douglass assumed the role of memorialists, commentators, and curators of the Douglass family archive in a bid to guarantee that not only their father's but their own stories would be written.

According to Ellen Gruber Garvey, Frederick Douglass himself was a pioneering advocate of scrapbooking as a radically revisionist activity for Black audiences. Always in the vanguard when it came to innovative ways in which African Americans might become "book makers," Gruber Garvey has unearthed a seminal moment in Douglass's life. As she writes, "In 1854 Frederick Douglass urged the readers of his newspaper to clip out an article called 'Black Heroes.'"[74] In a passage that it has so far proved impossible to locate in *Frederick Douglass Paper*, and despite an exhaustive examination of a microfilm copy, she quotes Douglass as issuing a direct instruction to his Black male readers in particular: "'Colored men! Save this extract. Cut it out and put it in your Scrap-book.'"[75] According to her

73 Gertrude E. H. B. Mossell, "Our Woman's Department," column in the *New York Freeman*, July 31, 1886. With grateful thanks to Gruber Garvey, *Writing With Scissors*.
74 Gruber Garvey, "Alternative Histories."
75 Ibid.

investigation, this "extract" provided a record of "armed African American soldiers in the Revolutionary War."[76] For Douglass this article was of vital importance to missing histories of Black military prowess by doing justice to the lives of the "'black men who had fought and bled for their country.'"[77] "In exhorting 'colored men!' to cut out the extract, put it in their scrapbooks, 'and use it at the proper time,'" she emphasizes, "Douglass suggested that the clipping itself could be ammunition for a cause, and that deploying it was the act of a soldier."[78] Gruber Garvey's conviction that "scrapbooks could be a weapon" was endorsed not only by Frederick Douglass himself but by his sons, two of whom, Lewis Henry and Charles Remond Douglass, had themselves "'fought and bled for their country'" decades earlier.[79]

A "Definitive" Archive?
Mapping the Walter O. Evans Douglass and Family Collection

As the result of decades of archival investigations into the lives and works of Frederick Douglass and his family members, *If I Survive: Frederick Douglass and Family in the Walter O. Evans Collection* reproduces their original writings alongside in-depth essays in which we share new research on the lives and works of Frederick Douglass and his sons, Lewis Henry, Frederick Jr., and Charles Remond Douglass. For the benefit of readers, we accompany full-page facsimiles of the original manuscripts, letters, speeches, and essays authored by Douglass and his family with detailed annotated transcriptions. Despite our best efforts, however, gaps and omissions remain regarding names, dates, and places. As a work in progress, we share these materials with readers with a view to inspiring future researchers to undertake further investigations. For readers interested in learning more about Douglass and his family, this book is part of two larger ongoing book projects, *Struggle for Liberty: Frederick Douglass's Family Letters, Speeches, Essays and Photographs* and *For Your Eyes Only: The Private Letters of Frederick Douglass and Family*.[80] Constituting a powerful absence, there is little to no physical trace—with the exception of the aforementioned newspaper article authored by Rosetta under the pen name "Justice," pasted into one of the surviving scrapbooks—of either of Douglass's daughters in the Walter O. Evans collection.

If I Survive begins by providing readers with a family tree and detailed chronologies in which we trace the lives, events, and works of Frederick Douglass and his

76 Ibid.
77 Ibid.
78 Ibid.
79 Ibid.
80 The result of exhaustive research in numerous US and UK archives, these volumes includes individual biographical chapters and annotated transcriptions of the newly excavated 800+ writings and portraits not only of Frederick, Lewis Henry, Frederick Jr., and Charles Remond—as examined here—but also of Rosetta and Annie Douglass. See Bernier, *Struggle for Liberty* and *For Your Eyes Only*.

sons for which we are indebted to the pioneering research of David Blight, Joseph L. Douglass Jr., Leigh Fought and Dickson Preston. As we saw above, while Douglass's life has been the repeated subject of an exhaustive number of biographies and chronologies during his lifetime and over a century since his death, the lives of Lewis Henry Douglass, Frederick Douglass Jr., and Charles Remond Douglass have as yet been awarded no such extensive treatment. In working up these timelines, we have relied extensively on Joseph Douglass Jr.'s "Douglass Family Chronology" that he appends to his history. In comparison to his collective chronology, however, we provide individual timelines for the benefit of readers who may be interested in researching one figure in particular. We are also indebted to Leigh Fought's recent biography for providing additional key information regarding the Douglass family genealogical tree. As of writing, however, none of these chronologies—not even Douglass's own—are definitive. Competing dates, differing accounts, incomplete records, and conflicting statements characterize the unpublished and published source materials that run a gamut from census records to public directories, military registrations, and newspaper accounts, among much more. As we continue to research the Douglass family, new discoveries are constantly coming to light that guarantee their lives and works remain an ever-shifting kaleidoscope.

Part II, "An 'Undying' Love Story," reproduces the intimate and romantic correspondence between Lewis Henry Douglass and Helen Amelia Loguen (1843–1936), his soon-to-be wife. Loguen was the daughter of one of Frederick Douglass's close friends, Jermain Wesley Loguen (1831–72), a self-emancipated freedom fighter, and Caroline E. Storum Loguen (1817–67), a woman who was born free and dedicated to the family's life's work as conductors on the Underground Railroad. In this part of the book, audiences are introduced to the "undying" love story between Loguen and Douglass as it develops over a handful of extant letters that were written between 1860 and 1862. As this archive very likely represents the private collection of Amelia Loguen—handed down through generations of the Douglass family—the bulk of the surviving letters are written by Lewis Henry. For the benefit of readers working to piece together their story, a few of the letters authored by Helen Amelia Loguen have been identified in other archives and are discussed in full here. As heartfelt meditations on love, this intimate epistolary archive confirms that theirs was an epic romance.

Part III, "'Men of Color, To Arms!'" traces Lewis Henry, Frederick Jr., and Charles Remond Douglass's service in the Civil War. Douglass's eldest son, Lewis Henry, enlisted in the 54th Massachusetts combat regiment and had the distinction of being appointed a sergeant, the highest non-commissioned rank for African American soldiers, whose military service was heavily circumscribed by white racist government protocol. As reproduced here, the letters he writes Helen Amelia Loguen from the Civil War front lay bare his own and his regiment's

life-and-death struggles in the blood and mire of battle. Recognizing that no letters authored by Charles Remond Douglass, who also enlisted in the 54th before his transferal to the 5th Massachusetts Cavalry, are included in the Walter O. Evans archive, we reproduce the letters he writes his mother and father, and which are held in the Frederick Douglass Papers at the Library of Congress Manuscripts Division. These letters are no less powerful, as he endures heavy gunfire and directly confronts his fears of mortality at the same time that he shares his hopes, fears, and dreams for his military unit.

Part IV, "The 'Incontestable Voice of History'" reproduces the original facsimile pages alongside annotated transcriptions of Frederick Douglass's autograph manuscripts that are held in the collection. These works are titled as follows: "Lecture on Santo Domingo," c. 1873; "The Louisiana Senator [P.B.S. Pinchback]," c. 1876; "William the Silent," 1876; "The Exodus from the South," c. 1879; "Eulogy for William Lloyd Garrison," 1879. We preface our reproduction of each manuscript and transcription by including a detailed essay in which we situate these works within their biographical, social, political, cultural, and historical contexts. While Douglass's "Lecture on Santo Domingo," c. 1873, and "William the Silent," 1876, exist in numerous—and each uniquely different—manuscript versions held in the Frederick Douglass Papers at the Library of Congress, there is no other surviving manuscript for "Eulogy for William Lloyd Garrison," 1879. Douglass's Garrison manuscript has the further distinction of being the sole work about which there can be no doubt that it was written in Douglass's own hand. Just as it is likely that at least parts, if not the whole, of "Lecture on Santo Domingo" and "William the Silent" were authored and/or annotated by Douglass, a close scrutiny of these manuscript pages reveals orthographic inconsistencies that introduce the possibility of at least one other author. The most likely candidate is Rosetta Douglass Sprague. Over her father's lifetime, Douglass's Oberlin-educated daughter played a key role in his literary history by acting as his amanuensis.

While Douglass's "Lecture on Santo Domingo," c. 1873, "William the Silent," 1876, and "Eulogy for William Lloyd Garrison," 1879, are complete drafts, "The Louisiana Senator [P.B.S. Pinchback]," c. 1876, and "The Exodus from the South," c. 1879, survive only as partial fragments. The difficulties surrounding provenance, date, and handwriting for these five manuscripts notwithstanding, they shed undisputed light on key moments within Douglass's postbellum activism. Among the areas these works address are the following: Douglass's campaigns for Black civil, electoral, and political rights; his insistence that the Civil War be remembered not only as a war for the end of slavery, but as a crucible for Black male combat heroism; his unrelenting critique of white US presidential racism; his commitment to the past as offering an educational blueprint for reform in the present, if only we heed its lessons; his denunciation of white abolitionist

paternalism; his long-term fight against Northern racism; his inconsolable sorrow at the rise of lynching and white mob rule; his outright rejection of all forms of civil, political, social, and cultural segregation that circumscribed Black lives. Collectively, these manuscripts bear witness to Douglass's unceasing war against the revival not only of the "spirit of slavery" but, and yet more damningly, of the "spirit of mastery" in a post-war era.[81]

Part V, "'I Glory in your Spirit'" examines the Douglass family's post-war freedom struggles by providing original facsimiles and annotated transcriptions of more than twenty letters held in the collection that are authored by Frederick, Charles Remond, and Lewis Henry Douglass following the Civil War. An eclectic and multi-directional archive in their own right, these letters betray their ongoing civil rights activism. They fought to combat the many slaveries—economic, electoral, political, historical, and cultural—that emerged to disenfranchise and discriminate Black lives in a post-war era. Among the issues examined by these letters are the following: radical educational reform and the freedom schools; the employment issues besetting African Americans generally and the discriminations encountered by Douglass's sons more particularly; Douglass's role as Minister to Haiti, and the controversies surrounding US plans for annexation of the Mole St. Nicholas; the World's Columbian Exposition in Chicago and its failures to do justice to African American history and culture.

Part VI, "'I was Born'" introduces readers to the lives and works of Frederick Douglass Jr. and his wife, Virginia L. Molyneaux Hewlett Douglass (1849–89). Their surviving autobiographies, letters, and poems lay bare the very real suffering endured by Black families living in a post-emancipation era. Here we provide the original facsimile pages and annotated transcriptions of *Frederick Douglass Jr. in brief from 1842–1890* (c. 1890), an unpublished autobiography which he completed in his own hand and inserted into the pages of one of his scrapbooks just two years before his death. As a result of Douglass Jr.'s determination to preserve the biographical history and writings of his wife, the collection is distinctive for including an untitled narrative of Virginia L. Molyneaux's life (c. 1890) alongside a reproduction of one of her poems, "To the Fifty Mass. Cavalry," (1864), both of which are copied into the same scrapbook as his autobiography by her husband following her death of consumption in 1889. While very little is known about her mother, Virginia Josephine Lewis Douglass (1817–78), Virginia Douglass's father was Aaron Molyneaux Hewlett (1820–71), the first African American faculty member of Harvard University as director of the Harvard Gymnasium.

In Part VII of *If I Survive*, "Narrative of the Life of Frederick Douglass, An American Slave and Freeman, as told by Charles Remond Douglass," we reproduce

81 Douglass, "Lessons of the Hour," p. 38.

the original facsimile pages alongside an annotated transcription of Douglass's youngest son's handwritten manuscript, "Some Incidents of the Home Life of Frederick Douglass" (circa February 1917), which he later delivered as a speech at the centenary commemorations celebrating the birth of his father. Working with Walter O. Evans Douglass and family visual archive, Part VIII reproduces all the prints of Frederick, Lewis Henry, and Charles Remond held in the collection. Additional subjects of these photographs include Charles Remond Douglass's sons, Joseph Henry Douglass and Haley George Douglass, as well as Charles A. Fraser and Helen Amelia Loguen Douglass's sister, Sarah Marinda Loguen-Fraser. As yet, many of the portraits of young children and solitary women are unidentified. Part IX of this book provides readers with a full inventory of the Walter O. Evans Douglass family collection as well as a detailed listing of primary archives and repositories and a bibliography of relevant primary and secondary materials. For readers interested in undertaking further research into the Loguen family, Part X, the final section of the book, lists all the letters and poems belonging to Helen Amelia Loguen and as authored not only by herself but by her mother, siblings, and friends.

As far as a note on provenance is concerned, Walter O. Evans explained in an interview with the authors that he obtained the bulk of this Frederick Douglass and Family Collection through Phil McBlain, an antiquarian dealer and specialist in rare and antique books and artifacts, in the 1980s. As a further conversation between the authors and McBlain—now the owner of McBlain Books in Hamden, Connecticut—reveals, these Douglass and family materials arrived at auction with no detailed provenance. Walter Evans also confirmed that not all of his Douglass and family archival materials were collected at the same time. He obtained some of the photographs and letters at different dates, and from various other collectors. While it is currently impossible to identify the original owner of Evans's Douglass collection with no room for doubt, a detailed examination renders it likely that these scrapbooks, letters, pamphlets, typescripts, and miscellaneous notes were originally held in the private archive of Frederick Douglass's eldest son, Lewis Henry Douglass. We would suggest that he assumed yet further responsibility by preserving his brother's archive following Frederick Douglass Jr.'s premature death in 1892. In keeping with Lewis Henry's own bequest, according to which he issued instructions that his collection go to Haley George, Charles Remond Douglass's son, at his death, it would appear very likely that his archive did indeed reach his nephew when he passed in 1908. Among the most compelling evidence supporting the claim that this archive was the property of Haley George—in addition to the proof provided by Lewis Henry's instructions—is the fact that the collection also includes Haley George's correspondence with his grandfather, many of his family photographs, and the draft manuscripts and letters written by his father, Charles Remond Douglass.

On these grounds, it is equally likely that he became the owner of his father's archive on his death in 1920.

As yet further ballast to the view that the bulk of Walter Evans's Douglass collection was originally the property of Haley George Douglass, an obituary written by William M. Brewer and published in *Negro History Bulletin* shortly after his death in 1954 makes the startling revelation that he "was working on what he hoped would be the definitive life story of Frederick Douglass."[82] As far as the sources for this "life story" were concerned, Brewer informs his readers that Haley George Douglass "had assembled many of the materials (his rare memories and oral traditions, however, may now be lost) and it is hoped that his brilliant son may in time complete the work."[83] "Mr. Douglass fervently wished this work to be his crowning achievement," Brewer observes, while he expresses a profound regret that he "did not finish it."[84] Not only did he "not finish it," but neither did his son, Joseph A. Douglass. Yet more revealingly, the "materials" held in his possession have never appeared in any public repository or institutional archive. In light of the fact that there would have been no better source materials on which to base "the definitive life story of Frederick Douglass," it is most likely the case that these were indeed the materials from which he was working.

We live in hope that one day Haley George Douglass's partial manuscript will be found. Complicating the conclusion that these materials were originally the property of Haley George Douglass, however, is the fact that Walter O. Evans obtained different materials at varying times and from numerous collectors. Due to the fact that Helen Amelia Loguen Douglass outlived her husband by nearly three decades and that the archive consists of a large number of letters written to her, there can be little doubt that she was an early collector and preserver of these materials. At this stage of our research into the Walter Evans collection, we still have more questions than answers. Our search for "marks, traces, possibles and probabilities" concerning the Douglass family lives, as "curiously, earnestly, anxiously we peer into the dark" for "glimpses" of their "character," shows no sign of abating in 2018.[85]

Within the prints and photographs collections held at Cedar Hill, Frederick Douglass's Washington, DC home and now the Frederick Douglass National Historic Site owned by the National Park Service, two prints of a photograph titled *Frederick Douglass in Front of His A Street NE Home, Washington D.C.*, dated 1876, survive (Figures 14 and 15).

82 Brewer, "Haley George Douglass," 146.
83 Ibid.
84 Ibid.
85 Douglass, *The Heroic Slave*, 175.

While any and all mention of Douglass's family members are omitted in the image's caption, neither print shows Douglass alone. Immediately to the far left of the sepia-colored print, which has been cropped, are two women, one man, and three children (Figure 15). In the grainy black-and-white print, additional figures appear: an adult and child hold hands as they stand in the far right of the image (Figure 14). On the grounds that the unknown photographer's subject is clearly the elegant façade of Douglass's home, which dominates the pictorial plane, these figures are each impossible to determine with any degree of accuracy. Typically, the one exception is Douglass himself. Viewers can identify him with effortless ease due not only to his centrality within the photograph but because of the distinctiveness of his height, posture, full beard, and white hair. As we are left with more questions than answers regarding the identity of the other adults and children in this photograph, we experience yet another poignant reminder of the renowned celebrity of the iconic Frederick Douglass versus the widespread invisibilization of his anonymous family.

We can only speculate, but can never know with any certainty, whether the woman standing by the entrance to the house is Anna Murray Douglass, or whether the other two adults are Nathan Sprague and Rosetta Douglass Sprague. Equally, we have no way of establishing the identity of the children, beyond the fact that the following Douglass grandchildren are a potential fit in terms of their ages in 1876: Alice Louisa and Harriet Bailey Sprague, Rosetta and Nathan Sprague's daughters; Frederick Aaron Douglass, Virginia and Frederick Douglass Jr.'s son; Joseph Henry Douglass and Charles Frederick Douglass, Charles Remond Douglass's sons. Yet more revealingly, while Frederick Douglass is not alone in either version of this photograph, he stands in isolation. Was this his choice? Was it on the advice of the photographer? Are there other versions of this photograph in which Douglass is portrayed by himself and with no family members at all? Was this photograph in which family members were also allowed to participate an afterthought?

Decades earlier, and very likely on the eve of the Civil War, Douglass broke with his repeated preference for creating a "sorrow image" by deciding to be photographed with Annie Douglass, his youngest daughter, in an intimate portrait which has only recently come to light.[86] No isolated Douglass, he has his arm around his daughter while he assumes a relaxed posture and adopts a peaceful rather than a pained expression: a first across his surviving visual archive. The visual antithesis of the vast majority of his photographs, in which he appears as a traumatized, solitary figure, here he lays bare his belief that it is "good to be among

86 See Bernier, "'To Preserve My Features in Marble,'" for a discussion of Frederick Douglass and the concept of "sorrow images." This portrait of Annie Douglass and her father came to light as a result of the collaborative research undertaken with John Stauff and Zoe Trodd for *Picturing Frederick Douglass*.

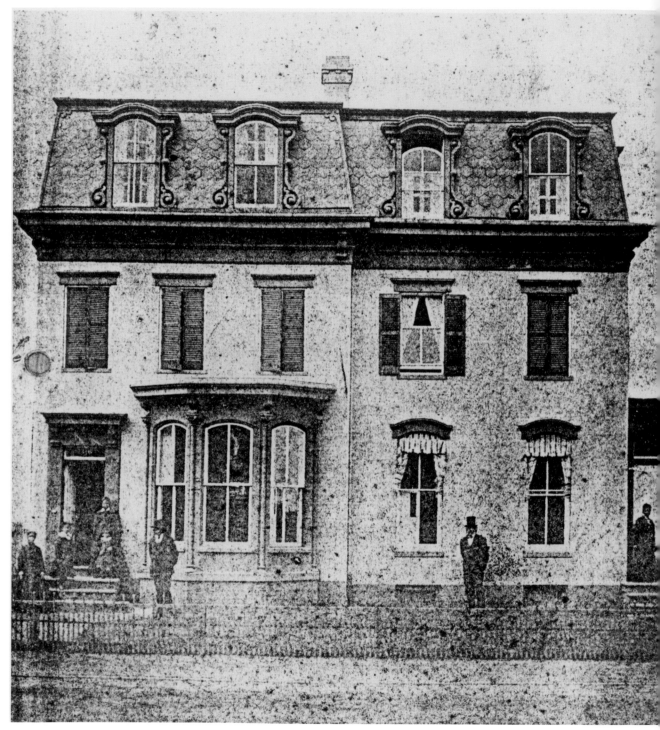

Figure 14: Anon., *Frederick Douglass in Front of His A Street NE Home, Washington D.C.*, 1876.
(National Park Service: Frederick Douglass National Historic Site, Washington, DC.)

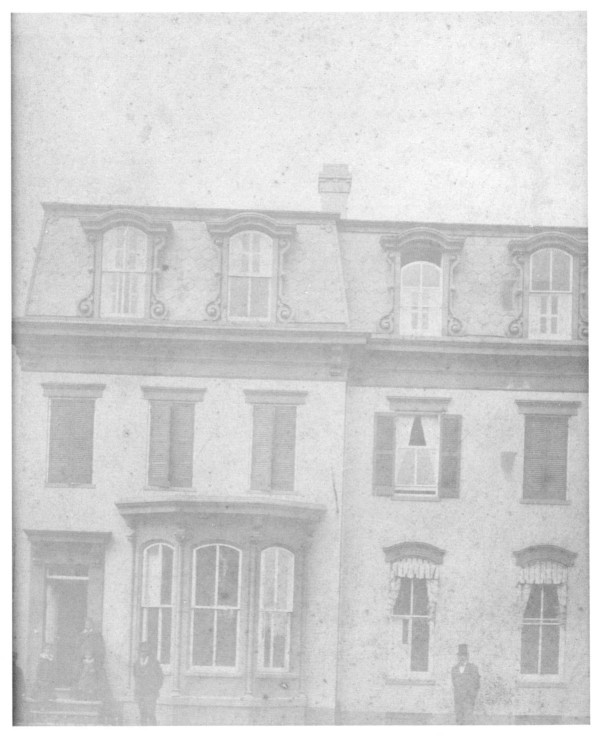

Figure 15: Anon., *Frederick Douglass in Front of His A Street NE Home, Washington D.C.*, 1876.
(National Park Service: Frederick Douglass National Historic Site, Washington, DC.)

Figure 16: Anon., *Helen Pitts Douglass*, n.d. (National Park Service:
Frederick Douglass National Historic Site, Washington, DC.)

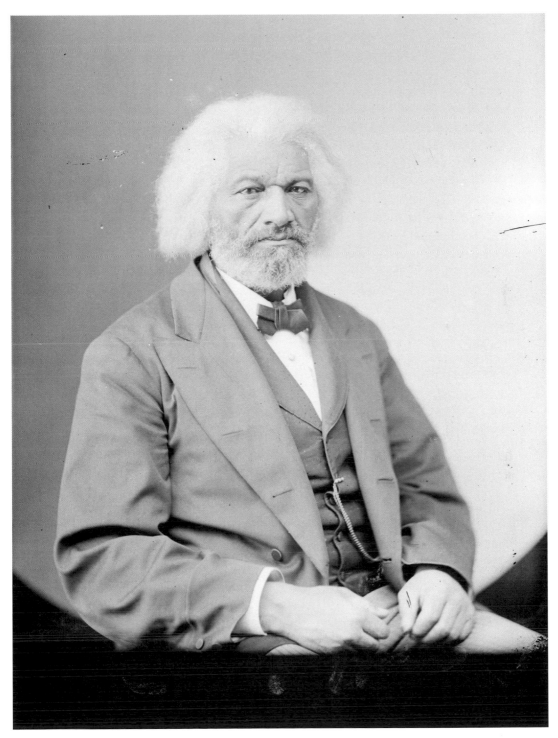

Figure 17: Mathew Brady, *Frederick Douglass*, c. 1877. (Prints and
Photographs Division, Library of Congress, Washington, DC.)

those whose welfare and happiness depend so much upon myself."[87] Writing her father on December 7, 1859, shortly before her death, Annie, Douglass's youngest daughter, communicated a heartfelt message from all the family members around her. "They all send their love," she confides to her father as she ends her letter, "From your affectionate daughter, Annie Douglass."[88] For the living, breathing, and fallible individual who led the isolated and isolating public life of Frederick Douglass—part myth, part symbol, and part icon—the love of his family was vital to his survival, enabling him to keep his body and soul together against all harrowing and seemingly insurmountable odds.

As the Walter O. Evans collection and ongoing research reveals, there can be no doubt that the told history of the father, Frederick Douglass, is the untold story of the daughters, Annie and Rosetta, and sons, Lewis Henry, Frederick Jr., and Charles Remond Douglass. Writing her mother in the wake of a family tragedy, Virginia L. Douglass issues a heartfelt plea that fittingly encapsulates Frederick Douglass and his family's lifelong hope. According to her husband, Frederick Douglass Jr., who records her words in one of his scrapbooks, she urges, "Let us all be even more closely bound together." In the Walter O. Evans collection, the lives, loves, works, hopes, dreams, and fear of the Douglass family are "closely bound together" for the first time.

87 Frederick Douglass to Anna Richardson, April 29, 1847.
88 Annie Douglass to Frederick Douglass, December 7, 1859.

Part I

Our Bondage and Our Freedom

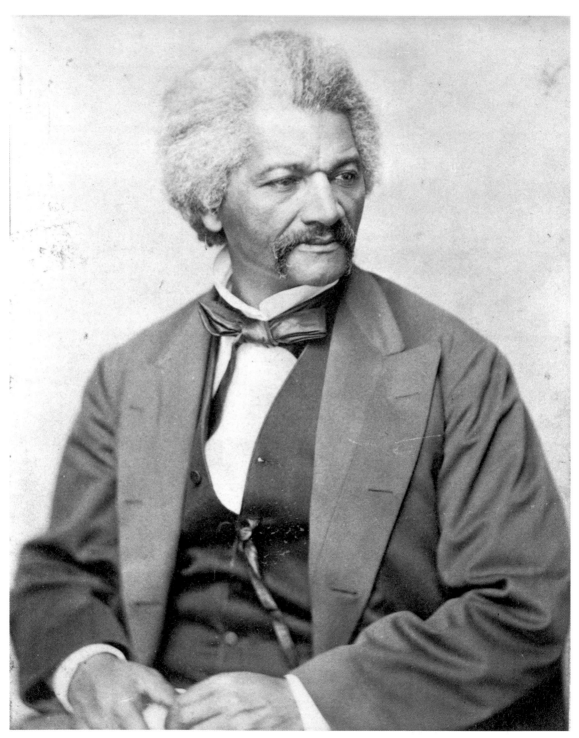

Figure 18: George Francis Schreiber, *Frederick Douglass*, 1870. (Prints and Photographs Division, Library of Congress, Washington, DC.)

Frederick Douglass and Family Chronologies

Frederick Douglass (1818–1895)

In compiling this chronology, we are indebted to Frederick Douglass for the information he provides in his three autobiographies, as well as to the groundbreaking research of his leading biographers.[1] The chronology is reproduced with the permission of Broadview Press, where it first appeared in abbreviated form at the start of Celeste-Marie Bernier's 2018 scholarly edition of Frederick Douglass's *Narrative of the Life of Frederick Douglass, An American Slave.*

May 1774	Betsey Bailey, Frederick Douglass's grandmother, is born on Skinner Plantation in Talbot County, Maryland.
Feb. 28, 1792	Harriet Bailey, Frederick's mother, is born on Skinner Plantation.
1813	Anna Murray is born to free parents in Denton, Caroline County, Maryland.
Feb. 1818	Frederick Douglass is born Frederick Augustus Washington Bailey to Harriet Bailey and an unidentified white man on Holme Hill Farm, Easton, Talbot County, State of Maryland.
Aug. 1824	Douglass is taken to Colonel Edward Lloyd's plantation, Wye River, where his master, Captain Aaron Anthony, lives. He is separated from his grandparents and introduced to siblings he has never previously met.
Aug. 27, 1825	Douglass's Aunt Jenny and Uncle Noah successfully run away from the plantation and reach freedom in the North.

1 See works by David Blight, Joseph L. Douglass Jr., Leigh Fought, Benjamin Quarles, Dickson Preston and John Stauffer in the bibliography.

Feb. 14, 1825	Harriet Bailey visits her son for the last time. She dies shortly afterwards, but no date for this survives in the plantation record.
Mar. 1826	Frederick Douglass is sent to Fells Point, Baltimore, to live with Sophia and Hugh Auld and to look after their son, Tommy. He begins to learn to read as a result of the teachings of Sophia Auld, until she is dissuaded by her husband. He obtains a copy of Caleb Bingham's *The Columbian Orator* and is inspired by the power of words to effect social change after reading the dialogue between the "master and slave."
Nov. 14, 1826	Death of Aaron Anthony.
Oct. 1827	After the "valuation and division of the property," Douglass is given to Lucretia Auld, with the result that he returns to Baltimore. Following Lucretia Auld's death, her husband, Thomas, marries his second wife, Rowena Hambleton.
July 18, 1832	Douglass's sister, Sarah Bailey, is "sold to Perry Cohee of Mississippi." She is "one of fifteen close relatives 'sold south' during Frederick's childhood."[2]
Mar. 1833	Douglass is sent to St. Michaels to live with Thomas and Rowena Auld. He begins teaching a Sabbath School for enslaved African Americans "at the house of a free colored man named James Mitchell."[3] However, Douglass immediately encounters violent opposition. Thomas Auld and his fellow white aggressors use "sticks and other missiles" to put a stop to his educational activities.[4]
Jan. 1, 1834	Thomas Auld resolves to break Douglass in body and spirit by putting him out "to be broken."[5] He sends him to live with Edward Covey, a white "negro breaker." At the peril of his life, Douglass is forced to stay with Covey for one year. During this time, he suffers from repeated acts of violence that prove emotionally and physically unendurable.
Aug. 1834	Douglass works in Covey's "treading-yard" with three other Black men named Bill Hughes, Bill Smith, and a man known only as "Eli." He becomes ill with a fever and collapses, with the result that he is brutally attacked by Covey. In desperation, Douglass returns to St. Michaels to appeal to Thomas

2 Preston, *Young Frederick Douglass*, 200.
3 Douglass, *Life and Times*, 136.
4 Ibid.
5 Ibid. 139.

Auld for mercy. No mercy is forthcoming, as he is instead sent back to Covey. During his journey through the woods on his way back to his torturer, Douglass encounters Sandy Jenkins, an enslaved man. Jenkins and his wife take pity on Douglass, giving him food to sustain him and a "root" to protect him. Inspired by such signs of Black solidarity and spiritual support, he returns to Covey with a new determination: "I was resolved to fight."[6] He is victorious: "During the whole six months I lived with Covey after this transaction, he never again laid the weight of his finger on me in anger."[7]

Jan. 1, 1835 Douglass's "term of service with Edward Covey expired on Christmas Day 1834," and he is hired out to William Freeland as a farm laborer.[8]

Apr. 1836 Inspired by his aunt and uncle's escape, Douglass devises a runaway plot. He convinces enslaved men Henry Harris, John Harris, Sandy Jenkins, Charles Roberts, and Henry Bailey to join him by using his oratorical powers of persuasion. As he later confirms, it is in convincing them to run that "I here began my public speaking."[9] He benefits from his literacy by writing everyone passes in a futile attempt to assist them in their escape. Even before they are able to put their plan into action, they are betrayed and incarcerated in Easton jail. While the other men are almost immediately set free, Douglass remains incarcerated until he is liberated a week later by Thomas Auld. Thomas Auld loses no time in sending Douglass back to Baltimore to live with his brother Hugh. As Douglass confirms, he was sent to Hugh with a promise: "Master Thomas told me he wished me to go to Baltimore and learn a trade; and that if I behaved myself properly he would *emancipate me at twenty-five*."[10] He is hired out to a white ship-builder, William Gardener, as a caulker on Fell's Point. Soon afterwards he is the victim of a terrible assault by white carpenters, who fear the encroachment of Black enslaved laborers on their livelihood. Hugh Auld tries to lodge a legal complaint against Douglass's

6 Ibid. 173.
7 Ibid. 176–7.
8 Ibid. 179.
9 Ibid. 194.
10 Ibid. 218.

	attackers, but fails on the grounds that the testimonies of Black witnesses are considered inadmissible in court. In fear of his life, Douglass is taken out of Gardener's shipyard and allowed to hire his time, with immediate financial benefits. Douglass plays an active role in the "East Baltimore Mental Improvement Society" organized by free African American men.
Sept. 3, 1838	Douglass borrows a friend's "sailor's protection"[11] papers and boards a train to Wilmington. He then takes a steamer for Philadelphia, and a train to New York. Anna Murray sells one of her feather beds to raise the funds for his flight.
Sept. 4, 1838	On his arrival in New York, Douglass meets a "sailor named Stuart"[12] who introduces him to David Ruggles, "the secretary of the New York vigilance committee."[13]
Sept. 15, 1838	Douglass writes a letter in which he sends for Anna Murray, and they are married by Reverend James W. C. Pennington. On September 17, 1818, they travel to New Bedford and receive aid from Nathan Johnson and his family. Douglass has at this time been protecting his identity by using the assumed name of "Johnson," an extremely popular surname. Nathan Johnson convinces him to adopt "Douglass" instead, as a homage to legendary freedom fighter Sir James Douglas, the hero of Scottish author Walter Scott's poem "Lady of the Lake." During this period, Douglass turns his hand to all manual work, making a living as a "common laborer."[14]
Feb. 1839	Douglass subscribes to *The Liberator* and hears a lecture by William Lloyd Garrison.
June 24, 1839	Frederick and Anna's daughter Rosetta is born.
Oct. 9, 1840	Frederick and Anna's son Lewis Henry is born.
Aug. 11–12, 1841	Douglass attends an "anti-slavery convention in Nantucket." As he reports, William C. Coffin, a white campaigner, "had heard me speaking to my colored friends in the little school house on Second street" and "he sought me out in the crowd and invited me to say a few words."[15] An immediate sensation with the audience, Douglass is appointed by John A. Collins,

11 Ibid. 246.
12 Ibid. 253.
13 Ibid.
14 Ibid. 259.
15 Ibid. 256.

	another white abolitionist, as an agent of the Massachusetts Antislavery Society.
Fall, 1841	Frederick, Anna, Rosetta, and Lewis Henry Douglass move to Lynn, Massachusetts.
Mar. 3, 1842	Frederick and Anna Douglass's son Frederick, Jr. is born.
1843	Douglass participates in the "one hundred conventions" campaign in support of the Massachusetts Anti-Slavery Society in New Hampshire, Vermont, New York, Indiana, and Pennsylvania. On September 16, 1843, he is viciously attacked by a white racist mob in Indiana. As a result he breaks his right hand, which never properly heals.
Oct. 21, 1844	Frederick and Anna Douglass's son, Charles Remond Douglass (named after his friend the antislavery campaigner Charles Remond) is born.
May 28, 1845	Douglass publishes his first autobiography, *Narrative of the Life of Frederick Douglass, An American Slave* at the Boston antislavery office.
Aug. 16, 1845	Due to fears for his safety, he travels on the steamship *Cambria* to undertake a transatlantic abolitionist tour of Ireland, England, Wales, and Scotland.
Sept. 1845	The first Dublin edition of Douglass's *Narrative* is published.
Oct. 25, 1845	Thomas Auld sells his ownership of Frederick to his brother Hugh for $100.
Oct. 6, 1846	Hugh Auld releases Douglass's manumission papers for £150 (about $710) following his receipt of funds raised by Ellen and Anna Richardson of Newcastle-upon-Tyne, England.
Dec. 12, 1846	Douglass is emancipated once his free papers are filed in Baltimore County Court.
Dec. 3, 1847	Douglass moves to Rochester, New York, and begins publishing *The North Star* (subsequently *Frederick Douglass' Paper* and *Douglass' Monthly*), funded by British monies. Frederick, Anna Murray, Lewis, Charles, and Frederick Jr. work together on the Underground Railroad.
Apr. 20, 1847	Douglass returns to Boston.
Feb. 1, 1848	Douglass meets John Brown.
July 19–20, 1848	Douglass begins his lifelong support of the women's liberation movement by attending the first Women's Rights Convention at Seneca Falls, New York.
Sept. 3, 1848	He publishes his letter "To My Old Master" in *The North Star* on the tenth anniversary of his escape.

Mar. 22, 1849	Frederick and Anna Douglass's second daughter, Annie, is born.
May 9, 1851	Douglass breaks with William Lloyd Garrison over his conviction of the necessity for political action to oppose slavery, and begins his lifelong friendship with Gerrit Smith, a Liberty Party supporter.
June 26, 1851	Douglass changes the name of *The North Star* to *Frederick Douglass' Paper* and receives financial aid from Gerrit Smith.
July 5, 1852	Douglass delivers his speech, "What to the Slave is the Fourth of July?" in Corinthian Hall, Rochester, New York.
1853	Douglass publishes his novella *The Heroic Slave* in white British editor Julia Griffiths' antislavery gift book, *Autographs for Freedom*.
Aug. 1855	Douglass publishes his second autobiography, *My Bondage and My Freedom*.
Feb. 1858	John Brown stays with Frederick Douglass in preparation for his Harpers Ferry rebellion.
Aug. 20, 1859	Douglass has a clandestine meeting with Brown at a stone quarry near Chambersburg, Pennsylvania. Brown asks Douglass to participate in his raid on the federal arsenal at Harpers Ferry, West Virginia, and Douglass refuses.
Oct. 17, 1859	Douglass escapes to Canada in the wake of John Brown's raid in order to evade arrest. As he later recalls, Virginian governor Henry Wise had informed President James Buchanan in a letter dated November 13, 1859: "I have information such as has caused me, upon proper affidavits, to make requisition upon the Executive of Michigan for the delivery up of the person of Frederick Douglass, a negro man, supposed now to be in Michigan, charged with murder, robbery, and inciting servile insurrection in the State of Virginia."[16]
Nov. 12, 1859	Douglass sails from Quebec to the United Kingdom. He delivers a number of speeches in different regions of England and Scotland during his six-month sojourn.
Mar. 13, 1860	Annie dies, and Douglass returns to the United States, inconsolably grief-stricken. Frederick Jr. records Annie's age at her death as "10 years 11 months +13 days" in one of the scrapbooks held in the Walter O. Evans collection. She is buried in Mount Hope Cemetery, Rochester, New York.

16 Ibid. 379.

Dec. 31, 1862	Douglass is a speaker at a reception held at Boston's Tremont Temple to celebrate Abraham Lincoln's Emancipation Proclamation, which comes through via telegram at midnight on January 1, 1863.
Feb.–July 1863	Douglass is appointed as an agent for the US Government to recruit Black soldiers into the Union army.
Mar. 2, 1863	Douglass publishes his appeal, "Men of Color, To Arms," in *Douglass' Monthly*.[17] Lewis Henry and Charles Remond enlist in the 54th Massachusetts Regiment. While Lewis Henry is instantly promoted to the rank of sergeant major and serves with commendation beside Colonel Robert Gould Shaw at Fort Wagner, Charles Remond is subsequently transferred to the Fifth Cavalry, where he acquits himself nobly. Frederick Jr. is appointed as a recruitment agent in Mississippi.
July 1863	Douglass meets with Abraham Lincoln to protest the treatment of Black combat soldiers.
Aug. 16, 1863	Douglass ends publication of *Douglass' Monthly*.
Nov. 17, 1864	Douglass returns to Maryland and delivers lectures in Baltimore. He is reunited with his sister Eliza.
July 1867	Douglass is reunited with his brother Perry in an emotional meeting, after which Perry comes to live with Douglass at his home in Rochester.
Jan. 1870	Douglass is appointed as a corresponding editor for the *New National Era*, only to assume the role of editor and buy the paper outright on December 12. Lewis Henry, Charles, and Frederick Jr. play a key role in managing, typesetting, and writing articles for publication.
Jan. 12, 1871	Douglass is awarded the position of assistant secretary of commission of inquiry to Santo Domingo. He tours Santo Domingo from January 18 to March 26 of the same year, including a visit to Jamaica. He endorses President General Grant's plans for the annexation of Santo Domingo to the United States.
May 11–12, 1872	Douglass is "nominated for Vice-President of United States on ticket with Victoria C. Woodhull by the Equal Rights Party, but instead campaigns for re-election of Grant."[18]

17 Ibid. 414.
18 Preston, *Young Frederick Douglass*, 203.

June 2, 1872	Douglass's house in Rochester is burned to the ground under suspicious circumstances. This incident represents a terrible financial and personal loss; the vast majority of his papers and materials, including early runs of *The North Star*, are destroyed.
July 1, 1872	Douglass and his family move to A Street NE in Washington, DC.
Mar. 1874	Douglass is appointed as President of the Freedmen's Bank.
Sept. 1874	Douglass ends publication of the *New National Era* due to ongoing financial difficulties. The Freedmen's Bank is dissolved in financial crisis, and he loses significant amounts of personal funds. Douglass is quick to defend himself in his *Life and Times*: "It is also due to myself to state, especially since I have seen myself accused of bringing the Freedmen's Bank into ruin, and squandering in senseless loans on bad security the hardly-earned moneys of my race, that all the loans ever made on the bank were made prior to my connection with it as its president."[19]
Apr. 14, 1876	Douglass attends the official unveiling of the Abraham Lincoln monument in Lincoln Park, Washington, DC, and delivers his "Oration in Memory of Abraham Lincoln."
Mar. 17, 1877	Douglass is appointed by President Rutherford B. Hayes as United States Marshal for the District of Columbia.
June 17, 1877	Douglass makes the return journey to St. Michaels to visit Thomas Auld on his "dying bed."[20]
1878	Douglass purchases Cedar Hill, in Anacostia, Washington, DC.
Jan. 1881	Douglass publishes his third autobiography, *Life and Times of Frederick Douglass*. He completes a final revised edition, significantly updated, a few years later in 1892.
Mar. 1881	Douglass is appointed by President James A. Garfield as Recorder of Deeds for the District of Columbia.
Aug. 4, 1882	Anna Murray Douglass dies.
Jan. 24, 1884	Douglass marries white women's rights campaigner Helen Pitts, who had been employed as his secretary.
Jan. 5, 1886	Douglass resigns as Recorder of Deeds for the District of Columbia.

19 Douglass, *Life and Times*, 493.
20 Ibid. 534.

Sept. 1886–Aug. 1887	Frederick and Helen Pitts Douglass undertake an extended tour of England, Ireland, France, Switzerland, Italy, Egypt, and Greece.
July 1, 1889	President Benjamin Harrison appoints Douglass as Minister Resident and Consul General to Haiti.
Sept. 1889	Douglass is appointed as Chargé d'Affaires for Santo Domingo as well as Minister to Haiti.
July 30, 1891	Douglass resigns his position as Minister Resident and Consul General to Haiti.
July 26, 1892	Frederick Jr. dies.
1892–3	Douglass serves as Commissioner of the Haitian exhibit at the World's Fair in Chicago and publishes *The Reason Why the Colored American is Not in the World's Columbian Exposition*, edited by Ida B. Wells.
Jan. 1894	Douglass delivers his anti-lynching speech, "Lessons of the Hour."
Feb. 20, 1895	Douglass attends the National Council of Women in Washington, DC. On his return, he collapses in the hallway at Cedar Hill with Helen and dies.
Feb. 25, 1895	Douglass's memorial service is held at Cedar Hill, and his body is exhibited for public view at the Metropolitan African Methodist Church.
Feb. 26, 1895	Douglass's body is taken by train to Rochester and is on public view at City Hall. His funeral is held in Rochester Central Presbyterian Church. Douglass is buried beside Anna Murray and Annie Douglass in Mount Hope Cemetery, Rochester.
Nov. 25, 1906	Rosetta Douglass Sprague dies.
Oct. 9, 1908	Lewis Henry Douglass dies.
Nov. 23, 1920	Charles Remond Douglass dies.

Lewis Henry Douglass (1841–1908)

In writing this first in-depth chronology of Frederick Douglass's eldest son, we are indebted to Lewis Henry himself for the hundreds of letters, speeches, and essays in which he provides vital biographical information. Writing biographies of his father during his lifetime, Lewis Henry Douglass's contemporaries, James Gregory and Frederic May Holland, have supplied researchers with key details and dates. In the last few years, Joseph L. Douglass Jr.'s collective family chronology and Leigh Fought's updated genealogical tree have proved equally invaluable. This

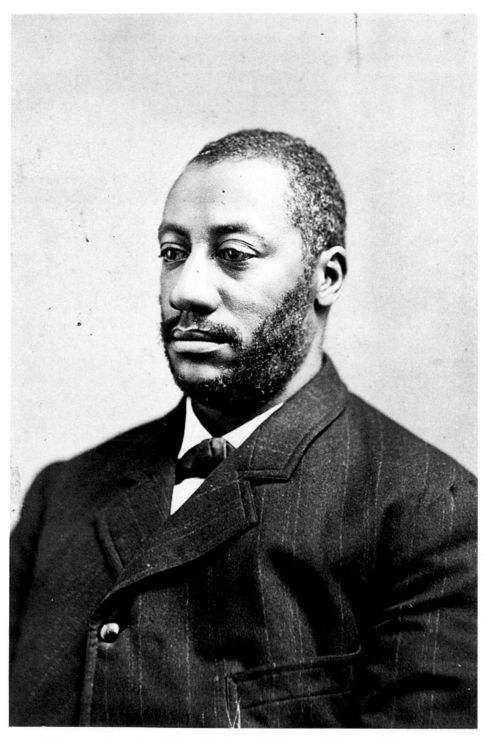

Figure 19: Anon., *Lewis Henry Douglass*, n.d. (Prints and Photographs Division, Moorland-Spingarn Research Center, Howard University, Washington, DC.)

FREDERICK DOUGLASS' OLD POST OFFICE.—Where the "North Star" was printed.

Figure 20: Anon., *Frederick Douglass's Old Post Office: Where the "North Star" was printed*, n.d. Reproduced James M. Gregory, *Frederick Douglass the Orator*. (Springfield, MA: Willey Company, 1893. Collection of the Rochester Public Library Local History Division, Central Library of Rochester and Monroe County, Rochester, NY.)

biographical research is very much still ongoing, especially with regard to Lewis Henry's labors as a teacher in a freedom school in Maryland, and his period of civil rights activism while living in Denver, Colorado.

Oct. 9, 1840	Lewis Henry Douglass is born to Anna Murray and Frederick Douglass in New Bedford, Massachusetts.
May 1, 1843	Helen Amelia Loguen is born to Caroline E. Storum and Jermain W. Loguen in Syracuse, New York.
Dec. 3, 1847	Lewis Henry and the Douglass family move to Rochester, New York. He attends a public school in the city.
c. 1850 onwards	At Anna Murray Douglass's suggestion, Lewis Henry begins work in Frederick Douglass's *North Star* office. As he later remembers, "Few who know how they work was done; how many sleepless nights and how many days were given up by his family his wife two sons and one daughter to succeed in the way of getting the paper to press and in mailing it and engaging in setting in type"[21] (Figure 20).

From this period onwards, Lewis Henry and the Douglass family work as conductors on the Underground Railroad. As James Gregory confirms, "At an early age Frederick with his brothers Lewis and Charles aided in piloting runaway slaves to Canada."[22] Booker T. Washington provides further detailed information by stating, "Mr. Douglass, or Mrs. Douglass in her husband's absence, calling the boys, Lewis, Fred. and Charles, would have fires started in that part of the house where fugitives were hidden away, and at an opportune time they were taken to Charlotte, seven miles from Rochester, and placed aboard a Lake Ontario steamer for Canada."[23] As Frederic May Holland summarizes, "When any new arrival took place, the little Douglass boys would go to and fro collecting funds, to pay the fare on the steamer across Lake Ontario."[24]

Oct. 16, 1859	John Brown's revolutionary attack upon Harpers Ferry, Virginia, takes place. On October 17, Brown and his men are captured by Robert E. Lee. Virginian governor Henry Wise secures John Brown's bag, in which a letter is found implicating Lewis Henry's father. Frederick Douglass is giving a lecture

21 Lewis Henry Douglass, "Untitled and undated handwritten statement."
22 Gregory, *Frederick Douglass*, 200.
23 Washington, *Frederick Douglass*, 160.
24 Holland, *Frederick Douglass*, 186.

in Philadelphia when the news breaks regarding John Brown's raid, and he begins his journey back, but not before sending a message to his eldest son. "I was now somewhat uneasy from the fact that sundry letters and a constitution written by John Brown were locked up in my desk in Rochester," Douglass remembers. "In order to prevent these papers from falling into the hands of the government of Virginia," he recalls, "I got my friend Miss Ottilia Assing to write to my dictation the following telegram to B. F. Blackall, the telegraph operator in Rochester, a friend and frequent visitor at my house, who would readily understand the meaning of the dispatch: 'B[.] F. BLACKALL, Esq., "Tell Lewis (my oldest son) to secure all the important papers in my high desk."'"[25]

1860

Lewis Henry's profession is identified—along with that of his brothers, Frederick Jr. and Charles Remond—as a "printer" in the US federal census. As Joseph Douglass writes, "no son was enrolled in any school. Journalism had become their first occupation and an enduring interest."[26] Lewis Henry and Frederick Jr. run "a grocery store located not far from their father's printing office in Buffalo Street in Rochester," but this enterprise is "short-lived."[27]

Aug. 9, 1862

He plans to take part in Abraham Lincoln's proposed Black migration scheme to Chiriquí, South America. As a report published in the *Rochester Daily Union and Advertiser* on October 9, 1862 confirms: "Lewis H. Douglass, son of Frederick Douglass, will leave his home in this city tomorrow for Washington, to report to Senator Pomeroy as one who is willing to join him in the expedition to Central America, where it is proposed to make an experiment in the way of founding a colony of colored people from the United States."[28] Frederick Douglass writes a letter of introduction for his eldest son to Senator Pomeroy in which he is careful to insist on his respect for his son's decision while he expresses his dissent from the political and intellectual principles underpinning this scheme. However, it was not to be. In a letter Lewis Henry writes Helen Amelia Loguen, reproduced

25 Douglass, *Life and Times*, 313.
26 Joseph Douglass, *Frederick Douglass*, 47.
27 Ibid. 102.
28 Qtd. ibid. 73.

in this book, he admits to his frustration and disappointment following the failure of the scheme.

1863	Lewis Henry begins "teaching school at Salem N.J."[29]
Mar. 25, 1863	Lewis Henry is inspired by the appeal issued on March 2 by his father, "Men of Color, To Arms!" to enlist in the Union army. He is also inspired by his younger brother, Charles Remond, who writes that "upon learning of my enlistment in the 54 Mass.," he "gave up his school and joined me."[30] Lewis Henry is recruited to Company F of the 54th Massachusetts regiment stationed at Camp Meigs, Readville, Boston. He is immediately promoted to the rank of sergeant major.
May 16, 1863	He is visited by Anna Murray, Rosetta, and Frederick Douglass at Camp Meigs, Readville. Frederick Douglass delivers a public oration in which he inspires Black soldiers to heroic deeds.
July 18, 1863	Lewis Henry participates in the assault on Fort Wagner, James Island, which results in the death of Robert Gould Shaw. The 54th Massachusetts regiment sustains devastating casualties and is celebrated for its heroism. Following this attack, he experiences ill health and is absent from active duty due to ongoing medical problems. He is examined by James McCune Smith, and convalesces in New York and then in Rochester at the family home.
Mar. 2, 1865	Lewis Henry is finally discharged on medical grounds from the Union army.
June 1865	Lewis Henry visits Ferry Neck, near to St. Michaels in Maryland, and meets with his father's sister, Eliza Mitchell, on June 5. He decides to teach at a school for "newly freed people" in "Royal Oaks, Talbot County, MD."[31] Yet more poignantly, he teaches women and men whom Frederick Douglass himself had taught while he was living as an enslaved man, before his school was broken up by the brutal actions of sabotaging white men. Charles Remond writes a letter to his father from Washington, DC on October 29, 1865, in which he informs him that Lewis Henry "sent me a copy of his speech before his night school which I think is

29 Charles Remond Douglass, "Some Incidents."
30 Ibid.
31 Joseph Douglass Jr., *Frederick Douglass*, 374.

	very good" and which appeared in the short-lived *True Communicator*, a newspaper published in Baltimore of which no copies have survived.[32]
Jan. 1866	Lewis Henry is now resident in Washington, DC, and signs a "petition calling for enfranchisement of all males in the nation's capital."[33] Their protest paves the way for early electoral reform in the district: "Universal male suffrage was achieved in the nation's capital more than three years prior to ratification of the Fifteenth Amendment."[34]
Feb. 1866	Lewis Henry attends the National Convention of Colored Men in Washington, DC with his father. As a first order of business, "The convention appointed a delegation to convey their concerns and petitions to President Johnson. This delegation included George T. Downing, Frederick and Lewis Douglass, John Jones, and William Whipper."[35] On February 7, 1866, they meet President Andrew Johnson, with the result that Frederick Douglass is "authorized to prepare a formal rebuttal."[36] Lewis Henry confirms that the authorship of this document belongs to his father and his father alone. As he writes in a handwritten note that he pastes onto the cover of one of his scrapbooks held in the Walter O. Evans collection: "This Scrap Book is valuable for it shows in part the action of a committee of Colored people who visited the Capitol of the Nation as a delegated body in the winter of 1866. Frederick Douglass indited [sic] the reply to the President of which George T. Downing sought to claim credit. I wrote the reply according to my father's dictation and not a word came from any body else." He provides researchers with an invaluable resource by gluing the original handwritten letter onto the pages of this scrapbook.
Aug. 27, 1866	Lewis Henry and Frederick Jr. arrive in Denver, Colorado. They are supported in their search for a living by Henry O. Wagoner, a civil rights campaigner and one of their father's lifelong friends. According to Joseph Douglass's findings, Lewis Henry opens up a "laundry business," a venture he

32 Charles Remond Douglass to Frederick Douglass, Washington, DC, October 29, 1865.
33 Joseph Douglass Jr., *Frederick Douglass*, 144.
34 Ibid. 145.
35 Ibid. 96.
36 Ibid. 196.

soon abandons. Following this failure, he and Frederick Jr. run a "restaurant business," but this enterprise does not last long either.[37]

While living in Denver, both brothers become an integral part of the Black civil rights campaigns taking place in the state. The state of Colorado was a hotbed of Black civil rights activism in the immediate aftermath of the Civil War. As Eugene H. Berwenger confirms, "[r]efusing to be satisfied with the termination of slavery in the South," Black protesters "waged a vigorous campaign from 1865 to 1867 to obtain the right to vote and to educate their children in public schools."[38] "In order that an intelligent vote of whatever persuasion might be encouraged, black leaders in Denver arranged for Lewis H. Douglass, son of Frederick Douglass, to teach evening classes on government and politics," he states.[39] As Charles Remond informs their father in a letter he writes from Rochester, dated February 10, 1866, "Fred in his last letter said that Lew. had a night school and was being well paid for teaching his scholars number about thirty and each pay 75 cts per ~~witt~~ week making a total of about $22,50 per week."[40] Henry O. Wagoner writes, in "Colored Men Awake to their Situation," an article published in *Rocky Mountain News* on January 23, 1867: "Permit me a small space in your paper to say, that, since we have been invested, by Congress, with the privilege of *exercising* the elective franchise in Territories, I would here say that to Lewis H. Douglass, son of the widely known 'Fred.' Douglass, is due the credit of Instituting a night school for adult colored persons, to teach old 'ideas how to shoot', by giving general instructions in the common branches of an English education, and also by inducing a thorough reading of the constitution of the United States, and investigating the general principles of the government; and by reading the newspapers of the day and explaining their political significance. Since we *are* voters, we want to be intelligent ones."[41] Lewis Henry and Frederick

37 Ibid. 102.
38 Berwenger, "Reconstruction on the Frontier," 313.
39 Ibid. 325.
40 Charles Remond Douglass to Frederick Douglass, February 10, 1866.
41 Henry O. Wagoner, "Colored Men Awake to their Situation," *Rocky Mountain News*, January 23, 1867.

	Jr. play an equally leading role in the "Colorado equal suffrage campaign."[42]
May 1867	Lewis Henry is appointed as a secretary of the Red, White, and Blue Mining Company. As a business set up by African Americans for African Americans, this company was "organized to exploit silver ores, which had been discovered in Colorado during the early 1860s."[43]
June 1867	Lewis Henry is involved with Frederick Jr. in integrating the public education system in Denver, with mixed results. As Joseph Douglass confirms: "Under a compromise, African Americans were accorded free basic education in the same school but on a separate floor. Following the departure of the Douglass Brothers, a separate school was set apart for African American students."[44] In this same year, he and Frederick Jr. begin a "printing business." However, Lewis Henry immediately encounters racially discriminatory barriers. While he is appointed as a "compositor for a local Democratic newspaper," he is unable to retain his position because "the local typographical union refused to extend membership privileges to him."[45] This is just one of a series of abuses he experiences at the hands of local and national printing unions, which are intent on sabotaging his attempts to work at his profession throughout his post-war professional career. Their exclusionary tactics rouse the ire of Frederick Douglass and inspire his speech, "Frederick Douglass and His Son: Young Douglass's Struggles for Life," which is published, among other places, in the *New York Tribune* on August 7, 1869.
1867–8	Lewis Henry and Frederick Jr. leave Denver, Colorado; Lewis Henry is still working for the mining company. According to Joseph Douglass's research, "by 30 December, Lewis was en route east to promote the enterprise. Proceeding via Rochester, he enlisted the support of his father, who purchased only ten shares."[46]

42 Joseph Douglass Jr., *Frederick Douglass*, 375.
43 Ibid. 103.
44 Ibid. 106.
45 Ibid. 103.
46 Ibid. 104.

Feb. 1868 He is living in New York City and residing with the family of Sylvester Rosa Koehler, a German migrant, as arranged by his father's friend and collaborator Ottilie Assing. During this period, "Lewis also traveled to Hoboken, where he spent two weeks with Assing."[47]

Apr. 23, 1868 He and Charles Remond become "affiliated with Grand Army of the Republic," the organization set up to meet the political, social, and civil needs of Civil War veterans.[48]

June 25, 1868 He is employed at the *Zion Standard and Weekly Review*, a newspaper owned by "the AME Zion Church to serve as the connectional journal." With good reason, Joseph Douglass speculates, "Presumably, Jermain W. Loguen, his future father-in-law and recently re-elected bishop, had a major role in Lewis's employment."[49] This newspaper soon ceases publication, and Lewis Henry returns to Washington, DC.

Jan. 13, 1869 He is involved with his brothers and father in the "National Convention of the Colored Men of America."[50] As Joseph Douglass maintains, "For the first and probably only time at a national colored convention, albeit for only two days, Douglass was joined by all three sons who were also accredited delegates."[51] His research leads him to conclude, "Lewis was initially appointed to the Committee on Rules, National Executive Commission, and later elected secretary."[52]

May 1869 Lewis Henry is employed as a printer in the Government Printing Office in Washington, DC, and is again subjected to the protest of a "dissident minority" who are opposed to the professional equality of Black men.[53]

July 20, 1869 He participates in the state Labor Convention of the Colored Men of Maryland.

Oct. 7, 1869 Lewis Henry and Helen Amelia Loguen are married at the Loguen family home in Syracuse, New York.

Dec. 6–10, 1869 He and his brothers take part in the Colored National Labor Convention in Washington, DC. Lewis Henry is appointed

47 Ibid. 114.
48 Ibid. 375.
49 Ibid. 125.
50 Ibid. 375.
51 Ibid. 124.
52 Ibid.
53 Ibid. 375.

as one of the secretaries.[54] On December 7, he proposes the following resolution: "That a special committee of five, composed of genuine laborers or practical mechanics, or artisans, be appointed by the Chair to draft a plan for the organization of a national union of laboring men to the end of securing a recognition of colored laborers and mechanics in the various workshops of the land; that the said national union submit a plan to the colored people of the country for organizing subordinate unions for the furtherance of the object in view."[55] His resolution is adopted, with the result that the founding of the Colored National Labor Union is "undoubtedly among the major actions of the convention."[56]

Jan. 1871 He takes over the "editorship" of *New National Era* from Frederick Douglass, who has been appointed by President General Grant to the Santo Domingo Commission. In the same year, he assumes the role of "commander of T. R. Hawkins Post No. 14" of the Grand Army of the Republic.[57]

June 30, 1871 He is appointed to the council for Washington, DC. As James Gregory writes, Frederick Douglass "had been appointed by President Grant in his first term a member of the council of the District of Columbia, but was compelled, by the pressure of other duties, to resign after a short time."[58] As a result, as Joseph Douglass confirms, "Grant immediately appointed his son, Lewis, to fill the vacated seat."[59] "On 30 June 1871, Lewis presented his credentials and was duly qualified and seated as the representative of the first council district," Joseph Douglass summarizes.[60] He confirms, "Lewis served through the second regular session, which ended on 20 June 1872. Immediately, he was appointed to the committee on printing."[61] "On 19 July, Lewis introduced his first measure, a joint resolution requesting Congress to appropriate funds to rebuild the Navy Yard Bridge, which served the Anacostia area," Joseph

54 Anon., *Proceedings of the National Convention*, 5.
55 Ibid. 13.
56 Ibid. 132.
57 Ibid. 240.
58 Gregory, *Frederick Douglass*, 58.
59 Joseph Douglass Jr., *Frederick Douglass*, 146.
60 Ibid.
61 Ibid.

Douglass states.[62] Lewis Henry "also initiated action to compel appropriate authorities to transfer to the trustees of the colored schools their portion of the school fund."[63] He was responsible for introducing "landmark legislation designed to achieve equal accommodation in restaurants and hotels."[64] As a result, his "measure became law about two years before the federal Civil Rights act of 1875."[65]

Feb. 19, 1872 He supports his father at a "mass meeting in support of Civil Rights Bill" held in Washington, DC.[66]

Dec. 1873 He participates with his father and Frederick Jr. in the Civil Rights Convention held in Washington, DC.

Apr. 13, 1875 He is appointed as a "special postal agent."[67]

1880 He is listed on the US Census as "Dep. Marshall" in Washington, DC.

Nov. 19, 1881 *Bethel Literary and Historical Association*, an African American debating society, is founded by Daniel Payne. This pioneering organization functions as a vital space in which Black campaigners and intellectuals discuss all aspects—political, social, legal, cultural, and philosophical—of the fight for Black equality. Lewis Henry plays a key role by assuming various administrative positions, including serving a term as president (1885–6). He, Charles Remond, and Frederick Douglass all deliver lectures on key topics related to radical protest and reform.

Nov. 1886 Lewis Henry is dismissed from the Washington, DC "recorder of deeds office" and opens up a business as a "real estate broker."[68]

Oct. 25, 1889 He and Charles Remond join "a group of distinguished African American men who formed an organization call the Central Bureau of Relief."[69]

Sept. 14, 1898 He and the other surviving members of Frederick Douglass's family are present at J. W. Thompson's ceremony in Rochester, New York, for the laying of the cornerstone of the bronze monument honoring their father.

62 Ibid.
63 Ibid.
64 Ibid.
65 Ibid.
66 Ibid. 375.
67 Ibid. 356.
68 Ibid. 378–9.
69 Ibid. 261.

Jan. 1899	He and Charles Remond are founder members of "a new post named in honor of their father, Frederick Douglass Post No. 21" in the Grand Army of the Republic.[70] As Joseph Douglass's research confirms, on "13 January, the post was officially installed in ceremonies at the Grand Army Hall," and "Lewis became the senior vice commander, whereas Charles was the adjutant."[71]
Feb. 1890	Lewis Henry, Frederick Jr., and Charles Remond participate in a Colored Convention held in Washington, DC. Rosetta Douglass Sprague writes, in a letter to their father on February 6, 1890: "This week we have had a colored convention—delegates from all ports of the United States and Territories being present—Lewis, Frederick and Charles were delegates—Lewis rather prominently so, as the association is to be known as the National Association of Colored Citizens of America."[72]
June 9, 1899	Lewis Henry and the rest of the Douglass family attend the ceremony in which the Frederick Douglass Monument is unveiled in Rochester.
1900	Lewis Henry is listed on the US Census as "(Agent) Real Estate." The census also records that Helen Amelia Loguen Douglass's sister, Sarah Marinda Loguen Fraser, is living with them as a boarder.
May 18, 1901	Lewis Henry is "co-sponsor of effort to raise funds for victims of Jacksonville, FL fire."[73]
Aug. 15, 1906	He participates in the "Second Niagara Movement meeting" held at Harpers Ferry, West Virginia.[74]
Sept. 19, 1908	He dies in Washington, DC. According to Robert Greene's findings, "He died on Saturday, September 19, 1908 at 1:10 am. His brother, Charles, was present at his bedside."[75]
June 21, 1936	Helen Amelia Loguen Douglass dies in Washington, DC. An obituary in the *African American* published on July 4, 1936, reads: "Mrs. Helen Amelia Douglass, widow of the late Lewis H. Douglass, eldest son of Frederick Douglass, died Sunday at

70 Ibid. 241.
71 Ibid.
72 Rosetta Douglass Sprague to Frederick Douglass, Washington, DC, February 6, 1890.
73 Joseph Douglass Jr., *Frederick Douglass*, 381.
74 Ibid.
75 Greene, *Swamp Angels*, 88.

Figure 21: Anon., *Frederick Douglass Jr.*, n.d. (National Park Service:
Frederick Douglass National Historic Site, Washington, DC.)

the home of her niece, Mrs. Fannie Howard Douglass, widow
of the violinist, Joseph Douglass Mrs. Douglass, who was
93, had made her home with the Joseph Douglasses for the
past five years, and had been ill for some time." The notice
confirms that, "she is survived by Mr. and Mrs. Haley
Douglass."[76]

Frederick Douglass Jr. (1842–1892)

The biographical information included in this timeline, in which we map the life
and works of Frederick Douglass Jr., has been unearthed from his numerous letters,
speeches, and essays as well as from his autobiography, *Frederick Douglass Jr. in
brief from 1842–1890* (c. 1890), a handwritten work he pasted onto the pages of
his scrapbook included in the Walter O. Evans collection and which we repro-
duce, unabridged, in this volume. Unless otherwise specified, all citations
provided here refer to this autobiography. More especially, we are indebted to
Frederick Jr. for painstakingly recording the dates of birth and death—even down
to the very hour and minute—of his and his wife Virginia L. M. Hewlett Douglass's
daughters and sons. In the majority of cases, conflicting dates have been recorded.
In these instances, we have opted for Frederick Jr.'s date and provided readers
with further information regarding the possible alternatives. Again, as in the case
of Lewis Henry Douglass's chronology, Douglass's contemporary biographers,
James Gregory and Frederic May Holland, have also supplied researchers with key
details and dates, while Joseph L. Douglass Jr.'s collective family chronology and
Leigh Fought's updated genealogical tree—especially with regarding to Frederick
Douglass Jr.'s family members—have played a vital role. This biographical
research is very much still ongoing in order to put flesh on the bare bones of
Frederick Douglass Jr.'s life, writings, and activism.

Mar. 3, 1842	Frederick Douglass Jr. is born in New Bedford, Massachusetts. Shortly thereafter, he and the Douglass family move to Lynn, Massachusetts. Frederick Jr. is briefly "placed in School in Lynn."
Dec. 3, 1847	He and the family move to Rochester, NY.
1849	Frederick Douglass Jr. attends a public school in Rochester. As he remembers, "I was sent to the public schools in Rochester and remained there a few months, when the colored children attending public schools were sent home on

76 Anon., "Obituary," *African American*, July 4, 1936.

account of their color. My father agitated this injustice and discrimination in Corinthian Hall every Sunday for three months, after which, the colored children were readmitted to the public schools." According to his summary: "I remained in school from then until I was twelve years old."

c. 1854 onwards He is apprenticed, along with Lewis Henry and Charles Remond Douglass, to the "printer[']s trade in my father[']s office" of the *North Star* at the instigation of his mother, Anna Murray Douglass. As he states, he "completed my trade at the age of sixteen." During this period, Frederick Douglass Jr. participates with the Douglass family on the Underground Railroad.

c. 1849 Virginia L. Molyneaux Hewlett is born in Cambridge, Massachusetts, to Aaron Molyneaux Hewlett and Virginia Josephine Lewis Hewlett. Aaron Molyneaux Hewlett was the first African American physical instructor at Harvard University. Virginia's many siblings include two brothers who subsequently became famous: Paul Molyneaux Hewlett (1856–91), a renowned Shakespearean actor, and Emmanuel D. Molyneaux Hewlett (1851–1929), a famous lawyer.

Oct. 16, 1859 John Brown's revolutionary attack upon Harpers Ferry takes place. According to Joseph Douglass Jr., who cites a source that has yet to be found, Frederick Jr. states, "'The sun seemed to rise and set to me in John Brown.'"[77] Prior to the revolutionary actions of John Brown, and while he was living with the Douglass family in Rochester, Frederick Jr. recalls, "I was the bearer of letters from the Rochester post office for John Brown, addressed 'Jay Hawkins,' care of Frederick Douglass, Lock Box 583." Frederick Jr. takes charge of raising funds for the surviving family following John Brown's execution.

1860 Frederick Jr. and Lewis Henry run a "Grocery business in Rochester, on the corner of Buffalo and Sophia streets."

1862 Frederick Jr. assumes responsibility for publishing *Douglass' Monthly*.

1863 Frederick Jr. does not enlist in the Union army during the Civil War, but instead serves as a recruiter: "I helped raise the 54th and 55th Massachusetts regiments of infantry and the 5th Massachusetts Cavalry." As he confirms, "I was

77 Qtd. Joseph Douglass Jr., *Frederick Douglass*, 63.

	commissioned by Governor Andrew of Massachusetts to go South on the Mississippi and recruit for the Massachusetts quota." Charles Remond remembers, "My brother Fred. and Mr. Aaron Coleman of Boston were appointed agents for the state of Massachusetts to go to Mississippi to recruit colored men for the 55 Mass. Inf."[78]
Aug. 27, 1866	Frederick Jr. moves to Denver, Colorado, with Lewis Henry. They are supported in their efforts to find employment by the civil rights campaigner and radical activist Henry O. Wagoner. As Frederick Jr. summarizes, "I went to Denver, Colorado, and engaged in Silver mining." Here he is referring to his participation with Lewis Henry in the Red, White, and Blue Mining Company, a business set up by and for African Americans. He and Lewis Henry play a leading role in the campaign for equal suffrage in Colorado. Frederick Jr. distinguishes himself yet further by participating in initiatives to desegregate state education. As he testifies, "I was among others instrumental in bringing about one public school for all American citizens of Denver."
1867	He moves to Cheyenne, Wyoming Territory, and is "employed by the Superintendent of Construction of the Union Pacific Railroad." His employment with this company is confirmed by the surviving scrapbooks in the Walter O. Evans collection: these comprise pre-printed pages in which the names of Union Pacific Railroad passengers and the size of their baggage are registered in Frederick Jr.'s own hand.
1868	He moves back to Rochester, New York.
1869	He departs for Washington, DC, and opens "a Grocery store in a place called Potomac City, now Hillsdale or Anacostia," where his brother Charles Remond is also living with his wife and children.
Jan. 13, 1869	Frederick Jr. participates with his brothers and father in the National Convention of the Colored Men of America.[79]
Aug. 4, 1869	He marries Virginia L. M. Hewlett in Cambridge, Massachusetts. Their marriage certificate is held in the family papers included in the Walter O. Evans collection.
Dec. 6, 1869	He participates as a "Delegate in the National Colored

78 Charles Remond Douglass, "Some Incidents."
79 Joseph Douglass Jr., *Frederick Douglass*, 375.

	Convention" held in Washington, DC, along with his brothers Lewis Henry and Charles Remond. He is also a "Delegate to the National Colored Labor Convention."
1869	He assumes the role of printer for the *New National Era*. As he confirms, "[I was] employed at my trade."
1870	He is appointed as "business manager of the office of the '*New National Era*.'" In 1871 he becomes "one of its proprietors."
June 17, 1870	Frederick Aaron Douglass is born in Cambridge, Massachusetts. While Frederick Jr. records his son's date as June 17, Joseph Douglass Jr. records a birthdate of nearly a month later: July 15, 1870.
Dec. 18, 1871	Virginia Anna Douglass is born in Washington, DC. Frederick Jr. records her date of birth as December 18; Joseph Douglass Jr. records a birthdate of September 18, 1871.
Aug. 11, 1872	Virginia Anna Douglass dies in Hillsdale, Washington, DC.
1873	Frederick Jr. participates in political campaigns in Washington, DC. He recalls, "I was regularly nominated by the Republicans of the First district of the District of Columbia, as their candidate to represent them in the House of Delegates under the Territorial form of government, and was defeated by a combination of Republicans with the Democrats by twenty-one votes."
Dec. 1873	He is involved with his father and Lewis Henry in the Civil Rights Convention held in Washington, DC.
Dec. 15, 1874	Lewis Emmanuel Douglass is born in Washington, DC; Joseph Douglass gives an alternative birthdate of January 5, 1875.
June 10, 1875	Lewis Emmanuel Douglass dies in Washington, DC.
1876	Frederick Jr. writes extensively for a number of newspapers, in which he debates all aspects of the ongoing campaigns for equal Black social, political, and legal rights. As he recalls, "I corresponded, politically with the Washington 'Chronicle' and the Rochester 'Democrat and Chronicle.'" In the same year, he confirms, "I was endorsed by President U. S. Grant for the position of Superintendent of the Patent Office building."
1877	He is "appointed Deputy under the Marshall for the District of Columbia."
Mar. 11, 1877	Maude Ardell (Frederick Jr.'s spelling) Douglass is born in

	Hillsdale, Washington, DC. Joseph Douglass lists her date of birth as c. March 10.
June 21, 1877	Maude Ardell Douglass dies in Hillsdale, Washington, DC.
Nov. 1877	Frederick Jr. joins Rosetta Douglass Sprague and Nathan Sprague in "signing women's suffrage petition."[80]
June 5, 1878	Charles Paul Douglass is born in Washington, DC.
Nov. 1878	Frederick Jr. writes in a surviving scrapbook held in the Walter O. Evans collection: "Charley Fred and Joseph Douglass came to live with F. Douglass Jr. on Monday before Thanksgiving November 1878, and were taken away by their father on Monday Jany 30 1881." This was very likely due to the protracted illness of Mary Elizabeth Murphy, Charles Remond's wife.
1880	Frederick Jr. again assumes the role of radical journalist in the ongoing fight for Black civil rights. As he remembers: "I corresponded politically with the Rochester 'Express,' Rochester 'Democrat and Chronicle' and the Indianapolis 'Journal.'"
1881	Frederick Jr. plays a key role in a legal trial. As he explains, "I was one of the officers placed in charge of the Jury empanelled to try the cause of Charles J. Guiteau, for the murder of President Garfield." He further confirms, "I was also one of the officers in charge of the Jury in the first 'Star route' trial." The Star Route trial concerned bribery charges brought against the US postal service.
Feb. 1883	He resigns as court bailiff and is hired by Frederick Douglass in the Recorder of Deeds Office.
June 23, 1883	Gertrude Pearl Douglass is born in Washington, DC.
Feb. 9, 1886	Frederick Aaron Douglass dies in Hillsdale, Washington, DC. Frederick Jr. poignantly records in a scrapbook in the Walter O. Evans collection that his son "died February 9 1886 at 140pm." He shares intimate information regarding his son's last moments by stating that "surrounding his death bed in his last moments" were the following family members: "His father, mother, sister & brother his grand father & wife, his aunt Amelia."
Oct. 30, 1886	Robert Smalls Douglass is born in Hillsdale, Washington, DC. Frederick Jr. records the exact time as "7.10am."
Apr. 1887	Frederick Jr. is "dismissed from recorder of deeds office"

80 Ibid. 377.

following a change of administration. As he explains, "I was employed in the office of Recorder of Deeds of the District of Columbia under Messrs. Wolf, Douglass and Matthews, and was suspended under Recorder Trotter, on the ground of my father's partizanship."

July 28, 1887	Frederick Jr. and Virginia take Gertrude Pearl and Robert Smalls Douglass to be "christened by Rev. Alexander Crummell," according to a handwritten note that Frederick Jr. includes in the one of the surviving scrapbooks held in the Walter O. Evans collection.
Nov. 2, 1887	Charles Frederick Douglass dies in Hillsdale, Washington, DC. Frederick Jr. records the time as "10.20pm."
Nov. 14, 1887	Gertrude Pearl Douglass dies in Hillsdale, Washington, DC. Frederick Jr. records her death as "3.07am."
Jan. 1888	Frederick Jr. joins Magnus Robinson as editor of the *National Leader*. He ceases his involvement a few months later. As he recalls, "I also edited the 'National Leader' of Washington D.C. during the Presidential Campaign for Harrison and Morton."
1888	He returns to journalism as a space for his protest against racial inequality. He records, "I corresponded politically with the Rochester 'Democrat and Chronicle,' Rochester 'Express,' Indianapolis 'Journal,' Washington 'Star' and the Detroit 'Plaindealer.'"
1889	He takes the lead in raising "a fund for the survivors of John Brown of Harper's Ferry fame, and organized the John Brown Republican Club of Anacostia D.C."
Dec. 14, 1889	Virginia Hewlett Molyneaux Douglass dies in Washington, DC. Frederick Jr. records her death as "1.20am." He writes in a scrapbook that she was "taken with hemorrhage" and died of "consumption." He provides further poignant details: "She was 40 years 6 months and 13 days old at the time of her death. She was married 4 months and 10 days longer than she remained single." He shares yet further private information: "Robert Smalls Douglass her youngest child was taken on this day by Hattie Sprague to his Aunts and remained there until Saturday August 1st 1891. At which time N. Sprague asked me to take him away which I did the same day. He Robert was away from home one year, nine and 14 days."
1890	Frederick Jr. is appointed "a delegate to the National colored Convention" on February 3.

Mar. 4, 1890	He is selected by "the Republican League of the District of Columbia" as "an Alternate to represent them in the National Republican League Convention held in Nashville, Tenn."
July 26, 1892	Frederick Jr. dies in Washington, DC. According to the medical report he "succumbed to 'pulmonary hemorrhage' and 'pneumonia-exhaustion', respectively the primary and secondary causes of death, as determined by J. A. Watson, the attending physician."[81]
Apr. 4, 1895	Charles Paul Douglass dies. Joseph Douglass gives an alternative date of death of April 3.
May 1910	Robert Smalls Douglass dies. Joseph Douglass gives an alternative date of death of April 27.

Charles Remond Douglass (1844–1920)

In writing this detailed chronology of the life and works of Charles Remond Douglass, we are working very closely with the biographical information he provided in his private correspondence and public essays as well as within "Some Incidents of the Home Life of Frederick Douglass," a commemorative speech he delivered circa February 1917 and which we reproduce in its entirety in this book. Again, as in the case of Lewis Henry and Frederick Douglass Jr.'s chronology, Douglass's contemporary biographers, James Gregory and Frederic May Holland, have also supplied researchers with key details and dates, while Joseph L. Douglass Jr.'s collective family chronology and Leigh Fought's updated genealogical tree have played a vital role. Biographical research into the life of Douglass's longest-living descendant is very much still ongoing, especially with regard to his civil rights activism and commitment to every fight for the social, political, legal, and national equality of all Black people in the last two decades of his life.

Oct. 21, 1844	Charles Remond Douglass is born in Lynn, Massachusetts, to Anna Murray and Frederick Douglass. He is named after Douglass's co-agitator, the writer and campaigner Charles Lenox Remond.
Dec. 3, 1847	Charles Remond moves with the Douglass family to Rochester, New York.
c. 1848	Mary Elizabeth Murphy is born in Pennsylvania to Sarah Murphy and Joseph Freeman.

81 Joseph Douglass Jr., *Frederick Douglass*, 255.

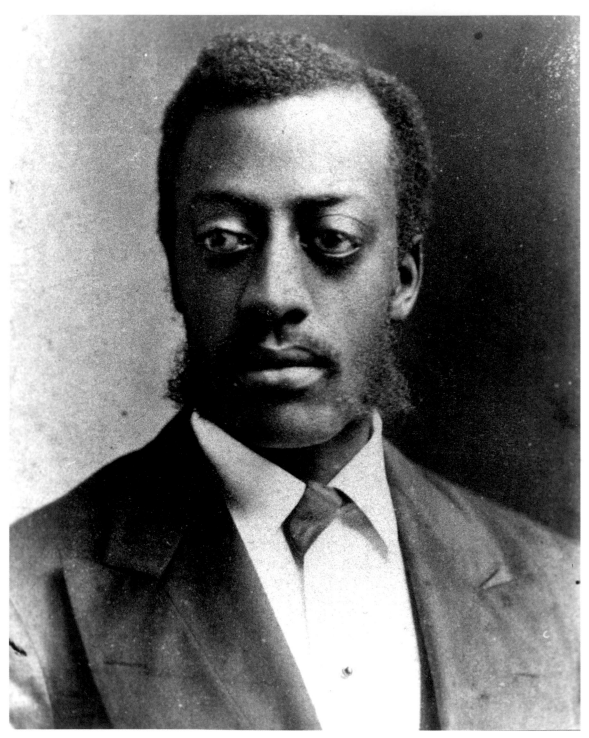

Figure 22: Anon., *Charles Remond Douglass*, n.d. (National Park Service:
Frederick Douglass National Historic Site, Washington, DC.)

1850 Charles Remond enrolls at six years of age into the public school at Rochester. As John W. Thompson confirms, Charles Remond "first attended No. 15 school on Alexander street."[82]

c. 1851 Laura Antoinette Haley Douglass is born in Canandaigua, New York, to Alfred Haley and Elizabeth Brooks.

c. 1854 Charles Remond assists in the mailing out of *Frederick Douglass' Paper*. As James Gregory confirms, "he began folding and delivering his father's papers to city subscribers, leaving school one day in each week for that purpose."[83] John W. Thompson corroborates Gregory's assessment, stating: "While attending school young Douglass also assisted once a week in his father's office, folding and carrying to the city subscribers the 'North Star.'"[84] Charles Remond himself recalled, "To maintain this paper every effort was put forth by every member of the family to keep it alive." "My brothers and sister were taken from school one day in each week to attend the folding and mailing of the paper until they became old enough to be apprenticed to the trade of type-setting," he writes, adding, "being too young I was continued in School until at the age of ten I was taken from school one day in each week to deliver the paper to local subscribers."[85]

Charles Remond and the Douglass family operate the Underground Railroad station from their home (Figure 23).

He remembers, "the Underground R.R., my father[']s home in Rochester being the last station on that road before reaching Canada the goal of the fleeing slaves' ambition." "We have often had to get up at midnight to admit a sleigh-load, and start fires to thaw them out," he recalls, conceding, "Every member of the family had to lend a hand to this work and it was always cheerfully performed. We felt that we were doing a christian and humane duty."[86]

1859 John Brown lives with the Douglass family in Rochester, New York, prior to his revolutionary attack on Harpers Ferry, Virginia, on October 16. As Charles Remond remembers,

82 Thompson, *An Authentic History*, 157.
83 Gregory, *Frederick Douglass*, 204.
84 Thompson, *An Authentic History*, 157.
85 Charles Remond Douglass, "Some Incidents."
86 Ibid.

Figure 23: Anon., *Frederick Douglass Home on Alexander Street, Rochester, N.Y.*, n.d.
The verso of the image reads: "Frederick Douglass home 'trap door' (for underground
railway)." (Collection of the Rochester Public Library Local History Division
Picture File, Central Library of Rochester and Monroe County, Rochester, NY.)

"While at our home I became his errand boy. I went twice a day to the post office two miles away to receive his mail which was sent to my father's box addressed to N. Hawkins, the assumed name of John Brown."[87]

1860 Charles Remond departs the Douglass family home. "The taunts of the school children whose parents were pro-slavery made the further attendance at No. 13 school of my youngest sister Annie and myself intolerable," he remembers, "so mother took her out of school at the age of 11 and sent her to a private teacher." As regards his own fate, "I went to work of my choosing on the farm of Thomas Pierson 20 miles from Niagara falls, and my brothers Lewis and Fred. continued at work on the paper."[88]

Apr. 18, 1863 He enlists in the 54th Massachusetts Regiment and is stationed at Camp Meigs, Readville, Boston. He maintains: "I had the honor of being the first to enroll at Rochester for the 54 Mass. Inf. Feb 9 1863."[89] There are competing opinions as to whether or not he was in fact the first soldier to enlist.

Mar. 19, 1864 He is honorably discharged from the 54th Infantry and is enlisted as a sergeant into the 5th Massachusetts Cavalry on March 26, 1864.

Sept. 15, 1864 He is discharged from the Union army on the grounds of ill health at the request of his father, who secures a dispensation from Abraham Lincoln.

Oct. 16, 1864 He is appointed a clerk in the Freedmen's Hospital in Washington, DC. As John W. Thompson confirms, "he was employed as hospital steward in the Freedmen's Hospital at Washington during the year of 1865."[90]

May 26, 1865 Charles Remond orchestrates the delivery of Abraham Lincoln's cane, bequeathed to Frederick Douglass by Mary Todd Lincoln.

Sept. 27, 1866 He marries Mary Elizabeth Murphy in Rochester.

Apr. 9, 1867 He is appointed as a clerk in the Freedmen's Bureau.

June 21, 1867 Charles Frederick Douglass is born in Rochester, New York.

Apr. 23, 1868 Charles Remond joins his brother Lewis Henry in

87 Ibid.
88 Ibid.
89 Ibid.
90 Thompson, *An Authentic History*, 158.

	participating in the Civil War Veterans' organization, the Grand Army of the Republic.
Oct. 27, 1868	Charles Remond builds a new house in Barry's Farm, Hillsdale, Anacostia, Washington, DC, with financial support from his father.
1869	He serves as "president of the city's Mutuals Baseball Club" in Washington, DC.[91]
Jan. 13, 1869	He attends with his father and brothers the National Convention of Colored Men in Washington, DC.
Mar. 1869	He ends his employment as a clerk at the Freedmen's Bureau.
Apr. 21, 1869	He takes up his position as a clerk in the Treasury Department.
July 3, 1869	Joseph Henry Douglass is born in Washington, DC.
Dec. 6, 1869	Charles Remond and his brothers are involved in the Colored National Labor Convention in Washington, DC.
Dec. 1869	He plays a key role in the public education system in Washington, DC. As a result, he is "successful in securing appointment of Black teachers," including Frederick Jr.'s wife, Virginia L. M. Hewlett Douglass.[92]
Jan. 12, 1871	Charles Remond is appointed as an assistant while his father is selected as the Assistant Secretary to the Santo Domingo Commission.
June 4, 1871	Annie Elizabeth Douglass is born in Washington, DC.
June 13, 1871	Charles Remond is appointed as "secretary-treasurer" of the "Washington County School Board." Writing while Charles Remond is still living, James Gregory confirms that "from 1871 to 1874, he was secretary and treasurer of the county schools, filling during the same period the position of school trustee. In this latter position he was instrumental in securing the first appointment of colored teachers in the county schools, and it was largely through his efforts that the equalization in the pay of colored teachers and the whites was accomplished."[93]
June 2, 1872	The Douglass family house burns to the ground under suspicious circumstances. Charles Remond returns with Frederick Douglass from Washington, DC, only to "find the ruins still smoking."[94]
July 1872	Annie Elizabeth Douglass dies, according to Frederick Jr.'s

91 For further information, see John Muller: <https://thelionofanacostia.wordpress.com/tag/douglass-family/> (accessed January 14, 2018).
92 Joseph Douglass Jr., *Frederick Douglass*, 375.
93 Gregory, *Frederick Douglass*, 205–6.
94 Charles Remond Douglass, "Some Incidents."

	record; Joseph Douglass records the date of her death as June 28.
Dec. 1872	Charles Remond works with Lewis Henry and Frederick Jr. on the *New National Era*.
Jan. 5, 1873	Julia Ada Douglass is born in Washington, DC.
Dec. 1873	Charles Remond and his father and brothers participate in the "Civil Rights Convention in DC."[95]
July 28, 1874	Mary Louise Douglass is born in Washington, DC. Frederick Jr. records her middle name by the initial "E" in his records.
June 30, 1875	Charles Remond is dismissed from his clerkship in the Treasury Department.
July 10, 1875	He is appointed as Consul of Puerto Plata, Santo Domingo.
Sept. 16, 1875	He arrives in Puerto Plata. His family move there in January 1876.
Oct. 12, 1877	He resigns as consul due to the long-term ill health of his wife.
Nov. 21, 1877	Edward Arthur Douglass is born in Corona, New York. Joseph Douglass lists an alternative birth date of Nov 27. Frederick Jr. identifies his middle name by the initial "E."
Nov. 27, 1877	Charles Remond leaves Puerto Plata to join his family living in Corona, New York. By this time, as John W. Thompson maintains, "he has been a pretty active correspondent for several papers."[96]
Sept. 19, 1878	Mary Elizabeth Murphy dies in New York City. As Frederick Jr. writes in a surviving scrapbook held in the Walter O. Evans collection, she is "buried September 21st 1878 in Cypress Hill Cemetery in front of Susan James Tomb, next to a tree, Near Corona, S. J. N.Y. State."
Dec. 1878	Charles Remond becomes "involved in West Indies trade, Corona, NY."[97]
Mar. 13, 1879	Edward Arthur Douglass dies in Uniontown, Washington, DC.
June 1880	Charles Remond moves back to Washington, DC.
Dec. 7, 1880	According to a reporter for the "Men of the Month" feature in *Crisis*, Charles Remond "helped to organize the Capital City Guards' Battalion, in which he served as captain and a

95 Joseph Douglass Jr., *Frederick Douglass*, 376.
96 Thompson, *An Authentic History*, 159.
97 Joseph Douglass Jr., *Frederick Douglass*, 377.

	Major member of the Grand Army of the Republic, being commander of amount of Post No. 21 and Assistant Patriotic instructor."[98]
Dec. 30, 1880	Charles Remond marries Laura Antoinette Haley.
Nov. 27, 1881	Haley George Douglass is born in "Canandaigua," according to Frederick Jr.'s handwritten record.
Sept. 1882	Charles Remond is appointed as a clerk in the Pension Office.
Nov. 2, 1887	Charles Frederick Douglass dies in Washington, DC. Frederick Jr. lists the exact time of his death as "10.20pm."
Nov. 3, 1887	Julia Ada Douglass dies in Washington, DC. Frederick Jr. records the date and time as "11:15pm."
Oct. 25, 1889	Charles Remond and Lewis Henry are integral to the "formation of Central Bureau of Relief."[99]
Mar. 7, 1890	Mary Louise Douglass dies. Frederick Jr. records her date of death as "March 7 1890 in Washington D.C. 820pm."
Apr. 10, 1893	Charles Remond purchases the land for Highland Beach, Maryland. His father buys a lot to build a summer cottage, "Twin Oaks," which is begun but remains unfinished when he dies. Charles Remond's business initiative results in a summer resort for elite African American families, including those of Booker T. Washington and Robert and Mary Church Terrell.
Nov. 9, 1895	Charles Remond is "temporarily dismissed from Pension Office clerkship," with the result that he becomes "self-appointed as pension agent."[100]
Dec. 21, 1895	He visits the Atlanta Exposition and "expresses reservations regarding Atlanta Compromise Speech."[101]
Spring 1898	He poses as the model for the statue of Frederick Douglass that is subsequently unveiled in Rochester, New York. The commemorative photograph taken by J. H. Kent is reproduced in this book. Sidney W. Edwards was the sculptor.
June 11, 1898	He issues a "call for African American Army officers" in a bid to combat the racist stranglehold of white military personnel.[102]
Sept. 14, 1891	He and the other Douglass family members attend the

98 Anon., "Charles Remond Douglass," 215.
99 Joseph Douglass Jr., *Frederick Douglass*, 379.
100 Ibid. 370.
101 Ibid. 380.
102 Ibid.

	ceremony dedicating the laying of the cornerstone of the Douglass monument in Rochester, New York.
June 9, 1899	He and the rest of the Douglass family participate in the public ceremony in which the Douglass Monument is unveiled.
May 1900	Haley George Douglass graduates from Harvard University.
Oct. 1903	Charles Remond "travels to promote Booker T. Washington's Program."[103]
May 22, 1904	He is the "featured speaker at dedication of Douglass Hall, Tuskegee commencement exercises."[104]
Mar. 15, 1919	Haley George marries Evelyn Virginia Dulaney in Washington, DC.
Nov. 23, 1920	Charles Remond dies in Washington, DC. As Robert Greene's research confirms, he died at "11:15pm of *interstice nephritis* with a contributing cause of *uremic coma*. He was treated by Charles Andrew Tignor, a Howard University College of Medicine graduate."[105]
Jan. 5, 1928	Laura Antoinette Haley Douglass dies in Washington, DC.
Dec. 7, 1935	Joseph Henry Douglass dies in Washington, DC.
Jan. 21, 1954	Haley George Douglass dies in Washington, DC.

103 Ibid. 381.
104 Ibid.
105 Greene, *Swamp Angels*, 88.

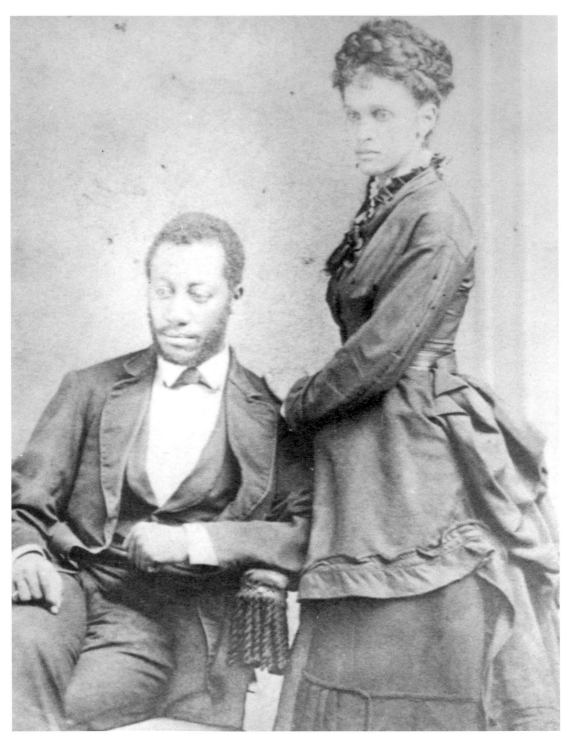

Figure 24: Anon., *Lewis Henry and Amelia Loguen Douglass.*, n.d. (National Park
Service: Frederick Douglass National Historic Site, Washington, DC.)

Part II

An "Undying" Love Story

Figure 25: Anon. *Helen Amelia Loguen*, n.d. (Onandaga Historical
Association Research Collection, Syracuse, NY.)

"A Heart of Love"

The Courtship of Helen Amelia Loguen
and Lewis Henry Douglass

"The slaves come to us with their frostbitten and bleeding feet, and
then we go to work to get them healed. Sometimes we have to keep
them for weeks and months," explains Jermain Wesley Loguen, a self-
emancipated freedom fighter and political activist (Figure 26).[1]

W riting on the eve of the Civil War in May 1859, Jermain Wesley Loguen
readily admits that his labors as an Underground Railroad conductor are
no solitary efforts. Working out of his family home in Syracuse, New York, he
confirms, "It takes about all the time of myself and family to see after their wants;
I mean the fugitives." "We have so much to do in the night that some nights we
get little or no sleep," he confides. Loguen bears witness to the fugitives' arrival
with terrible wounds: "They often come sick and must be cared for forthwith."
He holds nothing back in exposing the inhumanity of slavery by informing his
readers of the unimaginable depredations suffered by enslaved families. "We
have two mothers, with a child to care for with us at present," he reports. "Their
husbands were sold, and they made their escape and came to us some months
ago." He shares yet another harrowing story of family lives torn apart by slavery,
declaring, "We have a father that has just got to us with his little daughter about
three weeks old; its mother was taken from it, and the father then ran away with
the child, so that the men thieves could not get it." "While I write," Loguen states,
"in the room is a dear old mother telling to my wife about the selling of her

1 Jermain Wesley Loguen, "Letter to Frederick Douglass."

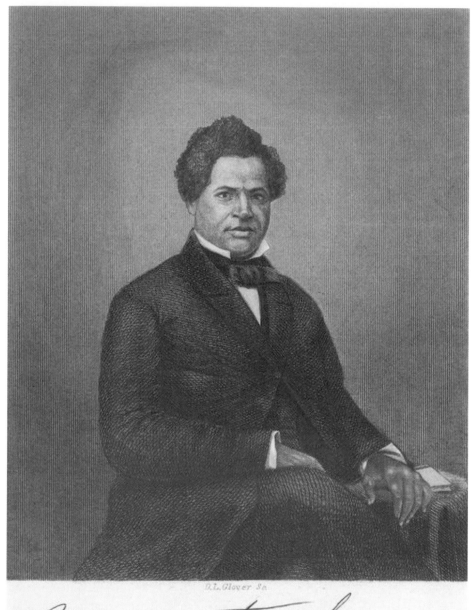

Figure 26: Anon., *Jermain Wesley Loguen*. Frontispiece, J. W. Loguen, *The Rev. J. W. Loguen, as a slave and as a freeman. A Narrative of Real Life.* (Syracuse, NY: J. G. K. Truair & Co., 1859.)

children to the far South. She is from Maryland; she has got some of her children with her." "Oh! what sorrow she has gone through," he helplessly exclaims.[2] Loguen's first-hand report of his activities as an Underground Railroad operator was published as a public letter he addressed to the editor of a radical Black abolitionist newspaper. Revealingly, as testimony he chose to print in *Douglass' Monthly*, this editor was no other individual than Frederick Douglass, his close friend and collaborator. Long-term brothers in the struggle, theirs was a relationship based on mutual respect and admiration. For Loguen, there was only one man who was "the model man among colored men; and that man is FREDERICK DOUGLASS."[3] "Would to God we had a FREDERICK DOUGLASS in every State of this wicked and hellish Union of political and church devils," Loguen declares. But he freely concedes, "We cannot all be Douglasses; but we could do a mighty work in this land for outraged humanity."[4]

Starkly contrasting to many of the African American reformers working on the abolitionist circuit who had been born free, Loguen shared Douglass's formerly enslaved origins. As for Douglass, so it was for Loguen: US plantation slavery was no abstract political concept, but a flesh-and-blood reality. At the heart of Loguen's determination to provide aid to "my poor fugitive brethren and sisters, that are coming to our house in their deep distress and anxiety of heart for liberty and a place of safety" was his empathetic understanding of their daily fight for existence: "I trust that I know how to feel for them in their distress, for a few years ago I was myself suffering with them on the plantations." "I ran away from my slavery," he states, only to admit, as Douglass repeatedly did, to the damaging extent to which language fails in even beginning to do justice to the enormity of his emotional and physical pain: "oh! the suffering I underwent tongue can never tell!" No outsider to the inexpressible "suffering" endured by enslaved people, Loguen, like Douglass, would never forget the physical and psychological wounding inflicted by the "peculiar institution." Also like Douglass, he found solace for his scars by engaging in a daily fight for the freedom of women, children, and men still living in slavery. "Since I escaped I have had the unspeakable happiness of helping about 1,500 others that were trying to obtain the same blessing—liberty—that I ran away for," he jubilantly declares.[5]

Working collaboratively, Loguen shared this "unspeakable happiness" of aiding enslaved women, children, and men not only with his wife, Caroline Storum Loguen, but with his eight daughters and sons: Elizabeth Letitia,

2 Ibid.
3 Loguen, *The Reverend J. W. Loguen*, 320.
4 Ibid.
5 Jermain Wesley Loguen, "Letter to Frederick Douglass."

45

Gabriella Clorinda, Helen Amelia (Figures 24, 25, and 27), Gerrit Smith, Sarah Marinda, Jermain William, Mary Catherine, and Cora Juliette Loguen.[6] While Elizabeth and Gabriella died at a tragically young age and Jermain and Cora passed away in early adulthood, Helen Amelia Loguen (1841–1936) survived. Scarcely a teenager in the late 1850s, Amelia's formative years were as defined by her exposure to the atrocities and abuses suffered by enslaved fugitives as was the early life of the man who was to become her husband: Lewis Henry, Douglass's eldest son and an equal collaborator in their family's Underground Railroad activism. Yet more similarly, just as the public life and works of Frederick Douglass dominated the "struggle for liberty" of his family members to the exclusion of all others, such was no less the situation facing the daughters and sons living in the shadow of Jermain Wesley Loguen's activism. For Helen Amelia Loguen and Lewis Henry Douglass, their shared family backgrounds (two formerly enslaved fathers turned freedom fighters), no less than their shared antislavery labors (not only their Underground Railroad activism, but their labors as teachers and civil rights protesters), undoubtedly played a powerful part in their falling in love. As the loves, losses, and longings of their surviving letters reveals, theirs was an intense emotional bond that was to last their lifetimes.

Among the most emotionally powerful, dramatic, and inspiring letters to be found in the Walter O. Evans Douglass and family collection is the private correspondence between Helen Amelia Loguen and Lewis Henry Douglass. These thirty-four letters date from the early 1860s and continue during Lewis's enlistment in the 54th Massachusetts combat regiment in the second year of the Civil War, on through to a post-emancipation era and the early twentieth-century fight for Black political, social, and economic equality. Within the pages of their beautifully written and courageous letters, they share their thoughts on passionate love, devastating war, abolitionist activism, civil rights, family grief, political rivalries, and literary influences. An emotional tour de force, they write their intimate letters against a backdrop of military, national, and political upheaval. Coming to life on yellowed sheets of crammed hand-writing, they are filled with the dreams, desires, jealousies, longings, sorrows, disappointments, and triumphs not only within their own lives but within the lives of African Americans fighting to keep body and soul together in the northern and southern states.

6 According to an anonymous article, "They had 8 children: Elizabeth Letitia died at 14 in 1855; Gabriella Clorinda died in 1847; Helen Amelia May 1 1843–June 26 1936; Gerri Smith August 26 1847–April 1918; Sara Marinda Jan 20 1850–April 9 1933; Jermain William December 30 1851–June 1884; Mary Catherine Dec 2 1853–March 24 1907; Cora Juliette May 23 1859–Jan 2 1885." See "The Loguen Family," 173.

For researchers working with this epistolary archive, a major difficulty immediately arises: only one of the surviving letters is authored by Amelia. Clearly, the reason that an overwhelming number of the letters are written by Lewis is due, quite simply, to the fact that this personal archive almost certainly originally belonged to Amelia herself. Self-evidently, she typically only kept the letters he sent to her. The difficulty of accessing Amelia's voice within these letters is further compounded by the gaps in the official records: if there is a struggle to piece together Lewis's chronology, there are all but insurmountable challenges facing researchers in beginning to put flesh onto the bones of Amelia's biography. These difficulties are symptomatic of the barriers facing researchers not only of Amelia's life story, but of nineteenth-century Black women's lives and their romantic relationships more generally.[7] Carol Hunter's groundbreaking research into the Douglass family is all the more remarkable given these difficulties. Her painstaking investigations lead her to confirm that Amelia, like her brothers and sisters, "benefitted from both their father's dedication to education and their mother's academic ability."[8] More particularly, Hunter emphasizes, "Helen Amelia, instructed by her mother and the Syracuse public schools, studied among other things chemistry, French and trigonometry."[9] "Becoming a teacher, she taught in the Hawley Street School for African American children in Binghamton, N.Y., while her father was assigned to Binghamton as a missionary pastor," Hunter notes, declaring, "She was also invited by Bishop Clinton of the AME Zion Church to teach freedmen in the South."[10] Again, however, we are confronted with very real dead ends. As Hunter concedes, "The *Syracuse Journal* quotes articles from *The Binghamton Standard* of Jan. 15, 1862 and March 30, 1864 reporting on the work of Amelia and Jermain in Binghamton," but to little avail, as "[c]opies of this paper have

7 Howard's pioneering article "The Courtship Letters of an African American Couple" is the exception to the rule. She examines nineteenth-century African American courtship, romance, and marriage as evidenced in the private letters of Calvin Lindley Rhone and Lucia J. Knotts. She emphasizes, as can be argued in the case of Amelia and Lewis, that Rhone and Knotts' "love letters reflect both the courtship customs and the romantic rhetoric of urban white middle-class Victorian Americans" (65). She experiences the same difficulties in undertaking her research as scholars encounter in the Loguen-Douglass archive and according to which, "Among the thirty-seven courtship letters saved in the Rhone Family Papers, thirty-five were Calvin's and only two were written by Lucia." Just as "Lucia must have been the one who actively saved the courtship correspondence," so it is the same situation for Amelia and Lewis. While there is a risk that "their correspondence could easily become dominated by his," Howard emphasizes, "her side of the conversation can be reconstructed from his" (68) in ways that are directly application for Amelia and Lewis; Lewis's letters equally make it possible to extrapolate Amelia's missing story.

8 Hunter, *To Set the Captives Free*, 71.

9 Ibid.

10 Ibid.

not survived."[11] Hunter is forced to admit defeat regarding whether Amelia "ever did teach in the South."[12]

And yet, "traces" and "marks" of Helen Amelia Loguen's life can be found if we investigate further afield. Extensive searching has led to the discovery of a private letter written by Jermain Wesley Loguen to his second eldest daughter from Syracuse on June 28, 1864, and held in the Gilder Lehrman Institute of American History collections. While the newspaper reports have not survived, Loguen himself confirms the labors of his daughter as a teacher. Writing his "dear Amelia," he confirms, "I shall try to be over on Saturday— tell your school I hope to see them on Sunday with their teacher."[13] Undoubtedly, Amelia had invited her renowned father to come and talk to her school children to share his experiences as an enslaved man and radical abolitionist. Yet more poignantly, this letter betrays Amelia's role as an intimate confidante and spiritual guide for her father in much the same way as Rosetta Douglass had provided emotional succor to hers. In this same letter, Loguen bares his soul to his daughter by confiding his mental angst: "I have not been well myself in my mind but I feel some better than I have for some days I hope to get better by the help of the Lord."[14] As we have seen in this book, a recurring exposure to emotional pain was similarly to haunt Douglass, as the memory of slavery continued to bleed through his everyday life as lived in a freedom that was in name only.

As evidenced here, no clearer reason for Loguen's sorrow can be found than his exposure to terrible bodily and emotional suffering as an enslaved man, no less than his exposure to the sufferings of enslaved people during his activist labors following his own act of self-liberation. In this regard, his decision to write a letter to his daughter not on blank paper but on the reverse of a public circular that was issued at the height of the family's Underground Railroad activism is no accident. Addressed "To the Friends of the Fugitives from Slavery" and dated June 5, 1860, this appeal was signed by leading white abolitionists including Samuel J. May. The statement begins as follows: "Since the Fall of 1857, the management of this business [the Underground Railroad] has been devolved almost wholly upon the Rev. J. W. LOGUEN and his family." As these white supporters urged, the Loguen family "are willing still to keep their house open as an asylum for the oppressed, and to help them on their way to free homes," but they are in need of financial assistance: "In order to do this he [Loguen] must depend upon the contributions of the benevolent of this city

11 Ibid.
12 Ibid.
13 Jermain Wesley Loguen to Helen Amelia Loguen, Syracuse, New York, June 28, 1864.
14 Ibid.

and elsewhere, for the support of his family and the aid of those who come to them in distress."[15] For Jermain Wesley Loguen, no less than for Frederick Douglass, the tragedies experienced by Jarm Logue and Frederick Augustus Washington Bailey refused to die in their new lives as liberated freedom fighters. Yet more poignantly, they were daily realities for which their eldest surviving children, Helen Amelia and Lewis Henry, shouldered full emotional and political responsibility.

These difficulties in tracing the life of Helen Amelia Loguen in the historical record have led to her widespread scholarly neglect. In his richly incisive examination of Jermain Wesley Loguen's activism, Milton Sernett discusses the Helen Amelia Loguen–Lewis Henry Douglass relationship by advising readers to "[s]ee the interesting exchange of letters between Amelia and Lewis, particularly one written by Lewis to his fiancée while serving with a black regiment in the Civil War after the assault on Fort Wagoner [sic]."[16] Here Sernett is not referring to the voluminous Loguen-Douglass correspondence held in the Walter O. Evans collection, but rather to four additional letters—one authored by Helen Amelia and dated April 10, 1862, and three written by Lewis and variously dated June 14, 1862, August 6, 1862, and August 18, 1862—that can be found in the Carter G. Woodson papers, accompanied by no provenance and held at the Library of Congress. As early as 1926—long after Lewis had passed away, but while Amelia was still living—Woodson published transcriptions of these letters with additional correspondence by other Black authors and activists in the *Journal of Negro History*.[17] In comparison with the Loguen-Douglass correspondence held in the Walter O. Evans archive, all four letters owned by Carter G. Woodson are dated prior to Lewis's enlistment in the Civil War. As we see later in this book, the Walter O. Evans Loguen-Douglass correspondence spans their entire lifetimes, lasting right up until Lewis's death in 1908.

Writing "[m]y dear Lewis" from Syracuse on April 10, 1862, Amelia's letter is the earliest letter to survive in Woodson's collection. She is at pains to apologize to Lewis for her "negligence in allowing so many weeks to pass away without writing." She explains her neglect on account of a tragic death in the family and the ongoing burden of her domestic responsibilities. "I have lost by death a dear aunt whose name was Mary Wills and her home was with my grandfather in Rusti Chautauque Co. N. Y.," she writes, confiding, "Father and Mother attended her funeral, leaving me to keep house and care for aunt

15 Ibid.
16 Sernett, "'A Citizen of No Mean City,'" 50.
17 See Woodson, "Letters of Negroes," 87–112.

Tinnie and little Tinnie who were both sick." She takes heart that she did not fail when faced with these personal challenges: "I flatter myself that I did remarkably well 'considering.'" "Little Tinnie," or Sarah Marinda Loguen, Amelia's younger sister, is to make repeated appearances across their correspondence held in the Walter O. Evans collection and reproduced in this book.

In comparison to her sister, about whom it is difficult to establish even the basic facts of her biography, Sarah Marinda Loguen has left a powerful historical trace. One of the earliest African American medical doctors, Sarah Marinda, nicknamed "Tinnie," graduated from Syracuse University Medical School in 1876. By 1879 she was living with Helen Amelia and Lewis Henry Douglass at their home in Washington, DC. At that time, as Eric D. V. Luft's research confirms, she opened a "private medical practice in a room on 13th Street, NW," and none other than "Frederick Douglass personally nailed up her shingle."[18] Scarcely a few years later, in 1882, she met and married Charles A. Fraser, a pharmacist to whom she was introduced by Charles Remond Douglass. They migrated to Puerto Plata, Santo Domingo, immediately after their marriage, whereupon Sarah Marinda Loguen excelled by passing further medical examinations at the University of Santo Domingo. As a result, she earned renown as "the Dominican Republic's first woman doctor and first paediatric specialist."[19]

As confirmed by the unexamined Helen Amelia Loguen family correspondence held in the Walter O. Evans archive—which is not reproduced but is inventoried for readers in the final part of this book—Sarah Marinda Loguen Fraser experienced profound personal and practical difficulties following her husband's sudden death a decade later, in 1894. As "Mate" (very likely Mary Catherine Loguen) writes Amelia on December 16, 1894, while visiting Sarah Marinda Fraser in Puerto Plata in the wake of her loss, "poor Tin I can understand her anxiety how terrible those hours of suspense were to her." Yet more revealingly, a fragment of a letter Amelia composed but very likely never mailed to Lewis and dated "Feb 16" states, "Poor Tin she does not want to hear of our leaving but if we remained two or three months longer she would feel just the same. I am hope hoping she will be able to follow us in a few months." In a torn and undated letter which Amelia most likely wrote Lewis during this same visit, she poignantly informs him, "we went to the cemetery and visited Mr Fraser's grave." Anecdotally, she confides, "Tin pointed out a house where Charlie used to live. I have now seen three houses that he occupied at different times while here." Here she is referring to Charles Remond Douglass's

18 Luft, *SUNY Upstate Medical University*, 67.
19 See Marc, "Sarah Loguen Fraser." For access to an original portrait of Sarah Marinda Loguen Fraser, see <http://www.hws.edu/academics/english/fraser.aspx> (accessed January 14, 2018).

employment as US consul to Puerto Plata. Recognizing the difficulties facing the recovery of Black women's lives in the white-dominant archive, Gregoria Fraser Goins, Sarah Marinda and Charles Fraser's only daughter, assumed the role of her mother's biographer. She refuses to leave the memorialization of Sarah Marinda Loguen's life to chance by authoring an unpublished biography of her life titled "Miss Doc," now held in the Moorland-Spingarn Research Center collections at Howard University. As Eric V. D. Luft states, "If 'Miss Doc' were to be edited and published as a book, it would be a great benefit to African American history, women's history and medical history alike."[20]

In no way resembling her sister "Tinnie," who was to excel as a student, Amelia tells Lewis of her impatience with the restrictions of formal education in her letter of April 10. "Spring has brought with it as usual, the ever dreaded, yearly school examinations, *dreaded* because they are so *very tedious*," she admits. She is exasperated to report that, "Monday I thought of nothing but Chloride of Sodium. Nitrate of Silver detection of arsenic, uses of Zinc etc etc; Tuesday, Parlez-vous francais? Comment-vous appelez-vous? and Je me porte tres bien." As if this was not affliction enough, she continues, "yesterday oh! terrible thought Plane Trigonometry." She readily concedes her futile attempts at "trying to show that Chemistry is one of the most useful and interesting studies imaginable." Her relief is palpable that all school examinations are over: "O! how refreshing on awaking this morning to know that all *such* is for a time past and that vacation is close at hand." Not for Amelia a sole focus on domestic duties and educational tasks, however. She seamlessly interweaves her personal frustrations with her preoccupation with political debates. As she observes, there was "[q]uite a contrast in the reception of Wendall Phillips [sic] in Washington and the manner in which he was treated in Cincinnati." Amelia concludes her letter with a rhetorical question in which she lays bare her disappointment with the immoral behavior of white men: "how filled up this world is with mean unprincipled men, will they ever be reformed?"

Clearly, Amelia is expressing her outrage at the villainous reception granted Phillips' lecture of March 24, 1862, in which he addressed the major causes undergirding the Civil War. As a newspaper commentator summarizes: "Mr. PHILLIPS said there were three questions which he would ask; How long is the war to last? What will become of Slavery? And, what will become of the Union?" Writing in the *Cincinnati Gazette* on March 25, the reporter continues, "Mr. P. then went on to say that he had been an Abolitionist for sixteen years. This remark was received with hisses and a few cheers." In taking a radical stand, he was met not only with verbal abuse but with physical injury:

20 Luft, "Sarah Loguen Fraser," 153.

"Presently two or three rotten eggs were thrown from the second tier, one of which struck the speaker on his right side, and covered his coat and pants with the filth." The writer commends the white abolitionist for his bravery in the face of these attacks: "Apparently unconcerned, Mr. PHILLIPS continued, when a paving-stone, thrown with great violence, struck near his feet. He still continued his remarks, but was frequently interrupted by hisses and cat-calls." Eventually the crowd took matters into their own hands and broke up the meeting altogether: "A rush was presently made down the stairs and into the middle of the aisle, and the cry, 'To the stage!' was shouted by the leader of the gang. Mr. PIKE used his influence to prevent them gaining access to the stage, and many hurled stools and canes at the crowd as they advanced."[21] For Amelia, the question as to whether such "unprincipled men" would ever be "reformed" remained unanswered because it was unanswerable in the context of the escalating mob law, racist violence, and discriminatory persecutions facing Black people in the second half of the nineteenth century.

A few months later, on June 14, 1862, Lewis writes "my own dear Amelia" from Rochester with a very different subject in mind. He is deeply uninterested in mundane domestic duties or even in wider political realities. For Lewis, these daily matters are of no consequence in comparison with his determination to communicate his passionate love to Amelia, the idealized subject of his affections. He begins his letter with a very different rhetorical question: "How can I express the pleasure it affords me to receive a letter written by the hand of her I love?" He is categorical in his conviction that, "To me that pleasure is inexpressible and I can not attempt to find words that will in any way give an idea of that pleasure, fearful that I may find myself netted by an inextricable net of conglomerated nonsense." Despite his very real fear that he will mire himself in incoherent language, he waxes lyrical by entering into a philosophical debate on love: "Men and women talk of Love, can any one describe it? Can any one give the reason why one person loves another to the exclusion of every one else, that is why one man loves a lady more than he does another and *vice versa* when ladies and gentlemen are so nearly alike." He is at pains to reassure Amelia of his unwavering devotion: "I know many ladies, who are amiable kind, talented and refined, all that a man could wish, and yet I cannot love them or do not love them as I love you, and they may be like you, but to me they are different, now who can tell wherein is the difference." "I am led to think that love is an unreasonable passion, that persons who love each other do so through the exercise of some other power than reason," he concludes.

21 Anon., "Wendell Phillips in Cincinnati," March 28, 1862.

In this letter, Lewis informs Amelia of his lack of free will by declaring, "some undefinable force attracts me to you, and I have no means of resisting it and would not if I had." "As the sun rises in the mornings and brightens into freshness, beauty and grandeur, hills, meadows, and forests that have been clouded in gloom by the black and awful midnight; so day after day freshens and brightens that respect esteem and love I bear you," he urges. Lewis is careful to insist that, "Not like the hills, meadows and forests disappearing from the sight in an impenetrable gloom of intense darkness by night but as a city appears to an early riser who ascends a hill that overlooks it, and sees it standing encircled and imprisoned by a misty vapor, just transparent enough to enable you to look beyond and see it standing in its majesty, is my love for you in my dreams by night." For Lewis, only the sublime beauty of the natural world can begin to approximate the sublime power of his love for Amelia. A few months later, on August 18, Lewis again writes from Rochester to confess to the failures of language to begin to do justice to the power of his emotions. "I have been and still am at a loss to express in words the deep feeling of mingled love and gratitude with which I was inspired by reading that kind letter of yours of the 27th July, breathing words from a heart filled with a confidence which a pure unalloyed affection can only inspire," he declares. While we are denied access to Amelia's expression of her feelings, Lewis readily admits to their transformative effect on his life: "your love of me, tells me that I am not a vile wretch, for you my dear are too noble minded and good to desire to join yourself to such." Lewis is careful not to compromise his masculinity at the same time that he concedes, "were I not a man I might shed tears of gratitude."

The Walter O. Evans Helen Amelia Loguen-Lewis Henry Douglass correspondence prior to Lewis's enlistment in the Civil War—consisting of nine surviving letters, beginning with the earliest dated December 22, 1860 and the latest written on December 29, 1862—is reproduced here as original facsimiles along with annotated transcriptions. Their epistolary archive traces the trials and triumphs of their epic romance to reveal that the "course of true love never did run smooth." Writing Amelia on December 22, 1860, Lewis enigmatically alludes to the love of his life as having ordered him not to contact her, only to ignore her demand entirely: "Is this wrong to write you after your request not to do so. I hope not." He reassures her that he demands no expression of commitment: "You need not look upon this in the light of a correspondence. I wish merely to wish you a merry Christmas, and a Happy New Year." And yet he is unable to sign his letter before giving full vent to his desire: "'Ever of thee I'm sweetly dreaming.'" Scarcely six months later, their intimacy is fully restored.

"Ever since you aprised [sic] me that it was not your intention to poke fun at me by that kiss I have ceased to fancy that you so intended or by that kiss you intended to ameliorate my feelings toward you," Lewis writes Amelia on June 1, 1861. He relies on a spirited play on her name to urge, "you have triumphantly succeeded in your Amelia-rating," readily intimating, "I would be glad to receive another Amelia-ration, as I shall hereafter call your love inspiring kiss." He defends himself against a charge of imagined neglect by explaining, "That cold 'good evening' when we met at our house the time of your visit on returning from the falls, I am excusable for." As he writes, "The time you were at our house in 1859 I did not even speak to you, in fact I was completely thrown into the shade by a younger brother who I remember staid away from the office for the purpose of entertaining you." While it is impossible to prove with any certainty which brother was his potential rival for Amelia's affections, we would argue that it is most likely to have been Frederick Douglass Jr. Then assisting in the publication of *Douglass' Monthly*, he is the only brother who was working in an "office." During this time, Charles Remond Douglass was living away from home as a farm laborer.

Writing of another early encounter, this time in "Geneva, August 1859," Lewis reminds Amelia of his having to contend with yet another rival. "[Y]ou were waited upon by a highly interesting (to say the least) 'clark' from Syracuse I believe on the discovery of which I 'sloped,'" he recalls. As investigation into the Amelia Loguen Douglass family correspondence, inventoried in the final part of this book, immediately reveals, the name of this potential suitor was almost certainly Henry J. Tatterson. A letter survives in this collection in which Tatterson writes Amelia from Niagara Falls on July 6, 1857, and identifies his profession as "Clerk of the House." His identity as a love rival is incontestable as he goes on to share "all my pent up feelings" with Amelia by confiding, "I have often thought of those beautiful moonlight nights that spread splendor all over the land." He shares Lewis's sense of failure in doing justice to his emotions by conceding, "I have a great deal to say to you that I cannot say on paper." The proof that Henry was Amelia's earlier suitor is confirmed not only by his impassioned expression of his "pent up feelings" but due to the fact that this was a letter she kept as a precious memento, along with the correspondence from her husband, throughout her lifetime. In this same archive, Gerrit Loguen, Amelia's brother, provides yet further evidence by writing a letter from Rochester simply dated June 12, in which he teases her mercilessly. "Dear sister when you and your adorer converse again do not talk so loudly as you did on a former occasion for I see his remarks have been published in the papers," he counsels. Gerrit relishes in his joke by pasting in a newspaper clipping that reads in part: "'Amelia—for thee, yes, at they

command I'd tear this eternal firmament into a thousand fragments; I'd gather the stars, one by one,'" to which an imaginary "Amelia" cautions, "'Don't, Henry, it would be so very dark!'" While the reference to Henry is ambiguous— Henry is Tatterson's first name, but also Lewis's middle name—it is almost certain that Gerrit selected this clipping as a humorous reference to Amelia's intimacies with "a highly interesting clerk": across her correspondence, Amelia never referred to Douglass's eldest son as Henry, but only ever as Lewis or Lew.

"It was hard to part, though I may not have shown it to be so," Lewis informs Amelia two months later, on September 24, 1861. "I see you now, as we drove off standing at the gate, your eyes beaming love for me, and thus will I see you wherever I may journey until I come back again," he remembers. For Lewis, love conquers all: "That memory of you may in sickness or pain far from home or friends, act as a soothing balm, and causing me to forget pain and loneliness, cheer up my spirits, fill my soul with hope and happiness." He is equally in no doubt, "That memory will spur me on, enable me to over come whatever obstacles sickness or pain, loneliness or unhappiness may interpose in the way of my reaching the object of my deepest love, my own dear Amelia." During his young adult years as beset by war, ill health, and personal turmoil of all kinds, Lewis's passionate love for Amelia had the epic power to triumph over all kinds of emotional and physical suffering. After enduring a week of illness, he writes Amelia on September 29 not only to tell her he has been "laid up sick with that terrible throat disease," but to declare his love for her in unequivocal terms: "When I Lewis H. Douglass, Box 2240, Rochester, county of Monroe, State of New York, U.S.A. tell you to love me not, may I be (hold on I was just about to write something not exactly adapted to ears polite, but I refrain) hung drawn and quartered." Across his letters, Lewis's language is drenched in the vocabulary of European courtly romance as he casts himself as a medieval knight in pursuit of a fair maiden.

Amelia's sole surviving letter is dated October 3, 1861. She writes in reply to Lewis's letter informing her of his "throat disease" and of his declaration of love by admitting to her surprise at his steadfastness. "I had expected a letter but had given up all hopes of ever hearing from you again," she confides, taking heart that, "when I learned of your sickness all was explained and I found myself mentally saying 'poor Lew I am so sorry that he has been sick.'" She is filled only with sorrow at his suffering. "How lonely you must have been during those long seven nights that you could not sleep," she writes, urging, "had I known it I should have been tempted to come and dispell [sic] in a slight measure their gloomy monotony." "I received your kind letter on the memorable 1st of October," she further observes as she again turns to political issues and the fight for Black civil rights by declaring, "On the quiet evening of that beautiful

day Memory and me [I] took a pleasant stroll in the well known past; ten long years have passed since Jerry was rescued." Here she commemorates the decade-long anniversary of the leading role her father played in the "Jerry Rescue." Working with other activists, Black and white, Jermain Wesley Loguen effected the escape from jail on October 1, 1851, of William Henry, an enslaved fugitive, who had been arrested and imprisoned under the Fugitive Slave Law by pro-slavery authorities in Syracuse.[22] "I was only eight then and yet I remember that day as distinctly as though it were but a <u>short time</u> ago," Amelia confides. "I can never forget the strange feelings that passed over me, when I heard all the bells in the city tolling, before we had heard what was the matter," she recalls, poignantly observing, "How many changes have taken place since <u>that</u> day, four dear ones who were then in the enjoyment of life and health are now silently sleeping their last long sleep." Here she memorializes the deaths not only of her aunt but of her brother Jermain William (1851) and sisters Elizabeth Letitia (1855) and Cora Juliette (1859), none of whom reached adulthood. For Amelia, the trials of the public arena remained inseparable from the tragedies of the domestic sphere. At the same time, she finds powerful solace in her grief from falling in love with Lewis. "Some that we did not know then are now <u>dear</u> friends," she writes, freely admitting, "I well remember the Celebration held three years ago, how I did want to have a little chat with <u>some one</u> but alas! had not the courage." She even concedes her erotic desire by adding a postscript the following "Morning," which reads: "I had a splendid little visit with you in my dreams last night." Lewis is unable to resist playing with his status as "some one" in one of the letters held in the Carter Woodson Papers. On August 6, 1862, he jubilantly writes, "'Some one' is very happy to know that another some one is enjoying herself."

"Through the medium of the mighty pen a love has grown up between us that baffles all description, and my prayer is that there may nothing arise that may in any way shake the firmness or overturn the foundation of our love which we have each made to [sic] known to one another," Lewis writes Amelia on December 8 1861. The different topics Amelia introduces into their letters notwithstanding, Lewis remains unwavering in his commitment to discussing their love. At the same time, he experiences anxiety at the prospect of a marital union that, unknown to him, is still eight years away due to the Civil War, which he imagines will take place much sooner. "Will not the familiarity of marriage blunt in a measure the real happiness of such moments," he rhetorically asks, reassuring them both by stating, "I trust not, yet we can see how

22 For more information on this case, see the article by Patenaude Roach and the book by Murphy listed in the bibliography.

others live who are married." As he confides, "There are some men however who marry because it is fashionable to be married not stopping to find whether he is in that blessed state love, and soon sickens of his companion in life and seeks pleasure in corner groceries and grog shops." Not for Lewis is this fate, as he lives and breathes that "blessed state love." "I want to marry you simply because I love you," he declares, stating, "and as my love for you has stood the test of nearly two years, and those years spent in absence from you and a portion of time not even having the pleasure of a letter from you, I base the hope on such a foundation that my love and your love may remain undying." For Lewis there is no question that "Such should be the love of husband and wife." On July 11, 1862, he is no less impassioned in his declarations, as he again points to the failures of language to communicate his joy: "I am happy! Words! Words! thou ready agents of man's ideas, why oh, why have you not the power of giving an expression to the deep heart and soul emotions?"

In a unique departure from Lewis's sole focus on his "undying love," however, he writes Amelia from Salem on November 20, 1862, to inform her of his disappointment in his intended participation in the anticipated expedition to Central America. "I started from home on the tenth of October, for Philadelphia to join Gen. Pomeroy at Washington, but on arriving in Philadelphia I saw by the papers that the day of departure from Washington for Central America had been indefinitely postponed," he confirms. "I became fearful that the whole scheme had fallen through and the prospect before me looked gloomy," he concedes, only to find that his fears had indeed been realized: Abraham Lincoln's projected "scheme" of Black migration to Chiriquí had been aborted due to the needs of the nation during the ongoing Civil War.

In a letter Frederick Douglass writes on September 16, 1862 to politician and lawyer Montgomery Blair he is careful to stipulate, in discussing a letter he wrote to Pomeroy about Lewis Henry, that "though it does not contradict my sentiments touching this new colonization enterprise, it does not fully express them. It was meant to be a simple note of introduction of my son to General Pomeroy as one desirous to join the contemplated Central American colony." Douglass is clear: "My son is of age, forms his own opinions, pursues his own plans and agrees with me, and differs from me in the exercise of that liberty according to American young men generally, who have their own way to make in the world."[23] Lewis holds nothing back in admitting his disappointment to Amelia. "You cannot imagine my feelings when I read that reply," he states, summarizing, "suffice it to say that I became dejected and miserable[,] thought of home, though not home sick, thought of you my own dear one, but had not

23 Frederick Douglass to Montgomery Blair, September 16, 1862, 284.

spirit spirit enough to even pen a line to you or to my home." Over a month later, however, he has processed his disappointment and is back to focusing on their love. Writing from Salem on December 29, 1862, he is again at peace: "How pleasant is it then to lie in bed, ever and anon peering out through the half closed blinds at the pale Queen of the Night, wondering does my dear Amelia gaze upon the same moon, and think of me." As he exclaims, "bye and bye I drop away and anyone [sic] to the beautiful land of dreams, where I again meet you, and we go on loving ever." As a man who was exposed to all forms of grief, sorrow, pain, and loss, Lewis finds spiritual salvation in his and Amelia's epic romance, taking solace in their going on "loving ever."

As a personal archive debating romantic love, untimely death, political activism, and military conflicts, the Helen Amelia Loguen and Lewis Henry Douglass correspondence held in the Walter O. Evans collection is invaluable for researchers investigating the lives of radical Black abolitionist families and their daily battle for existence, both at the height of chattel slavery and in its terrible aftermath. Their intimate epistolary archive sheds powerful light on the "struggles for liberty" that were endured not only by first-generation fathers who had been born in slavery but by their children, who were born in seeming freedom in the North but against a backdrop of slavery as a legal institution that was yet to be abolished. Slavery was no abstract phenomenon or distant reality for women and men such as Helen Amelia and Lewis Henry. In their daily lives, they worked hard to provide emotional support to the scarred bodies and traumatized minds of their fathers as well as to the enslaved fugitives of all ages who were pouring out of the South and living in their homes.

The Helen Amelia Loguen and Lewis Henry Douglass correspondence retains powerful importance in African American history as an archive of romantic love. As Eleanor Alexander argues in her richly illuminating study of "the tragic courtship and marriage" of Paul Laurence Dunbar and Alice Ruth Moore, "the intimate history of the African American middle class/elite is basically unexplored."[24] Yet more revealingly, her insistence that "the Dunbars' relationship was shaped by the legacy of slavery and the ideologies of nineteenth-century race, class, romantic love, and gender-role expectations—the prescribed and institutionalized cultural concepts of femininity and masculinity" can be directly applied to the under-researched lives and loves of Helen Amelia Loguen and Lewis Henry Douglass.[25] As it was for Dunbar and Moore, who were courting decades later, in the 1900s, so it was for Loguen and Douglass in the early 1860s: their lives were not less but potentially even more

24 Alexander, *Lyrics of Sunshine and Shadow*, 5.
25 Ibid.

defined by slavery's emotional and psychological legacies as well as by nine-teenth-century definitions of Black manhood and womanhood. "The letters, giving insight into the world of elite African American courting rituals, are a distinct contribution to African American history," writes Alexander of Dunbar and Moore in another summary, which again works just as effectively for describing the Loguen-Douglass correspondence.[26]

On offer in Lewis Henry's letters in particular is incontestable evidence of "the most compelling nineteenth-century love myths" that "love transcends and solves all problems." No more powerful confirmation of Alexander's conviction that "A good marriage was especially important to the African American middle class" on the grounds that, "Idyllic unions were symbols of proper conduct, and idealistic behaviors were necessary for racial advancement in a racialized nation," can be found than in their impassioned exchanges.[27] Equally, her emphasis that, "Courtship and marriage were important" because "many were the daughters and sons of ex-slaves, and generally slaves had been denied the rituals of romance and marriage that Euro-Americans took for granted" is incontestably a defining aspect of their lives.[28] The Helen Amelia Loguen-Lewis Henry Douglass intimate archive is all the more vital due to the startling fact that, as Alexander points out, "whether famous or not, only one scholarly article on elite African American courtship and marriage appears in the literature."[29] In this regard, if the "intimate history of elite African Americans is new territory," how much more so is this the case for "another untapped area of African American history, mainly, sexuality among the elite"?[30] This scholarly neglect may well explain not only the lack of any inves-tigation into Helen Amelia Loguen and Lewis Henry Douglass's romantic lives but also the swirling quicksand of racist assumptions, exoticized simplifications, and reductive objectifications that exerts a stranglehold over any and all attempts to analyze Frederick Douglass's own romantic and sexual lives.

Nearly a decade after they bared their souls to one another in their private correspondence, the dreams of Helen Amelia Loguen and Lewis Henry Douglass's hearts were finally fulfilled on October 7, 1869, when they were married at the home of Jermain Wesley Loguen. According to an unnamed guest writing in a newspaper clipping that Lewis Henry himself very likely

26 Ibid. 6.
27 Ibid. 78.
28 Ibid. 79.
29 Ibid. 7.
30 Ibid. 8, 8–9. In Alexander's study, she mentions "the sons of Frederick Douglass and their wives" as among "the premier couples of African American society" (ibid. 118). More especially, she mentions Helen Amelia Loguen Douglass's friendship with Matilda Dunbar.

pasted into one of the scrapbooks held in the Walter O. Evans collection, their wedding was "one of the most attractive and brilliant gatherings it has been my good fortune to mingle in for some time." As per this unnamed guest's report, "a large number of the personal friends of the young couple, as well as those of their distinguished sires, consisting of all colors, were present." The ceremony took place at ten in the morning in the gardens of the Loguen family home. "The bride, attired in a rich changeable silk poplin, neatly trimmed with white satin, stood gracefully beside the groom, whose fine form and unexceptionable suit of black, presented a pleasant contrast," this observer reports, noting, "Mr. Gerret [sic] S. and Miss Tinny Loguen, brother and sister of the bride, who waited on the happy pair, stood next." And yet, by far the most striking figures of the occasion were the fathers: this eyewitness writes in awe of "the commanding forms of Bishop Loguen and Frederick Douglass, towering above the entire company." After the wedding ceremony had been performed by Bishop S. T. Jones, the guest confirms, "The bridal party left Syracuse at 2.30 pm, on the 9th inst., to spend a few days at the Douglass homestead, at Rochester, N.Y.; from thence they go to Washington D.C., where Mr. Douglass is in the employment of the government and where they will reside."[31] On the same page of this scrapbook, there is a newspaper clipping from the Syracuse *Daily Standard* dated October 11th, 1869. Starkly contrasting to the focus on the "commanding forms" of their fathers in the other report, here Lewis and Amelia are the exclusive focus. "Mr. Douglass, although still youthful, has acquired a wide notoriety, and has made a record of which both himself and the race to which he belongs may well be proud," this commentator reports, observing that, "The bride is an accomplished lady, well fitted to make a mark in the best society, but of domestic tastes and habits, and the idol of the circle in which she moves."[32]

What had intervened between 1860 and 1869 to delay the fulfillment of Helen Amelia Loguen and Lewis Henry Douglass's hearts' desire? The Civil War. Writing on August 29, 1861, in the pages of the *Syracuse Daily Standard*, Jermain Wesley Loguen was categorical as to who should be fighting for Black freedom. "'One colored regiment of black men,'" he proclaims, "would do the cause of liberty more service than half a dozen regiments that are merely fighting for the *Constitution* and *Union*."[33] Among those to heed Jermain Wesley Loguen's call to fight in the "cause of liberty" no less than Frederick Douglass's later appeal urging "Men of Color, To Arms!" were none other than Lewis Henry and his young brother, Charles Remond Douglass. Over thirty years

31 No further information regarding the author, article title, publication, or date accompanies this report in the Walter O. Evans collection.

32 Anon., n.t., *Syracuse Daily Standard*, October 12, 1869.

33 Loguen, *Syracuse Daily Standard*, August 29, 1861.

Figure 27: Anon., *Helen Amelia Loguen Douglass*, n.d. (Prints and Photographs Division, Moorland-Spingarn Research Center, Howard University, Washington, DC.)

later, on May 24, 1899, Amelia writes Matilda Dunbar, Paul Laurence Dunbar's mother, "'We are in the midst of our Peace Jubilee or rather some kind of a Jubilee, but we colored people are not a part of it, for us there is no peace!'"[34] If it was the case that there was "no peace" for the "colored people" in 1899, war was the battle cry of 1863.

34 Hudson, *A Biography of Paul Laurence Dunbar*, 165.

1. Lewis Henry Douglass to Helen Amelia Loguen, Rochester, NY, December 22, 1860

Rochester, Dec. 22 1860

Dear Amelia;

Is this wrong to write you after your request not to do so I hope not. You need not look upon this in the light of a correspondence, I wish merely to wish you a merry Christmas, and a Happy New Year. I hope this may find you well. I am feeling extremely well I do not know when I have enjoyed a winter so well as this. I am looking with great pleasure to bonnie May for the renewal of our, (to me) most happy correspondence, until then I enjoy myself in seeking what pleasure may be found in wherusing your letters to me, especially the last one, "Ever of thee I'm sweetly dreaming"

Yours Lovingly
Lewis

1. Lewis Henry Douglass to Helen Amelia Loguen, Rochester, NY, December 22, 1860

Rochester, Dec. 22 1860

Dear Amelia:

Is this wrong to write you after your request not to do so. I hope not. You need not look upon this in the light of a correspondence. I wish merely to wish <u>you</u> a merry Christmas, and a Happy New Year. I hope this may find you well. I am feeling extremely well. I do not know when I have enjoyed a winter so well as this. I am looking with great pleasure to bonnie May for the renewal of our, (to me) most happy correspondence, until then I enjoy myself in seeking what pleasure may be found in re-perusing your letters to me, <u>especially</u> the last one.

"Ever of thee I'm sweetly dreaming."[35]

Yours Lovingly

Lewis

35 Perhaps a reference to "Ever of Thee," by George Linley and Foley Hall, a popular song from 1858 which begins: "Ever of thee I'm fondly dreaming,/Thy gentle voice my spirit can cheer."

Rochester, June 1 1861

My Dear Amelia:

Your letter bearing date May 29,
but unfortunately for me, not mailed
until the 31st reached me last
evening, finding me well. Ever
since you assured me that it
was not your intention to poke
fun at me by that kiss I
have ceased to fancy that you
so intended. If by that kiss
you intended to ameliorate
my feelings towards you, let me
assure you that you have triumphantly
succeeded in your Amelia —
rating. Just at the present
moment I would be glad to
receive another Amelia — ra-
tion, as I shall hereafter call
your love inspiring kiss they
are rations which I will
always be glad to receive.

. That cold "good evening" when we met at our house the time of your visit on returning from the falls, I am excuseable for though I had seen you on four occasions before I never had an introduction to you. The time you were at our house in 1857 I did not even speak to you, in fact I was completely thrown into the shade by a younger brother who I remember staid away from the office for the purpose of entertaining you, you will no doubt remember the circumstance. The next time I saw you was the 2d of Oct, 1857 at 6½ o'clock p. m. at your home, then I did not speak to you, and the next time I saw you was in June 1858 father and myself were on

our way to Mrs Granville,
then I had no introduction
to you and nothing but a "cold good
afternoon" escaped either of us, it
was on that occasion, that you
were dressed in that near
approach to masculine
unmentionables, bloomers, and sang
"I'll never see my darling
any more," you will also re-
member this occasion, again,
the next time we met was in
Geneva, August, 1859, then I
had no introduction to you but
I believe we exchanged nods as
we were walking down to the
park, this time you will re-
member as you were waited
upon by a highly interesting
(to say the least) "dark" from Syra-
cuse I believe on the discovery
of which I "sloped", leaving you
and Miss Douglass in the enjoy

2. Lewis Henry Douglass to Helen Amelia Loguen, Rochester, NY, June 1, 1861

Rochester, June 1 1861

My Dear Amelia:

Your letter bearing date May 29, but unfortunately for me, not mailed until the 31st reached me last evening, finding me well. Ever since you aprised [sic] me that it was not you intention to poke fun at me by that kiss I have ceased to fancy that you so intended if by that kiss you intended to ameliorate my feelings toward you, let me aprise [sic] you that you have triumphantly succeeded in your <u>Amelia</u>-rating. Just at the present moment I would be glad to receive another <u>Amelia</u>-ration, as I shall hereafter call your love inspiring kiss, they are rations which I will always be glad to receive.

That cold "good evening" when we met at our house the time of your visit on returning from the falls, I am excusable for, though I had seen you on four occasions before I never had an introduction to you. The time you were at our house in 1859 I did not even speak to you, in fact I was completely thrown into the shade by a younger brother who I remember staid [sic] away from the office for the purpose of entertaining you, you will no doubt remember the circumstance. The next time I saw you was the 2d of Oct. 1857 at 6 1/2 o'clock p.m. at your home, then I did not speak to you, and the next time I saw you was in June 1858, father and myself ~~was~~ were on our way to Mc. Granville, then I had no introduction to you and nothing but a "cold good afternoon" escaped either of us, it was on that occasion that you were dressed in that near approach to masculine unmentionables bloomers,[36] and sang "I'll never see my darling any more," you will also remember this occasion, again, the next time we was in Geneva,[37] August, 1859, then I had no introduction to you but I believe we exchanged words as we were walking down to the park, this time you will remember as you were waited upon by a highly interesting (to say the least) "clark" [sic] from Syracuse I believe, on the discovery of which I "sloped," leaving you and Miss Douglass in the enjoy [fragment ends]

36 For a discussion of Amelie's decision to wear "bloomers" see page 472 of this book.
37 A city in New York state.

3. Lewis Henry Douglass to Helen Amelia Loguen, Rochester, NY, September 24, 1861

Rochester, Sept. 24 1861

My Own Dear Amelia: Home once more, after a very pleasant visit at your house. The happy moments enjoyed will never be forgotten. This is a dark and rainy morning, and as I sit here in my room looking out upon the hills overhung by black and threatening clouds, seemingly intent upon washing away every thing beautiful in hood and garden, as they pour their watery contents with raging velocity down upon this mundane sphere, I turn from the gloom which is making itself felt, by the solemn, monotonous pattering of the rain upon the roof, to those beautifully bright hours, now flown, spent with you my own dear one, and with kind friends in Syracuse.

3. Lewis Henry Douglass to Helen Amelia Loguen, Rochester, NY, September 24, 1861

It was hard to part, though I may not have shown it to be so. I see you now, as we drove off standing at the gate, your eyes beaming love for me, and thus will I see you wherever I may journey until I come back again, it may be this year, or it may be next, it matters not how long, the memory of you at the gate will be ineffaceable. That memory of you may in sickness or pain far from home or friends, act as a soothing balm, and causing me to forget pain and loneliness, cheer up my spirits, fill my soul with hope and happiness, until I can once more grasp your hand in affectionate grasp and press it to my heart. That memory will spur me on, enable me to overcome whatever obstacles sickness or pain, loneliness or unhap-

fires may interfere in the way
of my reaching the object of my
deepest love, my own dear Amelia.
And when I come back success-
ful, who will enjoy with me the
fruits of that success, who will
be happiness and cheer to me?
Who will I rejoice to love and
cherish, protect and care for;
with whom will I go hand in
hand, down the pathway of life,
smoothing the way by the purest
love? No one, but with her whose
memory I now cherish as a price
less diadem wreathed in gold,
my own dear Amelia. May happi-
 ever
ness and love, be her companions,
and may she never forget me
who loves her above all others.
Remember me kindly to mother
and all. Mother says she would
 very you
be very happy to have come this winter
with you. Lovingly, Lewis H Douglass

3. Lewis Henry Douglass to Helen Amelia Loguen, Rochester, NY, September 24, 1861

Rochester, Sept. 24 1861

<u>My Own Dear Amelia</u>: Home once more, after a very pleasant visit at your house. The <u>happy</u> moments enjoyed will never be forgotten. This is a dark and rainy morning, and as I sit here in my room looking out upon the hills overhung by black and threatening clouds, seemingly intent upon washing away every thing beautiful in wood and garden, as they pour their watery contents with raging velocity down upon this mundane sphere. I turn from the gloom which is making itself felt, by the solemn monotonous pattering of the rain upon the roof. to those beautifully bright hours, now flown, spent with you my own dear one, and with kind friends in Syracuse.

It was hard to part, though I may not have shown it to be so. I see you now, as we drove off standing at the gate, your eyes beaming love for me, and thus will I see you wherever I may journey until I come back again, it may be this year, or it may be next, it matters not how long, the memory of you at the gate will be ineffaceable. That memory of you may in sickness or pain far from home or friends, act as a soothing balm, and causing me to forget pain and loneliness, cheer up my spirits, fill my soul with hope and happiness, until I can once more grasp ~~the~~ your hand in an affectionate grasp and press it to my heart. That memory will spur me on, enable me to overcome whatever obstacles sickness or pain, loneliness or unhappiness may interpose in the way of my reaching the object of my deepest love, my own dear Amelia. And when I come back successful, who will enjoy with me the fruits of that success, who will be happiness and cheer to me? Who will I rejoice to love and cherish, protect and care for; with whom will I go hand in hand, down the pathway of life, smoothing the way by the purest love? No one, but ~~with~~ her whose memory I now cherish as a priceless diadem wreathed in gold, my own dear Amelia. May happiness and love ever be her companions, and may she never forget me who loves her above all others.

Remember me kindly to mother and all. Mother* says she would be very happy to have you come this winter.

Lovingly, Lewis H. Douglass
write soon

* Anna Murray Douglass

4. Lewis Henry Douglass to Helen Amelia Loguen, Rochester, NY, September 29, 1861

Rochester, Sept. 29th /61

My Dear Amelia; Yours of the 15th is at hand, but I did not draw it from the P. O. until yesterday, as I have been laid up sick with that terrible throat disease and of course could not get out. I was not able to eat or drink for seven days, nor did not sleep during that period, and in order to force a passage through my throat so as to have me swallow enough to keep life in me, the doctor had to burn through the inflamed throat with caustic, which I assure is any thing but pleasant, it has left me as weak as a cat.

Your amusing description of the retreat from Pine Grove

4. Lewis Henry Douglass to Helen Amelia Loguen, Rochester, NY, September 29, 1861

reminds me of the Bull's
Run affair. It would have
really been amusing to one who
occupied a position in a dry
place to have seen you run-
ning like mad under the
dampening fire of liquid shot
and shell each putting forth
their energies and exerting
themselves to the utmost
to reach a place of security,
and when an occasional
thunder clap was heard, to
see the timid ones strike
out more lustily and roll out
of the whites of their eyes look-
ing as though they were afraid
they were about to be called
to leave this world of care and
sorrow, and journey to those
lands from whence no traveler
returns. I am glad however
you enjoyed it.

4. Lewis Henry Douglass to Helen Amelia Loguen, Rochester, NY, September 29, 1861

When I Lewis H Douglass, Box 224, Rochester, county of Monroe, State of New York, U. S. A. tell you to love me not, may I be (hold on I was just about to write some thing not exactly adapted to ears polite, but I refrain) hung drawn and quartered. No Amelia the letter I handed you when at our house contains exactly what I meant at the time I penned it and what I mean now and forever, simply that I love you and of course would naturally want you to love me, Remember me to all Charley has come home again to stay.

Affectionately,
Lewis

4. Lewis Henry Douglass to Helen Amelia Loguen, Rochester, NY, September 29, 1861

Rochester, Sept 29th /61

My Dear Amelia: Yours of the 15th is at hand, but I did not draw it from the P. O. until yesterday, as I have been laid up sick with that terrible throat disease and of course could not get out. I was not able to eat or drink for seven days, nor did not sleep during that period, and in order to force a passage through my throat so as to have me swallow enough to keep life in me, the doctor had to <u>burn</u> through the inflamed throat with caustic, which I opine is any thing but pleasant, it has left me as weak as a cat.

Your amusing description of the retreat from Pine Grove reminds me of the Bull's Run affair.[38] It would have really been amusing to one who occupied a position in a dry place to have seen you running like mad under the dampening fire of liquid, shot and shell each putting forth their energies and exerting themselves to the utmost to reach a place of security, and when an occasional thunder clap was heard, to see the timid ones strike out more lustily and roll out up the whites of their eyes looking as though they were afraid they were about to be called to leave this world of care and sorrow, and journey to those lands from whence no traveler returns. I am glad however <u>you</u> enjoyed it.

When I Lewis H. Douglass, Box 2240, Rochester, county of Monroe, Sate of New York, U.S.A. tell <u>you</u> to love me not, may I be (hold on I was just about to write something not exactly adapted to ears polite, but I refrain) hung, drawn and quartered.

No Amelia the letter I handed you when at our house contains exactly what I meant at the time I penned it and what I mean now and forever, simply that I love <u>you</u> and of course would naturally want you to love me. Remember me to all. Charley* has come home again to stay.

Affectionately

Lewis

38 A reference to the First Battle of Bull Run, in Virginia in July 1861, which saw the retreating Union forces routed by Confederate troops.

 * Charles Remond Douglass.

5. Helen Amelia Loguen to Lewis Henry Douglass, Syracuse, NY, October 3, 1861

Syracuse Oct 3d 1861

My Dear Lewis:

I was very glad to receive yours of Sept 29. I had expected a letter but had given up all hopes of ever hearing from you again, but when I learned of your sickness all was explained and I found myself mentally saying "poor Lew I am so sorry that he has been sick." How lonely you must have been during those long seven nights that you could not sleep, and had I known it I should have been tempted to come and dispell in a slight measure their gloomy monotony; that is if it were in my power so to do. Now you are so much better

5. Helen Amelia Loguen to Lewis Henry Douglass, Syracuse, NY, October 3, 1861

do take good care of your-self,
and I hope you may be very soon
strong and healthy as ever.

I should like to propose something
but being confident of, and at the
same time disliking so much that
gallant "No, I could not make it conve-
nient" I refrain.

We last week had a pleasant visit
from a Mr. Wright of Washington Co.
Pa. the same uncle Charlie that
assisted your father on a certain
occasion from Baltimore; you have
doubtless heard him spoken of. A
fine old man but so funny, he
would sit all day like an old
lady and knit, and when Sunday
came he was ready to preach and
sing. The Sunday night that he
was here I was very anxious to
hear him, but as I was half way

sick with the asthma, no one would
give their consent to my going out.
All came home at about half past
eleven and gave me such a glowing
discription of the sermon that I
resolved that if teasing would do
any good I would be there the next
night, and sure enough when the
time came father said I might go,
and I was well paid for we had
a regular "methodist shout."
I received your kind letter on the
1st of October, and it was almost
provoking to think that it should
be so pleasant, but had we "poor
coloured people" held a convention
I do believe it would have rained
"pitch forks and hoe handles" all
day. On the quiet evening of that
beautifuld day Memory and me

took a pleasant stroll in the well
known past; ten long years have
passed since Jerry was rescued.
I was only eight then and yet I
remember that day as distinctly as
though it were but a short time ago
I can never forget the strange feelings
that passed over me, when I heard
all the bells in the city tolling,
before we had heard what was
the matter. How many changes
have taken place since that day,
four dear ones who were then in the
enjoyment of life and health are
now silently sleeping their last
long sleep. Some that we did not
know then are now dear friends.
I well remember the Celebration

5. Helen Amelia Loguen to Lewis Henry Douglass, Syracuse, NY, October 3, 1861

held three years ago, how I
did want to have a little chat
with some one but alas! had
not the courage. I have forgotten
the first letter "I do not say
I wish I were or wish I were not"
you cant guess what that mean
and I will not tell you.

We are all quite well and
I take it for granted that we
all join in sending kind regards

My special regards to Charlie
and love to your mother.

I want to hear from you
but do not write if it tires
you, but wait till you are
stronger

Yours truly & affectionately

H. Amelia.

Morning.

I had a splendid little visit
with you in my dreams last night.

LHD HAE.

61

Mr. L. M. Douglass,
Box 2240
Rochester,
N.Y.

5. Helen Amelia Loguen to Lewis Henry Douglass, Syracuse, NY, October 3, 1861

Syracuse Oct 3d 1861

My Dear Lewis:

I was very glad to receive yours of Sept 29. I had expected a letter but had given up all hopes of ever hearing from you again, but when I learned of your sickness all was explained and I found myself mentally saying "poor Lew I am <u>so sorry</u> that <u>he</u> has been sick." How lonely you must have been during those long seven nights that you could not sleep, and had I known it I should have been tempted to come and dispell [sic] in a slight measure their gloomy monotony; that is if it were in my power so to do. Now you are so much better do take good care of your self, and I hope you may be very soon strong and healthy as ever.

I should <u>like</u> to propose something but being confident of, and at the same time disliking so much that gallant "No, I could not make it convenient" I refrain.

We last week had a pleasant visit from a Mr. Wright of Washington Co. Pa. the same uncle Charlie that assisted your father on a certain occasion from Baltimore; you have doubtless heard him spoken of. A fine old man but <u>so funny</u>, he would sit all day like an old lady and knit, and when Sunday came he was ready to preach and sing. The Sunday night that he was here I was very anxious to hear him, but as I was half way sick with the asthma, no one would give their consent to my going out. All came home at about half past eleven and gave me such a glowing description of the sermon that I resolved that if teasing would do any good I would be there the next night, and sure enough when the time came father said I might go, and I was well paid for <u>we</u> had a regular "methodist-shout."[39]

I received your kind letter on the memorable 1st of October, and it <u>was</u> almost provoking to think that it should be so pleasant, but had we "poor colored people" held a convention I do believe it would have rained "pitch-forks and hoe-handles" <u>all</u> day. On the quiet evening of that beautiful day Memory and me I took a pleasant stroll in the well known past; ten long years

39 A label attached to Methodist church practice in the nineteenth century which stressed the emotional, vocal aspects of worship.

[5] have passed since Jerry was rescued.[40] I was only eight then and yet I remember that day as distinctly as though it were but a <u>short time</u> ago. I can never forget the strange feelings that passed over me, when I heard all the bells in the city tolling, before we had heard what was the matter. How many changes have taken place since <u>that</u> day, four dear ones who were then in the enjoyment of life and health are now silently sleeping their last long sleep. Some that we did not know then are now <u>dear</u> friends. I well remember the Celebration held three years ago, how I did want to have a little chat with <u>some one </u>but alas! had not the courage. I have forgotten the first letter. "I do not say I wish I were or wish I were not" so you cant guess what that means and I will not tell you.

We are all quite well and I take it for granted that we all join in sending kind regards.

My special regards to Charlie and love to your Mother.

I want to hear from you but do not write if it tires you, but wait till you are stronger.

Yours truly & affectionately.

H. Amelia

Morning. I had a splendid little visit with <u>you</u> in my dreams last night.

L.HD. H.A.L.[41]

40 The rescue of an escaped enslaved man, William "Jerry" Henry, in 1851 in Syracuse, in which Amelia's father, Jermain Wesley Loguen, participated. See the introduction to this section.

41 These initials clearly represent Lewis Henry Douglass and Helen Amelia Loguen.

6. Lewis Henry Douglass to Helen Amelia Loguen, Rochester, NY, December 8, 1861

Rochester Sunday Dec 8, 1861

My Own Dear Amelia, I have just finished reading all the letters I have filed, received from you, there are a great many letters from you that I must confess I took no account of, more than to read them, and whatever became of them after that, I cannot tell. The first letter that I received from you is on file with the ones I have received more recently.

Those letters are remarkable, the meaning of many of them can be construed differently, we will take for example the first, it is as I have once before called it a "spunky letter," it pretends that you the writer, does not care a fig whether I remember you more than a week or not after you returned home from your visit to our house, and

ends with, "I am Your Friend."
However sagacious you are in many
things if you intended to show
to me an independent spirit
in that letter, you took exactly
the wrong course, although in
my answer to that letter I tried
to make it appear that I under
stood the letter in its offensive
sense. That letter gave me good
grounds to hope that the dear
little heart you professed to be
afraid of losing might by me be
found. The double dealing of that
letter was to me and is a source
of great pleasure. You will confess
that the spunk of that letter was
all sham, and that there was no
real spunk intended, that the
spunk was a kind of blind for
your real feeling which delica-
cy prevented you from express-
ing, so I understand your first

6. Lewis Henry Douglass to Helen Amelia Loguen, Rochester, NY, December 8, 1861

letter. And as with the first so has it been with many others, the brother arrangement which was invented by you, was intended as another blind or disguise of your real feelings, and to me another oasis in the desert of uncertainty of winning your love. After this oasis was reached and it became necessary to start on my journey hoping soon to find or discover another bright spot on which to gain a firmer foothold in this great desert, unconsciously to me narrowing down to a confession of our pure love, the journey was beset with more doubtings and anxieties than ever before, still there was a small voice whispering to me to proceed and you will ere long reached the desired haven and that if I faltered or turned back I might not be able to reach

6. Lewis Henry Douglass to Helen Amelia Loguen, Rochester, NY, December 8, 1861

the spot of "dear Sister" and lose my way in returning to "dear friend." Remembering that "Faint Heart never won Fair lady" it took but little philosophizing and reflection to bring the same saying to apply to ladies "not so fair" I concluded to travel on and my anxious journeyings were rewarded in so much that the oasis of Dear Sister and Dear Brother were forgotten though it was an oasis of much splendor, beauty and sublimity, for the reason that another had been found far more delightful, which was named "my own Dear Amelia and my own Dear Lewis" After this you started on a journey and was away during the whole winter season and must have landed

6. Lewis Henry Douglass to Helen Amelia Loguen, Rochester, NY, December 8, 1861

2

where there was but little to the love
for you could only remember the
oasis of brother. Soon however
your journeying brought you to
brighter spots, and "my own Dear
Lewis" was reached again. Thus has
the double writing of your first
and many of your other letters
led on to glorious results; results
that were intended from the first.
Through the medium of the mighty
pen a love has grown up between
us that baffles all description, and
my prayer is that there may nothing
arise that may in any way shake
the firmness or overturn the founda
tion of our love which we have each
made to known to one another. It may
be easy for you to find a man
to love other than myself, but for
me to find a lady more suited
to my mind and love than my
own dear Amelia, never!

89

6. Lewis Henry Douglass to Helen Amelia Loguen, Rochester, NY, December 8, 1861

How well I could enjoy myself were you here or I with you in Syracuse, but such is not the case and it may be well it is not so. Though a sweet kiss and fond embrace from you is something even to travel as far as Syracuse for. There is no language that can express the real joy of love experienced by me when on the Sunday evening after the family had all retired we sat together saying never a word for the reason that words could express nothing of the real sentiments of the hearts that were beating as one. Yes those were happy moments. can there be happiness? Will not the familiarity of marriage blunt in a measure the real happiness of such moments, I trust not, yet we can see how

6. Lewis Henry Douglass to Helen Amelia Loguen, Rochester, NY, December 8, 1861

others live who are married,
There are some men however
who marry because it is fashionable
to be married not stopping to find
whether he is in that blessed state
love, and soon sickens of his compan
ion in life and seeks pleasure in
corner groceries and grog shops.
I want to marry you simply
because I love you, and as my love
for you has stood the test of nearly
two years, and those years spent
in absence from you and a portion
of time not even having the pleas
ure of a letter from you, I base the
hope on such a foundation that my
love and your love may remain
undying. Such should be the love
of husband and wife. Now my
own dear Amelia I shall leave
off what may have been to you a decid-
ed bore to read. Remember me to
everybody in the family and you

6. Lewis Henry Douglass to Helen Amelia
Loguen, Rochester, NY, December 8, 1861

who was first timid friend, then dear friend, dear sister, and last but by no means least _my own dear_ Amelia, the last the broadest, the greenest and most loving delightful and beautiful oasis reached, receive for yourself the fullest and highest affection of a heart of Love overflowing for thee.

Ever thine in true Affection

Lewis

6. Lewis Henry Douglass to Helen Amelia Loguen, Rochester, NY, December 8, 1861

Rochester, Sunday Dec. 8, 1861

My own Dear Amelia. I have just finished reading all the letters I have filed, received from you, there are a great many letters from you that I must confess I took no account of, more than to read them, and whatever became of them after that, I cannot tell. The first letter that I received from you is on file with the ones I have received more recently.

Those letters are remarkable, the meaning of many of them can be construed differently, we will take for example the first, it is as I have once before called it a "spunky letter," it pretends that you the writer, does not care a fig whether I remember ~~her~~ you more than a week or not after you returned home from your visit to our house; and ends with, "I am Your Friend." However sagacious you are in many things if you intended to show to me an independent spirit in that letter, you took exactly the wrong course, although in my answer to that letter I tried to make it appear that I understood the letter in its offensive sense. That letter gave me good grounds to hope that the dear little heart you professed to be afraid of losing might by me be found. The double dealing of that letter was to me and is a source of great pleasure. You will confess that the spunk of that letter was all sham, and that there was no real spunk intended, that the spunk was a kind of blind for your real feelings which delicacy prevented you from expressing, so I understand your first letter. And as with the first so has it been with many others, the brother arrangement which was invented by you, was intended as another blind or disguise of your real feelings, and to me another oasis in the desert of uncertainty of winning your love. After this oasis was reached and it became necessary to start on my journey hoping soon to find or discover another bright spot on which to gain a firmer foothold in this great desert, unconsciously to me narrowing down to a confession of our pure love, the journey was beset with more doubtings and anxieties than ever before, still there was a small voice whispering to me to proceed and you will ere long reached the desired haven and that if I faltered or turned back I might not be able to reach the spot of "dear Sister" and lose my way in returning to "dear friend." Remembering that "Faint Heart never won <u>Fair</u> lady" it took but little philosophizing and reflection to bring the same saying to apply to ladies <u>not so fair</u>, I concluded to travel on, and my anxious journeyings were rewarded in so

much that the oasis of Dear Sister and Dear Brother were forgotten though if it was an oasis of much splendor, beauty and sublimity, for the reason that another had been found far more delightful, which was named "my own Dear Amelia and my own Dear Lewis." After this you started on a journey, and was away during the whole winter season, and must have landed where there was but little to love for you could only remember the oasis of brother. Soon however your journeyings brought you to brighter spots, and "my own Dear Lewis" was reached again. Thus has the double writing of your first and many of your other letters led on to glorious results; results that was were intended from the first. Through the medium of the mighty pen a love has grown up between us that baffles all description, and my prayer is that there may nothing arise that may in any way shake the firmness or overturn the foundation of our love which we have each made to known to one another. It may be easy for you to find a man to love other than myself, but for me to find a lady more suited to my mind and love than my own dear Amelia, never!

How well I could enjoy myself were you here or I with you in Syracuse, but such is not the case and it may be well it is not so. Though a sweet kiss and fond embrace from you is something even to travel as far as Syracuse for. There is no language that can express the real joy of love experienced by me when on the Sunday evening after the family had all retired we sat together saying never a word for the reason that words could express nothing of the real sentiments of the hearts that were beating as one. Yes those were happy moments, can there be happier? Will not the familiarity of marriage blunt in a measure the real happiness of such moments, I trust not, yet we can see how others live who are married. There are some men however who marry because it is fashionable to be married not stopping to find whether he is in that blessed state love, and soon sickens of his companion in life and seeks pleasure in corner groceries and grog shops.

I want to marry you simply because I love you, and as my love for you has stood the test of nearly two years, and those years spent in absence from you and a portion of time not even having the pleasure of a letter from you. I base the hope on such a foundation that my love and your love may remain undying. Such should be the love of husband and wife. Now own dear Amelia I shall leave off what may have been to you a decided bore to read. Remember me to everybody in the family and you who was first timid friend, then dear friend, dear sister and last but by no means last my own dear Amelia, the last, the broadest, the greenest and most loving, delightful and beautiful oasis reached, receive for yourself, the fullest and highest affection of a heart of Love overflowing for thee.

Ever thine in true Affection

Lewis

7. Lewis Henry Douglass to Helen Amelia Loguen, Rochester, NY, July 11, 1862

Rochester July 11 1862

My Own Dear Amelia: One week ago, this morning, about two o'clock, I arose from a sleepless bed, filled with hope, joy and love. If you should enquire what caused those feelings, I should answer the pleasure of shaking hands with a dear brother whom I had not seen for three months, his fine (to me) healthy appearance, denoting satisfaction, this caused feelings of joy and love. Hope, that cheering, encouraging Hope, which when on the verge of despair gilds the future with such rich, beautiful and bright tints, that one leaps from despondency, all forgetful of the dangers and drawbacks surrounding him, and presses on and on; Hope that cheers on the affections, that brings joy where there was sadness, happiness

7. Lewis Henry Douglass to Helen Amelia Loguen, Rochester, NY, July 11, 1862

where there was no pleasure, increases and intensifies Love, arousing the latent heart and soul affections, was caused by the drawing near of the moment when I was to take the cars to be transported to the arms of my own dearly beloved, and loving Amelia.

How painfully clear is it brought to me now, one week from the anticipation of much happiness and pleasure, that "Time flies." And who can describe the high bliss and sweet joy of the happy, happy, moments we spent together, let no writer attempt, let no artist pretend to even approximate to describe or picture the superlative happiness of those fleeting moments, lest he make a mock of them, or paralyze and benumb that sense of the beautiful which is so essential to the happy enjoyment of life.

One week more gone, and in that

7. Lewis Henry Douglass to Helen Amelia Loguen, Rochester, NY, July 11, 1862

week I have pressed to my heart and
vowed anew to love one of the purest
and most noble minded of girls. Is not
that enough to make me feel happy even
though she be many miles from me,
is it not enough to make one hap-
py to be assured from her own sweet
lips that his love is returned? Yes it
is, and I am happy! Words! Words!
thou ready agents of man's ideas, why
oh, why have you not the power of giving
expression to the deep heart and soul
emotions, if you had, I should in-
voke your aid to enable me to give
an idea of the intensity, depth, height
and fullness of that love I bear my
own sweet Nellie.

Father returned quite elated
with the celebration at Ithaca, he
met pa Loguen there, thought he
was looking very finely, hearty and
well. I wish now that I had
gone, but business at home would

7. Lewis Henry Douglass to Helen Amelia Loguen, Rochester, NY, July 11, 1862

have prevented my staying
all day. Dear Amelia
for your sake I will not smoke
any more. Remember me to all
that is if you wish.

Ever Lovingly

Lewis

P.S. Sat. morn—
I have attempted to write a good letter
to you but I fear I have failed, yet I
will not tear this up, but send it. Par-
don me for so doing, Lewis

July 11
1862

7. Lewis Henry Douglass to Helen Amelia Loguen, Rochester, NY, July 11, 1862

Rochester, July 11, 1862

My Own Dear Amelia: One week ago this morning, about two o'clock, I arose from a sleepless bed filled with hope, joy and love. If you should enquire what caused those feelings, I should answer the pleasure of shaking hands with a dear brother whom I had not seen for three months, his fine (to me) healthy appearance, denoting satisfaction, this caused feelings of joy and love. Hope, that cheering, encouraging Hope, which when on the verge of despair, gilds the picture with such rich, beautiful and bright tints, that one leaps from despondency, all forgetful of the dangers and drawbacks surrounding him and presses on and on. Hope that cheers on the affections, that brings joy where there was sadness, happiness where there was no pleasure, increases and intensifies Love, arousing the latent heart and soul affections, was caused by the drawing near of the moment when I was to take the cars to be transported to the arms of my own dearly beloved, and loving Amelia.

How painfully clear is it brought to me now, one week from the anticipation of much happiness and pleasure that "Time flies." And who can describe the high bliss and sweet joy of the happy, happy, moments we spent together, let no writer attempt, let no artist pretend to even approximate to describe or picture the superlative happiness of those fleeting moments, lest he make a mock of them, or paralyze and benumb that sense of the beautiful which is so essential beneficial to the happy enjoyment of life.

One week more gone, and in that week I have pressed to my heart and vowed anew to love one of the purest and most noble minded of girls. Is not that enough to make me feel happy even though she be many miles from me, is it not enough to make me happy to be assured from her own sweet lips that his love is returned? Yes it is, and I am happy! Words! Words! thou ready agents of man's ideas, why oh, why have you not the power of giving an expression to the deep heart and soul emotions? (excuse this blab) if you had, I should invoke your aid to enable me to give an idea of the intensity, depth, height, and fullness of that love I bear my own sweet Nellie.

[7] Father returned quite elated with the celebration at Ithaca,[42] he met pa Loguen* there, thought he was looking very finely, hearty and well. I wish now that I had gone, but business at home would have prevented my staying all day. Dear Amelia for your sake I will not smoke any more. Remember me to all that is if you wish.

 Ever lovingly
 Lewis
 PS. Sat. Morn.
 I have attempted to write a good letter to you but I fear I have failed, yet I will not tear this up, but send it pardon me for so doing Lewis

42 On July 8, 1862 Frederick Douglass had participated in a celebration in Ithaca, New York, to commemorate the recent abolition of slavery in the District of Columbia.
* Jermain Wesley Loguen.

8. Lewis Henry Douglass to Helen Amelia Loguen, Salem, NJ, November 20, 1862

Salem, New Jersey, Nov. 20 1862

My Own Dear Amelia: You no doubt having been thinking many hard and strange thoughts of me for not writing you sooner, but my dear, had you known the anxiety and distress of mind under which I have been nearly borne down by, you would have pardoned me, and when I tell you of my circumstances I am sure I will get your sympathy. As I wrote you, I started from home on the tenth of October for Philadelphia to join Gen. Somervy at Washington but on arriving in Philadelphia I saw by the papers that the day of departure from Washington for Central America had been indefinitely postponed. I knew not what to do. then I became fearful that the whole scheme had fallen through, and the prospect before me looked gloomy. I telegraphed to Washington inquiring when would the expedition sail, in one week I received an answer that it was impossible to tell. You cannot imagine my feelings when I read that reply, suffice it to say that I became dejected and miserable, thought of home, though not home sick, thought of you my own dear one, but had not spirit enough to even pen a line to your or to my home. You may think me foolish, but when you consider that I left home full confidence in the undertaking I was about to begin, thinking of nothing else for days and weeks you may know how sore was the disappointment, and the kind of feeling engendered by

8. Lewis Henry Douglass to Helen Amelia Loguen, Salem, NJ, November 20, 1862

that disappointment. I wrote many letters to Washington and at last got a reponse that the expedition would not go until spring, and a draft from Mr Pomeroy of thirty-six dollars; twelve dollars for the money I had expended in travelling, twenty four dollars for the time I had lost, which was four weeks, being just what I had demanded him to pay me My stopping in Philadelphia cost me nothing so I made six dollars a week out of the Government. And now dear Amelia I have located at Salem where Rosetta is teaching school, I have gone into the Restaurant business with good prospects. I have got Rosetta to write to you and now hope you will be good friends. I told her we were engaged, which she seemed glad of I merely write this to let you know that I am well, and to renew that correspondence which is the joy and pleasure of my life When I have more time I will write more fully to you of my intentions, now dear Amelia do not think hard of me I hope you were pleased with my photographs sent from Philadelphia and gave them to the respective persons who wished one, Miss Allie, and your neighbor whose name I now forget. My dear when you have some nice photographs taken please remember me, write me soon and let me know how you liked my photographs. Remember me to all at home. Ever Lovingly Lewis

8. Lewis Henry Douglass to Helen Amelia Loguen, Salem, NJ, November 20, 1862

Salem, New Jersey, Nov. 20 1862

My Own Dear Amelia: You no doubt having been thinking many hard and strange thoughts of me for not writing you sooner, but my dear, had you known the anxiety and distress of mind under which I have been nearly ~~been~~ bowed down, you would have pardoned me, and when I tell you of my circumstances, I am sure I will get your sympathy. As I write you I started from home on the tenth of October, for Philadelphia to join Gen. Pomeroy[43] at Washington, but on arriving in Philadelphia I saw by the papers that the day of departure from Washington for Central America had been indefinitely postponed. I knew not what to do then. I became fearful that the whole scheme had fallen through and the prospect before me looked gloomy. I telegraphed to Washington enquiring when would the expedition sail? In one week I received an answer that it was impossible to tell. You cannot imagine my feelings when I read that reply, suffice it to say that I became dejected and miserable thought of home, though not home sick, thought of you my own dear one, but had not ~~spiri~~ spirit enough to even pen a line to you or to my home. You may think me foolish, but when you consider that I left home full of confidence in the undertaking I was about to begin, thinking of nothing else for days and weeks, you may know how sore was the disappointment, and the kind of feeling engendered by that disappointment. I wrote many letters to Washington, and at last got a response that the expedition would not go until spring, and a draft from Mr. Pomeroy of thirty-six dollars; twelve dollars for the money I had expended in travelling, twenty four dollars for the time I had lost, which was four weeks being just what I had demanded him to pay me. My stopping in Philadelphia cost me nothing so I made six dollars a week out of the Government. And now dear Amelia I have located at Salem where Rosetta* is teaching school. I have gone into the Restaurant business with good prospects. I have got Rosetta to write to you and now hope you will be good friends. I told her we were engaged, which she seemed glad of. I merely write this to let you know that I am well, and to

43 Senator Samuel C. Pomeroy of Kansas (1816–91) was appointed by President Abraham Lincoln in 1862 to explore the possibility of founding a colony of free Black women, children and men, dubbed Linconia, in Chiriquí, a province of Panama.

 * Rosetta Douglass Sprague.

[8] renew that correspondence which is the joy and pleasure of my life. When I
have more time I will write more fully to you of my intentions; now dear Amelia
do not think hard of me. I hope you were pleased with my photographs sent
from Philadelphia, and gave them to the respective persons who wished one,
Miss Allie, and your neighbor whose name I now forget. My dear when you
have some nice photographs taken please remember me, write me soon and let
me know how you like my photographs. Remember me to all at home.

 Ever Lovingly
 Lewis

9. Lewis Henry Douglass to Helen Amelia Loguen, Salem, NJ, December 29, 1862

Salem, Dec, 29 1862

My own Dear Amelia! A Happy New Year to you my own true one. The beginning of the New Year will be very pleasant to me knowing that you do not merely love me, but have not regretted that dear promise of the 17th November. The delightful and buoyant winter breezes of Southern New Jersey are as soothing as our delightful May winds and they have a smooth velvety touch which brings with its sweetness, such as soothes the spirit of one who has a heart beating for a distant cherished one, it cools the heated brow, fevered with anx anxiety such as none but the true lover knows and then how sweet is it to think

of you. How pleasant is it then
to lie in bed, ever and anow peer-
ing out through the half closed
blinds at the pale Queen of the
Night, wondering does my
dear Amelia gaze upon the
same moon, and think of
me and as the Lesser Light
recedes slowly leaving shadow
upon the wall, in which imagin-
ations busy in my brain renders
me able to see you look-
ing earnestly in my eyes, and
then I feel myself ready to
seize the shadow and hug and
kiss it as I would the original
were she present, by and bye
I droop away and amgone to
the beautiful land of dreams,
where I again meet you and
we go on loving as ever.
Wherever I go I see married
people not exactly as loving

9. Lewis Henry Douglass to Helen Amelia Loguen, Salem, NJ, December 29, 1862

as they should be and now
der to myself shall I be a man
who will give my wife cause
to dislike me, or will my wife
give me cause to dislike her, and
then I remember what a dear
good creature you are at home
to everybody and I fear not,
knowing that I love sincerely
and deeply, and that I
am unchangeable in my
affections, that what I
love, I love dearly, and what
I hate, I hate with an in-
tenseness, and fervor that
knows no abatement.

I am more than persuaded
my dear that you really love
me, and that dear kind prom-
ise to ever love me, is so cheer-
ing, may happiness and pleas-
ure, sunshine, and beaming
hopes, with sweet realizations

9. Lewis Henry Douglass to Helen Amelia Loguen, Salem, NJ, December 29, 1862

be your lot. My Dear I am
tired out I cannot express myself
as I would. I hope Willie may be
better by the time this reaches you.
My dear be sure and answer
Rosetta's letter. Give my love
to all. Good night sweet
rest and peaceful dreams.
This is not parting after winding
the clock it is merely blowing
out the candle and going to rest without
a sweet kiss from you. Remember me. Your own loving
Lewis

9. Lewis Henry Douglass to Helen Amelia Loguen, Salem, NJ, December 29, 1862

Salem, Dec. 29 1862

<u>My Own Dear Amelia</u>: A Happy New Year to you my own true one. The beginning of the New Year will be very pleasant to me knowing that you do not merely love me, but have not regretted that dear promise of the 17th November. The delightful and buoyant winter breezes of Southern New Jersey are as soothing as our delightful May winds and they have a smooth velvety touch which brings with it sweetness, such as soothes the spirit of one who has a heart beating for a distant cherished one, it cools the heated brow, fevered with any anxiety such as none but the true lover knows, and then how sweet is it to think of you. How pleasant is it then to lie in bed, ever and anon peering out through the half closed blinds at the pale Queen of the Night, wondering does my dear Amelia gaze upon the same moon, and think of me, and as the Lesser Light recedes slowly leaving shadows upon the wall in which imaginations busy in my brain renders me ~~to~~ able to ~~decry~~ see you basking earnestly in my eyes, and then I feel myself ready to seize the shadow and hug and kiss it as I would the original were she present; bye and bye I drop away and am gone to the beautiful land of dreams, where I again meet you, and we go on loving as ever.

Wherever I go I see married people not exactly as loving as they should be, and wonder to myself shall I be a man who will give my wife cause to dislike me, or will my wife give me cause to ~~dislike~~ dislike her, and then I remember what a dear good creature you are at home to everybody and I fear not, knowing that I love sincerely and deeply, and that I am unchangeable in my affection, that what I love, I love dearly, and what I hate, I hate with an intenseness and fervor that knows no abatement.

I am more than persuaded my dear that you really love me, and that dear kind promise to ever love me, is so cheering, may happiness and pleasure, sun-shine, and beaming hopes, with sweet realizations be your lot. My Dear I am tired out I cannot express myself as I would. I hope Willie[*] may be better by the time this reaches you. My Dear be sure and answer Rosetta's letter. Give my love to all. Good night sweet rest and peaceful dreams. This is not parting after winding the clock it is merely blowing out the candle and going to rest without a sweet kiss from you. Remember me,

Your own Loving

Lewis

[*] Jermain William Loguen.

MEN OF COLOR

TO ARMS! TO ARMS!

NOW OR NEVER

This is our golden moment! The Government of the United States calls for every Able-bodied Colored Man to enter the Army for the

Three Years' Service!

And join in Fighting the Battles of Liberty and the Union. A new era is open to us. For generations we have suffered under the horrors of slavery, outrage and wrong; our manhood has been denied, our citizenship blotted out, our souls seared and burned, our spirits cowed and crushed, and the hopes of the future of our race involved in doubt and darkness. But now our relations to the white race are changed. Now, therefore, is our most precious moment. Let us rush to arms!

FAIL NOW, & OUR RACE IS DOOMED

this the soil of our birth. We must now awake, arise, or be forever fallen. If we value liberty, if we wish to be free in this land, if we love our country, if we love our families, our children, our home, we must strike *now* while the country calls; we must rise up in the dignity of our manhood, and show by our own right arms that we are worthy to be freemen. Our enemies have made the country believe that we are craven cowards, without soul, without manhood, without the spirit of soldiers. Shall we die with this stigma resting upon our graves? Shall we leave this inheritance of Shame to our Children? No! a thousand times NO! We WILL Rise! The alternative is upon us. Let us rather die freemen than live to be slaves. What is life without liberty? We say that we have manhood; now is the time to prove it. A nation or a people that cannot fight may be pitied, but cannot be respected. If we would be regarded men, if we would forever silence the tongue of Calumny, of Prejudice and Hate, let us Rise Now and Fly to Arms! We have seen what Valor and Heroism our Brothers displayed at Port Hudson and Milliken's Bend, though they are just from the galling, poisoning grasp of Slavery, they have startled the World by the most exalted heroism. If they have proved themselves heroes, cannot WE PROVE OURSELVES MEN?

ARE FREEMEN LESS BRAVE THAN SLAVES

More than a Million White Men have left Comfortable Homes and joined the Armies of the Union to save their Country. Cannot we leave ours, and swell the Hosts of the Union, to save our liberties, vindicate our manhood, and deserve well of our Country. MEN OF COLOR! the Englishman, the Irishman, the Frenchman, the German, the American, have been called to assert their claim to freedom and a manly character, by an appeal to the sword. The day that has seen an enslaved race in arms has, in all history, seen their last trial. We now see that our last opportunity has come. If we are not lower in the scale of humanity than Englishmen, Irishmen, White Americans and other Races, we can show it now. Men of Color, Brothers and Fathers, we appeal to you, by all your concern for yourselves and your liberties, by all your regard for God and humanity, by all your desire for Citizenship and Equality before the law, by all your love for the Country, to stop at no subterfuge, listen to nothing that shall deter you from rallying for the Army. Come Forward, and at once Enroll your Names for the Three Years' Service. Strike now, and you are henceforth and forever Freemen!

E. D. Bassett,	Rev. J. Underdue,	P. J. Armstrong,	Rev. J. C. Gibbs,	Elijah J. Davis,
William D. Forten.	John W. Price,	J. W. Simpson,	Daniel George,	John P. Burr,
Frederick Douglass,	Augustus Dorsey,	Rev. J. B. Trusty,	Robert M. Adger,	Robert Jones,
Wm. Whipper,	Rev. Stephen Smith,	S. Morgan Smith,	Henry M. Cropper,	O. V. Catto,
D. D. Turner,	N. W. Depee,	William E. Gipson,	Rev. J. B. Reeve,	Thos. J. Dorsey,
Jas. McCrummell,	Dr. J. H. Wilson,	Rev. J. Boulden,	Rev. J. A. Williams,	L. D. Cliff,
A. S. Cassey,	J. W. Cassey,	Rev. J. Asher,	Rev. A. L. Stanford,	Jacob C. White,
A. M. Green,	James Needham,	Rev. Elisha Weaver,	Thomas J. Bowers,	Morris Hall,
J. W. Page,	Ebenezer Black,	David B. Bowser,	J. C. White, Jr.,	J. P. Johnson,
L. R. Seymour,	James R. Gordon,	Henry Minton,	Rev. J. P. Campbell,	Franklin Turner,
Rev. William T. Catto,	Samuel Stewart,	Daniel Colley,	Rev. W. J. Alston,	Jesse E. Glasgow.

A Meeting in furtherance of the above named object will be held

And will be Addressed by

U. S. Steam-Power Book and Job Printing Establishment, Ledger Buildings, Third and Chestnut Streets, Philadelphia.

Figure 28: Anon., *Men of Color To Arms! To Arms!*, 1863.

Part III

"Men of Color, To Arms!"

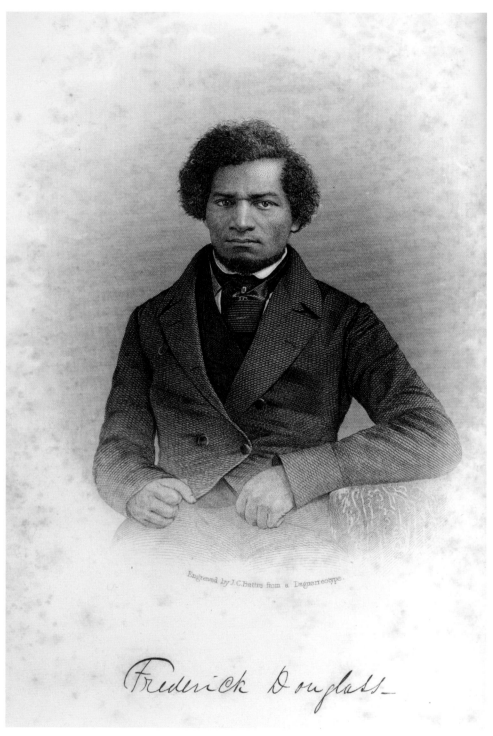

Engraved by J.C.Buttre from a Daguerreotype

Frederick Douglass

Figure 29: John Chester Buttre, *Frederick Douglass*, 1855. Frontispiece, Frederick Douglass, *My Bondage and My Freedom*, New York and Auburn: Miller, Orton & Mulligan, 1855. (Collection of the Rochester Public Library Local History Division, Central Library of Rochester and Monroe County, Rochester, NY.)

"civil and political liberty" of all people of African descent living in the US.[18] More particularly, he writes Gerrit Smith again on June 19, 1863, to confide, "Thus far am not ashamed of the part the colored troops have borne in the war." He immediately expresses his pride that, "Lewis my son is now in Florida. My son Charles reports to Col. Hallowell of the Mass. 55th next week."[19]

While Douglass confides his heartfelt admiration for his sons' self-sacrifice in suffering "hardships, dangers and death" to secure Black "civil and political" freedoms, the service of the thousands of African American men and women who participated in the Civil War has not only been dismissed but subjected to widespread marginalization and invisibilization within a national imaginary. As far as mainstream histories of the Civil War are concerned, the contributions—militarily, financially, socially, politically, and emotionally—of Black women and men are typically relegated to one or two lines at best, or to very brief footnotes. As a result, and with the exception of a handful of early pioneering historians who produced in-depth accounts of Black combat records in the immediate aftermath of the Civil War—including William Wells Brown and George Washington Williams—the vast majority of the research examining African American contributions to the war effort has appeared only in recent decades. Over the last thirty years or so, there has been an outpouring of histories, editions, and anthologies.[20] Gaps in the scholarship remain, however.

With the exception of a handful of seminal works, the military records of Lewis Henry, Charles Remond, and Frederick Jr. have been discussed in only a few sentences at best or, at worst, have been omitted entirely.[21] Writing as recently as 2016, Douglas Egerton observes, "Curiously, although black soldiers in the Union army have been the subject of numerous studies, no complete history of the three Massachusetts regiments exists."[22]

The Walter O. Evans collection comprises the vast majority of the extant Helen Amelia Loguen-Lewis Henry Douglass Civil War correspondence. In the following pages, we reproduce thirty-three letters authored by Lewis Henry and one letter written by Helen Amelia Loguen held in the Evans archive as facsimiles and annotated transcriptions. We also reprint two additional letters written by Lewis—one to Amelia, and one to his mother and father—in the immediate aftermath of the Battle of Fort Wagner: both are held in the Frederick Douglass

18 Ibid.
19 Frederick Douglass to Gerrit Smith, June 19, 1863, Gerrit Smith Papers.
20 See the bibliography for works by the following scholars: Adams, Berlin, Blatt, Brown, Coddington, Cornish, Dobak, Egerton, Emilio, Greene, Greenough, Hargrove, LaBarre, McPherson, Quarles, Redkey, Smith, Williams, Willis, and Yacovone.
21 See the bibliography for works by Egerton, LaBarre, and Willis.
22 Egerton, *Thunder at the Gates*, 8.

Papers at the Library of Congress. In this volume, we document Charles's military service by reproducing the original facsimiles and annotated transcriptions of the six letters he writes his mother and father from the frontlines. With one exception—a single letter survives only in printed form, as it was widely published in national and local newspapers—all of Charles's letters are also held in the Frederick Douglass Papers at the Library of Congress.

For scholars researching the military service of Frederick Douglass Jr., his contributions are much harder to find. Despite extensive searching, it would appear that none of his correspondence survives from this period. For traces of Douglass Jr.'s life, we have no option but to turn to the fragments of information that can be found in contemporary newspapers. An especially useful source is the anonymous article "Frederick Douglass's Son," published on November 28, 1863, in the *National Antislavery Standard* and "(copied from Syracuse Standard)." Here the writer confirms, "Frederick Douglas Jr., has enlisted in the 54th Massachusetts (colored) regiment, and will proceed immediately to the camp at Readville, Mass, where he will be engaged for the present in the recruiting service." "He is the last of Mr. Douglass's sons remaining at home," the author observes, "both of his brothers, Lewis and Charles, having joined the 54th Mass, now stationed on Morris Island." For this reporter, however, it is ultimately the eldest son's heroism that is singled out for commendation: "Sergeant Lewis Douglass is at present at home, slowly recovering from a severe attack of typhoid fever, the result of the arduous service preliminary to the capture of Morris Island and the terrible assault on Fort Wagner."[23]

While research into Frederick Jr.'s military service is still very much in progress, the extant letters written by Lewis Henry and Charles Remond from the Civil War frontlines provide unequivocal evidence of their determination to "complete Freedom's battle" by any and every means necessary: even if it meant dying for the "common cause."

23 Anon., "Frederick Douglass's Son," *National Antislavery Standard.*

Apr 15
1863

Miss H. A. Loguen
Box 685
Syracuse
NY

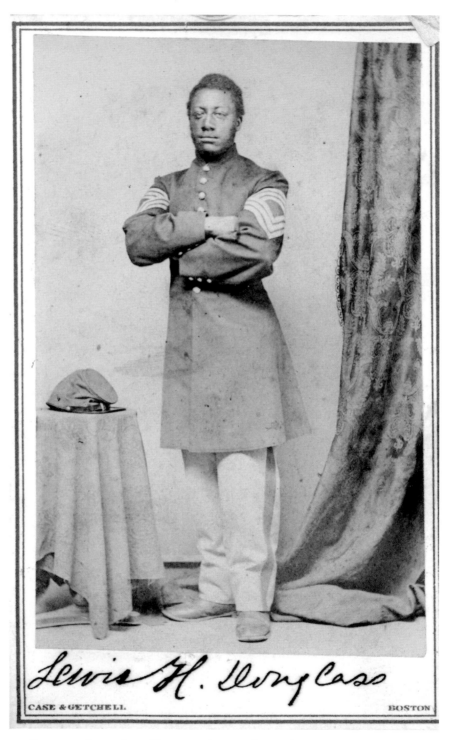

Figure 30: Anon., *Lewis Henry Douglass*, n.d. [c. 1863]. (Prints and Photographs Division, Moorland-Spingarn Research Center, Howard University, Washington, DC.)

"Do Not Think of Me in Pain"

Lewis Henry Douglass's Civil War Letters to Helen Amelia
Loguen, Anna Murray Douglass, and Frederick Douglass

"Sergt. Major—Res. Rochester, N.Y.; printer, 22; enl. March 25, 1863, as Private in Co. 'F'.; promoted to Sergt. Major, April 23, 1863; must. Same day; disch. May 10, 1864, for disability, as Sergt. Major."[1] So reads Lewis Henry Douglass's service record as compiled by the "Adjutant General" and included in the fourth volume of *Massachusetts Soldiers, Sailors, and Marines in the Civil War*, published in Norwood, Massachusetts, in 1932. A treasure trove of typed memos, handwritten correspondence, and official documents, the Civil War Records at the National Archives Records Administration in Washington, DC enable researchers to put flesh onto the bones of this skeletal history. And yet, the search for Douglass's eldest son in these official records initially results only in disappointing absences. On the one hand, the Regimental Descriptive Book includes vital statistics by recording key moments in his military career. According to this official document, Lewis was "Promoted to be Sergt Major from Co. F. 54 N.Y. Mar 25 1863"—an earlier date than that which appears in the biographical entry included in the fourth volume of the *Massachusetts Soldiers, Sailors, and Marines in the Civil War*—and he was "Wounded in the Assault on Fort Wagner July 18 1863 and discharged the service on order from AGO Dept of the East Feby 29 1864 by reason of disability." On the other hand, however, there are very real gaps in this record: the sections headed "Age," "height," "complexion," "eyes," "hair," "where born," and "occupation" are all left blank. Adding insult to injury, his name is erroneously spelled as "Louis F. Douglass." Faced with these startling omissions,

1 Anon., *Massachusetts: Soldiers and Sailors of the Revolutionary War*, vol. IV, 658.

the 54th Massachusetts Company Muster Roll fills in some of this missing information. On this document, in which he is provided with an earlier enrollment date of March 22, 1863, he is correctly identified as Lewis H. Douglass and his age is listed as 22 years. Far from complete, however, our research is ongoing as we continue the work of adjudicating between these factual discrepancies.

While key dates of Lewis's military service are difficult to verify, the Field and Staff Muster Rolls held at the National Archives shed powerful light on the nature and extent of the injuries he sustained at the Battle of Fort Wagner in July 1863.[2] In the immediate aftermath of his participation in this assault between Union and Confederate troops, he is listed as "absent" during the months of September and October. As a note accompanying these muster rolls explains, he was "Furloughed to Oct 14 now sick at New York unable to travel and certificate of disability sworn to before G.O. F. Notary Public." An invaluable source of information corroborating the severity of Lewis's illness can be found yet further afield. A report published in the *Anglo African* newspaper on September 26 reads as follows: "Sergeant Major. Lewis H. Douglass, 54th Massachusetts Volunteers, arrived in this city on the 22d inst., on thirty day's furlough 'for good conduct in the field.'" In keeping with the official record, the reporter gravely informs his readers that Lewis "lies very ill at Brooks House."[3] As Douglas Egerton's research confirms, Brooks House was located at 513 Broome Street, New York City. "As a hotel for well-to-do African Americans," he observes, "the Brooks House was doubtless far more sanitary than any of the army hospitals for white soldiers in the city."[4]

Far from the whole story, these all too brief muster rolls are accompanied by a collaboratively written medical report in which the details of Lewis's injuries are carefully recorded. While the name of one of the writers of this report is currently indecipherable, the name of the other medical expert is clear for all to see and is none other than James McCune Smith (Figure 31).

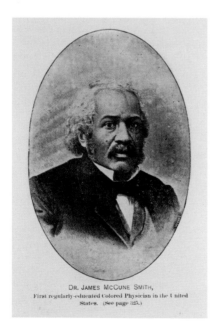

DR. JAMES McCUNE SMITH,
First regularly-educated Colored Physician in the United States. (See page 325.)

Figure 31: Anon., *James McCune Smith*. In Daniel Alexander Payne, *Recollections of Seventy Years*. (Nashville: A.M.E. Sunday School Union, 1888, p. 200.)

2 See Lewis H. Douglass Field and Staff Muster Rolls, Civil War Records, National Archives, Washington, DC.
3 Anon., *Anglo African*, September 26, 1863.
4 Egerton, *Thunder at the Gates*, 158.

McCune Smith was not only a renowned doctor—trained at the University of Glasgow, Scotland—but a radical abolitionist, campaigner for all Black civil and political liberties and, more importantly within this context, Frederick Douglass's close personal friend. There can be little room for doubt that Lewis's father played a key role in securing the best medical treatment for his eldest son, refusing to leave his fate in the hands of white military medical professionals.

James McCune Smith and his colleague begin their report, dated October 6, 1863, by confirming, "Sergeant Major Lewis H. Douglass of the 54th Mass Vols. arrived in this city by steamer Fulton from Hilton Head SC on the 23rd Sept. 1863." Their examination of his physical wounds on his arrival lead them to conclude, "He was then very ill with Diarrhea, cachexia and spontaneous gangrene of left half of scrotum." In their professional opinion, "He continues seriously ill at the present date, the slough having separated, leaving the part named entirely denuded." As they assert, "he is now too feeble to be safely removed from this city, and, in our judgment, several months must elapse before he will be able to do even the lightest military duty."[5] Over two weeks later, Frederick Douglass writes a letter to Gerrit Smith on October 20 in which he also attests to the severity of his eldest son's illness. "I have been during the last three weeks bending over the sick bed of my Dear Son Lewis who has been until now quite too ill to be removed home," he confides. For Douglass, however, the focus is not upon his son's injury but on his valor. In his letter to Smith he is exultant: "Lewis left Morris Island on a furlough granted him for 'good conduct in the field.'" Writing with more of a father's hope than a medical expert's sense of the reality of his son's condition, he takes an overly optimistic view of Lewis's physical state by insisting that he "will return to his post as soon as his health is restored."[6] All claims to the contrary, Douglass's hopes for Lewis's return to active duty were not to be realized.

As McCune Smith and his colleague predicted, and as the official records for Lewis's remaining period of military service indicate, he was exempted from undertaking "even the lightest military duty" due to his ongoing ill health. The official files for November 1863 through February 1864 confirm that Lewis Henry was still "Sick" and "Absent at Rochester NY on Surg Cert. of Disability." No longer hospitalized in New York and under McCune Smith's care, while he was still too ill to resume his military duties, he was at least well enough to return home to be nursed by the Douglass family. For the remaining period of his enlistment, Lewis experienced no miraculous recovery. According to the Field and Staff Muster rolls for March and April 1864, he was "Discharged the service" on the grounds of "disability" as early as February 21. An accompanying "Certificate

5 See Lewis H. Douglass, Civil War Records, National Archives and Records Administration.
6 Frederick Douglass to Gerrit Smith, October 20, 1863.

of Disability for Discharge," dated February 29, is an invaluable source of information not only regarding his injuries, but as concerns the brief facts of his biography that are missing from his Regimental Descriptive Book record. For the first time, the official archive provides a physical description, place of birth, and profession for Lewis by recording key details as follows: "Born in New Bedford. 25 years. 5 ft 9 inches Brown complexion brown eyes. Black hair. Printer." In this same certificate, a graphic account of his physical condition provides no doubt of his unsuitability for active service by confirming that he continues to suffer from a "Scrotal Abscess gangrenous in its character." He is seemingly getting worse rather than better as there is "now a fistulous opening" which has become infected "with discharge or puss." As a result, "He has done no duty since October 1863 and is unfit for Invalid corps," this unnamed military official writes. Ultimately, according to this report's findings, Lewis sustained a hero's injury in a "Disability incurred in the line of his duty." While references to Lewis Henry's health difficulties following the Civil War are few and far between, the private letters exchanged between him and his wife—as well as the Loguen family and friends more generally—establish that he suffered from repeated illnesses that were brought on by injuries he sustained during the war. Yet further confirmation of the likelihood that the "Scrotal Abscess" continued to impact on his life is provided by the fact that he and Helen Amelia were never to have children of their own.

Given that the official record is an unreliable repository of rudimentary dates and basic, although often erroneous, facts of Lewis's military service, we must turn to other sources for detailed accounts of his Civil War record. On August 8, 1863, the *National Anti-Slavery Standard* published an eyewitness account of the Battle of Fort Wagner. Writing from Morris Island, South Carolina, on August 1, an unidentified reporter provides a dramatic account of the 54th Massachusetts regiment's participation in this assault. "When about one thousand yards from the fort, the enemy opened upon them with shot, shell, and canister, which kept flying through their ranks incessantly, and wounding many of their best officers," this observer declares. She, or almost certainly he, applauds the heroism of the regiment by exalting, "still they pressed on through this storm of shot and shell, and faltered not, but cheered and shouted as they advanced." As was typical of mainstream reports, and even those published in antislavery newspapers, this author's initial focus is on white military prowess. Colonel Robert Gould Shaw "was one of the first to scale the walls," the reporter proclaims, only to commemorate his tragic end: "He stood erect to urge forward his men, and while shouting for them to press on was shot dead and fell into the fort." A martyr for the cause of Black liberation, Gould Shaw is not only politically and emotionally but physically united with his African American troops

in death: "His body was found with twenty of his men lying dead around him, two lying on his own body. In the morning they were all buried together in the same pit." Ultimately, however, this writer's interest is not exclusively on white bravery. Rather, this anonymous eyewitness singles out one man of the 54th Massachusetts Regiment in particular for his courage by reporting as follows: "Sergeant-Major Lewis H. Douglass, a son of Fred Douglass, by both white and negro troops is said to have displayed great courage and calmness, was one of the first to mount the parapet, and with his powerful voice shouted: 'Come on, boys, and fight for God and Gov. Andrew,' and with this battle cry led them into the fort."[7] This is not the only newspaper account to record Lewis Henry's "battle cry" of freedom: his rallying cry was to be repeatedly published across the national press, and was to result in widespread acclaim for his own and his regiment's exemplary feats of heroism.

While Frederick Douglass resists the temptation to single out his eldest son for commendation in his final autobiography, *Life and Times*, he applauds the Battle of Fort Wagner as a cause célèbre in the history of Black Civil War militancy. "The 54th was not long in the field before it proved itself gallant and strong, worthy to rank with the most courageous of its white companions in arms," he observes, declaring, "Its assault upon Fort Wagner, in which it was so fearfully cut to pieces, and lost nearly half its officers, including its beloved and trusted commander, Col. Shaw, at once gave it a name and a fame throughout the country."[8] "In that terrible battle, under the wing of night, more cavils in respect of the quality of negro manhood were set at rest than could have been during a century of ordinary life and observation," he confirms.[9] He is categorical in his conviction regarding this battle's seismic importance in guaranteeing the recognition of Black military prowess on a national stage: "After that assault we heard no more of sending negroes to garrison forts and arsenals, to fight miasma, yellow-fever, and small-pox."[10] According to Douglass, this event acts as the catalyst to a widespread realization of the exemplary abilities of Black combat soldiers, not in particular, but in general. "Talk of his ability to meet the foe in the open field, and of his equal fitness with the white man to stop a bullet, then began to prevail," he declares.[11] Ever mindful of his role as a historian working to commemorate exemplary feats of Black heroism, he takes great satisfaction in recording, "From this time (and the fact ought to be remembered) the colored troops were called upon to occupy positions which required the courage, steadiness, and endurance of

7 Anon., *National Anti-Slavery Standard*, August 8, 1863.
8 Douglass, *Life and Times*, 416.
9 Ibid.
10 Ibid.
11 Ibid.

veterans, and even their enemies were obliged to admit that they proved themselves worthy the confidence reposed in them."[12]

The Civil War Records held at the National Archives may well provide researchers with vital statistics regarding Lewis's official service, but it is to the intimate letters he writes Amelia and his mother and father, which are held in the Walter O. Evans collection and the Frederick Douglass Papers, that we must turn for an understanding of the flesh and blood realities he and his men endured at the frontlines. On March 31, 1863, Lewis writes Amelia a letter from the training grounds at Camp Meigs, Readville, Massachusetts, in which he is jubilant regarding his recent promotion: "I am now in camp with my regimentals on and instead of receiving the appointment of Quartermaster's Sergeant I have obtained the highest non-commissioned office in the regiment, which is that of Sergeant Major." Bolstering her spirits and his own, he readily admits, "My duties are not at present very arduous, I am a sort of privileged character being an officer of the staff meaning a sword &c &c." Deliberately he tells her of his journey to the camp with the other recruits rather than sharing his anxieties regarding the difficulties ahead. "I started from Syracuse with 17 men apparently able bodied and fit for soldiers," he explains, "we were to have second class cars, but owing to some misunderstanding the conductor failed to furnish them consequently we <u>had</u> to ride in first class cars which of course was very agreeable." In a time not for sorrow but for joy, he is buoyed up by Black solidarity in the freedom struggle: "my men amused themselves by singing John Brown and other songs to the delight of the white passengers in the car." Ever mindful of the need to dismantle white racist stereotypes, Lewis takes pride in their unblemished behavior by confiding, "The Syracuse men conducted themselves throughout the journey in a decorous and gentlemanly manner, giving me no trouble whatever."

While on their travels, Lewis informs Amelia in the same letter that they were not only joined by a "detachment of the Loguen guard" but they encountered, "my brother, who had in charge six men, starting from home with nine men and losing three by the way." Clearly, as Douglas Egerton writes, the "Loguen guard" is a reference to the combat troops who had been recruited by Amelia's father, Jermain Wesley Loguen.[13] Egerton draws on newspaper accounts to establish that "Loguen himself had been recruiting black employees of the New York and Erie Railroad, 'and putting them into the hands of the young Douglass boys,' as he told one reporter."[14] For Egerton, who works extensively with the Helen Amelia Loguen-Lewis Henry Douglass correspondence in the Walter O. Evans collection in his

12 Ibid.
13 Egerton, *Thunder at the Gates*, 78.
14 Ibid.

recent pioneering and exemplary study, the fact that Lewis's recruits gave him "no trouble whatever" confirms his view that, "the popular Lewis was a born leader of men."[15] As will be seen in the letters Charles Remond writes his mother and father from the frontlines, and in which he shares stories not only of his military prowess but of his taking a stand against numerous racist injustices, he may not have been a sergeant major but he was no less a courageous commander in his own right. While here and elsewhere in their wartime correspondence, Lewis and Amelia's courtship is an afterthought in comparison with the "tears and blood" of war, Douglass's eldest son is at pains to reassure his fiancée of his constancy before he signs off: "Whatever I have said in a joke about you not loving me means nothing, you are ever dear."

"You wish me to tell you of camp life," Lewis writes Amelia in a letter dated over a week later, on April 8. He immediately complies with her request by celebrating his physical fitness: "The first thing I did was to be examined by the surgeon to see if I was in any manner deformed, after which I was told to go to an officer whose business it is to take a description of my looks, and then swear me in to the service." Still jubilant over his immediate promotion to the rank of sergeant major, Lewis provides Amelia with painstaking details concerning his military uniform. As he explains: "My badge of office, is it so has three stripes placed on my coat in the shape of a half diamond, and three circular stripes rounding from the diamond." Not content with a written description, he inserts a drawing according to which he suggests it is "somewhat like this [Insertion of a drawing of a diamond] on each sleeve, and a wide stripe down the leg." Dramatically to the fore in the carte-de-visite portrait of Lewis Henry held in the Moorland-Spingarn Research Center collections is not only his empowered stance—he is photographed with his arms crossed, while his emotionally charged facial expression testifies to a man about to go to war—but his "badge of office," which is clearly on view on his shoulder sleeve (Figure 31).

In the letter Lewis writes Amelia on April 8, he ultimately refuses to confine himself solely to his regiment's daily routines. Rather, he admits to the men's internal disputes and the severity of the punishments they have received due to their subjugation under an all-white officer class. As he confides, "The soldiers amuse themselves by fighting each other, speaking up to the officers, for which they are immediately punished, by having large balls of iron to them or making them hold heavy weights for hours for striking a superior officer." While he includes no explicit critique, Lewis's references to the "large balls of iron" and "heavy weights" that have been inflicted on Black men simply for "speaking up" offer clear-cut proof that the Union army is no halcyon state of race relations.

15 Ibid.

Very much conscious that he is his father's son, Lewis confides his determination to safeguard his public reputation at all times. "I attended a levee in the evening of colored people which was just nothing," he admits. He is immediately careful to confirm, "I did not stay in the hall long having soon found out that there were 'all sorts' present I thought it would not be well for me to be known there." For all members of the Douglass family working to maintain an inviolate reputation, the issue of adhering to the core moral tenets of elite respectability politics was at a premium, even and especially during wartime. While he wholeheartedly assumes the responsibilities of a combat soldier as he embraces all aspects of his military service, Lewis consistently refuses to lose sight of his love for Amelia in this correspondence. In this letter, he relies on an emphatic use of underscoring to give weight to his heartfelt promise, "I shall always love you." Yet more poignantly, he implores her to "never give me up me for dead until you are certain of it." Lewis gives free reign to his anxiety by readily confiding to Amelia, "My fear is that I may be reported dead when I am not, it is often the case in battle." Lewis's fear is ultimately not of death, but of losing the love of his life.

While Lewis's letters to Amelia survive as an intimate archive in which they celebrate a loving relationship, they also perform a fundamental political function by providing a detailed record of exemplary Black military prowess as enacted during the Civil War. Scarcely a week later on April 15, 1863, Lewis triumphantly informs Amelia: "Our men are learning very fast and are now quite proficient in the manual of arms." With an elder brother's characteristically superior air, he further confides: "Charley is here and has taken charge of his company, he is a little green at first and has not learned yet to boss his men around, which is very necessary." Lewis's patronizing assessment notwithstanding, as we will see below, Charles's letters confirm that he did establish his authority in no uncertain terms, not only with the other men but with his superior officers. In the same letter in which Lewis argues for his greater military knowledge in comparison to that of his brother, he reveals he is a man of his time by endorsing gender essentialist stereotypes. Here he celebrates reason as belonging to men and men alone, relegating superstition to the women's sphere. "My dear girl, you are certainly not so lost to reason as to believe in ghosts," he chides Amelia in response to superstitious beliefs she very likely expressed in a letter that is no longer extant. Ultimately, however, he succeeds in keeping his own body and soul together by being guided by instincts that equally have nothing to do with reason. As he writes: "something tells me I will not be killed, though I may be wounded, and that is not so bad you know, it will be an honor." For the Douglass sons, to be wounded or even to die in the "struggle for the cause of liberty" was no sacrifice at all.

Over a month later, on May 20, Lewis's heroic front begins to show signs of cracking. "We are soon to leave," he confides to Amelia, only to ask, "Who will

return?" He offers up only a very brief admission of his anxiety, however. He immediately resumes his self-sacrificing endorsement of the necessity of war by focusing on his own and his regiment's role in ushering in a new era of freedom. "Remember that if I fall that it is in the cause of humanity, that I am striking a blow for the welfare of the most abused and despised race on the face of the earth[,] that in the resolution of this strife rests the question of our elevation, or our degradation, our happiness or our misery," he declares. At the same time, he gives vent to his personal struggles by imploring Amelia, "do not let your thoughts be worrying, do not think of me in pain, do not think of me enduring hardships, do not think of me grappling with that non-respecter of persons Death!" Rather, he advises, "Think of me as aiding in the glorious work of bursting from those chains which keep the husbands, wives, children, lovers and friends, of millions asunder, as aiding to the overthrow a system, the cruelty, tyranny and crime of which degrades millions of human beings to a level scarcely on a footing with the brutes." Clearly, Lewis's plea that Amelia not "worry" or think of him in "pain" and "hardships," has the twofold purpose of not only offering her reassurance but of bolstering his own spirits. For Lewis, all personal suffering ultimately pales in comparison with the "glorious work" of "bursting" women, children, and men from their "chains." As he sees it, their love has a purpose only in so far as the promise of their union has inspired him to labor for the "overthrow" of slavery. "Think of the joy, the inexpressible joy to those millions, freed from such a foul system, and then think that I threw in my mite to bring about that joy[,] that happiness, then rejoice yourself that you encouraged one you held dear to help bring about this bliss," he implores. According to Lewis's own admission, it would seem that Jermain Wesley Loguen's advice that women use their "Venus-inherited charms to encourage enlistments among our people," had in fact been heeded by his eldest surviving daughter and with very real results.

Writing from St. Simons Island, South Carolina, on June 18 following his arrival with the 54th Massachusetts regiment, Lewis informs Amelia of his immediate encounter with two legendary Black freedom fighters. The "first man to whom I was introduced was Robert Small[s]," he declares, adding, "I there met Harriet Tubman, who is a captain of a gang of men who pilot the Union forces into the enemy's country." As freedom fighters who were born into slavery, Robert Smalls and Harriet Tubman made a seismic impact on the course of the Civil War: Smalls as the heroic liberator of a confederate ship, *Planter*, which he brought over to Union lines (Figure 32), and Tubman as not only a legendary Underground Railroad operator but as a "nurse, spy and scout" who was singlehandedly engaged in gathering military intelligence in enemy territory (Figure 33).[16]

16 "Nurse, spy and scout" is written at the bottom of the Harriet Tubman photograph held at the Library of Congress and reproduced in this volume (Figure 33).

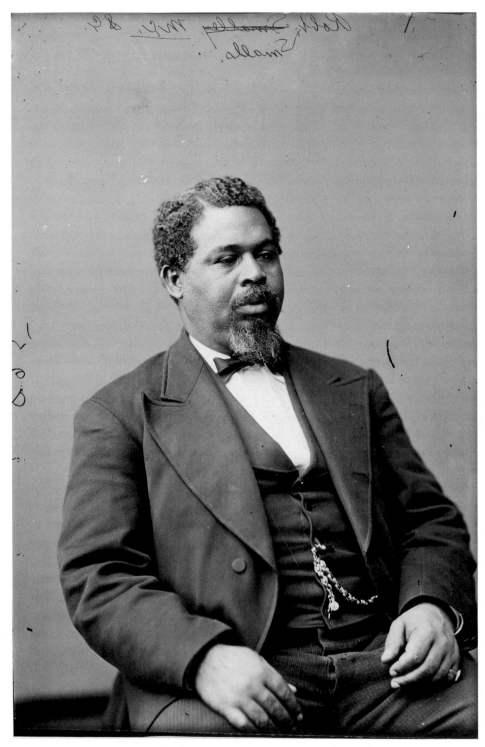

Figure 32: Anon., *Robert Smalls*, c. 1870–80. (Brady-Handy Photograph Collection. Prints and Photographs Division, Library of Congress, Washington, DC.)

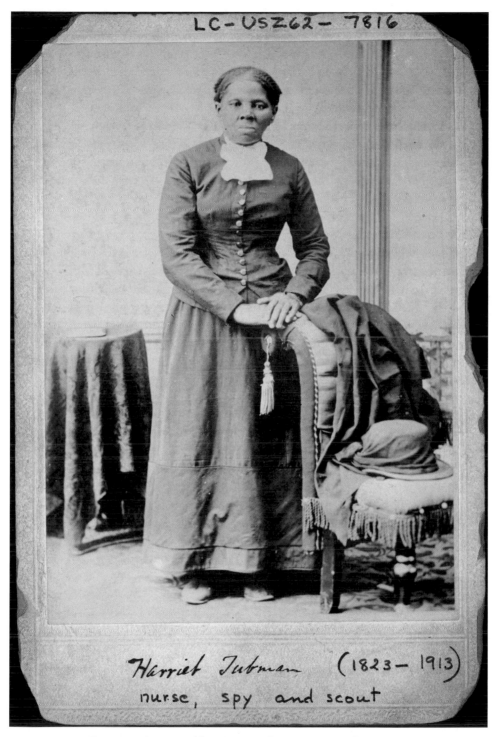

Figure 33: H. B. Lindsley, *Harriet Tubman*, c. 1871–6. (Prints and
Photographs Division, Library of Congress, Washington, DC.)

"I have been in two fights, and am unhurt. I am about to go in another I believe to-night. Our men fought well on both occasions," Lewis writes Amelia from Morris Island, South Carolina, a month later on July 20, just two days after the Battle at Fort Wagner.[17] Starkly contrasting to his earlier eulogy of individual freedom fighters Robert Smalls and Harriet Tubman, here he celebrates his regiment's collective exemplary military prowess by stating, "our men fought well." He provides an eyewitness account of the assault: "we charged that terrible battery on Morris Island known as Fort Wagoner [sic], and were repulsed with a loss of 3 killed and wounded." He repeats his declaration that he has not been injured: "I escaped unhurt." At the same time, he refuses to shy away from his life and death exposure to a "perfect hail of shot and shell." Whether—as is very likely—he is deliberately lying to protect Amelia's feelings, or whether he is not yet aware of the full extent of his injuries, Lewis refuses to discuss his physical wounding in favor of celebrating his belief that "[t]his regiment has established its reputation as a fighting regiment not a man flinched, though it was a trying time." He relies on hard-hitting language to describe the tragedies and traumas of the battlefield: "Men fell all around me. A shell would explode and clear a space of twenty feet, our men would close up again, but it was no use we had to retreat, which was a very hazardous undertaking." As a measure of the hell he has been through, he is ultimately incredulous that he has survived: "How I got out of that fight alive I cannot tell." And yet, he declares, "I am here." He testifies to his profound personal courage by insisting, "Should I fall in the next fight killed or wounded I hope to fall with my face to the foe." "Remember if I die I die in a good cause," he further implores Amelia, readily admitting: "I wish we had a hundred thousand colored troops we would put an end to this war." "I must bid you farewell should I be killed," he poignantly signs off, only to refuse to give up hope by issuing a heartfelt promise: "If I survive I shall write you a long letter."

"At about four in the morning the rebels made an attack on our pickets—who were about two hundred strong—with a force of nearly nine hundred men. Our men fought like tigers, one sergeant killing five men by shooting and bayonetting," Lewis reports in a no less powerful letter to his mother and father, written on the same day. Here he refuses to shy away from the spectacle of armed Black military prowess by holding nothing back regarding his regiment's physical courage against seemingly impossible odds. In a far more heart-rending account than the description of the blood and mire of battle that he shares with Amelia, he informs Anna Murray and Frederick Douglass of the full extent of his regiment's heroic self-sacrifice. "Saturday night, we made the most desperate charge on Fort

17 Lewis Henry Douglass's letter is held the Frederick Douglass Papers, Library of Congress Manuscript Division. Douglass also published the letter in *Douglass' Monthly*, August 1863.

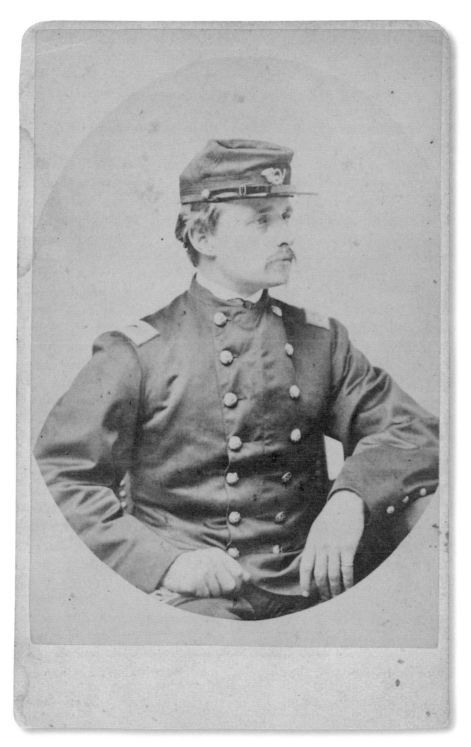

Figure 34: John Adams Whipple, *Robert Gould Shaw*, c. 1863. (Prints and
Photographs Division, Library of Congress, Washington, DC.)

Wagner," he summarizes, declaring, "Our loss in killed wounded and missing was 300. The splendid Fifty Fourth is cut to pieces all of our officers with the exception of eight are either killed or wounded." As a regiment "cut to pieces," he not only admits to their shared exposure to life-threatening dangers but also confides his own lucky escape from death: "I had my sword sheath blown away while on the parapet of the fort." "The grape and canister shell and Minnie swept us down like chaff, still our men went on and on," he declares as he takes pride in their collective heroism. He relies on the same jubilant phrasing to express his satisfaction that their exemplary actions at Fort Wagner have indeed "earned us our reputation as a fighting regiment." At this point, the news had not yet reached Lewis of Robert Gould Shaw's tragic death, as he still holds out hope for his survival: "Col. Shaw is a prisoner and wounded" (Figure 34).

In a revelation that must have angered both his mother and father, lifelong campaigners against all forms of discrimination and persecution, Louis pulls no punches regarding the role played by white racism in securing their defeat. "If we had been properly supported we would have held the fort," he reports. But, he explains, the necessary support was not forthcoming: "the white troops could not be ~~driven~~ made to come up." The "consequence" for the regiment, as Lewis confirms, was nothing less than devastating: "we had to fall back dodging shells and other missiles." As subjected to the discriminatory behavior of "white troops" who could not be "made to come up," the "reputation" of the 54th Massachusetts as a "fighting regiment" assumes even more heroic proportions. "If I die to night I will not die a coward," Lewis poignantly informs his mother and father. Implicit in his statement is the equation: Black manhood equals self-sacrificial courage, and white manhood equals self-serving cowardice.

Lewis finally admits to anxieties about his health in a letter he writes Amelia a few weeks later, on August 15: "I have thus far held out against the climate but I now fear that I am going to be sick." Faced with physically debilitating injuries, he refuses to be disheartened: "[I] am trying to be as cheerful as I can, which I think the best thing for a person when sick." He is also careful to reassure her that, "I have not been in any fight since the 18th of July," while he readily admits that they are living under a constant threat of violence: "three or four mornings ago we were called out at two o'clock, expecting men going to attack us, but they did not." Atypically for his wartime correspondence, he exalts not solely in Black male but in Black female heroism by confiding, "The colored women of Beaufort have shown their appreciation of the cause by helping take care of our sick and wounded, under the irrepressible Harriet Tubman." No less uncharacteristically for his extant war letters, Lewis turns his attention to the domestic sphere by issuing a heartfelt appeal to Amelia: "My dear girl keep a good heart[,] always

[remember] that I love you, and think of you, and all the dear ones in Syracuse often[,] in fact my mind is divided between you and home."

Ultimately, however, for a man writing from the Civil War frontlines, all remembrances of home pale in comparison to his current life-and-death situation. "As I am writing shells are flying and whizzing in our front about a mile off. Night before last a rebel shell came into but did not burst," he writes. A week later, on August 27, Lewis is no less focused on his regiment's battle for existence. As he writes, before the work of emancipation "can come to pass there must be work done, death must be dealt out, and must be received." Given that we have no written access to her thoughts and feelings, Amelia's anxiety on reading of Lewis's dangers can only be imagined. For Lewis, it is clear: whether he or his men live or die is of no account in comparison with their participation in "freedom's battle." "Some of us will live to see rebellion crushed and some of us will die crushing it," he declares. "Either is glorious."

The archive is silent for the next six months. No letters from Lewis to Amelia or to his mother and father have survived from this dramatic moment in US history, a pivotal time in the Black freedom struggle as well as in Lewis's own life. The first extant letter to fill this gap is written by Lewis to Amelia and dated January 31, 1864. Writing from Rochester, scarcely two weeks after the marriage of his sister Rosetta to Nathan Sprague on December 24, 1863, he is undergoing an extended period of convalescence from his wartime injuries, which have now been diagnosed and for which he is receiving treatment. Living away from the theater of war, Lewis is again able to return to the subject dearest his heart: "I have just had my attention attracted to those whom God has put together, and whom He has enjoined upon man not to tear asunder, or in other words the two who have promised on Christmas eve to love, obey, cherish and protect each other." As Douglas Egerton emphasizes, Lewis's attendance at his sister's wedding fills him with emotions regarding his own and Amelia's ongoing engagement. This was no era of equal rights for women and men; Lewis heeds only his own needs by informing Amelia, "You are thinking of teaching school for two or three years." The question on his mind regarding Amelia's decision to become a teacher has no bearing on her life, but is focused exclusively on what her decision means for him: "in case I should get my discharge, what will become of your promise to me?"

Writing to his father on August 22, 1864, after another six-month break in their extant correspondence, Lewis is again living in Morris Island. His decision to return to the Civil War frontlines was most likely influenced by Amelia's decision to follow through on her determination to work as a teacher in upstate New York. Now medically discharged from the army, as Douglas Egerton's research establishes, Lewis was "working as a sutler," and therefore responsible for supplying the

soldiers with their necessary provisions.[18] In this letter to his father, he is ever mindful of his younger brother's safety. He expresses a real sense of relief by admitting, "I am glad to learn that Charley is at Point Lookout and likely to remain there." He also expresses deep-seated concern for his recurring health problems by urging, "I hope that his fever is not serious." While he is himself still unable to undertake active military duty, he writes his father of other ways in which he is able to participate in the war effort. "There is one business very thriving here just at present and that is recruiting for Massachusetts quota," he confides. Recognizing that his father is ideally placed to make his suggestion a reality, he includes a proposal: "If Rochester or the State of New York would give me an appointment to recruit for them I could get a great many men providing the bounty is large enough." "Massachusetts is paying $50.00," he observes, noting that, "I see that the Express in noticing Fred's going to Vicksburg calls the attention of the people to Massachusetts['] example." While Lewis did not in fact take up the role of recruiter, he here provides one of the very few references—apart from the mentions made in his father's own final autobiography—to his young brother Frederick Jr.'s recruitment labors in Mississippi, a subject of ongoing research.

The Lewis Henry Douglass artifacts housed at the Moorland-Spingarn Research Center, Howard University, consist not only of the beautiful carte-de-visite portrait—in which he appears in full military regalia—but of a brass button. And it is no ordinary button. As the catalogue entry reads: "This button is from the coat of Sergt Major Lewis H. Douglass which was worn in the terrible assault on Ft. Wagner led by his regiment the 54th Mass. Vols. July 18 1863."[19] Here is nothing less than a literal fulfillment of Frederick Douglass's powerful prophecy: "'Once let the black man get upon his person the brass letter, U.S., let him get an eagle on his button, and a musket on his shoulder and bullets in his pocket, there is no power on earth that can deny that he has earned the right to citizenship.'"[20] As the lifetimes of Frederick, Lewis Henry, Frederick Jr., and Charles Remond reveal, the war for the Black man's "right to citizenship" was a war waged on every front and a life-and-death struggle in which survival was by no means guaranteed.

18 Egerton, *Thunder at the Gates*, 242.
19 Battle and Wells, *Legacies*, 102.
20 Qtd. Bernier, *Suffering and Sunset*, 45.

BOSTON
MAY
6
MASS

Miss H. Amelia Loguen
Care of Rev. M. Loguen
Binghampton
Broome Co
N.Y.

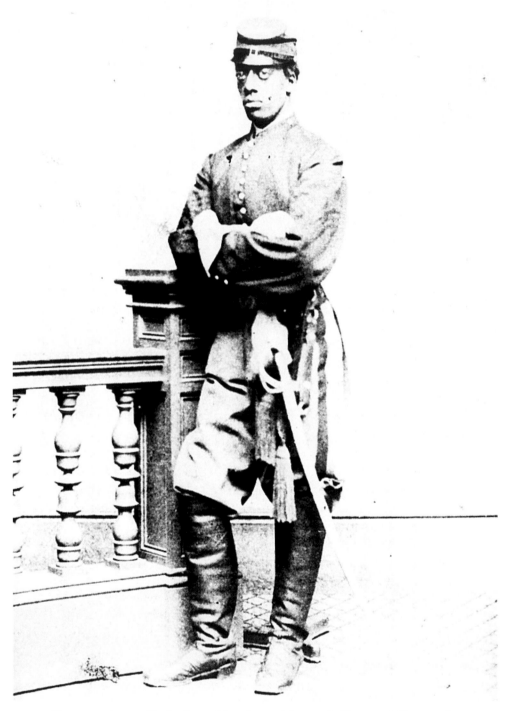

Figure 35: Anon., *Charles Remond Douglass*, n.d. [c. 1863]. (Prints and Photographs
Division, Moorland-Spingarn Research Center, Howard University, Washington, DC.)

"I Take a Bullet First"

Charles Remond Douglass's Civil War Letters to Anna Murray Douglass and Frederick Douglass

"Douglass Charles R. Priv.—Res. Rochester, NY.; printer; 19; enl. April 18, 1863; take a bulletmust. April 23, 1863; disch. By S.O. of War. Dept., March 19, 1864, for promotion in 5th Mass. Cav."[1] So reads Charles Remond Douglass's military service record as compiled by the "Adjutant General" and included, as was Lewis Henry's, in the fourth volume of *Massachusetts Soldiers, Sailors, and Marines in the Civil War*, published in Norwood, Massachusetts, in 1932. As Charles Remond not only served in the 54th Massachusetts regiment but was then transferred "for promotion" to the 5th Massachusetts Calvary, another entry summarizing his service can be found in the sixth volume of this work, published a year later in 1933. This additional record is equally bare-bones, and reads as follows: "Douglass, Charles R.—Priv.—Res. West Roxbury; printer; 19; enl. and must. March 26, 1864; disch. Sep. 15, 1864, as 1st Sergt. By S.O. No 301. A. G. O. dated Sept. 10, 1864."[2] As per the fate accorded Lewis Henry's combat service, Charles Remond's military record has been subjected to wide-spread neglect. The one exception is the exemplary study of the 5th Massachusetts Cavalry authored by Steven LaBarre and published as recently as 2016. In this volume, LaBarre discusses Charles's military service in depth and exalts in his status as "one of the more noteworthy African American soldiers of the period."[3] At the same time, he pulls no punches regarding the regiment's invisibilization in current scholarship, confirming, "The history of the 5th Massachusetts Cavalry is

1 Anon., *Massachusetts: Soldiers and Sailors of the Revolutionary War*, vol. IV, 686.
2 Anon., *Massachusetts: Soldiers and Sailors of the Revolutionary War*, vol. VI, 528.
3 LaBarre, *The Fifth Massachusetts*, 40.

a chronicle that has truly never received the proper attention that it deserves."[4] If the 5th Massachusetts Cavalry has "never received" its "proper" due, then this is even more the fate awaiting the lives of individual men—including renowned figures such as Charles—who served as combat soldiers in the regiment but whose military service has been subjected to widespread dismissal.

While the Civil War records held at the National Archives in Washington, DC are as characterized by omissions and gaps for Charles, as they are for Lewis Henry, they nevertheless constitute an invaluable repository which is vital for beginning to piece together Charles's military service.[5] In comparison to the inaccuracies besetting Lewis Henry's record, the entry for Charles in the Company Descriptive Book for the 54th Massachusetts Regiment not only lists his name correctly but offers confirmation that he enlisted on April 18, 1863. While Lewis Henry's entry is left almost entirely blank, Charles's is carefully filled in: he is identified as 19 years old, born in Lynn, Massachusetts, a Printer, and with a "Blk" complexion and hair and "Brown" eyes. As per the additional "Remarks" supplied by white commander Norwood P. Hallowell, Charles's service record reads as follows: "Promoted to be corporal Apr 18/63 by Col Shaw. Given sick leave from May 29/63 to June 29 63 Reduced to ranks June 29/63 by Col Hallowell. Discharged by War Department S.O. 122 March 19/63 to be 1st St in 5 Mass Cavalry." According to the 54th Massachusetts Company Muster Roll, Charles may not have been immediately appointed a sergeant major, as was his eldest brother, but he was nevertheless accelerated through the ranks. This record confirms that he was "Promoted to be corpl to rank as such from date of muster dated Apl 23/63 by order Col R. G. Shaw." According to Egerton's findings, Charles's promotion took place a few weeks earlier, on March 25, 1864. "Owing to both Charles's famous father and his flawless penmanship," he writes, "Shaw ordered him promoted to lance corporal within the month, and assigned to writing up the endless paperwork for the arriving recruits."[6]

While Charles's official record may be more detailed than the documents describing his eldest brother's term of enlistment, the written account of his military service is beset with far more difficulties. In stark contrast to Lewis's unblemished record, Charles's entries in the official military archive initially appear to confirm potential problems. On first glance, the muster role for July and August 1863 reads as a damning indictment of Charles's truancy: "Deserted from Rochester N.Y June 29/63." Yet more worryingly, a "Descriptive List of Deserters" dated September 12, 1863 includes Charles, with the handwritten comment that

4 Ibid. 180.
5 See Charles Remond Douglass, Civil War Records, National Archives Records and Administration, Washington, DC.
6 Egerton, *Thunder at the Gates*, 77.

he "Received furlough to Rochester NY for thirty days from May 29 to June 29 and has not reported for duty since." By way of further seemingly incontestable proof, Colonel Edward W. Smith writes a letter from "Head Quarters 54 Regt Mass. US Infantry Morris island SCm" on September 13 in which he pulls no punches regarding Douglass's youngest son's dereliction of duty: "I have the honor to transmit to you enclosed a descriptive list of Corporal Charles R. Douglass a deserter from this regiment in the month of July and reported 54 Mass during the month of August." As a result of his ongoing absence, the muster rolls for November and December confirm a demotion, according to which he was summarily "reduced to Pvt."

However, the official records soon tell a very different story. On closer inspection, they confirm that there has been a terrible misunderstanding, according to which Charles has been done an unforgivable disservice. A handwritten entry confirms the stark truth that Charles was "Reported deserter by error, absent sick at Readville Mass since June 29/63." Yet more evidence emerges from the fragment of an unsigned letter directed to Colonel Hallowell and dated January 28, 1864. Here the unnamed writer confirms, "Corpl Douglass of your regt has shown me yr note of Jan 7 after and while convalescent he was detained by Genl Pierce to help Lt Wulff in recruiting and has been reporting to me since." As a result, Charles is exonerated from all blame: "The fault of engaging him does not therefore rest with him." The muster rolls for January and February 1864 offer yet further ballast to his innocence by confirming he was "Absent sick at Readville Mss since June 29/63."

While Charles initially enlisted in the 54th Massachusetts regiment, he was soon transferred to the 5th Massachusetts Cavalry. As the muster rolls for March and April 1864 establish, he was "Dischgd to accept Promotion S.O. AGO Washington DC No. 122 March 19/64." According to Special Order Number 122 issued by Henry W. Littlefield, "2nd Lieut and Acting Adjutant 54 Mass Vols., "Private Charles R. Douglass Co. F 54th Mass Vols is honorably discharged the service to enlist in the 5th Regt Mass Cavy." Steven LaBarre has unearthed invaluable information regarding Charles's transfer as a result of his extensive research into the Massachusetts state archives. He has succeeded in locating a letter from Governor John Andrew to Secretary of War Edwin M. Stanton, dated March 14, 1864. This letter reads in full as follows:

I beg to request that Private Charles F. Douglass of Company F. 54th Reg't Mass. Vol. Infty may be discharged from the service in order to enable him to reenlist and receive a First Sergeant's warrant in the 5th Massachusetts Vol. Cavalry now raising here. C. F. Douglass is a son of Frederick Douglass. He, with a brother, enlisted in The 54th Mass. Infty, when that reg't was commenced early

in 1863. Just before the reg't marched Charles was taken ill with lung complaints, and was in hospital here for several months. Since his recovery he has remained here on recruiting service, and has rendered valuable assistance in recruiting the 5th Mass. Cavalry. By reason of his having been prevented by sickness from ever taking field with the 54th, and by reason of the influential position of his father among the colored people of the U.S. and the important aid and influence he has exerted in promoting colored military organizations, I present this application as entitled to special favor and I hope you may grant it. I request his discharge from the 54th Infty so that he may reenlist into the 5th cavalry, as avoiding the objections incidents to requests for transfers.[7]

Massachusetts Governor John Andrew makes the case for Charles's honorable discharge from the 54th and transfer as a "First sergeant" into the 5th Massachusetts Calvary on the basis not only of his ongoing "lung complaints," the fact that he never saw active duty "in the field," and his sterling capabilities as a recruiter, but also, and more importantly, due to his exalted status as a "son of Frederick Douglass" (Figure 36).

Recognizing the exceptional role played by Douglass in the recruitment drive, Andrew defends his request for this "special favor" by "reason of the influential position of his father among the colored people of the U.S. and the important aid and influence he has exerted in promoting colored military organizations." His argument worked: less than a week later, the War Department in Washington, DC issued Special Order No. 122 on March 19, 1864, according to which, "Private Charles H. [sic] Douglass, Company F, 54th Massachusetts Volunteers (Colored) is hereby honorably discharged the service of the United States to enlist in the 5th Massachusetts Cavalry, with a view to its appointment as 1st Sergeant in said regiment. By Order, the Secretary of War. E D Townsend, Assistant Adjutant General."[8] Revealingly, this was not the only favor to be conferred upon Douglass's youngest son during his military career.

Charles suffered from ongoing ill health, and consequently his service in the 5th Massachusetts Cavalry was short-lived. According to "Special Orders No. 301," dated September 10, 1864, issued by the War Department, and again signed by E. D. Townsend as Assistant Adjutant General, "Sergeant Charles R. Douglass 'I', 5th Massachusetts Cavalry (Colored) is hereby honorably discharged the service of the United States." As the entry recorded on the regiment's descriptive book further confirms, he was "Discharged service Sept. 15 1864 at Point Lookout

7 Rpt. LaBarre, *The Fifth Massachusetts*, 40.
8 Qtd. Greene, *Swamp Angels*, 85.

Figure 36: Anon., *John A. Andrew*, c. 1855–65. (Prints and Photographs
Division, Library of Congress, Washington, DC.)

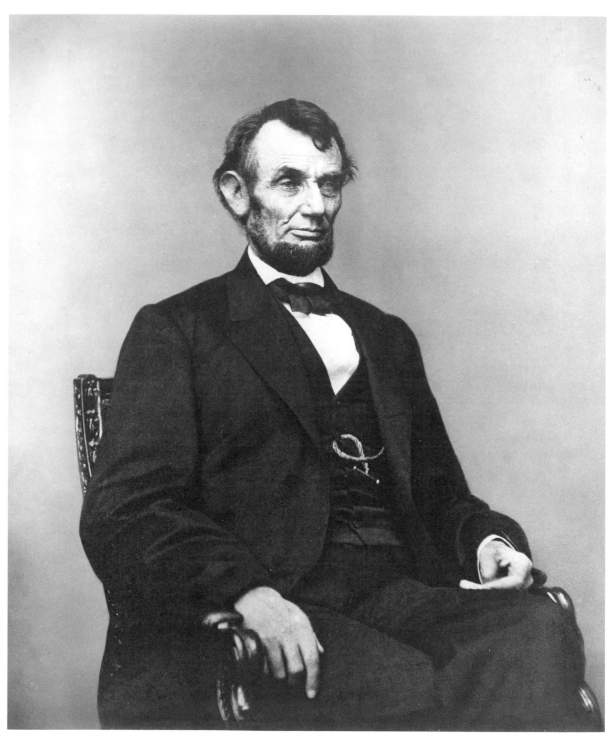

Figure 37: Anthony Berger, *Abraham Lincoln*, February 9, 1864. (Brady-Handy Photograph Collection. Prints and Photographs Division, Library of Congress, Washington, DC.)

Md."[9] Inarguably, a hand other than Charles's own had secured his early discharge. On August 29, no other individual than Frederick Douglass weighed in on his youngest son's behalf. He writes no less a person that President Abraham Lincoln with a heartfelt request:

> I have a very great favor to ask. It is, that you will cause my son Charles R. Douglass, 1st Sargent of Company I—5th Massachusetts dismounted cavalry now stationed at "Point Lookout" to be discharged—He is now sick—He was the first colored volunteer from the State of New York—having enlisted with his Older Brother in the Mass—54th partly to encourage enlistments—he was but 18 when he enlisted—and has been in the service 18 months.[10]

Douglass's plaintive appeal—in which he exaggerates his son's youth (he was in fact aged nineteen, not eighteen) and perpetuates the mythology that he was "first" to enlist—does not go unnoticed. Abraham Lincoln's President Special Order No. 301, dated September 10, 1864, consists of a single instruction: "Let this boy be discharged" (Figure 37).[11]

Despite Charles's prolonged bouts of sickness and the difficulties presented to researchers by the silence of the official archive regarding the military conflicts in which he participated, the extant letters he writes to his mother and father confirm that his combat record was impressive by any standard. He saw action in May and June 1864, not only during the skirmishes of the Bermuda Hundred Campaign—which took place outside Richmond—but also in the Second Battle of St. Petersburg, held a month later, and in Virginia. Faced with men dying all around him, Charles kept a level head and courageously fulfilled his military responsibilities as a sergeant responsible for a company of combat soldiers. As a result of his accomplishments, he had every reason to stand tall—as he does in the powerful daguerreotype held in the Walter O. Evans collection. Here he is not only attired in the uniform of the 5th Massachusetts Cavalry, but is shown with his bayonet and sword. Charles gives viewers of the image no option but to recognize the Black man's right to bear arms in the fight for freedom.

"Yesterday I went to Mr. Grimes['s] Church and Dr. Rock read a letter that he had recd. from his wife who is in Philadelphia," Charles writes his father from Camp Meigs on July 6, 1863. According to Dr. John S. Rock, a man who had

9 Charles Remond Douglass, Civil War Records, National Archives Records and Administration, Washington, DC.
10 Reproduced online in full at <http://www.nytimes.com/2002/02/16/arts/lincoln-online-new-treasures.html?mcubz=0> (accessed January 14, 2018).
11 Qtd. LaBarre, *The Fifth Massachusetts*, 116.

been born free only to become a pioneering medical doctor, lawyer, and radical abolitionist, the eyewitness testimony of his wife (who remains unnamed in the official records) leaves no room for doubt that "the Rebels were sending the negroes south as fast as they advanced upon our lines and that the colored people were rushing into Philadelphia." While Charles is delighted to learn "that yourself and Stephen Smith and others were doing all you could for them," he expresses fear for his father's safety by instructing him to "keep out of the hands of the rebels." No paragon of virtue in comparison with the unblemished record of his elder brother, Charles admits to giving full vent to his anger when faced with the white racist injustices he experiences at Camp Meigs. "This morning as I was about to take the train for camp I saw some returned soldiers from Newbern R. I.," he reports, adding that they "had just got the news that Meade had whipped the rebels and behind me stood an Irishman. I said that we had some sort of a Gen. now and that made the Irish mad and he stepped in front of me with his fist doubled up in my face and said 'aint McKellen a good Gen you black nigger.'" Charles has no qualms in admitting to his father that he was unable to remain passive in the face of this unnamed Irishman's demonstration of physical aggression and articulation of racist abuse. "I was so mad that I swear freely and I drew my coat and went at him," he reports, adding, "all the time there was a policeman on the opposite side watching our movements just as I went at him (he was heavier than me) the policeman came and stopped me and asked what the matter was I told him and he marched the other fellow off and that made all the other Irish mad." Exhibiting fearlessness in the face of very real physical threat—he "went at him" despite the fact that "he was heavier"—Charles is jubilant over his victory: "I felt better still I felt as though I could whip a dozen Irish." He expresses a newfound confidence in his physical superiority due to his proficiency in bearing arms. In a boastful defense of his actions, he explains to his father: "I did not care for them because I had my pistol and it was well loaded I am all right for I have got my mind made to shoot the first Irishman that strikes me they may talk but keep their paws to themselves." The extant archive is silent regarding Frederick Douglass's response to Charles's impassioned militancy: we can only imagine the emotions of a man who had repeatedly stood his ground against white physical threat on receiving this letter from his youngest son.

A few months later, on September 8, Charles again writes his father from Boston. This time he is no longer jubilant regarding his superior physical prowess over his white racist abusers. Rather, he is on the defensive, writing in response to a criticism his father has made (most likely in an earlier letter which is no longer extant) about his having stolen food. "I have never brought any disgrace upon the family and I never mean to," he reassures his father. Rather, Charles insists on his innocence of any and all charges made against him, declaring, "I

have never stolen from any body a chicken or any thing else." Intimidated by his father's disapproval, he makes a careful distinction between words and actions: "I have said that I would take a chicken or any thing else to eat when I was hungry but I have not done so." He also lends further support to his innocence by establishing the practical impossibility of his having participated in any wrongdoing: "I wrote that there had been chickens stolen by the boys in camp but as I have had to take charge of the camp I have never left it without permission." In this letter, Charles easily segues from heartfelt attempts to persuade his father that he is not guilty of the charge set against him, to trying to impress him with his capabilities as a soldier: "I have the praise to day of Gen. Peirce of keeping things up neat and orderly about the camp when all were sick except myself." He is equally at pains to inform his father that, while he may not be fighting on the battlefield, he is faced with death on every front. He writes matter-of-factly regarding a painful duty: "some nights I was up all night and stood over those that died and laid them out wrote to their friends and in fact done most all that was to do except doctor them."

In this letter Charles again returns to his father's charge that he has stolen food, only to blow the whistle on the key contributing factor to these Black soldiers' tragically premature deaths: their living in near starvation conditions. "I had to eat dry bread alone for we only got meat once a week and that was used to make soup for the sick we could say nothing to nobody against it," he informs his father. He refuses to be silent in the face not only of the sickness of the men but of his own suffering: "I was the only one on the ground that could get a chance to speak the rest being sick I fell away like a skeleton." Ever the protester and activist fighting for equal rights, Charles refuses to accept these conditions for either himself or his men. As he tells his father, he has no fear of tackling the authorities at the camp and calling them out on their hypocrisy: "I spoke to the doctor about it he could not account for it nor did he care: he had plenty." He exposes the injustice of the near starvation conditions of Black troops at the hands of white authorities yet further by declaring, "They would tell us that hospital rations were small and that we could not draw full rations." He instantly exposes their bare-faced lie for the immoral sham that it is by caustically observing, "that is a funny way to starve a lot of men in a State where there is plenty." Ultimately, in his determination to defend himself and his men from any and all charges of stealing, Charles not only refuses to placate his father but even goes so far as to warn him of his ignorance. "It dont seem to you that are home true that this can be but upon honor it is the truth," he writes. He also gives his father no philosophical room to maneuver by presenting him with a tragic reality: "there are men dying out to camp." Yet more revealingly, he proves he is his father's son by refusing to be quiescent: "I am going 'to complain' about it to day."

While we have no way of knowing Frederick Douglass's reaction to his son's plaintive appeal for his compassion, there can be little doubt that he would have empathized with Black hunger and would have been enraged by white greed. As he himself had written in his first autobiography, at a time when he was only a little older than his youngest son, stealing was not stealing if it was a fight for survival. Writing of himself and four other enslaved women and men, Douglass confides, "we were allowed less than a half of a bushel of corn-meal per week, and very little else, either in the shape of meat or vegetables." Stating, "It was not enough for us to subsist upon," he insists that they had no choice but to steal in order to survive: "We were therefore reduced to the wretched necessity of living at the expense of our neighbors. This we did by begging and stealing, whichever came handy in the time of need, the one being considered as legitimate as the other." Yet more revealingly, Douglass is no less incandescent in his anger toward whites who have "plenty" than his son when he recalls: "A great many times have we poor creatures been nearly perishing with hunger, when food in abundance lay mouldering in the safe and smoke-house."[12] As a formerly enslaved man who had fought near starvation conditions by every means necessary, it seems unlikely that Frederick Douglass the free man and father would have remained unmoved by the heartfelt plea with which Charles concludes his letter: "don't think hard of me because of what I said a person will do most anything before they will starve and will say anything."

In this same letter, Charles shares some good news by informing his father that "Lieut. Wulff to day is a going to establish a new camp new tents and every thing for the fifty fourth men that we are recruiting." This determination to reform the men's living conditions must have been a relief for Douglass in his ongoing role as an active recruiter to the regiment. As he would have realized only too well, it is one thing to sign men up to die on freedom's battleground, and another to sign their death warrant in unlivable conditions back at base camp. As Charles readily confirms, he is actively engaged in warring against all injustices. He not only takes a stand against the men's physically debilitating living conditions, but also expresses his opinion on their ongoing fight for equal pay. "I have been told that the fifty fourth would get their full pay in a month," he confirms to his father, as he remains immovable in his belief that there can be no moral compromise or equivocation. "I hope that our boys wont except [sic] of any less than what they enlisted for."

Charles's impassioned letter must have satisfied his father. Just two weeks later, on September 18, he writes again to express his heartfelt gratitude for his father's support: "I have just read your kind letter to me." He also includes information

12 Douglass, *Narrative*, p. 54.

that sheds light on the glitches in his military record by reporting, "I also had an interview with my Capt. who is on furlough he said that Col. Shaw never told him that I was to report to the 55 and after my furlough had passed two weeks Capt. Bridge put me down as a deserter but Col Shaw saw it and had it taken off as he knew that I was sick and not a deserter." In the face of these charges that he is a deserter, Charles is vehement in defense of his honor: "I will never desert I take a bullet first." In this same letter, he share his great pride in his father's fame by drawing his attention to an earlier request: "I wrote to you for a couple of your Photographs with your name written up them or upon the card I would like to give one to Lieut. Wulff whom I esteem as a true Friend and the others I want for myself." He is guilty of no fraternal jealousy, speaking only with pride of his elder brother's military distinctions: "There is a report around here that Lewis is agoing to have a commission as Lieut as soon as Gov. Andrew returns from Washington." While he admits, "I dont know how true it is," he is jubilant that "Lew is highly spoken of in Boston and New Bedford to[o]. Everyone says that he will receive the first commission." Across their extant wartime correspondence, Lewis Henry and Charles Remond consistently demonstrate solidarity not only with their regiments but with each other.

Over six months later, on May 31, 1864, Charles is no longer facing near starvation conditions and racist abuses in the North, but is fighting to survive in the blood and mire of battle at Camp Hamilton, City Point, Virginia. "Just as I am writing this there is heavy firing just about our picket line," he informs his father, readily admitting, "I expected to be called into line of battle every moment we have been fighting ever since our Regt. came here." A first-hand witness of the Bermuda Hundred Campaign—a series of battles between Union commander Benjamin Butler and Confederate general P. G. T. Beauregard—he explains, "I just mentioned on my first page Butler is bombarding Petersburg which is about seven miles from this camp." He also acknowledges their exposure to very real danger: "the firing is very steady we have just sent three colored Regiments toward Petersburg." "Our boys are very anxious for a fight I think their wishes will be complied with shortly," he writes. While he frankly concedes, "I am not over anxious" for a fight, he is unwavering in his determination "to meet the devils at any moment and take no prisoners." "Remember Fort Pillow will be the battle cry of the fifth Mass Cavalry," he prophesies. Here he is making a poignant reference to the massacre of Black troops at Fort Pillow, Tennessee, over a month earlier on April 12 by white commander and future Ku Klux Klan leader Nathan Bedford Forrest. According to Charles's testimony, Black troops of all backgrounds united across regions and regiments in their fight against white supremacist power.

Against this epic backdrop of union troops engaged in a "battle cry" of freedom, Charles takes great pride in informing his father of his own contribution to

the cause. "I have been the first to take a prisoner last week when on picket I espied a man in grey clothes dodge behind a tree," he writes. "I ordered him to step from behind the tree or I would knock a hole through him," he recalls, stating, "he stepped out I could see no gun I then ordered him to go on ahead of me which he did very reluctantly as soon as he had passed in front of me I cocked my piece." According to his report, the Confederate "stopped stone still and wanted to know if I meant to murder him," to which Charles confirms, "I spoke in a harsh tone for him to go on and if he stopped before I ordered him that I could shoot him he went on." Back at camp, "Capt. Wulff who was sitting under a tree Capt. ordered me to search him which I did well making him strip off every rag for he was covered with them I found a revolver dirk knife $50 in reb money $13 in gold and some silver coin and green backs." As he informs his father, this unnamed soldier "proved to be the man that owned the land where we were picketed." As a result, he is involved in liberating some enslaved people by bringing out a number of "contrabands from a farm house." While he is exultant that "I have had the praise of bringing in 'the first prisoner,'" he conveys that he and his men continue to endure life-threatening danger by mentioning that "the firing is getting very heavy out front."

A month later, on June 16, Charles again writes his father from City Point, Virginia. No longer part of the Bermuda Hundred Campaigns, he is now stationed at the frontlines of the Second Battle of St. Petersburg. This letter no longer survives as a handwritten original, but as a printed copy that was published in the *New York Tribune* and then reprinted in the *Lowell Daily Citizen and News* on June 27.[13] "Yesterday was a great day for me," he jubilantly begins. "About ten o'clock on Tuesday evening I was awakened by the major of my battalion (as I was then in command of the company, both lieutenants being away, and Capt. Wulff had been relieved of the command of this company), and ordered to have two days' rations prepared for my company." He successfully executes his military responsibilities, and the following day "about 400 of our regiment—the 5th Massachusetts—were soon into line." "We had gone but a short distance before we came upon the ambulance train," he poignantly writes as he is faced with a stark realization: "then I knew that some of us were not coming back again." "Everything looked like a fight," he informs his father, noting, "Soon Gen. Butler's

13 Steven LaBarre's pioneering research drew my attention to Charles Remond Douglass's letter as reprinted from the New York *Tribune* in the *Lowell Daily Citizen and News* on June 27, 1864. The letter was prefaced with the following remarks by the reporter: "We have had many brief accounts of the results of fighting before Petersburg; but not many details. The New York *Tribune* publishes the following letter from a son of FD, who, it seems, is a sergeant in the 5th Massachusetts cavalry, 18th corps, and 3d division (Gen. Hinks'). The letter was dated in camp at City Point Va., June 16, and is highly interesting and suggestive on many accounts."

army began to come across the Appomattox and proceed toward Petersburg. Then I began to smell a large-sized mice, and that was, there we were to make an attack on Petersburg."

As Lewis did for the Battle of Fort Wagner, so Charles does for the Second Battle of St. Petersburg, providing a dramatic account of his own and his regiment's heroism:

> We moved forward down the hill into a wheat-field; formed two lines of battle. Sending out our skirmishers, we soon met the enemy's advance pickets, and drove them back through two pieces of woods. Our regiment was in the second line of battle. As we came through the second piece of woods, the enemy opened on us with solid shot and shell. We kept on, however, until we reached the next piece of woods. Then we were only about a quarter of a mile from the enemy, they being drawn up in life of battle behind their breastworks. All this time we were under a withering fire from the rebel batteries. The underbrush was so thick in the woods that we could not form a line of battle; but we got into line as soon as we could, and waited to see what the first line of battle would accomplish. We had not long to wait before the first line of battle fell back upon us under a galling fire, which killed several of our men in the second line. Immediately after the first line fell back, we were ordered by our colonel to fix bayonets and charge, which we did in good style, driving the enemy from behind their first line of breastworks, and capturing one piece of artillery from the Johnnies. There we had only twenty men from any company in the fight, and we were right in front of the line, a little to the left of the center. Col. Russell was just in front of me, about a couple of yards; he cried out, "Come on, brave boys of the 5th!" and soon he was struck in the shoulder by a rifle-ball, merely taking off the shoulder-straps. In an instant our men began to fall around us pretty fast, but we drove the enemy off the fields, into the woods, on toward Petersburg.[14]

As one among hundreds of soldiers who fought to withstand "a withering fire from the rebel batteries" by risking life and limb on the battlefield, Charles provides a blistering first-hand account of Black combat heroism. He and the men within his company endure terrible bombardments as he recounts the "enemy opened on us with solid shot and shell." And yet, he confides, they did not falter: "We kept on." While he is candid regarding the very real difficulties they faced in navigating inhospitable terrain—the "underbrush was so thick in the woods that we could not form a line of battle"—he is exultant regarding the ease with which they "fixed their bayonets" and charged "in good style" with

14 Charles Remond Douglass to Frederick Douglass, *Lowell Daily Citizen and News*, June 27, 1864.

the immediate result that the "brave boys of the 5th" succeeded in "driving the enemy from behind." At the same time that he celebrates their triumphs, he holds nothing back in informing his father that his company's tragic duties include those of burying the dead: "While I am writing, we have got orders to return to the front, to escort the bodies of officers that fell yesterday."[15]

In this letter written to his father in the aftermath of battle, Charles ultimately refuses to lose sight of his jubilation over their military successes. "Before you receive this, you will no doubt hear of the fall of Petersburg, for our forces are at the last line of intrenchments, a quarter of a mile from the city," he reports, exultant to record: "The colored troops last night captured Fort Clifton, and several hundred prisoners." He is careful to reassure his father that "I am yet unhurt," while admitting that his participation in these conflicts has been at no little personal cost: "[I] am much worn out; my shoulders are raw, from the straps of my cartridge-box, as I had forty rounds in my box, two days' rations, canteen, blankets, and musket." As he realizes only too well, his survival, all his physical tiredness notwithstanding, is all the more miraculous given how many men died. "I am unhurt as yet, although several of our company fell around me."[16] While he was undoubtedly grateful for his son's survival, Charles's physical struggles no doubt motivated Frederick Douglass to write his letter asking Abraham Lincoln for his son's discharge over two months later, on August 29. Writing his first letter to his mother and father not as a soldier but as "Charles R. Douglass civilian" on September 15, by which time he is based at Point Lookout, Maryland, he confirms his father's request has been granted: "I am honorably discharged [from] the service of the United States."

Writing in impassioned language of the suffering and struggle endured by the brave "colored soldier" in his "strike for liberty and freedom" during the Civil War, Frederick Douglass remained categorical in his conviction: "It really seems that nothing of justice liberty or humanity can come to us except through tears and blood."[17] As Frederick Douglass the father was to carry the scars of slavery into his life as a freeman, so his sons Lewis Henry and Charles Remond were to remain burdened by the wounds of war, not only during their service as soldiers but in their later lives as veterans. All three men lived with traumatic and traumatizing memories of "tears and blood" that were not only beyond the pale of everyday experiences, but defied any attempts to put them into words. As African American World War I combat soldier Horace Pippin, no less engaged in the fight to prove "'we were men,'" decades later was later to urge, "'I can never forget suffering, and I will never forget sunset.'"[18]

15 Ibid.
16 Ibid.
17 Frederick Douglass, "Letter to Major G. L. Stearns," in *Life and Times* , 418–19.
18 Qtd. Bernier, *Suffering and Sunset*, ix.

10. Lewis Henry Douglass to Helen Amelia Loguen, Camp Meigs, Readville, MA, March 31, 1863

March 31, 1863

Camp Meigs, Readville, Massachusetts

My Own Dear Amelia: I am now in camp with my regimentals on, and instead of receiving the appointment of Quartermaster's Sergeant. I have obtained the highest non commissioned office in the regiment, which is that of Sergeant Major. My duties are not at present very arduous, I am a sort of privileged character being. an officer of the staff, wearing a sword &c.

It may perhaps be pleasing to you to know something of the manner in which my men that I left Syracuse with came here, and I will tell as briefly as possible. I started from Syracuse with 17 men apparently able bodied and fit for soldiers, we were to have second class cars, but owing to some misunderstanding the conductor failed to furnish them consequently we had to ride in first class cars which of course was very agreeable, on the way to Binghampton my men amused themselves by singing John Brown

and other songs to the delight of the
white passengers in the car. The Syracuse
men conducted themselves throughout the
journey in a decorous and gentleman-
ly manner, giving men no trouble what
ever, and I very often made the remark
to the other men who came under my
charge that I wished them to follow the
example of the Syracuse men. I could
trust them to get in and out of the car at
pleasure without any fear of their desert-
ing, a more earnest lot of men I do not
believe are in camp. When we arrived at
Binghampton we were met by a detachment
of the Loguen guard and escorted to a
colored church, and there met the volunteers
from Binghampton after a few minutes
hand shaking we were invited by Mr Jones
Mrs. Brown and another lady whose name
I have not to dinner, I and James High-
gate taking dinner at Mr. Jones' with pa
Loguen and Edmonia and Willella, after
dinner Mr. Jones and myself took a walk
"around town" until time for us to leave,
at which time we were escorted to the depot

10. Lewis Henry Douglass to Helen Amelia Loguen, Camp Meigs, Readville, MA, March 31, 1863

by the same detachment of the Loguen
guard, where I met my brother, who had
in charge six men, starting from home
with nine men and losing three by the way.

It is impossible for me to finish
this letter as I wish as I must post
the Regiment books immediately, that
is the order from the Adjutant. I
shall embrace the next opportunity
and write. Whatever I have said
in a joke about your not loving
me means nothing, you are
ever dear. I have enlisted for
three years or during the war
I am thought a good deal of here
I must close. Good Bye

 Ever Lovingly

 Lewis

Direct to Lewis H Douglass
 Sergt. Major
 54th Mass. Volunteers
Camp Meigs Readville
 Mass.

10. Lewis Henry Douglass to Helen Amelia Loguen, Camp Meigs, Readville, MA, March 31, 1863

March 31 1863

Camp Meigs, Readville Massachusetts

<u>My Own Dear Amelia</u>: I am now in camp with my regimentals on and instead of receiving the appointment of Quartermaster's Sergeant I have obtained the highest non-commissioned office in the regiment, which is that of Sergeant Major. My duties are not at present very arduous, I am a sort of privileged character being an officer of the staff meaning a sword &c &c

It may perhaps being pleasing to you to know something of the manner in which my men that I left Syracuse with came here and I will tell as briefly as possible. I started from Syracuse with 17 men apparently able bodied and fit for soldiers, we were to have second class cars, but owing to some misunderstanding the conductor failed to furnished them consequently we <u>had</u> to ride in first class cars which of course was very agreeable; on the way to Binghamton my men amused themselves by singing John Brown[19] and other songs to the delight of the white passengers in the car. The Syracuse men conducted themselves throughout the journey in a decorous and gentlemanly manner, giving me no trouble whatever, and I very often made the remarks to the other men who came under my charge that I wished them to follow the example of the Syracuse men. I could trust them to get in and out of the car at pleasure without any fear of their deserting, a more earnest lot of men I do not believe are in camp. When we arrived at Binghamton we were met by a detachment of the Loguen guard and escorted to a colored church and there met the volunteers from Binghamton after a few minutes hand shaking we were invited by Mr Jones, Mrs. Brown and another lady whose name I have not to dinner, I and James Highgate taking dinner at Mr. Jones" with pa

19 A reference to "John Brown's Body," a popular abolitionist marching tune from 1861 commemorating the execution of the antislavery revolutionary John Brown in 1859 (see Figure 63). John Brown (1800–59) was a US abolitionist who attempted an armed rebellion of enslaved people on the federal armory at Harpers Ferry in 1859 that resulted in the death of seven men. Brown was captured and executed in December of that year. Frederick Douglass first met Brown in 1847, beginning an ambiguous, complex relationship that lasted until the latter's death.

Loguen and Edmonia and Willella,[20] after dinner Mr. Jones and myself took a walk "around town" until time for us to leave, at which time we were escorted to the depot by the same detachment of the Loguen guard, where I met my brother, who had in charge six men, starting from home with nine men and losing three by the way.

It is impossible for me to finish this letter as I wish as I must post the Regiment books immediately, that is the order from the Adjutant. I shall embrace the next opportunity and write. Whatever I have said in a joke about your not loving me means nothing, you are ever dear. I have enlisted for three years or during the war. I am thought a good deal of here.

I <u>must</u> close. Good Bye

<u>Ever Lovingly</u>

Lewis

Direct to Lewis H. Douglass
Sergt. Major
54th Mass. Volunteers
Camp Meigs Readville
Mass.

20 Edmonia and Willella Highgate, along with their brother Charles, were members of a prominent African American family in Syracuse in the 1850s and 1860s. Charles enlisted as a Union soldier and was killed in action in 1865. Edmonia became the principal of a Black school in Binghamton before working as a missionary and educator in a number of schools in the US South organized by the American Missionary Association.

11. Lewis Henry Douglass to Helen Amelia Loguen, Camp Meigs, Readville, MA, April 8, 1863

Camp Meigs, April 8 1863
Readville Mass.

My Own Dear Amelia: I am once again the happy recipient of a good letter from you of whom I think so much. You wish me to tell you of camp life. I will, after first stating, that with the exception of a slight cold, I am enjoying good health. The first thing I did was to be examined by the surgeon to see if I was in any manner deformed, after which I was told to go to an officer whose business it is to take a description of my looks, and then swear me in to the service, I promising to obey all orders from the President of the United States down. After taking the oath I proceeded to the Quartermasters department, there to receive my clothing, which consists of every thing that "our sex" wear excepting a vest. My badge of office is three stripes placed on my coat in the shape of half diamond, and three

11. Lewis Henry Douglass to Helen Amelia Loguen, Camp Meigs, Readville, MA, April 8, 1863

circular stripes rounding off from the
diamond somewhat like this on
each sleeve, and a wide stripe down
the leg. After I was dressed reported to
the Adjutant who instructed me in
my duties. We have every morning
for breakfast one third of a six cent
loaf of bread, nearly a quart of coffee
a large piece of fresh or corn beef or
ham as the case may be. For dinner
we have beef and potatoes and the same quan-
tity of bread, sometimes bean soup, at
night constantly, rice and molasses.
The men sleep in barracks in bunks
two in each, I not having my quar-
ters prepared yet, the weather being
so stormy that there is no building going on, I
have to stop in the barracks along
with the privates. The rules are that I shall
have a room of my own with writing ma-
terials &c which I hope soon to occupy.
The soldiers amuse themselves by
fighting each other, shunking up to
the officers, for which they are immedi-
ately punished, by chaining large balls

of iron to them, or making them
hold heavy weights for hours, for striking a superior officer Death is the
punishment yet in the face of this
penalty one of the men knocked a
Lieutenant sprawling the other night, and
the Lieutenant's good nature would
not allow him to report the rascal, for if he had he would have certainly
been shot.

Thursday last I went into Boston
and staid all night at some free
friends of mine, I attended a levee
in the evening of colored people,
which was just nothing. I did not
stay in the hall long having soon
found out that there were "all sorts"
present I thought it would not be
well for me to be known there.

This morning we had an addition
to our regiment of seventy-three
men making our number five
hundred and forty-eight. My dear
girl I would like to have you occasionally send me a Syracuse paper

11. Lewis Henry Douglass to Helen Amelia Loguen, Camp Meigs, Readville, MA, April 8, 1863

or send to those young men who have
come from Syracuse they will take
it so kindly. And I shall tell them
that you sent it. Direct all papers
and letters to me. as usual The young
men from Boston and New Bedford
receive many little niceties from
their friends which keeps them in cheerful
spirits. I shall always love you, never
give me up for dead until you are
certain of it. My fear is that I may
be reported dead when I am not. it is
often the case in battle. Remember
me kindly to your mother father
and sisters and Miss Lewis. Oh! for one
sweet kiss. Do not cry.

Ever Lovingly

Lewis

11. Lewis Henry Douglass to Helen Amelia Loguen, Camp Meigs, Readville, MA, April 8, 1863

General Correspondence, Frederick Douglass Papers, Library of Congress.

Camp Meigs, April 8 1863

Readville Mass.

My own Dear Amelia: I am once again the happy recipient of a good letter from you of whom I think so much. You wish me to tell you of camp life, I will, after first stating that with the exception of a slight cold I am enjoying good health. The first thing I did was to be examined by the surgeon to see if I was in any manner deformed, after which I was told to go to an officer whose business it is to take a description of my looks, and then swear me in to the service, I promise to obey all orders from the President of the United States down. After taking the oath I proceeded to the Quartermasters department, there to receive my clothing, which consists of every thing that "our sex" wear excepting a vest. My badge of office, is it so has three stripes placed on my coat in the shape of a half diamond, and three circular stripes rounding off from the diamond somewhat like this [he inserts a diamond shape here ◇] on each sleeve, and a wide stripe down the leg. After I was dressed I reported to the Adjutant who instructed me in my duties. We have every morning for breakfast one third of a six cent loaf of bread, nearly a quart of coffee a large piece of fresh or corn beef or ham as the case maybe. For dinner we have beef and potatoes and the same quantity of bread, sometimes bean soup, at night constantly rice and molasses. The men sleep in barracks in bunks two in each, I not having my quarters prepared yet the weather being so stormy that there is no building going on, I have to stop in the barracks along with the privates. The rules are that I shall have a room of my own with writing materials &c which I hope soon to occupy. The soldiers amuse themselves by fighting each other, speaking up to the officers, for which they are immediately punished, by chaining large balls of iron to them or making them hold heavy weights for hours, for striking a superior officer Death is the punishment yet in the face of this penalty one of the men knocked a Lieutenant sprawling the other night and the Lieutenant's good nature would not allow him to report the rascal, for if he had he would have certainly been shot.

Thursday last I went into Boston and staid [sic] all night at some friends of mine. I attended a levee in the evening of colored people which was just nothing. I did not stay in the hall long having soon found out that there were "all sorts" present I thought it would not be well for me to be known there. This morning we had an addition to our regiment of seventy-three men making our number five hundred and forty-eight. My dear girl I would like to have you occasionally send me a Syracuse paper or send to those young men who have come from Syracuse they will take it so kindly. And I shall tell them that you sent it. Direct all papers and letters to me, as usual. They young men from Boston and New Bedford receive many little niceties from their friends which keep them in cheerful spirits. I shall always love you, never give me up me for dead until you are certain of it. My fear is that I may be reported dead when I am not, it is often the case in battle. Remember me kindly to your mother father and sisters and Miss Lewis. Oh! for one sweet kiss. Do no cry.

Ever Lovingly

Lewis

12. Lewis Henry Douglass to Helen Amelia Loguen, Camp Meigs, Readville, MA, April 15, 1863

Camp Meigs April 15
1863

My Own Dear Amelia;
Yours of the 12th is at hand
finding me much better
than when I last wrote you.
The mud has disappeared
and the sun is shining
and every body feeling
happy. Our camp has been
swept over this morning
every thing laid streight
barracks scrubbed and all
that can make the
place appear nice has
been done, for Governor
Andrew is to visit us to-day.
Our men are learning
very fast and are now
quite proficient in the
manual of arms, ~~our~~ our
evening dress parades
all reddy attract many

12. Lewis Henry Douglass to Helen Amelia Loguen, Camp Meigs, Readville, MA, April 15, 1863

many visitors from the city
of Boston every evening,
of both complexion
the paler brethren and
sisters however predomi-
nating. Charley is here
and has taken charge
of his company, he is a
little green at first and
has not learned yet to
boss his men around,
which is very necessary.
My dear girl, you are
certainly not so lost to reason
as to believe in ghosts, times
I know you are, but I do not
think you are in earnest
about never staying at
Sarah's any more all night.
My dear I hope some
day to call again on
Allie, something tells me
I will not be killed, though

I may be wounded, and
that is not so bad you know,
it will be an honor. I really
would like to be in Syra-
cuse when Sarah is mar-
ried. I may be able to be
there.

I have been feeling late-
ly like a person who is
said to be homesick, not
that I am sick of camp
life but I have not been
home but a week since
last October, and did
not have an opportu-
nity to see one half
of my friends. But we
cannot have every thing
we wish, so I will grin
and bear it.

Now my dear Amelia
I must give you a lov-
ing goodbye. Remember

me to everybody, ever re-
membering that I am
yours always

 Lovingly

 Lewis

P.S. I wish you could see
us before we leave, if
your large paternal
predecessor comes to Bos-
ton you come with him

 L.H.D.

12. Lewis Henry Douglass to Helen Amelia Loguen, Camp Meigs, Readville, MA, April 15, 1863

Camp Meigs April 15, 1863

<u>My Own Dear Amelia</u>:

Yours of the 12th is at hand finding me much better than when I last wrote you. The mud has disappeared and the sun is shining and every body feeling happy. Our camp has been swept over this morning, every thing laid straight, barracks scrubbed and all that can make the place appear nice has been done, fore Governor Andrew[21] is to visit us to-day. Our men are learning very fast and are now quite proficient in the manual of arms, our our evening dress parades all ready [sic] attract many many visitors from the city of Boston every evening of both complexion the paler brethren and sisters however predominating. Charley is here and has taken charge of his company, he is a little green at first and has not learned yet to boss his men around, which is very necessary.

My dear girl, you are certainly not so lost to reason as to believe in ghosts, timid I know you are, but I do not think you are in earnest about never staying at Sarah's* any more all night. My dear I hope some day to call again on Allie, something tells me I will not be killed, though I may be wounded, and that is not so bad you know, it will be an honor. I really would like to be in Syracuse when Sarah is married. I may be able to be there.

I have been feeling lately like a person who is said to be homesick, not that I am sick of camp life but I have not been home but a week since last October, and did not have an opportunity to see one half of my friends. But we cannot have every thing we wish, so I will grin and bear it.

Now my dear Amelia I must give you a loving goodbye. Remember me to everybody, <u>ever</u> remembering that I am yours always.

Lovingly
Lewis

P.S. I wish you could see us before we leave, if your large paternal predecessor comes to Boston you come with him
LHD

21 John Albion Andrew (1818–67), Governor of Massachusetts from 1861 to 1866. Andrew was a radical abolitionist, supportive of John Brown and often critical of Lincoln's handling of the Civil War. (See Figure 36.)

 * Sarah Marinda Loguen.

13. Lewis Henry Douglass to Helen Amelia Loguen, Camp Meigs, Readville, MA, May 9, 1863

Camp Meigs, Readville Mass
May. 9 1863

My Own Dear Amelia: A lovely day,
and a lovely letter from you, are exert-
ing themselves beneficially upon me.
The sunshine is having effect on the
"cullud pussons" who comprise the
regiment, they are kicking up their
heels, laughing in "our" peculiar style
making the echoes of the surround-
ing hills, and making the camp
ring with their hilarity.

Do tell me what it is that Miss
Hendale has been writing you that
you are afraid I will laugh at, I
promise not to laugh, if I do it will
be so low that you cannot hear it
now do not fail to tell me what
it is I am all curiosity to know.
Father was down Thursday to see
us, and will be down next week
again, he was much pleased at my
looking so well compared with my
thin visage when I was home. We
were the recipients of a box of niceties

from home last week, to which we
did ample justice, as you no doubt
might surmise, and I have the prom-
ise of another box from a lady in Phil-
adelphia. For fear of the "Green Eyed" I
will tell you her name, it is Dorsey,
Mrs. Louisa A. Dorsey, now let your
face cast off that look of scorn and indignation
and recall that wish that she were in
your reach that you might do I
know not what, and rejoice and be
exceeding glad that your Lewis has a lady
friend in Philadelphia

Thanks to Miss Edmonia, Charley and I
have been able to expose that scamp
Johnson to the men of his company
as a miserable, lying cur. When the evi-
dence of Johnson's perfidy was brought
out Charley could hardly restrain him-
self from knocking him down. As I
have had no direct correspondence
with Miss Edmonia since that memo-
rable letter some three years ago,
I hardly dare write to her thanking
her for her kindness.

13. Lewis Henry Douglass to Helen Amelia Loguen, Camp Meigs, Readville, MA, May 9, 1863

What in the world can be the matter
with Aunt Tinnie? "servant of a major"
where did she get such an idea, and
idea worthy of the most penetrative
mind (?) Poor Aunt Tinnie, if I only
had counted her all would have been
right. Do not get angry at me for this.
. I am glad you like "David Copperfield"
how beautifully are family relations de-
scribed. How many Miss Murdstones
there are. Do you know any. I do many
Remember me to all enquirers.
 Ever Yours
 Lewis

13. Lewis Henry Douglass to Helen Amelia Loguen, Camp Meigs, Readville, MA, May 9, 1863

Camp Meigs, Readville Mass. May 9 1863

My Own Dear Amelia: A lovely day and a lovely letter from you are exerting themselves beneficially upon me. The sunshine is having effect on the "cullud perssons" who comprise the regiment, they are kicking up their heels, laughing in "our" peculiar style making the echoes of the surrounding hills, and making the camp ring with their hilarity.

Do tell me what it is that Miss Hendace has been writing you that you are afraid I will laugh at. I promise not to laugh, if I do it will be so low that you cannot hear it, now do not fail to tell me what it is I am all curiosity to know.

Father was down Thursday to see us, and will be down next week again, he was much pleased at my looking so well compared with my thin visage when I was home. We were the recipients of a box of niceties from home last week, to which we did ample justice, as you no doubt might surmise, and I have the promise of another box from a lady in Philadelphia. For fear of the "Green Eyed" I will tell you her name, it is Dorsey, Mrs. Louisa A. Dorsey,[22] now let your face cast off that look of scorn and indignation, and recall that wish that she were in your reach that you might do I know not what, and rejoice and be exceeding glad that your Lewis has a lady friend in Philadelphia.

Thanks to Miss Edmonia, Charley and I have been able to expose that scamp Johnson to the men of his company, as a miserable lying cur. When the evidence of Johnson's perfidy was brought out Charley could hardly restrain himself from knocking him down. As I have had no direct correspondence with Miss Edmonia since that miserable letter some three years ago, I hardly dare write to her thanking her for her kindness.

What in the world can be the matter with Aunt Tinnie?[23] "servant of a major" where did she get such an idea, and idea worthy of the most penetrative mind (?) Poor Aunt Tinnie, if I only had courted her all would have been right. Do not get angry at me for this.

22 The "Louisa A. Dorsey" named here may well be Mary Louise Dorsey, the daughter of free-born Louise Tobias and Thomas J. Dorsey (1812–75), a man who had been born into slavery in Maryland and becomes an elite caterer and radical activist in Philadelphia.

23 "Aunt Tinnie" is the family nickname for Helen Amelia Loguen's Aunt Sarah, about whom research is ongoing. She is to be distinguished from "Tin" or "Tinnie" elsewhere in their correspondence, as these nicknames refer to Helen Amelia Loguen's sister, Sarah Marinda Loguen Fraser.

I am glad you like "David Copperfield," how beautifully are family relations described. How many Miss Murdstones there are.[24] Do you know any. I do, many. Remember me to all enquiries.

Ever Yours

Lewis

24 A reference to Charles Dickens's novel *David Copperfield* (1850), in which the character of Jane Murdstone is a troublemaking spinster.

Camp Meigs Readville
May 20, 1863

My Own Dear Amelia. I have
not had a word from you for
more than a week, but I
cannot complain when I
remember my own short
comings, and when I do re-
member them I reproach
myself, and can only wish
it had not been so. Mother
and Rosetta are now stop-
ping in Boston at Mrs.
De Mortie's they see us every
day, we are soon to leave
a week longer we may stay
then we go to the south
where I know not exactly.
Who will return? Selfish-
ness I have always tried
to avoid, but I hope I
may return, and with the

14. Lewis Henry Douglass to Helen Amelia Loguen,
Camp Meigs, Readville, MA, May 20, 1863

one who so dearly loves me,
one whose love all the
treasures of the earth can
not purchase from me,
the love of your own dear
self. Charley is sick in
the hospital. I trust nothing
serious he has a severe cold,
he is however somewhat
better than he has been.
My dear girl while I am
away, do not fret yourself
to death, oh! I beg of you, do
not. Remember that if I
fall that it is in the
cause of humanity, that
I am striking a blow for
the welfare of the most
abused and despised race
on the face of the earth, that
in the solution of this
strife rests the question

14. Lewis Henry Douglass to Helen Amelia Loguen, Camp Meigs, Readville, MA, May 20, 1863

of our elevation, or our
degradation, our happi-
ness or our misery.
Would you wish me ab-
sent from such a strife?
I know that your love wishes
that it were not necessary,
but I trust that your love
of the happiness of your race
and my race, reconciles you
to our separation which may
be forever.

Think of me often you will
but do not let your thoughts
be worrying, do not think of
me in pain do not think
of me enduring hardships, do
not think of me grappling
with that non-respecter of
persons Death! But think
of me as aiding in the
glorious work of busting

14. Lewis Henry Douglass to Helen Amelia Loguen, Camp Meigs, Readville, MA, May 20, 1863

those chains which keeps
the husbands, wives, children, lovers
and friends, of millions asunder,
as aiding to the overthrow a
system, the cruelty, tyranny
and crime of which degrades mil-
lions of human beings to a level
scarcely on a footing with the
brute. Think of joy, the inexpressi-
ble, to those millions, freed from
such a foul system, and then
think that I threw in my mite
to bring about that joy, that hap-
piness, then rejoice yourself
that you encouraged one you
held dear to help bring about this
bliss.
My dear girl I am sorry I did
not bring your photograph
with me, I shall send you mine
as I am now, a soldier, which
you will keep I trust you may
never be ashamed of it. Loved
One Good night I will just
say Good Bye.
Give my love to your mother and
Father and all.
Ever your own
Lewis

14. Lewis Henry Douglass to Helen Amelia Loguen, Camp Meigs, Readville, MA, May 20, 1863

Camp Meigs Readville May 20, 1863

My Own Dear Amelia, I have not had a word from you for more than a week, but I cannot complain when I remember my own shortcomings, and when I do remember them I reproach myself, and can only wish it had not been so. Mother and Rosetta are now stopping in Boston at Mrs. De Mortie's they see us every day, we are <u>soon</u> to leave a week longer we may stay, then we go to the south where I know not exactly <u>Who will return</u>? Selfishness I have always tried to avoid, but I hope I may return, and love the one who so clearly loves me, one whose love all the treasures of the south cannot purchase from me, the love of your own dear self. Charley is sick in the hospital, I trust nothing serious he has a severe cold, he is however somewhat better than he has been.

My dear girl while I am away, do not fret yourself <u>to death,</u> oh! I beg of you, do not. Remember that if I fall that it is in the cause of humanity, that I am striking a blow for the welfare of the most abused and despised race on the face of the earth, that in the solution of this strife rests the question of our elevation, or our degradation, our happiness or our misery. Would you wish me absent from such a strife? I know that your love of me wishes that it were not necessary that I should go but I trust that your love of the happiness of your race and my race, reconciles you to our separation which may be forever!

Think of me often you will, but do not let your thoughts be worrying, do not think of me in pain, do not think of me enduring hardships, do not think of me grappling with that non-respecter of persons Death! ~~But~~ Think of me as aiding in the glorious work of bursting loose those chains which keeps the husbands, wives, children, lovers and friends, of millions asunder, as aiding to ~~the~~ overthrow a system, the cruelty, tyranny and crime of which degrades millions of human beings to a level scarcely on a footing with the brutes. Think of the joy, the inexpressible joy to those millions, freed from such a foul system, and then think that I threw in my mite to bring about that joy, that happiness, then rejoice yourself that you encouraged one you held dear to help bring about this bliss.

My dear girl I am sorry I did not bring your photograph with me, I shall send you mine as I am now, a soldier, which you will keep, I trust you may never be ashamed of it. Loved one Good night, I will not say Good Bye.

Give my love to your mother and Father and all

Ever your own

Lewis

15. Lewis Henry Douglass to Helen Amelia Loguen, Camp Meigs, Readville, MA, May 27 [1863]

15. Lewis Henry Douglass to Helen Amelia Loguen, Camp Meigs, Readville, MA, May 27 [1863]

enough to return, I shall claim, My own dear Amelia, and that happiness of which we no doubt have both dreamed shall be enjoyed. Our regiment is a fine one, and no doubt will accomplish much, I do not the Governor of Massachusetts will ever have occasion to regret the steps he has taken in raising the regiment. I hope ere long there will be colored commissioned officers in the regiment, if there I stand a chance, and when I get promoted, I can

16. Lewis Henry Douglass to Helen Amelia Loguen, St. Simons Island, GA, June 18, 1863

St. Simons Island
Georgia, June 18/63

My Own Dear Amelia;

I am now in the State of Georgia, "away down in Dixie." Our journey over the "briny deep" was fraught with no remarkable incidents, we were six sea-sick days coming from Boston to Port Royal or Hilton Head. Our steamer the "De Molay" was tossed and pitched about by the waves like a plaything in the hand of a child, now away up up up, then down down, now on this side, now on that, frightening some while others had very serious expression on their faces. To see the men huddled about on deck looking as though Death would be welcome visitor

16. Lewis Henry Douglass to Helen Amelia Loguen, St. Simons Island, GA, June 18, 1863

was sad enough, many
wishing they never had
gone for a soldier.
I stood it first rate, I was
sick only a half hour
Arriving at Beaufort S.C.
the first man to whom
I was introduced was
Robert Small & there met
Harriet Tubman, who is
a captain of a gang of men
who pilot the Union forces
into the enemy's coun-
try. We staid in Beaufort
four days and then
came to this place A
week ago to day we went
to Darien Georgia ex-
pecting to have a fight
Darien lies on the
Altamaha river about
8 miles from its mouth
in going up the river
our gunboats shelled
the woods along the

16. Lewis Henry Douglass to Helen Amelia Loguen, St. Simons Island, GA, June 18, 1863

way, but could discover
no enemy. We landed
at Darien took some
$100,000, worth of different
articles consisting of
furniture which the
Rebels had run away
from a year ago and
never came back after.
We found two white
women in the town
and one white man
the escaped, the women
we left, after burning
every building or shel-
ter in the place to
the ground I felt a
little sympathy for
feminines. I hope to have
more to write of soon
Oranges, lemons and
peaches grow here
Remember me to all at
home, and to all en-
quirers, if there are any.
Believe me ever

16. Lewis Henry Douglass to Helen Amelia Loguen, St. Simons Island, GA, June 18, 1863

St Simons Island[26]

Georgia, June 18, 63

My Own Dear Amelia:

I am now in the State of Georgia, "away down in Dixie."[27] Our journey over the "briny deep" was fraught with no remarkable incidents, we were six sea-sick days coming from Boston to Port Royal or Hilton Head.[28]

Our steamer the "De Molier" was tossed and pitched about by the waves like a play thing in the hand of a child, now away up up up, then down, down now on this side, now over that, frightening some while others had very serious expressions on their faces. To see the men huddled about on deck looking as though Death would be welcome visitor was sad enough, many wishing they never had gone for a soldier.

I stood it first rate, I was sick only a half hour. Arriving at Beaufort S.C. the first man to whom I was introduced was Robert Small.[29] I there met Harriet Tubman,[30] who is a captain of a gang of men who pilot the Union forces <u>into</u> the enemy's country. We staid [sic] in Beaufort four days and then came to this

26 Until 1862, Confederate troops occupied St. Simons Island for its strategic position at the entrance to Brunswick harbour. With the redeployment of these soldiers in the defence of Savannah, the Union army in turn occupied the island and held it for the remainder of the conflict.

27 Lewis Henry Douglass cites the popular song "Dixie," which had originated in white racist Blackface minstrel shows in the 1850s, quickly becoming the unofficial anthem of the Confederacy.

28 Hilton Head is a headland at the entrance to Port Royal Sound.

29 Robert Smalls (1839–1915) was a freedom fighter, activist, and civil rights campaigner who had been born into slavery and who, in May 1862, gained his own freedom and that of many others by piloting a Confederate transport ship toward the Union naval blockade. He was instrumental in persuading Lincoln and his Secretary of War Edwin Stanton to allow African American men to fight for the Union. As a result, the First South Carolina Volunteers was formed in January 1863.

30 Harriet Tubman (c.1822–1913) was a freedom fighter, activist, and radical campaigner (Figure 33). Born into slavery and nicknamed "Moses," she not only effected her own liberation but was a major conductor on the Underground Railroad. During the Civil War she led a group of scouts around Port Royal, and by the time of Lewis Henry Douglass's letter had only recently (June 2 1863) accompanied an armed raid on a number of South Carolina plantations with the explicit aim of rescuing enslaved women, children, and men. See Larson, *Bound for the Promised Land* for further information.

[16] place. A <u>week</u> ago to day we went to Darien Georgia, expecting to have a fight. Darien lies on the Altamaha river, about 8 miles from its mouth, in going up the river our gunboats shelled the woods along the way, but could discover no enemy. We landed at Darien took some $100,000, worth of different articles consisting of furniture which the Rebels had run away from a year ago and never came back after.[31] We found two white women in the town and one white man the escaped, the women we left after burning every building or shelter in the place to the ground I felt a <u>little</u> sympathy for feminines. I hope to have more to write of soon. Oranges, lemons and peaches grow here.

 Remember me to all at home, and to all enquirers if there are any.
 Believe me ever
 Your Own
 Lewis

 Direct to Serjeant Major Douglass
 54th Mass Vols.
 Hilton Head
 ~~Dept of the South~~
 S.C.

31 Darien was looted and destroyed by Union troops (of the 54th Massachusetts Volunteers and the 2nd South Carolina Volunteers) on June 11, 1863.

17. Lewis Henry Douglass to Helen Amelia Loguen, Morris Island, SC, August 15 [1863]

Morris Island S.C. Aug. 15

My Own Dear Amelia: Your kind letters were duly received finding me suffering slightly from a pain in the head caused by the climate. I have thus far held out against the climate but I now fear that I am going to be sick, I hope not, and am trying to be as cheerful as I can, which I think the best thing for a person when sick I have not been in any fight since the 18th of July but three or four mornings ago we were called out at two o'clock, expecting were going to attack us, but they did not, so

we marched back to our
camp, after being among
the shells a half hour.
I see myself lionized in
the New York Tribune the
letter containing the puff
I herewith enclose

You wish to know how to send
a box to the sick and wound-
ed of the 54th you may
direct to the "Sick and wound-
ed Hospital No 6, Beaufort
S. C. send by Adam's Ex-
press. The colored women of
Beaufort have shown their
appreciation of the cause
by helping take care of our
sick and wounded under
the irrepressible Harriet Tub-
man.

My head aches so bad that
I scarcely what I am writing
so you must excuse

17. Lewis Henry Douglass to Helen Amelia Loguen, Morris Island, SC, August 15 [1863]

this disjointed scribble I am
very sorry that you did
not stay longer at our
house. I hardly know
what to think of your
praise Miss Elsa Thomas
after what we talked, but I
am glad you like her. By
the way I am quite glad
Miss Edmonia accompa—
nied you on your jour-
ney I wish you would re—
member me to her. My dear
girl keep a good heart al-
ways that I love you and
think of you and all the
dear ones in Syracuse
often in fact my mind
is divided between you
and home. Give my love,
my respects to Miss Sarah
Loguis and Allie and
when you write to Kitty

17. Lewis Henry Douglass to Helen Amelia Loguen, Morris Island, SC, August 15 [1863]

tell her she is well, and ask her how I am. As I am writing shells are flying and whizzing in our front about a mile off. Night before last a shell came into but did not hurt. I have got used to the music of shells they rebels are constantly throwing them from Sumter and Johnson, But we are all right we will have Charleston soon. Good Bye Ever Your

Lewis

17. Lewis Henry Douglass to Helen Amelia Loguen, Morris Island, SC, August 15 [1863]

Morris Island S. C. Aug. 15

<u>My Own Dear Amelia</u>: Your kind letters were duly received, finding me suffering slightly from a pain in the head caused by the climate. I have thus far held out against the climate but I now fear that I am going to be sick, I hope not and am trying to be as cheerful as I can, which I think the best thing for a person when sick. I have not been in any fight since the 18th of July but three or four mornings ago we were called out at two o'clock, expecting men going to attack us, but they did not, so we marched back to our camp after being among the shells a half hour. I see myself lionized in the New York Tribune, the letter containing the puff I herewith enclose.

You wish to know how to send a box to the sick and wounded of the 54th, you may direct to the Sick and wounded Hospital No 6, Beaufort S.C. send by Ailanis Express. The colored women of Beaufort have shown their appreciation of the cause by helping take care of our sick and wounded, under the irrepressible Harriet Tubman.

My head aches so bad that I scarcely what I am writing, so you must excused this disjointed scribble. I am very sorry that you did not stop longer at our house. I hardly know what to think of your praise Miss Elsa Thomas after what we talked, but I am glad you like her. By the way I am quite glad Miss Edmonia accompanied you on your journey, I wish you would remember me to her. My dear girl keep a good heart always that I love you, and think of you, and all the dear ones in Syracuse often in fact my mind is divided between you and home. Give my love, no, respects to Miss Sarah Lewis, and Allie and when you write to Kitty[32] tell her she is well, and ask her how I am. As I am writing shells are flying and whizzing in our front about a mile off. Night before last a rebel shell came into but did not burst. I have got used to the music of shells the rebels are constantly throwing them from Sumter and Johnson.[33] But we are all right we will have Charleston soon. Good Bye

Ever Yours

Lewis

32 Here Lewis Henry may be referring to Kittie Kendall, a family friend for whom letters were addressed to Helen Amelia Loguen. Some of these are held in the Walter O. Evans collection (see inventory at the end of this volume).

33 Forts Sumter and Johnson in South Carolina were held by Confederate forces during the Civil War and subjected to bombardment by Union troops.

18. Lewis Henry Douglass to Helen Amelia Loguen, Morris Island, SC, August 27, 1863

Morris Island, S. C August 27, 1863

My own Dear Amelia: Having some leisure moments, I know of no better or pleasing way to use them, than to write you. I have got so much better as to be able to attend to my duties again, still I am in no wise enjoying perfect health. The weather here is chilly and the atmosphere damp. It is now fall in this portion of the earth, and like tropical countries the rainy season has set in, and night and day, we feel the chill damp of a southern fall shower; some of our men awake in the middle of the night to find their tents blown down over them, and themselves the recipients of more than copious showers of rain, with the wind whistling, and slapping, the water soaked tent in their faces, producing a sensation as remote from delightful as the soft stroke of a loved one, is from the rough blow of a rowdy.

We are still living in expectancy; Charleston is not yet ours, still we see no reason to be any thing but hopeful, all our movements tend to weaken the enemy and strengthen

18. Lewis Henry Douglass to Helen Amelia Loguen, Morris Island, SC, August 27, 1863

our own positions, and make the fall of Charleston
a great deal more than a possibility, it is a cer-
tainty. What a day of rejoicing it will be the day
that heralds the downfall of that city, from
whose halls and streets rang first that treason
and disloyalty which has overturned the nation
produced a great deal of evil, and yet been the
source of much good unintended, I can imagine
I hear the bombastic speeches of windy orators
boasting of the invincibility of the United States,
hurling anathemas against France ready to
war with the whole world; and seeing the success of
the Emancipation Proclamation, finding abolitionism
popular they will avow themselves to always have
been abolitionists. And then at night one will
see the flaming rocket, the darting Roman candle
the sky brilliantly illuminated by bonfires on every
street corner, ragamuffins running here and
there with an old box or barrel, while the old
people are sitting home congratulating each
other upon the prospects of a speedy termination
of the war. This is fine to think of, but before
it can come to pass there must be work done,
death must be dealt out and must be received,
some of us will live to see rebellion crushed

and some of us will die smashing it. Either is
glorious. I had hoped that we would have taken
Charleston ere this, and that I could have ob—
tained a leave of absence and gone home, and
seen you my dear one, once more, and be
in Syracuse in time to be at the wedding
of Miss Lewis, but I am afraid it will be too
late for that affair when Charleston falls, never—
theless I intend to apply for a leave of absence
as soon as there is probability that it will be
granted, and then once more will I enjoy
the dear company of my Amelia, and take a stroll
to Oakwood, (weather permitting) may be call at the
High School, and have a loving time generally.
Our Regiment has been again placed in Col.
Montgomery's Brigade One of the men your
father recruited at Binghampton died this
morning he has been, sick nearly all the time
since he was enlisted his name is George
Addison. Now my dear I have written it may
be valueless to you, but I trust not. You must
excuse my not paying postage, as I am far away
from any post Office and cannot procure stamps.
Remember me to your mother and father
brothers and sisters. Ever Lovingly Lewis

18. Lewis Henry Douglass to Helen Amelia Loguen, Morris Island, SC, August 27, 1863

Morris Island S.C. August 27 1863

My Own Dear Amelia: Having some leisure moments, I know of no better, or pleasing way to use them than to write you. I have got so much better as to be able to attend to my duties again, still I am in no wise enjoying perfect health. The weather here is chilly and the atmosphere damp. It is now fall in this portion of the earth, and like tropical countries the rainy season has set in, and night and day, we feel the child damp of a southern fall shower; some of our men awake in the middle of the night to find their tents blown down over them, and themselves the recipients of more than copious showers of rain, with the wind whistling, and slapping the water-soaked tent in their faces, producing a sensation as remote from delightful as the soft stroke of a loved one is from the rough blow of a rowdy.

We are still living in expectancy; Charleston is not yet ours, still we see no reason to be any thing but hopeful, all our movements tend to weaken the enemy and strengthen our own positions, and make the fall of Charleston a great deal more than a possibility, it is a certainty. What a day of rejoicing it will be the day that heralds the downfall of that city, from whose halls and streets rang first that treason and disloyalty which has overturned the nation produced a great deal of evil, and yet been the source of much good unintended. I can imagine I hear the bombastic speeches of windy orators, boasting of the invincibility of the United States, hurling anathemas against France, ready to war with the whole world; and seeing the success of the Emancipation Proclamation[34] finding abolitionism popular, they will avow themselves to always have been abolitionists. And then at night one will see the flaming rocket, the darting Roman Candle the sky brilliantly illuminated by bonfires on every street corner, ragamuffins running here and there with an old box or barrel, while the old people are sitting home congratulating each other upon the prospects of a speedy termination of the war. This is fine to think of but in before it can come to pass there must be work done, death must be dealt out, and must be received, some of us will live to see rebellion

34 President Abraham Lincoln issued the Emancipation Proclamation on January 1, 1863, ordering the freedom of enslaved people in all areas of the Confederacy that had not already been returned to Federal control.

crushed and some of us will die crushing it. Either is glorious. I had hoped that we would have taken Charleston ere this, and that I could have obtained a leave of absence and gone home, and seen you my dear one, once more, and be in Syracuse in time to be at the wedding of Miss Lewis, but I am afraid it will be too late for that affair when Charleston falls, nevertheless I intend to apply for a leave of absence as soon as there is probability that it will be granted, and then once more will I enjoy the dear company of my Amelia, and take a stroll to Oakwood, (weather permitting) may be call at the High School, and have a loving time generally. Our Regiment has been again placed in Col. Montgomery's Brigade.[35] One of the men your father recruited at Binghampton [sic] died this morning he has been sick nearly all the time since he was enlisted, his name is George Addison. Now my dear I have written it may be valueless to you, but I trust not. You must excuse my not paying postage, as I am far away from any Post Office and cannot procure stamps. Remember me to your mother and father brothers and sisters.

Ever Lovingly
Lewis

35 James Montgomery (1814–71), Union colonel during the Civil War, was a staunch abolitionist and supporter of John Brown. He practiced an extreme form of warfare, earning a rebuke from Robert Gould Shaw, commander of the 54th Massachusetts Volunteers, for his orders to loot and burn the town of Darien, Georgia. (See Lewis Henry Douglass letter, June 18, 1863.)

19. Lewis Henry Douglass to Helen Amelia Loguen, Rochester, NY, January 31, 1864

Rochester, Jan. 31 1864
Sunday

My Own Dear Amelia: Yours
of January 29th. came to hand
this morning and right glad
was I to receive it. So you are going
to try life in the valley of the Sus-
quehannah, I hope you will like
it, what will become of Miss Al-
monia?

I have just had my attention
attracted to those whom God has
put together, and whom He has
enjoined upon man not to
tear asunder, or in other words
the two who have promised on
Christmas eve to love obey, cherish
and protect each other, I was at-
tracted by their whispering, and
I suspected that I was the
subject of their conversation so I
looked around to see but failed
to observe any thing, so I will
continue to write unmindful
of them. You are thinking of
teaching school for two or three

years, in case I should get my
discharge, what will become of your
promise to me? Two or three years and
you may "recive a higher calling"
what would you say to receiving
a "higher calling" sooner eh?
Amelia the last "town talk"
here among the "cullud" folks is
that Miss Jennie Morris and
I have been married slyly,
if it should come to your ears
do not believe it. My going to
the ball with her New Years night
I suppose gave rise to the "talk."
There must be something extraor-
dinary about us boys, for we
cannot speak to a colored girl
in this city but what she thinks
we have fallen in love with
her, I do not however think
it the case with Jennie, but
with others here, It is fun for me.
Fred. has been in Buffalo
nearly all of the past week
and is still there. We are hav-

ing a protracted meeting here,
I have attended two of them and
have not been convicted yet, I
cannot say how much longer I shall
stand out. Does pa Loguen exert
himself at your protracted meet-
ing, tell him for me not to do it,
for he will only lose flesh by it
and I do not think the results
will be sufficient recompense
for such a heavy loss. Remem-
ber me to mother sisters and broth-
ers one and all, also to the Mrs,
Jackson to be. Bye Bye Mealy,
 Your Loving
 Lewis

19. Lewis Henry Douglass to Helen Amelia Loguen, Rochester, NY, January 31, 1864

Rochester Jan. 31 1864

Sunday

<u>My Own Dear Amelia</u>: Yours of January 29th came to hand this morning and right glad was I to receive it. So you are going to try life in the valley of the Susquehanna; I hope you will like it, what will become of Miss Edmonia?

I have just had my attention attracted to those whom God has put together, and whom He has enjoined upon man not to tear asunder, or in other words the two who ~~have~~ promised on Christmas eve to love, obey, cherish and protect each other,[36] I was attracted by their whispering, and I suspected that I was the subject of their conversation so I looked around to see but failed to observe any thing, so I will continue to write unmindful of them. You are thinking of teaching school for two or three years, in case I should get my discharge, what will become of your promise to me? <u>Two</u> or <u>three</u> years and you may "receive a higher calling," what would you say to receiving a "higher calling" sooner eh?

Amelia the last "town talk" here among the "cullud" folks is that Miss Jennie Morris and I have been married slyly, if it should come to your ears do not believe it. My going to the ball with her New Year's night I suppose gave rise to the "talk." There must be something extraordinary about us boys, for we cannot speak to a colored girl in this city but what she thinks we have fallen in love with her, I do not however think it the case with Jennie, but with others here. It is fun for me.

Frederick Douglass Jr. has been in Buffalo nearly all of the past week and is still there. We are having a protracted meeting here, I have attended two of them and have not been convicted yet. I cannot say how much longer I shall stand out. Does Pa Loguen* exert himself at your protracted meeting? tell him for me not to do it, for he will duly lose flesh by it and I do not think the results will be sufficient recompense for such a <u>heavy</u> loss. Remember me to mother sisters and brothers one and all, also to the Mrs. Healy Jackson to be. Bye Bye

Your Loving

Lewis

36 Lewis Henry Douglass had been home to witness the marriage of his sister Rosetta to Nathan Sprague on December 24, 1863. Douglas Egerton writes of his return in *Thunder at the Gates*.

 * Jermain William Loguen.

20. Charles Remond Douglass to Frederick Douglass, Camp Meigs, Readville, MA, July 6, 1863

Readville Camp Meigs July 6th 1863

Dear Father

I have just returned to camp
from Boston where I spent the fourth
and fifth, Yesterday I went to Mr Grimes
Church and Dr Rock read a letter that he
had recd from his wife who is in Philadelphia
and that the rebels were sending the negroes
south as fast as they advanced upon
our lines and that the colored people
were rushing into Philadelphia
and that yourself and Stephen Smith
and others were doing all you could
for them I was glad to hear that only
keep out of the hands of the rebels,
this morning as I was about to take
the train for camp I saw some
returned soldiers from Newbern N. C.
we had just got the news that Meade
had whipped the rebels and behind
me stood a Irishman

1975

203

20. Charles Remond Douglass to Frederick Douglass, Camp Meigs, Readville, MA, July 6, 1863

I said that we had some sort of a
Gen. now and that made the
Irish mad and he stepped in
front of me with his fist doubled up
in my face and said aint Mc
Clellan a good Gen you black nigger
I dont care if you have got the
uniform on when he got done I was
so mad that I sweat freely and I
drew my coat and went at him
all the time there was a policeman
on the opposite side watching our
movements just as I went at him
he was heavier than any the policeman
came and stopped me and asked
what the matter was I told him
and he marched the other fellow
off and that made all the other
Irish mad and I felt better still
I felt as though I could whip a
dozen irish I did not care for them
because I had my pistol and
it was well loaded I'm all right

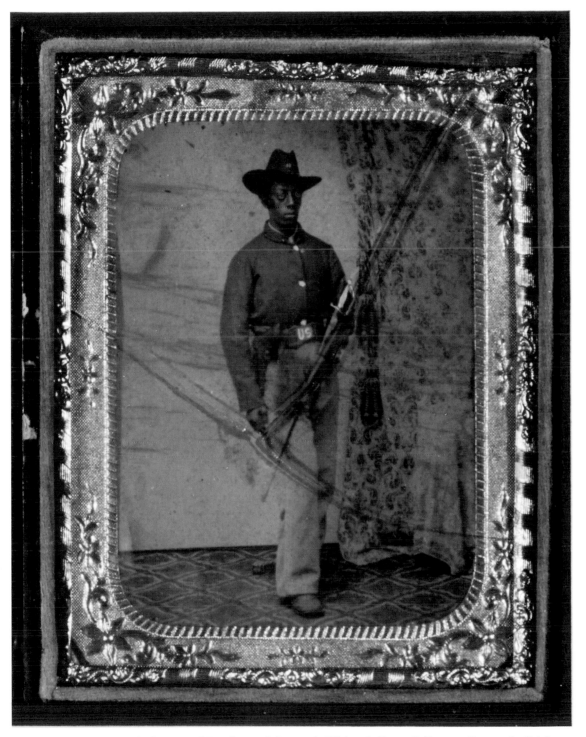

Figure 38: Anon., *Charles Remond Douglass*, n.d. [c. 1863]. (Walter O. Evans Collection, Savannah, GA.)

for: I have got my mind made to shoot the first Irishmen that strikes me they may talk but keep their paws to themselves.

We are expecting to leave here next week the men will get their Bounty this week we have a full band and drum corps and a good healthy looking set of men. I would like to see you before I go away the fleet has not been presented yet – if you will direct to the care of Martin Becker.
Comm. Sergeant –
5.5' Reg: Mass Vol

I have written home twice but have received no answer from them

please write

from your aff. Son

C. R. Douglass

20. Charles Remond Douglass to Frederick Douglass, Camp Meigs, Readville, MA, July 6, 1863

General Correspondence, Frederick Douglass Papers, Library of Congress

Readville Camp Meigs July 6th 1863

Dear Father

I have just returned to camp from Boston where I spent the fourth and fifth. Yesterday I went to Mr. Grimes Church and Dr. Rock[37] read a letter that he had recd. from his wife who is in Philadelphia and that the Rebels were sending the negroes south as fast as they advanced upon our lines and that the colored people were rushing into Philadelphia and that yourself and Stephen Smith[38] and others were doing all you could for them I was glad to hear that only keep out of the hands of the rebels. This morning as I was about to take the train for camp I saw some returned soldiers from Newbern N.C. one had just got the news that Meade had whipped the rebels[39] and behind me stood an Irishman. I said that we had some sort of a Gen. now and that made the Irish mad and he stepped in front of me with his fist doubled up in my face and said ain't McClellan[40] a good Gen you black nigger I dont care if you have got the uniform on when he got done I was so mad that I swear freely and I drew my coat and went at him all the time there was a policeman on the opposite side watching our movements just as I went at him (he was heavier than me) the policeman came and stopped me and asked what the matter was I told him and he marched the other fellow off and that made all the other Irish mad and I felt better still I felt as though I could whip a dozen irish I did not care for them because I had my pistol and it was well loaded I'm all right

37 John Stewart Rock (1825–66), a doctor, teacher, lawyer, abolitionist, and (in 1865) the first African American admitted to the bar of the Supreme Court of the United States.

38 Stephen Smith (c. 1795–1873), a successful businessman who, after purchasing his freedom from slavery in 1816, opened a lumber business in Pennsylvania. He was one of the first Black agents for *Freedom's Journal* and *The Emancipator*, two abolitionist publications, and he helped enslaved fugitives find freedom on the Underground Railroad.

39 General George Meade (1815–72) was appointed commander of the Army of the Potomac in June 28, 1863. Between July 1 and July 3 he led Union forces in the Battle of Gettysburg, to which Charles Remond is likely referring here.

40 George B. McClellan (1826–85), between November 1861 and March 1862 US general-in-chief of the Union army, had been removed from all military command in November 1862, following the Union defeat at Antietam in September that year.

for I have got my mind made to shoot the first Irishman that strikes me they may talk but keep their paws to themselves.

We are expecting to leave here next week the men will get their Bounty this week we have a full band and drum corps and a good healthy looking set of men. I would like to see you before I go away the flag has not been presented yet—if you write direct to the care of Master Becker.

Comm. Sergeant

55 Reg. Mass Sol

I have written home twice but have received no answer from them please write

from your aff. Son

C. R Douglass

21. Charles Remond Douglass to Frederick Douglass, Boston, MA, September 8, 1863

Boston Sept. 8th 1863

Dear Father

I have just received your letter of
Aug 28th with five dollars enclosed which I am
very thankful for as I was in want of it very much.
I have never brought any disgrace upon the family
and I never mean to I have never stolen from
any body a chicken or any thing else no one
can bring any such thing up against me I
have said that I would take a chicken or any
thing else to eat when I was hungry but I
have not done so I wrote that there had been
chickens stolen by the boys in camp but as
I have had to take charge of the camp I have
never left it without permission and I have
the praise to day of Gen. Peirce of keeping
things neat and orderly about the camp
when all were sick except myself I worked
hard to supply all the wants of the sick as I was
the only one able to do duty some nights I was
up all night and stood over those that died
and laid them out wrote to their friends

21. Charles Remond Douglass to Frederick Douglass, Boston, MA, September 8, 1863

and in fact done most all that was to do except
doctor them and I felt after a while to get
sick myself I could not drink coffee sweatened
with mollasses and of course I had to eat dry
bread alone for we only got meat once a week
and that was used to make soup for the sick
we could say nothing to nobody against it I
was the only one on the ground that could
get a chance to speak the rest being sick
I fell away like a skeleton I spoke to the
doctor about it he could not account for it
nor did he care he had plenty, they would tell us
that hospital rations were small and that we
could not draw full rations that is a funny
way to starve a lot of men in a State where there
is plenty We were used mean and when I wrote
home I said anything that came in my
head. It dont seem to you that are home true
that this can be but upon honor it is the truth
and to day there are men dying out to camp
I was out last night for the first time in a
week and the boys said that there had been
no doctor there all that day and there is one

21. Charles Remond Douglass to Frederick Douglass, Boston, MA, September 8, 1863

man then that will die and others that are very sick
I am agoing to complain about it to day. We were
treated like men when the Regt. was here but now
they are treated worse than dogs I am treated
better now that I am in the city and
Lieut. Wulff is a man every inch of him he
is a Swede by birth but he is my friend
he has done all he could to have the men satisfied but
there are higher officers than him the fault lys
in the Quarter master it is for the benefit
of his pocket that we dont have our
rations. Lieut. Wulff to day is agoing to establish
a new camp new tents and every thing for
the fifty fourth men that we are recruiting
and he will have charge of every thing commissary
department and all and then our men will
have what is right. I am well and in the office I
stay in Boston altogether. I saw a discharged soldier
yesterday from the fifty fourth and he told me that
he saw Lewis the day he left and that Lewis had
been sick (this the 17th of Aug) but that he was better again
they have such poor water down there and a great
many are sick from the effects of it

21. Charles Remond Douglass to Frederick Douglass, Boston, MA, September 8, 1863

I have been told that the fifty fourth would get their full pay in a month it has been explained that the U. S. Government would pay us ten dollars per month and Massachusetts will pay the other three and that we will get just what was promised us I hope that our boys wont except of any less than what they enlisted for. I can get my full pay next month right here. when any of my acquaintances meet me in the street they say why how thin you are I once could say that it was from sickness but this time it was from something else. give my love to all at home and dont think hard of me because of what I said a person will do most anything before they will starve and will say anything I did not starve but I felt myself falling away more and more and me while I did expect to be laid up sick.

Your Aff. Son

Please direct care Charles R Douglass
Lieut Hulse Readville

21. Charles Remond Douglass to Frederick Douglass, Boston, MA, September 8, 1863

General Correspondence, Frederick Douglass Papers, Library of Congress.

Boston Sept. 8th 1863

Dear Father

I have just received your letter of Aug 28th with five dollars enclosed which I am very thankful for as I was in want of it very much. I have never brought any disgrace upon the family and I never mean to I have never stolen from any body a chicken or any thing else no one can bring any such thing up against me I have said that I would take a chicken or any thing else to eat when I was hungry but I have not done so I wrote that there had been chickens stolen by the boys in camp but as I have had to take change of the camp I have never left it without permission and I have the praise to day or Gen. Peirce[41] of keeping things up neat and orderly about the camp when all were sick except myself I worked hard to supply all the wants of the sick as I was the only one able to do duty some nights I was up all night and stood over those that died and laid them out wrote to their friends and in fact done most all that was to do except doctor them and I felt after a while to get sick myself I could not drink coffee sweetened with molasses and of course I had to eat dry bread alone for we only got meat once a week and that was used to make soup for the sick we could say nothing to nobody against it I was the only one on the ground that could get a chance to speak the rest being sick I fell away like a skeleton. I spoke to the doctor about it he could not account for it nor did he care he had plenty, they would tell us that hospital rations were small and that we could not draw full rations that is a funny way to starve a lot of men in a State where there ~~was~~ is plenty We were used mean and when I wrote home I said anything that came in my head. It dont seem to you that are home true that this can be but upon honor it is the truth and to day there are men dying out to camp I was out last night for the first time in a week and the boys said that there had been no doctor there all that day and there is one man then that will "die" and others that are very sick I am going "to complain" about it to day. We were treated like men when the Regt. was here but now they are treated

41 Ebenezer W. Peirce (1822–1902), a general in the Union forces, commander of the 29th Massachusetts Infantry Regiment.

worse than dogs I am treated better now that I am in the city and Lieut. Wulff[42] is a man every inch of him he is a Sweede [sic] by birth but he is my friend he has done all he could to have the men satisfied but there are higher officers than him the fault lies in the Quarter master it is for the benefit of his pocket that we dont have our rations. Lieut. Wulff to day is a going to establish a new camp new tents and every thing for the fifty fourth men that we are recruiting and he will have charge of everything commissary department and all and then our men will have what is right. I am well and in the office I stay in Boston altogether. I saw a discharged soldier yesterday from the fifty fourth and he told me that he saw Lewis the day he left and that Lewis had been sick (this the 17th of Aug) but that he was better again they have such poor water down there and a great many are sick from the effects of it. I have been told that the fifty fourth would get their full pay in a month it has been explained that the U.S Government would pay us ten dollars per month and Massachusetts will pay the other three and that we will get just what was promised us I hope that our boys wont except [sic] of any less than what they enlisted for. I can get my full pay next month right here when any of my acquaintances meet me in the street they say why how thin you are I once could say that it was from sickness but this time it was from something else. give my love to all at home and don't think hard of me because of what I said a person will do most anything before they will starve and will say anything I did not starve but I felt myself falling away more and more and one while I did expect to be laid up sick.

 Your Aff. Son

 Charles R Douglass

 Please direct care Lieut Wulff Readville

42 Erik Wulff, First Lieutenant in the 54th Massachusetts Regiment.

22. Charles Remond Douglass to Frederick Douglass, Boston, MA, September 18, 1863

Boston September 18th 1863

Dear Father

I have just read your kind letter to me. Yesterday I had an interview with Col Hallowell of the 54th and he told me that I may have to go down to Morris Island early next month with a batch of conscripts for the 54th giving me to understand that I must be ready at a moments notice. I also had an interview with my Capt who is on furlough he said that Col. Shaw never told him that I was to report to the 55 and after my furlough had passed two weeks Capt. Bridge put me down as a deserter but Col Shaw saw it and had it taken off as he knew that I was sick and not a deserter. I will never desert I take a bullet first. Lieut: Wulff is trying hard to have me stay and help him as I suit him first rate. Are you acquainted with an old colored man in Boston by the name of Col. Vanderzuiker I believe. He was thought a great deal of here he died yesterday and will be buried sunday; I wrote to you for a couple

22. Charles Remond Douglass to Frederick Douglass, Boston, MA, September 18, 1863

of your Photographs with your name written upon them or upon the card I would like to give one to Lieut Wulff whom I esteem as a true Friend and the other I want for myself as I have one from each member of the Family except your own and Lewis' There is a report around here that Lewis is agoing to have a commission as Lieut as soon as Gov. Andrew returns from Washington I dont know how true it is but Lew is highly spoken of in Boston and New Bedford to, Everyone says that he will receive the first Commission. Col Hallowell says that the 54 boys have been worked hard but they are plucky yet and want to be in a fight, If I have to go by the 3d of next month I will write as soon as I receive orders to pack my knapsack my love to all the family and Friends if there are any I suppose that the McVicars and our folks dont visit any more.

 Your Aff. Son Charles R Douglass
 Care Lieut Erik Wulff
 Camp Meigs Readville

22. Charles Remond Douglass to Frederick Douglass, Boston, MA, September 18, 1863

General Correspondence, Frederick Douglass Papers, Library of Congress.

Boston September 18th 1863

Dear Father

I have just read your kind letter to me. Yesterday I had an interview with Col Hallowell[43] of the 54th and he told me that I may have to go down to Morris Island only next month with a batch of conscripts for the 54th giving me to understand that I must be ready at a moments notice. I also had an interview with my Capt who is on furlough he said that Col. Shaw[44] never told him that I was to report to the 55 and after my furlough had passed two weeks Capt. Bridge put me down as a deserter but Col Shaw saw it and had it taken off as he knew that I was sick and not a deserter. I will never desert I take a bullet first Lieut. Wulff is trying hard to have me stay and help him as I suit him first rate. Are you acquainted with an old colored man in Boston by the name of Col. Mandicku I believe. He is was thought a great deal of here he died yesterday and will be buried sunday: I wrote to you for a couple of your Photographs with your name written up them or upon the card I would like to give one to Lieut Wulff whom I esteem as a true Friend and the others I want for myself as I have one from each member of the Family except your own and Lewis'. There is a report around here that Lewis is agoing to have a commission as Lieut as soon as Gov. Andrew returns from Washington I dont know how true it is but Lew is highly spoken of in Boston and New Bedford to [sic], Everyone says that he will receive the first commission. Col Hallowell says that 54 boys have been worked hard but they are plucky yet and want to be in a fight. If I have to go by the 3d of next month I will write as soon as I receive orders to pack my knapsack my love to all the family and Friends if there are any I suppose that the McVicars and our folks don't visit any more.

Your Aff. Son Charles R Douglass
Care Lieut Erik Wulff
Camp Meigs Readville

43 Norwood Penrose Hallowell (1839–1914), US lieutenant-colonel, at the time of this letter was second-in-command of the 54th Massachusetts Regiment.

44 Robert Gould Shaw (1837–63), US commander of the 54th Massachusetts Regiment. Shaw had been killed at the second Battle of Fort Wagner on July 18, 1863.

Boston Dec. 20th 1863

Dear Father

I have applied for a furlong to
come home Christmas and I have been promised
one to start Wednesday but the trouble is that I
am unable to get means to come with here, as
I am not paid off yet and may not be before
next month. If you get this letter by monday
night I will be able to get an answer by
Wednesday. I have a case before the Court
tommorow morning I suppose that Fred.
made you acquainted with the nature of
the case but since Fred. has left I have had
my defendent rearrested and put under
$500 bonds so that now he is safe in jail
the reason that this was done Mr Stephenson
and Mr Sewell a lawyer whom I suppose
you know, understood that the man had
offered me one hundred dollars to settle
which was true he had but I refused under
any consideration because I saw that
I had friends to stand by me and to have

1978

218

23. Charles Remond Douglass to Frederick Douglass, Boston, MA, December 20, 1863

settled it for a little money would turn them against me and they told me that if I needed the money very bad that they would give me twice the sum sooner than see me settle it but I have never had any idea of settling it. I have got some friends here yet

my love to all the family

Yours aff Son

Chas R. Douglass

23. Charles Remond Douglass to Frederick Douglass, Boston, MA, December 20, 1863

General Correspondence, Frederick Douglass Papers, Library of Congress.

Boston Dec. 20th 1863

Dear Father

I have applied for a furloug [sic] to come home Christmas and I have been promised one to start Wednesday but the trouble is that I am unable to get means to come with here, as I am not paid off yet and may not be before next month. If you get this letter by monday night I will be able to get an answer by Wednesday. I have a case before the court tomorrow morning I suppose that Frederick Douglass Jr. made you acquainted with the nature of the case but since Fredk. has left I have had my defendant requested and put under $500 bonds so that now he is safe in jail the reason that this was done Mr Stephenson and Mr Sewell a lawyer whom I suppose you know, understood that the man had offered me one hundred dollars to settle which was true he had but I refused under any consideration because I saw that I had friends to stand by me and to have settled it for a little money would turn them against me and they told me that if I needed they money very bad that they would give me twice the sum sooner than see me settle it but I have never had any idea of settling it. I have got some friends here yet.

My love to all the family
Your Aff Son
Chas R. Douglass

Camp Hamilton City Point Virginia
near Bermuda Hundred May 31st 1864

Dear Father

I received your letter with
news yesterday afternoon I was very much pleased
to hear from home and to know if any were sick
I hope that you will be about soon. It is pretty
warm here at present and has been so for
several days, Sunday we all had green peas
for our dinners this morning I had chicken for
breakfast our Company went out on picket
yesterday afternoon and Capt. Wulff made a
raid on an old farm house outside our picket
lines and shot seven chickens one he sent to me
I staid in from picket just as I am writing this
there is heavy firing just above our picket line
I expect to be called into line of battle. every
moment we have been fighting ever since our Reg.
came here I mean our forces. Genl. Martindale
passed right by our camp day before yesterday
with his whole division he is from Rochester
is Brig. Gen has command of a division

1979

24. Charles Remond Douglass to Frederick Douglass, Camp Hamilton, City Point, VA, near Bermuda Hundred, May 31, 1864

I also saw Col. Fairchild of the New York
85th the firing I just mentioned on my first
page is Butler bombarding Petersburg which is
about seven miles from this camp but the
firing only seems to be about half mile distant
the firing is very steady we have just sent three colored
Regiments toward Petersburg the 22d Penn 1st Ohio an
4th Maryland these are the Regts that whipped Gen
Fitch Lee up the river the other day at Fort Powhatan
I suppose you heard of it through the papers they
were under Gen Wild at that time our boys are
very anxious for a fight & I think their wishes will
be complied with shortly as for myself I am not
over anxious but willing to meet the devils at
any moment and take no prisoners remember
Fort Pillow will be the Battle cry of the fifth Mass
Cavalry although I have been the first to take
a prisoner last week when on picket I espied
a man in grey clothes dodge behind a tree
Capt Wulff had just left me in a moment
I had my piece to bear on him I was only about
a dozen yards off and the old wild cat had
got so near me without being perceived

222

24. Charles Remond Douglass to Frederick Douglass, Camp Hamilton, City Point, VA, near Bermuda Hundred, May 31, 1864

I ordered him to step from behind the tree or I would knock a hole through him he stepped out I could see no gun I then ordered him to go on a head of me which he did very reluctantly as soon as he had passed in front of me I cocked my piece which went click click he stopped stone still and wanted to know if I meant to murder him I spoke in a harsh tone for him to go on and if he stopped before I ordered him that I would shoot him he went on I took him to Capt Wulff who was sitting under a tree Capt. ordered me to search him which I did well making him strip off every rag for he was covered with them I found a revolver dirk knife $3 in rebmoney $1 in gold and some silver coin and green backs he proved to be the man that owned the land where we were picketed I have the the revolver that I took from him it is a pepper box. I also brought in six contrabands from a farm house. I have had the praise of bringing in the first prisoner. the firing

223

24. Charles Remond Douglass to Frederick Douglass, Camp Hamilton, City Point, VA, near Bermuda Hundred, May 31, 1864

is getting very heavy out front. You spoke
of Capt Wulff shooting a man he did
in Baltimore the way it happened is this he ordered
all to fall in line which we did Acept
Sergt Jackson he staid out he was a little
drunk but not drunk enough to not
know what was right the Capt fell us
in to tell us that he was going to let us
go around and if we were insulted to
go in with a will and defend ourselves
so turning around he saw Jackson
out of the ranks he merely took him
by the arm and told him to keep in
the ranks when Jackson cursed him
the Capt then ordered him to take off
his stripes which he refused to do or to
let any body else & he said if they took
off his stripes that he would have to be
shot first the Capt then said I will shoot
you then and immediately drew his
revolver and shot at Jacksons head
Jackson dodged his head and the ball passed
through the heart of Albert White the
man that H. O. Wagoner brought out of
Bondage no more at Present
 Your Affectionate Son
 C R Douglass 1st Sergt Co I

24. Charles Remond Douglass to Frederick Douglass, Camp Hamilton, City Point, VA, near Bermuda Hundred, May 31, 1864

General Correspondence, Frederick Douglass Papers, Library of Congress

Camp Hamilton City Point Virginia
near Bermuda Hundred, May 31st 1864

Dear Father

I received your letter with Lewis yesterday afternoon I was very much pleased to hear from home and to know if any were sick I hope that you will be about soon. It is pretty warm here at present and has been so for several days. Sunday we all had green peas for our dinners this morning I had chicken for breakfast our Company went out on picket yesterday afternoon and Capt. Wulff made a raid on an only farm house outside our picket lines and shot seven chickens one he sent to me I staid [sic] in from picket just as I am writing this there is heavy firing just about our picket line I expected to be called into line of battle every moment we have been fighting ever since our Regt. came here I mean our forces. Genl. Martindale[45] passed right by our camp day before yesterday with his whole division he is from Rochester a Brig. Gen has command [sic] of a division I also saw Col. Fairchild[46] of the New York 89th the firing I just mentioned on my first page is Butler[47] bombarding Petersburg which is about seven miles from this camp but the spring only seems to be about half mile distant the firing is very steady we have just sent three colored Regiments toward Petersburg the 22nd Penn 3th Ohio and 4th Maryland these are the Regts that whipped Gen Fitch. Lee[48] up the river the other day at Fort Powhatan I suppose you heard of it through the papers they were under Gen. Wild[49] at that time our boys are very anxious for a fight I think their wishes will be complied with shortly as for myself I am not over

45 John Henry Martindale (1815–81), US Military Governor of Washington, DC, from November 1862 to May 1864. At the time of this letter he was assigned to the XVIII Corps and had fought in a series of battles at the town of Bermuda Hundred, Virginia, in May 1864.

46 Harrison Stiles Fairchild (1820–1901), US colonel and commander of the 89th New York Infantry.

47 Benjamin Butler (1818–93), a major US general of the Union army.

48 Fitzhugh Lee (1835–1905), a Confederate cavalry general, led an attack on May 24, 1864 on Fort Powatan (Pocahontas), only to be repulsed by African American troops stationed there.

49 Edward A. Wild (1825–91), Brigadier General and commander of Fort Powatan (Pocahontas).

anxious but willing to meet the devils at any moment and take no prisoners remember Fort Pillow[50] will be the battle cry of the fifth Mass Cavalry although I have been the first to take a prisoner last week when on picket I espied a man in grey clothes dodge behind a tree (Capt Wulff has just left me) in a moment I had my piece to bear on him I was only about a dozen yards off and the old wild cat had got so near me without being perceived I ordered him to step from behind the tree or I would knock a hole through him he stepped out I could see no gun I then ordered him to go on ahead of me which he did very reluctantly as soon as he had passed in front of me I cocked my peice [sic] when went click; click he stopped stone still and wanted to know if I meant to murder him I spoke in a harsh tone for him to go on and if he stopped before I ordered him that I could shoot him he went on I took him to Capt Wulff who was sitting under a tree Capt. ordered me to search him which I did well making him strip off every rag for he was covered with them I found a revolver dirk knife $50 in reb money $13 in gold and some silver coin and green backs he proved to be the man that owned the land where we were picketed I have the the revolver that I took from him it is in pepper box. I also brought in six contrabands from a farm house. I have had the praise of bringing in the first prisoner, the firing is getting very heavy out front. Lew spoke of Capt Wulff shooting a man he did in Baltimore the way it happened is this he ordered all to fall in line which we did except Sergt Jackson he staid [sic] out he was a little drunk but not drunk enough to not know what was right the capt fell us in to tell us that he was agoing to let us go around and if we were insulted to go in with a will and defend ourselves so turning around he saw Jackson out of the ranks he merely took him by the arm and told him to keep in the ranks when Jackson cursed him the Capt then ordered him to take off his stripes which he refused to do or to let any body else do he said if they took off his stripes that he would have to be shot first the Capt. then said I will shoot you then and immediately drew his revolver and shot at Jacksons head Jackson dodged his head and the ball passed through the heart of Albert White the man that H. O. Waggoner[51] brought out of bondage no more at Present

Your affectionate Son

C R Douglass 7th Sergt Co.

50 The Battle of Fort Pillow, Tennessee, on April 12, 1864 resulted in the defeat of Union forces and the tragic massacre of over 250 surrendering Black soldiers at the command of confederate Major General and future Ku Klux Klan leader Nathan Bedford Forrest (1822–77).

51 Henry O. Wagoner (1816–1901), civil rights activist and abolitionist, friend of Frederick Douglass, and recruiter during the Civil War of Black soldiers for regiments in Massachusetts and Illinois.

25. Charles Remond Douglass to Anna Murray and Frederick Douglass, Point Lookout, MD, September 15, 1864

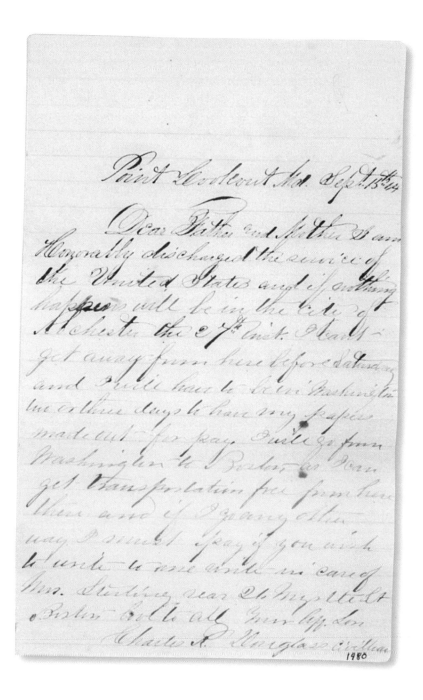

25. Charles Remond Douglass to Anna Murray and Frederick Douglass, Point Lookout, MD, September 15, 1864

General Correspondence, Frederick Douglass Papers, Library of Congress

Point Lookout Md. Sept. 15th 64

Dear Father and Mother I am honorably discharged the service of the United States and if nothing happens will be in the city of Rochester the 27th inst. I cant get away from here before Saturday and I will have to be in Washington two or three days to have my papers made out for pay. I will go from Washington to Boston as I can get transportation free from here there and if I go any other way I must pay if you wish to write to me write in care of Mrs. Stirling near 21 Myrtle St. Boston love to all

 Your Aff. Son

 Charles R. Douglass civilian [sic]

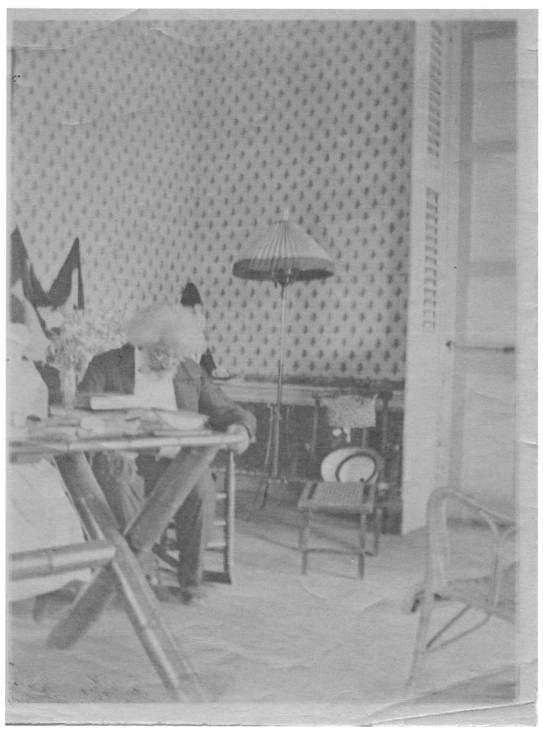

Figure 39: W. Watson, *Frederick Douglass Reading in Port-au-Prince Haiti Villa Tivoli*, c. 1890.
(National Park Service: Frederick Douglass National Historic Site, Washington, DC.)

Miss H. A. Loguen
Box 685
Syracuse
New York

Part IV

The "Incontestable Voice of History" in Frederick Douglass's Manuscripts

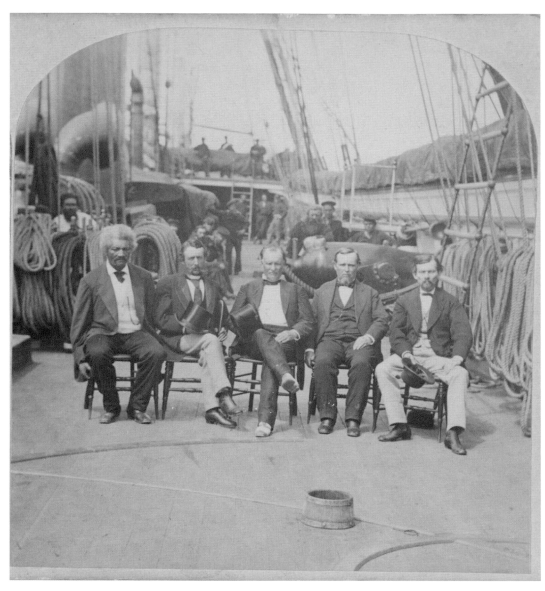

Figure 40: Anon., *Frederick Douglass with the Commissioners to Santo Domingo, Brooklyn Navy Yard, January 1871*. Albumen silver print. (The J. Paul Getty Museum, Los Angeles.)

26. "The Energy that Slumbers in the Black Man's Arm": Frederick Douglass, "Lecture on Santo Domingo," c. 1873

In 1871, President Ulysses S. Grant appointed Frederick Douglass as Assistant Secretary to the Commission of Inquiry to Santo Domingo, while Charles Remond Douglass was given the position of clerk. A hotbed of controversy, this commission was set up with the purpose of establishing whether Santo Domingo, the first Black republic in the western hemisphere, founded by freedom fighter, visionary, and military general Toussaint Louverture, was favorable to US annexation. In a bold departure from his longstanding political unity with the radical reformist vision of Charles Sumner, who was virulently opposed to US intervention in the country, Douglass was a staunch advocate for annexation.[1] As he argued in the draft manuscript of his speech "Lecture on Santo Domingo," included in the Walter O. Evans collection and reproduced here as original facsimile pages and an annotated transcription, the extension of US political power meant something very different in a post-emancipation era to what it would have signified at the height of chattel slavery. "There was a time in the history of our Republic, when the thought of an extention [sic] of its dominion was painful to me," he concedes. "Annexation meant the extention [sic] of slavery—the opening of new slave markets, the revival of the internal slave trade, the addition of more slave states, more slave representation in congress, and greater security to slavery at home and abroad." For Douglass, who had dedicated his life to antislavery campaigning, and who therefore had to believe that the Fifteenth Amendment's stipulation that all citizens had the right to vote regardless of "race, color, or previous condition of servitude" had successfully ushered in a new era of civil liberties following its ratification in 1870, the annexation of Santo Domingo provided him with no ethical quandary. "It now means the enlargement and security of human liberty," he insisted. As a measure of his heartfelt conviction, he rhetorically questioned: "where is their [sic] a nation, so enlightened, so liberal and so progressive as the people and government, of the United States?"

"If in the United States we have had our slavery, they in Santo Domingo have had theirs also," Douglass observes in this draft manuscript. He employs powerful language to urge that Santo Domingo was "the first cisatlantic country, to engage in the African trade and to Darken the dashing billows of the Atlantic with Congo blood." More especially, he employs a hard-hitting use of satire to denounce the "holy priest" Bartolomé de las Casas, whose "feeling of humanity" and "measure of

1 For a detailed discussion of Charles Sumner's opposition to Santo Domingo, see Levine, *Dislocating Race and Nation*, 207ff.

Christian benevolence" toward the terrible "sufferings of the slender natives" led to the founding of an inhumane system on an unprecedented scale via "the importation of slavery from Africa." Douglass cuts to the heart of western Christian hypocrisy by observing, "It is hard to believe when we remember the preeminent religiousness of the Spaniards, that in less than half a century, they had nearly exterminated the native population." Faced with these body-and-soul-destroying truths, he has no option but to conclude, "such is the incontestable voice of history." Across this speech, Douglass assumes the role not only of social reformer and political analyst but of historian, in a bid to do justice to the "incontestable voice of history" by telling the untold tragedies that beset Santo Domingo as a nation devastated by European and North American greed. On these grounds, annexation is no form of colonization but instead represents a long overdue act of philanthropy. According to Douglass's formulation, it was the responsibility of the US nation to provide Santo Domingo citizens with a government formulated on the principles of the "enlargement and security of human liberty" as just restitution for its centuries-long participation in the transatlantic slave trade that all but destroyed the country.

"While in the City of Santo Domingo, I stood upon what was said to be the very spot where, the first cargo of this human merchandize was landed. I will not stop here to describe sensations, or to make reflections upon the fact. I rather turn, to less distressing thoughts and feelings." So Frederick Douglass poignantly confides in the most emotionally charged passage of this manuscript. For Douglass, who had lived the first decades of his life as an enslaved man in the US South, the opportunity to stand on the "very spot" on which the "the first cargo of this human merchandize was landed" was an experience that defied literary expression. In the diary he kept during this voyage, he recorded this moment on February 7, 1871 with only the briefest of words: "Took a long walk by the river" to the "place where the first slaves were landed."[2] Across both his diary and draft speech, and despite his renowned eloquence, he insists on his right to silence, refusing to share his "distressing thoughts and feelings." In other draft manuscripts of this speech, held in the Frederick Douglass Papers at the Library of Congress, Douglass narrates this passage very differently. "While in the city of Santo Domingo, I was shown the very spot, and stood upon it where the first cargo of this human merchandize was landed in the western world," he writes.[3] Warring against any and all white racist detractors of Black humanity, Douglass immediately insists, "When we think of slavery both of natives, and the Africans in that Island, when we think of the ten thousand evils that slavery entailed upon the country—when we think of the violence and blood, and crime which continued there for ages

2 Douglas, *Frederick Douglass's Diary (Santo Domingo 1871)*, n.p. Sunday, January 29, 1871.
3 Douglass, "Santo Domingo," Folder 1, 25.

when we think of the indolence and repugnance to labor which slavery left behind it, the misrule, and bad government which have followed until this day, the wonder is not that [the] population is so sparse, but rather that it is so large."[4] For Douglass, any evidence of human survival is nothing short of miraculous in the context of slavery's "ten thousand evils." Yet more damningly, he not only denounces the terrible realities of transatlantic slavery but interrogates the failures of emancipation for Santo Domingo as a nation characterized by ongoing poverty and suffering. As he insists, "Slavery not only killed and destroyed by its life, but it killed and destroyed in its death."[5]

For Douglass, as always, the one and only antidote to his "distressing thoughts and feelings" is the missing history of Black heroism. "More than sixty years earlier, than ourselves, she was made to feel the storm of blood and fire, that follows ever—sooner or later, on the track of national crime," Douglass observes of Santo Domingo's revolutionary history. He jubilantly confides, "Her mountains were made to smoke, and her valleys to blaze with fierce wrath and revenge. Her Toussaints, her Dessalines, and her Christophes, were the first of her race, to teach the world that is dangerous to goad the energy that slumbers in the black man's arm." Across his antebellum and postbellum activism, Douglass repeatedly debated the atrocities of transatlantic slavery not as a source of Black victimization but as the catalyst to African diasporic revolutionary freedom struggles. Here and elsewhere, he immortalizes the lives and works of Toussaint Louverture, Jean-Jacques Dessalines, and Henri Christophe as the pioneering architects of the first Black republic in the western hemisphere and a powerful lesson to inhumane whites regarding the "energy that slumbers in the black man's arm." More especially, he rejects all racist stereotypes of Black heroes as inferior within a white imaginary by singling out the "character of the brave and sagacious Toussaint." As he records in his diary, Douglass sought out first-hand witnesses who could tell him about the history of this Black liberator in more depth. On Sunday, January 29, 1871, he writes of attending a "Speech on the strand of Samara Bay or Clara Bay with Mr. Dichmaiu an old butler hire of 60 years." As Douglass explains, "He knew Toussaint Cristophe to[o] and told me much of the struggle for freedom by these heroes and of the atrocities perpetrated by the French under the first Nap[oleon]."[6] For Douglass, Toussaint Louverture is the embodiment of exemplary heroism and the sole focus of numerous manuscripts.[7]

As immortalized in Douglass's Santo Domingo manuscript in particular, Toussaint Louverture's memory assumes exalted proportions in comparison with

4 Douglass, "Santo Domingo," Folder 2, 22–3.
5 Ibid. 23.
6 Douglass, *Frederick Douglass's Diary (Santo Domingo 1871)*, n.p. Sunday, January 29, 1871.
7 See Bernier, "'Emblems of Barbarism'" and Bernier, *Characters of Blood*, ch. 1.

the villainy of Napoleon Bonaparte. "It is not to be denied that the negroes of Santo Domingo—when once roused from their long suffering were terrible in their vengeance, and committed excesses at which humanity must always shudder," Douglass readily admits, only to insist that "the wildest and most shocking of these were paralleled, and provoked by the cries and excesses committed by the whites—who made war to enslave them." For Douglass, no race can rival whites for acts of barbarity. Here he draws parallels between the historical atrocities facing Santo Domingo's Black population and the contemporary injustices enacted on US soil against African American women, children, and men. As he insists, "this ~~thought~~ fact is especially worthy of thought at this moment when an effort is being made again to reduced [sic] to slavery the same race among ourselves, who have not been six years from the chains of Slavery." As Douglass urges, the example of Black freedom fighters in Haiti functions as an inspiration for African Americans living in a so-called post-emancipation US in which freedom is a mockery and sham. He pulls no punches regarding their daily fight for survival in the face of escalating attempts to "reduce" them to slavery by white vigilante mobs.

It is no accident that Douglass communicates his protest against French general Napoleon Bonaparte and his traitorous actions, which resulted in the destruction of the first Black republic and the incarceration of Toussaint Louverture, as the "first Ku Klux" in this manuscript. For Douglass, Louverture's heroism against all the odds and in the face of white inhumanity is nothing less than "a lesson for those men in our country who are still endeavoring by violence and midnight crimes to worry the American negro back into slavery." As he warns his white US audiences, "The negro is no less a man here than in Santo Domingo. He has tasted the sweets of Liberty and though slow to learn violence experience proves that he may learn at last—and woe to the south when the crushed worm shall turn." For Douglass writing in *Santo Domingo*, the Haitian experiment of a liberty that is Black-generated, Black-executed, and Black-maintained represents a warning to the "violence and midnight crimes" of Ku Klux Klan organizations that are working to "worry the American negro back into slavery" in the US. All protestations to the contrary regarding the US as a "nation, so enlightened, so liberal and so progressive," Douglass was only too aware of the cracks beneath the surface. These tensions suggest that more complex forces are at work in his advocacy of annexation, as his ambivalences have yet to be fully mapped and require further unpacking by scholars. Writing recently, Juliet Hooker provides an indispensable guide to researchers by emphasizing the importance of using his writings on Santo Domingo "to enlarge the conceptual terrain of Douglass scholarship by locating a more geographically capacious Douglass whose engagement with Latin America reveals an important

hemispheric dimension to his political thought." As a result, it becomes newly possible to "read Douglass more expansively as a theorist of democracy" beyond US shores and into the African diaspora.[8]

As regards provenance, Douglass's "Lecture on Santo Domingo" held in the Walter O. Evans Collection is dated to the year 1873 and is accompanied by a handwritten note supplied by the original dealer: "Manuscript in 2 different hands (neither in Frederick Douglass's) 42 pages. Lecture on Santo Domingo. To be delivered in the Mercantile Library. Perhaps dictated—This bears revision and corrections but not in Douglass's hand." There is no doubt that this is the draft of the speech Douglass first delivered in the St. Louis Mercantile Library. A version of this speech, simply titled "Santo Domingo: An Address Delivered in St. Louis, Missouri, on 13 Jan. 1873," was published in his and his sons' Washington, DC newspaper, *New National Era*, on January 23, 1873.[9] Nevertheless, there are significant differences between the speeches. In comparison with the draft manuscript held in the Walter O. Evans collection, this published speech is far shorter and includes significant omissions. Among these can be counted Douglass's poignant narration of his moment of standing on the shore where the first enslaved women and men had disembarked.

While the version of his speech that appeared in the *New National Era* may represent the only printed version to have survived, the Frederick Douglass Papers at the Library of Congress include five variant manuscripts. These Santo Domingo speeches are catalogued as follows: Folder 1, 56 pages, a handwritten manuscript; Folder 2, 41 pages, a handwritten manuscript; Folder 3, 27 pages, a typed manuscript; Folder 4, 38 pages, a typed manuscript; Folder 5, 29 pages, a handwritten manuscript. As far as establishing the exact date or order of composition for any of these typed and handwritten manuscripts is concerned, research is still ongoing. Yet more importantly, it is currently impossible to decide with any certainty whether Frederick Douglass completed any or all parts in his own hand. Despite the claims of the original dealer that this manuscript reproduced here was "Perhaps dictated" on the grounds that, "This bears revision and corrections but not in Douglass's hand," a close comparative analysis of the handwriting across all these speeches undoubtedly reveals Douglass's presence. At the same time that it is almost certainly the case that that his typed manuscripts are accompanied by his own annotations, it is equally inarguably the case that at least significant portions, if not all the sections, of his handwritten manuscripts were authored by Douglass himself. While a forensic analysis of his handwriting is urgently needed in order to settle all doubts, a working comparison of the handwriting on view in

8 Hooker, "A Black Sister," 690.
9 See Douglass, "Santo Domingo," in Blassingame, *Frederick Douglass Papers*, vol. IV, 342–55.

this manuscript with that in other manuscripts about which there is no ambiguity of his authorship renders it indisputable that significant sections were authored by Douglass himself.

As for who composed the parts that are not obviously in Douglass's handwriting, there can be little doubt that the most likely candidate is Rosetta Douglass Sprague. As she proclaimed, "I was my father's amanuensis," a role she fulfilled for the majority of his life, and especially during the decades before he married his second wife, Helen Pitts Douglass, in 1884.[10]

10 Qtd. Whittle, "Negroes in Washington," 9.

Figure 41: Anon., *Toussaint Louverture*, n.d. (Prints and Photographs
Division, Library of Congress, Washington, DC.)

26. Frederick Douglass,
"Lecture on Santo Domingo," c. 1873

Lecture on Santo Domingo
To be delivered in the mercantile
Library

26. Frederick Douglass, "Lecture on Santo Domingo," c. 1873

Ladies and Gentlemen:

I was last winter honored with an invitation by President Grant, to accompany a commission composed of three distinguished Gentlemen: Hon. Benjamin F. Wade of Ohio, Hon. Andrew D. White of Cornell university, and Doctor Samuel G. Howe of Boston. This honorable commission created by a resolution of Congress was authorized and directed to proceed to the island of Santo Domingo and to such other places, if any, as such commissioners may deem necessary, and there to inquire into and ascertain, and report, the political state and condition of the Republic of Dominica, the probable number of inhabitants, and the desire and disposition of the people of the said Republic, to become annexed to, and to form part of the people of the United States. I accepted the invitation and accompanied the Commission. I mention the fact not with a view to a statistical report as one of the witnesses which however entertaining in a book could scarcely be expected to please in a lecture, but as a fit explanation of the choice of the subject, which I have ventured to make my theme for this Evening. For accurate and complete information upon all the points of inquiry suggested by Congress I commend the able report of the honorable Commissioners

26. Frederick Douglass, "Lecture on Santo Domingo," c. 1873

Among that vast group or series of islands, adjacent to the American continent, and which by neighborhood at least, may claim a right to share its destiny. extending from the shores of Florida, eastwardly and southwardly, far into the broad atlantic, fringeing the gulf of Mexico, and the blue Carribean sea, as with a wreathe of tropical flowers, with Cuba on the west and Portorico, on the east, dominated by two Governments. Hayti on the one part and Dominaca on the other, three days sail from Key west, and six from Newyork, stands the island of santo Domingo. nearly as large as Ireland. and capable of sustaining a larger population, but to day, has not within her borders more than eight hundred thousand souls. and three fourths of these, are in Hayti, the smallest division of the island.

Putting aside the momentous political questions supposed to be involved in the future of santo Domingo; Putting aside the pronunced and sharply

26. Frederick Douglass,
"Lecture on Santo Domingo," c. 1873

defined differences of opinion, to which the proposition
to annex a part of that country to the United States
has given rise; putting aside the eloquent and powerful
opposition to that measure, by one of the nation's
ablest and most trusted senators. and on the other
hand, the support given that measure, by one of the
nation's most even minded and trusted Presidents.
whether we consider Santo Domingo geographically, and with
reference to climate, soil, commercial and other important
resources, or historically, as illustrating, peculiar phases
of civilization, and as enforcing, important lessons worthy upon
the attention of mankind. there is enough in that
country, to invite the american people to a better
acquaintance with its life and fortunes, than has
hitherto existed.

Santo Domingo may be viewed from two points of
observation. While abundant in material worthy
the attention of scholars and statesmen, to whom
no part of our planet, or our species can be
matter of indifference, this beautiful island

is abundant in those great facts and features, which appeal
directly and powerfully, to the poetic and better side
of human nature,

Not from the selfish, grasping, ambitious, and rapacious
side of human nature, not from that side which dreams
only of wealth and power, of silver, gold and precious
stones, which repines at natural limitations, and in
the name of manifest destiny, which is often but another
name, for injustice and violence by the strong towards
the weak, would annex the whole continent to the united
States, but from that nobler and better side, which allies
man to the infinite, leads him to despise narrow
prejudices of race and color, rejoices in human
progress and in the diffusion of light and liberty among
men, would I commend the contemplation
makes all the world our country and all mankind
our countrymen- would I commend the
Contemplation of Santo Domingo.

26. Frederick Douglass, "Lecture on Santo Domingo," c. 1873

the united states, but ~~to~~ from that nobler and better side, that side ~~which~~, which rejoices in human progress, and in the difusion of light and liberty throughout the world, would I commend the contemplation of Santo Domingo.

There are countries not less than individuals, which have their own sad experiences, to tell the world, and to whose story, ~~and to whose story~~ the world is ever more or less disposed to listen.

Poland, crushed and bleeding under the heel of despotic power, uttered a shriek which pierced the heart of the world. The great Hungarian, orator and statesman caused all eyes and hearts to turn to the wounds of his bleeding country, Ireland, whose sorrows are ever present, melts us by her wail from across the sea. France writhing in the folds of a double calamity, although plainly the author of her own misfortunes, sters compassion rather than reproach.

Great men put tongues in the earth whereon they live and move. Greece and Rome, have nothing for heart or imagination, apart from the great peoples of whom they constantly remind us.

It is no forced or extravagant association to say, in this Connection, that Santo Domingo,

26. Frederick Douglass, "Lecture on Santo Domingo," c. 1873

4

with her black and swarthy population, diminished and
and apparently diminishing, ~~apparently~~ bountifully blessed
by nature, and woefully cursed by man, now trembling
on the very verge of civilization, doubtful of her fate,
debating the question, whether she shall at last
be saved to peace, progress and happiness, or fall
away, into the measureless depths of barbarism, has
after her manner, and according to her measure
of importance in time and space, her claims to
present, her appeal to make, her story to tell.
Of what that story is, in all its fullness, detail,
and coloring, my lecture must be taken as the merest
indication. From the nature of the occasion
and the limits of the hour, I can at best but hint
its character, and feebly echo its import.

My object will however, be attained; if by
any thing I may be able to say, your minds may
be turned to this island, and to other and better sources
of information concerning it than a brief lecture
necessarily devoted to generalities can possibly be.

The island of Santo Domingo is an interesting
object of thought and feeling, not only because of its
past and present condition, but because of its
association, with the discovery and settlement of

246

5.

of the american continent by the white race.

First things, by virtue of being first things, especially when they are the beginnings of great epochs, the starting points of great events have a peculiar fascination for the minds and hearts of men. The cradle is a sacred object among household furniture. Since Adam, imagenation has strained for a glimpse of Eden, and has labored hard to set it forth in words, forms and colours,

Perhaps, no single event has occurred since the migration of men, which has more radically affected the conditions and relations of men, than the discovery and settlement of america by Europeans, and from this great fact, Santo Domingo borrows a real importance. As a country it stands among american first things_ and must ever be recognized as the Cradle of american beginnings.

Though not of the Caucascian race, and making no claim to any share of its greatness, and though I am not remarkably emotional, I must confess to something like a thrill, when for the first time I stepped upon the shores upon the shores of Santo Domingo, and thought that here, under my feet, and all around

26. Frederick Douglass, "Lecture on Santo Domingo," c. 1873

me is the first american soil trodden by Europeans;
that here first appeared the head of that mighty
Caucasian column, in its portentous and wonderous
march from east to west, and which has already
sent the lightening to announce its coming around
the world.

The mountains of Santo Domingo, for it is preeminently
a land of mountains. Some them, bold and striking
in out line, grand and majestic in altitude, lifting
their greyish blue summits seven thousand feet between
Sea and Sky, clothed all over with the verdure of Eternal
Summer, were the first lands to soothe and gladden
the strained and feverish eyes of him, who in the twilight
of scientific faith, sought the shores of a new world:
Here surrounded by the surpassing splendours of tropical
Nature, this balmy air, these delicious fruits and fragrant
flowers, where every prospect pleases. here under this most
beautiful of all Skies, were first planted the virtues and the
vices, the beauties and the deformities, of what was once
known as European Civivilization. a civilization destined
to bear here, as it had borne else where, its natural
fruits of good and evil. Oppulence, ease, luxury and
dissipation on the one hand, toil, Slavery, destitution and
misery on the other, but in sharper contrast.

26. Frederick Douglass, "Lecture on Santo Domingo," c. 1873

Here too, was first unfolded the solemn mysteries of the hebrew scriptures, and the sacred traditions of the Holy Roman Catholic Church. Here, the new world first heard the sound of the Christian gospel: and saw raised on high that wonderous symbol of relegious power the Cross of Christ

Long before old Plymouth Rock had yet a tongue and the psleams and prayers of Pilgrim fathers were heard on the wild new England shores. Santo Domingo was the recognezed centre, of a vast and powerful relegious organization whose ramifications reached far into south, and Central America.

From the beginning of its settlement this island, became the rediating point for Catholic Christianity, and the ambetion of the colonists, was to make it little Spain in character, as well as in name. Spain sent here, her ablest scholars and her most eloquent Devines – and here were displaged a zeal and an energy in church building for which Catholic Christians are remarkable. What they do for God, at least, has the merit of great earnestness. Their altars, their churches, their colleges and their convents, were on a scale of magnificence and grandeur hardly

8

Surpassed by ecclesiastical architecture and ornamentation in the parent Country. Wonder and amazement must have filled the minds of the simple natives as they beheld these stependous works in process of erection.

Santo Domingo, to day, not only in the manners and bearing of its people, but upon the face of the Country it self. proclaims the great religious earnestness of the people who framed its institutions and shaped its modes of thought and life. It is literally a land of Crosses and of Saints. At every stream and at almost every turn in its narrow roads and winding paths, you meet with the Cross—and wherever seen it is an object of respect and veneration. It marks all places of accident and unusual occurances. Propped up in a small round heap of stones—rudely thrown together on highway or by way—however exposed the situation, the cross is safe. No impious or wanton hand will be raised to strike it down. Wherever human life has perished or human bones repose, there is planted this mighty symbol to comfort the pious, and warn the thoughtless. Had man himself been the object of half the respect, still shown this wooden cross made by man—the history of this island might be read to day with greater freedom horror. But religion was every thing, man—was not much.

26. Frederick Douglass,
"Lecture on Santo Domingo," c. 1873

9.

Of all the Cities in this Sainted island, this holy land of the new
world, where towns, cities, bays, Streams, nearly all bear the
name of some Ancient Saint, the famous old city of Santo Domingo
affords to day, the best evidence of the power of the priesthood
over the earlier settlers of the Country.

The city itself in all its appointments is a curious object worth
almost worth a voyage to see it — and even a ship wreck if it turns
us worse than than the papers made of the Tennise.

Standing at the entrance of the Ozama — a beautiful river,
whose waters currant is here met by the ocean, and which makes for the
city a remarkably quiet harbor, as also an ample highway for
its commerce with the interior, Santo Domingo facing the
south, looks grandly out to Sea — with its vision only bounded
by where the blue waters meet the still bluer Sky.

Viewed at a distance of four or five miles from the
land, surrounded as it is, on three sides, by distant
mountains all draped as they are are, with passing shadow
from the fleecy firmament, the city in the foreground
makes a decidedly pleasant impression — an impression
however which it but feebly Sustains upon a nearer
approach.

251

10

The harbour of Santo Domingo, is studded with grim old forts. displaying high walls and towers, built according to Spanish science formidable to the eye, but evidently a poor defense against modern artillery. These stand mainly along the river shore. rather to protect the river than to defend from Sea.

For the most part Santo Domingo, is well laid out, Its streets are kept quite clean. They are long, straight and narrow. On either side they are lined by, flat roofed, red tiled, rough cast whitey brown houses & — presenting an appearance of great Solidity. Each one of these dwellings, is built exactly like the other. No line or Sign appears to mark a Separate residence. All look as if planned by the Same architect, built, by the Same work men, completed at the Same time, owned and occupied by the Same family. The thickness of the walls and the Style of Construction are doubtless, well enough Suited to the climate. which of course is the Main consideration. They resist alike the huracane and the fierce rays of the Sun. but they are oppressively monotonous, and offensive to our Republican love of variety. Of taste, and invention they have none. There is almost a total absence of what we call individuality in the Character of these houses Neat and clean. within and without; but low, staid, gloomy and Spiritless.

The outer walls, make the impression that they were first completed, *and were and independent work.*
and were afterwards partitioned off and fashioned into dwellings
according to the wishes of their occupants. Each family being
allowed so much space. Every thing about them conveys
a peaceful sense of oneness, which may easily be traced not
only to the climate, but to one Church, one faith and one
baptism; for religion here, enters into everything.

We in the United States let something of our regard for
ornament, show itself at our front doors. Nothing of the sort
is manifest in the dwellings of Santo Domingo. The people
seem indifferent as to the impression made by the entrance
to their houses. Their doors are of huge dimensions and swing
on heavy, long iron hinges. They are all after the barn door
order. and are in fact used as such, for the Spaniard
in his Spurs, does not dismount his Arabian Steed
till within the walls of his house, hence the horse
and his rider enter through the same door. The horse
is a small but strong, and beautiful animal, full of life,
and is never shod with iron. He seems perfectly at
home in the family of his master. In this he is not
singular, for all domestic animals here, sustain very friendly

12

relation to the families to which they belong.

To the eyes of american ladies, if not to those of american gentlemen, the windows of Santo Domingo dwellings would seem altogether atrocious. designed more to let out the dark than to let in the light. Though broad and high, the floor of the dwelling is so far ~~from~~, below the window sill, as to conceal all but the heads of the inmates. They are simply prison likes, iron grated, glassless, curtainless and are usually kept half closed, on the inside, by huge window shutters made after the patern of the doors.
One marked feature of the place, and which gives it the appearance of great antequity, is the old wall of solid masonry, still in pretty good condition, mounted at intervals by heavy guns, and pierced at others for the use of small arms, entered at several points through large gates gaurded by soldiers. This wall completely surrounds the city and thus walled, thus streeted, it is thus doored, thus

26. Frederick Douglass,
"Lecture on Santo Domingo," c. 1873

windowed, thus situated, at the mouth of
of the river of the Osama, looking out grandly
upon the broad blue sea. containing a population
of about seven thousand, noiseless and solemn,
as a New England sabbeth, you have the ancient
city of Santo Domeingo, the oldest metropolis of the
New world. once full of life and activity. it
contained within in these same old walls,
seventy thousand souls. full of life and activity.
Many of the massive and imposing relegious
structures, built in the days of its relegious
power, wealth and glory, still adorn the city.

In all her vicissitudes and trials, and
they have been many, the relegious character
of Santo Domeingo, has never deserted her.
With all sincerity and freedom from doubt, the people
of that old town will tell you, that in time
of drouth, they have only to display in the open
streets, a certain old cross said to have been
brought over by Christopher Columbus, in order
to bring rain from heaven. According to them
this cross is as potent to upon the windows

14

of heaven, as the prayers of a certain old prophet
were to shut them.

At the faintest dawn of each new day,
religious service is duly performed in all the
churches of the place. While the darkness of
night still makes visible the great Cross
in the southern sky, and her watchmen
who pace her streets all night, faithfully
telling the hours and the state of the weather
have scarcely ceased their dreary round,
when the ears of the people of Santo Domingo
are saluted with a perfect tumult of bells
more confused and excited than a fire alarm,
summoning the faithful to their altars, and
to their prayers, nor do they summon in
in vain. At the first wild clang of these
of the Church bells, the streets are thronged
with pious men and women, demurely winding
their way through through the darkness
to confess, if not to forsake their sins,
and pray for pardon.

An american visitor would find in Santo
Domingo many objects of curious interest,
and among those about which he would

15

linger longest, is the old church of SanFrancisco, It is
the most ancient, and was once the moht Splended,
religious edifice in that city if not in the island
It is now one Vast ruin, and the base uses to
which its once, sacred walls are put, involves a
somewhat puzzling contradiction to the generally
superstitious Character of the Santo Domingo people.
With strange and unaccountable irreverence, this
this holy place, this solemnly Consecrated temple
of God where he was supposed to meet his Saints,
the very approuch to the gates of which once
filled and thrilled the minds of men with deep
religious awe, is now only a large pen used
to enclose goats, swine and other animals and
raising them for the market. It is rented to
and old woman, who seems to have no sense
of impropriety in converting the solemn
temple into a stable for domestic animals.

16.

Besides raising pigs and goats and fowls, in the
holy place, she keeps bees, and has long lines
of Bee hives there for making honey. This
done chiefly for the wax a large item of
of Santo Domingo Commerce.

With a queer taste for seclusion the old lady
Preitess and proprietress, of this ghostly old
ruin, makes her home in one of the best pre-
-served part of its walls and seems very
well pleased with her ~~residence~~ gloomy residence,
An american much less superstitious would
as soon ~~things~~ think of hiding away at night
among tomb stones, as within the walls of this
old ruin. Somewhat shy in her manner
the old lady does not take it amiss to
be called upon to show the ruin nor does
she feel offended by any little grateful
testimonials that those whom she serves
may be pleased to leave in her hands.

26. Frederick Douglass,
"Lecture on Santo Domingo," c. 1873

But what a change is here! and what a lesson of the transcent character, of the most enduring and sacred works of men does this old ruin teach. A vision of the zeal, energy, the toil, sweat and skill here ~~had~~ employed, rises before us as we behold it. It was meant to stand forever. But now its mouldering remains, no longer ~~an~~ objects of pride and piety to all Santo Domingo, but rapidly mixing with the dust whence it was taken, and devoted to uses never dreamed of by its founders. Its lofty domes, its towers and turrets, its galleries, its pulpits and alters, have fallen. The day of its greatness and power, like that of its founders is past In its dessolation, it has not become the habitation of bats and owls, but the dreary shelter of pigs, goats and poultry, The whole scene is melancholy. Here and there amid the general decay. You see a grand old Roman archway, a broken pillar, an angle of an inner wall, which has sternly resisted the slow but certain and destructive shafts of time. But arch, Pillar, and angle, only loom over the more perishable, parts of the fallen structure like monuments over the shapeless graves of the dead! Some thing is added to the dreary ness of this scene, by the contrast it presents to the life, fulcness, of tropical nature - which fairly sports-

18

and laughs, in triumphs over art. Man's noblest achievements in architecture are but play things in her hands. She touches his cloud capped towers and gorgeous palaces and they crumble to ruin. to dust and ashes.

Favored by all her forces of climate and soil, She revels in destruction. The palm, the Cocoanut, the Banana, Zapodilla, and graceful olianda, with other tropicaly growths, rich and beautiful, rise high above, and fling their shadows, interlacing vines and creepers, which now cover the holy floors, where wealth and fashion once knelt in pride to pray. Her alth The priest, the alter, and the incense are gone, and the delightful chants of her sacred songsters have given place to the hum of industrious bees.

In looking here and elsewhere in the city, at the # ravages made by time and the elements, gloomy apprehensions will come for the hallowed structures of noble demensions, which have thus far braved their destructive power and yet make a solid and respectable appearance. It is impossible. not to feel that where old San francisco has gone these must go also

26. Frederick Douglass, "Lecture on Santo Domingo," c. 1873

Tropical heat and insular moisture, both ever active and sleepless here, powerful agents alike to create and to destroy, are already displaying their destructive tracing upon the alters, the pulpits and upon the walls, of the best preserved among them.

If in the United States, time wears, cities burn, churches fall, there is a spirit and a power in the land to build and restore them. Chicago ashes to day, is granite to morrow—but this old city of Santo Domingo—vegetating in the thick of an effete civilization—gives no sign of the wealth and energy that called these hallowed structures into existence. Her people worship at their altars, but the dauntless faith and the tremendous energy that built and fashioned them. The form is there, but the soul is gone.

It does not appear from the religious history of Santo Domingo, that piety and morality, religion and justice, are inseparable—but the contrary. If humanity has bled and justice has been outraged—they have never needed the sanction of the pious—in precept or example.

If in the United States we have had our slavery,

they in Santo Domingo have had theirs also.
If we have sold men to build churches, ~~babies~~
Babies, to buy Bibles, and women to support Missionaries
the Protestant of the North has but imitated the
bad example of his Catholic Brother of the South,

In whatever way the fact may be construed
whether to the support or to the prejudice of religion,
it demonstrates that there is a striking resemblance
between human creeds and human nature - and that the
one is seldom better than the other.

The tendency of religion to secure the order
and stability of society does not gain much strength
from the example of Santo Domingo. While no people
have been more religious, no people have been more
frequently or more violently driven asunder and broken
to pieces by social disturbances and by rapid alternations
of fortune.

Tracing the history of Santo Domingo from
the point of time when as Brougham has it, the
"daring genius of Columbus, pierced the night of ages
and opened to one world the sources of knowledge
power and happiness, and to another all unutterable
woe"- down to the present hour, and we troubles enough
for a national life of a thousand years.

26. Frederick Douglass, "Lecture on Santo Domingo," c. 1873

In view of the experence of this island, there is something
perful in the responsibility assumed by those who under take
to plant civilization in what they may call a barbarous
country.

Of course, nothing can be definitely known of the life
of Santo Domingo under the rule of her chiefs, the caciques,
but it is evident that ~~her life~~ their rule, was more friendly
to human life, than the civilization by which she was cursed.
Whatever, may have been the stillness of that fair and
beautiful island, previously, She has known no repose
since civilization entered her borders.
It was her Cot to be roused from her innocent barbarism
in a rude and startling manner. The night of her ignorance
was broken by no gradual dawn. Civilization such as it
was came upon her all at once, in the resplendent
blaze, of tropical noon day. Her wealth was her misfortune:
She has that within the sides of her mountains and in
the sands of her river beds, which in all ages, has throngod
the highways of the world with fierce and daring
adventurers.
The first ~~thing~~ inquired for by the Spaniards on landing
was gold — They wanted gold. The burning, bewildering
maddening lust for gold; the unappeasible desire for
sudden riches, the most blending and hardening

32

of all desires, attracted to her shores, a multitudinous and overwhelming tide of emigration. Her native population, feeble both in mind and body, vanished before it, as if smitten by the breath of almighty power.

It is hard to believe when we remember the preeminent religiousness of the Spaniards, that in less than a half a century, they had nearly exterminated the native population. From one million their numbers had fallen to sixty thousand souls. Yet such is the incontestible voice of history.

It is said, that in the mountains of Samana, a few of this woe smitten Carribean race are stile to be found. The mission of Christian civilization to these people, was robbery, slavery and death. and the fact that any of them remain to perpetuate the forms and features, of their ancestors, is due to the dens and caves by means of which; they were able to keep out of the way of that deadly civilization.

It was once said by Daniel O. Connell, that the history of Ireland, might be traced like the track of a wounded man by the blood. A strong and startling figure, but one more strong and startling

26. Frederick Douglass, "Lecture on Santo Domingo," c. 1873

is required

is required, for a true picture of the life of Santo Domingo. The experience of the western part of this island, under France, and the eastern part under Spain, and the whole alternately under one or the other of these fierce latin powers, has been of the bitterest and most destructive character. Every form of war, that could smite a nation, every species of oppression and treachery from within and from without, the effect of which is to destroy confidence, and to plant distrust and hate, in the hearts of men were here applied. Every calamity that can follow in the broad, black track of war, including famine and pestilence, have here conspired to render human society impossible.

With a look of wonder, if not of taunt, men ask why the population of Santo Domingo, is so sparse, and why its civilization is so feeble? Let them glance at the nature and history of its wars, its slavery, its slave trade, its terrific and countless revolutions, and they will wonder less, that the population so small and the civilization is so feeble, than they will wonder that it has any population at all, or still clings to the forms of civilized life.

24

~~Hungering~~

This Island was not only the first american Soil
to behold the sacred cross, and to hear the gospel
of the Son of Mary, but the first cisatlantic
country, to engage in the african Trade and
to Darken the dashing billows of the atlantic with
Congo blood.
Stile thirsting for gold, for ease, and splendour,
the pious Spaniards having murdered in their
fields and mines—nearly all their native Slaves,
and dried up the fountain of their native
Supply—threw, lustful eyes to wards the Shores of
Africa.
 A holy priest, a man, with a feeling of humanity
above his fellows, afflicted by the tears and
Sufferings of the slender natives—or the feed that
remained of them—Suggested as a measure
of Christian benevolence, the importation
of Slaves from Africa.
While in the city of Santo Domingo, I stood
upon what was said to be, the very

26. Frederick Douglass, "Lecture on Santo Domingo," c. 1873

Sketch here, the first Cargo of this human merchandize was landed. I will not stop here to describe sensations, or to make reflections upon the fact.

I rather turn, to less distressing thoughts and feelings. There are compensations in history as well as in nature. Santo Domingo, the first american soil to fasten upon itself, and upon the new world, the curse and crime of Slavery, was also the first to feel the dire consequences of that terrible curse and crime. More than Sixty years earlier, than ourselves_she was made to feel the Storm of blood and fire, that follows ever_Sooner or later, on the track of national crime. Her mountains were made to Smoke, and her valleys to blaze with fierce wrath and revenge. Her Toussaints, her Dessalines, and her Christophes, were the first of their race, to teach the world that it is dangerous to goad the energy that Slumbers, in the black man's arm.

As to the passions stirred and fostered here, no talent
is required to ~~sho~~ show some analogy, with the
physical character of the country itself. The
very soil is full of extremes. Wholesome and
Noxious growths abound. Light and Shade
glare and gloom, heat and Moisture, a Serene
Sky above, and Slumbering earthquakes beneath.
No orange is So Sweet. No orange is So bitter.
Both the bitter and the Sweet grow in the Same
garden. and draw their respective qualities from
the Same rich Soil . Kindness and Mercy
Sweet as Tropical flowers, Shine in the
Character, of the brave, Toussaint, Revenge and
Hate, deadly as tropical plagues, and poisons,
flash from the eyes and quiver on the lip
of the equally brave and the determined
Dessalene.
There is nothing lovely in vertue or hateful in vice

26. Frederick Douglass, "Lecture on Santo Domingo," c. 1873

nothing holy in truth, or corrupt in lies; nothing
that exalts men into heroes, and heroes into Gods
or debases men into monsters and monsters into fiends,
which we may not find here illustrated, magnified,
intensified.

The question as to which were the more cruel and
and demoniacal in their barbarities the whites or the
blacks has never been an open question for americans
until now. Judgement has long since been rendered
against the blacks—

The horrors, of Santo Domingo, the frightful horrors,
of Santo Domingo! Who has not heard and trembled
at these horrors: A thousand times they have
been invoked to excite the malign passions
of the whites against the blacks and to hurl
the fury of the mob, against the Abolitionists.
It was a crafty device, and did
its work of mischief well. For a long time it kept Santo
mingo an outcast among the nations of the earth. For
more than fifty years she knocked at the doors of this nation
for recognition and was fiercely driven away.

Never said, a member of Congress, who is
still living, and who at the time, spoke the sentiment
of the Country, "Never will I, never will my constituents, be

forced into to this recognition. This is the only body
of men who have emancipated themselves by butchering
their masters, They have been long free I admit; yet
if they had been free for centuries, if time himself
should confront me, and shake his hoary locks at my
opposition; I should say to him, I owe more
to my constituents, to the quiet of my people
than I owe, or can owe, to mouldy prescriptions
however ancient.

Well, Galileo dies, but the world moves. and along comes
another compensation. Santo Domingo is recognized,
and a better intelligence has lifted the blasting reproach
from the brows of the black heroes, who sought
only to be free, and fixed it upon the brows of those
who sought to enslave them.

The american people have had their eyes anointed by a
bitter experience. The treacherous and savage capabilities
of men who have lived by enslaving their fellow men- are
better understood now than ten years ago.

26. Frederick Douglass, "Lecture on Santo Domingo," c. 1873

We read these capabilities now in the characters of our Winders, Torretts, and Davies, in the horrors of Andersonvilles, and Saulsburys.

It is not to be denied that the negroes of Santo Domingo—when once roused from their long suffering were terrible in their vengeance, and committed excesses at which humanity must always shudder; but the wildest and most shocking of these were paralleled, and provoked by the crimes and excesses committed by the whites who made war to enslave them.

The blacks of this island were comparatively moderate in their dealings with their old masters in the first struggle to put off the yoke. It was not until they had been free, prosperous and happy six years, under the wise and benignant Government of Toussaint Louverture, and Bonaparte, the first his black, ~~sent~~ of our century— sent six hundred ships and forty thousand soldiers under the ablest generals that France could boast, to reenslave them, that the black and mulatto people of that island perpetrated their greatest horrors. And this ~~thought~~ fact is especially worthy of thought at this moment when an effort is being made again to reduce to slavery the same race among ourselves who have now been six years free from the chains of slavery.

271

26. Frederick Douglass,
"Lecture on Santo Domingo," c. 1873

Much has been said of the meanness and treachery
of the mulattoes of Santo Domingo- and of the
prejudice of the latter towards the blacks.

This island, in addition, to its other wars has
been cursed with that most accursed and implacable
of all wars- a war of races. It must be confessed too,
that the embers of this conflict still smoulder in that
island- and may break out again at any moment.

The foundation of the bad feeling between the two colors,
is easily comprehended. If the mulatto is treacherous
and malignant towards the blacks and whites. as he seems
to have been- it is not because nature has denied to
him qualities less noble than other varieties of men-
but because of his abnormal relations.

The mulattoes, from the beginning were constituted a separate,
Caste. By blood and position they were connected with
both the white and the black races of the island,
and by the same, they were separated from both
and made a peculiar people.

26. Frederick Douglass, "Lecture on Santo Domingo," c. 1873

The latin race, freer than the saxon, from mere prejudice of color and race, were not quite base enough to enslave their own flesh and blood in the persons of their mulatto children — and yet, were not noble enough to place them on a level with themselves.

Hence they made a compromise. They gave their mulattos an intermediate position, as well as an intermediate color.

Like all other compromises it has resulted in disappointment and misery to its framers.

Wrong is as logical and as exacting as right. Man must either be free, or slave. He will never be content with a condition of halfness. Concession is ever the fatal apple of discord in the end.

The mulatto, between the slave, and the slaveholder, was necessarily the friend of neither. He was in a condition to espouse or abandon the side of either as interest or passion might dictate.

Society, without consulting his wishes in the matter, had in advance, ordained him to be a disturbing force, a natural born conspirator. and such he has been and such he will be, till all notions of a barbarous caste shall have been swept from that country, as it certainly will

273

26. Frederick Douglass,
"Lecture on Santo Domingo," c. 1873

be in the end swept from our own great Republic. A man here may yet be made to receive indignities in the united States on account of race and Color – but the overwhelming tendency of our times, is to human equality.

I have no disposition to defend the mulattoes as against the blacks of Santo Domingo – but it is true to the truth of history to affirm that, to the mulattoes belong the credit of the origin of the terrible struggle, which finally gave freedom and independence to the whole people black as well as mulattoes

I went to Santo Domingo, as also did the honorable Commissioners in an impartial Spirit prepared either to oppose or to advocate annexation. I went there not as upon a holiday excursion as malice painted the Commission. but to see and learn for myself all that could be Known of the true condition of that Country –

26. Frederick Douglass,
"Lecture on Santo Domingo," c. 1873

It is, as intimated at the beginning, impossible, to describe
in detail, all the facts that came to my knowledge,
during my visit; but is due to you and to the
completeness of my lecture to state briefly the general
conclusions, forced upon me by all I saw and learned.
1st.

Latin civilization: Whatever may have been its merits and
achievements in other times and places, it has here
in Santo Domingo, been a most miserable failure. It has
brought one of the most beautiful and richest countries in
the world to the verge of ruin.

2dly There is nothing in the climate or soil nothing in the
conditions it affords for health and vigour of body
and mind, which have made this failure necessary.

3dly The cause of this failure is to be found in that rapacious spirit,
that insatiable greed for gold, which forgets the claims of a country
in a selfish individualism, which would reap where it has not
sown and gather where it hath not strewn which ex-
terminated the native population, and filled their places
with slaves from Africa, and spent the wealth gathered
here, not in efforts to improve the country, but,
in the follies and dissipations of foreign
countries, leaving ignorance, superstition and misery
in the land from which riches and luxuries were derived.

bequeathing to the country that gave them wealth and honor, only ignorance, superstition and misery.

3 dly

While the people of Santo Domingo, in their personal relations seem quiet, order loving, and peaceable, their political affairs have been in the hands of rival ambitious chiefs, one holding power, till put down by another revolutionary rival. The pronunciamentos of these chiefs fill the air, and keep the country in a constant state of alarm – and in a general state of insecurity wholly unfavorable to industry, and the acquisition and diffusion of wealth – No man knows the day – when his cow, horse or other property may be confiscated by some one of the revolutionary chiefs who may raise in the mountains, the cry of God and liberty.

4th

That society here has been so long running in the deeply worn grooves of political disorder –

26. Frederick Douglass,
"Lecture on Santo Domingo," c. 1873

and has become wasted by this peculiar revolutionary life,
that there seems no power to lift itself out of these
ancient grooves.

5thly

That this view of the situation is held the most intelligent
and patriotic citizens of Santo Domingo, and they are
therefore deeply and earnestly desirous, to be annexed
to some strong government, which could and would make
successful revolutions impossible and thereby destroy the
motive which prompts them, and by securing peace, would
revive, industry and commerce, and in a word save the
country from a return to barbarism.

6thly It was manifest to all who went to Santo Domingo,
including the opponents as well as the friends of
annexation, the vast majority of the people
of Santo Domingo are decidedly in favor of
annexation to the united States.

26. Frederick Douglass, "Lecture on Santo Domingo," c. 1873

Now having heard these statements and conclusions. if you ask am I in favor of the annexation of Santo Domingo, I answer, most assuredly I am.

There was a time in the history of our Republic, when the thought of any extension of its dominion was painful to me and to the friends of of free institutions generally.

Annexation then meant the extension of slavery — the opening of new slave markets, the revival of the internal slave trade, the addition of more slave States, more slave representation in Congress, and greater security to slavery at home and abroad.

26. Frederick Douglass, "Lecture on Santo Domingo," c. 1873

It now means the enlargement and security of human Liberty, the diffusion of knowledge and happiness, and the redemption of mankind from oppression, king craft, priest craft and superstition.

The friends of Santo Domingo, ask why extinguish this colored Nationality? I respect the sentiment that prompts the inquiry—but the answer is, when nationality ceases to be a reality, when it ceases to be a help—and becomes a positive hindrance; it is the plain duty of the people oppressed by it, to get rid of it, and it cannot be wrong to assist such people in laudable efforts to that end.

A national government imposes no trifling burdens and responsibilities, Such a government implies, wealth numbers and the power to insure order at home and to command respect abroad.

It means men and money: It means foreign and domestic relations. It means the sending of diplomatic agents to distant governments—and the reception of such agents in return. It means armies and navies. It means the ability to make and enforce treaties.

Titles, and tinsel show, His honor and His excellency, or his gracious Majesty, without these qualifications, are simply contemptible.

26. Frederick Douglass, "Lecture on Santo Domingo," c. 1873

Nations, like husbands must be either loved or feared, and vice versa.

Nations can not live by faith. In all that concerns Nationality. means must be kept steadily in view and must be proportioned to the ends to be accomplished. A train of Rail Road iron is not to be moved by the wings of a butterflies.

A small, and weak, Nationality, is out of joint with our times. Such Nationality fare badly enough in Europe. Where there is a necessity imposed upon the stronger ones, to protect them by maintaining what they call the balance of power.

But where no such necessity exists a small nationality, becomes the crushing armour of a giant, on the shoulders of a pigmy. It is a thin shelled egg among cannon balls and is apt to meet the fate of such an egg.

26. Frederick Douglass, "Lecture on Santo Domingo," c. 1873

The flag of such a nation instead of lifting its citizen with strength and pride, fills them with a gloomy and dispiriting sense of their weakness - is a flag that ought to be exchanged for another. Organization, extention, unification, and progress are the grand features of our age.

The English and German tongues are girdling the globe. No rival Houses of beligerent Barons now dispute the realm of England. The Teuton shouts over unified Germany. The long devided members of Italy have reunited. The attempt to devide our own states - and set up a little slave Confederacy, has failed. These facts are but the indications of the irresistible tendency of our times.

Now, the truth about Santo Domingo, is that she is to weak to stand alone. Her wise and patriotic men know it and feel it. They lay aside ambition and national distinction for the welfare of their country and instead of being taunted with selling their country they should be commended for their

wisdom and patriotism.

They believe that it is better to be a part of a strong nation, than the whole of a weak one.

But it is said that the extinction of this colored nationality, will be an untimely and an ungracious humiliation of the colored race and that the friends of that race should set their faces against it.

While I admit, that the motive at bottom of this objection is good and one which I highly respect — I am wholly unable to see any force in it.

There is no humiliation involved in the measure to either party.

It is remarkable that while abolitionists are endeavoring to guard Santo Domingo against the degradation of annexation, the anti

26. Frederick Douglass,
"Lecture on Santo Domingo," c. 1873

Abolitionists, are endeavoring to save the United States
from the degradation of such a union.

One or the other of these classes may be wrong, but both
cannot be right - though both may wrong.

I hold it neither degrading nor humiliating to be
made a citizen or a state of the United States, but an
but an honor and a privilege to be either.

Roam through the wide world and where
is their a nation, so enlightened, so liberal and so
progressive as the people and govern^ment, of the united
States? Wrongs there^are, many and great, but where
is there one, in which there is alike ground to look
for reform and improvement?

The men who framed and formed this union
knew the dignity and value of Nationality. But
they were no sentimental dreamers. They had the
wisdom to see that the whole is stronger than a
part - and that small states united, formed a safer
condition of Nationality - than small states devided.

26. Frederick Douglass, "Lecture on Santo Domingo," c. 1873

We are told that annexation is not to end with Santo Domingo.
and I ask what if it does not? [So ecd] What if Hayti, Cuba Jamaica
and other islands adjacent to our continent, should one
day, seek shelter under our flag and share our liberty and
our civilization? Our form of Government is ample and
admirably adapted to expansion. It was not our territorial
dimensions that brought division and strife. but slavery.
In religion and in politics, there are to principles that
have ever shook the world. One is liberal and progressive,
and, [the other] despotic and conservative. It is ever the same old
contest. The ages may change its form. but never its
substance. and all nations, kindreds, tongues and
people. must sooner or later take their lot with
the friends of one or the other.

26. Frederick Douglass, "Lecture on Santo Domingo," c. 1873

Ladies and Gentlemen:

I was last winter honored with an invitation by President Grant, to accompany a commission composed of three distinguished Gentlemen: Hon Benjamin F. Wade of Ohio, Hon Andrew D. White of Cornell University, and Doctor Samuel G. Howe of Boston.[11] to This honorable commission created by a resolution of congress was authorized and directed to proceed to the island of Santo Domingo and to such other places, if any, as such commissioners may deem necessary, and there to inquire into and ascertain, and report, the political state and condition of the Republic of Dominica, the probable number of inhabitants, and the desire and disposition of the people of the said Republic, to become annexed to, and to form part of the people of the United States: I accepted the invitation and accompanied the commission. I mention the fact not with a view to a statistical report—as one of the eye witnesses which however entertaining in a book could scarcely be expected to please in a lecture, but as a fit explanation of the choice of the subject which I have ventured to make my theme for this Evening. For accurate and complete information upon all the points of inquiry suggested by congress I commend the able report of the honorable commissioners.

Among that vast group or series of islands, adjacent to the american continent, and which by neighborhood at least, may claim a right to share its destiny—extending from the shores of Florida, eastwardly and southwardly, far into the broad atlantic, fringing the gulf of Mexico, and the blue Carribean [sic] sea, as with a wreathe of tropical flowers, with Cuba on the west and Portorico [sic] on the east, dominated by two Governments, Hayti on the one part and Dominaca [sic] on the other, three days sail from Key West, and six from New York, stands the island of Santo Domingo, nearly as large as Ireland, and capable of sustaining a larger population; but to day, has not within her borders more than eight hundred thousand souls, and three fourths of these, are in Hayti, the smallest division of the island.

Putting aside the momentous political questions supposed to be involved in the future of Santo Domingo; Putting aside the pronounced and sharply

11 Benjamin Franklin Wade (1800–78), US senator for Ohio until 1868; Andrew Dixon White (1832–1918), US co-founder and president of Cornell University; and Samuel Gridley Howe (1801–76), US abolitionist and physician, instrumental in establishing education for people with a visual impairment.

defined differences of opinion to which the proposition to annex a part of that country to the United States has given rise; putting aside the eloquent and powerful opposition to that measure, by one of the nation's ablest and most trusted Senators—and on the other hand, the support given theat measure, by one of the nation's most even minded and trusted Presidents,[12] whether we consider Santo Domingo geographically, and with reference to climate, soil, commercial and other important resources; or historically, as illustrating, peculiar phases of civilization, and as enforcing important lessons ~~worthy~~ upon the attention of mankind—there is enough in that country, to invite the American people to a better acquaintance with its life and fortunes, than has hitherto existed.

Santo Domingo may be viewed from two points of observation. While abundant in material worthy the attention of scholars and statesmen, to whom no part of our planet, or our species can be matter of indifference, this beautiful island is abundant in those great facts and features, which appeal directly and powerfully, to the poetic and better side of human nature.

Not from the selfish, grasping, ambitious, and rapacious side of human nature, not from that side which dreams only of wealth and power, of silver, gold and precious stones; which repines at natural limitations, and in the name of manifest destiny, ~~which is~~ often but another name, for injustice and violence by the strong towards the weak, would annex the whole continent to the United States; but from that nobler and better side, which allies man to the infinite, leads him to despise narrow prejudices of race and color, rejoices in human progress—and in the defusion [sic] of light and liberty among men, ~~would I commend the contemplation~~ makes all the world our country and all mankind our countrymen—would I commend the contemplation of Santo Domingo.

~~the united states; but from to that nobler and better side, that side which rejoices in human progress, and in the difusion of light and liberty throughout the world, would I commend the contemplation of Santo Domingo.~~

There are countries not less than individuals, which have their own sad experiences, to tell the world, and to whose story, ~~and to whose story~~ the world is ever more or less disposed to listen.

Poland, crushed and bleeding under the heel of despotic power, uttered a shriek which pierced the heart of the world. The great Hungarian orator and statesman caused all eyes and hearts to turn to the wounds of his bleeding country, Ireland, whose sorrows are ever present, melts us by her wail from

12 Opposition to annexation was led by Charles Sumner (1811–74), white US Senator for Massachusetts. President Ulysses S. Grant (1822–85) was a strong advocate in favour of the move.

across the sea. France writhing in the folds of a double calamity, although plainly the author of her own misfortunes, stirs compassion rather than reproach.[13]

Great men put tongues in the earth whereon they live and move. Greece and Rome, have nothing for heart or imagination, a part from the great peoples of whom they constantly remind us.

It is no forced or extravagant association to day, in this connection, that Santo Domingo, with her black and swarthy population, diminished and and [sic] apparently diminishing, ~~apparently~~ bountifully blessed by nature, and woefully cursed by man, now trembling on the very verge of civilization, doubtful of her fate, debating the question, whether she shall at last be saved to peace, progress and happiness, or fall away, into the measureless depths of barbarism, has after her manner, and according to her measure of importance in time and space, her claims to present, her appeal to make, her story to tell. Of what that story is, in all its fullness, detail and coloring, my lecture must be taken as the merest indication. From the nature of the occasion and the limits of the hour, I can at best but hint its character, and feebly echo its import.

My object will however, be attained; if by any thing I may be able to say, your minds may be turned to this island, and to other and better sources of information concerning it—than a brief lecture necessarily devoted to generalities can possibly be.

The island of Santo Domingo is an interesting object of thought and feeling, not only because of its past and present condition, but because of its association with the discovery and settlement of of [sic] the American continent by the white race.

First things, by virtue of being first things, especially when they are the beginnings of great epochs, the starting points of great events—have a peculiar fascination for the minds and hearts of men. The cradle is a sacred object among household furniture. Since Adam, imagination has strained for a glimpse of Eden, and has labored hard to set it forth in words, forms and colours.

Perhaps, no single event has occurred since the migration of men, which has more radically affected, the conditions and relations of men, than the discovery and settlement of America by Europeans, and from this great fact, Santo Domingo borrows a real importance. As a country it stands among American first things—and must ever be recognized as the cradle of American beginnings.

13 Douglass refers here to a series of revolutions in European countries in 1848. A prominent figure during Hungary's revolution against the Austrian Empire was Lajos Kossuth, whom Douglass would discuss in his lecture "Self-Made Men" (1872) among many other places across his unpublished and published oratory and writings.

Though not of the Caucasian race, and making no claim to any share of its greatness, and though I am not remarkably emotional, I must confess to something like a thrill, when for the first time I stepped upon the shores ~~upon the shores~~ of Santo Domingo, and thought that here, under my feet, and all around me is the first American soil trodden by Europeans; that here first appeared the head of that mighty caucasian column, in its portentous and wonderous [sic] march from east to west, and which has already sent the lightening [sic] to announce its coming around the world.[14]

The mountains of Santo Domingo, for it is preeminently a land of mountains, some stern ___ [?], bold and striking in outline, grand and majestic in attitude, lifting their greyish blue summits seven thousand feet between sea and sky, clothed all over with the verdure of eternal summer, were the first lands to soothe and gladden the strained and feverish eyes of him, who in the twilight of scientific faith, sought the shores of a new world: Here surrounded by the surpassing splendours of tropical nature, this balmy air, these delicious fruits and fragrant flowers, where every prospect pleases: here under this most beautiful of all skies, were first planted the virtues and the vices, the beauties and the deformities of what was once known as European civilization, a civilization destined to bear here, as it had borne elsewhere, its natural fruits of good and evil, oppulence, ease, luxury and dissipation on the one hand; toil, slavery, destitution and misery on the other, but in sharper contrasts.

Here too, was first unfolded the solemn mysteries of the hebrew scriptures, and the sacred traditions of the Holy Roman Catholic Church. Here, the new world first heard the sound of the Christian gospel and saw raised on high that wonderous [sic] symbol of religious power the Cross of Christ.

Long before old Plymouth Rock had yet a tongue on the psalms and prayers of Pilgrim fathers were heard on the wild New England shores, Santo Domingo was the recognized centre of a vast and powerful religious organization whose ramifications reached far into south, and central america.

From the beginning of its settlement this island, became the radiating point for Catholic Christianity—and the ambition of the colonists, was to make it little Spain in character, as well as in name. Spain sent here her ablest scholars and her most eloquent Divines, and here were displayed a zeal and an energy in church building for which catholic christians are remarkable. What they do for God, at least, has the merit of great earnestness. Their alters [sic], their churches, their colleges and their convents, were on a scale of magnificence

14 Christopher Columbus (1451–1506) landed on the island on December 5, 1492, naming it Española (Hispaniola). It was also referred to as Santo Domingo, which was in fact the name of a Spanish colony on the island that lasted until 1795.

and grandeur hardly surpassed by ecclesiastical architecture and ornamentation in the parent country. Wonder and amazement must have filled the minds of the simple natives as they beheld these stupendous works in process of erection.

Santo Domingo, to day, not only in the manners and bearing of its people, but upon the face of the country itself—proclaims the great religious earnestness of the people who framed its institutions and shaped its modes of thought and life. It is literally a land of crosses and of saints. At every stream and at almost every turn in its narrow roads and winding paths, you meet with the cross—and whenever seen it is an object of respect and veneration. It marks all places of accidents and unusual occurances [sic]. Propped up in a small round heap of stones—rudely thrown together on highway or by way—however exposed the situation, the cross is safe. No impious or wanton hand will be raised to strike it down. Wherever human life has perished or human bones repose, there is planted this mighty symbol to comfort the pious, and warn the thoughtless. ~~Had man himself been the object of half the respect, still shown this wooden cross made by man—the history of this island might be read to day with greater freedom horror. But religion was every thing, man was not much.~~

Of all the cities in this sainted island, this holy land of the new world, where towns, cities, bays, streams, nearly all bear the name of some eminent Saint, the famous old city of Santo Domingo affords to day, the best evidence of the power of the priesthood—over the earlier settlers of the country.

The city itself—in all its appointments is a curious object ~~worth~~ almost worth a voyage to see it—and even a ship wreck if it turns no worse ~~than~~ than the papers made of the *Tennessee*.[15]

Standing at the entrance of the Ozama, a beautiful river, whose ~~waters are~~ currant [sic] is here met by the ocean, and which makes for the city a remarkably quiet harbor, as also an ample highway for its commerce with the interior, Santo Domingo—facing the South, looks grandly out to sea—with its vision only bounded by where the blue waters meet the still bluer sky.

Viewed at a distance of four or five miles from the land, surrounded as it is, on three sides, by distant mountains, all draped as they ~~air~~ are, with passing shadows from the fleecy firmament, the city in the foreground makes a decidly

15 This was the ship on which Frederick Douglass and Charles Remond Douglass sailed with the US commissioners to Santo Domingo. Here Douglass is undoubtedly referring to widely circulated newspaper reports claiming that the ship had been lost at sea. As James W. Trent Jr. writes, "Because they were out of contact with telegraph equipment and were at sea an unusually long time, there was fear—unfounded as it turned out—that the *Tennessee* had wrecked off the coast of Cape Hatteras" (Trent, *The Manliest Man*, 260).

[sic] pleasant impression—an an impression however which it but feebly sustains upon a nearer approach.

The harbor of Santo Domingo is studded with grim old forts—displaying high walls and towers, built according to Spanish science formidable to the eye, but evidently a poor defense against modern artillery. These stand mainly along the river shore, rather to protect the river than to defend from sea.

For the most part Santo Domingo is well laid out, the streets are kept quite clean. They are long, straight and narrow. On either side they are laid by, flat roofed, red tiled, rough cast whitey brown houses, mostly presenting an appearance of great solidity. Each one of the dwellings, is built exactly like the other. No line or sign appears to mark a separate residence. All look as if planned by the same architect, built, by the same workmen, completed at the same time, owned and occupied by the same family. The thickness of the walls and the style of construction are doubtless, well enough suited to the climate which of course is the main consideration. They resist alike the huracane [sic] and the fierce rays of the sun, but they are oppressively monotonous, and offensive to our Republican love of variety. Of taste, and invention they have none. There is almost a total absence of what we call individuality in the character of these houses. Neat and clean—within and without, but low, staid, gloomy and spiritless.

The outer walls make the impression that they were first completed and were and [sic] independent work and were afterwards partitioned off and fashioned into dwellings according to the wishes of their occupants, each family being allowed so much space. Everything about them conveys a painful sense of oneness which may easily be traced not only to the climate, but to one church, one faith and one baptism, for religion here, enters into everything.

We in the United States let something of our regard for ornament, show itself at our front doors. Nothing of the sort is manifest in the dwellings of Santo Domingo. The people seem indifferent as to the impression made by the entrance to their houses. Their doors are of huge dimensions and swing on heavy, long iron hinges. They are all after the barn door order and are in fact used as such, for the Spaniard in his spurs, does not dismount his Arabian steed till within the walls of his house, hence the horse and his rider—enter through the same door. The horse is a small but a strong, and beautiful animal, full of life, and is never shod with iron. He seems perfectly at home in the family of his master. In this he is not singular, for all domestic animals here sustain very friendly relation to the families to which they belong.

To the eyes of American ladies, if not to those of American gentlemen, the windows of Santo Domingo dwellings would seem altogether atrocious, designed more to let out the dark than to let in the light. Though broad and high, the floor of the dwelling is so far ~~from~~ below the window sill, as to conceal all but the heads of the inmates. They are simply prison like, iron grated, glassless, curtainless, and are usually kept half closed, on the inside, by huge window shutters made after the patern [sic] of the doors.

One marked feature of the place, and which gives it the appearance of great antiquity, is the old wall of solid masonry, still in pretty good condition, mounted at intervals by heavy guns, and pierced at others for the use of small arms, entered at several points through large gates gaurded [sic] by soldiers. This wall completely surrounds the city—and thus walled, thus streeted, thus doored, thus windowed, thus situated at the mouth of the river of the ozama, looking out grandly upon the broad blue sea, containing a population of about seven thousand, noiseless and solemn, as a new England sabbeth [sic], you have the ancient city of Santo Domingo, the oldest metropolis of the new world. Once full of life and activity it contained within in these same old walls, seventy thousand souls, full of life and activity. Many of the massive and imposing religious structures, built in the days of its religious power, wealth and glory, still adorn the city.

In all her vicissitudes and trials, and they have been many, the religious character of Santo Domingo, has never desserted [sic] her. With all sincerity and freedom from doubt, the people of that old town will tell you, that in time of drouth [sic], they have only to display in the open streets, a certain old cross, said to have been brought over by Christopher Columbus, in order to bring rain from heaven. According to them this cross is as potent to open the windows of heaven as the prayers of a certain old prophet were to shut them.

At the faintest dawn of each new day, religious service is duly performed in all the churches of the place. While the darkness of night still makes visible the great cross in the southern sky, and her watchmen who pace her streets all night, faithfully telling the hours and the state of the weather have scarcely ceased their dreary round, when the ears of the people of Santo Domingo are saluted with a perfect tumult of bells more confused and excited than a fire alarm, summoning the faithful to their altars, and to their prayers, nor do they summon in in vain. At the first wild clang of these church bells, the streets are thronged with pious men and women, demurely winding their way through ~~through~~ the darkness to confess, if not to forsake their sins, and pray for pardon.

An american visitor would find in Santo Domingo many objects of curious interest and among those about which he would linger longest, is the old

church of San Francisco.[16] It is the most ancient, and was once the most splendid, religious edifice in that city if not in the island. It is now one vast ruin, and the base uses to which its once, sacred walls are put, involves a somewhat puzzling contradiction to the generally superstitious character of the Santo Domingo people. With strange and unaccountable irreverence, this this holy place, this solemnly consecrated temple of God—where he was supposed to meet his saints, the very approach to the gates of which once filled and thrilled the minds of men with deep religious awe, is now only a large pen— used to enclose goats, swine and other animals—and raising them for the market. It is rented to and [sic] old woman, who seems to have no sense of impropriety in converting the solemn temple into a stable for domestic animals. Besides raising pigs and goats and fowls, in the holy place, she keeps bees, and has long lines of Bee hives there for making honey. This done chiefly for the wax—a large item of of Santo Domingo commerce.

With a queer taste for seclusion the old lady priestess and proprietress, of this ghostly old ruin, makes her home in one of the best preserved part of its walls—and seems very well pleased with her ~~residence~~ gloomy residence. An american much less superstitious would as soon ~~things~~ think of hiding away at night among tomb stones, as within the walls of this old ruin. Somewhat shy in her manner the old lady does not take it amiss to be called upon to show the ruin—nor does she feel offended by any little grateful testimonials that those whom she serves may be pleased to leave in her hands.

But what a change is here! and what a lesson of the transcent [sic] character, of the most enduring and sacred works of men does this old ruin teach. A vision of the zeal & energy, the toil, sweat and skill here ~~laid~~ employed, rises before us as we behold it. It was meant to stand forever. But now its mouldering remains, no longer ~~an~~ objects of pride and piety to all Santo Domingo, but rapidly mixing with the dust whence it was taken, and devoted to uses never dreamed of by its founders. Its lofty domes, its towers and turrets, its galleries, its pulpits and altars, have fallen. The day of its greatness and power, like that of its founders is past. In its dessolation [sic], it has not become the habitation of bats and owls, but the dreary shelter of pigs, goats and poultry. The whole scene of melancholy. Here and there amid the general decay—you see a grand old Roman archway, a broken pillar, an angle of an inner wall, which has sternly resisted the slow but certain and destructive shafts of time. But arch, Pillar, and angle, only loom over the

16 Construction on the church of San Francisco began in 1544 and was completed in 1556. By the time of Douglass's visit, the structure was a ruin, having been damaged by earthquakes in 1673 and 1751.

more perishable, parts of the fallen structure like monuments over the shapeless graves of the dead! Some thing is added to the dreariness [sic] of this scene, by the contrast it presents to the life, fullness, of tropical nature—which fairly sports—and laughs, in triumphs over art. Man's noblest achievements in architecture—are but playthings in her hands. She touches his cloud capped towers and gorgeous palaces and they crumble to ruin—to dust and ashes.

Favored by all her forces of climate and soil, she revels in destruction. The palm, the coconut, the Banana, zapodilla,[17] and graceful oleanda, with other tropically growths, rich and beautiful, rise high above, and fling their shadows, interlacing vines and creepers, which now cover the holy floors, where wealth and fashion once knelt in pride to pray. Her alth The priest, the altar, and the incense are gone, and the delightful chants of her sacred songsters have given place to the hum of industrious bees.

In looking here and elsewhere in the city, at the ravages made of time and the elements, gloomy apprehensions will come for the hallowed structures of noble dimensions, which have thus far braved their destructive power, and yet make a solid and respectable appearance. It is impossible not to feel that where old San Francisco has gone these must go also—

Tropical heat and insular moisture, both ever active and sleepless here, powerful agents alike to create and to destroy, are already displaying their destructive tracery upon the alters [sic], the pulpits and upon the walls, of the best preserved among them.

If in the United States, time wears, cities burn, churches fall, there is a spirit and a power in the land to build and restore them. Chicago—ashes to day, is granite to morrow[18]—but this old city of Santo Domingo—vegetating in the thick of an effete civilization—gives no sign of the wealth and energy that called these hallowed structures into existence. Her people worship at their alters [sic], but the dauntless faith and the tremendous energy that built and fashioned them. The form is there, but the soul is gone.

It does not appear from the religious history of Santo Domingo, that piety and morality, religion and justice, are inseparable—but the contrary. If humanity has bled and justice have has been outraged—they have never needed the sanction of the H pious—in precept or example.

If in the United States we have had our slavery, they in Santo Domingo have had theirs also. If we have sold men to build churches, babies Babies, to

17 The sapodilla is a tropical tree with distinctive fruit.
18 Douglass refers to the great fire that engulfed over three square miles of Chicago on 8–9 October 1871, killing more than 250 people and destroying over 17,000 buildings.

[26] buy Bibles, and women to support missionaries the Protestant of the North has but imitated the bad example of his Catholic Brother of the South.

In whatever way the fact may be construed whether to the support or to the prejudice of religion, it demonstrates that there is a striking resemblance between human creeds and human nature—and that the one is seldom better than the other.

The tendency of religion to secure the order and stability of society does not gain much strength from the example of Santo Domingo. While no people have been more religious, no people have been more frequently or more violently driven asunder and broken to pieces by social disturbances—and by rapid alternations of fortune.

Tracing the history of Santo Domingo—from the point of time—when as Brougham has it, the "daring genius of Columbus, pierced the night of ages and opened to one world the sources of knowledge power and happiness, and to another all unutterable woe"—down to the present hour, and we troubles enough for a national life of a thousand years.[19]

In view of the experience of this island, there is something fearful in the responsibility assumed by those who undertake to plant civilization in what they may call a barbarous country.

Of course, nothing can be definitely known of the life of Santo Domingo under the rule of her chiefs, the Caciques,[20] but it is evident that her life their rule, was more friendly to human life, than the civilization by which she was invaded. Whatever, may have been the stillness of that fair and beautiful island—previously, she has known no repose since civilization entered her borders.

It was her lot to be roused from her innocent barbarism in a rude and startling manner. The night of her ignorance was broken by no gradual dawn. Civilization such as it was come upon her all at once, in the resplendent blaze, of tropical noon day. Her wealth was her misfortune. She had that within the sides of her mountains and in the sands of her river beds, which in all ages, has thronged the highways of the world with fierce and daring adventurers.

The first thing inquired for by the Spaniards on landing was gold. They wanted gold. The burning, bewildering maddening lust for gold; the unappeasable desire for sudden riches, the most blending and hardening of all desires, attracted to her shores, a multitudinous and overwhelming tide of

19 Douglass quotes from a speech delivered in the British House of Commons by Henry Brougham (1773–1868), later Lord Chancellor, on 13 July 1830. Brougham's opposition to the Slave Trade was expressed as early as 1804, in his 1804 book *A Concise Statement of the Question Regarding the Abolition of the Slave Trade.*
20 A Spanish word to describe a leader, chief, or "prince" of indigenous peoples of the Caribbean.

emigration. Her native population, feeble both in mind and body, vanished before it, as if smitten by the breath of almighty power.

It is hard to believe when we remember the preeminent religiousness of the Spaniards, that in less than a half a century, they had nearly exterminated the native population. From one million their numbers had fallen to sixty thousand souls. Yet such is the incontestable voice of history.

It is said, that in the mountains of Samana,[21] a few of this woe smitten Carribean [sic] race are still to be found. The mission, of Christian civilization to these people, was robbery, slavery and death, and the fact that any of them remain to perpetuate the forms and features, of their ancestors, is due to the dens and caves by means of which, they were able to keep out of the way of that deadly civilization.

It was once said by Daniel O'Connell, that the history of Ireland might be traced like the track of a wounded man by the blood.[22] A strong and startling figure, but one more strong and startling, is required is required for a true picture of the life of Santo Domingo. The experience of the western part of this island, under France, and the eastern part under Spain, and the whole alternately under one or the other of these fierce latin powers, has been of the bitterest and most destructive character. Every form of war, that could smite a nation, every species of oppression and treachery from within and from without, the effect of which is to destroy confidence, and to plant distrust and hate, in the hearts of men were here applied. Every calamity that can flow in the broad, black track of war—including famine and pestilence, have here conspired to render human society impossible.

With a look of wonder, if not of taunt, men ask why the population of Santo Domingo, is so sparse, and why its civilization is so feeble? Let them glance at the nature and history of its wars, its slavery, its slave trade, is terrific and countless revolutions, and they will wonder less, that the population is so small and the civilization is so feeble, than they will wonder that it has any population at all, or still clings to the forms of civilized life.

Hungering
This Island was not only the first american soil to behold the sacred cross, and to hear the gospel of the son of Mary, but the first cisatlantic country, to

21 Samaná is located in the northeastern part of Santo Domingo/the Dominican Republic.
22 Daniel O'Connell (1775–1847) was an Irish political leader who campaigned for the repeal of the Act of Union, which joined Great Britain and Ireland, and for Catholic emancipation. In September 1845 Douglass appeared alongside O'Connell at a rally in Dublin, and the Irishman soon took to calling Douglass "the Black O'Connell of the United States." Douglass attributes to O'Connell an observation by the Irish writer Thomas Moore (1779–1852) in *Memoirs of Captain Rock* (1824): "You may track Ireland through the statute book of England, as a wounded man in a crowd is tracked by his blood."

engage in the African trade and to Darken the dashing billows of the atlantic with Congo blood.

Still thirsting for gold, for ease, and splendour, the pious Spaniards—having murdered in their fields and mines—nearly all thire [sic] native slaves, and dried up the fountain of their native supply—threw lustful eyes towards the shores of Africa.

A holy priest, a man, with a feeling of humanity above his fellows, afflicted by the tears and sufferings of the slender natives—or the few that remained of them—suggested as a measure of Christian benevolence, the importation of slaves from Africa.

While in the City of Santo Domingo, I stood upon what was said to be, the very spot where, the first cargo of this human merchandize was landed. I will not stop here to describe sensations, or to make reflections upon the fact.

I rather turn, to less distressing thoughts and feelings. There are compensations in history as well as in nature. Santo Domingo, the first american soil to fasten upon itself, and upon the new world, the curse and crime of slavery, was also the first to feel the dire consequences of that terrible curse and crime. More than sixty years earlier, than ourselves, she was made to feel the storm of blood and fire, that follows ever—sooner or later, on the track of national crime. Her mountains were made to smoke, and her valleys to blaze with fierce wrath and revenge. Her Toussaints, her Dessalines, and her Christophes,[23] were the first of their race, to teach the world that is dangerous to goad the energy that slumbers in the black man's arm.

As to the passions stirred and fostered here, no talent is required to ~~sto~~ show some analogy, with the physical character of the country itself. The very soil is full of extremes. Wholesome and noxious growths abound. Light and shade glare and gloom, heat and moisture, a serene sky above, and slumbering earthquakes beneath. No orange is so sweet. No orange is so bitter. Both the bitter and the sweet grow in the same garden—and draw their respective qualities from the same rich soil. Kindness and mercy sweet as tropical flowers, shine in the character of the brave and sagacious Toussaint, revenge and hate, deadly as tropical plagues, and poisons, flash from the eyes and quiver on the lip of the equally brave and the determined Dessalene [sic].

There is nothing lovely in vertue [sic] or hateful in vice nothing holy in truth, or corrupt in lies; nothing that exalts men into heroes, and heroes into

23 Douglass refers here to three Haitian revolutinaries: François-Dominique Toussaint Louverture (1743–1803), leader of the Haitian Revolution and Santo Domingo's first Govenor-General; Jean-Jacques Dessalines (1758–1806), Louverture's lieutenant and, in 1804, self-declared first emperor of Haiti; and Henri Christophe (1767–1820), president (1807) and later king (1811) of Haiti.

Gods or debases men into monsters and monsters into fiends, which we may not find here illustrated, magnified, intensified.

The question as to which were the more cruel and and demoniacal in their barbarities the whites or the blacks has never been an open question for americans until now. Judgement has long since been rendered against the blacks.

The horrors, of Santo Domingo, the frightful horrors, of Santo Domingo! Who has not heard and trembled at these horrors: A thousand times they have been invoked to excite the malign passions of the whites against the blacks— and to hurl the fury of the mob, against the abolitonists.

It was a crafty device, and did its work of mischief well. For along [sic] time it kept Santo Domingo an outcast among the nations of the earth. For more than fifty years she knocked at the doors of this nation for recognition and was fiercely driven away.

Never said, a member of congress, who is still living, and who at the time, spoke the sentiment of the country, "never will I, never will my constituents, be forced into to this recognition. This is the only body of men who have emancipated themselves by butchering their masters. They have been long free I admit; yet if they had been for centuries, if time himself should confront me, and shake his hoary locks at my opposition; I should say to him, I owe more to my constituents, to the quiet of my people than I owe, or can owe, to mouldy prescriptions however ancient.[24]

Well, Galileo dies, but the world moves, and along comes another compensation. Santo Domingo is recognized, and a better intelligence has lifted the blasting reproach from the brows of the black heroes, who sought only to be free, and fixed it upon the brows of those who sought to enslave them.

The american people have had their eyes anointed by a bitter experience. The treacherous and savage capabilities, of men who have lived by enslaving their fellow men—are better understood now than ten years ago.

We read these capabilities now in the characters of our Winders, Forrests, and Davises, in the horrors of Andersonvilles, and Saulsbury's.[25]

24 Douglass quotes from a speech in December 1838, in the US House of Representatives, by Henry A. Wise (1806–76), a US member for the state of Virginia.

25 Douglass refers here to John H. Winder (1800–65), a white US Confederate officer who oversaw the running of prisoner of war camps; Nathan Bedford Forrest (1821–77), a US lieutenant general in the Confederate army guilty of war crimes at the Battle of Fort Pillow in April 1864, after the massacre of (surrendering) African American soldiers; Jefferson Davis (1808–89), president of the Confederate states from 1861 to 1865; Andersonville, a prisoner of war camp in Georgia that imprisoned some 45,000 Union soldiers during the Civil War, of which c. 13,000 died; and Salisbury Prison, North Carolina, another site of imprisonment for Union troops, holding at one time up to 10,000 men.

It is not to be denied that the negroes, of Santo Domingo—when once roused from their long suffering were terrible in their vengeance, and committed excesses at which humanity must always shudder; but the wildest and most shocking of these were paralleled, and provoked by the crimes and excesses committed by the whites—who made war to enslave them.

The blacks of this island were comparatively moderate in their dealings with their old masters in the first struggle to put off the yoke. It was not until they had been free, prosperous and happy—six years, under the wise and benignant Government of Toussaint Louverture, and Boneparte [sic], the first Ku Klux sent of our century—sent six hundred ships—and forty thousand soldiers— under the ablest generals that France could boast, to reenslave them, that the black and mulatto people of that island perpetrated their greatest horrors— and this thought fact is especially worthy of thought at this moment when an effort is being made again to reduced to slavery the same race among ourselves, who have now been six years free from the chains of Slavery.

Much has been said of the meanness and treachery of the mulattoes of Santo Domingo—and of the prejudice of the latter towards the blacks.

This island, in addition to its other wars, has been cursed with that most accursed and implacable of all wars—a war of races. It must be confessed too, that the embers of this conflict still smoulder in that island—and may break out again at any moment. The foundation of the bad feeling between the two colors, is easily comprehended. If the mulatto is treacherous and malignant towards the blacks and whites—as he seems to have been—it is not because nature has denied to him qualities less noble than other varieties of men—but because of his abnormal relations.

The mulattoes, from the beginning were constituted a separate caste. By blood and position they were connected with both the white and the black races of the island, and by the same, they were separated from both and made a peculiar people.

The latin race, freer than the Saxon, from mere prejudice of color and race, were not quite base enough to enslave their own flesh and blood in the persons of their mulatto children—and yet, were too not noble enough to place them on a level with themselves.

Hence they made a compromise. They gave their mulattoes an intermediate position, as well as an intermediate position color.

Like all other compromises it has resulted in disappointment and misery to its framers.

Wrong is as logical and as exacting as right. Man must either be free, or slave. He will never be content with a condition of halfness. Concession is ever the fatal apple of discord in the end.

The mulatto, between the slave, and the slaveholder, was necessarily the friend of neither. He was in a condition to espouse or abandon the side of either, as interest or passion might dictate.

Society, without consulting his wishes in the matter, had in advance, ordained him to be a disturbing force, a natural born conspirator—and such he has been and such he will be, till all notions of a barbarous caste shall have been swept from that country, as it certainly will be in the end swept from our own great Republic. A man here may yet be made to receive indignities in the United States on account of race and color—but the overwhelming tendency of our times, is to human equality.

I have no disposition to defend the mulattoes as against the blacks of Santo Domingo—but it is true to the truth of history to affirm that, to the mulattoes belong the credit of the origin of the terrible struggle, which finally gave freedom and independence to the whole people black as well as mulattoes.

I went to Santo Domingo, as also did the honorable commissioners, in an impartial spirit—prepared either to oppose or to advocate annexation. I went there not as upon a holiday excursion—as malice painted the commission, but to see and learn for myself—all that could be known of the true condition of that country.

It is, as estimated at the beginning, impossible, to describe in detail, all the facts that came to my knowledge, during my visit, but is due to you and to the completeness of my lecture to state briefly the general conclusions, forced upon me by all I saw and learned.

1st.

Latin civilization: Whatever may have been its merits and achievements in other times and places, it has here in Santo Domingo, been a most miserable failure. It has brought one of the most beautiful and richest countries in the world to the verge of ruin.

2dly There is nothing in the climate or soil—nothing in the conditions it affords for health and vigour of body and mind, whch have made this failure necessary.

3rdly The cause of this failure is to be found in that rapacious spirit, that insatiable greed for gold, which forgets the claims of a country in a selfish individualism, which would reap where it has not sown—and gather whether it hath not strewn, which exterminated the native population, and filled their places with slaves from Africa, and spent the wealth gathered here, not in efforts to improve the country, but, in the follies and dissippations [sic] of foreign countries, leaving ignorance, superstition and misery in the land from which riches and luxuries were derived—bequeathing to the country that gave them wealth and honor, only ignorance, superstition and misery.

3dly

While the people of Santo Domingo, in their personal relations seem quiet, order loving, and peaceable, their political affairs have been in the hands of rival ambitious chiefs, one holding power, till put down by another revolutionary rival. The pronounciamentos of the chiefs fill the air, and keep the country in a constant state of alarm—and in a general state of insecurity wholly unfavorable to industry, and the acquisition and defusion [sic] of wealth—No man knows the day—when his cow, horse or other property may be ~~caused~~ confiscated by some one of the revolutionary chiefs who may raise in the mountains, the cry of God and Liberty.

4th

That society here has been so long running in the deeply worn grooves of political disorder—and has become wasted by this peculiar revolutionary life, that there seems no power to lift itself out of these ancient grooves.

5thly

That this view of the situation is held the most intelligent and patriotic citizens of Santo Domingo, and they are therefore deeply and earnestly desirous, to be annexed to some strong government, which could and would make successful revolutions impossible—and thereby destroy the motive which prompts them, and by securing peace, would revive, industry and commerce, and in a word save the country from a return to barbarism.

6thly It was manifest to all who went to Santo Domingo, including the opponents as well as the friends of annexation, the vast majority of the people of Santo Domingo are decidedly in favor of annexation to the United States.

Now having heard these statements and conclusions if you ask am I in favor of the annexation of Santo Domingo I answer, most assuredly I am.

There was a time in the history of our Republic, when the thought of any extention [sic] of its dominion was painful to me and to the friends of free institutions generally.

Annexation then meant the extention [sic] of slavery—the opening of new slave markets, the revival of the internal slave trade, the addition of more slave sates, more slave representation in congress, and greater security to slavery at home and abroad.

It now means the enlargement and security of human Liberty, the defusion [sic] of knowledge and happiness, and the redemption of mankind from oppression, king craft, priest craft and superstition.

The friends of Santo Domingo, ask why extinguish this colored nationality? I respect the sentiment that prompts the inquiry—but the answer is, when nationality ceases to be a reality, when it ceases to be a help—and becomes a positive hinderance [sic], it is ~~a~~ the plain duty of the people oppressed by it, to

get rid of it, and it cannot be wrong to assist such people in laudable efforts to [26]
that end.

A national government imposes no trifling burdens and responsibilities, such a government, implies, wealth numbers and the power to secure order at home and to command respect abroad.

It means men and money: It means foreign and domestic relations. It means the sending of Diplomatic agents to distant governments and the reception of such agents in return. It means armies and navies. It means the ability to make and enforce treaties.

Titles, and tinsel show, His honor and his excellency, or his gracious majesty, without these qualifications, are simply contemptable.

Nations, like husbands must be either loved or feared, and visa [sic] versa.

Nations can not live by faith. In all that concerns nationality—means must be kept steadily in view—and must be proportioned to the ends to be accomplished. A train of Rail Road iron is not ~~to be~~ moved by the wings of a butterfly.

A small and weak nationality, is out of joint with our times. Such nationalities ~~fairs~~ fare badly enough in Europe—~~There~~ where, there is a necessity imposed upon the stronger ones, to protect them by maintaining what they call the balance of power.

But where no such necessity exists a small nationality, becomes the crushing armour of a giant, on the shoulder of a pigmy. It is a thin shelled egg among cannon balls and is apt to meet the fate of such an egg.

The flag of such a nation instead of lifting its citizen with strength and pride, fills them with a gloomy and dispiriting sense of their weakness—is a flag that ought to be exchanged for another. Organization, extention [sic], unification, and progress are the grand features of our age.

The English and German tongues are girdling the globe. No rival houses of beligerent [sic] Barons now dispute the realm of England. The Teuton shouts over unified Germany. The long divided members of Italy have reunited. The attempt to divide our own states—and set up a little slave confederacy, ~~has~~ failed. These facts are but the indications of the irresistible tendency of our times.

Now the truth about Santo Domingo, is that she is to [sic] weak to stand alone. Her wise and patriotic men know it, and feel it. They lay aside ambition and national distinction for the welfare of their country and instead of being taunted with selling their country they should be commended for their wisdom and patriotism.

They believe that it is better to be a part of a strong nation, than the whole of a weak one.

But it is said that the extinction of this colored nationality, will be an untimely and an ungracious humiliation of the colored race, and that the friends of that race should set their faces against it.

While I admit, that the motive at bottom of this objection is good—and one which I highly respect—I am wholly unable to see any force in it. There is no humiliation involved in the measure to either party.

It is remarkable that while abolitionists are endeavoring to guard Santo Domingo against the degradation of annexation, the anti abolitionists are endeavoring to save the United States from the degradation of such a union.

One or the other of these classes may be wrong, but both cannot be right— though both may wrong.

I hold it neither degrading nor humiliating to be made a citizen or a state of the United States; ~~but an~~ but an honor and a privilege to be either.

Roam through the wide world and where is their [sic] a nation, so enlightened, so liberal and so progressive as the people and government of the United States? Wrongs there are many and great, but where is there one in which there is alike ground to look for reform and improvement?

The men who framed and formed this union knew the dignity and value of nationality. But they were no sentimental dreamers. They had the wisdom to see that the whole is stronger than a part—and that small states united, formed a safer condition of nationality—than small states divided.

We are told that annexation is not to end with Santo Domingo, and I ask what if it does not so end? What if Hayti, Cuba jamaica and other islands adjacent to our continent, should one day, seek shelter under our flag and share our liberty and our civilization? Our form of government is ample and admirably adapted to expansion. It was not our territorial dimensions that brought division and strife, but slavery. In religion and in politics, there are to [sic] principles that have ever shook the world. One is liberal and progressive, and the other despotic and conservative. It is ever the same old contest. The ages may change its form—but never its substance—and all nations, kindreds, tongues and people—must sooner or later take their lot with the friends of one or the other.

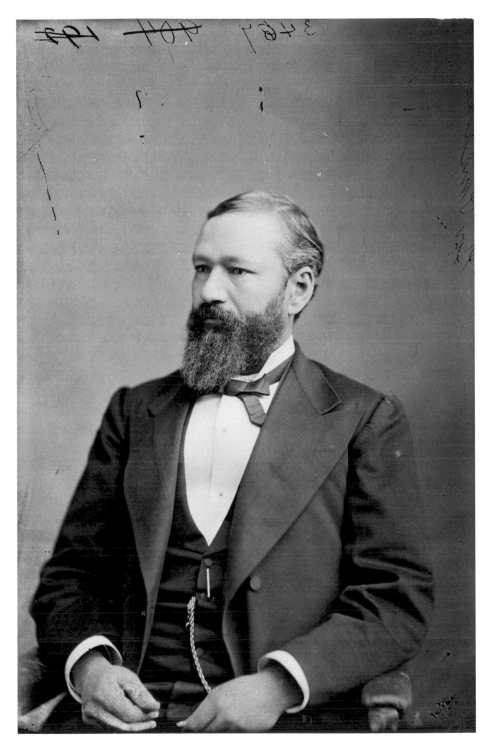

Figure 42: Anon., *P. B. S. Pinchback*, c. 1870–80. (Brady-Handy Photograph Collection. Prints and Photographs Division, Library of Congress, Washington, DC.)

27. "It is Hard for a White Man to Do Justice to a Black Man": Frederick Douglass, "The Louisiana Senator [P. B. S. Pinchback]"

A Civil War Union commander of Black troops, state governor, lawyer, businessman, and newspaper editor, Pinckney Benton Stewart Pinchback (1837–1921) was born in Macon, Georgia, to an emancipated enslaved mother, Eliza Stewart, and a white plantation owner, Major William Pinchback. As a lifelong advocate of the Republican Party, Pinchback made history as a result of his election to the Louisiana State Senate in 1868. Following the death of pioneering African American politician Oscar Dunn, he briefly became acting Lieutenant Governor of the state in 1871. As a result of the 1872 US election, Pinchback was appointed to the US House of Representatives, only to be denied his seat by an overwhelming senatorial vote on March 3, 1875. The injustice of Pinchback's defeat was all the more devastating given his long and protracted fight to obtain full civil liberties at the hands of a white US government that, all legislation to the contrary and in practice if not in theory, still maintained that African Americans "had no rights which the white man was bound to respect."[1]

The terrible inequalities suffered by P. B. S. Pinchback, whose political successes had been met only with persecution and racist exclusion, caught the attention of Frederick Douglass. As he writes in "The Louisiana Senator," a partial manuscript dated to circa 1876 and reproduced in the following pages in this volume: "While we would not impeach the wisdom or the justice of the U. S. Senate, and while we would demand nothing for a colored man—which we would not for a white man—we have no hesitation in saying that a wrong has been done in this case and that no time should be lost in retracting that wrong." Against the backdrop of a rising Ku Klux Klan and an ever-dominant white supremacist ideology, Douglass was under no illusion regarding the impossibility of a "colored man" receiving "justice" at the hands of the US legislature. On these grounds, he counseled Pinchback to seek out grassroots support from his Black voters instead. As he advises, "we say to Mr. Pinchback go straight to the people of your state: Tell them the whole story: They know your character and your services, both to the union and to Liberty and in our belief they will stand by you and sustain you." For Douglass, as always, the answer to white injustices was to be found in Black solidarity. He had absolutely no doubt that Pinchback's Black supporters would not abandon him in his hour of need. "They will not retreat a single inch," he insists.

1 See Roger B. Taney, "The Dred Scott Decision," <https://www.loc.gov/item/17001543/> (accessed January 14, 2018).

Douglass adopts unequivocal language to declare, "The colored citizen who after all that has happened, who would now desert you, would be a moral coward and a bad republican and a traitor to his race." Writing on behalf of all African American citizens who were fighting for their rights, Douglass holds Pinchback's plight up as evidence of the urgency of the collective campaign for civil rights in a post-emancipation era. "We can afford many things and make many sacrifices," he admits, only to stipulate, "we cannot afford to forsake our approved leaders and make ourselves contemptible by abandoning our right to be heard and seen and heard in the Senate or the Nation by a man of our own Choice."

As faced with the deadly forces of US political discrimination, Douglass takes heart not only from his belief in the bravery of the "colored citizen" but from his conviction in P. B. S. Pinchback's status as an exceptional individual. "A weaker man than Mr. Pinchback might have been diverted from his object or under the vexations and delays to which he has been subjected abandoned the pursuit in disgust," Douglass observes, jubilantly confiding, "He has done neither and we are persuaded that he will do neither." While Douglass despairs of white legal inequalities, as per his *Santo Domingo* lecture, he is inspired by his faith in the ultimate superiority of Black manhood. "With every consideration of justice, regularity and fair dealing on his side, if he is the man we take him to be, he will persevere till victory crowns his endeavors," he confidently predicts. While Pinchback did indeed "persevere" by every means necessary, the fact that Douglass's prediction that "Senator Pinchback (who has conducted himself with so much dignity and intelligence during this struggle) will be safely in his seat in the senate," never came to fruition is a searing indictment not of Black inferiority but of white inhumanity.

Douglass's admiration for Pinchback was by no means one-way: the two men were brothers in the struggle during their lifetimes. Among the correspondence held in the Frederick Douglass Papers at the Library of Congress is a letter authored by P. B. S. Pinchback. Writing from New Orleans on April 20, 1875, Pinchback informs Douglass of the racist barriers to which he has been repeatedly exposed while candidly expressing his fears regarding ongoing threats of racial violence. "The 'compromise' which is nothing more nor less than a further unloading of the Negro has been completed and the state is virtually in the house of our enemies," Pinchback summarizes, readily admitting, "I am again full of apprehensions for our people in this state." Like Douglass, Pinchback realized only too well that white racist prejudice had no limits when faced with the exceptional accomplishments of Black individuals. "It is plainly evident that the white Republican has become alarmed at the exhibition of manhood manifested by our people in claiming a fair share of representation in high places and are determined to rule or ruin him," Pinchback observes. He insists, "I state it as my firm

belief that white republicans here would infinitely prefer to see the meanest democrat in the state in the US senate than myself."[2]

While for Douglass the answer to white racist oppression could be found in the political activism of exemplary Black leaders like Pinchback, for Pinchback, it was Douglass and his philosophical and intellectual power that were the answer. "Oh God how I wish I had your knowledge and ability to grapple with the difficulties I see on every hand besetting me in this God forsaken section of our country," Pinchback exclaims, urging, "Our people stand so much in need of some giant mind to guide them in this crisis of our history." At the same time that he refuses to lose sight of Douglass's exalted prowess as a radical political reformer and activist, Pinchback is one of the very few commentators to recognize his "giant mind" and its power to solve the "crisis of our history."[3] While no letters written by Douglass to Pinchback survive in the Frederick Douglass Papers at the Library of Congress, one such letter is held in the Rubenstein Library at Duke University. Writing from Washington, DC on July 16, 1875, Douglass concludes his letter to Pinchback by stating: "With the immense political power now in our hands, if wisely exercised, the colored people of this country need not fail to have all their rights respected nor fail to secure a respectable and proportionate representation both in the states and in the nation."[4] As ever, Douglass's optimistic beliefs fail to match the dystopian realities. No more searing indictment of the failures of the US legislature to guarantee that African American "rights" were "respected" was to be found than in the case of P. B. S. Pinchback.

"I well remember the occasion that brought Governor Pinchback to Washington in those early days, and I shared with him and thousands of others of our race the confident hope and belief that he would be admitted to the seat he claimed and which was his of right, on the floor of the Senate Chambers. But it was not to be," remembers a contemporary observer, Edward E. Bruce Grit. While he pulls no punches regarding Pinchback's defeat, Bruce Grit celebrates his importance in the African American fight for political and social justice. As he writes, "I recall the reception accorded to him in the early 70s by the great Douglass at his residence 316 A Street, SE, a reception the like of which had never before been accorded to any public man of our race by the citizens of Washington, who turned out in thousands and marched with a brass band from the Ebbit House to the Douglass house where the Governor assisted by Mr. Douglass received and entertained the people who saw in PBS Pinchback, a sign for the political future of the Negro of the South and the country."[5]

2 P. B. S. Pinchback to Frederick Douglass, April 20, 1875.
3 Ibid.
4 Frederick Douglass to P. B. S. Pinchback, July 16, 1875.
5 Edward E. Bruce Grit, "Draft statement on P. B. S. Pinchback 80 birthday," May 1917. Rpt.

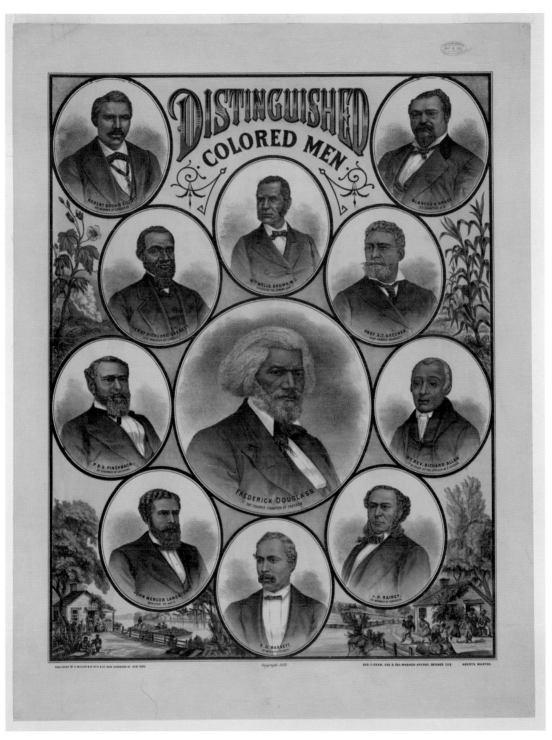

Figure 43: Anon., *Distinguished Colored Men*, c. 1883. (Prints and Photographs Division, Library of Congress, Washington, DC.)

Douglass not only "received and entertained" Pinchback, but he gave a speech entitled "The Country has not heard the last of P. B. S. Pinchback: An Address delivered in Washington DC on 13 March 1876," originally published in the *Washington National Republican* on March 14, 1876.[6] On this occasion, Douglass proclaimed, "I am not here to praise or to compassionate Governor Pinchback. He needs no eulogy. He needs no compassion."[7] "True, he has been defeated; true, he has been defeated by votes of the Republican party," Douglass concedes, only to insist that "the hour of his defeat is the hour of his victory."[8] Working to exalt exemplary feats of Black heroism, he relies on hagiographic language to celebrate the fact that Pinchback "has met this storm with the firmness of a hero, and the serenity of a martyr. He has shown in defeat the quality of certain success."[9]

In comparison with this unparalleled example of Black exceptionalism, white manhood is sorely lacking. Douglass reserves his condemnation for the racism of white Republican senators, stating: "they have acted from first to last under the influences of a mean and malignant prejudice of race."[10] As he realized only too well, the roots of this pernicious treatment were self-evident. "Slavery is dead, but its long, black shadow, in the form of prejudice, stretches broadly across our whole country, and will do so for some time yet to come," Douglass predicted.[11] As he knew only two well from personal experience: "The American people are accustomed to seeing the black man at the back door, and are filled with doubts when they see him at the front door."[12] He pulled no punches regarding the political, social, and cultural stranglehold exerted by white racism, insisting, "we all know that it is hard for a white man to do justice to a black man."[13] For Douglass, the example of P. B. S. Pinchback was a cautionary tale in the ongoing fight for freedom. As he asserted, Pinchback's suffering confirmed that "there is no middle ground for us. We must either have all the rights of American citizens or we must be exterminated, for we never can again be slaves."[14]

The manuscript of "The Louisiana Senator" held in the Walter O. Evans collection is four pages long. In the Frederick Douglass Papers a variant manuscript

Haskins, *The First Black Governor*, 259. The P. B. S. Pinchback Papers are held at the Moorland-Spingarn Research Center.

6　Douglass, "The Country has not heard the last of P. B. S. Pinchback," 422.
7　Ibid.
8　Ibid. 423.
9　Ibid.
10　Ibid. 424.
11　Ibid.
12　Ibid.
13　Ibid. 425.
14　Ibid. 427.

survives. Here Douglass celebrates Pinchback's tenacity by urging, "Senator P. B. S. Pinchback regularly elected by the only legal Legislature of the State of Louisiana is still in Washington and still knocking at the door of the body of which by every consideration of Law and fair dealing he is of right a member." He further observes, "There is something which inspires respect in the calm patient and persistent efforts of Mr. Pinchback to secure his seat."[15] While this manuscript is undated, there can be very little doubt that Douglass composed "The Louisiana Senator" as reproduced here a few years earlier than 1876, and almost certainly within the lifespan of his own and his sons' newspaper, *The New National Era*, which ceased publication in 1874. By way of internal evidence, Douglass provides proof for this earlier date by writing toward the end of his manuscript: "The New National Era would be false to its truth if it did not contend for all in our favor which the senate of the nation can honorably grant." Douglass's essay on Pinchback's fight for his political rights was very likely written as an editorial for publication in *The New National Era*, a newspaper conceived to safeguard Black rights in the "senate" and all areas of the "nation," and very likely dates from the beginning of Pinchback's struggle for his seat in 1872 or shortly thereafter.

As one of the celebrated Black male leaders who were appointed as an honorary pall-bearer at Frederick Douglass's funeral, P. B. S. Pinchback delivered a powerful address in which he expressed his admiration for his hero's lifelong fight for freedom. "Mr. Douglass was a self-made man; a manly man; a pre-eminent apostle of liberty," he insists, urging, "Parentless to all intents and purposes,—and worse still—a slave; denied by law the right to even learn the alphabet; that he should reach the heights he did, stamps him at once the most remarkable man the world has ever seen."[16] As Pinchback argues, Douglass's world-leading status as the "pre-eminent apostle of liberty" offered a guarantee that, "It will require no statue of marble or bronze, or granite monument, to perpetuate his name and fame."[17] For Pinchback and the thousands following in his footsteps, Douglass's "great services to humanity are a living monument, and it will last so long as memory holds a place in the brain of man."[18]

15 Douglass, "The Louisiana Senator."
16 Pinchback, "Address," 224, 225.
17 Ibid. 227.
18 Ibid.

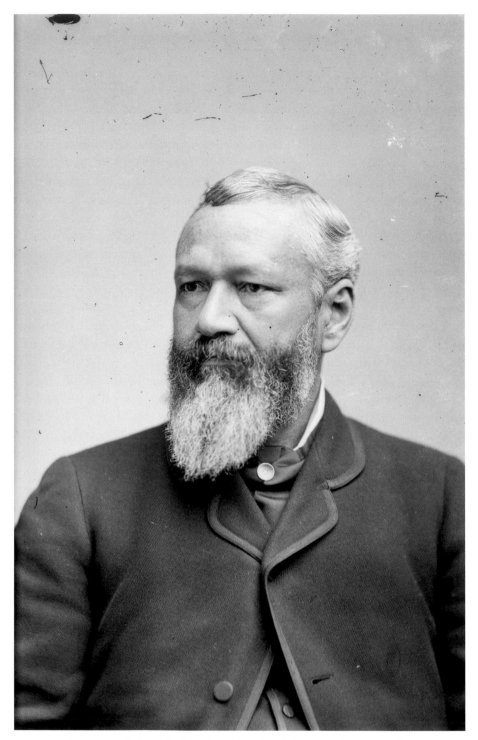

Figure 44: C. M. Bell, *P. B. S. Pinchback*, n.d. (Prints and Photographs Division, Library of Congress, Washington, DC.)

27. Frederick Douglass:
"The Louisiana Senator [P.B.S. Pinchback]," c. 1876

The Louisiana Senator.

Hon. P. B. S. Pinchback is still in Washington. He has not yet succeeded in obtaining his seat in the senate, but he has certainly deserved success. Whoever else may doubt his right to a seat in the U.S. Senate, it is plain that the senator himself has no such doubt. His calmness, patience and perseverance attest his faith in the goodness of his cause and in the justice of the body which has to pass upon his claim. At large cost of time, money and feeling he has bravely asserted his right—and honored the Governor and legislature by ~~whom~~ he is the whose action, accredited Senator of his State. So far as we can see, his ~~acts~~ course has been honorable alike to himself and to Louisiana. A weaker man than Mr Pinchback might have been deverted from his object—or under the vexations and delays to which he has been

27. Frederick Douglass:
"The Louisiana Senator [P.B.S. Pinchback]," c. 1876

subjected abandoned the pursuit in disgust. He has done neither and we are persuaded that he will do neither. With every consideration of justice, regularity and fair dealing on his side, if he is the man we take him to be, he will persevere till victory crowns his endeavors.

Accredited by the recognized legislature and Governor of his state the proper thing upon the face of his case was to admit him to his seat and settle any other questions concerning him afterwards. Failing to do this has subjected Mr Pinchback to a great disadvantage and has seriously prejudiced his case. The delay on the part of the Senate implies the existence of some monstrous wrong either in the man or in the manner of his election. and while he is powerless to explain.

27. Frederick Douglass:
"The Louisiana Senator [P.B.S. Pinchback]," c. 1876

3.

While we would not impeach the wisdom or
the justice of the U.S. Senate, and while we
would demand nothing for a Colored man
which we would not for a white man — we
have no hesitation in saying that a wrong
has been done in this case and that no time
should be lost in retracting that wrong.
If this shall not be done in the premises by the
Honorable Senate, then do we say to Mr Pinchback
go straight to the people of your State: Tell them
the whole Story: They know your Character
and your Services, both to the Union and
to liberty, and in our belief they will Stand
by you and Sustain you. They will not
retreat a single inch. The Colored Citizen
who after all that has happened, who would
now desert you, would be a moral Coward
and a bad Republican and a traitor to his race.

27. Frederick Douglass: "The Louisiana Senator [P.B.S. Pinchback]," c. 1876

We can afford many things and make
many sacrafices but we can not afford
to forsake our approved leaders and make
ourselves contemptible by abandoning our
right to be heard and seen and heard in
the Senate of the nation by a man of
our own choice. The Colored Citizens of
Louisana by their numbers, in ability, and
loyalty have a right to all they ask in
this matter and should demand nothing
less. The New National Era would be false
to its truth if it did not contend for
all in our favor which the senate of
the nation can honorably grant – Sooner
or later we certainly hope and believe that
Senator Pinchback (who has conducted
himself with so much dignity and intelligence
during this struggle) will be safely in his seat in the senate,

27. Frederick Douglass:
"The Louisiana Senator [P.B.S. Pinchback]," c. 1876

Hon: P. B. S. Pinchback is still in Washington. He has not yet succeeded in
obtaining his seat in the senate, but he has certainly deserved success.
Whoever else may doubt his right to a seat in the U.S. Senate, it is plain that
the senator himself has no such doubt. His calmness, patience and
perseverence [sic] attest his faith in the goodness of his cause and in the justice
of the body which has to pass upon his claim. At large cost of time, money and
feeling he has bravely asserted his right—and honored the Governor and
Legislature by ~~whom~~ whose action he is the accreditted [sic] Senator of his
State. So far as we can see, his ~~act~~ course has been honorable alike to himself
and to Louisiana. A weaker man than Mr Pinchback might have been diverted
from his object,—or under the vexations and delays to which he has been
subjected abandoned the pursuit in disgust. He has done neither and we are
persuaded that he will do neither. With every consideration of justice,
regularity and fair dealing on his side, if he is the man we take him to be, he
will persevere till victory crowns his endeavors.

~~Accreditted~~ Accredited by the recognized legislature and Governor of his
State the proper thing upon the face of his case was to admit him to his seat
and settle any other questions concerning him afterwards. Failing to do this
~~has~~ has subjected Mr Pinchback to a great disadvantage and has seriously
prejudiced his case. The delay on the part of the senate implies the existence
of some monsterous wrong either in the man or in the manner of his election,
~~and~~ while he is powerless to explain.

While we would not impeach the wisdom or the justice of the U. S. Senate,
and while we would demand nothing for a colored man which we would not
for a white man—we have no hesitation in saying that a wrong has been done
in this case and that no time should be lost in retracting that wrong.

If this shall not be done in the premises by the Honorable Senate, then we
say to Mr Pinchback go straight to the people of your state: Tell them the
whole story: They know your character and your services, both to the union
and to Liberty and in our belief they will stand by you and sustain you. They
will not retreat a single inch. The colored citizen who after all that has
happened, who would now desert you, would be a moral coward ~~and~~ a bad
republican and a traitor to his race.

We can afford many things and make many sacrifices, but we can not afford
to forsake our approved leaders and make ourselves contemptible by

[27] abandoning our right to be ~~heard and~~ seen and heard in the senate of the nation by a man of our own choice. The colored citizens of Louisiana by their numbers, an ability and Loyalty have a right to all they ask in this matter and should demand nothing less. The New National Era[19] would be false to its truth if it did not contend for all in our favor which the senate of the nation can honorably grant. Sooner or later we certainly hope and believe that Senator Pinchback (who has conducted himself with so much dignity and intelligence during this struggle) will be safely in his seat in the senate.

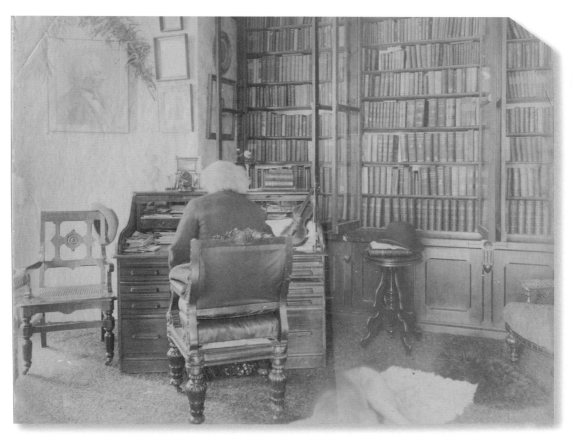

Figure 45: Anon., *Library at Cedar Hill*, c. 1893. (National Park Service: Frederick Douglass National Historic Site, Washington, DC.)

19 The *New National Era*, formerly the *New Era*, was the first national weekly newspaper for African Americans readers. It was edited and published by Frederick Douglass and his sons, Lewis Henry, Charles Remond, and Frederick Jr., between 1870 and 1874.

28. "My Own Murdered People": Frederick Douglass, "William the Silent," 1876

"I am this summer endeavoring to make myself a little more familiar with history. My ignorance of the past has long been a trouble to me," Frederick Douglass confides in a letter he writes from Rochester, New York, on August 24, 1868 to Gerrit Smith, a white US political reformer and intimate friend.[1] In the decades following the Civil War, Douglass successfully immersed himself in a program of wider reading in US and European history, philosophy, and literature by working with the guiding influence of free thinkers and radical intellectuals he respected, such as Ottilie Assing, a German-born journalist and writer. For Douglass, it was not only the case that a knowledge of the past could inspire a revolutionary blueprint for reform in the future, but that a demonstration of his capabilities as a historian would work against his repeated typecasting solely as a mouthpiece for antislavery activism within a white popular imaginary in the present. In the years following the Emancipation Proclamation issued in 1863, Douglass's cause was ostensibly over: enslaved African Americans were experiencing a freedom which, if slavery by another name, nevertheless resulted in the disbanding of any and all antislavery organizations. Speaking candidly of his feelings in his final autobiography, he recalled, "I felt that I had reached the end of the noblest and best part of my life; my school was broken up, my church disbanded, and the beloved congregation dispersed, never to come together again." As he soon realized: "The anti-slavery platform had performed its work, and my voice was no longer needed. 'Othello's occupation was gone.'"[2] And yet, Douglass's theatrical casting of himself as a Shakespearean Othello ultimately proved prophetic. As he confirms, he found his answer for his livelihood by participating in a new array of dramatic performances. "This question, however, was soon decided for me," he writes, explaining, "Invitations began to pour in upon me from colleges, lyceums, and literary societies, offering me one hundred, and even two hundred dollars for a single lecture."[3]

For Douglass, the war for his physical freedom at the height of slavery and the abolitionist podium was soon matched by his war for his intellectual and philosophical freedom on the lyceum lecturing circuit in a post-emancipation era. On July 29, 1871 Douglass wrote a letter to James Redpath, organizer of the Lyceum Bureau, in which he entertained no questioning of his intellectual liberties. "What upon earth can you want with the character of my lecture?" he

1 Frederick Douglass to Gerrit Smith, August 24, 1868, Gerrit Smith Papers.
2 Douglass, *Life and Times*, 453.
3 Ibid. 455.

rhetorically asked, insisting, "People ought by this time to take me on trust, especially as their expectations have already been remarkably moderate and never disappointed." He holds nothing back concerning his frustration at his perennial pigeonholing by declaring, "It is too late now to do much to improve my relation to the public. I shall never get beyond Fredk Douglass the self educated fugitive slave."[4] All Redpath's questioning to the contrary, however, Douglass, as Angela Ray argues, immediately became a "lyceum celebrity." Offering clear-cut proof that his audiences were "never disappointed," Douglass "appeared on Redpath's annual list of lecturers from 1869 through 1876." As receipts kept in the Frederick Douglass Papers confirm, he "customarily earned $50 and $125 per lecture, with $100 being his most common fee."[5]

No more categorical evidence of Douglass's post-war determination to "get beyond Fredk Douglass the self educated fugitive slave" can be found than in the subject matter of his lecture "William the Silent" (1876), in which he dramatized the military career of William I (1533–1584), Prince of Orange. Over multiple typed and handwritten drafts, and including the extended-length manuscript held in the Walter O. Evans collection and reproduced here, he debated this European monarch's pre-eminent role as the leader of "the desperate resistance of the two maritime provinces (Holland and Zeeland) against the Spanish armies sent to subdue them" in the name of religious freedom and in the decades prior to his death at the hands of a "fanatical Catholic" assassin.[6] By all accounts, however—including Douglass's own—the lecture was a failure. Writing a public letter to *The Revolution* on March 3, 1869, white women's rights activist Elizabeth Cady Stanton relied on deeply troubling language to inform her readers of an accidental meeting with Douglass in Ohio. While traveling with Susan B. Anthony, she writes, "we met Frederick Douglass, dressed in a cap and great circular cape of wolf skins," declaring, "He really presented a most formidable and ferocious aspect. I thought perhaps he intended to illustrate 'William the Silent' in his northern dress, as well as to depict his character in his Lyceum lecture." At the same time that Cady Stanton is not guilty of stereotyping Douglass as "the self educated fugitive slave," she perpetuates other, yet more disturbing, white racist assumptions surrounding his identity by relying on barbaric language to insist on his "formidable and ferocious aspect." All these difficulties notwithstanding, she confirms the success of Douglass's potentially performative reenactment of his historical subject matter by concluding, "We hear his lecture on 'William the

4 Frederick Douglass to James Redpath, July 29, 1871, rpt. Borome, "Some Additional Light," 217. This letter is also held in the Alfred W. Anthony Papers, New York Public Library and was brought to our attention by Angela Ray's pioneering research.
5 Ray, "Frederick Douglass," 627.
6 Jongkees, "William I."

Silent' much praised."[7] Over a decade later in 1884, however, she shares a different view by noting, "'some of the friends said he might as well be silent,'" as "none of his old-time fervor was ever roused by that lecture."[8]

Any and all pejorative views of his dramatic capabilities as evidenced in this lecture were shared by none other than Douglass himself. Beginning a very different lecture, "Our National Capital: An Address Delivered in Baltimore" on May 8, 1877, he justified his choice of subject matter by entertaining his audiences with an anecdote. "I have naturally enough thought it might be well for me to tell my story about our National Capital," he observes, only to admit, "There is another reason for the selection, not perhaps, so creditable": "I was in want of a subject, and in want of one that is popular."[9] Stating that "Popular lectures" must be on "popular subjects," he generated suspense for his audiences by speaking in general terms. "Several years ago it was my good or ill fortune to know a lecturer, who somewhat disastrously set this law at defiance," he recounts, noting, "From some cause or other, perhaps a desire to do something out of the common way, something high, grand and surprising, or perhaps from a mere paroxysm of self confidence in which he was made to feel himself equal to any achievement, he ventured before a brilliant Boston audience (all things in Boston are brilliant) clad in an intellectual armor which was evidently neither made, measured, nor meant for him, nor he for it."[10]

Still naming no names, Douglass presses on with the story of this fated "lecturer" by declaring, "He took for his theme the name of a great historical character, a man who lived and wrought in a remote age and country, a real hero in his day and generation, and one who had made the friends of civil and religious liberty immensely his debtor."[11] Despite every effort and every display of this orator's intellectual and imaginative prowess, the lecture of this "great historical character" fell dead before his listeners. "For the life of him, he could not bring the subject home to his audience," Douglass declares of this lecturer's failures, confiding, "He labored hard and really did his best; he was historical, philosophical, reformatory and belletristical; but all to no purpose."[12] He relies on humor to satirize the power of this unnamed lecturer's self-delusion by emphasizing, "He made a tremendous impression upon himself, but his audience escaped entirely." At the conclusion of his anecdote, he ended any and all suspense by revealing the identity of his luckless lecturer. "The morning paper purchased of a noisy news

7 Stanton, "Editorial Correspondence," 224.
8 Qtd. Ray, "Making History," 109.
9 Douglass, "Our National Capital," 444.
10 Ibid. 444–5.
11 Ibid. 445.
12 Ibid.

boy at the station, just as he was leaving Boston for new fields of glory added the last drop to his oratorical sorrows," Douglass narrates, noting: "Instead of giving him a splendid puff, a column report, and sending him on his way rejoicing; it simply discussed him with less than six lines, the substance of which was that Frederick Douglass, the well known colored lecturer, ought to have known better than to have attempted a lecture upon such a subject in Boston."[13] While the identity of the lecturer soon became self-evident, the identity of the lecture was to remain unspecified. And yet, there can be little doubt that Douglass was referring to the somnambulant effects produced on his audiences by his ill-fated oration, "William the Silent."

Even a cursory reading of Douglass's lecture on "William the Silent" held in the Walter O. Evans collection and reproduced here lays bare his determination to adapt epochal moments in medieval European history to suit the needs of a nineteenth-century US republic. As if all too aware of the failures of his subject to speak to the lives of his listeners, he urges: "The historian easily finds a clear, close and logical connection between the establishment of the Dutch Republic of three centuries ago—and of the American Republic which had recently just celebrated its first centennial: a connection between the war of the Netherlands against Spain, and the war of the American colonies against England: between William the Silent at the head of the Protestant forces and George Washington leading the armies of the Revolution." According to Douglass's historical research, "Both Republics, both wars; both men belong to the same great family of men, the great chain of events by which the cause of human Liberty, has gained its present ascendancy in the world."

At the same time that Douglass exalts in the idealized possibilities presented by the mythic spectacle of white heroism in the figures of William the Silent and George Washington, however, he refuses to lose sight of the suffering and sacrifices of Black citizens living in the US republic. He begins by celebrating the exemplary attributes of the Dutch people under William I's reign, only to end by debating the exceptional heroism of African Americans fighting for their existence in a post-emancipation era. "I know of no race of men more patient under wrongs more non resistant resisting in the face of temptation to violence; more hopeful that deliverance would come in some other way[,] more hopeful believing that they thirst for blood would be at last satisfied—and cease," he proclaims, "unless I accept except my my [sic] own murdered people who are daily slaughtered in the same spirit on account of their political opinions." For Douglass, the lesson of William the Silent is only usable in so far as it speaks to the unending freedom struggles of "my own murdered people." He

13 Ibid.

draws a powerful analogy between both nations by interpreting the misguided belief of the Dutch that they "could successfully resist Spanish persecution without experiencing the authority of the King" prior to William I's reign, as a "similar folly" to the conviction held by the US citizens that it would be possible "to put down a slaveholders rebellion without in any wise injuring the delicate relation of master and slave."

As Douglass summarizes, "They were restrained by the doctrine of the devine [sic] right of Kings. We were restrained by a similar reverence for slavery." Again, for Douglass, the answers to any and all histories of persecution is the revolutionary promise of heroic manhood in all its guises. He is under no doubt that, "What George Washington was in the darkest hours of the war of American Independence What Toussaint was to the Black Republic of Hayti when the armies of Napolian [sic] encamped about it and attempted its reenslavement: What Abraham Lincoln was to this country when James Buchanan had surrendered it to slaveholding Rebels[,] that and more was William the Silent to his country and to the cause of civil and religious Liberty." The popular failures of "William the Silent" notwithstanding, Douglass nevertheless succeeds in introducing his audiences to epic moments in European history as recontextualized through US histories, ideologies, and political contexts that devastate Black lives in particular. As Angela Ray emphasizes, "Douglass thus performed popular lecturing as both education and entertainment, while simultaneously creating a platform persona of a race spokesman and social critic."[14]

Before Douglass "learned wisdom" from his "bitter experience" of boring his audiences, with the result that he self-confessedly "scrupulously shunned the classic shade of antiquity," he authored eight manuscript versions of "William the Silent." These include the handwritten manuscript reproduced here, consisting of 73 pages, as well as the seven drafts held in the Frederick Douglass Papers at the Library of Congress. These are catalogued as follows: Folder 1, 34 pages, typed, annotation by Douglass; Folder 2, 13 pages, typed, annotation by Douglass; Folder 3, handwritten manuscript, 49 pages; Folder 4, partly handwritten, partly typed manuscript, 26 pages; Folder 5, handwritten manuscript, 75 pages; Folder 6, 26 pages, handwritten manuscript; Folder 7, 26 pages, handwritten manuscript. In the case of the handwritten manuscripts—including the version reproduced here—and as per *Santo Domingo*, the majority of these versions consist of a combination of Douglass's own handwriting and that of Rosetta Douglass Sprague. While the original dealer writes in an accompanying penciled note that this speech is "in another hand," she or he acknowledges that, "Revisions and corrections" are "in F.D.'s hand."

14 Ray, "Frederick Douglass," 628.

Among the published versions of this lecture is Douglass's delivery of "William the Silent" in Cincinnati, Ohio, as early as February 8, 1869. The printed version of this speech betrays more differences than similarities with the manuscript included here on the grounds that it is a fraction of the length. The brevity of this speech combined with its early date render it almost certain that Douglass produced this unpublished manuscript much later. Very likely Douglass chose to revisit the speech in order to insert further comparisons between the Dutch nation and the US republic in a bid to cultivate his audience's enthusiasm by rendering his subject matter more relevant to their national context. In an especially bold departure from the manuscript held in the Walter O. Evans collection, Douglass included this provocative declaration in his published speech: "I may announce what subject I please, but I have never been able to ascend an American platform, and get off without bringing the nigger with me in some shape or other."[15]

Clearly, Douglass relies on a pejoratively racist term as no sign of internalized self-hatred but in order to invert its negative associations and celebrate the exemplary role played by a Black heroic masculinity in the pursuit of equal rights for all. "Deny the very manhood of the nigger and you are all right," he informs his audiences, "but admit that, and it is all up with you; admit that the nigger is a man and you must admit that he is a responsible being, and he is a subject of law; admit that he is a subject of law, and he may be a citizen, and if a citizen a soldier, and if a soldier a voter, and if a voter he may be voted for, and if voted for, he may go to Congress, and if he goes to Congress, there is no telling where he may not go."[16] For Frederick Douglass the dramatist, historian, and novelist, there was "no telling where he may not go." While William was silent, Frederick wielded powerful oratory in a lifelong war to secure the intellectual and political freedom of all Black peoples. A testament to his success, he relied not only on oratory but on the writing of autobiographies, essays, letters, and political histories as he marshaled every creative means necessary to get "beyond Fredk Douglass the self educated fugitive slave."

15 Douglass, "William the Silent," in Blassingame, *Frederick Douglass Papers*, vol. IV, 193.
16 Ibid. 193–94.

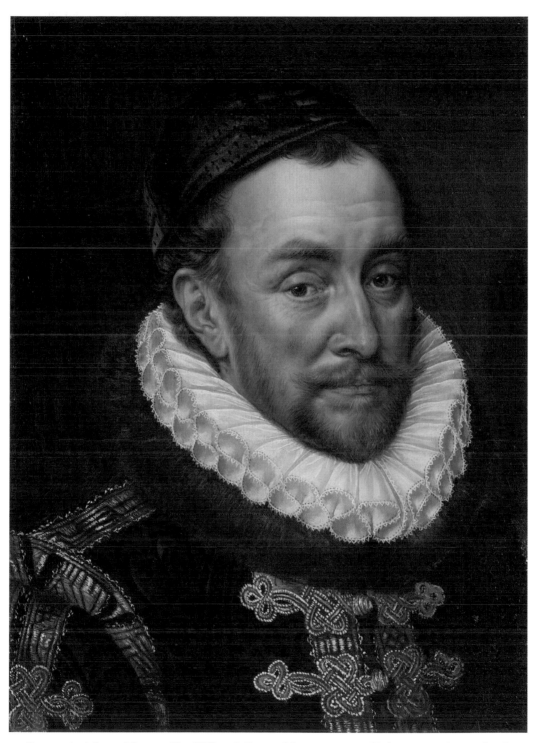

Figure 46: Adriaen Thomasz Key, *William I, Prince of Orange*, c. 1579. (Rijksmuseum, Amsterdam.)

1876

William the Silent as revised in 1876.

28. Frederick Douglass: "William the Silent," 1876

I venture to Speak to you this evening of a great
historical character, of a great people, and of a
great war: Of a great people because only a
great people can produce and sustain great
Men; Of a great war, because war is a great
School, and developes great qualities and Characters,

Deplore it as we may and must the red sea
lies ever between the pilgrim and the promised land.
War, War! Stern and terrible war, seems to be
the inevitable and inexorable condition demanded
for every Considerable additions made to the
liberties of mankind. The world moves, but only
by fighting every inch of its disputed way: Right
and wrong seem alike endowed with fighting
qualities: If the one does not prevail, the other
will and must.

Two thousand years of the Christian religion
with its benedictions for peace makers; have
left this one ghastly fact as incontestable
as ever. Non resistance finds little support

in the example of Christian nations.

Freedom is valued not only for what it is, but for what it Costs. They who receive it as a gift can never wear it as grandly and defend it as bravely, as they who have wrenched it from the iron hand of the tyrant. Philosophy and experience teach one and the same lesson at this point. They are whipt oftenest who are whipt easiest. Cowardly submission is an open invitation to aggression. The lines, and limits of national and individual liberty may be well defined in theory- written in books, & framed into laws; but human power respects no no lines or limitations which have not been traced and may not be retraced in blood.

Among all the great wars of nations and parts of Nations, waged to obtain a larger measure of liberty or defend and maintain liberties already acquired and established, there, is perhaps, not one

28. Frederick Douglass: "William the Silent," 1876

in history or song, more remarkable for duration,
for heroic fortitude, for thrilling incidents, for far
reaching consequences, and beneficent results than
was the war waged by the Netherlands against
Spain in which Phillip II. and William Prince of
Orange, now known as William the Silent, were the
respective leaders.

For a grand and vivid picture of this tremendous
conflict of more than a half a century, the Protestant
world is more indebted to J. Lothrop Motley the
warm personal friend of the late Charles Sumner
than to any of the many writers who have
attempted that work. His history of the Dutch Republic _A history of that war._
is a masterly production. It leaves nothing to be
denied, doubted, or desired. His gravest charges,
and most startling statements, _against the Catholic Church in the struggle_ are amply supported
by documentary testimony, not to be gainsayed
by either of the interested parties, laid bare. _The errors on both sides are fully and vividly_
I make haste to acknowledge my own
indebtedness to Mr. Motley _this Author_ for my conception

of the noble character William the Silent. and my
knowledge of the facts and events of that
terrible war of which William he was preeminently the
hero.

No apopology whatever is needed for calling
the attention to the debt we owe the Dutch
people for their part they took in their tremendous
conflict. Our own freedom of thought to day in matters
of religion, which is so precious and priceless
is largely due to their heroic endeavors hardships and sufferings,
during their war with biggotry, and persecution,

Though separated from our times by the space
of three centuries, though more than three thousand
miles of the wide waste of waters, divide that
two countries, we are in larger measure than
any other nation, the direct recipients
of the beneficent results of the Netherland war,
It was a fight by common friends against
a common foe.

The historian easily finds a clear, close and

5

establishments of the
logical connection between the Dutch Republic of three
centuries ago — and the American Republic which
 recently
has just celebrated its first Centennial: a
connection between the war of the Netherlands
against Spain, and the war of the American
Colonies against England; between William the
 at the head of the Protestant forces leading the armies of the Revolution
Silent, and George Washington; Both Republics,
both wars; both Men: belong to the same great
family of men, the great
Chain of events by which the Cause of human
Liberty, has gained its present ascendency
in the world. They stand related to each other
in the sense of Cause and effect. The elder
was essential to the existence of the younger
Republic. — It is a significant fact that before
Before setting sail finally from the old
world to the new. the Pilgrim fathers betook
 and
themselves to Holland, tarried there eleven years.
Their years in the dutch Republic, served them
 in
as, a school preparatory to the greater school
of free Institutions since established. by their

6

on this continent by their descendents.

Of course, in the space of the single hour allotted to me, I can give minute details neither ~~neither~~ neither of the Netherland war nor of the causes that produced it.

Sufficient ^however for this occasion it may be to state, briefly the relation subsisting between the Netherlands and Spain prior to the war which finally resulted in the ^establishment of Dutch Republic and the triumph of free worship and free thought in Europe, and some outline of the causes which forced the Netherlands into rebellion.

If we could go back three centuries, and take our stand upon the soil of the Netherlands we should find that country within the limits and under the laws of what was then ^known as the Spanish Empire, ^with ~~and~~ Charles the V. the reigning ~~Monarch~~. Tarrying here a while we shall soon see this warlike King— worn out and broken down at the early age ~~of~~ of fifty six —piously humbly

330

7

abdicating the proudest throne in Europe, in
favor of his son Phillip second: We shall also
find that the new king, unlike his father, disdains
to reside any where, outside of Spain: You will
find too that he is thoroughly Catholic as he is
thoroughly spanish, and has therefore nothing
in common with his dutch subjects and that
he does not in any wise seek to conciliate them.
He holds them from the first at more than arms
length and Scarcely regards them as loyal subjects.
His plan of governing them was in the highest
degree distastful to them. He committed them to the
Care of a regent in the person of his Sister Margaret
of Parma— and made Cardinal Granville her
prime Minister or Secretary: Besides Margaret
and Granville, the Regent and the Cardinal, there
was a legislative body, in the Netherlands, Known
as the States General, a body which in theory
possessed powers, analgous to those exercised
by the american Senate, but practically

8

under Phillip it exercised no power at all: You
 were
will also find that the reins of Governments ~~are~~
firmly and completely held in the hands of the
new King _ and that the people hade no voice
 in their ~~own~~ governments.
whatever. The States general where they once
had some share in making the laws could
~~now~~ do nothing, without Granvelli, and
Granvelli could do nothing without Margaret,
and Margaret could do nothing without
Phillip.

This long handed Government, with its head
in Spain, and its hands in the Netherlands
was particularly friendly to sinuosities of all
kinds _ The large space between the head and
hands, was kept full of doubt, delay and
intrigue, and falsehood. As a consequence
a deep, and general distrust was felt at both
 in Spain and in the Netherlands
extremes, the ruled and the rulers. For there
can be no trust where there is no truth.
 One of the first indications of

9.

the troubles coming upon this people, was the arrival among them of large bodies of Spanish troops. For Phillips had scarcely got seated upon the throne of his father, before he began to invade the Netherlands, in a manner at once stealthy and sinister. All the important towns and cities of that low country were speedily garrisoned, by Spanish soldeers. Their uniforms and arms were visible every where, and were objects of strong and ever increasing hate and dread among the people, They could not readily discern the purpose for which they were sent among them. Every day brought some instance of conflict between the common people and the Spanish soldeers. These served to deepen the animosity already deep, and to kindle resentment always ready to blaze forth on both sides, and upon the slightest provacation. The troops were haughty and the people were sullen. The conditions were plainly present for a terrible war and war came at last.

¹⁰ A war ~~whose~~ the

ᵃ fierceness and wrath, of which was only equalled by

its ~~endurance.~~ long duration.

The quarrel ~~was~~ then, as ~~it~~ the quarrel is now, and ever,

will be, was the new against the old and

the old against the new: The people against

the King and the King against the people. It

was knowledge against ignorance, and reason

against superstition. It was freedom against

authority and, Charity against bigotry. (~~Two ideas~~)

Until, Philip the Dutch people, though oppressed had

enjoyed a certain measure of liberty. The

change from Charles to Phillip was from bad

to worse. The little finger of the latter being ~~was~~

heavier than the whole body of the former.

The Spanish yoke, heavy and grievous

to be borner under Charles, became galling

bloody and intollerable under ~~Phillip.~~ the new King.

On ascending the throne the ~~New King~~ Phillip seems

to have given his mind to one grand

idea, and ~~had~~ to have dedicated all his

11

powers and
opportunities to the one purpose of realizing
that one idea, ~~and to make~~ of making Catholicism supreme
throughout
& all his dominions.

To accomplish this high, religious ~~purpose~~ object
he evidently thought that no means were
and
too harsh or ~~too~~ cruel, no artifice too mean
or too immoral. The sacred claims of justice
mercy and truth, could not be allowed to stand
in the way of this one high religious purpose
of making his dominions entirely of the
Roman Catholic faith. ~~He was literally the~~
In his blindness, to accomplish this end
~~pale horse in the Apocalypse xxxx,~~ He employed
death in every form, which could affright the
souls of men. The informer named the victim
— the inquisition Condemned, and at once
the warm blood flowed, the flames rose, and
living human flesh crackled, peeled and
burnt to ashes. It is sad to think that
so small a concession to liberty as the right
to
worship the infinite according to the dictates

12

of ones own conscience, could only be
purchased at the cost of so much ^blood and suffering.
Difference of belief from the true church meant
death, as well as damnation, and Phillip's
seemed determined that none ~~un~~ guilty of this
dreadful offense should escape. ~~His~~ Their agents, ^of religion.
The church was ^inventive,
~~were singularly~~ ~~fruitful of inventions~~ in the art
of destroying human life, and ^in the means ^exquisite of ^torture.
There was death by hanging, death by strangling
death by drowning, death by shooting, death
by starving, death by poisoning. Some were
torn asunder by horses attached to each limb,
Some were chopped to pieces in detail beginning
with the first joints of their fingers, and continuing
by piecemeal, till the whole man was destroyed.
Some were disembowelled alive: Some had
their hearts ~~torn~~ out and flung into their faces
But there is no innumerating all the horrors
perpetrated in ^the propagation and ~~defense~~ of the faith, ~~and~~
and supremacy of the holy Roman Catholic

28. Frederick Douglass: "William the Silent," 1876

religion.

Before there was any organized resistance in the
Netherlands, to these accumulated and numberless
horrors: before the phlegmatic Dutch people could
be lashed into open war, upon their biggotted and
cruel persecutors — at least one hundred and thirteen
thousand Protestants had suffered the rigorous tortures
of the Spanish Inquisition.

The patience and forbearance of these people was
alike wonderful and painful to contemplate. Walking
among them, and beholding the atrocities to which they were
subjected — the heart aches and breaks with the inquiry
as to when will the tormented turn upon their
meet fire with fire
tormentors — and give blow for blow, and ~~meet~~ death with
death.!

I know of no race of men more patient under
resistant
wrongs. more non ~~resisting~~ in the face of temptation
to violence; more hopeful that deliverance would
more ~~hopeful~~ believing
come in some other way, that the thirst for blood
at last
would be satisfied — and cease, unless I ~~accept~~ accept my

14

my own murdered people who are daily slaughtered
in the same spirit on account of their political
opinions.

It was the wisdom as well as the desposetion of the
Dutch people to make haste slowly. They endured
the fierce wrath of bigotry and bondage, tile they
could bear it no longer. — They were preeminently
a peaceful people — and were ready to purchase
peace almost at any price.

There submission to wrong however was not the
result of any insensibility to wrong — as is some-
times slanderously attributed to my own race.
These people employed all the means in their
power to secure peace, by ~~moral~~ peaceful means — by
appeals to reason, justice and humanity — and
it was not until they had faithfully tried
all such measures, — not until they had
fairly beseiged the Spanish throne with
arguments, petitions and remonstrances — not
until one chartered right after another

15

had been wantonly stamped out: it was not until the
able and bloody duke of Alva. was sent with his veteran
Spanish army, to exterpate the last vestige of liberty;
it was not until they saw the mantle of moral
death drawn around them by the steel clad hand
of Superstition and bigotry, *and all hope was gone* that they ventured at
last upon open ~~to~~ and organized resistance.
When this momentous crisis was once reached:—Oppressors
received a lesson which ought to suffice for all time— and
would if men were not mad— They demonstrated that
a nation strong to suffer may *be* equally strong to fight. Their
fire and fierceness, *of the Dutch* in battle, were only equalled by their
heroic firmness, and matchless fortitude. In their
poverty of arms, they reversed the order of prophecy—
They literally, *beat* their plough-shares into swords and
their pruning hooks into spears, and taught not
only their sons, but their daughters the art of
war.

It is a remarkable fact, that in some of the
most desperate battles of this protracted war—

16.

women bore a conspicuous part. and in the
fury of battle were not less brave and steady
than the veteran Soldiers, *themselves*. Sisters stood by brothers
wives by husbands, resolved to succeed or perish
together in the Cause of Freedom.

The argument that women ought not to vote because
they cannot fight falls to the ground in the light
of this Dutch example. Yet I would not base
the right to do the one, on the ability to do the
other. The *such* logic is about as bad as to say because
a man cannot fly he has no right to walk — or
that he ought not to do any thing because he cannot
do every thing.

Many analogies ~~may~~ may be traced between
this war, against Spain, and the Colonial war
against England, the war for religious liberty
and the war for political liberty. But the
cause of the colonies against England
was light as air compared with *the* cause
of the Netherlands against Spain.

17.

George called for money: Phillips called for blood. George was selfish, haughty, tyrannical, and cruel. Phillips was a fanatic, cold blooded and cruel. He would in cold blood, exterminate a race for the glory of God.

In several particulars the American people had a decided advantage over the Dutch people. The fathers of this Republic had fully counted the cost. They knew from the first, just what they were about: The Dutch, on the contrary, did not know— they had not considered— In the earlier stages of their troubles, they behaved like frolicksome boys— and indulged grotesque sports on the very verge of war. While they sought peace, they permitted practices which could only lead to war. The fathers of the American Republic marched by a previously ascertained line, while the Netherlands only drifted as upon an unknown sea without chart or compass and with no definite port in view.

In this respect they resembled us more in our recent war with rebellion, than the fathers in their war with England.

19.

They went into the war with Spain without a policy. as we went into the war with the rebel South without a policy.

Though the Dutch people from the first were fighting for the right of Self Government, they did not dare to admit that pregnant fact to themselves and much less did they dare to proclaim it in the Ear of listening Europe. Such radicalism could not come but by a long course of preparation and by suffering. They flattered themselves that they could successfully resist Spanish persecution without impeigning the authority of the King by whom persecution was enjoined and inflicted.

We repeated a similar folly when we proposed to put down a slaveholders rebellion without in any wise inquiring the delicate relation of master and slave. They were restrained by the doctrine

20.

of the devine right of kings. We were restrained
by a similar reverence for slavery. The pulpits
of both countries as usual were in large measure
responsible for both errors

It is a notable fact that the people of the Netherlands
made no successful resistance to Spanish power
tile they exploded the delusion of kingship
by devine right – and the same was true
of us. We made no headway against our
slaveholding rebellion till we exploded our
devine right delusion and parted with our
reverence for slavery. The abandonment
of both errors was the turning point in
the fortunes of both wars. By it both were
made consistent, logical and strong.
Neither nations, nor individuals are apt
to see the whole truth at first. Time and
events are the great instructors of the
race – and it is interesting to observe how
rapidly a people may sometimes be

2/ insensibly

whirled forward by these in the straight line
of wisdom and duty, They are often converted
and moved forward without their own
knowledge – and accept the truth in
action, which they still deny in theory.
It is one of the convincing evidences of
a moral government of the universe
that that the discovery and adoption
of one truth, naturally leads to the
discovery and adoption of another. The
one makes the other in some sense
certain if not inevitable. Right and
wrong are equally logical as well as
equally belligerant. The friends of slavery
were not less logical than were the friends
of antislavery. Mr Calhoun was consistent
in denying all human rights to the
Negro. He saw that the end of the
journey was involved in the first
step. He saw that to admit that the

28. Frederick Douglass: "William the Silent," 1876

negro had any rights he meant admit that
he had all rights. — If a man, then a freeman,
if a freeman then a citizen. If a citizen, then
a tax payer and voter — and if a voter, then
elligible to congress and if to congress —
there was no knowing where else he might
go. It is observable that,
at first, on the side of the dutch, the
contest was purely physical. No great moral
principle or idea loomed visibly, above
the struggle. They fought simply against
a recognized hurtful and hostile power. They simply
gave back blow for blow. They had the
courage to fight, but lacked the courage,
or perhaps the comprehension, to declare
what they were fighting for. They stood
by the old in theory, while they fought for
the new in practice. They talked of the
"Accords," "Joyful entrance's and "Covenants"
old papers, which had long ago lost their

22.

28. Frederick Douglass: "William the Silent," 1876

23. And about which nobody cared

significance. They did not dare to deny the right of the king, or to deny the right of the Church, to control the religious convictions of the people. The right to detect and punish heretics they freely conceded. It was not the persecution to which they objected, but the rigor of the persecution; It was not the principle, but the form, not the inquisition, but the Spanish Inquisition not the God anointed and God appointed Phillip the King, but his wiley ministers and brutal soldiers, against which and whom they rebelled and fought. Had they foreseen whither they were tending — what venerable doctrines, both of religion and Government, they would be compelled at last, to abandon and oppose, it is fair to assume that they would have been amazed — affrighted and probably deterred from the understaking altogether.

They did not see the end from the beginning any more than we did, in our late war,

and it is well that they did not. War is a stern
disciplinarian and a great teacher. Nothing so
rapidly opens the eyes of a nation and puts
them further beyond the power of sleep — than war.
All through the struggle, one step prepared the
way for another. So it was with the Netherlands.
It was not until after years of terrible war, and
suffering that the statesmen of that country, could
be brought to see that complete and absolute
religious liberty was the only ground of safe
footing for themselves and for mankind.
When they boldly took the position that a
man's religious convictions were not to
be interfered with by any power on earth
outside of himself- they placed their cause
upon the solid rock— and were a long way
on the road to the right of self Government
as well.
The union of these two elements, moral and
political power. was among the first conditions

25.

of final success.

Grand and powerful, however as is civil, liberty, when viewed as a motive of action, it arouses no such enthusiasm, and lifts men to no such heights of daring, as will a desire for religious freedom and a fetterless mind. If men will wade through blood for the one, they will wade through blood and fire for the other. It is the religious side of this Netherland war, which makes it a luminous point in history and will make it a fascinating subject of thought with after coming generations

About the most wonderful thing connected with this war — was its duration. and the seeming impossibility, of a strong nation to overcome and crush a weak one, when in the the weak one's rights. Never were belligerants, to all appearance more unequally matched than in this war. The country of William itself is a mere dot upon the map of Europe. fitter in its

28. Frederick Douglass: "William the Silent," 1876

natural condition for amphibious animals than
for men, a low flat country, not given directly
to mankind by Providence — but won from
the waves of a turbulent sea by the utmost
vigilence and the most heroic industry. Its
population was only about three millions,
and though they were a hardy and virtuous
people, their habits and customs were all
strongly averse to war.

It is not upon such ~~such upon~~ such flat and
oozy parts of the earths surface, that poetry
and eloquence, locate the noblest love of
liberty and ^the most^ ~~heroic~~ deeds in her behalf. For
these qualities we usually look to deep valleys
and lofty mountains, where the wild winds
rave, ~~and~~ where the eagle soars and sends
his ~~wild~~ fierce scream against the blast ^as he makes his flights towards^ ~~the sun.~~

The population of the Netherlands were
not only ~~weak~~ few in numbers, they were
weak by reason of their sectarian divisions

27.

jealousies and rivalries. They were not only devided but antagonistic. They were composed of Catholics, Lutherans Calvinists Anabaptists the latter an Ishmaelitish Sect. *Its hand against every mans and every hand against it* Each of these bodies was watchful, lest the other should gain some advantage.

In fact the Protestant denominations of that day probably dreaded and hated each other only a little less than they hated and dreaded the common enemy. As to day we have to thank the violence and extravagance of the South for the abolition of slavery—and for the union of these States upon a more enduring bases, so also we have to thank the violence and fury of Romanism of the sixteenth Century for the Dutch Republic and for a larger measure of Religious liberty.

From first to last, the Protestants were held together less by any internal

28. Frederick Douglass: "William the Silent," 1876

principle of cohesion than by external Catholic
pressure, and even this did not secure unbroken
fidelity to the common cause.

There were times, when one sect was perfectly
willing to purchase, relief for itself at the
sacrifice of the common cause. The History
shows too, that as there were tories in the
American revolution and as there were
copperheads during our late war, so there
were tories and copperheads in the Netherlands
it was there, as here a united South against
a divided north.

Some openly took part with the common
enemy, While others tried to stand upon
neutral ground.

Such then was the country; Such were
the relations of its sects and parties —
Rent asunder at the centre, divided
and crippled at the very point where
it should have been most united and strong.

29.

a mass of ill assorted and conflicting matereals
apparently incapable of any considerable
resestance, an easy prey to the spoiler.

Now opposed to the people of this
small country, thus devided, confused and
ill assorted what have we? We have the
Spanish Empire in its palmiest days
and in the plenitude of its power, Vast
grand and compact. a Unit in all the
elements of national strength,
There stood the Dwarf— there stood the
geant and between the two the battle
field. Spain thoroughly prepared,
alert, & orderly, with purpose fixed,
with plans matured, Calmly surveying
the whole field, knowing just when, where
and how to strike.
Her Government from Phillips down
worked with the precision of a Corless
Engine. Her Statesmen were among the

28. Frederick Douglass: "William the Silent," 1876

ablest, and her generals among the most
skillful and brave. She was in fact at
the zenith of her greatness. England,
France, Germany and all the world at
that time admitted her power. She was
great in her internal resources, great in
public order, great in her respect for
legal forms and for ~~great in war~~ the authority of her
rulers. Besides all this and more—Spain
was supported by the active approval,
of his holiness the Pope—and by the
ardent sympathy of the Catholic World.
For sinews of war she had the wealth of
two continents at her command,
She had still another advantage. She was
used to war. She was enured to its perils
and hardships by an apprenticeship of
legal centuries. Her history was a history
of brilliant military achievements. She
had driven back the moors, humbled

31.

the crescent and expelled all opposing creeds and sects from her borders. Her soldiers were soldiers of the cross. They went into the Netherlands flushed with victory, and overflowing with military ardor. They would have gone any where else, in the same cause and in precisely the same spirit. They were, ready for any field however remote, and for any foe however formidable. In fighting with the Netherlands, they were sustained by a double inspiration. It was loyalty to the King and fidelity to the true faith. It was loyalty and piety against treason and heresy. order against riot, and discipline against the mob.

To take up arms against a nation thus strong and thus inspired – must have seemed to the wise and prudent Dutch statesman of that day, like the madness of rushing

28. Frederick Douglass: "William the Silent," 1876

from safety to danger and certain ruin—about
as mad as seemed the attempt of dear
old John Brown to conquer Virginia with
twenty two men

But it is proper to say that the acceptance
of the guage of war, was not a matter of
choice. There ~~was no avoiding the contest~~ final contest was unavoidable.
It was the irrepressible conflict of the
sixteenth Century. The ~~middle ground~~
of compromise was impossible. The
alternative with them as with us was
slavery or freedom. The pope is absolute,
or the Pope is nothing. ~~If he binds in~~
The hand that binds in heaven, must not
be bound on earth. For men are too practical
and logical to believe, that what is weak and
contemptible here, is, of ~~boundless~~ (Can be of) power and authority
elsewhere.

Too much honor cannot be awarded
to the Dutch people for what they dared suffered

33

and achieved in the cause of civil and religious
liberty. If this were there only claim to the
gratitude of ~~mankind~~ <ins>civilized men</ins> they would stile hold
a place among the greatest benefactors of
mankind. <ins>It is their glory that</ins> ~~They bore~~ the brunt of Popish power
in Europe and made free thoughts possible in
the world.

You will pardon me another analogy.
The experience of this people in the earlier
years of the war, was strikingly like our
own experience during the earlier part
of our late war with slavery.
Like ourselves, it was their sad misfortune ~~to~~
at the beginning to be afflicted with raw
recruits and ~~incompetent generals~~ and
sometimes with treacherous ones. Like
ourselves they had their Bull Runs, their
Balls Bluffs, and their Fredericksburghs. Like
ourselves, they were educated by warfor-
war. And like ourselves they learned to

conquer their own prejudices and abandon
their superstetions - and, thus to overcome their
Spanish enemies.
But alas! how slow and painful was the
process: Through what startling reverses,
what mortal agony; what dreadful disasters
by flood and field; what horrors of blood
and fire, this wisdom was gained.
The destruction of life at the first was almost
wholly on the wrong side. Before the
skillful generals, the veteran troops
and superior arms of Spain the badly
appointed and badly commanded and
hastily organized armies of the Reformation
were swept down like hay before the
scythe, They were not merely repulsed
and demoralized, but were routed, cut to
peices, scattered, pursued, overtaken,
murdered, annihilated in detail.
 For nothing however was this war

35.

more remarkable, than for the success of
the weaker party in raising successive
armies in the face of the most chilling
and hope crushing disasters. As fast
as one army was destroyed another was
immediately created. Nothing but a quench-
less love of liberty and a fortitude which no
reverse could break down – can explain the
almost endless succession of armies brought
into the field.

No word painting is needed – to paint in high
colors the heroic qualities of the Dutch people.
The simple facts are more eloquent than
fine rhetoric. Subjected to crimes, outrages,
sack and pillage, with all their incidental
abominations of rapine and murder; defeated
in almost every great battle; the sympathy
of the Christian world against them, they
still persevered, and year after year, for more
than fifty
thirty years continued the war.

28. Frederick Douglass: "William the Silent," 1876

The horrors perpetrated ~~by the slave holders of~~ ~~the south~~ during our late civil war have sometimes been compared with those committed by the Spaniard against the Dutch. Badly, as I think of the American slaveholders, I do not accept this comparison. The cruelties employed in the interest of physical slavery have never quite equalled those inflicted for the maintenance of religious slavery.

Nevertheless both wars prove that the moral dispositions of men are about the same in all ages, and countries. Give any man among you, absolute power over the bodies of men — and he will become a wild beast, ready to tear and slay upon very slight provocation. On the other hand give even a Saint, absolute power over the souls of men with the right to enforce his authority by pains and penalties, his religious creed and history shows, he will become something more terrible than a wild beast. Crimes and cruelties

37.

which other men commit in fits of sudden
anger, the pious tyrant will commit
without wrath, without passion — without
remorse, without shame, and with saintly
satisfaction. The cruelty of Phillip plainly
enough had its source, and mainspring not in the natural
man which is said to be enmity towards
God, but in the spiritual man, ready to kill or be killed for his God He was
not cruel by nature, only by grace —
When he burned the body of an heretic or chopped
off his head — he did the one or the other, in
obedience to God. The age was dark and
the net-work of superstition was thick and
strong. Nobody thought in his day, that error
in matters of faith might be tolerated while
truth was left free to combat it. History
credits Phillip with great kindness towards
those who agreed with him. The Lamb only
became a lion in the interest of a pure
Religious faith. It was natural that he

28. Frederick Douglass: "William the Silent," 1876

should assume that the religion which was good
enough for his own beloved spain, much be
good enough for the people of the Netherlands.
The seeds of the dawning reformation had
never been allowed to take root in spain.
The few seed carried there were scattered,
not sown — and fell upon stony ground,
They sprang up suddenly and were cut down
quite as suddenly. They vanished in the hot fires
of the Inquisition.

The case was just the reverse in the Netherlands. There
the good seed fell upon good ground, took deep
root, grew and flourished — and ~~brought and~~
brought an abundant harvest, some thirty
some sixty and some an hundred fold.

But alas! the age was dark with them as well
as with their spanish persecutors. As these
converts became numerous and strong — they
imitated the bad example of their enimies.
and behaved recklessly — lawlessly and scandalously.

39

These attacks upon the old church were
wrathful and furious. Their words were
not more violent than their blows. They
poured contempt upon the sacred altars of Mother
Church. They ridiculed her miracles, broke
her her sacred vessels, cast down her saintly
images. defaced her holy pictures; held mammoth
outdoor meetings, preached their forbidden
doctrines, and lead the people away from
the faith of their fathers and the church of their
veneration.

One of the most important lessons taught by
this religious war is that when men fling
away reason and accept the rule of faith
alone, the worst possible things can be done
from the best possible motives. and for how
little, mere conscentiousness must in our Pass
in establishing the rightfulness of any
act or measure.

28. Frederick Douglass: "William the Silent," 1876

40

There is no absolutely reason to doubt that in burning and slaughtering the Protestants Phillip felt himself discharging a sacred religeous deity. The evil in his eyes must have been shocking and full of danger to the souls of men — and it was natural for him to think that it was for him to apply the remedy. Persecution had unified the faith of Spain and why not the Netherland.

In the selection of his agents Phillip showed admirable skill and judgement — as well as an unhesitating conviction of the holiness of his mission. The command of his first grand army to enforce a sound religeous faith, was given to the Duke of Alva — He was an able general and a devoted Catholic, His mission was to burn, destroy and exterminate, and never was cold blooded and cruel work committed to hands more cold blooded and cruel. It might be said of him, as Byron said of the pirate. He was the mildest mannered man that ever scuttled ship or cut a throat.

363

41.

It was the boast of Alva that he had killed
in cold blood eighteen thousand Protestants
and history proves the boast well
founded.

The appearance of this man of piety and
persecution, with his army of twenty
thousand Exterminators in 1567 upon
the field of the Netherlands had one good
effect; It put an end to all doubt and
suspense, as to the intentions of Phillip.
It Called to the front the ablest men of the
invaded Country and Compelled men generally
to take sides. There had been riots, insurrections
mobs and Collisions between the parties of
the old and new religion, but until Alva
the war was without form.

Among the many noble spirits thus called
to the front of this tremendous Conflict
by the presence of this Iron hearted Duke
of Spain— there was one great Character

28. Frederick Douglass: "William the Silent," 1876

which towered high above all the rest — a man
wise in counsel, strong in arm, high in
position, great in wealth — and one whose
life long deportment had won the entire confiden...
of his Countrymen, a man in whom the Warrior
was only surpassed by the Statesman, and
the Statesman by the self sacrificing lover
of mankind — and that man was William
Prince Of orange, now known as William
the Silent.

The value of one great man, when a nation
is in trouble has been often illustrated — and
never better than ~~than~~ in the ~~pre suck instance~~ in the Case of William.
But for the presence and power, of this one
great man, it is not easy to see, how any
successful resistance could have been
made to Spanish power in the Netherlands.
Happily the crises did not demand more
than the Country was able to supply.
There was not one element in William's

43

character, not one mental attribute, not one physical or social perfection which could have been spared from the leader of a country so divided and distracted against one so united determined and strong.

It was his wisdom, forbearance, dignity and statesmanship which silenced the angry waves of sectarian divisions and religious contentions among his countrymen. It was his great spirit that brought together and fused into a solid bolt the chaotic element of his country and dashed it against the massive forces of Spain. under Alva. To him more than to any other we are indebted for the ~~for the~~ noble example set to mankind by his people in this vast and momentous struggle for the right. It was the ~~holy fire~~ fire of his quenchless patriotism which warmed the hearts of the Dutch people

and 44

made them invincible.

Through all the earlier part of the war, mainly desasterous to the party of the Reformation.
William
this Man showed how a great man devoted to a great cause, fired by a great artist, resolved to survive or perish, with it with his cause can convert, the most appalling disasters and succession defeats into new motives to renewed exertion.

In estimating his character and achievements, it must be remembered that William of Orange was not the leader of a simple contest with Spain. Neither in war nor in statesmanship was he measuring arms merely with Alva and Phillip 2d. Even such a task would have been one before which many strong men might quail—but to William belonged a heavier and more difficult task. The outside world was from the first a deeply interested party to the contest—Though his military activities

45.

were confined to the Netherlands, his statesman
ship was required abroad. To cope with Spain
he must cope with France England and Germany,
His relations with Henry, Firdenand and
Elizabeth, often required greater exertion than
his relations with Phillip and his able
Ministers. These external relations with their
manifold and conflicting vicissitudes imposed
burdens which could be borne only by an
intellectual giant, and such a giant he proved himself.
Though busy with his troubles at home, some of
which touched not only the state but his own
hearth stone and Pillow – he never wavered
nor wearied. In the thick of them all, he
was seen steadily, threading his way through
the intricate network of foreign diplomacy –
playing off the rival ambitions of one
Court against another; now parrying a
medetated blow and now winning reluctant
support – now exciting the hopes of one

28. Frederick Douglass: "William the Silent," 1876

46

nation, and now the fears of another, as one
or the other stroke of policy promised service to the
great cause to whose defence he had now dedicated
all his powers. and staked his life.

We know men best by comparison one with another,
those of one age with those of another age.
But it is not easy to find men or circumstances
to match in this case. In some important respects
William of Orange stands alone in history,
No Ruler ever had just such a religious war
on his hands,

What George Washington was in the darkest
hours of the war for American Independence
What Toussaint was to the black Republic
of Hayti when the armies of Napolean
encamped about it and attempted its
reenslavement. What Abraham Lincoln
was to this country when James Buchanan
had surrendered it to Slaveholding Rebels
that and more was William the silent

47

to his country and to the cause of civil and
religious Liberty,

But of the three illustrious men thus
 one
mentioned, the ~~man~~ who most resembled
the great man of the Netherlands was that
preeminently self made Man Abraham
 one
Lincoln a ~~man~~ who embodied ~~in~~ more
of the best elements of the American Character
than any man who has occupied the
Presidential Chair.

In the matter of his social position and
training William stands in striking Contrast
to Abraham Lincoln. William was highborn.
a Prince of the blood, ~~Royal~~ surrounded from
the cradle, with the best Conditions that great
wealth and high position could purchase –
Lincoln Sprung from the lowest round of the
 With nothing to support him but his simple
social ladder. manhood. marked
 There was also a ~~marked~~
 is a
difference in the respective mental Character
of the two Men.

28. Frederick Douglass: "William the Silent," 1876

William was preeminently a leader of thought as well as of men — He was ever in the front and never in the rear of his people. He was to them as a pillar of fire by night, and as a pillar of cloud by day — shielding them alike from heat and from darkness.

Abraham Lincoln, great and good as he was, did not lead the thought and feeling of his country. He did not create events or opportunities. But he was wise enough to accept the advantages of both. He did not make public sentiment nor did he repress it, but adjusted and timed his measures to its demands — And yet these two men so strikingly unlike in some important particulars — the products of different ages and civilizations — the out-growths of different social conditions. the one a prince and the other a democrat, one the child of wealth and the other of toiling poverty. were stamped by nature with the same lineaments of a common nobility and appointed to a common mission in the world.

49. as we have seen
Both men, were at the heads of fearfully devided
peoples; and both possessed, in large measure
the high qualities needed to soften asperities and
heal devisions among men. The war in both
 on
cases was carried, between a united south on the
 a
one hand and devided north on the other: Both
men had foes of their own household — and
both had disguised traitors in their camps.
Both William and Lincoln were in the midst
of their years — when the body and the mind are
both at their best. Yet before age had plucked
the fire from their hearts or dimmed the
light in their eyes, the heavy cares of state
had plowed deep furrows in the brows of
both men — The country men of William soon
learned to call him father william — and those
of Lincoln soon learned to call him father
Abraham — and for the same reason: the
people believed in both men and trusted
both as children trust their fathers.

We trace him in his noble course, not merely over the howling chasm of a long and harrowing war—spanning the dreadful gulf with his cheerful spirit like the rainbow, always most serene and beautiful when the clouds were blackest and the tempest loudest but as one of the noblest benefactors of mankind—for he was preeminently a discoverer and organizer of truth into the laws and customs of his country.

To form any just idea of the force and effect of a great public character, we must measure the power of the resistance with which he has to contend. It is easy to be a giant among pigmies and to be a cannon ball among egg shells.

Greatness like most other things in the world is relative not absolute—An idea or an achievement which would secure honor and distinction in one age and in one class of circumstances, would do neither in another age and in other circumstances. A man to be truly great must not be behind the times or even abreast with his times—but in

55

advance of his times.

It was something for Humbolt to cross the continent when he did it. Any man can do it now. Thoughts and opinions which towered high above the ordinary range of mind in the sixteenth century, are now on a level with the masses. Learning which was then in the cloister, has now gone out among the people and the standard of greatness is steadily advancing.

I shall attempt no biographical sketch of this man. I have seen him only in the whirl wind and tempest of events— and give only glimpses and impressions of his character. For better knowledge of him read the history of his country. His name coupled with deeds of highest renown will be found there, glowing on every page.

As already intimated the war for religious liberty in the Netherland did not begin in earnest until the Duke of Alva invaded the country. It was then and not until then that William allied himself to the struggling cause of the

56,

Reformation. After that invasion and to the ^banishment^ of Spanish

power ^from^ ^it was^ the Netherlands. Orange against Alva, and Alva

against Orange — and never had combatants greater reason

to respect the ability of each other, ^than these two generals.^ Spain had no Captain

superior to Alva. and Rome had no disciple more

obedient to her ghastly teachings.

Much that looked like war had happened previously to Alva's

Advent. Margaret the regent and Granvelli the secretary —

had been busily, though somewhat blindly at work. The

Inquisition had yielded a considerable harvest of blood.

emeuts and riots were abundant, but these mobocratic

tumults, were signs, the shaddows of coming events —

the swift flying Clouds darkening the sky before the ^coming^

storm of fire and hail!

Something of the Character of William may be learned from

his deportment during the ten years preceeding the

^time of his taking part in the^ war. While the broad current of events was sweeping

on towards the dreadful Cataract of ^blood,^ war, the conduct of

William was marked by the most rigid prudence.

To out-ward seeming he was wholly unconscious of the part

371

he was destined act in this opening drama. He was a vigilent observer, but a silent one. It sometimes happens that more talent is required to be silent than to speak — and he is a wise man who knows just when, where and how far it is best to declare his views.

His Title: William the silent was acquired under peculiar circumstances. Full eight years prior to the great war, while hunting in the woods of Vincennes, with Henry of France and the Duke of Alva, he learned from the lips of Henry, a plot entered into by Henry and Phillip, to exterminate all the Protestants in their respective kingdoms. This dark and bloody purpose was devulged to him as to a consenting party — and a co-conspirator. He was himself a catholic and a Prince, and it was easy to regard him as an ally in this pious plan of extermination. He does not seem to have been surprised and startled by the revelation. His face was a blank and he heard

28. Frederick Douglass: "William the Silent," 1876

it without word or sign. There were no traces
in his countenance to tell whether he shared or
shuddered at the infernal purpose.
His wonderful reticence and self control on this
memorable occasion won for him the surname
by which he is now best known in history. He
was ever afterwards called William the Silent.

It must not be inferred from this title that
william was incapable of speech; On the contrary.
he is creditted with being one of the most eloquent
and impressive speakers of his age.

Though silent in the woods of Vincennes,
from the hour when this bloody secret was dropt
into his ear— William's purpose was formed
fixed and unalterable, From that hour, he resolved that no
effort of his should be spared to defeat the
murderous and inhuman purpose now declared of the kings
of France and Spain. But the time to unveil ~~declare~~
~~this purpose~~ . revolution did not come till long after
this conversation with the Royal Hunters.

59

Weaker nerves and a hotter heads than his
would have denounced the hell black plot at
once, and given notice of their inflexible opposition,
but the wisdom of feeling is not always the
wisdom of reason. While such righteous indignation
and the frank expression of it, *would have* been creditable to
the heart of William it would have done no
credit to his judgement. Men are not necessarily
guilty of duplicity and falsehood because they
prefer to be the masters of their own secrets –
and to chose their own times and places for
declaring themselves.

William knew that his time was not yet –
and therefore proceeded as usual. His manner
of life was so ordered as to avert suspicion in
a quarter where suspicion would have been
destruction to himself and to his cause.

His style of living was much after
the mode of the noblemen of his country – only
his was more liberal and splended theirs.

28. Frederick Douglass: "William the Silent," 1876

For his wealth was vast and his hospitality boundless.
While however, the noblemen of his day and country
were gluttonous and drunken, the habits of William
were temperate and his life blameless.

History paints him as a man of sound body
and of sound mind; a sincere friend– a cheerful
companion– and remarkably found of society.
His education was exceptionally liberal– and his
attainments large. He was in his day a fine
Scholar– wrote six different languages and
what is more remarkable spoke most of them
fluently.

His deep nature was early discovered by Charles
the fifth and that discriminating Monarch, who
well knew how to choose his <ins>diplomatic</ins> agents– Selected
William even before he had reached the full age
of manhood, to conduct important business
for him at foreign Courts. The skill and
ability with which he discharged these, <ins>difficult affairs</ins> ~~duties~~
gave him a reputation <ins>for wisdom</ins> far beyond his years.

70.

He was no malcontent, no enthusaist, no disturber of the settled order of society.

Year after year rolled on. and the rapidly rising Reformation, to outward appearance touch.ed him no where. It was thus far mainly confined to the common people.

In the effort to give ascendency to the new religion particular trades and callings were especially prominent. The poor are ever dissatisfied with things as they are, and hear the new truth gladly, while the rich and great are satisfied witthy things as they are. The agitation among the Tanners, Dyers and weavers, was loud, deep, long and portentous. William heard its roar – knew its meaning, but remained silent – and continued to move upon that high plain of society not easily reached by new truths.

A loyalist in politics, a catholic in religion, a member of the council general, an adviser to the Regent, Margaret of Parma – a cousin to the reigning monarch – a sovereign in Rank. a man surrounded by all the

28. Frederick Douglass: "William the Silent," 1876

luxuries that wealth could purchase or friends could bestow. William was courted on all sides by the highest circles of his country.

Many sought him for his great wealth, but others sought him for his great wisdom, and for the strength and the security which companionship with a strong man gives those who come near him.

Honored and trusted by the nobles, loved and adored by the common people, he was just the man to carry his country whither soever he might be disposed to lead.

His interest however bound him to the orthodox side of his country and, his times. By position he was a Conservative, both in politics and religion.

No friend of his could have suspected that a man so elevated in position so prudent in conduct, so boundless in wealth, so highly connected—so universally honored and courted, was only watching and waiting, for the right moment to place himself at the head of one of the most comprehensive revolutions that ever shook the

385

72

World.

Almost at the very outset of Williams career as
a leader of the forces of the Reformation, he was
met by an event which sorely tested his fitness
for the place he had assumed. I allude to Saint
Bartholomew— the slaughter of twenty five thousand
protestants in a single night. Invited to a marriage
these unsuspecting thousand and were systematically slaughtered.
they attended a masacre where they, the guests
were the victims. The monsterous treachery of
this unexpected blow at the point from which
William had assurances of support in his struggle
with Alva, was overwhelming and would have
utterly disheartened any leader less heroic.

In his hands, William held the fullest
assurance of sympathy and cooperation, of the very men by
whose orders and devices this wholesale slaughter
of his friends was perpetrated. At the hour
when the streets of Paris were flooded with the
warm red blood of Protestants— he was expecting
reenforcements from that quarter.

He had letters in his hand to that effect from Henry.

No event during the war was so stunning. The friends of the reformation were for the moment shocked, appalled and paralyzed. It was like striking an iceberg ~~at midnight~~ at midnight in mid ocean, when the ship heaves, trembles and ~~begins to~~ with all on board. But this astounding blow sinks. ~~The occasion~~ brought out the grandest qualities of ~~William the Silent~~ the young leader of his people. While all others seemed struck dumb and helpless the Prince of Orange held firmly on his way.

Undaunted courage, unwavering persistency, inflexible determination, marked his every movement — and the contagion of his glorious qualities, gave victory over even this terrible calamity.

When his best plans failed, as they often did fail. When one army after another was annihilated when one city after another was surrendered, when starvation had broken down the fortitude of his garrisons — when his lands were covered over with mortgages and his purse was empty: when his sons and brothers, one after another were slain

74

When the very air was burdened with the
wails of his famished countrymen, crying
for peace, William bated no job of heart or hope—
and his voice was still for war.

It has been attempted to dim the lustre of this noble
spirit by the imputation of ambitious motives. It
has been said that William desired to make himself
King of the Netherlands.

No great statesman and patriot was ever more
easily defended from such a charge. General
principles, as well as special facts prove the
entire disinterestedness of this great leader.

Outside of Liberty enlightenment
and progress, William had nothing to seek or
desire. He was already covered with honors and
loaded with wealth.

In an open rupture with Spain, no man had
more to loose, and [no man] less to gain— no man had
less to hope and [no man] more to fear than
William of Orange.

75.

It may be admitted that something of the grandeur of his character, would be lost, if it could be shown that he had in anywise acted from a narrow and selfish motive.

It is plain however, that neither ambition, rashness nor necessity can help us to explain his course. Coolness, and deliberation mark every step of his way, ~~into the war of the Reformation.~~

No man in the movement, had a better understanding of the sacrifices to be made, or the dangers to be encountered. He knew the power of Spain. He knew the fury of Phillip and in all he said and did he acted upon positive Knowledge.

He lived in an age of spies, as we live in age of detectives and he availed himself of their agency to find out the inmost thought and purpose of the King of Spain. He has been much censured upon this ground. He kept a spy in the house of Phillip to obtain this Knowledge.

I am not much in love with this mode of acquiring information. Spys and detectives are disagreeble people and are only to be employed

76

upon extraordinary occasions.

But this may be said of this part of William's conduct.
Whatever the moral sense of mankind may now say on
the subject, spys were not inconsistent with the Political
Morality of the sixteenth centuries.

Besides in the case before us there was no
Malevolent curiosity. William was dealing with
a man of deep and terrible designs upon his
Country: To be forewarned was to be fore armed.

This too may be said in defense of
his system of espionage: William had good reason
to know that his own private life and words were
subjected to a similar unwelcome inspection.

Margaret and her accomplished Secretary
were not less watchful than himself. Every act
of his life was carefully observed and promptly reported
to Phillip at Madrid: So that it was diamond cut
diamond.

But outside of William's direct means of
information he knew what to expect from

28. Frederick Douglass: "William the Silent," 1876

77

any participation in the new religion.

He had the unhappy experience of Counts Egmont
and Horne, before him. They were men of courage
equal to William, but lacked his coolness and
sagacity: Yet even these men fore saw the coming wrath
and sought shelter and safely by deserting the cause.
There way of retreat, owing to their early indiscretion
in connection with the new religion was far more
difficult and dangerous, than would have
been his had he chosen to follow their example.

Both Egmont and Horn had at an
early day openly identified themselves with
the "beggars" as the Reformers were scornfully
called and this fatal fact was as well known
at Madrid, and to Phillip as it was known
in the Netherlands.

Nothing can be more affecting than ~~was~~ the
interview, as given in history between these unfortunate men and
and William; where they announced to him
their purpose to seek the service and friendship

78

of Phillip. Nothing more earnest, eloquent and wise, was ever addressed by one friend to another, than Williams appeal to his two friends against going to Phillip. They however failed to take his advice – and paid the penalty for their over confidence in kingly clemency with their lives.

They were received by Phillip with smiles, as penitents were always received: They departed from the Royal presence with smiles; as penitents always departed but only to be imprisoned, shot, hanged, beheaded, burnt, poisoned or stoned to death as it might please his Catholic Majesty to direct.

It is a remarkable fact, that Phillip's clemency never extended beyond the point of choice of the manner of putting his victims to death.

In his view a repentent heretic was much better prepared to die than to live – much fitter for heaven than for Earth, and his practice conformed to his theory.

He was always logical if not always right.

83.

William though a catholic, was no theologian. His mind was too broad for the narrow reasonings of Theology. His ideas came of practical Statesmanship and of a broad and world embracing humanity. He took the world as he found it, and as in the nature of things it must be found. He saw that men would differ and must differ — and that the only true remedy for ills that grow out of this difference was to be found in mutual respect for the Right to differ. Out of Williams abundant love of man — not out of his love for God, out of his philosophy not out of his theology, out of his reason not out of his faith came his healing ideas of toleration.

He loved his fellow men. He had compassion even for the guilty wretch by whom he was slain.

We should never think of this good man of the Netherlands without remembering how vastly we are indebted to him for the ~~~~ liberty of thought and speech we now enjoy — I shall not undertake to give you the exact measure of that debt — or the measure of the man to whom it is due. We have no scales in which to weigh his worth — no standard

standard by which to determine his services. He
toiled, suffered and died. We live. It is easy to say that the
world moves, since Galilei. It is easy to cross the ocean
since columbus. It is easy to walk in the night when the
moon and the stars are bright in the sky. It is easy to
dwell amid fruitful fields when the pioneer has removed
the noxious weeds and poisonous vapor. It is easy
to speak of British liberty since Magnacharta. It is easy
to be a catholic in Rome, an abolitionist where there is no slavery,
and so now it is easy to preach and practice freedom of
thought since William the silent and the Dutch
Republic.

28. Frederick Douglass: "William the Silent," 1876

I venture to speak to you this evening of a great historical character, of a great people, and of a great war: Of a great people because only a great people can produce and sustain great men, and developes [sic] great qualities and characters.

Deplore it as we may and must the red sea lies ever between the pilgrim and the promised land. <u>War, war!</u> Stern and terrible war, seems to be the inevitable and inexorable condition demanded for every considerable additions made to the liberties of mankind. The world moves, but only by fighting every inch of its disputed way: Right and wrong seem alike endowed with fighting qualities: If the one does not prevail, the other will and must.

Two thousand years of the christian religion with its benedictions for peace makers, have left this one ghastly fact as incontestable as ever. Nonresistance finds little support in the example of Christian nations.

Freedom is valued not only for what it is, but for what it costs. They who receive it as a gift can never wear it as grandly and defend it as bravely, as they who have wrenched it from the iron hand of the tyrant. Philosophy and experience teach one and the same lesson at this point. They are whipt oftenest who are whipt easiest.[17] Cowardly submission is an open invitation to aggression. The lines, and limits of national and individual liberty may be well defined in theory—written in books, & framed into laws; but human power respects ᴨᴏ no lines or limitations which have not been traced and may not be retraced in blood.

Among all the great wars of nations and parts of nations, waged to obtain a larger measure of liberty or defend and maintain liberties already acquired and established, there is perhaps, not one in history or song, more remarkable for duration, for heroic fortitude, for thrilling incidents, for far reaching consequences, and beneficial results than was the war waged by the Netherlands against Spain—in which Phillip II. and William Prince of Orange, now known as William the Silent, were the respective leaders.

For a grand and vivid picture of this tremendous conflict of more than a half a century, the Protestant world is more indebted to J. Lothrop Motley[18] the

17　Douglass, in My *Bondage and My Freedom* (1855), describes the brutal flogging of an enslaved woman, Nelly, writing: "They prefer to whip those who are most easily whipped. The old doctrine that submission is the best cure for outrage does not hold good on the slave plantation. He is whipped oftenest who is whipped easiest" (95).

18　John Lothrop Motley (1814–77), US author and diplomat. Douglass refers to Motley's popular history *The Rise of the Dutch Republic* (1856).

warm personal friend of the late Charles Sumner[19] than to any of the many writers who have attempted ~~that work~~ a history of that war. His ~~history of the~~ Dutch Republic is a masterly production. It leaves nothing to be denied, doubted, or desired. His gravest charges, and most startling statements against the Catholic Church in that struggle are amply supported by documentary testimony. ~~not to be gain said by either of the interested parties~~ The errors on both sides are fully and vividly laid bare.

Figure 47: Henry Schille, *Charles Sumner*, c. 1874. (Prints and Photographs Division, Library of Congress, Washington, DC.)

19 Charles Sumner (1811–74), US politician and senator for Massachusetts, was a passionate anti-slavery advocate. He was nearly killed on the Senate floor in 1856 by a South Carolina congressman, Preston Brooks (1819–55), who objected to a speech that Sumner had given criticizing white US slaveholders.

I make haste to acknowledge my own indebtedness to ~~Mr Motley~~ this [28]
author—for my conception of the noble character of William the Silent and
~~my knowledge~~ of the facts and events of that terrible war of which ~~William he~~
he was preeminently the hero.

No appology [sic] whatever is needed for calling ~~the~~ attention to the debt
we owe the Dutch people for their part ~~taken~~ they took in that tremendous
conflict. Our own freedom of thought to day in matters of religion ~~which is~~ so
precious and priceless is largely due to their heroic endeavors hardships and
sufferings, ~~during their war with biggotry and persecution~~.

Thought separated from our times by the space of three centuries; though
more than three thousand miles of the wide waste of waters divide the two
countries, we are in larger measure than any other nation, ~~I know of~~ the direct
recipients of the beneficent results of the Netherland war. It was a fight by
common friends against a common foe.

The historian easily finds a clear, close and logical connection between the
establishment of the Dutch Republic of three centuries ago[20]—and of the
American Republic which had recently ~~just~~ celebrated its first centennial: a
connection between the war of the Netherlands against Spain, and the war of
the American colonies against England: between William the Silent at the
head of the Protestant forces and George Washington leading the armies of
the Revolution: Both Republics, both wars; both men belong to the same great
family of men, the great chain of events by which the cause of human Liberty,
has gained its present ascendency in the world. They stand related to each
other in the sense of cause and effect. The elder was essential to the existence
of the younger Republic. It is a significant fact that before ~~Before~~ setting sail
finally from the old world to the new the Pilgrim fathers betook themselves to
Holland and tarried there eleven years.[21] ~~These years in the dutch Republic,~~
~~served them~~ as in a school preparatory to the greater school of free Institutions
since established ~~by their~~ on this continent by their descendents.

Of course, in the space of the single hour allotted to me, I can give minute
details ~~nether~~ neither of the Netherland war nor of the causes that produced it.

Sufficient however for this occasion it may be to state, briefly the relation
subsisting between the Netherlands and Spain prior to the war which finally
resulted in the establishment of [the] Dutch Republic and the triumph of free
worship and free thought in Europe, and some outline of the causes which
forced the Netherlands into rebellion.

20 The Dutch Republic was formed in 1581, when the Netherlands separated from Spanish rule.
21 The early settlers of Plymouth, Massachusetts, first left England for the Netherlands, living in
 Leiden until 1620.

If we could go back three centuries, and take our stand upon the soil of the Netherlands we should find that country within the limits and under the laws of what was then known as the Spanish Empire with ~~and~~ Charles the V. the reigning monarch:[22] Tarrying here a while we shall soon see this warlike king—worn out and broken down at the early age of fifty six—piously humbly abdicating the proudest throne in Europe, in favor of his son Phillip [the] second: We shall also find that the new king, unlike his father, disdains to reside any where, outside of Spain: You will find too that he is thoroughly catholic as he is thoroughly Spanish and has therefore nothing in common with his dutch subjects—and that he does not in any wise seek to conciliate them. He holds them from the first at more than arms length and scarcely regards them as Loyal Subjects.

His place of governing them was in the highest degree distasteful to them. He committed them to the care of a regent in the person of his sister Margaret of Parma[23]—and made Cardinal Granville[24] begotted Catholic her prime minister or secretary: Besides ~~Gra~~ Margaret and Granville, the Regent and the Cardinal, there ~~is~~ was a legislative body of old time standing ~~in the Netherlands~~, known as the states general,[25] a body which in theory possessed powers, analogous to those exercised by the American senate, but practically under Phillip it exercised no power at all: you will also find that the reins of government ~~are~~ were firmly and completely held in the hands of the new king—and that the people had no voice whatever in their own governments. The states general where they once had some share in making the laws could ~~now~~ do nothing, without Granville; and Granville could do nothing without Margaret, and Margaret could do nothing without Phillip.

This long handed Government, with its head in Spain, and its hands in the Netherlands was particularly friendly to sensuosities of all kinds. The large space between the head and hands was kept full of doubt, delay ~~and~~ intrigue, and falsehood. As a consequence a deep and general distrust was felt at both extremes in Spain and in the Netherlands—the ruled and the rulers. For there can be no trust where there is no truth.

22 Charles V (1500–58), ruler of the Spanish Empire, the Holy Roman Empire, and the Habsburg Netherlands.

23 Margaret of Parma (1522–86) was Governor of the Netherlands from 1559 to 1567. She was the illegitimate daughter of Charles V.

24 Antoine Perrenot de Granvelle (1517–86), statesman and cardinal, appointed chief councillor in 1559 to the regent Margaret of Parma.

25 The States General originated in the fifteenth century as an assembly of the provincial states of the Burgundian Netherlands. In 1579, during the Dutch Revolt, the States General split as the northern provinces rebelled against Phillip II.

One of the first indications of the troubles coming upon this people, was the arrival among them of large bodies of Spanish troops. For Phillip had scarcely got seated upon the throne of his father, before he began to invade the Netherlands, in a manner at once stealthy and sinister. All the important towns and cities of that low country were speedily garrisoned, by Spanish soldiers. Their uniforms and arms were visible everywhere, and were objects of strong and ever increasing hate and dread among the people, They ~~who~~ could ~~not~~ readily discern the purpose for which they were sent among them. Every day brought some instance of conflict between the common people and the Spanish soldiers. These served to deepen the animosity already deep, and to kindle resentment always ready to blaze forth on both sides, and upon the slightest provocation. The troops were haughty and the people were sullen. The conditions were plainly present for a terrible war and war came at last. ~~In~~ ~~a~~ A war ~~whose~~ the fierceness and wrath of which was only equalled by its ~~endurance~~ long duration.

The quarrel ~~was~~ then, as the quarrel ~~it~~ is now, and ever will be, was the new against the old and the old against the new: The people against the king and the king against the people. It was knowledge against ignorance and reason against superstition. It was freedom against authority and charity against bigotry. ~~(Two ideas)~~

Until Philip [sic] the Dutch people, though oppressed had enjoyed a certain measure of Liberty. The change from Charles to Phillip was from bad to worse. The little finger of the latter being ~~was~~ heavier than the whole body of the former. The Spanish yoke, heavy and grevous [sic] to be borner [sic] under Charles, became galling bloody and intollerable [sic] under ~~Phillip~~ the new king. On ascending the throne the ~~new king~~ Phillip seems to have given his mind to one grand idea, and ~~had~~ to have dedicated all his powers and opportunities to the one purpose of realizing that one idea, ~~and to make~~ of making Catholicism supreme ~~in~~ throughout all his dominions.

To accomplish this high, religious ~~purpose~~ object he evidently thought that no means were too harsh or too cruel, and no artifice too mean or too immoral. The sacred claims of justice mercy and truth, could not be allowed to stand in the way of this one high religious purpose of making his dominions entirely of the Roman Catholic faith. ~~His was literally the pale horse in the apocalyptic vision.~~ In his blindness to accomplish this end He employed death in every form, which could affright the souls of men. The informer named the victim—the inquisition condemned, and at once the warm blood flowed; the flames rose; and living human flesh crackled, peeled and burnt to ashes. It is sad to think that so small a concession to liberty as the right to worship the infinite according to the dictates of ones own conscience, could only be purchased at the cost of so much blood and

suffering. Difference of belief from the true church meant death, as well as damnation, and Phillip seemed determined that none ~~are~~ guilty of this dreadful offense should escape. These ~~His~~ agents of religion. The church ~~were~~ was singularly ~~fruitful of invention~~ inventive in the art of destroying human life and in the means of exquisite torture. There was death by hanging, death by strangling death by drowning, death by shooting, death by starving, death by poisoning—some were torn asunder by horses attached to each limb, some were chopped to pieces in detail beginning with the first joints of their fingers and continuing by piecemeal, till the whole man was destroyed—some were disembowelled alive: some had their hearts torn out and flung into their faces. But there is no innumerating [sic] all the horrors perpetrated in the propagation and defense ~~defense~~ of the faith, ~~and~~ and supremacy of the holy Roman Catholic religion.

Before there was any organized resistance in the Netherlands, to these accumulated and numberless horrors: before the phlegmatic Dutch people could be lashed into open war, upon their biggotted [sic] and cruel persecutors—at least one hundred and thirteen thousand Protestants had suffered the rigorous tortures of the Spanish Inquisition.

The patience and forbearance of these people was alike wonderful and painful to contemplate. Walking among them, and beholding the atrocities to which they were subjected—the hearts aches and breaks with the inquiry as to when will the tormented turn upon their tormentors—and give blow for blow meet fire with fire and ~~meet~~ death with death!

I know of no race of men more patient under wrongs more non ~~resisting~~ resistant in the face of temptation to violence; more hopeful that deliverance would come in some other way, more ~~hopeful~~ believing that they thirst for blood would be at last satisfied—and cease; unless I ~~accept~~ except my my [sic] own murdered people who are daily slaughtered in the same spirit on account of their political opinions.

It was the wisdom as well as the disposition of the Dutch people to make haste slowly. They endured the fierce wrath of bigotry and bondage, till they could bear it no longer. They were preeminently a peaceful people, and were ready to purchase peace almost at any price.

There [sic] submission to wrong however was not the result of any insensibility to wrong—as is sometimes slanderously attributed to my own race. These people employed all the means in their power to secure peace by ~~moral~~ powerful means—by appeals to reason, justice and humanity—and it was not until they had faithfully tried all such measures;—not until they had fairly beseiged [sic] the Spanish throne with arguments, petitions and remonstrances—not until one chartered right after another had been wantonly

stamped out; it was not until the able and bloody duke of Alva.[26] was sent with his veteran Spanish army, to extirpate the last vestige of liberty; it was not until they say the mantle of moral death drawn around them by the steel clad hand of superstition and bigotry and all hope was gone that they ventured at last upon open ~~war~~ and organized resistance. When this momentous crisis was once reached:- Oppressors received a lesson which ought to suffice for all time—and would if men were not mad—They demonstrated that a nation strong to suffer may be equally strong to fight. ~~For the fire Their~~ For the fire and fierceness of the Dutch in battle, were only equalled by their heroic firmness and matchless fortitude. In their poverty of arms, they reversed the order of prophecy [sic]—They literally beat their ploughshares into swords and their pruning hooks into spears, and taught not only their sons, but their daughters the art of war.

It is a remarkable fact, that in some of the most desperate battles—of this protracted war—women bore a conspicuous part, and in the fury of battle were not less brave and steady than the veteran soldiers themselves. Sisters stood by brothers wives by husbands, resolved to succeed or perish together in the cause of freedom.

The argument that women ought not to vote because they cannot fight falls to the ground in the light of this Dutch example. Yet I would not base the right to do the one, on the ability to do the other. ~~The~~ Such logic is about as bad as to say because a man cannot fly he has no right to walk—or that he ought not to do anything because he cannot do everything.

Many analogious [sic] ~~may~~ may be traced between this war, against Spain, and the colonial war against England, the war for religious Liberty and the war for political Liberty. But the cause of the Colonies against England was light as air compared with the cause of the Netherlands against Spain.

George[27] called for money: Phillip called for blood. George was selfish, haughty & tyrannical. ~~and cruel.~~ Phillip was a fanatic, cold blooded and cruel. He would ~~in cold blood~~ exterminate a race for the glory of God.

In several particulars the american people had a decided advantage over the Dutch ~~people~~. The fathers of this Republic had fully counted the cost. They knew from the first, just what they were about: The Dutch on the contrary did not know—they had not considered. In the earlier stages of their troubles they behaved like frolicksome boys—and indulged grotesque sports on the very

26 Fernando Álvarez de Toledo, 3rd Duke of Alba de Tormes (1507–82), was governor of the Netherlands between 1567 and 1573.

27 George III (1738–1820), king of Great Britain and Ireland (1760–1820). His government, headed by Lord North, was deeply unpopular in the US colonies for its unilateral levying of taxes on the colonists without their consent.

verge of war. While they saught [sic] peace, they permitted practices which could only lead to war. The fathers of the American Republic marched by a previously ascertained line, while the Netherlands only drifted as upon an unknown sea without chart or compass and with no definite port in view.

In this respect they resembled us more in our recent war with rebellion, than the fathers in their war with England. They went into the war with Spain without a policy, as we went into the war with the rebel south without a policy.

Though the Dutch people from the first were fighting for the right of self Government, they did not dare to admit that pregnant fact to themselves—and much less did they dare to proclaim it in the Ear of listening Europe. Such radicalism could not come but by a long course of preparation and by suffering. They flattered themselves that they could successfully resist Spanish persecution without experiencing the authority of the King by whom persecution was enjoined and inflicted.

We repeated a similar folly when we proposed to put down a slaveholders rebellion without in any wise injuring the delicate relation of master and slave. They were restrained by the doctrine of the devine [sic] right of Kings. We were restrained by a similar reverence for slavery. The pulpits of both countries as usual were in large measure responsible for both errors.

It is a notable fact that the people of the Netherlands made no successful resistance to Spanish power till they exploded the delusion of kingship by devine [sic] right—and the same was true of us. We made no headway against our slaveholding rebellion till we exploded our devine [sic] right delusion and parted with our reverence for slavery. The abandonment of both errors was the turning point in the fortunes of both wars. By it both were made consistent, logical and strong.

Neither nations, nor individuals are apt to see the whole truth at first. Time and events are the great instructors of the race—and it is interesting to observe how rapidly a people may sometimes be insensibly whirled forward by these in the straight line of wisdom and duty. They are often converted and moved forward without their own knowledge—and accept the truth in action, which they still deny in theory. It is one of the convincing evidences of a moral government of the universe that that the discovery and adoption of one truth, naturally leads to the discovery and adoption of another. The one makes the other in some sense certain if not inevitable. Right and wrong are equally logical as well as equally belligerent [sic]. The friends of slavery were not less logical than were the friends of antislavery. Mr Calhoun[28] was consistent in

28 John C. Calhoun (1782–1850), 7th vice president of the United States (1825–32), was a white supremacist and staunch defender of slavery, asserting in a speech in the US Senate on February

denying all human rights to the negro. He saw that the end of the journey was involved in the first step. He saw that to admit that the negro had any rights he must admit that he had all rights—If a man, then a freeman, If a freeman then a citizen. If a citizen, then a tax payer and voter—and if a voter, then elligible [sic] to congress and if to congress—there was no knowing where else he might go.

It is observable that, at first on the side of the dutch, the contest was purely physical. No great moral principle or idea loomed visibly above the struggle. They fought simply against a recognized hurtful and hostile power. They simply gave back blow for blow. They had the courage to fight, but lacked the courage, or perhaps the comprehension, to declare what they were fighting for. They stood by the old in theory, while they ~~fighting~~ fought for the new in practice. They talked of the "accords," "joyful entrances"—and "covenants" old papers, which had long ago lost their significance and about which nobody cared. They did not dare to deny the right of the king, or to deny the right of the church, to control the religious convictions of the people. The right to detect and punish heretics they freely conceded. It was not the persecution to which they objected but the rigor of the persecution; It was not the principle, but the form, not the inquisition, but the Spanish Inquisition not the God anointed and God appointed Phillip ~~the king~~, but his wiley [sic] ministers and brutal soldiers, against which and whom they rebelled and fought. Had they foreseen whither they were tending—what venerable doctrines, both of religion and Government, they would be compelled at last to abandon and oppose, it is fair to assume that they would have been amazed, affrighted and probably deterred from the undertaking altogether.

They did not see the end from the beginning any more than we did, in our late war, and it is well that they did not. War is a stern disciplinarian and a great teacher. Nothing so rapidly opens the eyes of a nation and puts ~~them~~ it further beyond the power of sleep than war. All through the struggle with us, one step prepared the way for another: So it was with the Netherlands. It was not until after years of terrible war, and suffering that the statesmen of that country, could be brought to see that complete and absolute religious Liberty was the only ground of safe footing for themselves and for mankind. When they boldly took the position that a man's religious convictions were not to be interfered with by any power on earth, outside of himself, they placed their cause upon the solid rock, and were a long way on the road to the right of self Government as well.

6, 1837 that slavery was a "positive good": <http://teachingamericanhistory.org/library/document/slavery-a-positive-good/> (accessed January 14, 2018).

The union of these two elements, moral and political power, was among the first conditions of final success.

Grand and powerful, however, as is civil liberty, when viewed as a motive of action, it arouses no such enthusiasm, and lifts men to no such heights of daring, as will a desire for religious freedom and a fetterless mind will do. If men will wade through blood for the one, they will wade through blood and fire for the other. It is the religious side of this Netherland war, which makes it a luminous point in history and will make it a fascinating subject of thought with after coming generations.

About the most wonderful thing connected with this war—was its duration and the seeming impossibility of a strong nation to overcome and crush a weak one, when the weak one is in the right. Never were belligerants [sic] to all appearance more unequally matched than in this war. The country of William itself is a mere dot upon the map of Europe, fitter in its natural condition for amphibious animals than for men, a low flat country, not given directly to mankind by Providence but won from the waves of a turbulent sea by the utmost vigilance and the most heroic industry. Its population was only about three millions, and though they were a hardy and vertuous [sic] people, their habits and customs were all strongly averse to war.

It is not upon such upon such flat and oozy parts of the earths surface, that poetry and eloquence locate the noblest love of liberty and the most heroic deeds in her behalf. For these qualities we usually look to deep valleys and lofty mountains—where the wild winds rave, and where the eagle soars and sends his wild fierce scream against the blast as he makes his flight towards the sun.

The population of the Netherlands were not only weak few in numbers, they were weak by reason of their sectarian divisions, jealousies and rivalries. They were not only divided but antagonistic. They were composed of Catholics, Lutherans, Calvinists, Anabaptists the latter an Ishmaelitish sect. Its hand against every mans and every hand against it.[29] Each of these bodies was watchful, lest the other should gain some advantage.

In fact the Protestant denominations of that day probably dreaded and hated each other only a little less than they hated and dreaded the common enemy. As to day we have to thank the violence and extravagance of the South for the abolition of Slavery—and for the union of these States upon a more

29 Anabaptism is a Christian denomination generally thought to have its genesis in the sixteenth century. Its core belief is that baptism is only valid once an individual consciously declares his or her faith and desires to be baptized. "Ishmaelitish" is from Ishmael, the outcast son of Abraham, "whose hand is against every man, and every man's hand against him" (Genesis 16:12).

enduring basis, so also we have to thank the violence and fury of Romanism of the sixteenth century for the Dutch Republic and for a larger measure of religious Liberty.

From first to last, the Protestants ~~was~~ were held together less by any internal principal of cohesion than by external catholic pressure, and even this did not secure unbroken fidelity to the common cause.

There were times, when one sect was perfectly willing to purchase, relief for itself at the sacrifice of the common cause. ~~The~~ History shows too, that as there were tories in the American revolution, and as there were copperheads during our late war,[30] so there were tories and copperheads in the Netherlands. It was there, as here a united South against a divided north.

Some openly took part with the common enemy, while others tried to stand upon neutral ground.

Such then was the country; such ~~was~~ were the relations of its sects and parties—rent asunder at the centre, divided and crippled at the very point where it should have been most united and strong, a mass of ill assorted and conflicting materiels [sic] apparently incapable of any considerable resistance, an easy prey to the spoiler.

Now opposed to the people of this small country, thus divided, confused and ill assorted, what have we? We have the Spanish Empire in its palmiest days and in the plenitude of its power. Vast grand and compact—a unit in all the elements of national strength. There stood the Dwarf—there stood the giant and between the two the battle field. Spain thoroughly prepared, alert, & orderly, with purpose fixed, with plans matured, calmly surveying the whole field, knowing just when, where and how to strike.

Her Government from Phillip down worked with the precision of a Corliss Engine.[31] Her statesmen were among the ablest, and her generals among the most skillful and brave. She was in fact at the zenith of her greatness. England, France, Germany and all the world at that time admitted her power. She was great in her internal resources, great in public order, great in her respect for legal forms and ~~for~~ great in ~~her~~ the authority of her rulers. Besides all this and more—Spain was supported by the active approval, of his holiness the Pope—and by the ardent sympathy of the Catholic world. For services of war she had the wealth of two continents at her command.

30 The term "Tory" was used in the American Revolution to those who remained loyal to the British Crown. During the US Civil War, "copperheads" was the nickname given to a faction of Northern Democrats who opposed the conflict and argued for a peace deal with the Confederacy. A copperhead is a venomous snake common in the United States.

31 The Corliss steam engine was invented by George Henry Corliss (1817–88) of Rhode Island, and patented in 1849.

She had still another advantage. She was used to war. She was enured to its perils and hardships by an apprenticeship of eight centuries. Her history was a history of brilliant military achievements. She had driven back the moors, humbled the crescent and expelled all opposing creeds and sects from her borders. Her soldiers were soldiers of the cross. They went into the Netherlands flushed with victory, and overflowing with military ardor. They would have gone any where else, in the same cause and in precisely the same spirit. They were ready for any field however remote and for any foe however formidable. In fighting with the Netherlands, they were sustained by a double inspiration. It was ~~fidelity~~ loyalty to the king and fidelity to the true faith. It was loyalty and piety against treason and heresy, order against riot, and discipline against the mob.

To take up arms against a nation thus strong and thus inspired—must have seemed to the wise and prudent Dutch statesman of that day, like the madness of rushing from safety to danger and certain ruin—about as mad as seemed the attempt of dear old John Brown to conquer Virginia with twenty two men.[32]

But it is proper to say that the acceptance of the guage [sic] of war, was not a matter of choice. The~~re was no avoiding the contest.~~ final contest was unavoidable. It was the irrepressible conflict of the sixteenth century. ~~The middle ground of~~ compromise was impossible. The alternative with them as with us was slavery or freedom. The pope is absolute, or the Pope is nothing. ~~If he binds in~~ The hand that binds in heaven, must not be bound on earth. For men are too practical and logical to believe, that what is weak and contemptible here, is ~~of necessity~~ (can be of) boundless power and authority elsewhere.

Too much honor cannot be awarded to the Dutch people for what they dared suffered and achieved in the cause of civil and religious Liberty. If this were there [sic] only claim to the gratitude of ~~mankind~~ civilized men—they would still hold a place among the greatest benefactors of mankind. It is their glory that they bore the brunt of Popish power in Europe and made free thoughts possible in the world.

You will pardon me another analogy. The experience of this people in the earlier years of the war was strikingly like our own experience during the earlier part of our late war with Slavery.

Like our selves, it was their sad misfortune ~~to~~ at the beginning to be afflicted with raw recruits and incompetent generals—and sometimes with treacherous ones. Like ourselves they had their Bull Runs, their Balls bluffs,

32 See letter 10, footnote 1.

and their Fredericksburghs [sic].³³ Like ourselves, they were educated by war for war, and like ourselves they learned to conquer their own prejudices and abandon their superstitions—and thus to overcome their Spanish enemies.

But alas! how slow and painful was the process: Through what startling reverses, what mortal agony; what dreadful disasters by flood and field; what horrors of blood and fire, this wisdom was gained. The destruction of life at the first was almost wholly on the wrong side. Before the skillful generals, the veteran troups and superior arms of Spain—the badly appointed and badly commanded and hastily organized armies of the Reformation were swept down like hay before the schythe [sic]. They were not merely repulsed and demoralized, but were routed, cut to peices [sic], scattered, pursued, overtaken, murdered, annihilated in detail.

For nothing however was this war more remarkable, than for the success of the weaker party in raising successive armies in the face of the most chilling and hope crushing disasters. As fast as one army was destroyed another was immediately created. Nothing but a quenchless love of Liberty and a fortitude which no reverse could break down—can explain the almost endless succession of armies brought into the field.

No word painting is needed—to ~~paint in high~~ colors the heroic qualities of the Dutch people. The simple facts are more eloquent than fine rhetoric. Subjected to crimes, outrages, sack and pillage, with all their incidental abominations of rapine and murder; defeated in almost every great battle; the sympathy of the christian world against them, they still persevered, and year after year, for more ~~thirty~~ than fifty years continued the war.

The horrors perpetrated ~~by the slaveholders of the south~~ during our late civil war have sometimes been compared with those committed by the Spaniards against the Dutch. Badly, as I think of the american ~~slaveholders~~ rebels I do not accept this comparison. The cruelties employed in the interest of physical slavery have never quite equaled [sic] those inflicted for the maintenance of religious slavery.

Nevertheless both wars prove that the moral dispositions of men are about the same in all ages, and countries. Give ~~the~~ any man among you, absolute power over the bodies of men, and he will become a wild beast, ready to tear and stay upon very slight provocation. On the other hand give even a saint absolute power over the souls of men with the ~~power~~ right to enforce his authority by pains and penalties, ~~his religious creed~~ and history shows, he will

33 Douglass cites three early defeats in Virginia for Union forces during the Civil War: the First Battle of Bull Run (July 21, 1861); the Battle of Ball's Bluff (October 21, 1861); and the Battle of Fredericksburg (December 11–15, 1862). Of the three battles, the latter was the most brutal, with Union casualties more than three times as heavy as those suffered by the Confederacy.

become something more terrible than a wild beast. Crimes and cruelties which other men commit in fits of sudden anger, ~~your~~ the pious tyrant will commit without wrath, without passion—without remose, without shame—and with saintly satisfaction. The cruelty of Phillip plainly enough had ~~their~~ its source and mainspring not in the natural man which is said to be enmity towards God, but in the spiritual man ready to kill or be killed for his God. He was not cruel by nature, ~~but~~ only by grace. When he burned the body of an heretic, or chopped off his head—he did the one or the other, in obedience to God. The age was dark and the network of superstition was thick and strong. Nobody thought in his day, that error in matters of faith might be tolerated while truth was left free to combat it. History credits Phillip with great kindness towards those who agreed with him. The Lamb only became a Lion in the interest of a pure Religious faith. It was natural that he should assume that the religion which was good enough for his own beloved Spain, must be good enough for the people of the Netherlands. The seeds of the dawning reformation had never been allowed to take root in Spain. The few seed [sic] carried there were scattered, not sown—and fell upon stony ground. They sprang up suddenly and were cut down quite as suddenly. ~~They~~ and vanished in the hot fires of the Inquisition.

The case was just the reverse in the Netherlands. There the good seed fell upon good ground, took deep root, grew and flourished—and ~~brought and~~ brought an abundant harvest, some thirty some sixty and some an hundred fold.

But alas! the age was dark with them as well as with their Spanish persecutors. As these converts became numerous and strong, they imitated the bad example of their enimies [sic]—and behaved recklessly, lawlessly and scandalously. Their attacks upon the old church were wrathful and furious. Their words were not more violent than their blows—They poured contempt upon the sacred alters [sic] of mother church. They ridiculed her miracles, broke ~~their~~ her sacred vessels, cast down her saintly images—defaced her holy pictures; held mammoth outdoor meetings, preached their forbidden doctrines, and lead the people away from the faith of their fathers and the church of their veneration.

One of the most important lessons taught by this religious war is that when men fling away reason and accept the rule of faith alone, the worst possible things can be done from the best possible motives—and for how little, mere conscientiousness must ~~in ever~~ pass in establishing the rightfulness of any act or measure.

There is no absolute reason to doubt that in burning and slaughtering the Protestants Phillip felt himself discharging a sacred religious duty. The evil in his eyes must have been shocking and full of danger to the souls of men—and

it was natural for him to think that it was for him to apply the remedy. Persecution has unified the faith of Spain, and why not the Netherlands.

In the selection of his agents Phillip showed admirable skill and judgement—as well as an unhesitating conviction of the holiness of his mission. The command of his first grand army to enforce a sound religious faith, was given to the Duke of Alva. He was an able general and a devoted Catholic. His mission was to burn, destroy and exterminate, and never was cold blooded and cruel work committed to hands more cold blooded and cruel. It might be said of him, as Byron said of the pirate. ~~of~~ He was the mildest mannered man that ever scuttled ship or cut a throat.[34] It was the boast of Alva that he had killed in cold blood eighteen thousand Protestants and history proves the boast well founded.

The appearance of this man of piety and persecution, with his army of twenty thousand Exterminators in 1567 upon the field of the Netherlands had one good effect: It put an end to all doubt and suspense, as to the intentions of Phillip. It called to the front the ablest men of the invaded country and compelled men generally to take sides. There had been riots, insurrections, mobs and collisions between the parties of the old and new religion, but until Alva the war was without form.

Among the many noble spirits thus called to the front of this tremendous conflict by the presence of this Iron hearted Duke of Spain, there was one great Character which towered high above all the rest, a man wise in counsel, strong in arm, high in position, great in wealth—and one whose lifelong deportment had won the entire confidence of his countrymen, a man in whom the warrior was only surpassed by the statesman, and the statesman by the self sacrificing lover of mankind—and that man was William Prince of Orange, now known as William the Silent.

The value of one great man; when a nation is in trouble has been often illustrated—and never better than ~~than~~ in the ~~present instance~~ in the case of William. But for the presence and power, of this one great man, it is not easy to see, how any successful resistance could have been made to Spanish power in the Netherlands. Happily the crises did not demand more than the country was able to supply. There was not one element in William's character, not one mental attribute, not one physical or social perfection which could have been spared from the leader of a country so divided and distracted against one so united determined and strong.

34 Douglass quotes from *Don Juan*, Canto III, stanza 41, written by Lord Byron (George Gordon Byron, 1788–1824) and published in 1821: <http://www.gutenberg.org/files/21700/21700-h/21700-h.htm> (accessed January 14, 2018).

It was his wisdom, forbearance, dignity and statesmanhsip which silenced the angry waves of sectarian divisions and religious contentions among his countrymen. It was his great spirit that brought together and fused into a solid bolt the chaotic elements of his country and dashed it against the massive forces of Spain. ~~under Alva~~. To him more than to any other we are indebted for the ~~for the~~ noble example set to mankind by his people in this vast and momentous struggle for the right. It was the ~~hot fire~~ fire of his quenchless patriotism which warmed the hearts of the Dutch people and made them invincible.

Through all the earlier part of the war, mainly disasterous [sic] to the party of the Reformation ~~this man~~ William showed how a great man devoted to a great cause, ~~fired by a great crisis~~ resolved to survive or perish, ~~with his cause~~ with it can covert, ~~the most~~ appalling disasters and successive defeats into new motives to renewed exertion.

In estimating his character and achievements, it must be remembered that William of Orange was not the leader of a simple contest with Spain. Neither in war nor in statesmanship was he measuring arms merely with Alva—and Philip ~~2nd~~ . Even such a task would have been one before which many strong men might quail—but to William belonged a heavier and more difficult task. The outside world was from the first a deeply interested party to the contest. Though his military activities were confined to the Netherlands, his statesmanship was required abroad. To cope with Spain he must cope with France England and Germany. His relations with Henry, Ferdinand and Elizabeth, often required greater exertion than his relations with Phillip and his able ministers.[35] These external relations with their manifold and conflicting vicissitudes imposed burdens which could be borne only by an intellectual giant, and such a giant he proved himself. Though busy with his troubles at home, some of which touched not only the state but his own hearth stone and Pillow—he never wavered nor wearied. In the thick of them all, he was seen steadily, threading his way through the intricate network of foreign diplomacy—playing off the rival ambitions of one court against another: now parrying a meditated blow—and now winning reluctant support—now exciting the hopes of one nation, and now the fears of another, as one or the other stroke of policy promised service to the great cause to whose defence he had now dedicated all his powers, and staked his life.

We know men best by comparison one with another, those of one age with those of another age. But it is not easy to find men or circumstances to match

35 Henry II, King of France from 1547 to 1559; Ferdinand I, Holy Roman Emperor from 1558 to 1564; Elizabeth I, Queen of England and Ireland from 1558 to 1603

in this case. In some important respects William of Orange stands alone in history. No Ruler ever had just such a religious war on his hands.

What George Washington was in the darkest hours of the war of American Independence What Toussaint[36] was to the Black Republic of Hayti when the armies of Napoleon ~~encamped~~ about it and attempted its reenslavement: What Abraham Lincoln was to this country when James Buchanan had surrendered it to slaveholding Rebels[37] that and more was William the Silent to his country and to the cause of civil and religious Liberty.

But of the three illustrious men thus mentioned, the ~~man~~ one who most resembled the great man of the Netherlands—was that preeminently self made man Abraham Lincoln[38]—~~a man~~ one who embodied ~~in~~ more of the best elements of the American character than any man who has accepted the Presidential chair.

In the matter of his social position and training, William stands in striking contrast to Abraham Lincoln. William was highborn, a Prince of the blood, ~~royal~~ surrounded from the cradle with the best conditions that great wealth and high position could purchase—Lincoln sprung from the lowest round of the social ladder. with nothing to support him but his simple manhood. There was also a ~~marched~~ marked difference in the respective mental characteristics of the two men.

William was preeminently a leader of thought as well as of men—He was ever in the front and never in the rear of his people. He was to them as a pillar of fire by night, and as a pillar of cloud by day—shielding them alike from heat and from darkness.[39]

Abraham Lincoln, great and good as he was, did not lead the thought and feeling of his country. He did not create events or opportunities. But he was wise enough to accept the advantages of both. He did not make public sentiment nor did he repress it, but adjusted ~~he~~ and timed his measures to its demands.—And yet these two men—so strikingly unlike in some important particulars—the products of different ages and civilizations:—the outgrowths of different social conditions. The one a prince and the other a democrat, one

36 Born into slavery, François-Dominique Toussaint Louverture (1743–1803) led a successful anti-colonial and antislavery revolution in the French colony of Saint-Dominique (now Haiti) between 1791 and 1804, as he became the founder of the first Black republic in the western hemisphere. See Bernier, *Characters of Blood*, Chapter One.

37 James Buchanan (1791–1868), 15th president of the United States between 1857 and 1861. Buchanan was supportive of the Dred Scott case (1857), which denied citizenship to African Americans by decreeing that they had "no rights which the white man was bound to respect": <https://www.loc.gov/item/10034357/> (accessed January 14, 2018). He also advocated the admission of Kansas as a slaveholding state to the Union. He was succeeded as president by Abraham Lincoln.

38 Abraham Lincoln (1809–65), 16th president of the United States.

39 A reference to Exodus 13:21–2.

the child of wealth and the other of toiling poverty, were stamped by nature with the same ~~noble~~ lineaments of a common nobility and appointed to a common mission in the world.

Both men as we have seen were at the heads of fearfully divided peoples; and both possessed, in large measure the high qualities needed to soften asperities and heal divisions among men. The war in both cases was carried on between a united south on the one hand and a divided north on the other: Both men had foes of their own household—and both had disguised traitors in their camps. Both William and Lincoln were in the midst of their years—when the body and the mind are both at their best. Yet before age had plucked the fire from their hearts or dimmed the light in their eyes, the heavy cares of state had plowed deep furrows in the brows of both men. The countrymen of William soon learned to call him father William—and those of Lincoln soon learned to call him father Abraham—and for the same reason: the people believed in both men and trusted both as children trust their father. While Abraham Lincoln lived and was seen at the capital of the nation, the loyal people never lost heart or hope: Though a hundred battles were fought and lost, ~~they~~ Lincoln never doubted of final success. In William theirs was the same unwavering and unfailing trust.

Both men were remarkable for their extremely cheerful disposition and withall for their capacity for the most serious devotion to whatever business they might have in hand. Both men too, were often berated for their apparent levity. Extremes meet here as they meet elsewhere. The man that laughs heartiest is the man that weeps deepest—and the one extreme enables him to support the other.

While moving about between besieged cities starving garrisons, and inquisitorial fires bearing a heavier load of responsibility than any other man in his country, William still found moments for great cheerfulness. Men who are incapable of this feeling, in such circumstances charged him with levity. They did not know that the further the pendulum swings one ~~way~~ direction the farther it must swing in the other.

Great loving hearts were in the breasts of both men. Their amiable qualities called out corresponding qualities in all who came about them.

It is remarkable that these two men, resembling each other so much in their temper, character and in their relations to their times, should ~~also~~ have resembled each other in the manner of their deaths. When William died as he did die, at the hands of a most persistent and treacherous assassin—a wretch who only the day before had received from the good man, a charity—he died invoking mercy and pardon for his guilty murderer.[40]

40 Balthasar Gérard (1557–84), a Catholic, shot William in July 1584 with a gun paid for with money that William had offered as a gift to him two days before.

Could our own Lincoln have spoken after the assassens [sic] bullit [sic] [28]
went crashing through his brain, it would have been entirely like him to have
pled also for mercy for his merciless murderer. "Malice toward none charity
toward all, was his motto in life and in death.[41]

It is worthy of remark too, that William the Silent, and Abraham Lincoln
were alike fortunate as to the time at which they were called away from the
stormy scenes of life. Both saw the mighty works of their great lives nearly
completed and died amid the glorious triumphs of their cause.

William though long under the ban of king and Pope, an outlaw, though long
pursued by assassins though large rewards had been offered for his assassination
though five different attempts had been made to take upon his life, he lived to
see his country free, his Spanish enemies worn out and broken down—the
sectarian divisions of his country healed—the armies of Spain defeated and
driven away- its proud navies swept from the from the sea, and the Pillars of the
Dutch Republic, of which he was chief builder firmly established.

Men now make pilgrimage to the place where William fell, and while
freedom has a home anywhere on the american continent grateful pilgrims will
find their way to the grave of Abraham Lincoln.

Great hearted men! though three centuries stretch away like an ocean
between you, though three centuries have intervened, you were cast in the
same generous mould, you were coworkers in the same great cause, and paid
the same extremely penality [sic] for your devotion—and together shall your
memories be cherished forever!

I have said that William of Orange was a warrior. He was that and a great
deal more. He was at once a statesman and a philosopher—and a lover of
mankind We trace him in his noble course, not merely over the howling chasm
of a long and harrassing war, spanning the dreadful gulf with his cheerful spirit
like the rainbow, always most serene and beautiful when the clouds were
blackest and the tempest loudest, but as one of the noblest benefactors of
mankind—for he was preeminently a discoverer and organizer of truth into
the laws and customs of his country.

To form any just idea of the force and effect of a great public character, we
must measure the power of the resistance with which he has to contend. It is
easy to be a giant among pigmies and to be cannon ball among egg shell.

Greatness like most other things in the world is relative not not absolute—
An idea or an achievement which would secure honor and distinction in one

41 The final paragraph of Abraham Lincoln's second inaugural address (March 4, 1865) begins:
 "With malice toward none, with charity for all, with firmness in the right as God gives us to see
 the right, let us strive to finish the work we are in, to bind up the nation's wounds." See <https:/
 /www.loc.gov/rr/program/bib/ourdocs/Lincoln2nd.html> (accessed January 14, 2018).

age and in one class of circumstances, would do neither in another age and in other circumstances. A man to be truly great must not be behind the times or even a breast with his times—but in advance of his times.

It was something for Fremont to cross the continent when he did it.[42] Any man can do it now. Thoughts and opinions which towered high above the ordinary range of mind in the sixteenth century are ~~now~~ on a level with the mind masses ~~now~~ in nineteenth century. Learning which was then in the cloister, has now gone out among the people, and the standard of greatness is steadily advancing.

I shall attempt no biographical sketch of this man. I have seen him only in the whirlwind and tempest of Events—and give only glimpses and impressions of his character. For better knowledge of him read the history of his country. His name coupled with deeds of highest renown will be found there, glowing on every page.

As already intimated the war for religious liberty in the Netherland did not begin in earnest until the Duke of Alva invaded the country. It was then and not until then that William allied himself to the struggling cause of the Reformation. After that invasion and ~~to~~ the ~~end~~ banishment of Spanish power ~~in~~ from the Netherlands, ~~It~~ it was Orange against Alva, and Alva against Orange—and never had combatants greater reason to respect the ability of each other than these two generals. Spain had no captain superior to Alva— and Rome had no disciple more obedient to her ghastly teachings.

Much that looked like war had happened previously to Alvas advent. Margaret the regent and Granville the secretary—had been busily, though somewhat blindly at work. The Inquisition had yielded a considerable harvest of blood. ___ [?] and riots were abundant; but these mobocratic tumults, were signs, the shadows of coming events—the swift flying clouds darkening the ~~coming of~~ sky before the coming storm of fire and hail!

Something of the character of William may be learned from his deportment during the ten years preceeding [sic] the time of his taking part in the war. While the broad current of events was sweeping on towards the dreadful cataract of ~~war~~ blood, the conduct of William was marked by the most rigid prudence. To outward seeming he was wholly unconscious of the part he was destined act in this opening drama. He was a vigilent [sic] observer, but a silent one. It sometimes happens that more talent is required to be silent than to speak—and he is a wise man who knows just when, where and how for it is best to declare his views.

42 John C. Frémont (1813–90) was a US explorer and politician who led four expeditions into the American west during the 1840s.

His Title: William the Silent was acquired under peculiar circumstances.
Full eight years prior to the great war, while hunting in the woods of
Vincennes, with Henry of France and the Duke of Alva, he learned from the
lips of Henry, a plot entered into by Henry and Phillip, to exterminate all the
Protestants in their respective kingdoms. This dark and bloody purpose was
divulged to him as to a consenting party and a co-conspirator. He was himself a
Catholic and a Prince, and it was easy to regard him as an ally in this pious
plan of extermination. He does not seem to have been surprised and startled
by the revelation. His face was a blank and he heard it without word a sign.
There were no traces in his countenance to tell whether he shared or
shuddered at the infernal purpose. His wonderful reticence and self control on
this memorable occasion won for him the surname by which he is now best
known in history. He was ever afterwards called William the Silent.

It must not be inferred from this title that William was incapable of speech.
On the contrary he is creditted [sic] with being one of the most eloquent and
impressive speakers of his age.

Though silent in the woods of Vincennes, from the hour when this bloody
secret was dropt into his ear—William's purpose was formed fixed and
unalterable. From that hour, ~~He~~ he resolved that no effort of his should be
spared to defeat the murderous and inhuman purpose now declared of the
kings of France and Spain. But the time to ~~declare this purpose~~ unveil
revolution did not come till long after this conversation with the royal Hunters.
Weaker nerves and a hotter heads than his would have denounced the hell
black plot at once, and given notice of their inflexible opposition; but the
wisdom of feeling is not always the wisdom of reason. While such righteous
indignation and the frank expression of it would have been creditable to the
heart of William it would have done no credit to his judgement. Men are not
necessarily guilty of duplicity and falsehood because they prefer to be the
masters of their own secrets—and to chose [sic] their own times and plans for
declaring themselves.

William knew that his time was no yet—and therefore proceeded as usual.
His manner of life was so ordered as to advert suspicion in a quarter where
suspicion would have been destruction to himself and to his cause.

His style of living was much after this mode of the noblemen of his
country—only his was more liberal and splendid theirs. For his wealth was vast
and his hospitality boundless. While however, the noblemen of his day and
country were gluttonous and drunken, the habits of William were temperate
and his life blameless.

History paints him as a man of sound body and of sound mind; a sincere
friend a cheerful companion, and remarkably fond of society. His education was

exceptionally liberal—and his attainments large. He was in his day a fine scholar, wrote six different languages and what is more remarkable spoke most of them fluently.

His deep nature was early discovered by Charles the fifth and that discriminating monarch, who well knew how to choose diplomatic agents, selected William even before he had reached the full age of manhood, to conduct important business for him at foreign courts. The skill and ability with which he discharged these ~~duties~~ difficult affairs gave him a reputation for wisdom far beyond his years. He was no malcontent, no enthusiast, no disturber of the settled order of society. Year after year rolled on, and the rapidly rising Reformation, to outward appearance touched him nowhere. It was thus far mainly confined to the common people.

In the effort to give ascendancy to the new religion particular trades and callings were especially prominent. The poor are ever disatisfied [sic] with things as they are, and hear the new truth gladly while the rich and great are satisfied with things as they are. The agitation among the Tanners, Dyers and Weavers, was loud, deep long and portentous. William heard its roar, knew its meaning, but remained silent, and continued to move upon that high plain [sic] of society and easily reached by ~~knew~~ truths.

A loyalist in politics, a catholic in religion, a member of the council general; an adviser to the Regent, Margaret of Parma—a cousin to the reigning monarch—a sovereighn [sic] in rank, a man surrounded by all the luxuries that wealth could purchase, or friends could bestow. William was courted on all sides by the highest circles of his country.

Many sought him for his great wealth, but others sought him for his great wisdom, and for the strength and the security which companionship with a strong man gives to those who come near him.

Honored and trusted by the nobles, loved and adored by the common people, he was just the man to carry his country whether so ever he might be disposed to lead.

His interest however bound him to the orthodox side of his country and his times. By position he was a conservative, both in politics and religion.

No friend of his could have suspected that a man so elevated in position so prudent in conduct, so boundless in wealth, so highly connected—so universally honored and courted, was only watching and waiting for the right moment to place himself at the head of one of the most comprehensive revolutions that every [sic] shook the world.

Almost at the very outset of Williams career as a leader of the forces of the Reformation, he was met by an event which sorely tested his fitness for the

placed he had assumed. I allude to Saint Bartholomew[43]—the slaughter of twenty five thousand protestants in a single night: Invited to a marriage ~~they~~ these unsuspecting thousands attended a massacre ~~where they, the guests were the victims.~~ and were systematically slaughtered. The monsterous treachery of this unexpected blow at the point from which William had assurances of support in his struggle with Alva, was overwhelming, and would have utterly disheartened any leader less heroic.

In his hands, William held the fullest assurance of sympathy and cooperation of the very men by whose orders and devices this wholesale slaughter of his friends was perpetrated. At the hour when the streets of Paris were flooded with the warm red blood of Protestants—he was expecting reinforcements from that quarter. He had letters in his hand to that effect from Henry.

No event during the war was so stirring. The friends of the reformation were for the moment shocked, appalled and paralyzed. It was like sticking an iceberg ~~at midnight~~ in mid ocean at midnight when the ship heaves, trembles and ~~begins to~~ sinks with all on board. ~~The occasion~~ But this astounding blow brought out the grandest qualities of ~~William the Silent~~ the young leader of his people. While all others seemed struck dumb and helpless the Prince of Orange held firmly on his way.

Undaunted courage, unwavering persistency, inflexible determination, marked his every movement—and the contagion of his glorious qualities, gave victory over even this terrible calamity.

When his best plans failed, as they often did fail: When one army after another was anihilated [sic]—when one city after another was surrendered; when starvation had broken down the fortitude of his garrisons—when his lands were covered over with mortgages and his purse was empty: when his sons and brothers, one after another were slain When the very air was burdened with the wails of his famished countrymen, crying for peace, William bated no jot of heart or hope—and his voice was still for war.

It has been attempted to dim the lustre of this noble spirit by the imputation of ambitious motives. It has been said that William desired to make himself King of the Netherlands.

No great statesman and patriot was ever more easily defended from such a charge. General principles, as well as special facts prove the entire disinterestedness of this great leader.

43 The St. Bartholomew's Day massacre began on August 23, 1572 (the eve of the feast of Bartholomew the Apostle) and was a systematic group of assassinations and violence directed against French Protestants. The violence spread from Paris to a number of other French cities. Modern estimates of the death toll vary from 5,000 to 30,000.

Outside of Liberty enlightenment and progress, William had nothing to seek or desire. He was already covered with honors and loaded with wealth.

In an open rupture with Spain, no man had more to loose [sic] and no man less to gain—no man had less to hope and no man more to Fear than William of Orange. It may be admitted that something of the grandeur of his character would be lost, if it could be shown that he had in any wise acted from a narrow and selfish motive.

It is plain however, that neither ambition, rashness nor necessity can help us to explain his course. Coolness, and deliberation, mark every step of his way. ~~into the war of the Reformation.~~

No man in the movement, had a better understanding of the sacrifices to be made, or the dangers to be encountered. He knew the power of Spain. He knew the fury of Phillip, and in all he said and did he acted upon positive knowledge.

He lived in an age of spies, as we live in age of detectives—and he availed himself of their agency to find out the inmost thought and purpose of the King of Spain. He has been much censured upon this ground. He kept a spy in the house of Phillip to obtain this knowledge.

I am not much in love with this mode of acquiring information. Spys [sic] and detectives are disagreeable people, and are only to be employed upon extraordinary occasions.

But this may be said of this part of William's conduct. Whatever the moral sense of mankind may now say on the subject, spys [sic] were not inconsistent with the Political morality of the sixteenth century.

Besides in the case before us there was no malevolent curiosity. William was dealing with a man of deep and terrible designs upon his country: To be forewarned was to be forearmed.

This too may be said in defense of his system of espionage: William had good reason to know that his own private life and words were subjected to a similar unwelcome inspection.

Margaret and her accomplished secretary were not less watchful than himself. Every act of his life was carefully observed and promptly reported to Phillip at Madrid: so that it was diamond cut diamond.

But outside of William's direct means of information he knew what to expect from any participation in the new religion.

He had the unhappy experience of Counts, Egmont and Horne [sic], before him.[44] They were men of courage equal to William, but lacked his

44 Lamoral, Count of Egmont (1522–68), and Philip de Montmorency, Count of Horn (1518?–68), were both members of Phillip II's court and opposed the imposition of the inquisition

coolness and sagacity: yet even these men foresaw the coming wrath and sought shelter and safety by deserting the cause. There [sic] way of retreat, owing to their early indiscretion in connection with the new religion was far more difficult and dangerous, than would have been his had he chosen to follow their example.

Both Egmont and Horn had at an early day openly identified themselves with the "beggars" as the reformers were scornfully called, and this fatal fact was as well known at Madrid, and to Phillip, as it was known in the Netherlands.

Nothing can be more affecting than ~~was~~ the interview as given in history between these unfortunate men and and William, when they announced to him their purpose to seek the service and friendship of Phillip. Nothing more earnest, eloquent and wise, was ever addressed by one friend to another, than Williams appeal to his two friends against going to Phillip. They however failed to take his advice, and paid the penalty for their over confidence in kingly clemency with their lives.

They were received by Phillip with smiles, as penitents were always received: They departed from the Royal presence with smiles, as penitents always departed but only to be imprisoned, shot, hanged, beheaded, burnt, poisoned or stoned to death—as it might please his catholic majesty to direct.

It is a remarkable fact that Philip's [sic] clemency never extended beyond the point of choice of the manner of putting his victims to death.

In his view a repentent heretic was much better prepared to die than to live—much fitter for heaven than for Earth, and his practice conformed to his theory.

He was always logical if not always right.

He assumed that the genuineness of a heretic heresy, when confessed by himself, could not well be questioned—but that his repentence, for obvious reasons was quite another thing, and fairly open to doubt. In such a case the pious king deemed it proper to give the church the benefit of the doubt and leave the rest to heaven.

During eight or ten stormy years as already intimated, William's position was one of repression rather than of encouragement to the new religion. He was opposed to the defacement and distruction of church propety. He had no sympathy with the iconoclasts. His mental organization and his culture alike made him preeminently a man of law and order. He was naturally a judge and a peacemaker among men.

into the Netherlands. While William fled the country, Egmont and Horn remained and were captured and executed.

It is one of the evidences of his moral greatness that he was oftener called upon to quell religious tumults than any other man in the Netherlands.

When Amsterdam Antwerp and Brussels were scenes of of riot and blood shed; when the voice of Margaret and Granville were alike impotent, William alone could calm the storm, silence the waves and arrest the tide of violence and blood.

I will not dwell longer upon the merits of this good man. His noble character is vindicated, upon general principles. Enough has been said to show, that while in temper and disposition, in religion and station; in royal rank and princely inheritance; in all his anticedents [sic] and immediate surroundings, he had the strongest inducements to a conservative career; he pursued exactly the opposite course: espoused the struggling cause of religious Liberty, and faithfully served that cause with his life and with his death.

It is a grand thing for any man however humble to espouse an unpopular and persecuted cause, but a grander thing still, for a rich and great man to do so. Such causes, however just and praiseworthy have few such converts. Wealth, power and position are usually on the side of the oppressor—until truth has taken root among the common people.

When William joined the reformation, he heard the voice of the Christ of his day. He sold all he had and gave to the poor. One such example redeems an age and lifts the earth nearer heaven. We all breathe freer, see further and feel nobler and are brought in to sweeter union with the Infinite when we can point to such an example of self denial.

But the greatest service rendered by this great man was not his generalship in war but his discovery of a great social truth: a truth which makes society possible. It was his merit that while living in an age of darkness and superstition—when charity was weakness, and toleration a crime against religion—when Liberty meant only a chartered privilege and human rights was without a name—when Government was only seen in crowns and religion in mitres; when Protestants as well as Catholics were stern and relentless persecutors; William had the wisdom to discover and the courage to declare the principle of self Government and of religious toleration—and to make these the law for his country.

It would be interesting to ascertain from which side of William's character and mental exercises, he was able to discover the principle of religious toleration? Did it come from his religion or his reason? from his love of God or his love of man? from faith, or from facts.

I think that for whatever else we may be indebted to religion we owe it nothing for the idea of religious toleration. Faith is the most imperious, exacting and unreasoning and intolerant quality which can take up its place in

the human mind. It knows nothing of compromise and of agreeing to disagree. Its natural language is this: believe or be accursed. It knows ~~know~~ no middle ground and is nothing if not absolute and infallible.

William though a catholic, was no theologian. His mind was too broad for the narrow reasonings of Theology. His ideas came of practical statesmanship and of a broad and world embracing humanity. He took the world as he found it, and as in the nature of things it must be found. He saw that men would differ, and must differ—and that the only true remedy for ills that grow out of this difference was to be found in mutual respect for the right to differ. Out of William's abundant love of man—not out of his love for God, out of his philosophy not out of his theology; out of his reason not out of his faith came his healing ideas of toleration.

He loved his fellow men. He had compassion ~~upon~~ even for the guilty wretch by whom he was slain. We should never think of this good man of the Netherlands without remembering how vastly we are indebted to him for the ~~reli~~ liberty of thought and speech we now enjoy. I shall not undertake to give you the exact measure of that debt—or the measure of the man to whom it is due. We have no scales in which to weigh his worth—no standard standard [sic] by which to determine his services. He toiled, suffered and died. We live. It is easy to say that the world moves since Galileo: It is easy to cross the ocean since Columbus: It is easy to walk in the night when the moon and the stars are bright in the sky: It is easy to dwell amid fruitful fields when the pioneer has removed the noxious weeds and poisonous vapor: It is easy to speak of British Liberty since Magna charta [sic]:[45] It is easy to be a catholic in Rome, an abolitionist where there is no slavery, and so now it is easy to preach and practice freedom of thought since William the Silent and the Dutch Republic.

45 Magna Carta, a charter agreed by King John of England in 1215, established for the first time that everybody, including the monarch, was subject to the law.

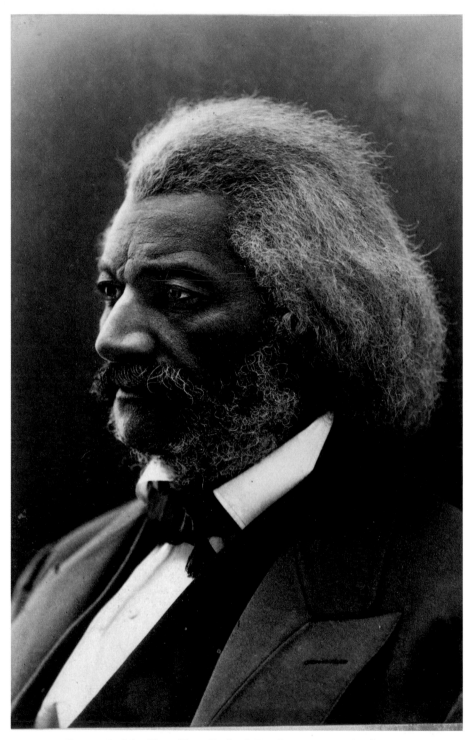

Figure 48: John Howe Kent, *Frederick Douglass*, 1879–83. (Collection of the Rochester Public Library Local History Division, Central Library of Rochester and Monroe County, Rochester, NY.)

29. "The Welfare of the Coloured People: Frederick Douglass, "The Exodus from the South," c. 1879

Frederick Douglass's "The Exodus From the South," dated circa 1879, survives as a one-page fragment in the Walter O. Evans collection. Writing on a subject in which he had been embroiled in controversy, Douglass begins by readily confessing, "One of the latest subjects upon which I differed from a large class of my fellow citizens was what is called the Exodus of the Freedmen from the Southern States to Kansas and other northern states which was urged with much vehemence and show of reason." As he further confides in a draft sentence which he does not complete: "There has seldom arisen any question touch[ing] the welfare of the colored people of the South upon which I have found myself so much at variance with those who had their ~~interests~~." For an in-depth summation of Douglass's provocative arguments against the Black flight from the US South in the aftermath of the Civil War, readers are advised to consult his essay, "The Negro Exodus from the Gulf States," which appeared in the *Journal of Social Science* in 1880.[1] Douglass's article was immediately followed by an impassioned reply by Richard T. Greener in which he took the opposite view, arguing in favor of "The Emigration of Colored Citizens from the United States."[2]

In stark contrast to his one-page draft manuscript reproduced here, Douglass provides a detailed discussion of his arguments in his published essay, "The Negro Exodus from the Gulf States." As he observes, "The Exodus has revealed to southern men the humiliating fact that the prosperity and civilization of the South are at the mercy of the despised and hated negro."[3] Douglass relishes in the vulnerability of "southern men" by jubilantly insisting that whites have no choice but to understand "that the giving or withholding of his labor will bless or blast their beautiful country."[4] Recognizing that, "the work of the South requires bone, sinew and muscle of the strongest and most enduring kind for its performance," he takes great delight in the fact that such "bone, sinew and muscle" is beyond the capacity of white men.[5] As Douglass argues, while it may be "shocking for a southern man to contemplate, it is now seen that nothing less powerful than the naked iron arm of the negro can save her."[6] On these grounds, Douglass's rationale for protesting against Black migration is the fact that even racist whites have

1 Douglass, "The Negro Exodus," in Blassingame, *Frederick Douglass Papers*, vol. IV, 511–32.
2 Greener, "The Emigration," 22–35.
3 Ibid. 512.
4 Ibid.
5 Ibid.
6 Ibid. 513.

been made to understand that, "as a southern laborer, there is no competitor or substitute" for the "naked iron arm of the negro."[7]

Celebrating the promise of freedom presented for Black men living in a post-slavery moment, Douglass declares, "His chains were broken in the tempest and whirlwind of civil war," with the result that, "His labor made him a slave, and his labor can, if he will, make him free, comfortable and independent."[8] For Douglass, it was inarguably the case that Black wealth could be accrued only in the South. He was immovable in his belief that "more cotton and sugar can be raised by the same hands under the inspiration of liberty and hope than can be raised by the same hands under the influence of bondage and the whip."[9] By comparison, if African Americans opted for migration, he argued, only destitution awaits: "without a home; again out under the open sky; with his wife and his little ones. He lines the sunny banks of the Mississippi, fluttering in rages and wretchedness; he stands mournfully imploring hard-hearted steamboat captains to take him on board; while the friends of the emigration movement are diligently soliciting funds."[10] For Douglass, the emigration of a formerly enslaved people results solely in white profiteering and Black impoverishment.

Yet more revealingly, Douglass relies on his own personal experience as an enslaved man who was denied any and all family ties due to the inhumanity of slavery to communicate his protest against Black exodus. "Of all the galling conditions to which the negro was subjected in the days of his bondage, the worst was the liability of separation from home and friends," Douglass declares. "His love of home and his dread of change made him even partially content in slavery. He could endure the smart of the lash, worked to the utmost of his power, and be content till the thought of being sent away from the scenes of his childhood and youth was thrust upon his heart."[11] For Douglass, Black migration from the South perpetuated the pain of chattel bondage by yet again resulting in the same loss of home and family. According to his argument, therefore, if enslaved women and men "could endure the smart of the lash" to keep families together, then a freed people could survive their post-emancipation daily struggles on the grounds that now there is "hope that the negro will ultimately have his rights as a man, and be fully protected in the South."[12]

Douglass is under no illusion regarding the suffering newly freed peoples were facing. "The unjust conduct charged against the late slaveholders is eminently

7 Ibid.
8 Ibid. 513–14.
9 Ibid. 515.
10 Ibid.
11 Ibid. 516.
12 Ibid. 522.

probable," he observes, arguing, "It is an inheritance from the long exercise of irresponsible power by man over man."[13] He rejects white supremacist arguments by stating, "It is not a question of the inferiority of the negro, or the color of his skin."[14] Rather, as he argues, "Tyranny is the same proud and selfish thing everywhere, and with all races and colors."[15] For these reasons, the North is no halcyon utopia of race relations. Speaking from his own bitter experiences, Douglass readily concedes, "Within the last forty years, a dark and shocking picture might be given of the persecution of the negro and his friends, even in the now preeminently free State of Massachusetts."[16] At the same time, he urges, "Bad as is the condition of the negro today at the South, there was a time when it was flagrantly and incomparably worse."[17] He takes heart and hope that, "A few years ago he had nothing; he did not have himself, his labor and his rights to dispose of as should best suit his own happiness. But he has now even more."[18]

All his virulent protestations to the contrary, however, Douglass ultimately refused to stand in the way of African Americans who sought a new life in the North. He is insistent: "no encouragement should be given to any measures of coercion to keep them there. The American people are bound, if they are or can be bound to anything, to keep the North gate or the South open to black and white, and to all the people."[19] When faced with any form of physical persecution, Douglass is categorical in his advocacy of Black resistance, returning to his liberty or death arguments of an antebellum era: "If it is attempted by force or fraud to compel the colored people to stay, then they should by all means go; go quickly, and die, if need be, in the attempt."[20] "To attempt to keep these freedmen in the South, who are spirited enough to undertake the risks and hardships of emigration, would involve great possible danger to all concerned," he predicts.[21] As always, he returns to the example of a longstanding history of heroic Black masculinity. "Ignorant and cowardly as the negro may be, he has been known to fight bravely for his liberty," Douglass observes, summarizing, "He went down to Harper's Ferry with John Brown, and fought as bravely and died as nobly as any."[22] Douglass never passes up the opportunity to give his audience a lesson in Black revolutionary history: "There have been Nathaniel Turners and Denmark Veseys

13 Ibid. 519.
14 Ibid.
15 Ibid.
16 Ibid. 522.
17 Ibid.
18 Ibid.
19 Ibid. 531.
20 Ibid.
21 Ibid.
22 Ibid.

among them in the United States, Joseph Cinques, Madison Washingtons and Tillmons on the sea, and Toussaint L'Ouvertures on land."[23] He relies on the testimony of white racist oppressors to declare: "Even his enemies, during the late war, had to confess that the negro is a good fighter, when once in a fight. If he runs, it is only as all men will run, when they are whipped."[24]

No more powerful vindication against Greener's criticism that "Mr. Douglass grants the negro's misery, but tells him to wait," can be found than in Douglass's unequivocal declaration: "In no case must the negro be 'bottled up' or 'caged up.' He must be left free."[25] Douglass was in no doubt that, "To forcibly dam up the stream of migration would be a measure of extreme madness as well as oppression" as "The fever of freedom is already in the negro's blood."[26] Writing in "Mr. Douglass Defended," an article published in the *New York Globe* a few years later on May 26, 1883, under the pen name "Justice," Rosetta Douglass Sprague is insistent that all of Greener's criticisms dissolve in the face of Douglass's own unparalleled history of labor in the cause. "Mr. Douglass believed in work; young, strong and a heart in his cause he worked with a will early and late, with an enthusiasm worthy of the man and the hour," she writes. As his eldest daugther dismissively concludes of his detractors, "Words are easily quoted. Work has to be performed."[27]

23 Ibid. 532.
24 Ibid.
25 Ibid. 531.
26 Ibid. 532.
27 This article was published under the pen name "Justice," titled, "Mr. Douglass Defended," and printed in the *New York Globe* on May 26, 1883. It is pasted into one of the pages of the Walter O. Evans scrapbooks.

DOUGLASS, THE ORATOR

Figure 49: Charles Milton Bell, *Frederick Douglass*, c. 1881. Reproduced in Phil. A. Whipple, *Negro Neighbors: Bond and Free: Lessons In History and Humanity*. (Boston: Woman's American Baptist Home Society, 1907. The New York Public Library Digital Collection.)

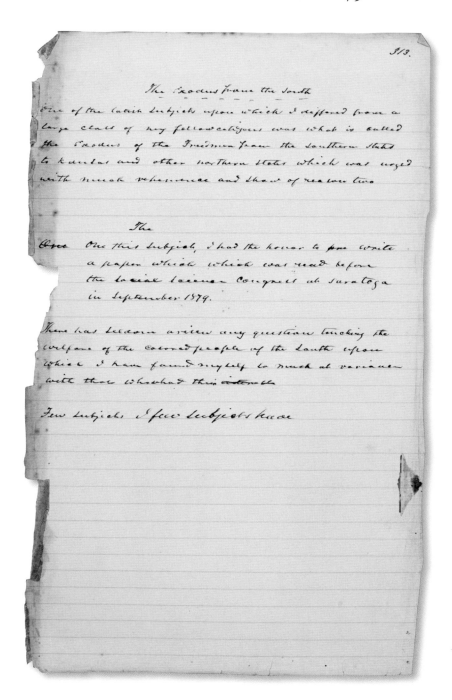

29. Frederick Douglass:
"The Exodus from the South," c. 1879

One of the latest subjects upon which I differed from a large class of my fellow citizens was what is called the Exodus of the Freedmen from the Southern States to Kansas and other northern states which was urged with much vehemence and show of reason two

The
~~One~~ On this subject, I had the honor to ~~pre~~ write a paper which which [sic] was read before the social science congress at Saratoga in September 1879.[28]

There has seldom arisen any question touch the welfare of the colored people of the South upon which I have found myself so much at variance with those who had their ~~interests~~

Few subjects I few subjects have

28 The American Social Science Association, founded in Boston in 1865, held its general meeting in 1879 at Saratoga, NY. Frederick Douglass refers to his talk "The Negro Exodus from the Gulf States." For more, see the introductory essay to this manuscript.

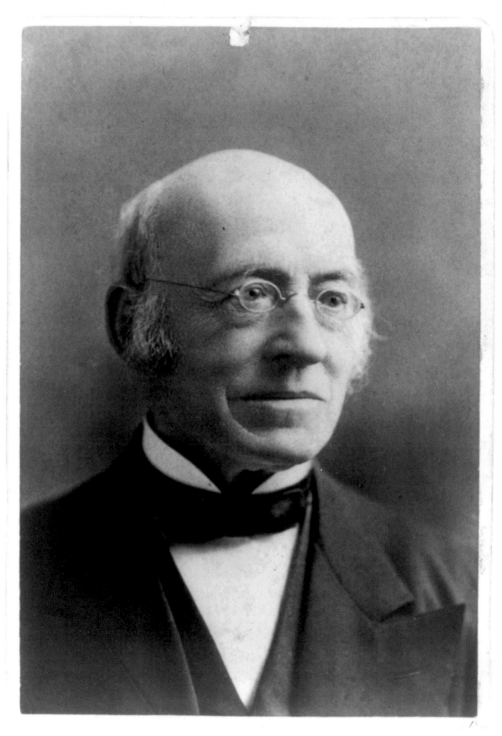

Figure 50: James Notman, *William Lloyd Garrison*, c. 1870–9.
(Prints and Photographs Division, Library of Congress, Washington, DC.)

30. "A Great Example of Heroic Endeavor": Frederick Douglass, "Eulogy for William Lloyd Garrison," 1879

Writing Rosetta Douglass Sprague from Port-au-Prince, Haiti, on April 4, 1891, Frederick Douglass expressed his satisfaction with Frederic May Holland's recently published biography of his life. "It is the best written sketch of my life yet written by any outsider and says things of me that I never could have said of my self although they may be true," he exults. Douglass singles out for praise Holland's success in "having done me right and justice about my difference with the Garrisonians and for this he is entitled to my thanks."[1] And it was precisely the fight for "justice" to my "difference with the Garrisonians" in general and with William Lloyd Garrison (1805–79), white radical antislavery campaigner and reformer and Douglass's early mentor and surrogate father figure in particular, that was to define his struggle for independence not only from proslavery ideology but from white Northern racism. As Douglass was all too painfully aware, while his body had been bought and sold on the auction blocks of the US South, his soul was repeatedly traded on the white abolitionist podium. Among white anti-slavery campaigners, Black lives typically only mattered in so far as they were serviceable to the cause.

As William Lloyd Garrison reminisces, he and Douglass first met in August 1841. Writing in his preface to Douglass's first autobiography, *Narrative of the Life of Frederick Douglass, an American Slave*, he recalls: "I attended an antislavery convention in Nantucket, at which it was my happiness to become acquainted with FREDERICK DOUGLASS."[2] "I shall never forget his first speech at the convention," he remembers. He freely admits to "the extraordinary emotion it excited in my own mind—the powerful impression it created upon a crowded auditory, completely taken by surprise—the applause which followed from the beginning to the end of his felicitous remarks."[3] According to Garrison, it was this meeting with Douglass which caused him to experience an epiphany regarding his unequivocal hatred of slavery as an inhumane institution. His decades of activism notwithstanding, he recalls, "I think I never hated slavery so intensely as at that moment; certainly, my perception of the enormous outrage which is inflicted by it, on the godlike nature of its victims, was rendered far more clear than ever."[4]

1 Frederick Douglass to Rosetta Douglass Sprague, April 4, 1891, Frederick Douglass Papers, Library of Congress.
2 Garrison, *Narrative of the Life*, iii.
3 Ibid. iv.
4 Ibid.

As Garrison confides, his horror at slavery's injustices was exacerbated by his realization that, on contemplating Douglass, "There stood one, in physical proportion and stature commanding and exact—in intellect richly endowed—in natural eloquence a prodigy—in soul manifestly 'created but a little lower than the angels'—yet a slave, ay, a fugitive slave."[5] He was appalled to comprehend, "by the law of the land, by the voice of the people, by the terms of the slave code, he [Douglass] was only a piece of property, a beast of burden, a chattel personal, nevertheless!"[6] And yet, Garrison chose to expose the immorality of Douglass's legal status as a "piece of property" not by insisting on his equal humanity but by relying on deifying language to celebrate his exemplary "godlike nature." As Douglass was to find only a few years later, there is only one way to go from being placed on such an exalted pedestal: downwards.

Writing of their meeting in his second autobiography, *My Bondage and My Freedom*, Douglass remembered the anxiety he experienced in being "induced to speak out the feelings inspired by the occasion, and the fresh recollection of the scenes through which I had passed as a slave."[7] At that point in his life, scarcely a year or two out of slavery, Douglass was suffering from extreme emotional angst. As a result, this speech stands out in his memory as "the only one I ever made, of which I do not remember a single connected sentence."[8] He confides his exposure to an overwhelming sense of personal struggle, admitting, "It was with the utmost difficulty that I could stand erect, or that I could command and articulate two words without hesitation and stammering. I trembled in every limb."[9] While language failed him despite his exalted status as a man who was soon to become a lionized orator, celebrated for his exceptional eloquence, the reverse was the case for Garrison. "Mr. Garrison followed me, taking me as his text," Douglass recalled, observing, "whether I had made an eloquent speech in behalf of freedom or not, his was one never to be forgotten by those who heard it. Those who had heard Mr. Garrison oftenest, and had known him longest, were astonished. It was an effort of unequalled power, sweeping down, like a very tornado, every opposing barrier, whether of sentiment or opinion."[10]

According to this unequal dynamic, Garrison the white emancipator was inspired to deliver an "eloquent speech in behalf of freedom" that was of "unequalled power" not by engaging thoughtfully, respectfully, and on equal terms with Douglass the self-emancipated individual but by "taking" his life as "his

5 Ibid.
6 Ibid.
7 Douglass, *My Bondage*, 357–8.
8 Ibid. 358.
9 Ibid. 243.
10 Ibid. 358.

text." According to this formulation, the liberation of enslaved people was the work not of individuals such as Douglass but of white radical reformers such as Garrison. For white campaigners seeking their spiritual liberty from the national sin of slaveholding, the emancipation of enslaved people ultimately meant freedom for themselves. As Douglass immediately realized, his fight for freedom had not ended but had only just begun on his arrival in the North.

Over a decade later, Douglass held nothing back in denouncing the tendencies toward objectifying and dehumanizing formerly enslaved Black women and men that were exhibited by his white abolitionist sponsors and their white antislavery audiences. "Many came, no doubt, from curiosity to hear what a negro could say in his own cause," he observed. Adding insult to injury, Douglass expressed his anger that, "I was generally introduced as a 'chattel'—a 'thing'—a piece of southern 'property'—the chairman assuring the audience that it could speak."[11] For Douglass, no more categorical proof of white abolitionists' failures to liberate themselves from their own racism and recognize Black equality could be found than in their repeated association of his humanity with chatteldom. He punctures beneath the surface of their seemingly radical belief system to establish that he was no psychologically complex individual for Garrison and his supporters, but, at best, a "prodigy" and, at worst, a "'thing,'" "a piece of southern 'property,'" and even an incongruous spectacle that inspired disbelief because "it could speak." Yet more damningly, he directly critiqued his former mentor by remembering, "'Tell your story, Frederick,' would whisper my then revered friend, William Lloyd Garrison, as I stepped upon the platform."[12] As a result, Douglass had no option but to disagree. "I could not always obey, for I was now reading and thinking," he explains, "New views of the subject were presented to my mind."[13] He issued a declaration of authorial and philosophical independence by maintaining, "It did not entirely satisfy me to narrate wrongs; I felt like denouncing them."[14]

Douglass's rejection of Garrison's insistence that he solely confine himself to his story as an enslaved man marked the beginning of their very real differences of opinion, which were to set in during the late 1840s and early 1850s and eventually lead to the termination of their friendship. The gulf between the two men widened on three key issues: Douglass's rejection of the Garrisonian position that the US constitution was a proslavery document and a "'covenant with death and an agreement with hell'";[15] Douglass's increasing belief in the necessity of violence to end slavery, on the grounds that (in the words of Lord Byron, whom he repeatedly quoted), "'Know ye

11 Ibid. 360.
12 Ibid. 361.
13 Ibid.
14 Ibid. 361–2.
15 Qtd. Yacovone, "A Covenant with Death."

not/Who would be free *themselves* must strike the blow'";[16] and Douglass's determination to use monies he had obtained on his transatlantic lecturing tour of Scotland, Ireland, England, and Wales to set himself up as editor of his own newspaper. Rather than a series of disagreements kept between themselves, the Douglass-Garrison split was a very public affair that drew supporters and detractors on both sides.

Writing an editorial in his newspaper on December 9, 1853, Douglass explicitly denounced his former mentor by stating, "incidents have been occurring, and coming to my knowledge with more or less frequency, painfully foreboding a fierce and bitter warfare upon me, under the generalship of Wm. Lloyd Garrison, with a view to destroy my anti-slavery usefulness, and, possibly to drive me from the field of public antislavery effort." "All this, of course, will be disclaimed," he bitterly observed, satirically insisting, "*Word*-wise, these Garrisonians are my best friends; *deed*-wise, I have no more vigilant enemies." Ultimately, Douglass refused to be victimized and took matters into his own hands. He made any rebuilding of their relationship impossible by calling Garrison to account for his own self-interest. "When under the tall shadow of the ships and ware-houses of New Bedford, now more than twelve years ago, Mr. Garrison called me to his side," he confirms, "I thought it was to serve the cause of my broken-hearted people that he wanted me; *not*, certainly to build up a sect, *re*ligious or *ir*-religious, of which Mr. Garrison was to be the acknowledged head and Bishop."

Yet more damning than Garrison's own vainglory for Douglass was his and his followers' inherent racism. As he writes, nothing could prepare him for the fact that "*prejudice against my race* would be invoked" in their current contest. According to this racist hierarchy, Douglass knew the drill: "the *white* man [was] to *rise*, as an injured benefactor; and the *black* to *fall*, as a miserable *ingrate*." All these personal and political attacks to the contrary, Douglass rejected derogatory dismissals of himself as a "miserable *ingrate*." He retained the moral high ground by bearing witness to the sufferings of bond women, children, and men and holding fast to his role as a "fugitive slave" risking life and limb for the Black freedom struggle. As Douglass fearlessly proclaimed, "I will not consent to be coaxed or driven from the side of my enslaved brethren."[17]

Decades later, the emotional conflicts and political disagreements between Douglass and Garrison were still so deeply entrenched that they remained irreconciled at the latter's passing on May 23, 1879. A source of hope in the face of despair, however, was that these bitter disagreements had no bearing on the next generation: one of Garrison's sons, Francis Willard, reached out to Douglass by

16 Douglass is quoting from Lord Byron's *Childe Harold* at the beginning of Part IV of his novella *The Heroic Slave*, 225.
17 Douglass, *Frederick Douglass' Paper*, December 9, 1853.

appointing him as "the principal eulogist at a memorial meeting" held "on the evening of 2 June 1879 at the Fifteenth Street Presbyterian Church in Washington, D.C."[18] Black and white audiences attended, and Robert Purvis, legendary Underground Railroad activist and reformer, chaired the meeting. An anonymous writer for the *Washington Post* was present at the meeting and observed Douglass "'taking out a bundle of manuscript,'" summarizing: "'[he] proceeded to read a very feeling and suitable tribute to the distinguished dead.'"[19]

A very likely candidate for this "bundle of manuscript" is the speech undoubtedly written in Douglass's own hand and held in the Walter O. Evans collection. In stark contrast to his lectures on Santo Domingo, William the Silent, and the Exodus, no other manuscript version survives. The sole printed circulation of this speech was a pamphlet entitled "This is a Sad and Mournful Hour: An Address Delivered in Washington D.C. on 2 June 1879 Speech on the Death of William Lloyd Garrison, at the Garrison Memorial Meeting in the 15th Street Presbyterian Church, Monday, June 2, 1879," a copy of which is held in the Library of Congress Frederick Douglass Papers. The few differences between Douglass's holograph manuscript and the printed typed pamphlet render it likely that this manuscript was very close to the copy used for the printed text. Given his renown as an extempore orator, Douglass's decision to "read" out his lecture met with criticism from the *Washington Post* editor, for whom, "'An off-hand speech by Douglass on such a subject as the life and service of Garrison would have no doubt been the effort of his life.'"[20] Nothing could have been further from the truth, in light of their complex history. For Douglass, the decision to read was undoubtedly deliberate in order to keep his emotions in check and ensure he did not become distracted by their fraught history, but rather stayed focused on Garrison's reusable legacies for all current and future freedom struggles.

"There are times when silence is more potent than speech, when words seem too thin, tame and poor to express our thoughts and feelings," Douglass poignantly opens this memorial address. Immediately, and very likely due to his difficult personal history with Garrison, he chose to dispense with his private self in favor of insisting on his representative status: "It seems just that we of the colored race should speak at such a moment, even though our speech, should be thin, poor, broken and imperfect." Laying aside all their acrid disputes, Douglass unreservedly celebrates his former mentor's life: "In the death of William Lloyd Garrison, we behold a great life ended, a great purpose achieved, ~~a beautiful car~~ great career beautifully furnished, and a great example of heroic endeavor nobly established."

18 Blassingame, *Frederick Douglass Papers*, vol. IV, 503.
19 Ibid.
20 Ibid.

Writing against a backdrop of the rise of slavery's spirit in a post-emancipation era, Douglass was insistent that their personal acrimonies immediately fall away only to leave behind Garrison's unparalleled status as a "great example of heroic endeavor." "For our own good and the good of those who come after us, we cannot let this event sink too deeply into our hearts," Douglass urges, warning, "we cannot too often recur to this life and history—or too closely copy this Example." Garrison the reusable political icon is not to be sacrificed to the private, problematic Garrison, according to Douglass's reformist vision.

In a canny sleight of hand, Douglass makes his audiences aware of Garrison's fallibilities by a signposted refusal to discuss them: "This is not the time and the place for a critical, and ~~in every sense an~~ accurate measurement of William Lloyd Garrison." No sanitizer of Black-white relations among antislavery campaigners, he readily alludes to their differences of opinion, if only in diluted terms: "Speaking for myself—I have sometimes thought him uncharitable to those who differed from him. Honest himself, he could not always see how men could differ from him and still be honest." And yet, he refuses to demonize Garrison by carefully stipulating, "To say this of him is simply to say that he was human and it may be added when he erred here, he erred in the interest of truth. He revolted at half-ness, abhorred compromise, and demanded that men should be either hot or cold." For Douglass, the political currency of Garrison's life as dedicated to the cause is at a premium above all else. "Our Country is again in trouble," he declares, as he is under no illusion that, "A spirit of evil has been revived which we fondly hoped was laid forever."

Against a backdrop of the escalating racist persecutions and discriminations facing Black citizens who were being denied all rights, he is candid: "in this conflict between the semi barbarous past—and the higher civilization which has logically and legally taken its place, we shall sorely miss the mind and voice of William Lloyd Garrison." Douglass personally triumphs over his own complex feelings toward Garrison by choosing the path of generosity and forgiveness: "In him I saw the resurrection and life of the dead and buried hopes of my long enslaved people." "Let us guard his memory as a precious inheritance," he proclaims, urging, "let us teach our children the story of his life, let us try to imitate his vertues [sic], and endeavor as he did, to leave the world freer, nobler and better than we found it." As Garrison had sought to use the "story" of Douglass as a catalyst for the end of slavery, so Douglass makes free and candid use of Garrison's example to usher in a "freer, nobler and better world" in a post-emancipation era. Ultimately Douglass insisted in a powerful addition he made to his printed version of this address, and which is absent from his manuscript: "For to live is to battle—and he battled from first to last."

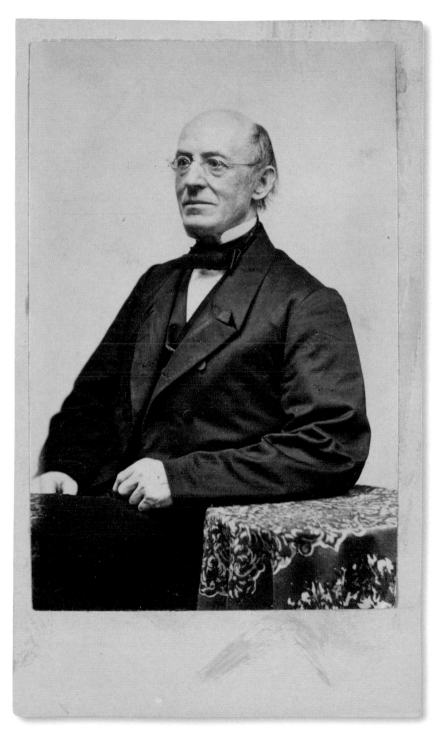

Figure 51: Anon., *William Lloyd Garrison*, c. 1870.
(Prints and Photographs Division, Library of Congress, Washington, DC.)

1.

Mr President and friends.

There are times when silence is more potent than speech, when words seem too thin, tame and poor to express our thought and feelings. I am impressed with a sense of this distinction in contemplating the event that has brought us here tonight. An hour spent here in silent meditation upon that solemn event, would perhaps be more impressive than any formal address can be. But the heart ever pressed for utterance in the presence of a great affliction and sorrow. It seems meet that we of the colored race should speak at such a moment, even though our speech should be thin, poor, broken and imperfect. In a case like this any word, or sign of grief or gratitude will be tolerated in us.

To every antislavery man and woman in the land, to every friend of impartial liberty at home or abroad, and especially every colored man, this is a sad and mournful hour. The abolitionists of this country were never a numerous class. Their power and influence was always greater than their numbers for they with them the invisible and infinite forces of the moral universe. But lately death has been busy in reducing their already thinned ranks. Some of the earliest friends and most eminent of them all have gone the way of all the earth, much in advance of their great leader. Only a few of those noble and brave men and women who rocked the antislavery movement in its cradle, who watched and worked during the first years of its existence, and saw with gratitude its steady growth and development, from the tiny thing it was at the beginning to the giant it became in the end, are still on the stage of busy life. Here and there at broad intervals one and another may be found standing like stately pillars of a fallen temple.

Mr President, you are fortunate. Only a few like yourself can now tell from actual experience, from earnest participation, something of the darkness and peril that brooded over the land when the antislavery movement was born. You can name its friends, trace its history. You can tell of the wonderous trials, persecution and hardships through which those early workers had to roll; how step by step, the antislavery sentiment of the country rose "from" weakness to strength, from conflict to victory and from shame to glory. I can tell of the fire and fury with which it was assailed in its infancy - how the heroes of that day sought life, held friends were sometimes only rescued from danger and death by hiding themselves from the wrath and fury of the mob.

Mr President,
It is a thrilling story. After coming generations will read and wonder. But soon the time will come when no living witness will be left to tell it. One pillar after another, has already fallen and others are falling - one luminous star after another has disappeared. We have witnessed their departure with throbbing hearts and silent awe.

30. Frederick Douglass:
"Eulogy for William Lloyd Garrison," 1879

and now the brightest and steadiest of all the shining hosts of our
moral sky has silently and peacefully descended below the
distant horizon whither all are tending, no more to take part
in the busy scenes of human life.

In the death of William Lloyd Garrison, we behold a great life ended,
a great purpose achieved, a beautiful ~~~~ on a great career beautifully
finished, and a great example of heroic endeavor nobly established.

For our own good and the good of those who come after us, we cannot
~~all this event sinks too deeply into our hearts we cannot~~
too often recur to this life and history or too closely copy this example.

The world has seen many heroes, Some who have
founded empires, Some who have overthrown Governments, some who
have with their broad swords ~~hewn them~~ hewed their way to fame
and fortune. There have been great Bishops, great Kings, great
Generals and great Statesman but these great ones, owed their greatness
~~ness~~ to circumstances apart from themselves, Our great Bishops,
have had great churches behind them, our great rulers, great nations
behind them, ~~or~~ Our great Generals, great armies behind them,
Their light was brilliant but borrowed. It was not so with
~~But~~ the great man whose memory we celebrate to night.
He owed nothing to his early surroundings, He was born to poverty, to
labor and Hardship. He was his own guide and his own college, and He stood among the learned
and great of his day by his own exertion. He moved not with the tide, but
against it. He rose not by the power of the church or the state,
but in bold and defiant opposition to the mighty power of both.
It was the glory of this man that he could stand alone with the truth
and calmly await the result! as we all know
He went forth a slender youth, without purse, without scrip, without
friends and without fame, to battle with a system of boundless
wealth and power. He had faith in the simple truth and faith
in himself. He was modest and retiring in his disposition but his
zeal was like fire, and his courage like ~~steel~~ steel,
and during all his fifty years of service, in sunshine and storm,
no doubt or fear, as to the final result, ever shook his manly breath. him

No wonder that in their moral blindness men called him a
fanatic and a mad man. for against such overwhelming odds
it was thought that nothing, but madness would venture to
contend. But there was nothing of madness in the composition
of William Lloyd Garrison or in his espousal of the cause to
which he gave his mind and heart.

30. Frederick Douglass:
"Eulogy for William Lloyd Garrison," 1879

the world that was thought, felt and said of him. A candid examination of his character and his work in the world, may disclose somethings, we would have had otherwise. Speaking for myself. I have sometimes thought him uncharitable to those who differed from him. Honest himself, he could not always see how men could differ from him and still be honest. To say this of him, is simply to say that he was human and it may be added when he erred here, he erred in the interest of truth. He revolted at halfness, abhorred compromise, and demanded that men should be either hot or cold.

This great quality though sometimes in excess, is one explanation of his successful leadership. What it cost him in breadth and numbers, he gained him in condensation and intensity. He held his little band well in hand and close to his person. No leader was ever more loved by the circle about him. Absolute in his faith no sect could proselyte him, inflexible in his principles no party could use him, content with the little circle about him he did not mingle directly, and largely with the great masses. By a single principle he tried all men, all parties and all sects. What his name stood for at the beginning it stands for now and will so stand forever.

It is said that the wicked shall not live out half their days. This is true in more senses than one: "For the coward and the small in soul scarce do live". Mr Garrison, lived out his whole existence. Although he had reached a good old age, time had not dimmed his intellect, nor darkened his moral vision, nor quenched the ardor of his genius.

His letter published three weeks before his death, on the exodus from Mississippi and Louisiana had in it all the energy and fire of his youth.

Men of three score and ten are apt to live in the past. It was not so with Mr Garrison, He was during all his latest years, fully abreast with his times. No event or circumstance bearing upon the cause of justice and humanity, escaped his intelligent observation. His letter written a few months ago upon the Chinese question was a crowning utterance. It was in harmony with the guiding sentiment of his life "My Country is the world and all mankind are my countrymen".

30. Frederick Douglass:
"Eulogy for William Lloyd Garrison," 1879

Mr President,

heavy billows Our Country, is again in trouble. The ship of State is again at sea. She trembles and plunges, and plunges and trembles again. Every timber in her vast hull is made to feel the heavy Strain. A spirit of evil has been revived which we fondly hoped was laid forever. Doctrines are proclaimed, claims are asserted, and pretentions set up which were as we thought all extinguished by the logic of the war Cannon balls. I have great faith Sir, that the nation will deal with this new phase of affairs, wisely, vigorously and Successfully; but in this Conflict between the semi barbarous Past and the higher civilization which has logically and legally taken its place, we shall Sorely miss the mind and voice of William Lloyd Garrison. Firm and fearless, Clear sighted and Strong, quick to discern the right, eloquent and able to defend it, he would in this, as in other trial hours, prove a fountain of light, and a tower of Strength.

Mr President:

In the first year of my freedom, while residing in the City of New-Bedford massachusetts, it was my good fortune; to see and hear for the first time, the man who was then, and will ever be regarded, as the Chief apostle of the immediate and unconditional Emancipation of all the Slaves of America.

I never shall forget my feelings on that occasion. Upon first blush, as I looked upon him from the gallery of old Liberty Hall — a Hall that was then deserted by attendies for popular objects, and hence only fit for abolition meetings.

I was only a few months from the house of bondage. I never shall forget the feelings with which I used to hear this man. It was more than forty years ago. It was in old Liberty Hall. It was a large but delapidated old place. Its wood work was marred, its doors off hinges, and its windows broken by stones and other missiles, thrown to break up abolition meetings. For such meetings they were like free meetings in the South outside of protection. Upon first blush, I saw as I sat in the gallery of this old Hall — that the hour and the man were well met, and well united. In him, there was no Contradiction between the Speech and the Speaker. The man and his cause were one. was there. But what a Countenance, what firmness and benignity — what evenness of temper, what Serenity of mind, what sweetness of Spirit

30. Frederick Douglass:
"Eulogy for William Lloyd Garrison," 1879

were written as by the pen of angel on that countenance! A million of human faces might be searched without finding one like his— at least so it then seemed to me. In him I saw the resurrection and life of the dead and buried hopes of my long enslaved people. As I now remember his speaking. he was not as the phrase goes an orator. There was no striking gestures, no fine flow of words, no dazzling rhetoric, and no startling emphasis. His power as a speaker, was the power which belongs only to manly character, earnest conviction, and high moral purpose. He complied with Emerson's idea of a true Reformer. It was not the utterance but the man behind it that gave weight and effect to his speech. Though he was quite young at the time I first saw him, Mr. Garrison, was even then a venerable looking man. His part in the battle of life had been at the front. The serious work he had been called to perform had left its tracery upon his matured features. Popular displeasure and bitter persecution had poured upon him, their wrath. Two of the slave states had offered rewards for his head. He had already become a tempting target for the assassins bullet. A halter had been upon his neck, and the mad cry of hang him! hang him! had sounded in his ear. He had felt the damp walls of more than one prison, and had withstood the peltings of many furious mobs. He had been driven from the doors of the church he loved and had been made to feel the keen cutting edge of social ostracism; He had been taunted, ridiculed, caricatured, misrepresented and denounced by the vulgar and treated with contempt and scorn by the rich and great. Yet there he stood, without bitterness, without hate. without violence in speech or act, in thought or will. self poised, erect and serene, He neither bewailed his hardships nor exulted over his triumphs His one single purpose was to excite sympathy for the enslaved, and make converts to the doctrine that slavery was a sin against God and man and ought to be immediately abolished.

Now that this man has filled up the measure of his years, now that the leaf has fallen to the ground as all leaves must fall, Let us guard his memory as a precious inheritance, let us teach our children the story of his life, let us try to imitate his virtues and endeavor as he did, to leave the world freer, nobler and better than we found it.

30. Frederick Douglass:
"Eulogy for William Lloyd Garrison," 1879

Mr President[21] and friends.

There are times when silence is more potent than speech, when words seem too thin, tame and poor to express our thoughts and feelings. I am impressed with a sense of this destitution in contemplating the Event that has brought us here tonight. An hour spent here in silent meditation upon that solemn event, would perhaps be more impressive than any formal addresses can be. But the heart ever presses for utterance in the presence of a great affiliation and sorrow. It seems meet that we of the colored race should speak at such a moment, even though our speech, should be thin, poor, broken and imperfect. In a case like this any word, or sign of grief or gratitude will be tolerated in us.

To every antislavery man and woman in the land, to every friend of impartial Liberty at home or abroad, and especially every colored man, this is a sad and mournful hour. The abolitionists of this country were never a numerous class. Their power and influence was [sic] always greater than their numbers for they [had] with them the invisible and infinite forces of the moral universe. But lately death has been busy in reducing their already thinned ranks. Some of the earliest truest and most eminent of them all have gone the way of all the earth much in advance of their great leader. Only a few of those noble and brave men and women who rocked the antislavery movement in its cradle, who watched and worked during the first years of its existence, and saw with grateful [word omitted] its steady growth and development, from the tiny thing it was at the beginning to the giant it became in the end, are still on the stage of busy life. Here and there at broad intervals one and another may be found standing like stately pillars of a fallen temple.

Mr. President, you are fortunate. Only a few like yourself can now tell from actual experience, from earnest participation, something of the darkness and peril that brooded over the land when the antislavery movement was born. You can name its friends, trace its history. You can tell of the wonderous [sic] trials, persecution and hardships through which those early workers had to pass, how step by step, the antislavery sentiment of the country rose from weakness to strength, from conflict to victory and from shame to glory. You can tell ~~how~~ of the fire and

21 The Garrison Memorial meeting was presided over by Robert Purvis (1810–98), a prominent abolitionist, radical reformer, activist, and conductor on the Underground Raiload. He played a key role in US antislavery history by working with Garrison to found the American Anti-Slavery Society in 1833.

fury with which it was assailed in its infancy, how the Herods[22] of that day sought its life, how its friends were sometimes only rescued from danger and death by hiding themselves from the wrath and fury of the mob.

Mr. President,

It is a thrilling story. Aftercoming generations will ~~won~~ read and wonder. But soon the time will come when no living witness will be left to tell it. One pillar after another, has already fallen and others are falling—one luminous star after another has disappeared. We have witnessed their departure with throbbing hearts and silent awe, and now the brightest and steadiest of all the shining hosts of our moral sky has silently and peacefully descended below the distant horizon whither all are tending, no more to take part in the busy scenes of human life.

In the death of William Lloyd Garrison, we behold a great life ended, a great purpose achieved, ~~a beautiful car~~ a great career beautifully furnished, and a great example of heroic endeavor nobly established. For our own good and the good of those who come after us, we cannot let this event sink too deeply into our hearts, we cannot too often recur to this life and history—or too closely copy this Example.

The world has seen many heroes, some who have founded Empires, some who have overthrown Governments, some who have with their broad swords ~~hewen have~~ hewed their way to power fame and fortune. There have been great Bishops, great Kings, great Generals—and great statesman—but these great ones for the most part owed their greatness to circumstances apart from themselves. Our great Bishops, have had great churches behind them, our great rulers, great nations behind them, ~~or~~ Our great Generals, great enemies behind them. Their light was brilliant but borrowed. It was not so with ~~But~~ the great man whose memory we celebrate to night. He owed nothing to his early surroundings. He was born to poverty, to labor and Hardship. He was his own guide and his own college, ~~and~~ He stood among the learned and great of his day by his own exertion. He moved not with the tide, but against it. He rose not by the power of the church or the state, but in bold and defiant opposition to the mighty power of both. It was the glory of this man that he could stand alone with the truth—and calmly await the result. He went forth a slender youth as we all knew without purse, without scrip,[23] without friends and without fame, to battle with a system of boundless wealth and power. He had faith in the simple truth and faith in himself. He was modest and retiring in his disposition, but his ~~His~~ zeal was like fire, and his courage like ~~steal~~ steel, and

22 A reference to Matthew 2:1–23, which describes the "Massacre of the Innocents" as ordered by Herod, the Roman king of Judea.

23 The *OED* defines "scrip" as a "small bag, wallet, or satchel."

during all his fifty years of service, in sunshine and storm, no doubt or fear as to the final result ever shook his manly breast.

No wonder that in this moral blindness men called him a fanatic and a mad man—for against such overwhelming odds it was thought that nothing, but madness would venture to contest. But there was nothing of madness in the composition of William Lloyd Garrison—or in his espousal of the cause to which he gave his mind and heart.

He had duly measured the mighty system of slavery and knew the ten thousand sources of influence by which it was sustained. He knew how it had dictated the policy of political parties, controlled the action of statesman, wielded the powers of the Government, dominated the pulpit, chained and fettered the christian church, sheltered itself from attack in the Bible; forced itself into the Constitution, moulded the manners, morals and religion of the times, into its own image; and created conditions in all directions, favorable to to [sic] its own existence and permanence, but above all he knew the terrible strength and vehemence of the contempt, hate and scorn, everywhere felt for the class whose cause he undertook to plead and knew moreover that the same malign spirit of hate would attach to him. But none of these things moved him. He knew the immeasurable heat of the furnace through which he would be required to pass: No man knew it better—while no man could bear it less. ~~or~~ or bear it with more equinimity [sic] and unflinching fortitude.

Massachusetts is a great state. She has done many great things. She has given to our country many scholars and statesmen, many poets and philosophers, many discovers [sic] and inventors, but no son of hers, has won for her a more enduring ~~fame~~ honor, or for himself a more enduring fame, than William Lloyd Garrison: No one of her sons has stamped his convictions in lines so clear, deep and ineffaceable into the very life and future of ~~this nation~~ the Republic.

Of no man is it more true than that being dead he yet speaketh.[24] The lessons he taught fifty years ago, from his garret in Boston, are only yet, half learned by the nation. Our General has fallen, but ~~our~~ his army will march on. His words of wisdom, justice and truth, will be echoed by the voices and votes of millions, till every jot and tittle[25] of them all shall be fulfilled.

Mr President.

This is not the time and the place for a critical, and ~~in every sense, an~~ accurate measurement of William Lloyd Garrison, but no friend of his, has

24 Hebrews 11:4: "By faith Abel offered unto God a more excellent sacrifice than Cain, by which he obtained witness that he was righteous, God testifying of his gifts: and by it he being dead yet speaketh."

25 The *OED* defines "tittle" as "The smallest or a very small part of something."

need to fear the application to him [of] the severest tests of honest and truthful criticism. He himself courted such criticism. He never refused to see, or allowed his readers to see ~~the worst that could be said of him.~~ the worst that was thought, felt and said of him. A candid examination of his character and his work in the world, may disclose some things, we would have had otherwise. Speaking for myself—I have sometimes thought him uncharitable to those who differed from him. Honest himself, he could not always see how men could differ from him and still be honest. To say this of him, is simply to say that he was human, and it may be added when he erred here, he erred in the interest of truth. He revolted at halfness, abhored [sic] compromise, and demanded that men should be either hot or cold.

This great quality though sometimes in excess, is one explanation of his successful leadership. What it cost him in breadth and numbers, it ~~he~~ gained him in condensation and intensity. He held his little band well in hand and close to his person. ~~They~~ No leader was ever more loved by the circle about him. Absolute in his faith no sect could proselyte him, inflexible in his principles no party could use him, content with the little circle about him he did not mingle directly and largely with the great masses. By a single principle he tried all men, all parties and all sects. What his name stood for at the beginning it stands for now and will so stand forever.

It is said that the wicked shall not live out half their days.[26] This is true in more senses than one: "For the coward and the small in soul scarce do live."[27] Mr. Garrison lived out his whole existence. ~~Time had not~~ Although he had reached a good old age, time had not dimmed his intellect, nor darkened his moral vision, nor quenched the ardor of his genius.

His letter published three weeks before his death, on the exodus from Mississippi and Louisiana—had in it all the energy and fire of his youth.[28]

Men of three score and ten are apt to live in the past. It was not so with Mr. Garrison. He was during all his latest years fully abreast with his times. No event or circumstance bearing upon the cause of justice and humanity, escaped his

26 Psalm 55:23: "But thou, O God, shalt bring them down into the pit of destruction: bloody and deceitful men shall not live out half their days; but I will trust in thee."

27 A line from *Festus*, an epic poem published in two editions (1839, 1845) by the English writer Philip James Bailey (1816–1902).

28 In response to Southern violence and exploitation, as well as to the removal of federal amendment rights, around 6,000 African Americans migrated to Kansas. Frederick Douglass was opposed to this move; his 1880 essay "The Negro Exodus from the Gulf States" argued that African Americans should remain in the Southern states to fight for their civil and political rights. (For more on this, see the introductory essay to "The Exodus from the South.") Douglass refers here to Garrison's letter of April 22, 1879, in which he agreed to coordinate a fund to support those displaced by the move to the midwest.

intelligent observation. His letter written a few months ago upon the Chinese question was a crowning utterance. It was in harmony with the guiding sentiment of his life. "My country is the world and all mankind are my countrymen."[29]

Mr President

Our Country is again in trouble. The ship of state is again at sea. Heavy billows are surging against her sides. She trembles and plunges, and plunges and trembles again. Every timber in her vast hull is made to feel the heavy strain. A spirit of evil has been revived which we fondly hoped was laid forever. Doctrines are proclaimed, claims are asserted, and pretentions [sic] set up which were as we thought all extinguished ~~we thought~~ by the logic of ~~the war~~ cannon balls. I have great faith sir, that the nation will deal with this new phase of affairs, wisely, vigorously and successfully; but in this conflict between the semi barbarous past, and the higher civilization which has logically and legally taken its place, we shall sorely miss the mind and voice of William Lloyd Garrison. Firm and fearless, clear sighted and strong, quick to discern the right, eloquent and able to defend it, he would in this, as in other trial hours, prove a fountain of light, and a tower of strength.

Mr President:

In the first year of my freedom, while residing in the City of New-Bedford Massachusetts, it was my good fortune, to see and hear for the first time, the man who was then, and will ever be regarded, as the chief apostle of the immediate and unconditional Emancipation of all the slaves of America. ~~I never shall forget my feelings on that occasion. Upon first blush, as I looked upon him from the gallery of old Liberty Hall—a Hall that was then deserted by assemblies for popular objects, and hence only fit for abolition meetings. I~~

I never shall forget the feelings with which I went to hear this man: I was only a few months from the house of bondage. It was more than forty years ago. It was in old Liberty Hall. It was a large but dilapidated old place. Its woodwork was marred, its doors off-hinges, and its windows broken by stones and other missiles thrown to break up abolition meetings—for such meetings then, were like free meetings in the south outside of protection. Upon first blush, I saw as I sat in the gallery of this old Hall, that the hour and the man were well met, and well united. In him, there was no contradiction between the speech and the speaker. The man and his cause were one. But what a countenance was there! what firmness and benignity—what evenness of

29 Garrison's letter, published in the February 27, 1879 edition of the *New-York Tribune*, was an attack on the Republican presidential nominee James Blaine (1830–93), who was a strong supporter of the anti-Chinese "fifteen passenger bill," which restricted the number of Chinese immigrants on any US-bound vessel to fifteen. The bill passed Congress in 1879 but was vetoed by President Rutherford B. Hayes (1822–93).

temper, what serenity of mind, what sweetness of spirit were written as by the pen of [an] angel on that countenance! A million of human faces might be searched without finding one like his—at least so it then seemed to me. In him I saw the resurrection and life of the dead and buried hopes of my long enslaved people. As I now remember his speaking, he was not as the phrase goes, an orator. There was [sic] no striking gestures, no fine flow of words, no dazzling rhetoric, and no startling emphasis. His power as a speaker, was the power which belongs only to manly character, earnest conviction, and high moral purpose. He compiled with Emerson's idea of a true Reformer.[30] It was not the utterance but the man behind it that gave weight and effect to his speech. Though he was quite young at the time I first saw him, Mr. Garrison, was even then a venerable looking man. His part in the battle of life had been at the front. The serious work he had been called to perform had left its tracery upon his matured features. Popular displeasure and bitter persecution had poured upon ~~had po~~ him, their wrath. Two of the slave states had offered rewards for his head.[31] He had already become a tempting target for the assassin's bullit [sic]. A halter had been upon his neck, and the mad cry of hang him! hang him! had sounded in his ear. He had felt the damp walls of more than one prison, and had withstood the peltings of many furious mobs. He had been driven from the doors of the church he loved and had been made to feel the keen cutting edge of social ostracism. He had been taunted, ridiculed, caricatured, misrepresented and denounced by the vulgar and treated with contempt and scorn by the rich and great. Yet there he stood, without bitterness, without hate, without violence in speech or act, in thought or wish. Self poised, erect and serene. He neither bewailed his hardships nor exulted over his triumphs. His one single purpose was to excite sympathy for the enslaved, and make converts to the doctrine that slavery was a sin against God and man and ought to be immediately abolished.

Now that this man has filled up the measure of his years, now that the leaf has fallen to the ground as all leaves must fall, Let us guard his memory as a precious inheritance, let us teach our children the story of his life, let us try to imitate his vertues [sic], and endeavor as he did, to leave the world freer, nobler and better than we found it.

30 A reference to the US essayist and lecturer Ralph Waldo Emerson (1803–82), who had shared a stage with Douglass when he gave his speech on "Emancipation in the West Indies" in Concord, MA, on August 1, 1844.

31 In 1831 Georgia offered a reward of $5,000 for Garrison's arrest and conviction; and after Garrison wrote in praise of Nathanial Turner's revolution, also in 1831, North Carolina issued a warrant for his arrest on a charge of seditious libel.

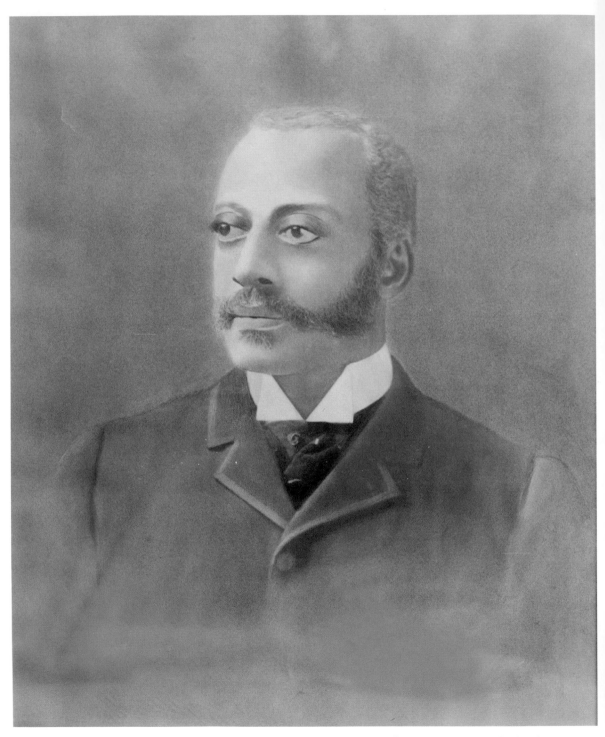

Figure 52: Anon., *Portrait Located at the Home of Frederick Douglass [Charles Remond Douglass]*, n.d.
(Photographic print by Carol M. Highsmith. Prints and Photographs Division, Library of Congress, Washington, DC.)

Part V

"I Glory in Your Spirit"

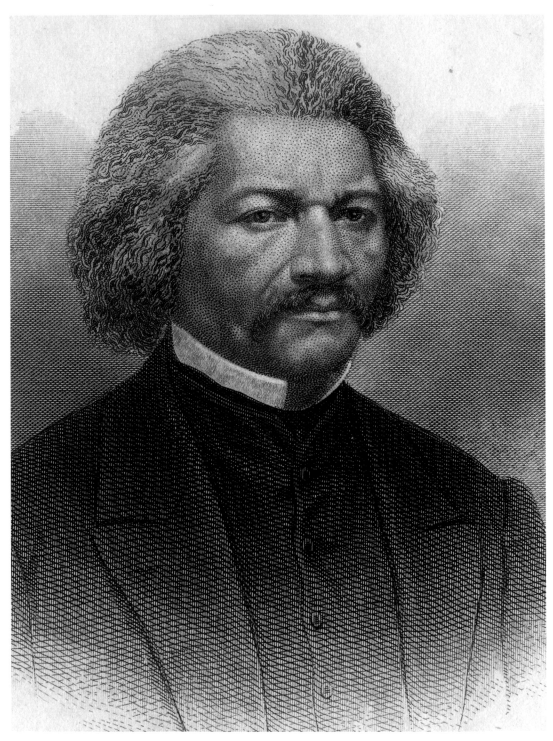

Figure 53: Alexander Hay Ritchie, *Frederick Douglass*, n.d. (Collection of the Rochester Public Library Local History Division, Central Library of Rochester and Monroe County, Rochester, NY.)

"Pluck, Pluck My Boy is the Thing that Wins"

Frederick Douglass and Sons Fight for the Cause of Liberty
in a Post-Emancipation Era

"In the days of slavery, when I was a slave, a negro having a master might work at any trade or calling in the southern States, and at Washington, without any opposition," Frederick Douglass recalls in a speech he delivered in Medina, New York, a few years after the Civil War on August 10, 1869.[1] "While his wages went into the pockets of another, while the bread that he earned in the sweat of his face was to be eaten by another, while he was to toil that another might live at ease he could do so without opposition," he declares. Living in the aftermath of the abolition of slavery and in an era of seeming freedom, Douglass is devastated to comprehend the body-and-soul-destroying opposition facing Black women and men in every area of their lives. Now, "when he has his own mouth to feed, his own back to clothe, his own body to shelter, his own children to support and educate, the case is different," he maintains. Douglass itemizes the oppressive forces at work in preventing skilled Black men from earning a living in a post-emancipation era by stating, "White bricklayers, white carpenters, and white printers combine to prevent any black man from working at these respective trades, and attempt to bend the Government to this narrow and selfish purpose." Douglass denounces the heart-wrenching depredations enacted against Black men, insisting, "I have heard of putting men in a tight place, and have sometimes been severely pinched myself, but I know of no tighter place than that into which it is attempted to place the negro to-day." He names and shames the destructive

1 Anon., "The Printer Douglass," *National Republican*, August 10, 1869.

consequences of a white supremacist stranglehold according to which not only is there no way out but there is no way up for his newly emancipated people. Douglass appeals to his audiences by evoking their sense of justice: "I think that you will agree with me that the case is hard won for the negro." He pulls no punches regarding the inequalities that circumscribe Black men's lives: "If he steals we send him to prison; if he begs we spurn him from our doors as a good for nothing; if he attempts to work we combine to prevent him and even threaten his life."[2] According to Douglass's analysis of unequal race relations—which reads as if he is speaking not to nineteenth- but to twenty-first-century injustices—he diagnoses a traumatizing state of affairs. Black men face incarceration, homelessness, and life-and-death situations in their daily battle not to live but simply to exist in a white racist US society.

Among the thousands of Black men fighting for the right to work at their trades and professions at the risk of their own lives, Frederick Douglass admits to taking a "personal interest" in the difficulties facing one man in particular: his eldest son, Lewis Henry. Douglass is categorical in his conviction that the difficulties endured by his son speak to the challenges facing all Black men. "Lewis H. Douglass represents our whole people, rising from degradation to respectability, and from proscription to equal rights," he avows. He urges his son's representative importance by maintaining, "The principle involved is one for which every man ought to contest." For Douglass, the civil liberties of all US citizens, irrespective of racial differences, are compromised if a single "principle" of discrimination is allowed to stand. As he explains, the "principle" at stake "involves the right to life, liberty, and the pursuit of happiness, and it is the business of every American citizen, white and black, to stand for this principle, each for all and all for each, as the sheet anchor of a common safety." Douglass cuts to the heart of the matter by observing, "I believe there never was a crime committed for which apologies of some sort could not be made, and the attempt to degrade and starve a colored printer at Washington is no exception to the general rule."[3]

Coming to grips with the barriers—political, social, economic, and legal—standing in the way of Lewis Henry's earning a living at the printing trade, Frederick Douglass lists the oppositions to his son's right to work only to expose their basis in racism. "It is alleged that he is an improper person to be allowed to work; that he has at some time of his life worked at a lower rate of wages than that fixed upon as the proper one by the Printers' Union; that he has worked in a town or city where such Unions existed, and did not become a member; that he has served no regular apprenticeship, that the card permitting him to work in the

2 Ibid.
3 Ibid.

Government printing office was improperly issued, and much else of the same sort," he summarizes. Douglass gives full vent to his frustrations at the ludicrousness of these claims, none of which have any foundation in fact, by conceding, "I have neither time nor patience to expose and refute in detail these paltry allegations." Rather, he reserves his "time and patience" for a hard-hitting denunciation of the "miserable shams," suffered by his son. As Douglass the protective father insists, these "shams" have been reprehensibly "designed to give a color of decency to one of the meanest acts of cruelty and injustice ever perpetrated against a fellowman." For Frederick Douglass, the formerly enslaved man and lifetime political agitator, one reason and one reason alone accounts for Lewis Henry's inhumane treatment: "his crime was his color. It was his color in Denver, it was his color in Rochester, and it is his color in Washington to-day."[4]

Writing of the difficulties endured by Lewis Henry as a man convicted for the "crime" of "his color," Douglass poignantly narrates his son's fight for employment at the printer's trade in Rochester, a city in which the Douglass family had lived for over two decades. His compassion is fully roused as he shares in Lewis Henry's hurt and betrayal. "One of the saddest spectacles that ever assailed my eyes or pained my heart was presented in that city, though it is clearly personal," he writes. His son's exposure to unforgivable acts of discrimination at the hands of a white racist US society is only exacerbated by his veteran status. Douglass can barely contain his anger when he reminds himself and his audiences that Lewis Henry "had just returned from the war; had stood on the walls of Fort Wagner with Colonel Shaw; had borne himself like a man on the perilous edge of battle, and now that the war was nearly over, he had returned to Rochester somewhat broken in health, but still able and willing to work at his trade." Douglass the father is heartbroken to realize that his son Lewis Henry, a man who had put his life on the line for freedom as a combat soldier, is forced to live hand to mouth as a veteran, "broken in health," and denied all opportunities of earning a living despite his superior skill at his "trade." As a man who was able to effect his own self-emancipation from slavery, he is devastated to realize he is helpless to aid his son. He poignantly tells how Lewis Henry "begged in vain of his fellow-worms to give him leave to toil": "Day after day, week after week, and month after month, he sought work, found none, and came home sad and dejected." As faced with his son's disappointments which he, Frederick Douglass, the renowned freedom fighter and activist, is unable to ameliorate, he is left with no choice but to conclude: "I had felt the iron of negro hate before, but the case of this young man gave it a deeper entrance into my soul than ever before."[5] For Douglass, living

4 Ibid.
5 Ibid.

459

with a father's sorrow, his own suffering pales in comparison with the sacrifices endured by his son. He is traumatized to realize that the next generation remains as, if not more, vulnerable to the "iron of negro hate."

Douglass is incandescent regarding the racist inequalities besetting his son's attempt to work at his trade in light of his own track record as an employer of an integrated workforce on his newspapers, *The North Star*, *Frederick Douglass Paper*, and *Douglass' Monthly*. "For sixteen years I had printed a public journal in Rochester," he declares. He is at pains to emphasize, "I had employed white men and white apprentices during all this time; had paid out in various ways to white men in that city little less than a hundred thousand dollars." As compared with his own egalitarian practice of employing "white apprentices," each of whom benefited financially as well as professionally from these business relationships, he is morally outraged by the exclusionary practices endured by Lewis Henry: "here was my son, who had learned his trade in my office, a young man of good character, and yet unable to find work at his trade because of his color and race." Recognizing the seemingly limitless power of "negro hate," Douglass is in no doubt as to the source of his son's persecution: "There is no mistaking the purpose and destiny to which a portion of our white fellow-citizens would devote the colored people of this country."[6] As a man who was not only able to philosophize but to debate every form and feature of slavery as a morally bankrupt institution, he is equally adept at theorizing all aspects of the "spirit of slavery" which had begun to bleed through every arena of Black lives in a post-emancipation era.[7] Douglass is under no illusion that, "in the unwillingness to allow the negro to own land, in the determination to exclude him from all profitable trades and callings, there is clearly seen the purpose to crush our spirits, to cripple our enterprise, and doom us to a condition of destitution and degradation below all other people in America."[8] As faced with a "Ku Klux" spirit that works to "crush," "cripple," and "doom" Black people to "destitution and degradation," Douglass risks losing sight of all hope and succumbing solely to despair.[9]

6 Ibid.

7 Douglass, *Life and Times*, 277.

8 Anon., "The Printer Douglass," *National Republican*, August 10, 1869. In "Let the Negro Alone: An Address Delivered in New York," a variant speech he delivered a few months earlier on May 11, 1869, Douglass exposed the nefarious consequences of white racist hate. "We are restricted to two or three employments," he stated. He laid bare the inequalities facing his eldest son: "I can more easily to-day enter my son in a law office in Rochester, than I can get him into a shipyard to help build ships." He was in no doubt as to why: "The reason is that the higher you go up in the gradations of intelligence, the further you get from prejudice, the more reasonable men are." (Reproduced in Blassingame, *Frederick Douglass Papers*, vol. IV, 203).

9 Anon., "The Printer Douglass," *National Republican*, August 10, 1869.

And yet, as ever, Frederick Douglass refuses to allow either himself or Lewis to surrender their lives to white racist hate. In a private letter he writes his eldest son over two decades later, on November 29, 1885, and in which he remains painfully aware of the discriminations Lewis still faces, he advises him to persist in all his endeavors. "Set to work at whatever offers you a living and show the world your independence and ability to live by yourself without official position," he counsels. All white supremacist forces notwithstanding, he jubilantly insists on and emphatically underlines his lifelong conviction, "Pluck, pluck my boy is the thing that wins."[10] For Frederick and Lewis, no less than for Frederick Jr. and Charles, a determination to "work at whatever offers you a living," despite all external forces that conspire to "doom us to a condition of destitution and degradation," remains the catalyst to their lives.[11] As their post-emancipation writings held in the Walter O. Evans collection bear witness, neither the father nor the sons in the Douglass family lost any opportunity to denounce, critique, and protest all injustices facing Black men. Wielding words as weapons, Lewis Henry, Frederick Jr., and Charles Remond proved beyond all doubt that they were Frederick Douglass's sons and indeed a "chip off of the old block."[12]

"Silent Contempt": Lewis Henry Douglass's Fight against "Negro Haters"

"I address you for the purpose of withdrawing my application, made nearly ten years ago, for membership to your organization," Lewis Henry Douglass informs the Washington, DC-based Columbian Typographical Union No. 101 in January 1871. In this handwritten letter, which he pastes onto the pages of one of the extant scrapbooks in the Walter O. Evans collection, he insists that the union has given him no choice as to his course of action due to their persecutory behavior: "I am impelled to this step by the manner you have treated me in considering my application." He refuses to allow this racist organization to "crush" his "spirit," brooking no dissent: "I consider that should I longer allow my application to remain in your Union to be constantly thrust into a corner there to lie month after month and year after year, I not only give you an opportunity to gratify a senseless prejudice emanating from a cowardly hate, and a blunted sense of justice, but violate my own self respect." Here indeed is a powerful demonstration of Lewis's "pluck" in the face of any and all discrimination, and of his determination to retain his "self respect" against all odds. At the same time that

10 Frederick Douglass to Lewis Henry Douglass, Paris, November 29, 1885, Library of Congress.
11 Anon., "The Printer Douglass," *National Republican*, August 10, 1869.
12 Lewis Henry Douglass to Amelia Loguen, January 20, 1895.

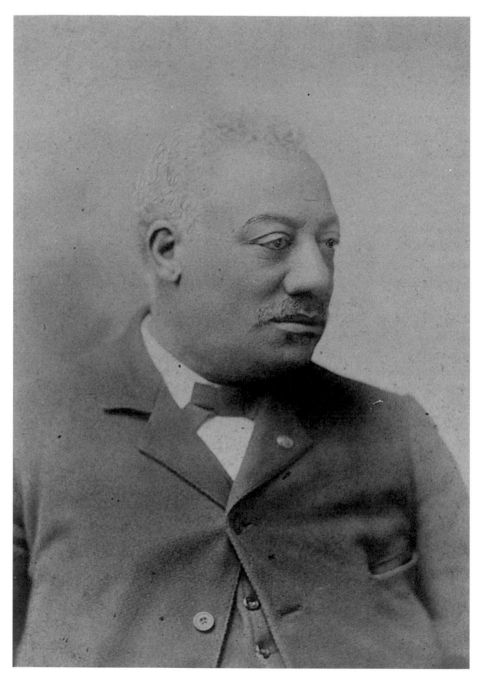

Figure 54: Anon., *Lewis Henry Douglass*, n.d. (Prints and Photographs Division, Moorland-Spingarn Research Center, Howard University, Washington, DC.)

Lewis was waging his one-man war, his younger brother Charles was full of hope in his eldest brother's ultimate victory. Writing their father from Washington, DC on May 25, 1869, he is brimful of a buoyant optimism. "Lewis is creating a great deal of excitement here among newspaper men and typos," he asserts. He takes heart that, "the Typographical Union and has assured Lew. that he need have no fears of being removed." And yet Charles's prediction that "Lewis's case will be an opening for other young colored men should he be accepted as a member in the Union" was never to be realized: "senseless hate" and "cowardly prejudice" remained the order of the day.

Over a decade later, on October 6, 1883, Lewis Henry printed a public letter "To the Editor" of the *Evening Star*, a newspaper published in Washington, DC. More than ten years on, and his anger at his inhumane treatment shows no sign of abating: "The truth is that the Union treated me in an unfair, not to say cowardly, manner." He reiterates his earlier statement that "A committee of the Union, to which was referred my application, after a most thorough investigation, reported in favor of my admission," to no avail: "Instead of taking a vote, the Union proceeded to violate its own laws by postponing consideration of the report." "This postponing was gone through with at several monthly meetings of the Union," he states, only to confirm that, over a decade later, it is still not over: "now more than fourteen years have glided by, and your humble servant is still out in the cold and under the ban of Typographical Union No. 101."[13] No more powerful testament to this racist organization's willful whitewashing of their nefarious practices can be found than in George G. Seibold's decision to omit any reference to this controversy in his volume, *Historical Sketch of Columbian Typographical Union Number One Hundred and One,* published in Washington, DC in 1915, nearly a decade after Lewis had passed away in 1908.

A few years previously, and at the time of Frederick Douglass's delivery of his poignant speech dramatizing his son's determination to "work at his trade," Lewis's exclusion not by the Columbian Typographical Union but by a state-led union attracted the attention of the national press. In an interview with "The Colored Compositor Douglass," published in the *Evening Star* on May 22, 1869, a reporter gives Lewis the opportunity to talk about his extensive experience at the printing trade. "Mr. Douglass, I see that you know how to distribute. (He was distributing type, while talking, with the facility of an old hand.) Are you equally expert in setting up?" the interviewer asks. "I ought to be," Lewis Henry replies, "I was brought up in a printing office. For seventeen years I have been most of the time engaged, either in setting type or keeping books, in a printing office." Coming to grips with his ongoing struggle for employment, this reporter questions

13 Lewis Henry Douglass, "To the Editor of the *Evening Star*," *Evening Star*, October 6, 1883.

Lewis about the discriminatory barriers he encountered in the attempt to set himself up as a printer while he was living in Denver, Colorado. "Mr. Douglass, it has been stated that you applied for admission to the Denver Union, and was rejected as an 'improper person,'" the reporter declares. Lewis answers any and all libels of his "improper" character by combining an unequivocal defense of his actions with an equally emphatic condemnation of the Denver Union. "That is not so," he corrects his interviewer, urging, "I made no formal application, and there was, consequently, no refusal." He replaces the reporter's erroneous version of events with an accurate account of the affair, stating: "I expressed a desire to join the Denver Union to the foreman of the *Gazette* office, but he declined to present an application for me on the ground that he did not wish to incur the odium of so doing." Lewis condemns the immorality of this organization's white racist working environment by using their own persecutory language. As he recalls, "I worked setting type only about three weeks in Denver, and was discharged because a white compositor there objected to working with 'a nigger.'"[14]

Writing a public letter to a "D. W. Flynn" which is published in the *Rochester Democrat* two days later on May 24, 1869, Lewis responds to further questions concerning why he did not become a member of the printer's union in Denver, exposing their immoral status as yet another institution run by white racists. "In the city of Denver I made inquiry of different members of the Typographical Union as to whether I could be admitted as a member of their society," he explains, only to confide the insurmountable barriers set in place by "negro hate": "I was informed that I could not be admitted because of my being a colored man." "My conversation was had with some of the prominent members of the Union, who said they wished it could be done, but the time had hardly come yet to make the test," he concludes. Here Lewis demonstrates no compunction about denouncing the self-serving lack of courage that led this union to back away from egalitarian practices for fear of meeting with disapprobation. He relies on satirical language to critique the white paternalist rhetoric to which he was subjected: "They sought to console me by reminding me that the people and nation had made rapid strides in ameliorating the condition of 'your (my) people,' and counselled me not to expect everything at once." As his father had done before him, he was no less quick to identify the "iron of negro hate" when he saw it. "It was not difficult for me, with the experience of my race before me, to see that it was useless to attempt to press my claims before the Denver Union to a favorable issue," he states. Lewis was under no illusion that he was dealing with an organization, all claims to the contrary, that was "composed, as I know it to be, largely of negro-haters."[15]

14 Anon., "The Colored Compositor Douglass," *Evening Star*, May 22, 1869.
15 Lewis H. Douglass to W. Flynn, *Rochester Democrat*, May 24, 1869.

The nefarious treatment meted out to Lewis by the Columbian Typographical and Denver printers' unions is far from the sole subject he protests against in the letters he writes for publication in national and state newspapers. As early as October 16, 1867, he publishes an article debating "Black Loyalty" in the *Colorado Tribune*. Writing with the authority of a Civil War combat soldier turned veteran, he pulls no punches regarding the national debt owed to Black soldiers, denouncing the persecutions they endured during their combat service. "It is well known to all who remember the state of affairs relative to the negro at the outbreak of the rebellion, that all his efforts to be of service to the Union army, was met with contempt and positive refusal," he reminds his audiences. As he knew only too well from his personal experience as a sergeant major in the 54th Massachusetts regiment, Black soldiers endured the life-and-death dangers of the battlefield, as equally suffered by white combat troops, but with an additional burden: Black combat soldiers were exposed to daily depredations that were born solely of racist "contempt."[16] As we see in the letters he and Charles write from the frontlines, these ran a gamut from brutal reprisals suffered on the frontlines to starvation and barbarically excessive discipline in camp life.

"One fact in particular stands out boldly and shows the base ingratitude of some who had command of the national defenses," writes Lewis Henry in this public letter, explaining: "I refer to the Fort Pickens affair." Working to provoke the protest of readers who were almost certainly unaware of this incident, which is still little known today, he summarizes: "When that fort was threatened by the rebels, a few negroes, (slaves) who had overheard the planning of the rebels, left the plantations of their masters, and, struggling through forests and swamps at dead of night, torn and lacerated by thorns, weak and worn by their journey, arrived at Fort Pickens with their story of warning to the commander, not to meet with the consideration the importance of their mission would seem to demand, but to be bound hand and foot, and *returned back to their master the very next day*."[17] Lewis is referring to an incident which took place on March 12, 1861, at Fort Pickens in Florida. Contemporary historian Adam Wasserman writes: "some runaway slaves arrived to the Fort Pickens, a Federal base in Florida, 'entertaining the idea,' according to the commander there, 'that we were placed here to protect them and grant them their freedom.'" As per Wasserman's detailed account, white racist union officials soon disabused the men of any notion of gaining their liberty by handing them "'over to the city marshals.'"[18] As another historian, Bruce Levine,

16 Lewis Henry Douglass, "Black Loyalty," *Colorado Tribune*, October 17, 1867.
17 Ibid.
18 Wasserman, *A People's History*, 432.

thoughtfully summarizes, "On March 12, 1861, eight Florida slaves escaped from their masters and appeared at the gates of Fort Pickens."[19]

Writing of the Fort Pickens incidents Lewis reveals what is missing from the nineteenth-century official account: any reference to these enslaved people's suffering and sacrifice. These "torn and lacerated" men "struggling through forests and swamps" arrived at Fort Pickens not out of a sense of self-preservation but because they had a "story of warning" to tell.[20] Revealingly, their "story of warning" was not only summarily dismissed by Union generals in the 1860s but remains very little known today. It is only if we pay due attention to Lewis's narration, in which he places the perspective of enslaved people up front and center, that we can begin to realize that these fugitives came not for their own survival but to support the Union cause by sharing vital military intelligence at profound personal risk. For Lewis, their diaboli-cal treatment at the hands of racist whites succeeds only in compounding their acts of heroism. No further evidence is needed of white Northern discrimination. He issues an unequivocal rhetorical question: "I ask if such treatment was calculated to inspire the negroes with any great love for the Union and its defenders?"[21]

"I will say that the writer of this letter, on the morning of the appearance of Abraham Lincoln's proclamation, calling for 75,000 men, immediately wrote a letter to the Governor of the State in which he resided, (New York) offering his services, with a number of other colored young men, as soldiers, which was met with silent contempt," Lewis poignantly writes in the same public letter. Here he lends further ballast to his protest against the inhumane treatment endured by the "weak and worn" enslaved men arriving at Fort Pickens by freely admitting to the "silent contempt" he himself faced when he offered to "unchain his black arm" in the fight for the Union cause, months before the call for enlistments into the 54th and 55th Massachusetts regiments. As Lewis remembers, the racist stranglehold exerted by the "iron of negro hate" ensured that Black combat troops had a fight on their hands for the right to risk their lives on the battlefield. "When blacks offered their services, they were met with the cry that 'this is a white man's war,' and white men threatened to throw down their arms if blacks were permitted to fight for the Union," he summarizes. And yet, as he emphasizes here and elsewhere, and as his own distinguished military career confirms, untold histories of the "pluck" of Black women and men ultimately triumphed: "Though constantly repulsed and

19 Levine, *The Fall of the House of Dixie*, 97.
20 Lewis Henry Douglass, "Black Loyalty," *Colorado Tribune*, October 17, 1867.
21 Ibid.

insulted, the blacks remained loyal, and determined to aid the Union army when opportunity presented."[22]

"For their loyalty the blacks suffered throughout the country, North as well as South," Lewis Henry reminds his audiences. Any and all instances of "black loyalty" exerted a terrible physical and psychological toll on the lives of Black women, children, and men. "Witness the riot in New York when innocent orphan children were made the victims of treasonable hate," he recalls. He is horrified to remember that "their only asylum" was "torn and burned down over their heads, aged and decrepit colored men murdered wherever found on the streets, houses sacked and pillaged, and the sick found in them knocked in the head like so many mad dogs."[23] Here he is referring to the atrocities and abuses enacted by white inhumane mobs against Black women, men, and children during the New York draft riots of July 1863. In a terrible tragedy, the Colored Orphan Asylum, housing between 600 and 800 children, was singled out for destruction and set on fire by arsonists. As "the Minutes of the Board Meeting from July 25, 1863, several days after the riots ended," record: "'On the 13th July at 4 PM, an infuriated mob . . . surrounded the premises of the Asylum and 500 of them entered the house . . . they deliberately set fire to it . . . simply because it was the home of unoffending colored orphan children.'"[24] According to Lewis, if white racist mobs could betray no compunction about murdering innocent children, what qualms would they have about subjecting Black veterans to unspeakable acts of violence and violation? Writing in a post-war era, he observes, "though the blacks poured out their blood lavishly for the cause of the Union, they meet with hatred and opposition in all their efforts to better their condition, in the house of those they have, through thick and thin, aided to safety and security from their enemies."[25] Just as Black sacrifice has no end, white injustices know no bounds when it comes to the lives of either "innocent orphan children" or self-sacrificingly heroic combat veterans.

Over a decade later, on December 10, 1881, Lewis writes a "Letter to the Editor" of the *People's Advocate*, an African American newspaper published by J. W. Cromwell, in which he dispenses with his unequivocal meditation on "hatred and opposition." Instead, he takes heart and hope in the face of his ongoing despair by being overjoyed to witness the founding of an increasing number of Black organizations dedicated to debating urgent issues of social and political reform. He singles out the Bethel Literary and Historical Association—an

22 Ibid.
23 Ibid.
24 Quoted by Matthew Murphy in his blog entry: <http://blog.nyhistory.org/burning-of-orphan-asylum/> (accessed January 14, 2018).
25 Lewis Henry Douglass, "Black Loyalty," *Colorado Tribune*, October 17, 1867.

institution for which he was to serve as president and to deliver lectures along with his father and Charles—for especial commendation. He writes, "The society organised, as I understand by suggestion of Bishop Payne of the A. M. E. Church, and which meets on Tuesday evenings at Bethel Hall, for the purpose of discussing important topics relative to our people, has not only made a good beginning but it has opened the way to much needed thoughts on subjects that have been shamefully neglected by the colored people of this country." As it is for his father, so it is for his eldest son, that consciousness-raising among African American audiences regarding hidden histories of Black heroism has a powerful role to play in ameliorating the social and political conditions of all Black peoples, formerly enslaved and free. "Our people apparently are the only class in this land, composed of so many different races and classes of the human family, who fail to discover among themselves heroes and heroines and to honor and respect the memory of those of their kind who have performed deeds worthy of emulation, or who have been martyrs as grand and noble as any treated of in the annals of any other race or people in the world," he declares.[26]

As a public institution that is the first to be devoted to sharing the lives of Black "heroes and heroines" as a catalyst to inspire "deeds worthy of emulation" by women and men living in a post-war era, Lewis is in no doubt that the Bethel Literary and Historical Association "is doing a good work in bringing out the names of great men and women of our race that remind us that we may make 'our sublime.'" At the same time, he refuses to sanitize the tensions—moral, social, political, and cultural—within the urban Washington, DC Black community between those who, like himself, were largely self-educated, and those who had received a university or college education. Writing of the repeated ways in which "'our sublime'" is denigrated and denied within a white exclusionary imaginary, he opines, "Too frequently do our colored graduates in their orations fail to use examples of learning, bravery and worthy efforts made by people of our own race, substituting therefore often praises and high encomiums upon those who have denounced, persecuted and outraged us." For Lewis, "colored graduates" can commit no greater crime than the crime of internalized self-hatred and willful collusion with their white racist detractors. As he argues, there is no substitute for sharing "examples of learning, bravery and worthy efforts" of renowned African American campaigners as a catalyst for Black audiences to undertake their own "deeds worthy of emulation."

Lewis is unequivocal in his protest against any misplaced beliefs in white superiority, warning, "We must cease to believe that all learning, all noble deeds, all devotion to principles and all glorious martyrs are confined to the race

26 Lewis Henry Douglass, "Letter to the Editor," *People's Advocate*, December 10, 1881.

or class that has done so much toward degrading the Negro in this country to such a degree as to have nearly extinguished that which is the most important factor in the upbuilding of a people—self-respect." Again, Lewis returns to the psychological and emotional premium he places on "self-respect" as integral to individual identity formation and the preservation of collective Black social and political freedoms. For Lewis, "self-respect" is the sole line of defense against white racists who have "denounced, persecuted and outraged us."[27]

In the following pages, we reproduce the original facsimiles and annotated transcriptions of the Walter O. Evans Lewis Henry Douglass post-war correspondence. In total, this collection consists of seventeen letters to Amelia (two of which are written in the closing years of the Civil War, but after Lewis Henry had been discharged from his military service on health grounds); a letter to the Columbian Typographical Union; a letter to W. J. Vernon, Esq.; and a letter to Lewis from Frederick Douglass.

Writing in the last year of the Civil War but following his medical discharge from the Union army, Lewis sends Amelia a letter from Rochester on May 20, 1864. Far from the tragedies and traumas of the battlefield, he takes joy in his natural surroundings as a balm to his soul: "All nature looks cheerful, the birds are singing, and as I look out of my window the playful ground squirrel is running up and down the fence in sportive joy." "Why should I not feel cheerful too?" he jubilantly confides. He readily admits: "It is really delightful to be here in my own room seated as I used to be two years ago on bright mornings and refreshing evenings writing you a letter, with that dear box full of your own dear letters to me, close at hand." Writing of letters written by Amelia that have no longer survived, he confirms that this box of "dear letters" "brings to mind the many pleasant thoughts of thee which I then did indulge, and marks more pleasant the love with which I hold you at present." Safe from the blood and mire of the Civil War frontlines, he has the mental and emotional space to share his "undying love": "In those days you were loved with all my heart, and the time which has intervened has not only not lessened that love but has strengthened it a hundred fold." While their marriage is—unbeknownst to Lewis Henry—still years away, he is confident in his anticipation of their wedded bliss: "Soon I hope to call you my own, and to be your own, and then to live on happily together, as I know we shall."

A few months later, Lewis is again living in the South. On September 28 he writes Amelia a letter from Mitchellville, Maryland, in which he declares, "The natives seem to enjoy themselves very much here. I can hear them singing and praying nearly every night in their prayer meetings." As he concludes,

27 Ibid.

"They are a happy people." Lewis is candid regarding the social, political, cultural, and emotional distinctions between his own background—as a Northern urban free man—and the upbringing of formerly enslaved women and men within a rural South. Writing in the detached language of an outsider, he accentuates the spiritual and religious differences between these women and men and himself. At the same time he glosses over their exposure to sacrifice and suffering by generalizing, "They are a happy people." Here Lewis would do well to heed his father's words, written decades earlier in 1845, taking to task a common misconception: "I have often been utterly astonished, since I came to the north, to find persons who could speak of the singing, among slaves, as evidence of their contentment and happiness." He wastes no time in correcting this grievous error: "It is impossible to conceive of a greater mistake," urging, "Slaves sing most when they are most unhappy. The songs of the slave represent the sorrows of his heart; and he is relieved by them, only as an aching heart is relieved by its tears."

While Lewis hears the "singing and praying" of newly freed women and men as evidence that they are "happy," there can be no doubt that their actions communicate a range of emotions, including the "sorrows" of their "heart." While they may have been liberated from legal bondage, they still bear the weight of their enslaved origins and the ongoing challenges generated by its abuses—family separations, health difficulties, lack of education, discriminatory persecutions, and internalized self-hatred, among much more—as they face the tragedies of a freedom that remains in name only. Ultimately, for Lewis writing to Amelia, their seeming happiness works only to compound his inconsolable sorrow. "It no doubt would seem strange to you that amidst so much happiness I should not share some of it, but I can tell you that I share but little," he declares. As he confides, his heart is full only of loneliness because "her whom I love above all others, she that is to be the companion of my life, my own dear Amelia, is far far away." He issues a plaintive plea: "how can I be happy?"

Far from inconsolable, however, Lewis ultimately proves that "pluck" wins out over despair. He is able to take solace in the freedom and privileges that are the right of his gender and off limits to Amelia. "I am a young man and must do as thousands of other young men, do who consider themselves men, are doing," he declares. "I would not give a fortune for my experience with the world. I feel more self reliant, more independent, than I should had I forever hung around home." As liberated from the constraints of the domestic sphere, he benefits from an "experience with the world" to which Amelia, as a "true woman", as theorized by Barbara Welter, subjected to its social and cultural conventions, is denied access. On these grounds, their surviving correspondence is an invaluable resource for the briefest of hints regarding her decision to

commit acts of defiance. A revealing case in point is Amelia's determination to take a radical stand in her choice of attire. As early as June 1, 1861, in a letter Lewis writes Amelia from Rochester, he communicates his shock to find her "dressed in that near approach to masculine unmentionables bloomers"—the fashion style, consisting of a small skirt and pants, which was controversially associated with women's rights campaigner Amelia Bloomer. Clearly Amelia Loguen, a woman facing barriers born of race and gender and daily restrictions to her freedom, was as determined to express her own self-reliance and independence as Lewis.

In the letter Lewis Henry writes Amelia on September 28, 1863, he readily acknowledges that the responsibility for the delay of their marriage rests solely on his shoulders. "I should have pressed you ~~for to marriagey~~ marry me two years ago had I felt that I was to remain in any one place, or in other words had my mind been more settled," he castigates himself. He confides his reasons for procrastinating: "I was full of Africa, Central America, or any where to make a fortune and a name." For Lewis, the right to a "fortune and a name" is solely a masculine prerogative. And yet, despite the benefits he accrued from his rights as a man, however beset by very real and impregnable barriers of racial discrimination, he is unable to escape from exposure to genuine emotional turmoil. "Ever since that time," he confides in this letter, "I have been so unsettled, that I have nearly lost my identity." He concedes, "I do not know where my home is, I have none, and if I did not love you above all else I would care for none."

No longer a young man wanting "to make a fortune and a name," Lewis writes Amelia as a combat veteran struggling with the memory and experience of war. His heartbreaking realization that "I have nearly lost my identity" speaks to the emotional disassociation and physiological difficulties that are consistent with symptoms of post-traumatic stress disorder as typically suffered by combat veterans. Equally, his sense of rootlessness and dislocation is also very likely a result of the displacement he experienced during the war. For the vast majority of soldiers returning home, the familiar domestic sphere was to become unfamiliar and even alien territory after their exposure to the battlefield with all its incomprehensible horrors. In this letter—and just as her father, Jermain Wesley Loguen, had relied on Amelia for emotional support—Lewis gives vent to terrible depression: "I sometimes feel very gloomy and discouraged." "I have enough to make me feel so," he further confirms. Here he makes a candid reference to the fact that he has been discharged from the war "with an enemy that crosses me in nearly every undertaking, and that is poor health." And yet, while he returns from the Civil War frontlines not only psychologically but physically wounded, he refuses to be defeated: "I do not intend to be discouraged."

"Why hast thou forsaken me?" Lewis despairingly asks Amelia in a letter he sends her a few months later, on March 26, 1865. Writing from the Douglass family home in Rochester, he sets aside any and all emotional accounts of his internal struggles to instead hold her to account for his sense of abandonment: "I have been home five weeks and have only received one letter from you." As per his father's habit, he relies on an idiomatic use of language when faced with personal difficulties, stating, "Unable longer to repress my anxiety to hear from you, I have determined to write you and enquire 'what's de matter.'" While he waits to learn "what's de matter," he shifts from focusing on their private difficulties to debating public issues. "What think you up your way of the war," he asks. He summarizes the Douglass family position as follows: "It is our opinion that the Rebels hardly know which way to turn now to get out of their terrible difficulty. They see their vision of an empire founded on the unpaid toil of black millions fading away from their longing sight." He and his family members are exultant: "where a year and a half ago we saw boastful countenances and heard threats of riding over the north rough shod and planting the stars and bars on the capitol of Washington, we now see downcast hungry faces, and hear mournful prayers that the war may cease." As he reports, they all take great delight in realizing, "Our forces are every where victorious." Writing with the knowledge of a combat veteran, but one who had not yet realized the war was to end in a matter of weeks, he expresses his own personal opinion that, "I think by the 1st of July this "cruel war" will so far as any more pitched battles are concerned be over." As he and the Douglass family understand only too well, however, the end of the war is only the beginning as far as the freedom struggle for all Black people is concerned. He writes of their heartfelt conviction that, "To be sure there will be a great deal to do for some time to come, in the way of entirely crushing the mob spirit which will prevail at the South." As political commentators, radical activists, and dissident protesters, Lewis joins his brothers and father in the work of "crushing the mob spirit."

Nearly another year passes, and on January 7, 1866, Lewis has again returned to the South. He is now living in Ferry Neck, Talbot County, Maryland, the region in which his father had been enslaved and where surviving members of his family were still living. He fills in the gaps of his own biography by sharing vital information with Amelia concerning his political activities. "I have just returned from the city of Baltimore where I have been to attend the colored State Convention," he writes. He jubilantly reports: "I was honored by being chosen temporary Chairman of the Convention, after which I was made chairman of the business committee." He is exultant in his triumphs: "I also had the honor to prepare the address to the Legislature of the State which was received very flatteringly by the Convention." He proves himself a "chip off of

the old block" by confirming his key role in working to effect legal reforms for the benefit of Black lives. "We organized a State League and have taken measures to bring a suit against the State of Maryland for the purpose of making a test question as to the legality of refusing the colored man the right to give evidence in courts of justice against white as well as colored citizens of the United States living in Maryland," he confirms. In stark contrast to the typically intimate tone of his letters, he introduces formality by referring to himself in the third person: "Mr. Wm. E. Matthews of Baltimore city and Lewis H. Douglass of Talbot County have been chosen by the Convention and the State League of Maryland to represent the colored people of the State in Washington during the present session of Congress." Clearly, he has not lost sight of his determination to make his "mark" and "a name." He is delighted at his election, which "I conceive to be the highest eminence that I have ever yet attained and places me still nearer that high mark to which I am aiming." We could almost be reading the words of his father when Lewis expresses his determination to triumph over all obstacles: "when I get up I can look back and say that I have come up not without trials and tribulations, but come up I will." There can be no question that Lewis loses his identity in the immediate aftermath of his military service only to find a new one as a radical activist working for political reform.

A few years later, on February 10, 1868, Lewis writes Amelia from Philadelphia to tell her of his "unpleasant" encounter with white Northern violence: "I went with some half dozen ladies and one gentleman over to Camden New Jersey to a skating park, and while there we were surrounded by a number of white boys and young men, who made insulting remarks to the ladies which we took no notice of." Recognizing their very real danger and that it would be impossible to stay "without a collision," he recounts, "I proposed that we leave, and assisted the girls in taking off their skates, keeping one pair in my hands to fight with, if attacked." According to Lewis's account, his combat training stands him in good stead. "The mob seeing that we were going away without replying to their insult, made a rush at me," he writes, "and attempted to knock me down, which I very successfully stopped by splitting his head with the skates." He demonstrates his utter fearlessness by confiding, "on one of them rushing up to catch hold of me, I let drive at him with my skate, he threw up his hand to stop the blow, and I took his thumb nearly off." As he emphasizes, his violent act of self-defense inspires the ire of the mob: "the whole crowd bore down on me so that I had to run for my life." "I succeeded in getting away without a scratch, the mob getting the worst of it," he triumphantly informs Amelia. He celebrates the power of Black bravery over and above white fear by conceding, "If they had not been cowards they could have beat me to death." And what was the source of the mob's anger? "They were

enraged at the nice appearance of the ladies whose parents are all wealthy and their dresses were superior to any white ladies on the place," he confirms. For Lewis, writing to the love of his life, this incident is less important as an indictment of white racist violence and more significant as a cause célèbre of his own heroism. "I have the praise of great coolness," he reports, noting, "all expected that I would be stricken down and killed, as I would have been had I shown the least fear." For a man who had braved military assaults such as Fort Wagner, the actions of a racist "mob" held no terrors.

A few years later, on July 5, 1869, Lewis writes Amelia from Washington, DC to discuss their wedding, which is finally only months away after all their years of courtship. "Amelia I don't know that I ever intimated to you that my preference is that the wedding or marriage should be conducted with least possible display," he declares. As he admits, "this, however, is only my preference, don't think that any arrangement you may make will meet with my disapprobation." A couple of weeks later, and as their nuptials are nearing ever closer, he writes of his jubilation at having received his father's seal of approval. Lewis takes great delight in informing Amelia, "I learn from father that he called on you a few days ago, and that he was much pleased, so much so that he congratulates me on my choice, and more than intimates that to Fred and myself we took to marry in keeping with our own position, descanting quite fully on your many good points." Here, Frederick Douglass betrays his inarguable class biases by celebrating Helen Amelia Loguen and Virginia L. M. Hewlett Molyneaux as exemplary matrimonial candidates for Lewis and Frederick Jr. due to their possession of refined attributes that are "in keeping with our position."

After their wedding takes place in 1869, the Walter O. Evans collection includes a series of letters Lewis writes Amelia, now his wife, concerning the lives of family members and their daily trials and tribulations. He no longer relies on epic language to celebrate their love but instead focuses on the rituals, activities, and relationships of the domestic sphere. As of writing, research is still ongoing into identifying the name of every family member and friend he mentions in this correspondence. Perhaps the most unforgettable comment Lewis makes in these letters is his troubled, and indeed troubling, discussion of his sister, Rosetta Douglass Sprague. In a letter of January 30, 1895, less than a month before his father passes away on February 20, he updates Amelia on mundane matters— "Rosa's plum pudding was without doubt very fine. She watched you make it to some purpose"—only to rely on problematic language to confide that, as regards his sister, "We try to treat her well as you know. On the whole she does well but the 'nigger' will show itself once in a while."

Alongside Lewis's letters to Helen Amelia Loguen, the Walter O. Evans collection includes a letter Frederick Douglass writes his son from Rochester. Dated

only a few years after the Civil War, on July 21, 1869, he writes to compliment Lewis: "I have just read with satisfaction in the Tribune, your brief but comprehensive and pertinent note acknowledging your election to honorary membership in the Soldiers and Sailors Union of Philadelphia." "I watch with with [sic] intense interest all that concerns you and emanates [sic] from you in this struggle," he reassures him. As Douglass readily admits, "[I] am deeply gratified by every well aimed blow you deal the selfishness and meanness which seeks to humble, degrade and starve you." For Frederick Douglass the father, Lewis as his eldest son is ideally placed to become a future leader. "If the effort now making to cast you down and through you to cast down and destroy your race shall serve to place you before the country as one of the leaders of your people, and a representative of their cause," he informs him. He urges, "your experience will only conform to that of many other men who have risen to distinction in the world by persecution." Notably to the fore in Frederick Douglass's advice to Lewis is his own lifelong belief that he repeatedly voices to any and all of his critics: "Do not judge me by the heights to which I have arisen, but by the depths from which I have come." As far as the surviving archive is concerned, Frederick Douglass's acknowledgment that Lewis is set to become "one of the leaders of your people" and a "representative of their cause" is an unequivocal endorsement of the respect he repeatedly pays to his eldest son.

The letter written by Lewis that Frederick Douglass singles out for especial commendation is one which was "read at a recent meeting of the Soldiers and Sailors' Union, in Philadelphia" on July 14, 1869. Here, Lewis expresses his heartfelt gratitude for the "unanimous election and declaration of myself as an honorary member of the Soldiers and Sailors' Union." "I accept this mark of your esteem as an evidence of the principle that actuates your organization, and for which while in the war we fought, viz. that all men are created free and equal," he declares. In the passage that most likely inspired Frederick Douglass's exultation in his leadership abilities, Lewis provides a hard-hitting invective against the rise of white racist persecution in a post-war era. "Now that efforts are being made by those whom you successfully met on the field of battle, not to re-enslave the late bondman, but to exterminate him by depriving him of the privilege of earning his bread," he declares. He advises the Soldiers and Sailors' Union that, "it is eminently in keeping with your struggle for the right in the late war that you extend a hand of encouragement to an oppressed race that with you shared the perils of the battle-field for the salvation of the nation."[28] For Lewis Henry as for Frederick Douglass, justice for Black people is not a privilege to be conferred but a right to be taken.

28 Lewis Henry Douglass to W. A. Short, *Elevator*, August 13, 1869.

The correspondence held in the Walter O. Evans collection provides irrefutable proof that Lewis took his father's proclamation that he would become "one of the leaders of your people, and a representative of their cause" very seriously. Writing W. J. Vernon Esq., Register of the Treasury, on December 3, 1907, he informs him, "I have long wished to have an opportunity for a consultation with you." "Owing to my ill health I have never found it so convenient as now when I am rapidly convalescing," he declares. Here Lewis acknowledges, "You did me the honor of expressing your willingness to listen to me and I am more than certain of my desire to hear you express your views as to how the colored voter should stand." Writing in the months before he dies, Lewis is still working to protect the rights and privileges of the "colored voter." As he knew only too well, and in ways that were to prove prophetic not only for nineteenth- but for twentieth- and twenty-first-century civil rights freedom struggles, the right to the ballot is at the heart of the fight for equality of all Black peoples, then and now.

"We Don't Want You":
Frederick Douglass Jr.'s Fight for "A Man's Right to Work"

Just as his elder brother, Lewis Henry, fought for the right to take up his trade as a printer, Frederick Douglass Jr. faced equally insurmountable barriers in his attempts to work at his profession. On May 21, 1869 he writes from Washington, DC to Simon Wolf, Register of Deeds, with an enquiry: "I have the honor to request an appointment as clerk in the office of which you have the distinguished honor to be the head." Frederick Jr. does not hesitate to acknowledge the injustices maintained by a racist playing field, stating, "I belong to that despised class which has not been known in the field of applicants for position under the Government heretofore." He insists on his right to an "appointment as clerk" due to the debt he is owed by the US nation, both because he is a veteran and because he is the son of an enslaved man. "I served my country during the war, under the colors of Massachusetts, my own native State," he writes, emphasizing, "[I] am the son of a man (Frederick Douglass) who was once held in a bondage protected by the laws of this nation; a nation, the perpetuity of which, with many others of my race, I struggled to maintain." According to his rationale, he is owed a "position under the Government" not only because his father had been denied his freedom but because he himself "served"—not as a combat fighter, as per his brothers, but as a recruiter—in the war for the "perpetuity" of the US nation. Frederick Jr.'s summary of the difficulties he experiences in his fight for employment as a printer reads almost identically to the persecutions endured by Lewis in his battle to gain access to the same profession. As Frederick Jr. confides, "I am by trade a printer,

but in consequence of combinations entered into by printers' unions throughout the country, I am unable to obtain employment at it."[29]

Writing an optimistic reply to Frederick Jr. dated the same day, Simon Wolf appears to adhere to a very different set of principles to those endorsed by the individuals from whom Lewis Henry sought a livelihood. "I see no reason in the world why you or your race should not have full countenance in the struggle for progress and education," he writes. He even goes so far as to pledge his personal support: "I am particularly happy in being the means of encouraging you."[30] And yet, just as Lewis faced endless dead ends in securing a position to work at his trade, all these protestations of social justice to the contrary, the fulfillment of his professional ambitions was equally not to be for Frederick Jr. Rather, and as was the case with the employment difficulties facing Lewis, Frederick Jr.'s barriers to earning a living had the powerful result of galvanizing their father's social and political protest. Writing in defense of "A Man's Right to Work," in an article published in the *Massachusetts Spy* a few months later on August 20, 1869, Frederick Douglass is categorical in naming and shaming white discriminatory practices by stating, "the Typographical Union of Washington has denied that right to a black man because he was black."[31] This time he draws on personal experience by focusing on the injustices facing Frederick Jr. rather than on Lewis Henry, as he accompanies his article with the letter from his middle son to Simon Wolf. Frederick Jr.'s searing letter provides ballast to Frederick senior's moral outrage that, "*Douglass*, the printer, is forbidden to work at that employment which he has practiced, for which he is qualified." "The allegation is not that he is disqualified, but that he is black," Frederick Douglass attests. He is in no doubt as to Frederick Jr.'s superior abilities, commenting, "for ought we know to the contrary he may be a better printer than any one of those who object to him." Here and elsewhere, Douglass holds up the exclusionary treatment faced by both his sons as test cases that offer irrefutable proof of the lack of logic underpinning these acts of white racist injustice. As he rhetorically questions, "Men may deny the blacks a great many privileges, but how in all honesty can they be refused permission to work?"[32]

This is not the only instance in which Frederick Douglass weighs in in defense of his middle son's fight for employment. In a letter held in the Walter O. Evans collection and reproduced here, he writes Judge George F. Edmunds on August 29, 1876 to express his ire: "Just as I am leaving to work in the Republican cause in the State of Maine, I am informed of a discrimination in your action in the

29 Frederick Douglass Jr., "To Simon Wolf," May 21, 1869, *National Republican*, May 22, 1869.
30 Ibid.
31 Frederick Douglass, "A Man's Right to Work," *Massachusetts Spy*, August 20, 1869.
32 Ibid.

refusing to give any of the printing to my son Frederick and of your giving it to Gibson and Brothers." Douglass is unequivocal in his protest against the treatment of his son: "If this statement is correct, I have no hesitation in saying that the policy of sacrificing friends to conciliate others is neither wise nor just." While his sons argue for their right to employment due to their veteran status and the fact that their father had been enslaved, Frederick Douglass constructs his case on the basis of his having dedicated his life to equal rights activism. He informs Edmunds in no uncertain terms: "I have worked hard in this cause for nearly forty years—I have neither asked nor received office, but I would like to see something like a recognition of my services in fair treatment to my son Fredk." He is candid regarding his financial struggles and ongoing losses, readily admitting, "I am a poor man and have lost ten thousand dollars following your words of encouragement in the effort to establish the New National Era." In the final analysis, Douglass has no compunction about stooping to personal attack. He ends his letter on an incomplete sentence in which he gives full vent to his righteous anger: "I naturally enough feel grieved that you, fattening as you have done for years upon the triumph of the cause for which I have labored." His protest was to no avail, however: Frederick Jr. continued to be refused work as a printer, and to suffer from white racist exclusionary practices.

Across his post-war writings, Frederick Jr. shares his father's and his brothers' refusal to succumb to the injustices of white racist hate. He remains unceasing in his campaign for the social, political, economic, legal, educational, and civil liberties of all Black women, children, and men. Writing an article on "Southern Terrorism," which he published in the *Rochester Democrat and Chronicle* on September 2, 1876, he is under no illusion regarding the seismic consequences of the rise of mob rule. "The same old issues are yet to be settled, the war is to be refought, the spirit of disloyalty is the same now as in 1860," he insists. As he observes, white mob rule is nothing new under the sun: "The rebels have been perpetrating these black outrages for a number of years past." Yet more poignantly, he diagnoses a dystopian state of affairs according to which matters are only worsening: "As they have been encouraged, and apologised for by the gush of the north, and have failed to have the strong arm of the United States government bring them to justice." He is unequivocal in his conviction that "they have grown more and more violent in their assaults upon men every year since the close of the rebellion."[33]

Writing only a day later, on September 3, 1876, Frederick Jr. publishes a letter to the "Editor" of the *Washington Chronicle* in which he continues to debate the

33 Frederick Douglass Jr., "Southern Terrorism," *Rochester Democrat and Chronicle*, September 2, 1876. This article is pasted onto the pages of one of the scrapbooks in the Walter O. Evans collection.

ongoing unfreedoms of Black peoples. "Talk about the rebels having rights, they have all the rights; the rights to murder, unpunished, in a so-called civilized community, is the king of rights," he satirically declares.[34] Yet more damningly, he writes a letter "To the Editor" of the *New York Times* on September 24 titled, "A Solid South: The New Reign of Terror—Colored Men Murdered." Here he holds nothing back in denouncing the rise of white Southern lynchlaw: "The North can stand by and see without interference white and black men who fought in the late war for the preservation of the Union kukluxed, murdered, and driven into the swamps by the very men who moved Heaven and earth to destroy the country." For Frederick Jr., as for his father, the reason for the barbaric treatment facing Black men in particular is easily diagnosed: "The more ignorant and degraded a colored man is in the South the less apt he is to be molested."[35] As Frederick Jr. realized only too well, a Black man in a position of vulnerability and dispossession was no violation of white Southern privilege, but a Black man in a position of power and equality was a reality not to be tolerated on any terms.

Writing an article published in *The Progressive American* on November 6, 1879, Frederick Jr. debates the "exodus question," a subject that, as we have seen earlier in this volume, remained a source of controversy for his father. Frederick Jr. begins by reminding his audiences of an uncomfortable truth: "it is well that I should state right here that the colored people have been held as slaves in this country for more than two hundred years." As he insists, a new era of seeming freedom as secured by bloodshed and appearing against a backdrop of centuries of slavery has resulted only in the escalation of body-and-soul-destroying violence and violations enacted against Black people. "They were emancipated during the war; they have been endowed with the elective franchise since the war," he observes; but with tragic results: "they have been outrageously treated by their former oppressors, when they attempted to use the privileges given them by the loyal North." While he considers the newly freed people's right to any and all unchecked freedoms of movement by confirming, "I recognize their right to go when and where they please," he issues a warning that the North is no utopia of race relations. Frederick Jr. draws on his own personal experience to confirm, "I am somewhat acquainted with the prejudices a black man in the North generally encounters in finding employment on the streets or in the workshops of all kinds."[36]

34 Frederick Douglass Jr., "Editor: Washington Chronicle," *Washington Chronicle*, September 3, 1876. This article is pasted into the pages of one of the scrapbooks in the Walter O. Evans collection.
35 Frederick Douglass Jr., "To the Editor of the New York Times: A Solid South: The New Reign of Terror—Colored Men Murdered," *New York Times*, September 24, 1876.
36 Frederick Douglass Jr., "The Exodus," *The Progressive American*, November 6, 1879. This article is pasted into the pages of one of the scrapbooks in the Walter O. Evans collection.

As Frederick Jr. argues in this essay, the figures speak for themselves: "You can count the number of skilled colored laborers who learned their trade in the North, and were allowed to work at it, in a manner on your fingers—so few they are." On these grounds, he admits he would be derelict of his social and political responsibility if he were to misrepresent these realities to those intent on fleeing the South: "I think it the duty of every lover of his people to speak out, and show those who are penniless and contemplate emigration to the West, that there are thorns to encounter before reaching the 'milk and honey,' instead of causing them to believe the reverse." He confirms the insurmountable barriers he faces in gaining work at his own profession. "I am a printer by trade, and never worked in any office outside of one owned by my father up North in my life," he confides. He asserts that he was prevented from working at his trade by both political parties: "The Republican offices were always full when I knocked at their doors seeking employment, and the Democratic officers would tell me frankly—'No; we don't want you.'" And yet, just as defeat was not an option for his eldest brother and his father, Frederick Jr. refuses to lose sight of his optimistic belief in the future amelioration of his race. "I feel confident that a better day, not far distant, is dawning upon our outraged people of the South," he insists, urging, "I feel assured that right and justice—though slow—will triumph in the end."[37] As the inspirational labors of contemporary activists lay bare in the twenty-first century, the fight for "right and justice" has lost none of its momentum now, two hundred years after the birth of Frederick Jr.'s father.

"Claims of Colored Soldiers": Charles Remond Douglass's Protest against "Acts of Injustice"

The fight for a livelihood that dogged the existence of Lewis Henry and Frederick Jr. was no less pressing for their youngest brother, Charles Remond. Writing Benjamin F. Butler, Civil War veteran, politician, and lawyer, on March 12, 1869, he admits, "I am in search of employment in some one of the Departments as Clerk, or some other similar situation." He defends his right to urge his case on the grounds that he is a combat veteran: "I was at one time under your command being a Sergeant in the 5th Mass. Cavalry when you were in command of the Army of the James." According to his summary, "My father (Frederick Douglass) was engaged for some time in raising recruits for the 54th, 55th & 5th colored regiments from Massachusetts, and I was one of the first colored men enrolled in Col. Shaw's 54 Regt. & remained in the service until the war closed." While he celebrates the fact that "Congress adopted a resolution some time since giving to

37 Ibid.

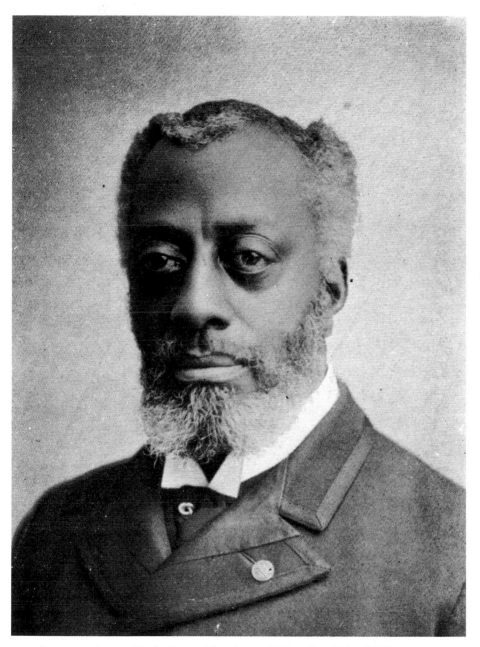

Figure 55: Anon., *Charles Remond Douglass*, n.d. Reproduced John W. Thompson,
Authentic History of the Douglass Monument. (Rochester: Rochester Herald
Press, 1903. Collection of the Rochester Public Library Local History Division,
Central Library of Rochester and Monroe County, Rochester, NY.)

honorably discharged soldiers and sailors the preference in the employment of clerks & c in the several departments," he is under no illusion regarding the racist fate suffered by Black veterans. He confirms, "the claims of colored soldiers were entirely ignored by the last administration and our only hope now is in the present one."[38] As per his father and brothers' refusal to be defeated, Charles's fight for employment, no less than his determination that a white governmental administration meet "the claims of colored soldiers," was unceasing and would define his lifelong activism.

"I have the honor to request an appointment in your Department as clerk," Charles writes George S. Boutwell, Secretary of the Treasury, just two weeks later on March 24. "I am aware of the many applications on file in the several executive departments of the Government deserving of consideration," he admits. However, he is careful to insist that "my case is a little different from many of those." As he writes, the source of his difference is self-evident: "I responded to the first call made for colored troops by entering the 54th Regiment Mass. Vols, and after being discharged therefrom, re-enlisted in the 5th Mass. Cavalry continuing in the service until the close of the war." As per the cases made by Lewis and Frederick Jr. for employment, he reinforces his right to a position by relying on the fame of his father: "My father (Frederick Douglass) raised the most part of two regiments that went to the war from the States of Mass. and Pennsylvania." He strengthens his application by mentioning Lewis's and Frederick Jr.'s military service: "I also had two older brothers who served alike with myself." For Charles, the evidence of the Douglass family's collective heroism works only to compound his sense of injustice at his financial impoverishment. "Since the war I have struggled hard to support myself and family," he admits, urging, "The great prejudice that exists against employing colored men in respectable positions has worked hard against me." On these grounds, he informs Boutwell that he is his last hope: "now sir, I applied to you to give me a trial."[39]

In contrast to Lewis Henry and Frederick Jr.'s failed attempts to gain steady employment, Charles's application is successful. He ends his position as a clerk in the Freedmen's Bureau in March, only to begin employment as a clerk in the Treasury Department on April 21. Scarcely a decade goes by, however, and he is again facing the same difficulties. As confirmed by a letter Frederick Douglass writes John C. New from Washington, DC, on March 6, 1882, his youngest son has a fight on his hands to gain a living. "I shall feel under very great obligation to you if you will give the application of my son Charles favorable consideration,"

38 Charles Remond Douglass to Benjamin F. Butler, March 12, 1869. Application for a Clerkship Files, National Archives Records Administration, College Park, MD.
39 Charles R. Douglass to George S. Boutwell, March 24, 1869. Application for a Clerkship Files, National Archives Records Administration, College Park, MD.

Douglass writes New. He makes his claim not only on the grounds that Charles "is fully qualified to fill; the place for which he asks," but because "He was the first colored man in the State of New York to enlist in the service of the country." This is very likely a deliberate exaggeration—it seems almost certain that Douglass knew he was not the first—intended to galvanize white support and bolster his son's exemplary attributes as "a sober industrious and painstaking man."[40]

The issue of the ongoing fight for the political, social, educational, and legal rights of all newly emancipated Black citizens was to dominate Charles's activities as a veteran. He writes an article addressing "The Colored Exhibit" and the "Reasons Why It Should be Provided for" at the World's Columbian Exposition in Chicago, which is published in the *Washington Post* on June 6, 1892. As clipped into the pages of a surviving Walter O. Evans scrapbook, he holds nothing back in his protest. "In your issue of June 1 you clip from the New York *Sun* an editorial criticism adverse to the proposition of the colored citizens of this country asking for a separate exhibit of the evidences of their industrial and intellectual development from 1863, the year of their emancipation from bondage, to the year 1893," he writes. He is categorical in his denunciation, drawing his readers' attention to the fact that "The *Sun* says that the colored citizens can make no worse mistake politically and economically than by continually calling attention to themselves as a separate class of the community." Charles holds the staff at the *Washington Post* to account by observing, "You appear to agree with the position of the *Sun*, and add that this disposition on the part of the whites toward the colored people is one of their chief grievances, and you admit, justly so." For Charles, the reasons underpinning any alleged claim of Black people as a "separate class" have their roots not in racist arguments of Black inferiority but in the villainous legislation of a white supremacist nation. He brooks no dissent, issuing the following stipulation:

Under the following conditions I believe the position you take would be indorsed [sic] by every fair-minded negro American: When the Government of the United States ceases to place a black mark against the name of every negro in office in its published "Blue Book" and Departmental rosters to distinguish him from other American citizens; when the rights of the negro before the law and at the ballot-box are as well protected as those of any other American citizen; when the United States Government eliminates the color line in taking the United States census and enumerating only native and foreign born, male, female, adults, and children; when our local police court judges refrain from lecturing the colored people generally for every offensive committed by a negro;

40 Frederick Douglass to John C. New, Washington, DC, March 6, 1882. Application for a Clerkship Files, National Archives Records Administration, College Park, MD.

when police officials cease arresting negroes on trumped-up and false charges in order to make records for themselves, and against the negro as a race; when our police superintendent is denied the privilege and pleasure of annually furnishing to the press statistics tending to degrade and show that the negro American is the greatest criminal in the community; when the white man ceases to magnify every misdemeanor committed by a negro, and holds it up as a charge against a whole race, will it then be time for negro Americans to cease asking the world to look at the other and better side of the picture.

For Charles, the sole barrier to Black progress is white injustice. He is under no illusion regarding the intellectual, political, social, and cultural damage wrought by the exclusion of African American history and culture from the World's Columbian Exposition. "Coming here where there are 8,000,000 of us, and visiting our Fair and not seeing a single representative of the race in any official position about the Fair," he points out that, "naturally enough our enemies could create the impression that we are a worthless class, have made no material advancement since emancipation, and thereby justify in the minds of foreigners the many acts of injustice committed against us."[41]

Frederick Douglass bolsters his youngest son's heartfelt protest by expressing the same view in his contribution to the pamphlet *The Reason Why the Colored American is Not in the World's Columbian Exposition*, published in the same year. "The colored people of America are not indifferent to the good opinion of the world, and we have made every effort to improve our first years of freedom and citizenship," he observes. He shares Charles's determination to voice their disappointment at their exclusion, confiding, "We earnestly desired to show some results of our first thirty years of acknowledged manhood and womanhood."[42] Charles was no less focused on the rights of Black people to "show some results." "Set out as we are as a separate class from apprenticeship in Government workshops, denied trades by unions and other combinations," he insists that there is no doubt that the absence of all trace of African American history and culture results in the widespread belief that "nothing about the Fair came from us."[43] Like his father, he expresses his great pride that "in spite of these hindrances we have made sufficient advancement as not to be ashamed to let the world see and judge for itself." As Charles concludes, "Our white fellow citizens ought not to be afraid to give us a showing, even if they are ashamed of the causes leading up to our asking for it."[44] For Frederick Douglass, these shameful "causes" which have

41 Charles Remond Douglass, "The Colored Exhibit," *Washington Post*, June 6, 1892.
42 Douglass, "Introduction," *The Reason Why*, n.p.
43 Charles Remond Douglass, "The Colored Exhibit," *Washington Post*, June 6, 1892.
44 Ibid.

supplied "the grounds of the prejudice, hate and contempt in which we are still held by the people" have their origin in one historical reality: "Slavery."

Writing a few years later on June 14, 1901, in an article he titled, "The Negro Soldier," published in the *Plaindealer* newspaper, Charles testifies to his lifelong determination to memorialize the combat heroism of Black men. "Five minutes is too short a time to go into the history of the Negro as a soldier," he writes. He assumes the role of the radical revisionist historian to argue that, "From the beginning of our government to the present time the Negro has figured in our wars on land and sea, and his valor has been duly attested on numerous occasions prior to the war of the rebellion, and the late war with Spain." Charles is careful to emphasize that there is no one standard of heroism by which all men should be assessed. He pulls no punches regarding the stranglehold exerted by white racist prejudice, declaring, "The Negro as a soldier must be judged seperately [sic], and apart from the white man as a soldier." As he observes, patriotism is off limits for the Black combat soldier as he "has no incentive to do and die for his country," while the white soldier "has every incentive placed before him." Adding insult to injury, he is incensed that Black Civil War combat veterans in particular have no choice but to watch as men who fought for the Confederacy have not only been pardoned but have received financial rewards that are weighing down the nation. He writes, "The negro soldier of '62 to '65 has lived to see stars and bars placed upon the shoulders of men who led rebel hosts against them and the flag they bore, and who are also responsible for the enormous pension roll carried by the government today."[45]

For Charles, these injustices are all the more abhorrent in light of the Black soldier's exemplary record: "The Negro soldier has never faltered before an enemy. Nothing save almost complete annihilation has ever caused him to retreat. That is the testimony of friend and foe alike." And yet, despite or even because of "all the ingratitude shown him by the Nation," Charles remains adamant in his belief in the suitability of military service for Black men. "[M]y advice to our young men is to get into the army and navy, learn all you can of the arts of war," he counsels. "Get the benefit [sic] of the splendid discipline it affords, and bear up under adverse criticism from prejudiced sources, and live and fight it down." For Charles, the US military service is a platform for the display of exemplary Black military prowess and a crucible for the annihilation of all racist prejudices. "The Nation is slow in rewarding the Negro," he declares, realizing only too well that, "In the eyes of the many he is yet an alien, though he has been here many generations." On these grounds, the inarguable evidence of Black participation in any and all military conflicts offers categorical proof that, "It cannot be said that he is retrograding."[46]

45 Charles Remond Douglass, "The Negro Soldier," *Plaindealer*, June 14, 1901.
46 Ibid.

Charles Remond remains immovable in his belief in Black progress, all white supremacist actions to the contrary: "Notwithstanding the powerful influences exerted against his every effort to rise, he is steadily advancing along all lines." "Despite all the ills they have borne, the Negro soldier has made for us a name and fame that could not have come to us from any other source," he observes in a categorical celebration of Black heroism. "They may discount our intellectual abilities, our capacity for getting together and building up one another, our enterprise, and our frugality," he concedes, only to insist, "as soldiers, none others are truer, nobler, or braver; and a race or class of people who can boast such representatives among the nation's defenders need not despair of its future in the Nation."[47] For Charles Remond, as for Frederick Jr., Lewis Henry, and Frederick Douglass, a belief in the exceptional attributes of the "Negro soldier" was to lie at the heart of their post-war activism and to undergird their fight for the equal rights of all Black citizens.

The Past of Frederick Douglass versus the Future of Lewis Henry, Frederick Jr., and Charles Remond Douglass

The nine letters written by Frederick Douglass held in the Walter O. Evans collection and reproduced here cover a wide range of personal and public issues that relate not only to the Douglass family in particular, but to Frederick Douglass's fight for the social, political, intellectual, legal, and educational rights of all Black people living in the US. At a glance, these letters shed light on the following areas of Douglass's private life and public campaigns for civil liberties in a post-emancipation era: his activism on behalf of his sons, according to which he lent his assistance in their fight to obtain employment; his decades-long friendship with German born intellectual, writer, and artist Ottilie Assing; his correspondence with radical white antislavery campaigners such as Catherine Swan Brown Spear; his letters with his grandson Haley George Douglass (Figure 56), in which he encourages him in his musical development; and last but by no means least, his radical defense of his diplomatic career while he held the position of US Minister and Consul to Haiti between 1889 and 1891.

47 Ibid.

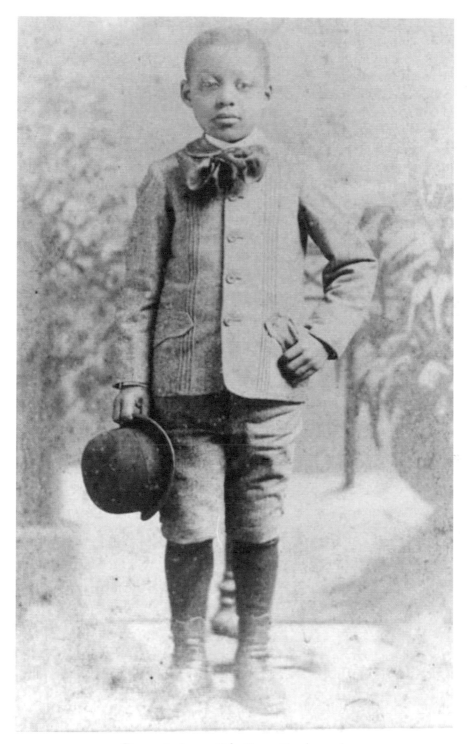

Figure 56: Anon., *Haley George Douglass*, n.d.
(National Park Service: Frederick Douglass National Historic Site, Washington, DC.)

In a letter dated simply February 25—but accompanied by an envelope postmarked March 10, 1891—Frederick Douglass writes Charles a letter from Port-au-Prince during his tenure as US Minister and Consul to Haiti. In his private correspondence with his son, he writes of his frustration with the declaration made by William Calvin Chase, editor of the *Washington Bee*, concerning the supposed termination of his tenure. "I see that the Bee says I have resigned," he confides, caustically observing, "The same paper said I would stay in Hayti only six months." Douglass's sense of triumph that he has defied his critics by outlasting their predictions lays bare the bitter extent of the jealousies, rivalries, and in-fighting among Black leaders in the post-emancipation era. He is under no illusion that not only does he receive no support from the majority of elite Black campaigners, but that his defeat is their collective wish. "No doubt my resignation would be very welcome news to those who want the place," he observes. Ever the militant against any attempt to place barriers in his way—and regardless of whether they come from Black or white opponents—Douglass takes great satisfaction in holding onto his post. "With every disposition to be amiable I cannot bring myself to oblige them just yet," he maintains. Douglass is careful to request Charles's confidentiality, insisting, "I say this for your private eye and not for the purpose of having the lie contradicted. I leave that to time—for I shall take my own time for resigning." He has no interest in justifying his actions to his detractors. Rather, Douglass takes the view that, "The fellows that set afloat these stories should be allowed whatever satisfaction momentary lying can give them."

In this same letter, Frederick Douglass expresses his virulent disapproval of the political actions of John Mercer Langston, the first African American Senator from Virginia, and his long-time adversary. "I see that Langston has lost no time in betraying his trust," Douglass observes. Here he is referring to Langston's proposal in favor of a "sixteenth amendment to the Constitution, which would provide for a national literacy test" for all US citizens, Black and white, as a necessary qualification in determining their right to vote.[48] While Douglass recognizes Langston's amendment is aimed at all US citizens, he holds him to account for the devastating impact his proposed legislation would have on all African Americans. "He knows full [well] that to make suffrage depend upon an educational test will furnish a motive both to keep them from education and to keep them from voting," Douglass declares. He is in no doubt that Langston is playing directly into the hands of white racists. As he realizes—and as he knows Langston himself understands only too clearly—"The South as little want[s] the Negro educated as it wants them to

48 Dinnella-Borrego, "John Mercer Langston," 220.

vote—and it would see in every effort to educate the negro, an effort to give them supremacy." On these grounds, Douglass denigrates Langston as "a trickster not a statesman."

In an undated letter Douglass writes Charles a month or two later and shortly before "April 1891," the date of the postmark on the accompanying envelope, he turns away from public matters to empathize with his youngest son's personal tragedies. "I feel deeply for you because yours has been a most bitter experience," he writes, poignantly conceding, "Few families have been made to suffer as yours has in the loss of dear ones." While he was still only in his mid-forties, Charles's suffering had indeed been terrible. By the 1890s and while his father was still alive, he had experienced the tragic "loss" of as many as six "dear ones": his daughters Annie Elizabeth, Julia Ada, and Mary Louise Douglass; his sons Edward Arthur Douglass and Charles Frederick Douglass; and his first wife, Mary Elizabeth Murphy. Douglass refuses to allow his son to surrender to his sorrow, however. As he counsels, "your experience should make you strong." He issues a father's comfort by reminding Charles: "You are still young and strong and have I hope much of life and usefulness before you." "It is not for you to despair," he further insists, as he reminds Charles that "The world is still before you." For Frederick Douglass, Charles's life is full of social, political, moral, and cultural possibilities due to his exemplary conduct. "You are leading an honorable life and setting a noble example," he praises his son. He advises him to take heart in his accomplishments because, "Your life is useful, if not all that you could wish it in some respects." In a lesson he repeatedly applied to his own life, Douglass reassures Charles that, "you can conquer all your ills by bravely meeting them." In a rare moment of candor, Douglass the father admits to a personal need for letters from his youngest son and his immediate family members in order to sustain his spirits. "You hardly know how glad I am to have letters from you," he insists as he expresses his heartfelt desire, "I hope you will keep it up."

In this same letter Douglass writes Charles from Port-au-Prince, he returns to a frank discussion of his political difficulties. "You will see by the papers that I am passing through something [of] an ordeal just now myself," he declares. Here he is referring to the fact that, "The papers in the states are telling of trouble between myself and Rear Admiral Gheardi [sic]." The "trouble" Douglass is experiencing concerns charges that were made against him regarding his personal and political differences of opinion with military general Bancroft Gherardi. He and Gherardi held to a different set of moral principles and political priorities as regards the right of the US to acquire the Mole St. Nicholas as a naval station from Haiti. As scholar Millery Polyne argues, "In July of 1891, Douglass resigned from his post as U.S. Minister when it became unmistakably evident that the U.S. State

Department wanted to obtain the coaling station against the will of the Haitian government—thus challenging the sovereignty of the first black Republic in the Western Hemisphere."[49] Writing in the midst of the diplomatic controversies he endured long before his resignation and in the first half of 1891, Douglass cautions Charles to maintain his counsel by insisting, "I hope you will say nothing on the subject." At the same time, however, Douglass, realizing only too well the very real dangers presented by the threat to his health while he was living in Port-au-Prince, sought to leave a record of his actions with his son in case he did not return. "I will give you a hint which will enable you to explain to yourself what may some day [be] explained more fully to the public," he confides. He is emphatic in his resolve that, "if I am forced to defend myself from unjust criticism & false charges concerning my inefficiency—I shall do this."

"In the first place you you [sic] must bear in mind that no man of color was desired by the merchants of New York as minister to Hayti," Douglass counsels Charles in his letter. Ever the astute observer of US racist policies, he understood all too clearly that the position he held was one that had been typically reserved "not only for a white man but a white man who will favor not merely American interests in general, but the interests of Wm. P. Clyde in particular." Douglass cuts to the heart of the matter by summarizing Clyde's determination to protect and expand his financial "interests" via his ownership of "a line of steamers between New York and several Ports of Hayti." He also holds nothing back regarding the problems he encountered due to excessive white US capitalist greed, emphasizing that Clyde sought "to put several more Steamers on this line." While Douglass admits that he initially "gave the measure my warm support as I thought that the presence of these American steamers might be made useful to Hayti," he soon changed his mind. As he informs Charles: "Mr. Clyde's agent wished me to go a step or two further in promoting their enterprise than I felt at Liberty to go and further than I felt it right to go." Douglass holds fast to his moral compass by placing the ethical needs of Haiti as a Black Republic before those of the US as an imperialist and colonizing nation. His non-compliance has immediate consequences: "I have offended the said agent Read—and possibly the Secretary of the Navy Admiral Gheardi [sic] and Mr. Clyde." And yet he has no qualms about facing their disapproval, as his conscience is clear due to the superior morality of his actions. He is at peace when he writes, "You will see by this that I am in a position to fully defend myself if I should find it necessary to do so."

49 Polyne, "Expansion Now!", 6.

LE GÉNÉRAL HIPPOLYTE, PRÉSIDENT D'HAÏTI
(1889)

Figure 57: Anon., *Le General Hippolyte (President d'Haiti, 1889)*.
Reproduced S. Rouzier, *Dictionnaire géographique et administratif universel
d'Haïti illustré*. (Paris: Imprimerie Brevetée Charles, 1892.)

"Then came the demand for a U. S. coaling station at the Mole St. Nicholas," Frederick Douglass informs his son in the same letter. He readily concedes that he sought to convince the Black Republic of the legitimacy of this "demand" by confirming, "This too I have pressed upon the Haytian Government." And yet, as he immediately realizes—but as the US nation was slow to understand, due to its racist myopia—"such is the prejudice of Haytians against allowing Americans to get a foothold on any part of their country that this coaling station business has failed." "As a consequence Rear Admiral Gharardi [sic] was sent here two months ago to accomplish what I failed to accomplish," Douglass observes. He is careful to defend his actions to his son for posterity, stating, "I have honestly cooperated with him in this matter but we have thus far failed." Douglass's quickness to shoulder the responsibility for this failure by urging that, "as some one must be blamed for the failure I selected to bear this blame," is revealing. There can be very little doubt that Douglass deliberately chose to fail on ethical and moral grounds. As a result, he is satisfied with taking the "blame" if it means that Haiti retains her independence from white US imperialist power. As a man who sought only success throughout his lifetime, here is a rare instance in which he is able to live with his seeming political failure. For Douglass, any and all seeming failures to execute the demands of the US government fade in comparison with his jubilation that Haiti has retained her national freedom and remains inviolate in the face of white US attempts at subjugation: on these grounds, his failure is no failure at all. "I write these facts so that in case any accident should befall [I] may be able to vindicate my memory," Douglass concludes. Again, he reminds Charles of his obligation to remain silent except for informing his eldest brother, confirming, "As I am not writing to Lewis by this mail I wish to share with him the contents of this letter—but of course you will let no body else see those contents." Clearly, while Rosetta Douglass Sprague played a key role in Frederick Douglass's literary life as his amanuensis and active editor of his writings, the surviving correspondence between Douglass and all three sons confirms their essential role as his advisors and confidants in controversial political matters.

Decades earlier, writing Frederick Douglass, his lifelong inspiration and close personal friend, from Denver, Colorado on August 27, 1866, the radical activist and political campaigner Henry O. Wagoner expresses his heartfelt thanks for receiving letters in which "you have been pleased to Express grateful sentiments towards me, for the very little it has been in my power to do for your two sons, Lewis and Frederick, just previous to, and since their arrival in this Territory" (Figure 58). Writing to Frederick Douglass the father during the period in which his sons Lewis Henry and Frederick Jr. were living in Denver, Wagoner readily admits, "What I have done for your boys, is but a feeble expression of my constitutional disposition to help my race in particular, and mankind in general." For

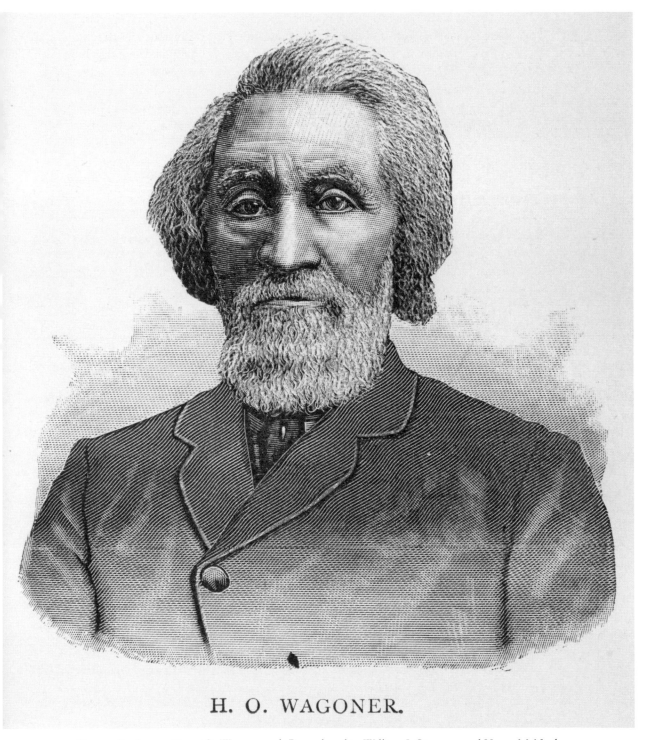

H. O. WAGONER.

Figure 58: Anon., *Henry O. Wagoner*, n.d. Reproduced in William J. Simmons and Henry McNeal Turner, *Men of Mark: Eminent, Progressive and Rising*. (G. M. Rewell & Company, 1887.)

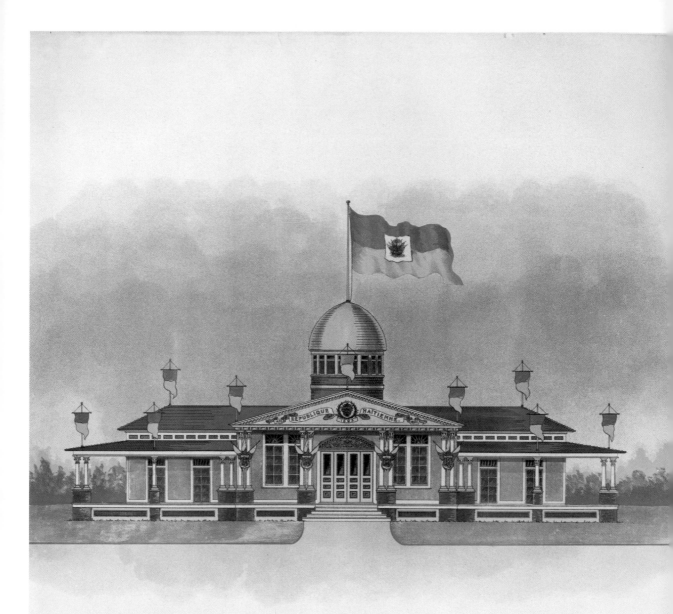

Figure 59: Anon., *Pavilion de la République d'Haïti à Exposition Universelle de Chicago*, 1893.
(Prints and Photographs Division, Library of Congress, Washington, DC.)

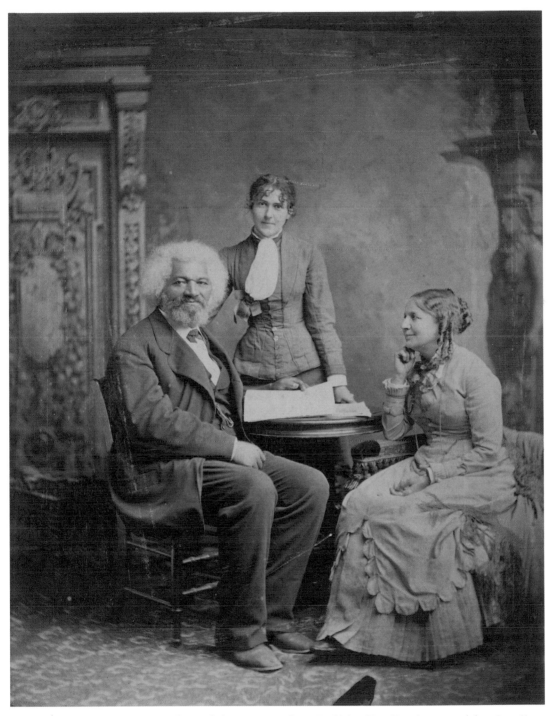

Figure 60: Anon., *Frederick Douglass with the Pitts Sisters* [his wife, Helen Pitts Douglass, seated; her sister Eva Pitts standing], c. 1884. (National Park Service: Frederick Douglass National Historic Site, Washington, DC.)

Douglass no less than for Wagoner, the activism of the next generation has a key role to play in their shared determination not only to "help" all Black people but "mankind in general." "As you have well said to Frederick, that he and his brother have 'a future,' but you and I have very little more left than 'a past,'" Wagoner reminds Douglass. For Douglass, living in the last decades of his life, his sons continued to hold vital political, social, and moral importance due to their self-appointed role in effecting "future" reforms. Wagoner shares Douglass's confidence in his letter by reassuring his friend, "I can easily discover that they are both very desirous of succeeding in their undertaking, whatever they may finally verge into; and, the will to do, is almost success."[50]

Writing Charles decades later from the Haitian Pavilion at the World's Columbian Exposition in Jackson Park, Chicago on October 7, 1893, and in a letter held in the Walter O. Evans collection, Douglass is no less triumphant regarding the "future" success of his sons in general and his youngest son in particular. Celebrating Charles's exemplary strength of character, he declares, "I glory in your spirit." While Frederick Douglass may have conceded to Henry Wagoner decades earlier that he had "very little more left than 'a past,'" in this letter to Charles written only a few years before his death he is no less jubilant regarding the significance of his own example. "I am certainly doing some good in the life I am living," he confides. All political controversies to the contrary, Douglass is adamant that his own contributions are far from over, declaring, "I am holding up the standard for my people." As shown here, and while he has more of a "past" than a "future," Frederick Douglass continues to relish in his representative status. As he jubilantly informs Charles, "you would be proud to see [the] respect and esteem I am every where commanding for my race as well as for myself." Incontestably, Frederick Douglass the father "glories in the spirit" not only of his sons but of himself. Over their lifetimes, Lewis, Frederick Jr., and Charles shared their griefs, loves, hopes, dreams, and sorrows as they worked together in the family business voiced by their father as "holding up the standard for my people."

50 Henry O. Wagoner to Frederick Douglass, August 27, 1866, General Correspondence, Frederick Douglass Papers, Library of Congress.

Rochester, May 20 1864

My own Dear Amelia: Seated
am I this bright and beautiful
morning in my own woman's
home, inhaling the sweet per-
fumes of blossoming cherry, apple
and pear trees to write you my
dear one a letter. All nature
looks cheerful the birds are sing-
ing, and as I look out of my win-
dow the playful ground squirrel
is running up and down the
fence in sportive joy. Why should
I not feel cheerful too? I do
feel cheerful, and will try and
write you a cheerful letter, so
that you also may forget gloom.
I arrived safely in Syracuse on
the evening of Tuesday, and
found Mrs. Highgate and family
at your home. After tea Jinnie
and I accompanied them to their

homes and Tinnie and I had a
very pleasant walk back. She is a
dear girl and loves you very much,
I love her because she does. We ar-
rived home Wednesday evening
met at the depot Miss Jennie
Morris, who desired to be remem-
bered to you whenever I write. Louise
De Mortie is still at our house
I do not know whether she wishes
to be remembered or not as she
is not up.

It is really delightful
to be here in my own room seated
as I used to be, two years ago on bright
mornings and refreshing evenings
writing you a letter, with that dear
box full of your own dear letters
to me, close at hand It brings
to mind the many pleasant
thoughts of thee which I then did
indulge, and makes more pleas-
ant the love with which I hold

31. Lewis Henry Douglass to Helen Amelia Loguen, Rochester, NY, May 20, 1864

you at present. In those days you
were loved with all my heart
and the time which has intervened
has not only not lessened that
love, but has strengthened
it a hundred fold. Soon I hope
to call you my own, and to be
your own, and then to live on
happily together, as I know we shall.
I promise you that there shall
be no Way's Hotel scare crows, in
order to test your love, or to plague
you just for the amusement of
it. I am sorry now that I
indulged in any such fun when
I was at Binghamton, however,
there was no harm doing I hope.
The letter that Mrs. Lee told
me I would get on my arrival
home, was here sure enough
hurrah for Mrs. Lee. Remember
me kindly to Mrs. Jones, and
accept my heartiest love for yourself
Lewis H. D.

31. Lewis Henry Douglass to Helen Amelia Loguen, Rochester, NY, May 20, 1864

Rochester, May, 20 1864

My Own Dear Amelia: Seated am I this bright and beautiful morning in my own room at home, inhaling the sweet perfumes of blossoming cherry, apple and pear trees, to write you my dear one a letter. All nature looks cheerful, the birds are singing, and as I look out of my window the playful ground squirrel is running up and down the fence in sportive joy. Why should I not feel cheerful too? I do feel cheerful, and will try and write you a cheerful letter so that you also may forget gloom. I arrived safely in Syracuse on the evening of Tuesday, and found Mrs. Highgate and family at your home. After tea Tinnie[*] and I accompanied them to their homes and Tinne and I had a very pleasant walk back. She is a dear girl and loves you very much, I love her because she does. We arrived home Wednesday evening, met at the depot Miss Jennie Morris, who desired to be remembered to you whenever I write. Louise de Mortie is still at our house. I do not know whether she wishes to be remembered or not, as she is not up.

It is really delightful to be here in my own room seated as I used to be two years ago on bright mornings and refreshing evenings writing you a letter, with that dear box full of your own dear letters to me, close at hand. It brings to mind the many pleasant thoughts of thee which I then did indulge, and makes more pleasant the love with which I hold you at present. In those days you were loved with all my heart, and the time which has intervened has not only not lessened that love, but has strengthened it a hundred fold. Soon I hope to call you my own, and to be your own, and then to live on happily together, as I know we shall. I promise you that there shall be no Way's Hotel scare crows, in order to test your love, or to plague you just for the amusement of it. I am sorry now that I indulged in any such fun when I was at Binghamton, however, there was no harm done I hope. The letter that Mrs. Lee ~~promised~~ told me I would get on my arrival home, was here sure enough, hurrah for Mrs. Lee. Remember me Kindly to Mrs. Jones, and accept my heartiest love for yourself.

Lewis H. D.

* Sarah Marinda Loguen.

32. Lewis Henry Douglass to Helen Amelia Loguen, Mitchellville, MD, September 28, 1864

Mitchellville, Sept. 28th 1864

My own Dear Amelia: Having
a little leisure, and being in
the disposition, I have seated
myself for the purpose of wri-
ting to you, how interesting
may be, I am not able at
the beginning to judge, as I am
writing so as not to be idle
with my hands as I certainly
am not, with my thoughts
for I have been thinking
of you and wondering
where you are.
We have had a day with
a variety of weather, in the
morning early it was quite
chilly, before noon it rained
and at noon it was very
hot, in the afternoon it
cooled off again, and now
in the evening, the weather

32. Lewis Henry Douglass to Helen Amelia Loguen, Mitchellville, MD, September 28, 1864

is delightful, how long it
will last so, it is impossible
to conjecture.

The natives seem to enjoy
themselves very much here
I can hear them singing
and praying nearly every
night in their prayer
meeting. They are a happy
people. It no doubt would
seem strange to you, that
amidst so much happiness
I should not share some
of it, but I can tell you that
I share but little. Those whom
I love and respect are miles
away, their voices are hush-
ed to me, their congenial
society is missing, and her
whom I love above all others,
she that is to be the compan-
ion of my life, my own dear
Amelia is far, far away, how

32. Lewis Henry Douglass to Helen Amelia Loguen, Mitchellville, MD, September 28, 1864

can be happy! Happy I am
only in the hope that I
may find it letter soon to be with
you once again, never to
go so far away. But I am a
young man and must
do as thousands of other
young men who consider
themselves men, are doing.
I would not give a fortune
for my experience with the
world, I feel more self reliant
more independent, than I
should had I forever hung
around home. I hope to be
able to pay a visit home but
I cannot now tell when,
my employer Mr. Whitfield
is very sick while I am
much better than I was
when I last wrote, and I
have his whole business in
my care, which I assure

you is quite a responsibility.
I am loth to return home
at present because my pros-
pects are looking much better.
I must you know have an
eye to that which is a great
help towards making life,
married or single, happy or
unhappy that is money;
for without that we would
be like a ship without a
helm, soon go to wreck on the
rock of Poverty, and being
a man it behoves me, assuredly
to look out for breakers. I have
wasted a good deal of money,
enough to build and furnish
a snug little cottage even in
these times of high prices, like
many other young fellows,
but I am thankful that I
spent not a cent in a manner

32. Lewis Henry Douglass to Helen Amelia Loguen, Mitchellville, MD, September 28, 1864

ner to be ashamed of though
I may regret the expenditure
ever so much.

I should have pressed you
too to marrige me two years
ago had I felt that I was
to remain in any one
place, or in other words had
my mind been more settled
I was full of Africa, Central
America, or any where to
make a fortune and a
name. Ever since that
time I have been so un-
settled, that I have nearly
lost my identity. I do not
now know where my home
is, I have none, and if
I did not love you above
all else I would care for
none. I sometimes feels
very gloomy and discouraged
and I have enough to make

me feel es. I have an enemy that crosses me in nearly every undertaking, and that is poor health, however I do not intend to be discouraged. Now my dear girl I have written an uninteresting letter I fear and must stop. Give my love to all the family, and receive for yourself the undying love of

Lewis

32. Lewis Henry Douglass to Helen Amelia Loguen, Mitchellville, MD, September 28, 1864

Mitchellville, Sept. 28, 1864

My own Dear Amelia: Having a little leisure, and being in the disposition, I have seated myself for the purpose of writing to you, how interesting I may be, I am not able at the beginning to judge, as I am writing so as not to be idle with my hands, as I certainly am not with my thoughts, for I have been thinking of you and wondering where you are.

We have had a day with a variety of weather in the morning early it was quite chilly, before noon it rained and at noon it was very hot, in the afternoon it cooled off again, and now in the evening, the weather is delightful, how long it will last so, it is possible to conjecture.

The natives seem to enjoy themselves very much here. I can hear them singing and praying nearly every night in their prayer meetings. They are a happy people. It no doubt would seem strange to you that amidst so much happiness I should not share some of it, but I can tell you that I share but little. Those whom I love and respect are miles away, these voices are hushed to me, their congenial society is missing, and her whom I love above all others, she that is to be the companion of my life, my own dear Amelia, is far far away; how can I be happy? Happy I am only in the hope that I may find it better soon to be with you once again, never to go so far away. But I am a young man and must do as thousands of other young men, d̶o̶ who consider themselves men, are doing. I would not give a fortune for my experience with the world. I feel more self reliant, more independent, than I should had I forever hung around home. I hope to be able to pay a visit home but I cannot now tell when. My employer Mr. Whitfield is very sick, while I am much better than I was when I last wrote and I have his whole business in my care, which I assure you is quite a responsibility. I am loth to return home at present because my prospects are looking much better. I trust you know [sic] have an eye to that which is a great help towards making life, married or single, happy or unhappy, that is money; for without that we would be like a ship without a helm, soon go to wreck on the rock of Poverty; and being a man it behooves me as such, to lookout for heaven. I have wasted a good deal of money, enough to build and furnish a snug little cottage even in these times of high prices, like many other young fellows, but I am thankful that I

spent not a cent in a manner to be ashamed of, though I may regret the expenditure ever so much.

I should have pressed you ~~for~~ to ~~marriage~~ me two years ago had I felt that I was to remain in any one place, or in other words had my mind been more settled. I was full of Africa, Central America, or any where to make a fortune and a name. Ever since that time, I have been so unsettled, that I have nearly lost my identity. I do not know where my home is, I have none, and if I did not love you above all else I would care for none. I sometimes feels very gloomy and discouraged, and I have enough to make me feels so. I have an enemy that crosses me in nearly every undertaking, and that is poor health, however I do not intend to be discouraged.

Now my dear girl I have written an uninteresting letter I fear and must stop. Give my love to all the family and receive for yourself the undying love of
Lewis

33. Lewis Henry Douglass to Helen Amelia Loguen, Rochester, NY, March 26, 1865

Rochester, March 26, 1865.

My own Dear Amelia: "Why hast thou forsaken me"? I have been home five weeks and have only received one letter from you. Unable longer to repress my anxiety to hear from you, I have determined to write you and enquire "what's de matter." I am feeling quite well now after my sore throat which I wrote you of in my last some two weeks ago. I have been thinking that you were probably flooded down your way, which might have made it impossible for mails to ~~leave~~ leave ye flourishing city of Busti, consequently had you written me that is the reason I have received no letter. We have been under water in this city, in our main streets, the arcade was so full of water rushing at a tremendous rate through it, that it was dangerous for boat to enter, and those unlucky individuals who were caught there by the freshet had the pleasure (if so it was) of remaining two days and nights before they could be rescued. It was a singular sight to see boats rowed through our main streets. All our bridges over the river

were submerged. Main Street bridge on which
stores are built was knocked and bruised fear
fully. Logs dashed over the bridge and through
the stores knocking the ends out of three of them
so that they caved in. Two large stone and
brick building were caved in by the flood.
I can't describe the immense damage done
to the city and private property amounting to
more than a million of dollars. Your father
was with us last week for a few minutes looking
well and hearty. What think you up your
way of the war. It is our opinion that the Reb
els hardly know which way to turn now to get
out of their terrible difficulty. They see their
vision of an empire founded on the un-
paid toil of black millions fading away from
their longing sight, and where a year and a half
ago we saw boastful countenances and heard
threats of riding over the north rough shod
and planting the stars and bars on the capitol
of Washington we now see downcast hungry
faces and hear mournful prayers that the
war may cease, and men who were then to die
in the last ditch rather than to surrender
to the sneaking Yankees, are pouring into our

33. Lewis Henry Douglass to Helen Amelia Loguen, Rochester, NY, March 26, 1865

lines from the rebel army in large numbers. Our forces are every where victorious, and I think by the 1st of July this "cruel war" will so far as any more pitched battles are concerned be over. To be sure there will be a great deal to do for some time to come, in the way of entirely crushing the ___ spirit which will prevail at the South. I have written you this letter hoping that you are well and that nothing has occurred to cause you to discontinue writing me. Give my love to all. Trusting that you hold me as dearly as I do you I remain

Affectionately Your

Lewis

P.S.
Amiable, Kind hearted lass!
May you ever love me true;
Ever dear as I love you.
Like the depth of Soundless ocean
Is my depth of love for thee,
As I trust yours is for me.

L.H.D.

33. Lewis Henry Douglass to Helen Amelia Loguen, Rochester, NY, March 26, 1865

Rochester, March 26, 1865.

My Own Dear Amelia: "Why hast thou forsaken me?" I have been home five weeks and have only received one letter from you. Unable longer to repress my anxiety to hear from you, I have determined to write you and enquire "what's de matter." I am feeling quite well now after my sore throat which I wrote you of in my last some two weeks ago. I have been thinking that you were probably flooded down your way, which might have made it impossible for mails to ~~leave~~ leave ye flourishing city of Busti:[51] consequently had you written me that is the reason I have received no letter. We have been under water in this city, in our main streets; the arcade was so full of water rushing at a tremendous rate through it, that it was dangerous for boats to enter, and those unlucky individuals who were caught there by the freshet had the pleasure (if so it was) of remaining two days and nights before they could be rescued. It was a singular sight to see boats rowed through our main streets. All our bridges over the river were submerged. Main Street bridge on which stores are built was knocked and bruised fearfully. Logs dashed over the bridge and through the stores, knocking the ends out of three of them so that they caved in. Two large stone and brick buildings were caved in by the flood. I can't describe the immense damage done to the city, and private property, amounting to more than a million of dollars. Your father was with us last week for a few minutes looking well and hearty. What think you up your way of the war. It is our opinion that the Rebels hardly know which way to turn now to get out of their terrible difficulty. They see their vision of an empire founded on the unpaid toil of black millions fading away from their longing sight, and where a year and a half ago we saw boastful countenances and heard threats of riding over the north rough shod and planting the stars and bars on the capitol of Washington, we now see downcast hungry faces, and hear mournful prayers that the war may cease, and men who were then to die in the last ditch rather than to surrender to the sneaking Yankees, are pouring into our lines from the rebel army in large numbers. Our forces are every where victorious, and I think by the 1st of July this "cruel war" will so far as any more pitched battles

51 Busti, a town in Chautauqua County, New York.

are concerned be over. To be sure there will be a great deal to do for some time to come, in they way of entirely crushing the mob spirit which will prevail at the south. I have written you this letter hoping that you are well and that nothing has occurred to cause you to discontinue writing me.

Give my love to all. Trusting that you hold me as dearly as I do you I remain
Affectionately Yours
Lewis

P.S. Amiable, Kind hearted lass!
May you ever love me true;
Ever dear as I love you.
Like the depth of soundless ocean
Is my depth of love for thee,
As I trust yours is for me. L.H.D.

Ferry City MD Jan. 7, 1866

My Own Dear Amelia:— I have just return-
ed from the city of Baltimore where I have
been to attend the colored State Convention.
I was honored by being chosen temporary
chairman of the Convention, after
which I was made chairman of the busi-
ness committee, I also had the honor
to prepare the address to the Legislature
of the State which was received very flat-
teringly by the Convention. We had
a rather stormy Convention there
being so many ignorant men as
delegates but on the whole the conven-
tion was a success and I feel morally
certain will be productive of much
good. We organized a State League
and have taken measures to bring
a suit against the State of Maryland
for the purpose of making a test question
as to the legality of refusing the colored
man the right to give evidence in
courts of justice against white as well
as colored citizens of the United States
living in Maryland. Mr. Wm. E.
Matthews of Baltimore city and
Lewis H. Douglass of Talbot County have
been chosen by the Convention and
the State League of Maryland to rep-
resent the colored people of the State
in Washington during the present
session of Congress I will conse-
quently spend the remainder of the
winter in Washington or Balti-
more this I conceive to be the highest

eminence that I have ever yet attained and places me still nearer that high mark to which I am aiming. And when I get up I can look back and say that I have come up not without trials and tribulations, but come up I will.

My holiday was work all the time. Christmas I way all day lost in the fog on the Chesapeake bay all through. Christmas next I was busy at the convention. I am now preparing for my departure tomorrow for Washington. I will write you from Washington when I get there. Give my love to everybody and do not forget that I love you

Yours Affectionately
Lewis H Douglass

34. Lewis Henry Douglass to Helen Amelia Loguen, Ferry Neck, MD, January 7, 1866

Ferry Neck, Jan. 7, 1866

My Own Dear Amelia:—I have just returned from the city of Baltimore where I have been to attend the colored State Convention.[52] I was honored by being chosen temporary Chairman of the Convention, after which I was made chairman of the business committee. I also had the honor to prepare the address to the Legislature of the State which was received very flatteringly by the Convention. We had a rather stormy convention there being so many ignorant men as delegates, but on the whole the convention was a success and I feel morally certain will be productive of much good. We organized a State League and have taken measures to bring a suit against the State of Maryland for the purpose of making a test question as to the legality of refusing the colored man the right to give evidence in courts of justice against white as well as colored citizens of the United States living in Maryland. Mr. Wm. E. Matthews of Baltimore city and Lewis H. Douglass of Talbot County have been chosen by the Convention and the State League of Maryland to represent the colored people of the State in Washington during the present session of Congress. I will consequently spend the remainder of the winter in Washington or Baltimore. This I conceive to be the highest eminence that I have ever yet attained and places me still nearer that high mark to which I am aiming. And when I get up I can look back and say that I have come up not without trials and tribulations, but come up I will.

My holiday was work all the time. Christmas I was all day lost in the fog on the Chesapeake bay all through Christmas week I was busy at the Convention. I am now preparing for my departure tomorrow for Washington. I will write you from Washington when I get there. Give my love to everybody and do not forget that I love you.

Yours Affectionately
Lewis H Douglass

52 Starting in 1830, in Philadelphia, free and formerly enslaved African Americans organized themselves through a number of state and national political conventions. The Colored Conventions movement collected funds, organized collective action, and established educational programmes, all in the service of resisting pre- and post-Civil War racist discrimination. The Maryland State Convention took place on January 5, 1866.

35. Lewis Henry Douglass to Helen Amelia Loguen, Denver, CO, September 30, 1866

Denver Sept 30 1866

My Dear Amelia: Your letter of the 18th is at hand having made its trip from Syracuse to this place in nine days. While I was thirty five days in crossing the plains from the Missouri river. The reason for the swift arrival of your letter is because of the progress made in building the Pacific railroad which is now only three hundred miles from here.

We have a most bad weather here since I last wrote, ranging from one extreme to the other. One day we have had it biting cold and the next so warm that summer clothing was much in demand. Snow on the mountain we have all the year round, but last week we got a goodly quantity in the valley. An agricultural fair was held here last week at which was exhibited some of the largest vegetables I ever saw. There were turnips two feet in circumference four inches thick and a foot across, cabbages weighing from thirty to forty pounds were quite common. Vegetables grown in Colorado attain the largest size imaginable, potatoes weighing from five to eight pounds, squashes large enough for coffins. We have no fruit except wild

517

faint.

I think this a very healthy country
the mortalit is very small, we have
no consumptives nor rheumatics here.
In the mountains not far from here is a
spring destined in time to rival
the famous Saratoga. It is a boiling
spring where the water comes comfort-
ably warm out of the ground. It is
the pool of Siloam of the new world nick-
out the delay and anxiety that was
necessary at the pool spoken of in
Holy Writ where the afflicted had to
wait for the troubling of the water
 This is however fine, nature has made
it a rough country. To appreciate the
high cultivation and refinement
of your city, you should see such
a country as this where every body
is ready to cut everybody's throatt
for a cent. But as the railroad
advances matters change for the better.
 I saw by the New York papers that
Dr. Randolph was to stump the
State of New York and was to visit
Syracuse. The world moves. Andrew
Johnson stocks is fast waning and
I trust the great State of New York
will speak in more than thunder
tones against the villainy and
usurpation of the murderer President

35. Lewis Henry Douglass to Helen Amelia Loguen, Denver, CO, September 30, 1866

Onward and upward seems to
be Gerrit's motto judging from the ex-
cellence and correctness with which
he has finished his second success-
ful attempt at pen portraits. The pic-
ture of John Brown is so life like, and
perfect as almost to be beyond criticism
I think Gerrit might do something
very fine if he would get a few the leading
radicals and make a picture in
a circle with some leader for the
centre picture and the others all
around it Charles Sumner's profile
would make an excellent picture
and at the same time an easy
one. He could get some friend of
your father's to buy a photograph of
Sumner in Washington as they are
always for sale there. If he could draw
an excellent picture and have it
photographed and the fact of its being
executed by a colored man he could
sell a great many. I saw much poorer
drawings than Gerrit's admired
in Washington hanging in the
rotunda of the capitol I am sure
that such excellent pictures as Gerrit
makes would if hung in the same
place attract more than ordinary
attention and he can have them
hung there I wish he would draw
a life size head of Sumner and
send it to Washington to some friend

35. Lewis Henry Douglass to Helen Amelia Loguen, Denver, CO, September 30, 1866

and have it hung in the rotunda
It would be heard of all over the country.
Love to all.
Ever Affectionately
Lewis

Sep 30
1866

35. Lewis Henry Douglass to Helen Amelia Loguen, Denver, CO, September 30, 1866

Denver Sept. 30 1866

My Dear Amelia: Your letter of the 18th is at hand having made its trip from Syracuse to this place in nine days. While I was thirty-five days in crossing the plains from the Missouri river. The reason for the swift arrival of your letter is because of the progress made in building the Pacific railroad which is now only three hundred miles from here.[53]

We have a most had weather here since I last wrote ranging from one extreme to the other. One day we have had it biting cold and the next so warm that summer clothing was much in demand. Snow on the mountain we have all the year round, but last week we got a goodly quantity in the valley.

An agricultural fair was held here last week at which was exhibited some of the largest vegetables I ever saw. There were turnips two feet in circumference four inches thick and a foot across, cabbages weighing from thirty to forty pounds were quite common. Vegetables grown in Colorado attain the largest size imaginable, potatoes weighing from five to eight pounds, squashes large enough for coffins. We have no fruit except wild fruit.

I think this a very healthy country the mortality is very small, we have no consumptives nor rheumatics here. In the mountains not far from here is a spring destined in time to rival the famous Saratoga. It is a boiling spring where the water comes comfortable, warm out of the ground. It is the pool of Siloam[54] of the new world without the delay and anxiety that was necessary at the pool spoken of in Holy Writ where the afflicted had to wait for the troubling of the water.

This is, however fine nature has made it, as rough country. To appreciate the high cultivation and refinement of your city you should see such a country as this where every body is ready to cut every body's throat for a cent. But as the railroad advances matters change for the better.

53 The First Transcontinental Railroad, known as the Pacific Railroad, was built between 1863 and 1869 and connected the already existing rail network at Omaha, Nebraska with the Pacific coast. It would not be until 1870 that Denver would be connected to the railroad by the opening of the Denver Pacific Railway, which connected Denver and the Pacific Railroad at Cheyenne, Wyoming.

54 The Pool of Siloam, constructed to provide a water supply to the city of Jerusalem. In the New Testament, Jesus instructs a man who is unable to see to wash in the pool and his sight is restored (John 9:7).

[35] I saw by the New York papers that Dr. Randolph was to stump the State of New York and was to visit Syracuse. The world moves. Andrew Johnson stocks is fast waning and I trust the great State of New York will speak in more than thunder tones against the villain and usurpation of the murderer President.[55]

Onward and upward seems to be Gerrit's* motto judging from the excellence and correctness with which he has finished his second successful attempt at pen portraits. The picture of John Brown is so life-like, and perfect as almost to be beyond criticism. I think Gerrit might do something very fine if he would get a few of the leading radicals and make a picture in a circle with some leader for the centre picture and the others all around it Charles Sumner's profile would make an excellent picture and at the same time an easy one. He could get some friends of your father's to buy a photograph of Sumner in Washington as they are always for sale there. If he could draw an excellent picture and have it photographed and the fact of its being executed by a colored man he could sell a great many. I saw much poorer drawings than Gerrit's admired in Washington hanging in the rotunda by the capital. I am sure that such excellent pictures as Gerrit makes would if hung in the same place attract more than ordinary attention, and he can have them hung there. I wish he would draw a life size head of Sumner and send it to Washington to some friend and have it hung in the rotunda. It would be heard of all over the country. Love to all.

Ever affectionately
Lewis

55 Lewis Henry Douglass's dissatisfaction with the presidency of Andrew Johnson (1808–75) may have coalesced in 1866 around Johnson's refusal to support the Civil Rights Act, the first federal law to affirm citizens' equality under the law. Johnson had twice vetoed the bill before it was enacted on April 9, 1866.
* Gerrit Smith Loguen.

36. Lewis Henry Douglass to Helen Amelia Loguen, Philadelphia, PA, February 10, 1868

Philadelphia Feby 10 1868

My Dear Amelia: I am still in
the "Quaker City," but will leave for
Baltimore in a day or two. On Saturday
I met with a rather unpleasant adven-
ture. I went with some half dozen ladies
and one gentleman, over to Camden
New Jersey to a skating park, and
while there we were surrounded by a
number of white boys and young
men, who made insulting remarks
to the ladies which we took no notice
of; seeing that we could stay no longer
there without a collision, I proposed
that we leave, and assisted the girls
in taking off their skates, keeping one pair
in my hands to fight with, if attacked,
The mob seeing that we were going
away without replying to their insults
made a rush at me, (the other gentle
man being in the house used for putting
on skates) and attempted to knock me

down, which I very successfully stopped
by splitting his head with the skates, this
rather brought the croud to a halt for a
minute, and then they made another
rush at me, and as I stood my ground
they did not come close enough for
me to hit them, they then attempted
to run behind me and knock me down
so I feel back a little way, and on
one of them rushing up to catch
hold of me, I let drive at him with
my skate, he threw up his hand to
stop the blow, and I took his thumb
nearly off, with that the whole croud
bore down on me so that I had to
run for my life and take shelter in
the house belonging to the Park. I succeed-
ed in getting away without a scratch, the
mob getting the most of it. If they had
not been cowards they could have beat
me to death. But they feared my sharp
skates which they saw I had the deter-
mination to use. My scarf and hat

36. Lewis Henry Douglass to Helen Amelia Loguen, Philadelphia, PA, February 10, 1868

were taken from me, but was again by one of the young ladies, whom the roughs dared not strike. They were enraged at the nice appearance of the ladies whose parents are all wealthy and their dresses were superior to any white ladies on the place. One who cried out "where did you get the money to hire your good clothes to go skating in?"

The adventure cost me nothing, and I have the praise of great coolness, all expected that I would be stricken down and killed, as I would have been had I shown the least fear.

I attended a grand ball here last thursday night. Love to all.

Yours Lovingly
Lewis

36. Lewis Henry Douglass to Helen Amelia Loguen, Philadelphia, PA, February 10, 1868

Philadelphia Feby 10 1868

My Dear Amelia: I am still in the "Quaker City," but will leave for Baltimore in a day or two. On Saturday I met with a rather unpleasant adventure. I went with some half dozen ladies and one gentleman over to Camden New Jersey to a skating park, and while there we were surrounded by a number of white boys and young men, who made insulting remarks to the ladies which we took no notice of; seeing that we could stay no longer there without a collision, I proposed that we leave, and assisted the girls in taking off their skates, keeping one pair in my hands to fight with, if attacked. The mob seeing that we were going away without replying to their insult, made a rush at me, (the other gentleman being in the house used for putting on skates) and attempted to knock me down, which I very successfully stopped by splitting his head with the skates, this rather brought the crowd to a halt for a minute, and then they made another rush at me, and as I stood my ground, they did not come close enough for me to hit them, they then attempted to run behind me and knock me down so I fell back a little way, and on one of them rushing up to catch hold of me, I let drive at him with my skate, he threw up his hand to stop the blow, and I took his thumb nearly off, with that the whole crowd bore down on me so that I had to run for my life and take shelter in the house belonging to the Park. I succeeded in getting away without a scratch, the mob getting the worst of it. If they had not been cowards they could have beat me to death. But they feared my sharp skates which they saw I had the determination to use. My scarf and hat were taken from me, but was taken back again by one of the young ladies, whom the roughs dared not strike. They were enraged at the nice appearance of the ladies whose parents are all wealthy and their dresses were superior to any white ladies on the place. The mob cried out "where did you get the money to hire your good dresses to go skating in?"

The adventure cost me nothing, and I have the praise of great coolness, all expected that I would be stricken down and killed, as I would have been had I shown the least fear.

I attended a grand ball here last Thursday night. Love to all.

Yours Lovingly

Lewis

37. Lewis Henry Douglass to Helen Amelia Loguen, Washington, DC, July 5, 1869

Washington, July 5 1869

My Dear Amelia

I have been necessitated to allow your letter to go unanswered for a day or two, but I trust as Toots says "it's of no consequence," Now as to the day, so far as I am concerned, Saturday or any other day of the week would make no difference with me. I will tell you Amelia, I shall have you name the day, as custom has made it your prerogative so to do. I will not be able to leave here before the 2th October at any rate, I shall in all probability to go directly to Rochester, if I go by the way of New York city shall call on you at Syracuse but if I go by the direct road from Baltimore I cant of course call on my way as time will be with me an important element, I may take the route through Pennsylvania home. But I think we have time enough left to settle definitely upon the day.

As to that threatening letter sent me

527

do not be alarmed. The New York Tribune
says in regard to it that "threatened men
live long" and calls on the government
to sustain me in my present position
if it should be necessary to have a regi-
ment of soldiers to guard me. Quite a stir
for an insignificant human being like
me to be kicking up.

Gerrit will stand
up with me to keep me in courage
when I promise to obey (?) you &c. who will
stand up with you when you promise to
command me.

Amelia I don't know that
I ever intimated to you that my prefer-
ence is that the wedding or marriage
should be conducted with least possible
display; this, however, is only my preference,
don't think that any arrangement you
may make will meet with my disapproba-
tion. To-day the S. School with which I am connected
is to hold a picnic, and I have been
pretty busy for the last week. I sat
down to write a good letter but am constant

by believed or must close. Love to all. will
write to Lewis in a day or two

Your Affectionate

Lewis

37. Lewis Henry Douglass to Helen Amelia Loguen, Washington, DC, July 5, 1869

Washington July 5 1869

My Dear Amelia

I have been necessitated to allow your letter to go unanswered for a day or two, but I trust as Toots says "it's of no consequence." Now as to the day, so far as I am concerned, Saturday or any other day of the week would make no difference with me. I will tell you Amelia, I shall have you name the day, as custom has made it your prerogative so to do. I will not be able to leave here before the 24th October at any rate. I shall in all probability to go directly to Rochester, if I go by the way of New York city shall call on you at Syracuse, but if I go by the direct road from Baltimore I can't of course call on my way, as time will be with me an important element. I may take the route through Pennsylvania home. But I think we have time enough left to settle definitely upon the day.

As to that threatening letter sent me do not be alarmed. The New York Tribune says in regard to it that "threatened men live long" and calls on the government to sustain me in my present position if it should be necessary to have a regiment of soldiers to guard me. Quite a stir for an insignificant human being like me to be kicking up.

Gerrit will stand up with me to keep me in courage when I promise to obey (?) you &c who will stand up with you when you promise to command me.

Amelia I don't know that I ever intimated to you that my preference is that the wedding or marriage should be conducted with least possible display: this, however, is only my preference, don't think that any arrangement you may make will meet with my disapprobation. To-day the S. School with which I am connected ar is to hold a picnic, and I have been pretty busy for the last week. I sat down to write a good letter but am constantly bothered so must close. Love to all. Will write to Gerrit in a day or two.

Your Affectionate

Lewis

38. Lewis Henry Douglass to Helen Amelia Loguen, Washington, DC, July 17, 1869

Washington, July 17, 1869

My Dear Amelia,

Your letter of the 13th inst is received. I have been suffering with the tooth ache for nearly a week, but am now happy over it. Because of a disposition of Charley's wife to be exceedingly disagreeable I have ceased to board with him, and am now boarding in the city of Washington. I hardly know yet whether I shall board this coming winter or keep house. I much prefer housekeeping. Charley is the father of another son.

I learn from father that he called on you a few days ago, and that he was much pleased, so much so that he congratulates me on my choice, and more than intimates that to tend and myself he looks to marry in keeping with our own position, descanting quite freely on your many good points

38. Lewis Henry Douglass to Helen Amelia Loguen, Washington, DC, July 17, 1869

What do you mean by saying that you come second in my love, I am utterly unable to understand you. Must I repeat that I love you in the fullest meaning of that word. It may be however, that in my last letter I did not express myself clearly which has led you to infer something harsh. Do not draw such inferences from any thing I may write, for my dear Amelia I am touched daily by the conquering made by the printers. Now don't I pray you think any thing I say that seems harsh, for I love you sincerely, heartily.

I am to appear by shadow in the Harper's Weekly I suppose next week. By the way if you have any influence with that brother Gerrit of yours, have him hurry up those pictures I sent for.

Think only of the happiness in store for us, if we in love, constant

38. Lewis Henry Douglass to Helen Amelia Loguen, Washington, DC, July 17, 1869

and true to each other. Many
temptations have been mine
but I always think of you
 Your loving
 Lewis
Gov't Printing Office

38. Lewis Henry Douglass to Helen Amelia Loguen, Washington, DC, July 17, 1869

Washington, July 17, 1869

My Dear Amelia,

Your letter of the 13th inst is received. I have been suffering with the tooth ache, for nearly a week, and am now happily over it. Because of a disposition of Charley's wife to be exceedingly disagreeable I have ceased to board with him, and am now boarding in the city of Washington. I hardly know yet whether I shall board this coming winter or keep house. I much prefer house keeping. Charley is the father of another soul.

I learn from father that he called on you a few days ago, and that he was much pleased, so much so that he congratulates me on my choice, and more than intimates that to Fred and myself he looks to marry in keeping with our own position, descanting quite fully on your many good points. What do you mean by saying that you come second in my love I am utterly unable to understand you. Must I speak that I <u>love</u> you in the fullest meaning of that word. It may be however that in my last letter I did not express myself clearly which has led you to infer something harsh. Do not draw such inferences from any thing I may write, for my dear Amelia I am ___ [?] daily by the ___ [?] made by the ___ [?]. Now don't I pray you think of anything I say that seems harsh, for I love you sincerely, heartily.

I am to appear by shadow in the Harper's Weekly I suppose next week.[56] By the way if you have any influence with that brother Gerrit of yours, have him hurry up those pictures I sent for.

Think only of the happiness in store for us, if we in love, constant and true to each other. Many temptations have been mine but I always think of you

Your loving

Lewis

Gov't Printing Office

56 This likeness of Lewis Henry Douglass in *Harper's Weekly* has yet to be located.

39. Frederick Douglass to Lewis Henry Douglass, Rochester, NY, July 21, 1869

Rochester July 21. 1869

My dear Lewis:

I have just read with satisfaction in the Tribune, your brief but comprehensive and pertinent note acknowledging your election to honorary membership in the Soldiers and Sailors Union of Philadelphia.

I watch with with intense interest all that concerns you and emanates from you in this struggle and am deeply gratified by every well aimed blow you deal the selfishness and meanness which seeks to humble, degrade and starve you.

If the effort now making to call you down and through you to call down and destroy your race shall serve to place you before the country, as one of the leaders of your people, and a representative of their cause your experience will only conform to that of many other men who have risen to destruction in the world by persecution.

I send you this only to let you know that I am vigilent and observe all that is passing. We are all well here. Miss Assing read your letter aloud at table to day.

Make my love to Charles and Frederick and to "Libby."

Your affectionate Father,

Frederick Douglass

Write "early and write often"

535

39. Frederick Douglass to Lewis Henry Douglass, Rochester, NY, July 21, 1869

My dear Lewis:

I have just read with satisfaction in the Tribune, your brief but comprehensive and pertinent note acknowledging your election to honorary membership in the Soldiers and Sailors Union of Philadelphia.

I watch with with intense interest all that concerns you and eminates [sic] from you in this struggle and am deeply gratified by every well aimed blow you deal the selfishness and meanness which seeks to humble, degrade and starve you.

If the effort now making to cast you down, and through you to cast down and destroy your race, shall serve to place you before the country as one of the leaders of your people, and a representative of their cause, your experience will only conform to that of many other men who have risen to distinction in the world by persecution.

I send you this only to let you know that I am vigilant and observe all that is passing. We are all well here—Miss Assing[57] read your letter aloud at table to day.

Make my love to Charles and Frederick and to "Libby."

Your affectionate Father,

Frederick Douglass

Write "early and write often"

57 Ottilie Assing (1819–84), a German feminist, intellectual, and radical, established a twenty-eight-year friendship with Frederick Douglass after reading his second autobiography, My *Bondage and My Freedom* which she translated into German in 1860.

40. Lewis Henry Douglass to Helen Amelia Loguen, Washington, DC, September 15, 1869

Washington, Sept. 15, 1869

My dear Amelia, Yours of the 12th inst is at hand, and I am with no commen pleasure seated for the purpose of answering the heart cheering letter from you. To know that anything I have written has given you pleasure is to me cheering. One week has rolled around since I occupied the same spot on which I now am writing to you what you are pleased to call a good letter. One week nearer my love "Thou art so near and yet so far." Tomorrow to an expectant is something interminable to look into, but it must roll around, and when it does, or if nothing goes contrary, we shall meet face to face once more. What a meeting! nearly two years will have elapsed since on that cold and stormy January night I gave you a parting kiss in the kitchen, and then Gerrit (our faithful friend) and I took the covered sleigh that served for a street car for the depot

40. Lewis Henry Douglass to Helen Amelia Loguen, Washington, DC, September 15, 1869

Since then I have seen you only in dreams, and I have known you by the deep and fervent love, I have for you. All the anxiety and misgivings of the past two years will, I trust, when I again clasp that hand, and kiss those lips of yours, vanish from my mind, as the dusk of morning fadeth before the dazzling rays of the rising sun. But it is useless for me to attempt to pen an expression of my feelings of happiness as I this moment am living in bright anticipations of joy to come. It will be so pleasant on next Wednesday evening to be penning a letter to you in answer to one just received.

 I wish you would ask Gerrit for me, how he is going to dress. I am going to dress in a full suit of black, with nothing white but gloves, shirt, collar, and neck tie. Thinking he might want to dress like me I will thereby give him this information. Please get his dress for me. There is one name on your list of invitations, that if he should come, could

40. Lewis Henry Douglass to Helen Amelia Loguen, Washington, DC, September 15, 1869

should speak to me, I would say some
thing quite offensive to him. I do not
see on the list of Syracusans the names
of your friend Sarah Sims or rather Sarah
Jackson; are you not now friends? As
you are to send Charley and lady an invite, I
will consider him off my list. Give my
love to all

 Your loving

 Lewis

P.S. Is n't Julia Luckett in this city?

40. Lewis Henry Douglass to Helen Amelia Loguen, Washington, DC, September 15, 1869

Washington, Sept. 15, 1869

My dear Amelia. Yours of the 12th inst is at hand, and I am with no common pleasure seated for the purpose of answering the heart-cheering letter from you. To know that anything I have written has given you pleasure is to me cheering. One week has rolled around since I occupied the same spot on which I now am writing to you what you are pleased to call a good letter. One week nearer my love. "Thou art so near, and yet so far!" Two weeks to an expectant is something interminable to look into, but it must roll around, and when it does, or if nothing goes contrary, we shall meet face to face once more.

What a meeting! nearly two years will have elapsed since on that cold and stormy January night I gave you a parting kiss in the kitchen and then Gerrit ever faithful friend and I took the covered sleigh, that served for a street car, for the depot. Since then I have seen you only in dreams, and I have known you by the deep and fervent love I have for you. All the anxiety and misgivings of the past two years will, I trust, when I again clasp that hand, and kiss those lips of yours vanish from my mind, as the dusk of morning glideth before the dazzling rays of the rising sun. But it is useless for me to attempt to pen an expression of my feelings of happiness as I this moment am living in bright anticipations of joy to come. It will be so pleasant on next next Wednesday evening to be penning a letter to you in answer to one just received.

I wish you would say to ask Gerrit for me, how he is going to dress. I am going to dress in a full of suit of black, with nothing white but gloves, shirt collar, and neck tie. Thinking he might want to dress like me I will, through you, give him this information. Please get his views for me. There is one name on your list of invitations, that if he should come, and should speak to me, I would say something quite offensive to him. I do not see on the list of Syracuseans the names of your friend Sarah Lewis or rather Sarah Jackson; are you not now friends? As you are to send Charley and lady an invite, I will consider him off my list. Give my love to all

Your loving
Lewis
P.S. Isn't Julia Luckett in this city?

41. Lewis Henry Douglass to Helen Amelia Loguen
Douglass, [Washington, DC], December 5, 1870

Dec. 5, 1870

Amelia

Dear Wife: I left
the office this p.m. to look
after Fred's case. in the
printing office. I don't
think I will be here to
dinner as I am going
over to Charley's

Affectionately
Lew.

P.s. This is the first note
I have written you
since we are married

41. Lewis Henry Douglass to Helen Amelia Loguen Douglass, [Washington, DC], December 5, 1870

Dec. 5, 1870

Amelia

Dear Wife: I left the office this p.m. to look after Fred's case in the printing office. I don't think I will be here to dinner as I am going over to Charley's.
Affectionately
Lew.
P.S. This is the first note I have written you since we were married

42. Lewis Henry Douglass to Columbian Typographical Union No. 101, [Washington, DC], January 1871

Jan. 1871

To Columbian Typographical Union No. 101:

Gentlemen:

I address you for the purpose of withdrawing my application made nearly two years ago, for membership to your organization. I am impelled to this step by the manner you have treated me in considering my application.

My application has been regularly referred to the Committee on Nominations and a favorable report on it has been made by the majority of said committee; and in accordance with your Constitution you should have proceeded to an election by ballot. I quote from your constitution:

"An application being regularly
made, it shall be referred to the
Committee on Nominations. The
committee shall report at the same
or next stated meeting, and if the
same be favorable the Union shall
proceed to an election by ballot, &c."
In my case the Union proceeded
not to ballot, but to postpone action
on the favorable report of the com-
mittee. This line of proceeding has
been kept up to the present moment
postponement after postponement
until I am convinced that it is
your purpose to continue to iso-
late your own laws for all time.
I consider that should I longer allow
my application to remain in
your Union to be constantly
thrust into a corner there to lie
month after month, and
year after year, I not only
give you an opportunity to grati-
fy a senseless prejudice emanating
from a cowardly hate, and a blunt-
ed sense of justice, but violate my

42. Lewis Henry Douglass to Columbian Typographical Union No. 101, [Washington, DC], January 1871

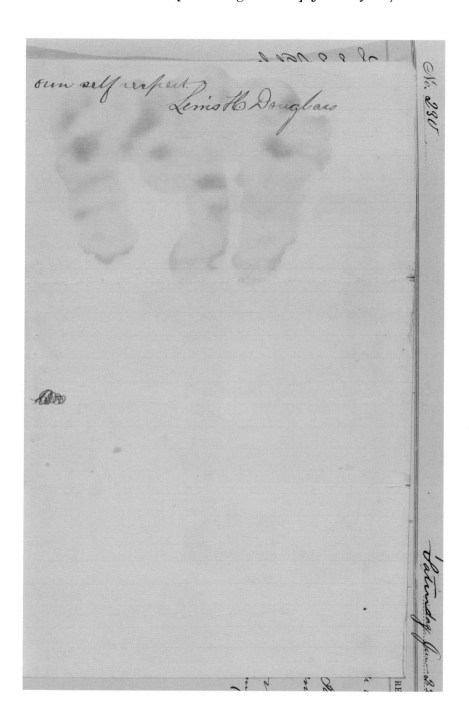

42. Lewis Henry Douglass to Columbian Typographical Union No. 101, [Washington, DC], January 1871

To Columbian Typographical Union No 101:[58]
Gentlemen:

I address you for the purpose of withdrawing my application, made nearly ten years ago, for membership to your organization. I am impelled to this step by the manner you have treated me in considering my application.

My application has been regularly referred to the Committee on Nominations and a favorable report on it has been made by the majority of said committee, and in accordance with your Constitution you should have proceeded to an election by ballot—I quote from your constitution:

"An application being regularly made, it shall be referred to the Committee on Nominations. The committee shall report at the same or next stated meeting, and if the same be favorable the Union shall proceed to an election by ballot &c."

In my case the Union proceeded not to ballot, but to postpone action on the favorable report of the committee. This line of proceeding has been kept up to the present moment, postponement after postponement until I am convinced that it is your purpose to continue to violate your own laws for all time. I consider that, should I longer allow my application to remain in your Union to be constantly thrust into a corner there to lie month after month and year after year, I not only give you an opportunity to gratify a senseless prejudice emanating from a cowardly hate, and a blunted sense of justice, but violate my own self respect.

Lewis H. Douglass

58 As revealed in their surviving papers, the Columbia Typographical Union No. 101 was founded in Washington, DC, as early as 1814. Full access to their archival records can be found at the following digital repository: <https://reuther.wayne.edu/files/LR001577.pdf> (accessed January 14, 2018). See the bibliography for further information: Seibold, *Historical Sketch*, 1915.

Washington D.C. August 29. 1876.

Judge Edmunds

My dear Sir:

Just as I am leaving
to work in the Republican cause
in the State of Maine, I am informed
of a discrimination in your action
in refusing to give any of the printing
to my son Frederick and of your
giving it to Gibson and Brothers.
If this statement is correct, I have
no hesitation in saying that the
policy of sacrificing friends to
conciliate others is neither wise
nor just. I have worked hard in
this cause for nearly forty years—
I have neither asked nor received
office—but I would like to see something
like a recognition of my services
in fair treatment to my son Fredk

43. Frederick Douglass to Judge Edmunds, Washington, DC, August 29, 1876

I am a poor man and have lost ten thousand dollars by following your word of encouragement in the effort to establish the New National Era, and I naturally enough feel grieved that you, fattening as you have done for years upon the triumph of the cause for which I have labored.

Faithfully yours
Fred.k Douglass

43. Frederick Douglass to Judge Edmunds, Washington, DC, August 29, 1876

Judge Edmunds[59]
My dear Sir:

Just as I am leaving to work in the Republican cause in the State of Maine, I am informed of a discrimination in your action in refusing to give any of the printing to my son Frederick and of your giving it to Gibson and Brothers. If this statement is correct, I have no hesitation in saying that the policy of sacrificing friends to conciliate others is neither wise nor just. I have worked hard in this cause for nearly forty years—I have neither asked nor received office, but I would like to see something like a recognition of my services in fair treatment to my son Fredk. I am a poor man and have lost ten thousand dollars following your words of encouragement in the effort to establish the New National Era—and I naturally enough feel grieved that you, fattening as you have done for years upon the triumph of the cause for which I have labored.

Faithfully yours
Fredk. Douglass

59 George Franklin Edmunds (1828–1919), at the time of this letter, was US senator for Vermont and chairman of the Committee on the Judiciary in the Senate.

44. Frederick Douglass to Mrs. Marks, Washington, DC, February 13, 1884

Washington D.C. Febry 13. 1884

Dear Mrs Marks.

I had a letter from Miss Assing only one week ago. She is now in Florence Italy. Her letters have been very cheerful during all the time of her absence. She has travelled much and seen much that is interesting. She speaks of coming home next summer. Should she do so I am sure she will seek and find you among the first of her old friends, for she holds you among her first and fastest.

With kind regards to your respected daughter. Yours truly

Fredk Douglass

44. Frederick Douglass to Mrs. Marks, Washington, DC, February 13, 1884

Washington D.C. Febry 13. 1884

Dear Mrs Marks,

I had a letter from Miss Assing only one week ago. She is now in Florence Italy. Her letters have been very cheerful during all the time of her absence. She has travilled [sic] much and seen much that is interesting. She speaks of coming home next summer. Should she do so I am sure she will seek and find you among the first of her old friends for she holds you among her first and fastest.

With kind regards to your respected daughter. Yours truly

Fredk. Douglass

Port au Prince Feb. 25.

My dear Charles:

I see that the Bee says
I have resigned. The wish is father
to the thought. The same paper said
I would stay in Hayti only six months
No doubt my resignation would be
very welcome news to those who
want the place. With every disposi
tion to be amiable I cannot bring
myself to oblige them just then. I
say this for your private eye and
not for the purpose of having the
lie contradicted. I leave that to
time — for I shall take my own
time for resigning. The fellows
that set afloat these stories should
be allowed whatever satisfaction
momentary lying can give
them. The aspirants for the place

45. Frederick Douglass to Charles Remond Douglass, Port-au-Prince, Haiti, February 25, 1891

much "wait a little longer." I have received a letter from Frederick which gives me some hope that he has ere this once more got into some work. I am glad to learn that his boy Paul is doing better. What do you hear of Weiners? — He was still in New York when I last heard from. He seems to have dropt me, as soon as I could lend him no more money. This is according to a very old saying lend your money and lose your friend. I will tell you that I have acquitted Lewis of all blame for the mutilation of my speech. I see that Langston has lost no time in betraying his trust. He knows full

45. Frederick Douglass to Charles Remond Douglass, Port-au-Prince, Haiti, February 25, 1891

3

them to make suffrage depend upon
an educational test will furnish
a motive both to keep them from
education and to keep them from
voting – The South as little wants
the Negro educated as it wants
them to vote – and it would
see in every effort to educate the
Negro, an effort to give them
supremacy. He is a trickster
not a statesman. I am very
glad to have from Joe a good
account of Haity's progress –
I think you and Laura may
well take comfort in that boy –

45. Frederick Douglass to Charles Remond Douglass, Port-au-Prince, Haiti, February 25, 1891

What I lack in this letter you must make up in reading the enclosed I send to Joe.

This country is about as peaceful as it ever is and it is never without disturbance or rumour of disturbance. The President is just now absent from the Capital on a tour to the South. Make my love to Laura and Hailey, and kind rememberances to Mr and Mrs Colbert. Write me when you can of all the news about town Affectionately

Your father.

45. Frederick Douglass to Charles Remond Douglass, Port-au-Prince, Haiti, February 25, 1891

My dear Charles:

I see that the Bee[60] says I have resigned. The wish is father to the thought. The same paper said I would stay in Hayti only six months. No doubt my resignation would be very welcome news to those who want the place. With every disposition to be amiable I cannot bring myself to oblige them just yet. I say this for your private eye and not for the purpose of having the lie contradicted. I leave that to time—for I shall take my own time for resigning. The fellows that set afloat these stories should be allowed whatever satisfaction momentary lying can give them. The aspirants for the place must "wait a little longer"—I have received a letter from Frederick which gives me some hope that he has ere this once more got into some work. I am glad to learn that his boy Paul[*] is doing better. What do you hear of Winor?—He was still in New York when I last heard from. He seems to have dropt me as soon as I could lend him no more money. This is according to a very old saying Lend your money and lose your friend. Joe[†] will tell you that I have acquitted Lewis of all blame for the mutilation of my speech. I see that Langston has lost no time in betraying his trust. He knows full that to make suffrage depend upon an educational test will furnish a motive both to keep them from education and to keep them from voting—The South as little want the Negro educated as it wants them to vote—and it would see in every effort to educate the negro, an effort to give them supremacy. He is a trickster not a statesman. I am very glad to have from Joe a good account of Hailey's [sic][‡] progress—I think you and Laura may well take comfort in that boy. What I lack in this letter you must make up in reading the enclosed I send to Joe.

The country is about as peaceful as it ever is—and it is never without disturbance or rumour of disturbance. The President is just now absent from the Capital on a tour to the South. Make my love to Laura and Hailey, and kind remembrances to Mr and Mrs Colbert. Write me when you can of all the news about town. Affectionately

Your father.

60 The *Washington Bee* was a weekly newspaper founded in 1882 and aimed at a Black readership. For most of its forty-year existence it was edited by the lawyer and editor William Calvin Chase (1854–1921).

 * Charles Paul Douglass.
 † Joseph Henry Douglass.
 ‡ Haley George Douglass.

46. Frederick Douglass to Charles Remond Douglass, c. April 1891

Very dear Charles: Yours is the only letter telling me of the death of Louisa. Since I learned the nature of her disease and the impossibility of any cure, it is a relief that she has passed way beyond the reach of pain and death. The blow is a sad one to us all—but we must suffer and be strong. I feel deeply for you because yours has been a most bitter experience. Few families have been made to suffer as yours has in the loss of dear ones.

but your experience should
make you strong. You are
still young and strong and
have I hope much of life
and usefulness before you.
It is not for you to despair.
The world is still before you.
You are leading an honorable
life and setting a noble example
Your life is useful, if not all
that you could wish it in some
respects—but you can conquer
all your ills—by bravely
meeting them. I have no
time to look into the

Ordway papers just now, for
the same Sleeplace paper that brought
your letter and the Hale will
leave in an hour or more
and carry letters to Neoash
for the States and I have one
or more beside this
to you to be sent by her.
You hardly know how
glad I am to have
letters from you and I
hope you will keep it
up— You will see by
the papers that I am passing
through something an ordeal

just now myself. The
papers in the States are
telling of trouble between
myself and Rear Admiral
Gherardi. I hope you will
say nothing on the subject—
but I will give you a hint
which will enable you to
explain to yourself what
may some day explained
more fully to the public—
If I am forced to defend my
self from unjust criticism &
false charges concerning
my inefficiency. — I shall do this!

In the first place you
you must bear in mind

that no man of color was
desired by the Merchants of New
York as minister to Hayti. 2dly That
the please is wanted not only for a
Whiteman but a White man who
will favor not merely american
interests in general, but the interest
of Wm P. Clye in particular. That
the said Wm P. Clyde, runs a line
of steamers between New York &
several Ports of Hayti— that he
also wishes to put several more
Steamers on this line, but in
order to do so— he wishes to
obtain a subsidy of several
hundred thousand dollars
not from the United States
but from the Government
of Hayti. For this purpose

has had an agent a certain
Captain Bood in Port au Prince
during a year past, that Mr Clyde
has the ear and the support of
the Secretary of State and the
Secretary of the Navy and
that these officials have
wished me to procure the
Haytian Government to make
this rich donation to Mr
Clyde as far as I could
do so Constituently with
my position as Minister
resident. Accordingly I
gave the measure my
warm support as I
thought that the Presence
of these American Steamers

might be made useful to
Hayti as well to American
interests, but the time came
when Mr Clyde agent wished
me to go a step or two further
in promoting this enterprise
than I felt at liberty to go and
further than I felt it right
to go. He wanted me to when
I went to the Palace to take
leave of President Hyppolite
to press upon him on that
mere cerimonial occasion,
the duty of granting this
Concession five hundred
thousand dollars to Mr Clyde.
This I felt out of place
and I refused to do it.

The next thing the same party
asked me to do was to promise
the Haytian Government that if
they it would grant this Clyde
Concession, I would not press
the claims of other american
citizens against the Haytien
government. This I could not
and would not do and in
this I have offended the said
agent Read and possibly
the Secretary of the Navy.
Admiral Gheardi and Mr
Clyde. You will see by
this that I am in a
position to fully defend
My self if I shall find
it necessary to do so.
Then came the demand for

46. Frederick Douglass to Charles Remond Douglass, c. April 1891

& a U. S. Coaling Station at the Mole St Nicholas. This too I have pressed upon the Haytian Government. But such is the prejudice of Haytiens against allowing Americans to get a foot hold on any part of their country that this coaling station business has failed. As a consequence Rear Admiral Gherardi was sent here two months ago to accomplish what I failed to accomplish — I have honestly cooperated with him in this matter but we have thus far failed. and as some one must be blamed for the failure I selected to bear this blame. I write these facts so that in case any accident should befall

may be able to vindicate
my memory. As I am not
writing to Lewis by this mail
I wish to share with him the
Contents of this letter—but
of course you will let
no body else see those
Contents—In haste lovingly
Yours. Father

LEGATION OF THE UNITED STATES
PORT AU PRINCE, HAITI

Chas. R. Douglass,
318. A St. N.E.
Capitol Hill
Washington D.C,
U. S. A,

5.th
Rec: Monday
Recd

Apr.
1891

46. Frederick Douglass to Charles Remond Douglass, c. April 1891

My dear Charles: Yours is the only letter telling me of the death of Louisa. Since I learned the nature of her disease and the impossibility of any cure, it is a relief that she has passed way beyond the reach of pain and death. The blow is a sad one to us all—but we must suffer and be strong. I feel deeply for you because yours has been a most bitter experience. Few families have been made to suffer as yours has in the loss of dear ones, but your experience should make you strong. You are still young and strong and have I hope much of life and usefulness before you. It is not for you to despair. The world is still before you. You are leading an honorable life and setting a noble example. Your life is useful, if not all that you could wish it in some respects—but you can conquer all your ills—by bravely meeting them. I have no time to look into the Ordway papers just now, for the same ~~paper~~ steamer that brought your letter and the note will leave in an hour or more and carry letters to___ [?] for the States and I have one or more besides this to you to be sent by her. You hardly know how glad I am to have letters from you and I hope you will keep it up—You will see by the papers that I am passing through something an ordeal just now myself. The papers in the states are telling of trouble between myself and Rear Admiral Gheardi [sic].[61] I hope you will say nothing on the subject—but I will give you a hint which will enable you to explain to yourself what may some day explained more fully to the public—if I am forced to defend myself from unjust criticism & false charges concerning my inefficiency—I shall do this.

In the first place you you must bear in mind that no man of color was desired by the merchants of New York as minister to Hayti. 2dly, That the place is wanted not only for a white man but a white man who will favor not merely American interests in general, but the interests of Wm. P. Clyde in particular.[62] That the said Wm. P. Clyde, runs a line of steamers between New York & several Ports of Hayti—that he also wishes to put several more Steamers on this line, but in order to do so—he wishes to obtain a subsidy of several hundred thousand dollars not from the United States but from the Government of Hayti. For this purpose has had an agent a certain captain

61 Bancroft Gherardi (1832–1903), Italian American rear admiral of the United States Navy and commander-in-chief of the North Atlantic Fleet, was commissioned by US president Benjamin Harrison to negotiate for the acquisition of the Haitian port of Môle-Saint-Nicolas.

62 White US businessman William P. Clyde, the owner of the Clyde Line, a steamship company headquartered in Philadelphia and New York, operating a lucrative service to Santo Domingo and other Caribbean islands.

Read in Port au Prince during a year past. That Mr. Clyde has the ear and the support of the secretary of state and the secretary of the navy and that these officials have wished me to pressure the Haitian Government to make this rich donation to Mr. Clyde as far as I could do so consistently with my position as minister resident. Accordingly I gave the measure my warm support as I thought that the presence of these American steamers might be made useful to Hayti as well to American interests, but the time came when Mr. Clydes agent wished me to go a step or two further in promoting their enterprize than I felt at Liberty to go and further than I felt it right to go. He wanted me on when I went to the Palace to take leave of President Hyppolite[63] to press upon him on that mere ceremonial occasion, the duty of granting this concession five hundred thousand dollars to Mr. Clyde. This I felt out of place and I refused to do it. The next thing the same party asked me to do was to promise the Haytian Government that if they it would grant this Clyde concession, I would not press the claim of other American citizens against the Haytian government. This I could not and would not do and in this I have offended the said agent Read—and possibly the Secretary of the Navy, Admiral Gheardi [sic] and Mr. Clyde. You will see by this that I am in a position to fully defend myself if I should find it necessary to do so. Then came the demand for a U.S. coaling station at the Mole St. Nicholas. This too I have pressed upon the Haytian Government. But such is the prejudice of Haytians against allowing Americans to get a foothold on any part of their country that this coaling station business has failed. As a consequence Rear Admiral Gheardi [sic] was sent here two months ago to accomplish what I failed to accomplish—I have honestly cooperated with him in this matter but we have thus far failed, and as some one must be blamed for the failure I selected to bear this blame. I write these facts so that in case any accident should befall may be able to vindicate my memory. As I am not writing to Lewis by this mail I wish to share with him the contents of this letter—but of course you will let no body else see those contents—In haste lovingly yours. Father

63 Florvil Hyppolite (1828–96), president of Haiti from 1889 to 1896.

47. Frederick Douglass to Lewis Henry Douglass, [Port-au-Prince, Haiti], March 7, 1891

March 7. 1891

My dear Lewis.

I am anxious for further
news touching Amelia's health. My
absence from home has been marked
by so many changes and some of
them so distressing that I feel quite
easily alarmed when I am told
of ailments in our circle. Mrs
Douglass though some better is still
down with rheumatic fever. I
am nothing to brag of, but I
still keep on my feet — to do
which is considered very well
for a man of my years in

in such a climate. The story
that I have resigned and am
to be home in May has reached
here. But there is no truth in it.
People who know my staying
qualities ought to know better.
Chase possibly had some object
in setting such stories afloat—
He is off last year with the
same story. One would think
that people would distrust
the statements of a man who
never tells the truth when
he thinks it to his interest

to tell something else. I am
very anxious to know how
Fred made out in obtaining
a situation. I shall never
forget that Mr Bruce might
and did not recall him him
at the Recorders office. The
more I think of Fred's care,
the more I see the need
which a young man has
of making and keeping
friends with men of his
day and generation. A
man who does not care
for any body is apt to

47. Frederick Douglass to Lewis Henry Douglass, [Port-au-Prince, Haiti], March 7, 1891

to feel in the end that
Nobody cares for him. In
respect Frank has been unwise
He has never push himself in
the way of making personal
friends. He has met the world
with a frown. It will be well
for him if his past experience
makes him more amiable
to his surroundings. Please
get the enclosed to Henry
Make my love to Amelia
and to our dear Joe.

Affectionately
your Father.

47. Frederick Douglass to Lewis Henry Douglass, [Port-au-Prince, Haiti], March 7, 1891

My dear Lewis:

 I am anxious for further news touching Amelia's health. My absence from home has been marked by so many changes and some of them so distressing that I feel quite easily alarmed when I am told of ailments in our circle. Mrs. Douglass though some better is still down with rheumatic fever. I am nothing to brag of, but I still keep on my feet—to do which is considered very well for a man of my years in in [sic] such a climate. The story that I have resigned and am to be home in May has reached here. But there is no truth in it. People who know my staying qualities ought to know better. Chase possibly has some object in setting such stories afloat—He led off last year with the same story. One would think that people would distrust the statement of a man who never tells the truth when he thinks it to his interest to tell something else. I am very anxious to know how Fredk made out in obtaining a situation. I shall never forget that Mr Bruce might and did not reinstate him in the Recorders office. The more I think of Freds case, the more I see the need which a young man has of making and keeping friends with men of his day and generation. A man who does not care for any body is apt to to find in the end that nobody cares for him. In respect Fredk. has been unwise. He has never put himself in the way of making personal friends. He has met the world with a frown. It will be wise for him if his past experience makes him more amiable to his surroundings. Please get the enclosed to Henry. Make my love to Amelia and to our dear Joe.

 Affectionately
 Your father.

48. Frederick Douglass to Catherine Swan Brown Spear, Cedar Hill, Washington, DC, March 7, 1892

Cedar Hill.
Anacostia, D.C.

March 7th 1892

Catherine Swan Brown Spear.

My dear friend: Thanks for your kind good friendly letter. I too feel the happier for my visit. You will feel sorry for us. Helen's precious mother died last Thursday and Helen with her two sisters have taken their mother's remains to western New York to place them in the family lot. Helen may not return for a week or more. I will keep your letter for her. We all miss the dear gentle mother. She was dear to us all. Though she was nearly blind and very deaf. She was very happy— and made others happy—

I do not know anything about the life

of our old friend Garnett. I have seen
no account of it—and hardly it
has been written. Please remember
me kindly to all your dear circle
I enjoyed the "concord of sweet sounds"
given me after the lecture. I never
heard Abel play better.

Very truly yours

Frederick Douglass

48. Frederick Douglass to Catherine Swan Brown Spear, Cedar Hill, Washington, DC, March 7, 1892

[Handwritten on the top in pencil: "Letter to Grandmother Spear from the negro lecturer, Frederick Douglass"]

March 7th 1892

Catherine Swan Brown Spear.[64]

My dear friend: Thanks for your kind good friendly letter. I too feel the happier for my visit. You will feel sorry for us. Helen's precious mother died last Thursday and Helen with her two sisters have taken their mother's remains to Western New York to place them in the family lot. Helen may not return for a week or more. I will keep your letter for her. We all miss the dear gentle mother. She was dear to us all. Though she was nearly blind and very deaf—she was very happy—and made others happy.

I do not know anything about the life of our old friend Garnett [sic].[65] I have seen no account of it and hardly it has been written. Please remember me kindly to all your dear circle. I enjoyed the "concord of sweet sounds" given me after the lecture. I never heard Abel play better.

Very truly yours
Frederick Douglass

64 Catherine Swan Brown Spear (b. 1814), white US reformer and temperance advocate.

65 Henry Highland Garnet (1815–82), abolitionist, author, educator, and reformer. While Douglass had initially voted against Garnet's advocacy of radical rebellion in his "Address to the Slaves of the United States of America," when the speech came up for debate at the National Convention of Colored Citizens in Buffalo, New York, in 1843, he soon endorsed his radical philosophy of Black liberation.

49. Frederick Douglass to Charles Remond Douglass, Exposition Universelle de Chicago, Haitian Pavilion, Chicago, IL, October 7, 1893

EXPOSITION UNIVERSELLE DE CHICAGO,
PAVILLON HAITÏEN.

Jackson Park, Oct 7th 1893.

My dear Charley.

Thanks for your good letter and copy of the Lewis letter. I agree with you as to its damaging character. I see not how with this evidence before it the Senat can confirm this crafty bad man—I glory in your spirit. While I should be sorry to have you lose your place. I should regret much more should you fail to do your whole duty in this contest.

I am still suffering from my cough and am tempted to break away and come home. The climate here is very much moist and changeable. And I do not recover from one cold before I am down with another. I shall try however to pull through to the end of the Fair. I have just returned from Detroit. I lectured there to a good audience Thursday night. Many of the best people of the city were out to hear me—and among them my friend Genl Alger. I saw several members of George Clarks family. They all inquired kindly for you. Joseph H. is still in Chicago—but I think will soon be off with his musical company. He is playing finely—but I urge him on to perfection. I note what you say of the fruit at Cedar hill. It grieves me much that trees I have planted with so much care—and fruit that should minister to our comfort and happiness—are going to waste. I should be glad if you would have my winter apples and pears picked and saved so that I can have a little apple sauce the coming winter. They might be put in barrells—and left just back of the study. Please see to this—and take besides for your own use all the fruit you need—To cure my writing

49. Frederick Douglass to Charles Remond Douglass, Exposition Universelle de Chicago, Haitian Pavilion, Chicago, IL, October 7, 1893

I dictate so much and write so little that I am losing my facility for writing. I shall rejoice when I can again plant my feet on Cedar Hill. It seems hard to have such a home and enjoy it so little. Still, perhaps I ought to be contented. I am certainly doing some good in the life I am living. I am holding up the standard for my people— You would be proud to see respect and esteem I am every where commanding for my people as well as for myself. Please make my love to Laura and Haley— I wish you lived near enough to Cedar Hill to give an eye to the place while I am absent.

Your affectionate father

Fred.k Douglass

EXPOSITION UNIVERSELLE DE CHICAGO,
PAVILLON HAÏTIEN.

Charles R. Douglass

318. A. St. N. East

Washington D.C.

3.ᵉ
Frederick to Charles
Study of Standard
for my people

Oct
1893.

49. Frederick Douglass to Charles Remond Douglass, Exposition Universelle de Chicago, Haitian Pavilion, Chicago, IL, October 7, 1893

Exposition Universelle de Chicago, Pavilion Haitïen, Jackson Park October 7, 1893.[66]

My dear Charley.

Thanks for your good letter and copy of the Lewis letter. I agree with you as to its damaging character. I see not how with this evidence before it the Senate can confirm this crafty bad man—I glory in your spirit. While I should be sorry to have you lose your place, I should regret much more should you fail to do your whole duty in this contest.

I am still suffering from my cough and am tempted to break away and come home. This climate here is very ~~most~~ moist and changeable, and I do not recover from one cold before I am down with another. I shall try however to pull through to the end of the Fair. I have just returned from Detroit. I lectured there to a good audience Thursday night. Many of the best people of the city were out to hear me and among them my friend Genl. Alger.[67] I saw several members of George Clark's family. They are enquired kindly for you. Joseph H. is still in Chicago but I think will soon be off with his musical company—He is playing finely but I urge him on to perfection. I note what you say of the fruit at Cedar Hill. It grieves me much that trees I have planted with so much care—and fruit that should minister to our comforts and happiness—are going to waste. I should be glad if you would have my winter apples and pears picked and saved so that I can have a little apple sauce the coming winter. They might be put in barrels and left just back of the study. Please see to this—and take besides for your own use all the fruit you need. Excuse my writing I dictate so much and write so little that I am losing my facility for writing. I shall rejoice when I can again plant my feet on Cedar Hill. It seems hard to have such a home and enjoy it so little. Still, perhaps I ought

66 The World's Columbian Exposition was held in Chicago in 1893 in honor of Christopher Columbus's voyage to the Americas in 1492. A photographic archive is held at the University of Chicago and can be viewed online at <http://photoarchive.lib.uchicago.edu/db.xqy?one=apf3-00127.xml> (accessed January 14, 2018).

67 Russell Alexander Alger (1836–1907), at the time of this letter, had been US governor of Michigan and would go on to become US Secretary for War. He had fought during the Civil War at Boonesville and Gettysburg.

[49] to be content. I am certainly doing some good in the life I am living. I am holding up the standard for my people—You would be proud to see respect and esteem I am every where commanding for my race as well as for myself. Please make my love to Laura and Haley—I wish you lived near enough to Cedar Hill to give an eye to the place while I am absent.

Your affectionate father
Fredk. Douglass

50. Haley George Douglass to Frederick Douglass, Washington, DC, March 3, 1893

Washington, D.C.
March, 3rd 1893.

Dear Grandpa

I received the flute you kindly sent me last evening. I can play a little on it now, but I think after a while I will be able to play much better. I am more than thankful to you for it.

Your affectionate Grandson,
Haley George Douglass.

50. Haley George Douglass to Frederick Douglass, Washington, DC, March 3, 1893

Washington, D.C.

March, 3rd 1893.

Dear Grandpa

I received the flute you kindly sent me last evening. I can play a little on it now, but I think after a while I will be able to play much better. I am more than thankful to you for it.

Your affectionate Grandson,

Haley George Douglass.

51. Frederick Douglass to Haley George Douglass,
Cedar Hill, [Washington, DC], March 7, 1893

Cedar Hill: March. 7th 1893.

My dear Haley Douglass

Your letter of thanks for the
Flute I had the pleasure to
give you, was duly received
by me this morning. Mrs
Douglass & and I, both agreed
that your letter was a nice one.
Go on, my dear boy, you are a
boy now, but you will be a man
some day, and I hope a wise and
good man. Your affectionate
Grand pa

Frederick Douglass

51. Frederick Douglass to Haley George Douglass, Cedar Hill, [Washington, DC], March 7, 1893

Cedar Hill: March. 7th 1893.

My dear Haley Douglass,

 Your letter of thanks for the Flute I had the pleasure to give you, was duly received by me this morning. Mrs. Douglass and I, both agreed—that your letter was a nice one—Go on, my dear boy, you are a Boy now, but you will be a man some day—and I hope a wise and good man. Your affectionate

 Grand pa

 Frederick Douglass

52. Lewis Henry Douglass to Helen Amelia Loguen Douglass, [Washington, DC], December 19, 1894

LEWIS H. DOUGLASS,
Real ✦ Estate ✦ Broker,
609 F Street. N. W.,
(Room 11.)

Washington, D. C. *Dec. 19* 189 4

My Dear Amelia, Your letter came to
hand the 13th inst. I have delivered all
the messages it contained. Christmas is
near at hand. Fred wants to go home that
day and Rosa wants to go to the Home
So I will have to get my dinner at a restau-
rant and wander around town or stay
in the office all day. I took dinner at
father's thanksgiving day and I can't ex-
pect to go over there for a dinner on Xmas.
Mrs. Briggs (aunt Eveline) is very sick
and may not live. Henrietta Watkins
through my efforts, is at the Hospital for
a trained nurse's course. She is an old
friend of Annie's. By the way you did
not mention Annie in any of your
last letters. She says that she will write by
this mail. I hope that the papers I am
sending you may interest you and
Tin too. What is the fare from where
you are to San Domingo City and
back? I would like for you to see

587

52. Lewis Henry Douglass to Helen Amelia Loguen Douglass, [Washington, DC], December 19, 1894

that place if possible. What does Tin
say to that. If it dont cost too much it
might be a good thing. Miss Atwood says
that Mrs. Pardo knows of a good place to stop
in that city. Of course if it would be extrava-
gant to go there then dont think of it. I
have at last succeeded in getting Irene Brown
in the Recorder's office. Willis Madden sends
regards to Kitty and to you. Ruen is making
a plum pudding for father. I may have to go
to Rochester soon. I will, of course, take in
Syracuse. Mrs. Mary Cooper has written me
a letter she thinks you have changed because you
did not let her know about leaving. I wrote her
and told her you left with unexpected sudden-
ness, and that we had to inform Kate by
telegraph. You are in a new country and
find plenty with which to fill a letter. There
is nothing out of the usual here. I inclose
another $10 which may come handy. Give
my love to Tin. Tell me whether you get the news-
papers all right or not. I shall have Ed.
send the New York World and Tribune
the day the boat sails so that you may
have the latest news. All are well at the
house. Kiss Kitty and Gregoria for me.
 As ever Lew.

52. Lewis Henry Douglass to Helen Amelia Loguen Douglass, [Washington, DC], December 19, 1894

December 19 1894

My Dear Amelia, Your letter came to hand the 13th inst. I have delivered all the messages it contained. Christmas is near at hand. Fred wants to go home that day and Rosa wants to go to the Home so I will have to get my dinner at a restaurant and wander around town or stay in the office all day. I took dinner at father's thanksgiving day and I can't expect to go over there for a dinner on Xmas. Mrs. Briggs (aunt Eveline) is very sick and may not live. Henrietta Watkins, through my efforts, is at the Hospital for a trained nurse's course. She is an old friend of Annie's. By the way you did not mention Annie in any of your last letters. She says that she will write by this mail. I hope that the papers I am sending you may interest you and Tin too. What is the fare from where you are to San Domingo City and back? I would like for you to see that place if possible. What does Tin say to that. If it don't cost too much it might be a good thing. Miss Astwood says that Mrs. Pardo knows of a good place to stop in that city. Of course if it would be extravagant to go there then don't think of it. I have at last succeeded in getting here Brown in the Recorder's Office. Willis Madden sends regards to Kitty and to you. Rosa is making a plum pudding for father. I may have to go to Rochester soon. I will, of course, take in Syracuse. Mrs. Mary Cooper has written me a letter she thinks you have changed because you did not let her know about leaving. I wrote her and told her you left with unexpected suddenness, and that we had to inform Mate[*] by telegraph. You are in a new country and find plenty with which to fill a letter. There is nothing out of the usual here. I inclose [sic] another $10 which may come handy. Give my love to Tin. Tell me whether you get the newspapers all right or not. I shall have Ed. send the New York World and Tribune the day the boat sails so that you may have the latest news. All are well at the house. Kiss Kitty and Gregoria[†] for me.

As ever

Lew.

[*] Mary Loguen Cromwell (Amelia's sister).

[†] Gregoria Alejandrina Fraser Goins (daughter of Charles Fraser and Sarah Loguen).

LEWIS H. DOUGLASS,
Real ÷ Estate ÷ Broker,
934 F Street N. W.,
ROOM 11.

Washington, D. C. *Jany 20* 189*5*

My Dear Amelia: Yours by the New York
reached me on the 16th inst. We were all anx-
ious to hear from you. We are all well.
Jennie Crummell sent me a nice mince
pie last week, also a fine pin cushion
for you. Aunt Luckett is here stopping
at Charley Shorters. We went over to fathers
Thursday night. Father was more than
glad to see her. She sends love to you and
Jim. By the way you say nothing of Jim.
How is he? Has she perfected her plans?
Joe's farewell concert was a success.
Father and Joe played "Home Sweet
Home" together. It was very affecting and
was received with great applause. It took
place Friday night the 18th. Henrietta
Watkins has backed out of the hospital
already. She is not an Annie Simmes.
Annie is at the head of her ward, I
am glad Kitty is not here. The small pox
has attacked a pupil in the Magruder
Building. I am afraid we will have it

53. Lewis Henry Douglass to Helen Amelia Loguen Douglass, [Washington, DC], January 20, 1895

around for some time yet. My vaccina-
tion "took." I have given all the messages
you sent in your letter, I send every next
Saturday's Star and have asked Eato
to send two New York papers the day the
boat sails. So you ought to have had
quite a lot of reading matter each
Steamer. I had Mrs. Barier Ella and
Mrs. Cooper to dinner one evening
last week. The old lady is quite
pleasant. I have been before the Grand Jury
as a witness in the case of Taylor and
Chase. Taylor has had Chase arrested
for libel. I think Chase will get it this
time. He makes some terrible charges
against Taylor as to lewdness. I think the
trial will be rich. I think I told you that
Irene Brown has been appointed in the
Recorders office. I have not found time
to get to Syracuse yet. I expect to go soon.
I send ten dollars in this letter. I think it is
well to have money away from home.
this will make fifty dollars I have sent.
I see by the Tribune that the boat will sail
Tuesday so I am writing at home to-day
(Sunday) Gregoria's and Kitty's letters were
very pleasant to me, I wish you would

591

LEWIS H. DOUGLASS,

Real + Estate + Broker,

934 F Street N. W.,

ROOM 11.

Washington, D. C., _____ 189_

thank them for sending them.

What does Tin think of doing? It
wouldn't be nice to think of remaining in
that country. Of course I can't tell away
up here how things are down there.
I think however that it is not the place
for a lone woman with a child and
the child a girl. Do you hear or know
any thing of Mrs "Poe" Spencer's friends
down there? If you do write me about
them so that I may tell Poe.

I should have been delighted to have seen Kit
and Greg. Christmas day. There was a
little girl here Xmas eve. She stayed all
night. She is Rosa's niece named Gertie
She had no Christmas anticipations. So I
sent Fred out and she bought a pair
of stockings for the little girl and hung
them up and Santa Claus brought her
something. A doll, nuts, candies, oranges
&c &c. The next morning the child was
delighted. I gave her a two cent piece

53. Lewis Henry Douglass to Helen Amelia Loguen Douglass, [Washington, DC], January 20, 1895

as my Xmas present to her besides using my influence with Santa Claus. Gertie Page is to dine with us to-day. She is a very practical some body and has proposed to come over here from fathers and do any mending that I might want done. She is quite gray and not yet 27. I saw a letter to her from her father in which he expresses his regret that his daughter cant meet you. She is a chip off of the old block and every body likes her

Daisy Nahar is stopping at fathers and she and Dr. Foy are at it hammer and tongs. Of course you know Foy is a medical student at Howard. Give my love to Tin. Tell her if there is any-thing that she wants me to do to let me know.

It is a good thing that the children can enjoy themselves give my love to them. Tell Kitty the reason I love her is because she loves me and I dont want her to forget me while she is having everything so pleasant I am glad she has a good appetite

As ever

Lew

53. Lewis Henry Douglass to Helen Amelia Loguen Douglass, [Washington, DC], January 20, 1895

Jan'y 20 1895

My Dear Amelia: Yours by the New York reached me on the 16th inst. We were all anxious to hear from you. We are all well. Jennie Crummell[68] sent me a nice mince piece last week, also a fine pin cushion for you. Aunt Luckett is here stopping at Charley Shorter's. We went over to father's Thursday night. Father was more than glad to see her. She sends love to you and Tin. By the way you say nothing of Tin. How is she? Has she perfected her plans? Joe's farewell concert was a success. Father and Joe played "Home Sweet Home" together. It was very affecting and was received with great applause. It took place Friday night the 18th. Henrietta Watkins has backed out of the hospital already. She is not an Annie Simms. Annie is at the head of her ward. I am glad Kitty is not here. The small pox has attacked a pupil in Magruder Building.[69] I am afraid we will have it around for some time yet. My vaccination "took." I have given all the messages you sent in your letter. I send every week Saturday's Star and have asked Eato to send two New York papers the day the boat sails. So you ought to have had quite a lot of reading matter each steamer. I had Mrs. Barrier Ella[70] and Mrs. Cooper to dinner an evening last week. The old lady is quite pleasant. I have been before the Grand Jury as a witness in the case of Taylor and Chase.[71] Taylor has had Chase arrested for libel. I think Chase will "get it" this time. He makes some terrible charges against Taylor as to lewdness. I think the trial will be rich. I think I told you that Irene Brown has been appointed in the Recorder's office. I have not found time to get to Syracuse yet. I expect to go soon. I send ten dollars in this letter. I think it is well to have money away from home. This will make fifty dollars I have sent. I see by the Tribune that the boat will sail Tuesday so I am writing at home

68 Jennie Crummell, second wife of Alexander Crummell (1819–98), minister, academic, and advocate of pan-African nationalism.

69 The William Beans Magruder School, opened in 1887 in Washington, DC.

70 Harriet A. Barrier (1835–1915) and her daughter Ella D. Barrier (1852–1945), who taught in Washington, DC schools over forty years.

71 Charles Henry James Taylor (1857–99), US journalist and political organizer, was at the time of this letter Recorder of Deeds for the District of Columbia (a position Frederick Douglass had held between 1881 and 1886). Chase had accused Taylor of political corruption and inappropriate sexual behaviour, prompting Taylor to sue for criminal libel. Chase was convicted and imprisoned for ninety days.

to-day (Sunday) Gregoria's and Kitty's letters were very pleasant to me. I wish you would thank them for sending them.

What does Tin think of doing? It wouldn't be wise to think of remaining in that country. Of course I can't tell away up here how things are down there. I think however that it is not the place for a lone woman with a child and the child a girl. Do you hear or know any thing of Miss "Pen" Spencer's friends down there? If you do write me about them so that I may tell Pen.

I should have been delighted to have seen Kit and Greg. Christmas day. There was a little girl here Xmas eve. She stayed all night. She is Rosa's niece named Gertie.[*] She had no Christmas anticipations. So I sent Fred[†] out and she bought a pair of stockings for the little girl and hung them up and Santa Claus brought her something. A doll, nuts, candies, oranges &c &c. The next morning the child was delighted. I gave her a ten cent piece as my Xmas present to her besides using my influence with Santa Claus. Gertie Page[72] is to dine with us to day. She is a very practical somebody and has proposed to come over here from fathers and do any mending that I might want done. She is quite gray and not yet 27. I saw a letter to her from her father in which he expresses his regret that his daughter cant meet you. She is a chip off of the old block and every body likes her.

Daisy Nahar is stopping at father's and she and Dr. Foy are at it hammer and tongs. Of course you know Foy is a medical student at Harvard. Give my love to Tin. Tell her if there is anything that she wants me to do, to let me know.

It is a good thing that the children can enjoy themselves give my love to them. Tell Kitty the reason I love her is because she loves me and I don't want her to forget me while she is having every thing so pleasant. I am glad she has a grand appetite.

As ever

Lew

72 Gertie Page is Florence Gertrude Page (1862–1917), who studied at Howard University and boarded in a house owned by Frederick Douglass and Helen Pitts Douglass in Washington, DC. In later oral testmony, she stated that she had found Frederick Douglass's body when he collapsed from a heart attack. For more information, see the following link: <https://knappmuseum.word-press.com/historical-documents/the-page-family-part-iii/> (accessed January 14, 2018).

* Gertrude Pearl Douglass.

† Fredericka Douglass Sprague..

54. Lewis Henry Douglass to Helen Amelia Loguen Douglass, [Washington, DC], January 30, 1895

LEWIS H. DOUGLASS,

Real + Estate + Broker,

609 F Street, N. W.,

(ROOM 11.)

Washington, D. C. *Jan'y* 30 189 5

My Dear Amelia: Yours, per Saginaw, at hand
We are all well. Miss Gertie Page has been
spending a few days with Fred. which makes
it very pleasant. You would like her. She is
much like her father. She is visiting father.
I had Mrs. Barrier, daughter, and Mrs.
Cooper to dinner a few days ago. May
be I mentioned it in my other letter.
If I did I have forgotten it. I had some
of Joe's friends last Thursday night to
meet a Mr. Hodges a singer from
Boston who volunteered and did assist
Joe in his farewell concert. I have mailed
you the Colored American containing no-
tices of the concert. I have also mailed the
Calendars you ask for. We are having
a good deal of bad weather. At this time
sleighing is very good. Tell Kitty that
Frederick is going coasting with her
sled. I told her that if she broke it
she would have to buy Kitty a new one
and she has agreed to my terms. How

I would like to see all of you. Kitty would
be delighted here now. The small pox is
abating. Aunt Luckett is still here. She
spent one day at father's. Geo. Cook does
not come to our house. I don't understand
it. Do you? I am sorry to hear that you have
been sick. I am going to Rochester Saturday
night. I will have the first Sunday there
that I have had in twenty-five years. As
soon as I get through with Rochester I
will go to Syracuse Mrs. Storum got after
me the other day and tried to explain
why she did not bid you good bye. She
says you always averted your face when
she was standing at the door as if you did
not want to speak to her and that you
and I both talked about her saying
that she had prejudice. I asked her to
tell me her authority for her assertion.
She did not give it, thus showing the
meanest kind of prejudice. For there can
be nothing meaner than judging a person
on reports from cowards who do not
want their names given. You are certainly
economical. I send a five dollar bill
in this letter. It is well to have money
by you when you are away from home

LEWIS H. DOUGLASS,
Real + Estate + Broker,
609 F Street. N. W.,
(ROOM 11.)

(2)

Washington, D. C. _____ 189_

Rosa's plum pudding was without very fine. She watched you make it to come purpose. We try to treat her well as you know. On the whole she does well but the "nigger" will show itself once in a while. She seems to feel that good herin and good looks in others are a wrong to her. Rosa Sprague frequently comes in for a night. Does Kitty learn anything at school? Will she be able to go on when she returns? I hope she will come back the same Kitty that ran down the gang plank and gave me last tug the morning you sailed. I wonder if she will ever realize just how much she is to me. And then to think how completely I have had to give her up this winter when I thought she would be here. The sleigh bells are jingling and the people are very merry. Kitty and I would have taken some of it in. Sleighing has been good for the past four days. I send Sunday Post

marked and Tuesdays Post marked.
Everybody sends remembrances to you and
Tim. I have not seen Annie Simons this
week. She is a woman that shows what
determination can do. Without any
worthy advantage of schools she has
force into the hospital and become
one of the most trusted of the nurses. It
does seem to me that the self made col-
ored people out strip the college folks.
Henrietta Watkins was much liked but
her health failed her and she resigned.
She wished to be remembered to you
Renie Brown seems to be grateful and so
does her mother. Renie begins to look better
already. Fred. attracts a good deal of
young company to which I do not object
of course. there is a young theological
student who seems to be impressed with
the damsel and Fred. evidently thinks
it very great Charley Morris has been
here and paid father three hundred
dollars borrowed money but refuses to
pay Annie's funeral expenses. Damn
him. Love to all. I hope Tim will
come out all right. there is room here
for her at any time As ever
Lew.

54. Lewis Henry Douglass to Helen Amelia Loguen Douglass, [Washington, DC], January 30, 1895

Jan'y 30 1895

My Dear Amelia: Yours, per Saginaw, at hand We are all well. Miss Gertie Page has been spending a few days with Fred. which makes it very pleasant. You would like her. She is much like her father. She is visiting father. I had Mrs. Barrier[73], daughter Ella and Mrs. Cooper[74] to dinner a few days go. May be I mentioned it in my other letter. If I did I have forgotten it. I had some of Joe's friends last ~~Friday~~ Thursday night to meet a Mr. Hodges a singer from Boston who volunteered and did assist Joe in his farewell concert. I have mailed you the Colored American[75] containing notices of the concert. I have also mailed the Calendars you ask for. We are having a good deal of bad weather. At this time sleighing is very good. Tell Kitty that Fredericka is going coasting with her sled. I told her that if she broke it should have to buy Kitty a new one and she has agreed to my terms. How I would like to see all of you. Kitty would be delighted here now. The small pox is abating. Aunt Luckett is still here. She spent ~~the~~ one day at father's. Geo. Cook[76] does not come to our house. I don't understand it. Do you? I am sorry to hear that you have been sick. I am going to Rochester Saturday night. I will have the first Sunday there that I have had in twenty-five years. As soon as I get through with Rochester I will go to Syracuse. Mrs. Storum got after me the other day and tried to explain why she did not bid you good bye. She says you always averted your face when she was standing at the door as if you did not want to speak to her and that you and I both talked about her saying that she had prejudice. I asked her to tell me her authority for her assertion. She did not give it, thus showing the worst kind of prejudice. For there can be nothing meaner than judging a person on

73 Frances Barrier Williams (1855–1944), an educator, political campaigner, and activist.
74 Anna Julia Coooper (1858–1964), an philosopher, educator, speaker, campaigner, and author.
75 *The Colored American* was a weekly newspaper, founded in 1893 and published in Washington, DC until 1904. Written by and aimed at a Black readership, this newspaper was founded by editor and publisher Edward Elder Cooper, who had been born into slavery in Duval County, Florida, in 1859 and who died in 1908.
76 George William Cook, who was born into slavery in Winchester, Virginia in 1855 and died in Washington, DC in 1931. He was a close friend of the Douglass family.

reports from cowards who do not want their names given. You are certainly economical. I send a five dollar bill in this letter. It is well to have money by you when you are away from home.

Rosa's plum pudding was without doubt very fine. She watched you make it to some purpose. We try to treat her well as you know. On the whole she does well but the "nigger" will show itself once in a while. She seems to feel that good hair and good looks in others are a wrong to her. Rosa Sprague* frequently comes in for a night. Does Kitty learn anything at school? Will she be able to go on when she returns? I hope she will come back the same Kitty that ran down the gang plank and gave me last tag the morning you sailed. I wonder if she will ever realize just how much she is to me. And then to think how completely I have had to give her up this winter when I thought she would be here. The sleigh bells are jingling and the people are very merry. Kitty and I would have taken some of it in. Sleighing has been good for the past four days. I send the Sunday Post marked and Tuesdays Post marked. Everybody sends remembrances to you and Tin. I have not seen Annie Simms[77] this week. She is a woman that shows what determination can do. Without any worthy advantage of school she has gone into the hospital and become one of the most trusted of the nurses. It does seem to me that the self made colored people out strip the college folks. Henrietta Watkins was much like but her health failed her and she resigned. She wished to be remember to you Renie Brown seems to be grateful and so does her mother. Renie begins to look better already. Fred. attracts a good deal of young company to which I do not object of course. There is a young theological student who seems to be impressed with the damsel and Fred. evidently thinks it very great. Charley Morris[78] has been here and paid father three hundred dollars borrowed money but refuses to pay Annie's funeral expenses. Damn him. Love to all. I hope Tin will come out all right. There is room here for her at any time. As ever,

Lew.

77 Annie Simms Banks (1862–1963), an African American educator and political campaigner.
78 Charles Satchell Morris (1865–1931), an African American journalist and editor, married Annie Douglass Sprague.
 * Rosabelle Mary Sprague.

55. Lewis Henry Douglass to Helen Amelia Loguen Douglass, Washington, DC, February 18, 1895

LEWIS H. DOUGLASS,
Real ÷ Estate ÷ Broker,
609 F Street. N. W.,
(Room 11.)

Washington, D. C. Feby 18 1895

Dear Amelia: We are all well. Your letter reached me Saturday the 16th inst. I reached home from Syracuse Wednesday the 13th inst. My experience up north was something to remember. I can only remember such cold weather as that of last week as we were having in 1854. I was hemmed in and a prisoner, as it were, in Syracuse. The cold was intense, the thermometer registering 19 below zero in Syracuse and along the line of the New York Central Railroad. I had to go north in the matter of the Rochester property. I had heard nothing from the property in the way of money since August. I have made Gertie Blackall agent. I collected $104 while I was up there and paid taxes and my expenses and turned over $60 to Rosetta. I get nothing for my time, trouble and care. I am glad to know that the money I send is considered as a sensible thing to do. Fredericka has

55. Lewis Henry Douglass to Helen Amelia Loguen
Douglass, Washington, DC, February 18, 1895

told you of the trouble with the pipes. I am
having them thoroughly repaired. It will
cost a considerable sum. I hope Tin can
arrange so as to leave San Domingo. What
are the prospects? Her money can be in-
vested in the United States at good profit
as soon as the financial muddle here
is settled. It is now in a fair way of being
straightened out. You will let me know
definitely as to your coming home so
that I can come to New York. This letter
ought to reach you by the 2d of March at
furthest. I would take the latest steamer
in April so as to get as far away
from the March storms as possible. We
have not gotten over the ocean disasters
of this winter and are considerably
worked up by them. I sent you full accounts
by papers mailed by last steamer. I send by
this mail more papers. I send a funny paper
which will enliven you Tin and the chil-
dren. I tried to get Trilby in pamphlet form
for Tin but have been unable to find it.
It is the latest rage. It appeared in
Harper's Monthly. I guess you read it. If I
can find it for this mail will send
it. Well I left here on the night of the

LEWIS H. DOUGLASS,
Real + Estate + Broker,
609 F Street. N. W.,
(Room 11.)

Washington, D. C. _____ 189

2d inst, for Rochester. I took a sleeper but I
arranged with the porter to furnish me blan-
kets and two pillows and not make up my
bed. So I sat up down the curtains and rested
better than I do lying down. I did the same
coming back. I found everything about the
same at Mate's. She hustling for the support
of the family as usual. She is a brave woman
and ought to have had an appreciative
husband. Aunt Tin has not looked so well
in a long time. I gave her a boute of money.
I was up to Loguen's two evenings and the
boys sang for me nicely. Charley seems to
be the favorite because of his looks. Gerrit
is in my opinion the boy of force and
ability. Lewis don't seem so promising. Jer-
maine is quite another fellow. He is steady
reads books which Gerrit lends him
and is not out on the corners any more.
I gave him a pair of arctics to keep his feet
warm. I did not make Mela any present
this time as I gave her a dress in the

55. Lewis Henry Douglass to Helen Amelia Loguen Douglass, Washington, DC, February 18, 1895

summer when I went after Kitty. Tell Kitty
that this is a big dog now and is very
much thought of by the family. The Riers are
all the same and send love. Hattie, Chloe
sends love and Louise Johnson. Mrs. Blackall
and Mrs. Lucy N. Coleman I called on
Minnie Blackall Bishop on West Onon-
daga St. I had not seen her for thirty years
She and her husband invited me to dinner
but I had to leave next day so could
not accept. Annie Simms is on night duty
and has to go to bed at ten in the morning
and stay till six in the evening. I have
seen her but once in a month. She
stole out one morning last week and
came to the house before I left for the
office. Inclosed find $10. Give Kitty 25 cents for me. Do
the same for Gregoria. See why you don't know how I miss her
I want to see the whole gang of you. I certainly feel sorry for Tim,
I am keeping a stiff upper lip and shall be glad enough when
you can all be home. Gatie Page has gone back to painting. Father
likes her very much, and thinks she ought to stay at his
house all the time. She has done some mending for me. She
is very willing. Deil has young company which makes
it quite lively up our house. I sent you papers from Syra-
cuse. One was a paper given over to the women to
be edited by them for one day. Give my love to
Tim Kitty and Gregoria. I shall ask Eato to
send Wednesday's N.Y. papers to you. The boat
is advertised to sail Wednesday. I am not satisfied
with this letter. Gerrit is carried away with
your letters to Mate. Write him one
 as ever Lew

605

55. Lewis Henry Douglass to Helen Amelia Loguen Douglass, Washington, DC, February 18, 1895

Feb'y 18 1895

Dear Amelia: We are all well. Your letter reached me Saturday the 16th inst. I reached home from Syracuse Wednesday the 13th inst. My experience up north was some thing to remember. I can only remember such cold weather as that of last week as occurring in 1854. I was hemmed in and a prisoner, as it were, in Syracuse. The cold was intense, the thermometer registering 19 below zero in Syracuse and along the line of the New York Central Railroad. I had to go north in the matter of the Rochester property. I had heard nothing from the property in the way of money since August. I have made Gertie Blackall agent. I collected $104 while I was up there and paid taxes and my expenses and turned over $60 to Rosetta. I get nothing for my time, trouble and care. I am glad to know that the money I send is considered as a sensible thing to do. Fredericka has told you of the trouble with the pipes. I am having them thoroughly repaired. It will cost a considerable sum. I hope Tin can arrange so as to leave San Domingo. What are the prospects? Her money can be invested in the United States at good profit as soon as the financial muddle here is settled. It is now in a fair way of being straightened out. You will let me know definitely as to your coming home so that I can come to New York. This letter ought to reach you by the 2d of March at furthest. I would take the latest steamer in April so as to get as far away from the March storms as possible. We have not forgotten over the ocean disasters of this winter and are considerably worked up by them. I sent you full accounts by papers mailed by last steamer. I send by this mail more papers. I send a funny paper which will enliven you Tin and the children. I tried to get Trilby in pamphlet form for Tin but have been unable to find it. It is the latest rage. It appeared in Harper's Monthly.[79] I guess you read it. If I can find it for this mail will send it. Well I left here on the night of the 2d inst., for Rochester. I took a sleeper but I arranged with the porter to furnish me blankets and two pillows and not make up my bed. So I sat up drew the curtains and rested better than I do lying down. I did the same coming back. I found everything about the same at Mate's. She hustling for the

79 *Trilby*, a novel by Franco-British author George du Maurier (1834–96), was published serially in *Harper's Monthly* in 1894, before appearing in book form the following year. In its first year of publication it sold 200,000 copies.

support of the family as usual. She is a brave woman and ought to have had an appreciative husband. Aunt Tin has not looked so well in a long time. I gave her a bottle of rum. I was up to Loguen's two evenings and the boys sang for me nicely. Charley seems to be the favorite because of his looks. Gerrit is in my opinion the boy of force and ability. Lewis don't seem so promising. Jermain is quite another fellow. He is steady reads books which Gerrit lends him and is not out on the corners any more. I gave him a pair of ___ [?] to keep his feet warm. I did not make Mela[80] any present this time as I gave her a dress in the summer when I went after Kitty. Tell Kitty that Chris is a big dog now and is very much thought of by the family. The Rices were all the same and send love. Hattie, Chloe sends love and Louise Johnson, Mrs. Blackall[81] and Mrs. Lucy N. Coleman.[82] I called on Minnie Blackall Bishop[83] on West Onandaga St. I had not seen her for thirty years. She and her husband invited me to dinner but I had to leave next day so could not accept. Annie Simms is on night duty and has to go bed at ten in the morning and stay till six in the morning. I have seen her but once in a month. She stole out one morning last week and came to the house before I left for the office. Inclosed [sic] find $10. Give Kitty 25 cents for me. Do the same for Gregoria. Gee whiz you don't know how much I miss her. I want to see the whole gang of you. I certainly feel sorry for Tin. I am keeping a stiff upper lip and shall be glad enough when you can all be home. Gertie Page has gone back to father's. Father likes her very much and thinks she ought to stay at his home all the time. She has done some mending for me. She is very willing. Fred has young company which makes it quite lively at our house. I sent you papers from Syracuse. One was a paper given over to the women to be edited by them for one day. Give my love to Tin Kitty and Gregoria. I shall ask Eato to send Wednesday's N.Y. Papers to you. The boat is advertised to sail Wednesday. I am not satisfied with this letter. Gerrit is carried away with your letters to Mate. Write him one.

As ever Lew

80 The Walter O. Evans collection holds a letter in Helen Amelia's correspondence by an author identified simply as Mela, written from Alabama. See the inventory at the end of this book.

81 Sarah Colman Blackall, a white US women's rights campaigner who lived in Rochester and was a close Douglass family friend.

82 Lucy N. Coleman (1817–1906), a white US abolitionist, women's rights campaigner, author, and friend of the family.

83 Minnie Blackall Bishop was the daughter of Sarah Colman and Burton F. Blackall and a radical campaigner in her own right.

56. Lewis Henry Douglass to Helen Amelia Loguen Douglass, Washington, DC, October 9, 1900

LEWIS H. DOUGLASS,
Real Estate Broker,
609 F ST. N. W.,
(Room 11.)

Washington, D. C. Oct. 9 ——— 189 1900

Dear Amelia: Thanks for beautiful present. Its a dandy. Sim gave me a globe so that I can travel in my mind all around the world. Reg gave me a necktie and Miss Nugent gave me a silver spoon for tea. It is cold today. I was expecting a call to Connecticut but it has not materialized yet. If you have not given Leon money for bicycle yet when you do so you should go with him and see him make the payment. I am glad that the recipients of Jermain's caresses are willing to settle. I hope that Mate is fully guaranteed that it is settled. Let me know just how it was done. Did you ever get a Tribune containing criticism of performance of David Harum in New York? Roland Johnson called Sunday evening and partook of guava jelly with us. There was a slight coolness observable on the part of some of the household but it wore off. Give my love to all. Kit got me expecting Maltese and then "treen" me down. Kisses for me. As use Lew.

56. Lewis Henry Douglass to Helen Amelia Loguen Douglass, Washington, DC, October 9, 1900

Oct. 9 1900

Dear Amelia: Thanks for beautiful present. It's a dandy. Tin gave me a globe so that I can travel in my mind all around the world. Greg gave me a necktie and Miss Nugent gave me a silver spoon for tea. It is cold today. I was expecting a call to Connecticut but it has not materialized yet. If you have not given Leon money for bicycle yet when you do so you should go with him and see him make the payment. I am glad that the recipients of Jermain's caresses are willing to settle. I hope that Mate is fully guaranteed that it is settled. Let me know just how it was done. Did you ever get a Tribune containing criticism of performance of David Hanem in New York? Roland Johnson called Sunday evening and partook of guava jelly with us. There was a slight coolness observable on the part of some of the household but it wore off. Give my love to all. Kit got me expecting ___ [?] and then "turn" me down. Kiss her for me.

As ever

Lew.

57. Lewis Henry Douglass to Helen Amelia Loguen Douglass, Washington, DC, July 5, 1905

LEWIS H. DOUGLASS,

Real Estate Broker,

2002 17th ST., N. W.,

Washington, D. C., July 5 1905

My Dear Amelia: So you are away up in Ogdensburg. Well that is quite distance up north. That is a fine country and full of Republicans. That is the banner county of Republicanism in the State of New York

Cassie Aunty has been appointed to school. We had a quiet time out to Susie Cook's It was a quiet day by reason of the stringent orders of the Chief of Police issued for the control of the 4th of July There were firecrackers in the day and rockets and balloons at night No heavy firing of cannons nor pistols

Say what have done with my new shirt the blue one I can't find it any where?

Haley came up to Cook's in the evening and we all sat on the porch and gazed at the fireworks We are all well here I am going to have Frenchy Tyson come up and get the picture. Mrs Tyson promised me that she would send for it Ellis Brown Supervising Principal of the colored schools is dead. Remember me to all,

As ever

Lewis H. Douglass

57. Lewis Henry Douglass to Helen Amelia Loguen Douglass, Washington, DC, July 5, 1905

July 5 1905

My Dear Amelia: So you are away up in Ogdensburg.[84] Well that is quite distance up north. That is a fine country and full of Republicans. That is the banner county of Republicanism in the State of New York.

Cassie ___ [?] has been appointed to school. We had a quiet time out to Susie Cook's. It was a quiet day by reason of the stringent orders of the Chief of Police issued for the control of the 4th of July. There were fire-crackers in the day and rockets and balloons at night. No heavy firing of cannons nor pistols.

Say what have done with my new shirt, the blue one. I can't find it any where?

Haley came up to Cooks in the evening and we all sat on the porch and gazed at the fire works. We are all well here. I going to have Frenchy Tyson come up and get the picture. Mrs. Tyson promised me that she would send for it. Ellis Brown Supervising Principal of the colored schools is dead. Remember me to all.

As ever
Lewis H. Douglass

84 A city in St. Lawrence County, New York.

WASHINGTON, D.C.
JUL 5
9 - PM
1905

Mrs. Lewis H. Douglass
424 Westcott St.
Syracuse, N. Y.

58. Lewis Henry Douglass, Scrapbook, Washington, DC, August 2, 1907

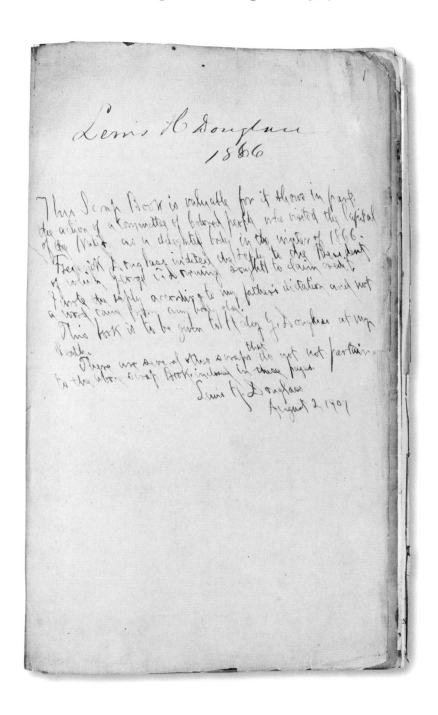

Lewis H. Douglass
1866

This Scrap Book is valuable for it shows in part the action of a committee of colored people who visited the Capital of the Nation, as a delegated body in the winter of 1866. Frederick Douglass indited the reply to the President of which George T. Downing sought to claim credit. I wrote the reply according to my father's dictation and not a word came from any body else.

This book is to be given to Haley G. Douglass at my death.

There are several other scraps that do not pertain to the above Scrap Book included in these pages.

Lewis H. Douglass
August 2, 1907

58. Lewis Henry Douglass, Scrapbook, Washington, DC, August 2, 1907

Lewis H Douglass

1866

This Scrap Book is valuable for it shows in part the action of a committee of Colored people who visited the Capital of the Nation as a delegated body in the winter of 1866.[85] Frederick Douglass indited [sic] the reply to the President of which George T. Downing[86] sought to claim credit. I wrote the reply according to my father's dictation and not a word came from any body else.

This book is to be given to Haley G. Douglass at my death.

There are several other scraps that do not not pertain to the above scrap Book, inclosed [sic] in these pages.

Lewis H. Douglass

August 2, 1907

85 Lewis Henry Douglass accompanied Frederick Douglass to the National Convention of Colored Men in Washington, DC, in February 1866.

86 George T. Downing (1819–1903) was an abolitionist and civil rights activist who had been born into freedom and who became a leading Underground Railroad conductor and radical reformer. At the National Convention of Colored Men, both Downing and Douglass addressed US president Andrew Johnson, urging him to support the Fourteenth Amendment guaranteeing equal protection under the law.

LEWIS H. DOUGLASS

CONVEYANCING. MAKING WILLS.

NOTARY PUBLIC

NO. 2002 17th ST. N. W.

Washington, D. C., Dec, 3, 1907.

W. J. Vernon Esq.,
Register of the Treasury,
Dear Sir: I have long
wished to have an opportunity for a consultation
with you. Owing to my ill health I have
never found it convenient to go, as now when I am rapidly
convalescing. You did me the honor of ex-
pressing your willingness to listen to me and I
am more than certain of my desire to hear you
express your views as to how the colored
voter should stand. If you will kindly designate
when I can see you at your home I will
avail myself of your kind consideration and
promptly attend on you at any time you see
fit to name. Yours respectfully,
Lewis H. Douglass

59. Lewis Henry Douglass to W. J. Vernon Esq., Washington, DC, December 3, 1907

Dec, 3, 1907

W. J. Vernon Esq.[87]

Register of the Treasury,

Dear Sir: I have long wished to have an opportunity for a consultation with you. Owing to my ill health I have never found it so convenient as now when I am rapidly convalescing. You did me the honor of expressing your willingness to listen to me and I am more than certain of my desire to hear you express your views as to how the colored voter should stand. If will kindly designate when I can see you at your home I will avail myself of your kind consideration and promptly attend on you at any time you see fit to name.

 Yours respectfully,
 Lewis H. Douglass

87 William Tecumseh Vernon (1871–1944), educator, minister in the African Methodist Episcopal Church, and Register of the Treasury from 1906 to 1911. He was the author of *The Upbuilding of a Race* (1904).

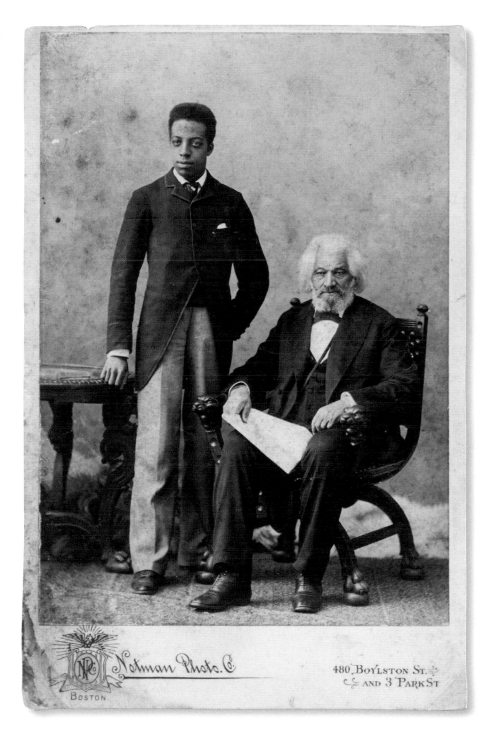

Figure 61: Anon. [Dennis (or Denys) Bourdon], *Joseph Henry Douglass and Frederick Douglass*, May 10, 1894. (Boston: Notman Photographic Company. Walter O. Evans Collection, Savannah, GA.)

Mrs H. Amelia Logden
Care of Rev. JW Logden
Binghampton
Broome Co
N.Y

Part VI

"I Was Born"

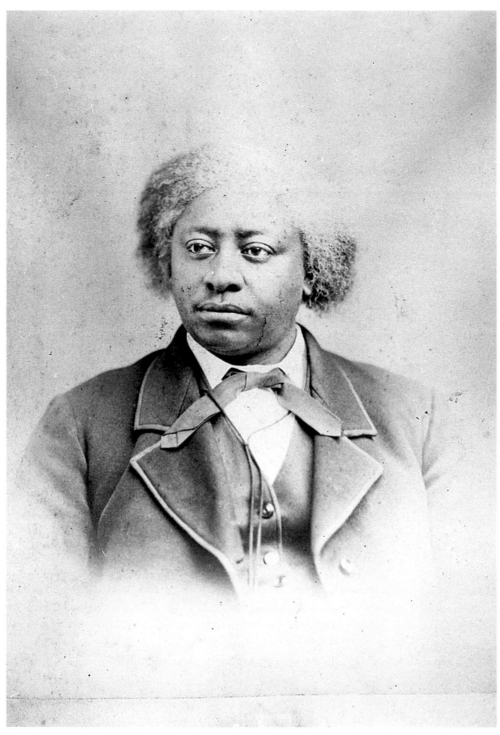

Figure 62: Anon., *Frederick Douglass Jr.*, n.d. Reproduced James M. Gregory, *Frederick Douglass the Orator*. (Springfield, MA: Willey Company, 1893. Collection of the Rochester Public Library Local History Division, Central Library of Rochester and Monroe County, Rochester, NY.)

Suffering and Sacrifice

Frederick Douglass Jr. and Virginia Hewlett Molyneaux Douglass's Unpublished Works

"I feel that we children have shared in a measure, your sacrifices for the good of the Cause in years past, hence I feel the slurs and smears pointed at you," Frederick Douglass Jr. writes Frederick Douglass from Washington, DC, on July 26, 1883.[1] He is at pains to remind his father that, great as his "sacrifices" have been, he, no less than Rosetta, Lewis Henry, Charles Remond, and Annie Douglass, have not themselves been immune to hardship, pain, and suffering. According to Frederick Jr., they have all made practical, emotional, political, social, and familial "sacrifices for the good of the Cause." His poignant conclusion is immediately borne out. Even a very brief foray into the lives of Douglass's daughters and sons, let alone an in-depth examination of their writings and activism, bears witness to their sufferings. And yet, in this same letter, Frederick Jr. ultimately testifies to his determination to offer his father emotional support. "Don't allow yourself to be troubled by anything," he reassures him. He insists, "with truth on our side Lew, Charley and I will be able to keep the flies off."[2] Rather than Frederick Douglass assuming the role of protector of his children, here and elsewhere during his life as an activist, reformer, and editor, Frederick Jr. shoulders the responsibility—with Charles and Lewis no less than Rosetta—of defending their father's honor against all persecutors, Black or white.

Surviving in one of the scrapbooks held in the Walter O. Evans collection and reproduced in the following pages is Frederick Jr.'s autobiography, *Frederick*

1 Frederick Douglass Jr. to Frederick Douglass, Washington, July 26, 1883, General Correspondence, Frederick Douglass Papers, Library of Congress.
2 Ibid.

Douglass in brief from 1842–1890. A rare and invaluable document shedding light on Frederick Jr.'s life as an activist and as an author of radical writings, *Frederick Douglass Jr. in brief from 1842–1890* fills in many gaps of his biography regarding his multiple careers as an antislavery reformer, a war recruiter, a printer, a grocer, a newspaper editor, a civil rights campaigner, an electoral reform advocate, an educational reformer, and a political correspondent, among much more. He completed this brief narrative less than two years before his tragically premature death of consumption on July 26, 1892; his wife, Virginia Hewlett Molyneaux Douglass, had passed away from the same illness on December 14, 1889. Frederick Jr. joins Annie Douglass as the two Douglass children outlived by their father. An avid record-keeper, Frederick Jr. added more to these surviving scrapbooks than his autobiography. As detailed in the family chronologies near the beginning of this book, Frederick Jr. performed vital work for researchers, then and now, by assuming the role of the Douglass family historian. In black ink and with a measured and beautifully even hand, he meticulously records the dates of birth and death—often down to the very minute and hour—of all the Douglass family members.

Writing in the blank spaces he has generated by pasting newspaper clippings of his own, his brothers', and his father's speeches on only parts of the lined pages of these scrapbooks, Frederick Jr.'s determination to record the birth and death dates of all the Douglass family members is a deliberate gesture. He was very likely self-consciously righting the wrongs of history suffered by his father, for whom such family records were unavailable. As Frederick Douglass senior candidly confirms decades previously in his 1845 autobiography, *Narrative of the Life of Frederick Douglass, An American Slave*, "I have no accurate knowledge of my age, never having seen any authentic record containing it." For Douglass, the absence of these detailed records is yet another devastating result of US chattel slavery as an inhumane system of bondage. "By far the larger part of the slaves know as little of their ages as horses know of theirs," he observes. He is under no illusion that white racist prejudice is at the heart of this terrible erasure: "it is the wish of most masters within my knowledge to keep their slaves thus ignorant."[3] As we celebrate Douglass's two-hundred-year birthday in 2018, it is all the more important to remember that we are commemorating it as having been a year later—1818—than the year in which he himself, and Frederick Jr., believed he was born.

For all readers pouring over Frederick Jr.'s carefully inserted dates of birth and death for each of the Douglass family members, it soon becomes clear that Frederick Jr.'s duty as a family historian carried heavy burdens. While he took great joy in recording the birth of his own and his brother's and sister's children,

3 Douglass, *Narrative*, 1.

he also shouldered the terrible responsibility of recording their many premature and untimely deaths. As we see in each son's individual chronology, infant mortality in the Douglass family was devastatingly high. As a measure of the emotional toll his role as a family historian was taking, Frederick Jr. repeatedly intersperses his handwritten records of each child's poignant suffering and early death with fragments of elegiac poetry. One especially powerful ode to personal grief he includes in one of the scrapbooks reads as follows: "As onward through life we/are driven/There's a sigh that cannot be repressed,/A longing for those who before us/Have attained to that heavenly rest."

By far the most devastating loss haunting Frederick Jr.'s life, however, is the death of his wife, Virginia Hewlett Molyneaux Douglass, on December 14, 1889. In his self-appointed role not only as a record-keeper of her death but as a eulogist to her life, he inserts a brief biography of Virginia Douglass's life onto the pages of the same scrapbook in which he writes his autobiography. A week after she passed away, on December 21, he writes a powerful statement in which he does poignant justice to her memory: "My dear wife Virginie L. Douglass, was honest, affectionate, self-sacrificing and generous to a fault. She was loving and loveable. She did her duty well. No man ever had a better wife and few have ever been honored by having one as good. She was a true woman as her parents intended she should be." For Frederick Jr., as for Lewis Henry, the necessity that Virginia Molyneaux Douglass and Helen Amelia Loguen Douglass adhere to the dominant conventions of genteel and "true" womanhood that were typical for white upper-class women only—including such personal attributes as self-sacrifice, duty, and honor—was at a premium as theorized by Barbara Welter. As a hard-hitting testament to Frederick Jr.'s grief, he chose to include a haunting postscript: "We were married 20 years 6 months and 10 days. She was 40 years 6 months and 13 days old at the time of her death. She was married 4 months and 10 days longer than she remained single." For Frederick Jr., a record of the facts and figures of Virginia's life are a comfort for his grief, and work to mitigate his devastating emotional turmoil. He assuages his pain yet further by quoting lines of poetry in which he celebrates his wife's life as one dedicated to acts of self-sacrifice: "To hide her cares her only art,/Her pleasures, pleasures to impart,/In ling'ring pain, in death resign'd,/Her latest agony of mind/Was felt for him who could not save/His all from an untimely grave."

Writing a letter to Rosetta from Port-au-Prince in Haiti on January 20, 1890, Frederick Douglass shares his sorrow at Frederick Jr.'s loss. "I am very glad . . . that you and your family could do something to smooth poor Virginia's way to the grave," he praises Rosetta, only to express his sadness that "Frederick seems to be entirely broken up by the loss of his wife." And yet, as an individual who was ever a searcher for hope in the face of despair, Douglass takes inspiration from their intimacy. "I believe they truly loved each other," he confides. He takes

heart from his belief that, "where love is there is happiness within however the wind may blow without."[4] We can only imagine what emotional impact these words would have had on Rosetta, whose own life was beset by the emotional trials and economic tribulations caused by her difficult marriage with Nathan Sprague, a formerly enslaved man who, like her father, had fought and secured his own freedom (Figure 13).

Just over a week later, on January 3, Frederick Jr. himself writes Helen Pitts Douglass, his father's second wife, to express his heartfelt gratitude for her kindness (Figure 16). "Thanks for your kind words of sympathy," he confides, reassuring her that, "While they do not heal the deep cut, they tend to lessen the pain." And yet, his "pain" runs deep. "Virginia was my <u>all</u>," he confides. He admits, "my reason during this present strain serves me," only to confess that nothing can alleviate his suffering, on the grounds that "my feelings refuse to be comforted." As faced with the enormity of his loss, he takes comfort only in the role he played in supporting Virginia in her last moments. "If I am grateful for anything, it was for my ability to do for my dear deserving wife at a critical time," he declares. "My heart and hand never failed me as long as there was breath in her body," he proudly exults, only to confide his recent collapse in the wake of her death: "since then I've been good for nothing." Frederick Jr.'s personal traumas are yet further compounded by the ongoing difficulties he endured in the relentless forces of discrimination besetting his professional life. "If I could be employed, I would recover myself more especially," he confirms. And yet, these challenges are as nothing compared to his grief. He closes his letter by reinforcing his father's conviction that "they truly loved each other" in his powerful declaration: "Virginia and I lived <u>close</u> together, otherwise my feelings would not be my master."[5]

"I had a letter from Frederick some time ago which showed him to be in a very despondent condition," Frederick Douglass again writes Rosetta from Port-au Prince a few months later, on April 12, 1890. He confides that Frederick Jr.'s grief shows no sign of abating as he shares his candid concern for his son's mental health. And yet, he soon replaces any and all empathy he feels for Frederick Jr.'s sorrow with his conviction that the responsibility for alleviating his "despondent condition" ultimately rests with his son and his son alone. "He says if I fail him now he is lost," Douglass writes, only to insist, "He aught to feel in no such way." "No [one] fails unless he fails himself," he avows. As steeped in dominant conventions associated with a normative masculinity, Douglass the father maintains a

4 Frederick Douglass to Rosetta Douglass Sprague, January 30, 1890, General Correspondence, Frederick Douglass Papers, Library of Congress.
5 Frederick Douglass Jr. to Mrs. Frederick Douglass, January 31, 1890, General Correspondence, Frederick Douglass Papers, Library of Congress.

hard line regarding individual responsibility. He stipulates, "Each man is the author of his own destiny and the architect of his own fortune."[6] And yet, Douglass asks more of his son than he himself asked of humankind more generally. Across his repeated lectures on "Self-made Men" he was careful to reiterate, "Properly speaking, there are in the world no such men as self-made men." His conviction that, "The term implies an individual independence of the past and present which can never exist" is tellingly absent in his insistence that his son assume the role of sole "author" and "architect" of his own "destiny" and "fortune."[7] In his letter, Frederick Douglass is equally adamant that his son's grief is nothing new and that he should therefore not surrender to his suffering: "Sorrow and death have been the lot of all men and will so continue, but this should not cause any to lose heart or hope."[8] Rather, he takes the view that his son has benefited from kindness and generosity for which he should be grateful: "Frederick has been fortunate in having friends raised up for him and his children." Yet more revealingly, he gives vent to his own sense of injured pride by confiding, "It has come to my ears that I have done nothing for Frederick." "I am sorry that such a report should reach me for there is no foundation for it," he further insists. He freely expresses his sense of injustice by throwing down the gauntlet to Frederick Jr. and his other sons: "I shall be glad to see any son of mine do as much for his sons as I have done for mine." "But enough of this," he impatiently concludes, admitting, "There is no <u>sting</u> like the sting of ingratitude." As a rare moment in the surviving private family correspondence, here he gives vent to his conflicting emotions and lays bare the complexities of the father-son relationships within the Douglass family.

The Walter O. Evans collection memorializes Frederick Jr. and Virginia's twenty-year marriage in other ways, including by holding the original copy of their wedding certificate. According to this handwritten document, a "Mr. Frederick Douglass Jr. of Rochester N. York" was united in holy matrimony to a "Miss Virginia L. M. Hewlett of Cambridge Mass" by "Rev. William Howe, at Cambridge, Aug. 4 1869." As a newspaper clipping pasted into one of the scrapbooks from the *Cambridge Press* and dated a few days later on August 7, 1869, reads: "The ceremony was performed at the house of the bride's father on Dunster street, Rev. William Howe officiating. At the conclusion of the ceremony, a grand reception was given the friends of the happy couple, at which many gentlemen of the College, and other citizens were present." As published a few days later on August 11, and inserted into the same scrapbook, another account

6 Frederick Douglass to Rosetta Douglass Sprague, April 12, 1890, General Correspondence, Frederick Douglass Papers, Library of Congress.
7 Douglass, "Self-Made Men," 1872.
8 Frederick Douglass to Rosetta Douglass Sprague, April 12, 1890.

of their wedding ceremony appears with a controversial title: "Reported Marriage of Fred. Douglass, Jr., to a White Woman." The reporter offers no further comment on Frederick Jr.'s bride's racial identity, simply confirming, "A dispatch from Boston to Pomeroy's New York Democrat says that on Friday night Fred. Douglass, Jr., son of Fred. Douglass, led to the altar the 'accomplished daughter of Prof. A. Molyneux Hewtt. of Harvard University.' There was a grand reception in the evening."

A reason for this reporter's mistake regarding Virginia Douglass's racial origins is supplied by another newspaper clipping, this time from the *Syracuse Standard* and dated August 15, 1869. "Mr. Fred. Douglass, Jr., and his bride, the daughter of Prof. Hewitt, of Harvard University . . . were the guests of Bishop J. W. Loguen last week," this reporter notes. She or he is careful to confirm that "Mrs. Douglass is of that brunette shade of complexion that would readily enable her to pass muster in the most fashionable circles as a belle, were the fact of her blood unknown." As a wider examination of the public accounts of their marriage soon establishes, the ambiguity surrounding Virginia Douglass's race was to prove a major source of political commentary and public controversy. In many ways the sensation surrounding her alleged whiteness and their marriage was a forerunner for the disapproval and death threats Frederick Douglass was to receive on his marriage to Helen Pitts, who was indeed a white woman, over a decade later in 1882.

While Frederick Jr. was determined to insert his own autobiography onto the pages of this extant scrapbook, he was equally focused on preserving edited selections of his wife's personal biography, correspondence, and writings. In the same scrapbook in which he includes his own autobiography, he inserts a brief narrative of Virginia's life. Frederick Jr. focuses on her intellectual accomplishments by writing, "She graduated from the Cambridge High School in 1868 with honors." He displays his admiration for her literary achievements by confirming that, "In 1864 she composed and read a poem at Dedham Mass., dedicated to the 5th Massachusetts Cavalry." Frederick Jr. was not content with recording that Virginia had written this poem, but went a stage further by choosing to reproduce it in full in this same scrapbook. Out of respect for this document's importance to Virginia and Frederick Jr., we include the original facsimile and annotated transcription in the following pages for the benefit of readers. While summarizing her outstanding career as a schoolteacher, he is at pains to confirm her authorship of "the historical sketch of Frederick Douglass as published in 'Men of Mark': by William J. Simmons."[9] He is especially incensed that Simmons had "assumed authorship" of this extensively detailed and eloquently written account of Douglass's life, a groundbreaking

9 See Simmons, *Men of Mark*, 65–87.

contribution to the historical record. Frederick Jr.'s confirmation of Virginia's authorship establishes beyond all doubt that one of Frederick Douglass's first biographers was not only female but a member of his extended family. At the same time, he blows the whistle on the ways in which Black female literary prowess is repeatedly invisibilized not only within a European but an African American male mainstream tradition. He makes the poignant decision to conclude his brief biography of Virginia's life by returning to his own loneliness. Frederick Jr. closes with an elegiac appeal to Virginia for her succor beyond the grave, expressing a poignant hope: "May her sweet spirit ever guide and direct my walks."

In comparison to the life of Helen Amelia Loguen Douglass, any and all direct trace of Virginia Douglass in the official archive is difficult to locate. There is currently no extant portrait and no surviving manuscripts, with two exceptions. The General Correspondence files in the Frederick Douglass Papers held in the Library of Congress include a letter from Virginia to Anna Murray Douglass, in close proximity to her husband's birthday on March 3, 1882. Addressing the letter to "Dear Mother" from "Your affectionate Daughter," she writes, "We wish to have you, Father and Lew come down this evening if only for a little while. You know it is the fortieth anniversary of Fred's birth. This morning when he saw his birthday cake he said he wished you all to come and eat a piece of it with him. He did not think of it before. Please come. He will feel so badly if you say no. I would have come up myself to urge you but could not very well. Fred said he would ask father down the street, but we thought you would be sure to come if you knew it in time. Please come, and I am sure you will feel better for having taken the ride."[10]

Clearly, Virginia played a key role in assisting the Douglass family in maintaining their intimate social and emotional relationships. A handwritten note authored by Virginia also appears in one of the extant scrapbooks held in the Walter O. Evans collection. Her very real presence in these scrapbooks, not only as a subject but as a contributing author, shores up the view that they were originally the property of the Frederick Jr. family household and the result of their collaborative efforts. In this note from "Virginie to Fred," which she writes directly onto one of the lined pages, she includes the following inscription, "To my husband on his fortieth birthday Mar. 3/82. When you gather all your dear ones/A wreath of love to weave,/I only ask this little boon,/That you'll remember ___ [?]" Perhaps Virginia's note proves that her fortieth birthday present to her husband was indeed this and possibly other scrapbooks. For Frederick Jr. as her grieving husband, his determination to record their family's lives, loves, and losses in its

10 Virginia L. A. Douglass to Anna Murray Douglass, March 3, 1882, General Correspondence, Frederick Douglass Papers, Library of Congress.

pages—alongside public clippings of the Douglass family letters and speeches—was yet another way to stay close to his wife and keep her spirit alive in his memory.

Warring against the vast gaps in the archive regarding Virginia Douglass's life, Frederick Jr. takes it upon himself to include a "copy" of the letter that she writes "to her mother" on December 7, 1871. As written following the death of her father, Aaron Hewlett Molyneaux, Frederick Jr. reproduces Virginia's letter in full as follows:

> My dear, my darling mother and dear sister and brothers, God keep you—It is hard for us—my heart is aching—I can't write—I can't see my father again, but you must kiss him for me. You will have strength given you in the day of trouble. I can't come. Mother keep up for your children. You must be mother and father. Mother don't give up. Sister and brothers stand by mother. Let us all be even more closely bound together. We have lost our dear one, but let us thank God his suffering is over. Fred will be husband father and brother to us all—Mother let him help you. Kiss father and put this hair of Fred's and Fred Aaron and mine and a little bit of each of yours and put it on his breast under his shirt, and so together we may bury him. God help and sustain you all. Your daughter and sister in affliction and love Virginie L. Douglass.

In this heartfelt and emotively charged letter, Virginia not only gives vent to her overwhelming grief—"my heart is aching—I can't write—I can't see my father again"—but she also testifies to her fundamental role as a source of emotional support for the entire family. She gives her mother strength by refusing to waver in her conviction, "You will have strength given you in the day of trouble," and by insisting, "don't give up." She issues equal invaluable instructions to her siblings: "Sister and brothers stand by mother." For Virginia, family solidarity has the power to triumph over grief as she confides, "Let us all be even more closely bound together." While she is devastated to lose her father, she takes comfort that he is liberated from pain by expressing gratitude, "let us thank God his suffering is over." Perhaps shedding light on Frederick Jr.'s motivation for copying out this one letter in particular, Virginia betrays her close ties to her husband by stating, "Fred will be husband father and brother to us all," as she implores, "Mother let him help you."

Beyond Frederick Jr.'s record-keeping, a wider search in the Walter O. Evans collection scrapbooks reveals a newspaper clipping of a letter "to the editor" authored by no less a figure than "Virginia Douglass Jr." herself and dated September 22, 1881.[11] No other publication information survives as to where or in which newspaper it appeared. Writing a public protest letter rather than a private family

11 Virginia Douglass Jr., "Letter to the Editor," n.d., n.t., September 22, 1881. The only additional information that appears on this page reads: "Washington Sunday Item October 2d. 1881."

missive, she issues a virulent protest against school segregation and the dire influence of prejudice. "Last week at a meeting of the school board, a communication was received from Prof. J. M. Gregory, asking permission to send his child to the Prescott school," she writes, only to avow, "It is humiliating to all freemen that at this day such a step is necessary." Here James M. Gregory, Douglass's biographer and a family friend, no longer represents his own interests but those of "all freemen" in his fight for racial equality in education. She is adamant regarding the injustice that has been done, stating that Gregory's determination to obtain an equal education for his child was "not, however, asking a favor, but demanding a right."

A key source of Virginia's protest against the inequalities of educational segregation is her conviction that, "In our schools children are supposed to be fitted for the life that will be before them when their school-days have passed." On these grounds, she exposes the illusory impossibility of any and all white racist attempts to enforce racial divisions by rhetorically questioning, "Will it be possible in that life to keep the two races apart always?" "Has it not been shown in the last few years that the hated face of the negro is apt to be met anywhere and everywhere that any other face is encountered?" she jubilantly declares, observing, "In the State Legislatures, in both Houses of Congress, in important departments of the government, even as the chief officers in those departments, at Presidential receptions, as ministers to other countries, the negro has taken part." As she questions: "Is it not a shame that innocent, healthy minded children should have the seeds of that foul disease, race prejudice, planted where only good and useful vegetation should be encouraged?" She introduces incendiary language that is worthy of her father-in-law by exposing the spurious foundations and corrosive effects of racism.

As Virginia Douglass powerfully argues here, discrimination is learned: "Prejudice is not natural, it is infectious, it comes from contact, from association, from example." "The difference in our schools cannot be made from any feeling that the negro is inferior in mental ability, for that could be too easily disproved," she urges, noting, "We have our teachers of color from the Normal school down to the infant department who are in every way the equals of teachers occupying the same positions in the white schools." "Besides these we can point with pride to professional men, lecturers, editors &c., of our own color, so it cannot be on account of their lack of ability," she further observes, indirectly referring to the myriad accomplishments of the men within the Douglass family. Virginia's conclusion that "Prof. Gregory should have the firm support of all lovers of justice and equality without regard to race or color," lays bare her lifelong commitment to the Douglass family business of an ever-vigilant campaign for "justice and equality" in which "color" is "no crime."[12]

12 Ibid.

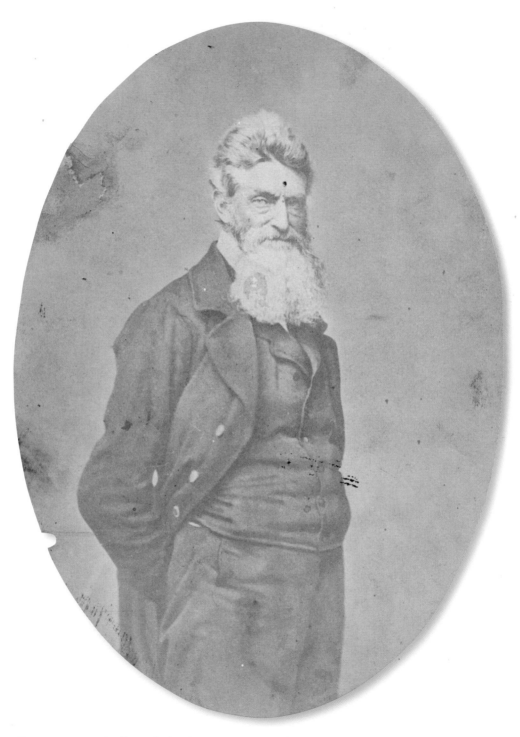

Figure 63: James Wallace Black, *John Brown*, c. December 12, 1859. Reproduction of daguerreotype by Martin M. Lawrence. (Prints and Photographs Division, Library of Congress, Washington, DC.)

60. Frederick Douglass Jr., "Frederick Douglass Jr. in Brief from 1842–1890" [c. 1890]

My parents were Frederick and Anna Douglass.
I was born in New Bedford, Massachusetts, on the 3rd day
of March 1842. I was placed in school in Lynn, Mass., at
the age of six years. In 1848 my parents moved to Roch=
ester N.Y. In 1849 I was sent to the public schools in Roches=
ter and remained there a few months, when the colored child=
ren attending public schools were sent home on account of their
color. My father agitated this injustice and discrimination in
Corinthian Hall every Sunday for three months, after which,
the colored children were readmitted to the public schools.
I remained in school from then until I was twelve years
old. I was then put to the printers trade in my fathers office,
and completed my trade at the age of sixteen. In 1859, I
was the bearer of letters from the Rochester post office for
John Brown, addressed "Jay Hawkins," care of Frederick
Douglass, Lock Box 533. John Brown at that time was
stopping at the residence of my father. At the age of
18, I went into the Grocery business in Rochester, on the
corner of Buffalo and Sophia streets. In 1862, I conducted
my fathers paper, "Douglass Monthly." In 1863, I helped raise
the 54th and 55th Massachusetts regiments of infantry and the
5th Massachusetts Cavalry. In 1864, I was Commissioned by
Governor Andrew of Massachusetts, to go South on the
Mississippi and recruit for the Massachusetts quota.
In 1866 I went to Denver, Colorado, and engaged in Silver
mining. I was among others instrumental in bringing about
one public school for all American citizens of Denver,
Colorado. In 1867, I went to Cheyenne, Wyoming Territory, and
was employed by the Superintendent of Construction of the
Union Pacific Railroad. In 1868, I returned to Rochester,
N.Y, thence to Washington D.C. and opened a Grocery store in a
place called Potomac City, now Hillsdale or Anacostia. In
1869, I was married in Cambridge, Massachusetts to
Miss Virginia L. Molyneaux Hewlett, daughter of Professor
and Mrs Virginia Molyneaux Hewlett. I returned to
Washington the same year, and was employed at my
trade in the office of the "New National Era,"

60. Frederick Douglass Jr., "Frederick Douglass Jr. in Brief from 1842–1890" [c. 1890]

I was a Delegate to the National colored Convention held in Washington in 1869. I was also a Delegate to the National Colored Labor Convention held in Washington the same year. In 1870, I was made business manager of the office of the "New National Era," and in 1871 became one of its proprietors. In 1873, I was regularly nominated by the Republicans of the First district of the District of Columbia,

as their candidate to represent them in the House of Delegates under the Territorial form of government, and was defeated by a combination of bolting Republicans with the Democrats by twenty-one votes. In 1876, I corresponded, politically with the Washington "Chronicle" and the Rochester "Democrat and Chronicle." The same year I was endorsed by President U. S. Grant for the position of Superintendent of the Patent Office building. In 1877, I was appointed Deputy under the Marshal for the District of Columbia. In 1880, I corresponded, politically with the Rochester "Express" Rochester Democrat and Chronicle" and the Indianapolis "Journal." In 1881, I was one of the officers placed in charge of the Jury empanneled to try the cause of Charles J. Guiteau, for the murder of President Garfield. I was also one of the officers in charge of the Jury in the first "Star route" trial. I was employed in the office of Recorder of Deeds of the District of Columbia under Messrs. Wolf, Douglass and Matthews, and was suspended under Recorder Trotter, on the ground of my father's partizanship. This was so stated to me by Recorder Trotter. In 1888, I corresponded politically with the Rochester "Democrat and Chronicle," Rochester "Express, Indianapolis "Journal" Washington "Star" and the Detroit "Plaindealer." I also edited the "National Leader" of Washington D.C. during the Presidential Campaign for Harrison and Morton. In 1889 I raised a fund for the survivors of John Brown of Harper's Ferry fame, and organized the John Brown Republican Club of Anacastia D.C. In 1890, I was chosen a delegate to the National Colored Convention which was held the third of February in Washington D.C., I was chosen by the Republican League of the District of Columbia, an Alternate to represent them in the National Republican League Convention held in Nashville, Tenn., on the 4th of March 1890

<div align="right">Frederick Douglass jr.</div>

60. Frederick Douglass Jr., "Frederick Douglass Jr. in Brief from 1842–1890" [c. 1890]

My parents were Frederick and Anna Douglass.

I was born in New Bedford, Massachusetts, on the 3rd day of March 1842. I was placed in school in Lynn, Mass., at the age of six years. In 1848 my parents moved to Rochester N.Y. In 1849 I was sent to the public schools in Rochester and remained there a few months, when the colored children attending public schools were sent home on account of their color. My father agitated this injustice and discrimination in Corinthian Hall[13] every Sunday for three months, after which, the colored children were readmitted to the public schools. I remained in school from then until I was twelve years old. I was then put to the printers trade in my fathers office, and completed my trade at the age of sixteen. In 1859, I was the bearer of letters from the Rochester post office for John Brown, addressed "Jay Hawkins," care of Frederick Douglass, Lock Box 583. John Brown at that time was stopping at the residence of my father. At the age of 18, I went into the Grocery business in Rochester, on the corner of Buffalo and Sophia streets. In 1862, I conducted my father's paper, "Douglass's Monthly." In 1863, I helped raise the 54th and 55th Massachusetts regiments of infantry and the 5th Massachusetts Cavalry. In 1864, I was Commissioned by Governor Andrew of Massachusetts, to go South on the Mississippi and recruit for the Massachusetts quota. In 1866, I went to Denver, Colorado, and engaged in Silver mining. I was among others instrumental in bringing about one public school for all American citizens of Denver, Colorado. In 1867, I went to Cheyenne, Wyoming Territory, and was employed by the Superintendent of Construction of the Union Pacific Railroad. In 1868, I returned to Rochester N.Y., thence to Washington, D.C., and opened a Grocery store in a place called Potomac City, now Hillsdale or Anacostia. In 1869, I was married in Cambridge, Massachusetts to Miss Virginie L. Molyneaux Hewlett, daughter of Professor and Mrs. Virginia Molyneaux Hewlett. I returned to Washington the same year, and was employed at my trade in the office of the "New National Era."

I was a Delegate to the National colored Convention held in Washington in 1869. I was also a Delegate to the National Colored Labor Convention held in Washington the same year.[14] In 1870, I was made business manager of the

13 Corinthian Hall was the major lecture hall in Rochester, New York. Built in 1849, as well as Douglass it hosted Ralph Waldo Emerson (1803–82) and Charles Dickens (1812–70).

14 The National Colored Labor Convention, meeting in 1869, resulted in the formation that year of the Colored National Labor Union, an organization of over 200 Black mechanics, tradespeople, and engineers, to agitate for the equal representation of African Americans in the workplace.

office of the "New National Era," and in 1871 became one of its proprietors. In 1873, I was regularly nominated by the Republicans of the First district of the District of Columbia, as their candidate to represent them in the House of Delegates under the Territorial form of government, and was defeated by a combination of bolting Republicans with the Democrats by twenty-one votes. In 1876, I corresponded, politically with the Washington "Chronicle" and the Rochester "Democrat and Chronicle." The same year I was endorsed by President U. S. Grant for the position of Superintendent of the Patent Office building. In 1877, I was appointed Deputy under the Marshal for the District of Columbia. In 1880, I corresponded, politically with the Rochester "Express," Rochester "Democrat and Chronicle" and the Indianapolis "Journal." In 1881, I was one of the officers placed in charge of the Jury empaneled [sic] to try the cause of Charles J. Guiteau,[15] for the murder of President Garfield. I was also one of the officers in charge of the Jury in the first "Star route" trial.[16] I was employed in the office of Recorder of Deeds of the District of Columbia under Messrs. Wolf, Douglass and Matthews, and was suspended under Recorder Trotter,[17] on the ground of my father's partizanship. This was so stated to me by Recorder Trotter. In 1888, I corresponded politically with the Rochester "Democrat and Chronicle," Rochester "Express," Indianapolis "Journal," Washington "Star" and the Detroit "Plaindealer." I also edited the "National Leader" of Washington D.C. during the Presidential Campaign for Harrison and Morton. In 1889 I raised a fund for the survivors of John Brown of Harper's Ferry fame, and organized the John Brown Republican Club of Anacostia D.C. In 1890, I was chosen a delegate to the National colored Convention which was held the third of February in Washington D.C. I was chosen by the Republican League of the District of Columbia, an Alternate to represent them in the National Republican League Convention held in Nashville, Tenn., on the 4th of March 1890

Frederick Douglass Jr.

15 Charles Julius Guiteau (1841–82), lawyer and writer, assassinated President James Garfield (1831–81) in 1881, believing that he had been overlooked for political position and that he was following God's orders. Guiteau was convicted of murder and hanged.

16 The Star route trials in 1882 and 1883 were the culmination of federal investigations into US postal officials receiving lucrative bribes for awarding postal delivery contracts in the southern and western states.

17 James Monroe Trotter (1842–92) had joined the 55th Massachusetts Volunteer Infantry during the Civil War, rising to the rank of 2nd Lieutenant. Following Frederick Douglass, he was appointed in 1887 to the position of Recorder of Deeds for the District of Columbia.

61. Frederick Douglass Jr., Untitled Biography of Virginia L. M. Hewlett [c. 1890]

Virginia L. M. Hewlett was born in New York state on the first day of June 1849. Her parents were Aaron M. and Virginia M. Hewlett. She moved to Cambridge Massachusetts at an early age and entered school. She graduated from the Cambridge High school in 1868 with honors. In 1864 she composed and read a poem at Dedham Mass., dedicated to the 5th Massachusetts Cavalry. In 1869 she was married to Frederick Douglass Jun., of Rochester N.Y. In 1870 she was the first colored teacher ever appointed to teach school in the County of Washington District of Columbia. In 1871, she was promoted to the principalship of the Hillsdale school in the District of Columbia. In 1873, she was transferred to the principalship of public schools near Howard University in the County. She was highly complimented by different school Trustees and Superintendent Wilson for her efficiency as a teacher. Her many acts of charity are well known by the citizens of Hillsdale. She compiled the historical sketch of Frederick Douglass as published in "Men of Mark," by William J. Simmons, the authorship of which William J. Simmons assumed. She was the mother of seven children, five of whom received her tender care until death. She was faithful, energetic, true and loving as a wife and mother, and was as calm, patient and loving to all who came near her when stricken down to her bed with disease. In the winter of 1888 her brother Emanuel was stricken down with typhoid fever. Through her unceasing efforts in his behalf for weeks, he was spared, but she was stricken down with nervous prostration from which she never fully recovered; but his life was saved, mainly, so the doctor said, ~~mainly~~ through and by her faithful nursing.

635

61. Frederick Douglass Jr., Untitled Biography of Virginia L. M. Hewlett [c. 1890]

She made it pleasant for those who were kind enough to raise a helping hand during her affliction, and had an abiding faith, unassumingly in her salvation. She lived a pure and upright life, and on the 14th of December 1889, this sweet, loving spirit passed away. May her sweet spirit ever guide and direct my walks. I have not the slightest doubt of her salvation.

 her husband
 Frederick Douglass Jr.
Anacostia D. C. March 3rd 1890.

To the fifth Mass. Cavalry. Presented to the non commissioned officers at a Ball given by them March 29th 1864 at Dedham Mass. Miss Virginie L. Molyneaux Hewlett.

Soldiers we have met together,
But soon we'll part perhaps forever.
Though there may be sorrow in our hearts,
Though tears may fall from our eyes,
Still we feel, our loyal brothers
You are struggling for your right,
And you soon will win and keep it
By your bravery and might.
Brothers do ye feel afraid?
Would ye now give up the glory?
On, on, ye forever on, for God and victory
He has heard his people's cry,
Has promised succor from on high.
There have many gone before you.
Many more are here to follow.
Foward, then, and let this be your cry,
"Living we will be victorious,
Or dying our deaths shall be glorious."

61. Frederick Douglass Jr., Untitled Biography of Virginia L. M. Hewlett [c. 1890]

Virginie L. M. Hewlett was born in New York state on the first day of June 1849. Her parents were Aaron M. and Virginia M. Hewlett. She moved to Cambridge Massachusetts at an early age and entered school. She graduated from the Cambridge High School in 1868 with honors. In 1864 she composed and read a poem at Dedham Mass., dedicated to the 5th Massachusetts Cavalry. In 1869 she was married to Frederick Douglass Jun., of Rochester N.Y. In 1870 she was the first colored teacher ever appointed to teach school in the County of Washington District of Columbia. In 1871, she was promoted to the principalship of the Hillsdale school in the District of Columbia. In 1873, she was transferred to the principalship of public schools near Howard University in the County. She was highly complimented by different school Trustees and Superintendent Wilson for her efficiency as a teacher. Her many acts of charity are well known by the citizens of Hillsdale. She compiled the historical sketch of Frederick Douglass as published in "Men of Mark," by William J. Simmons, the authorship of which William J. Simmons assumed.[18] She was the mother of seven children, five of whom received her tender care until death. She was faithful, energetic, true and loving as a wife and mother, and was as calm, patient and loving to all who came near her when stricken down to her bed with disease. In the winter of 1888 her brother Emanuel was stricken down with typhoid fever. Through her unceasing efforts in his behalf for weeks, he was spared, but she was stricken down with nervous prostration from which she never fully recovered, but his life was saved, mainly, as the doctor said, mainly through and by her faithful nursing.

She made it pleasant for those who were kind enough to raise a helping hand during her affliction, and had an abiding faith, unassumingly in her salvation. She lived a pure and upright life, and on the 14th of December 1889, this sweet, loving spirit passed away. May her sweet spirit ever guide and direct my walks. I have not the slightest doubt of her salvation.

her husband

Frederick Douglass Jr.

Anacostia D.C. March 3rd 1890.

18 William J. Simmons (1849–90), writer, journalist, educator, and president of the American National Baptist Convention. *Men of Mark* (1887) sketches the lives of 177 African American men: Frederick Douglass is the subject of the first chapter.

She made it pleasant for those who were kind enough to raise a helping hand during her affliction, and had an abiding faith, unassumingly in her salvation. She lived a pure and upright life, and on the 14th of December 1889, this sweet, loving spirit passed away. May her sweet spirit ever guide and direct my walks. I have not the slightest doubt of her salvation.

> her husband
> Frederick Douglass Jr.

Anacostia D.C. March 3rd 1890.

To the fifth Mass. Cavalry. Presented to the non commissioned officers at a Ball given by them March 29th 1864 at Dedham Mass. Miss Virginie L. Molyneaux Hewlett.

Soldiers we have met together,
But soon we'll part perhaps forever.
Though there may be sorrow in our hearts,
Though tears may fall from our eyes,
Still we feel, our loyal brothers
You are struggling for your right,
And you soon will win and keep it
By your bravery and might.
Brothers do ye feel afraid?
Would ye now give up the glory?
On, on, ye forever on, for God and victory
He has heard his people's cry,
Has promised succor from on high.
There have many gone before you.
Many more are here to follow.
Foward, then, and let this be your cry,
"Living we will be victorious,
Or dying our deaths shall be glorious."

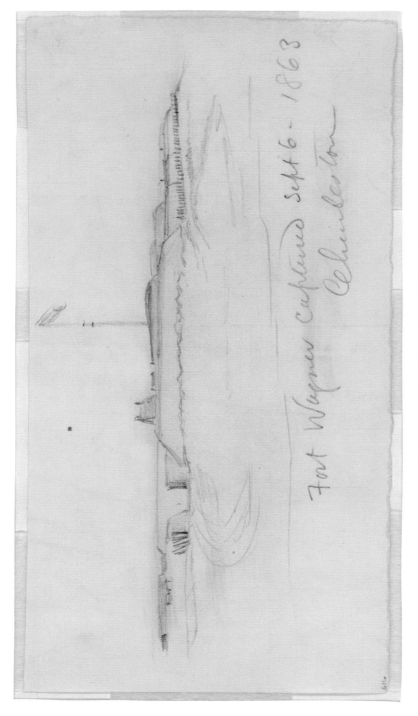

Figure 64: Alfred R. Waud, *Fort Wagner Captured, September 6, 1863.* (Prints and Photographs Division, Library of Congress, Washington DC.)

62. Virginia L. M. Hewlett, "To the Fifth Mass. Cavalry," 1864

A breath of submission breathe not,
The sword that ye draw sheathe not;
For its scabbard is left where your martyrs are laid,
And the vengeance of ages has whetted its blade.
Think of those who've gone before you,
Remember those who fell at Wagner,
At James Island, and Olustee,
Think of the gallant Colonel Shaw
Among the brave he was the bravest
Among the noble was the noblest.
And then ~~remember~~ remember Governor Andrews
So noble, generous, true,
Remember Governor Andrews
In all that you may do
You have heard of the Commission
Of the brave Lieutenant Swales;
Can their memories ever perish?
No! never! while one loyal heart is found,
Their names shall stand forever.
When history shall unfold her story
Of right and wrong of shame and glory,
Then shall their noble deeds be told,
Then shall all men behold
Their right to claim such glory.
Soldiers would ye share their fame
Would ye bear a glorious name?
Forward then and God will speed you:
Our fervent prayers are always with you.
Strike for old Massachusetts!
Strike for our Bay State true!
Strike for our glorious Union!
Strike for liberty or death!
Strike till the last armed foe expires!
Strike for your altars and your fires!
Strike for the green graves of your sires
God and your native land.

62. Virginia L. M. Hewlett, "To the Fifth Mass. Cavalry," 1864

Forward though the enemy,
Should number ten to one!
Forward for God is with you
And the battle ye shall win.
Brothers have ye wives or daughters?
If ye have oh strike for them!
Hasten to the battle field
Resolve to live or die like men.
Falter not while one slave breathes,
Break their chains or share their grief.
Soldiers could ye breathe the air
The slave is forced to breathe,
Or could ye lead the life
That they are forced to lead?
Brothers think of them in pity,
Think oh think and try to save,
Or if that prove unsuccessful,
Better they were in their graves.
Brothers when this war is ended
If the South should gain the day,
What of those who're left in bondage
What of those you've failed to save?
But stop my brothers do not answer
I know right well what you would say;
You are bound to conquer slavery
Or you'll fill the martyr's grave

 Virginia L. M. Hewlett 13 years old
 now Virginia L. Douglass

62. Virginia L. M. Hewlett, "To the Fifth Mass. Cavalry," 1864

In Frederick Douglass Jr's handwriting.

To the fifth Mass. Cavalry. Presented to the non commissioned officers at a Ball given by them March 29th 1864 at Dedham Mass. Miss Virginie L. Molyneaux Hewlett

> Soldiers we have met together,
> But soon we'll part perhaps forever.
> Though there may be sorrow in our hearts,
> Though tears may fall from our eyes,
> Still we feel, our loyal brothers
> You are struggling for your right,
> And you soon will win and keep it
> By your bravery and might.
> Brothers do ye feel afraid?
> Would ye now give up the glory?
> On, on, ye forever on, for God and victory
> He has heard his people's cry,
> Has promised succor from on high.
> There have many gone before you.
> Many more are here to follow,
> Forward, then, and let this be your cry,
> "Living we will be victorious,
> On dying our deaths shall be glorious."
> A breath of submission breathe not.
> The sword that ye draw sheathe not;
> For its scabbard is left where your martyrs are laid,
> And the vengeance of ages has whetted its blade.
> Think of those who've gone before you,
> Remember those who've gone before you,
> Remember those who fell at Wagner,[19]
> At James Island, and Olustee,[20]

19 There were two Battles of Fort Wagner, in South Carolina, on July 10–11 and July 18, 1863, respectively. Both were Confederate victories.

20 The Battle of James Island, South Carolina (also known as the Battle of Secessionville) was fought on June 16, 1862; the Battle of Olustee, Florida was fought on February 20, 1864. Both conflicts resulted in Confederate victories.

Think of the <u>gallant Colonel Shaw</u>
Among the brave he was the bravest
Among the noble was the noblest.
And then ~~rember~~ remember <u>Governor Andrews</u> [sic][21]
So noble, generous, true,
Remember <u>Governor Andrews</u> [sic]
In all that you may do
You have heard of the Commission
Of the brave Lieutenant Swales; [sic][22]
Can their memories every perish?
No! never! While one loyal heart is found,
Their names shall stand forever.
When history shall unfold her story
Of right and wrong of shame and glory,
Then shall their noble deeds be told,
Then shall all men behold
Their right to claim such glory.
Soldiers would ye share their fame
Would ye bear a glorious name?
Forward then and God will speed you:
Our fervent prayers are always with you.
Strike for old Massachusetts!
Strike for our Bay State true!
Strike for our glorious Union!
Strike for <u>liberty</u> or death!
Strike till the last armed foe expires!
Strike for your altars and your fires!
Strike for the green graves of your sires
God and your native land.
Forward though the enemy
Should number ten to one!
Forward for God is with you
And the battle ye shall win.
Brothers have ye wives or daughters?
If ye have oh strike for them!
Hasten to the battle field

21 John Albion Andrew (1818–67), Governor of Massachusetts.
22 Stephen Atkins Swails (1832–1900) fought with the 54th Massachusetts Regiment and was the first African American soldier to be promoted to commissioned rank against all white racist discriminatory odds.

Resolve to live or die like men.
Falter not while one slave breathes,
Break their chains or share their grief.
Soldiers could ye breathe the air
The slave is forced to breathe,
Or could ye lead the life
That they are forced to lead?
Brothers think of them in pity,
Think oh think and try to save,
Or if that prove unsuccessful,
Better they were in their graves.
Brothers when this war is ended
If the South should gain the day,
What of those who're left in bondage
What of those you've failed to save?
But stop my brothers do not answer
I know right well what you would say;
You are bound to conquer slavery
Or you'll fill the martyr's grave

Virginia L. M. Hewlett 13 years old
now Virginia L. Douglass.

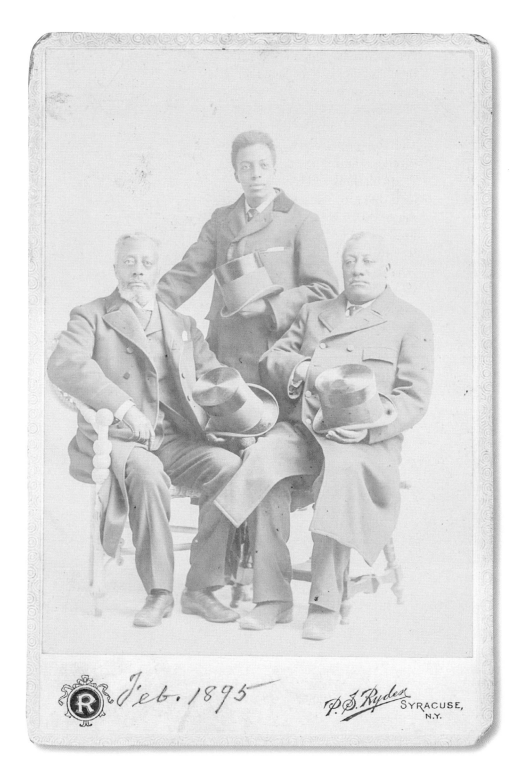

Figure 65: Anon., *Charles Remond, Joseph Henry, and Lewis Henry Douglass*, February 1895.
(Walter O. Evans Collection, Savannah, GA.)

Part VII

Narrative of the Life of Frederick Douglass, An American Slave and Free Man, as told by Charles Remond Douglass

Figure 66: Addison Scurlock, *Charles Remond Douglass*, n.d. [c. 1910–20]. (Prints and Photographs Division, Moorland-Spingarn Research Center, Howard University, Washington, DC.)

The "Sacrifices of my Father[']s Family"

Charles Remond Douglass as Family Historian

"Charles R. Douglass, son of Frederick Douglass, spoke on 'Some Incidents of the Home Life of Frederick Douglass' at the Lincoln Memorial Church, Washington D.C., Tuesday, February 13." So reads a reporter's introduction to an account of Douglass's youngest son's speech printed in the *New York Age* on February 22, 1917, the then imagined one-hundred-year anniversary of his father's birth.[1] In an article titled "Douglass Centenary Memory Honored at Rochester; Son Tells of Father's Career," the *Age* reprints Charles's oration with some prefatory remarks that read as follows: "The one hundredth anniversary of the birth of Frederick Douglass was celebrated throughout the country last week, colored and white citizens paying tribute to his memory." The celebration was held at the Lincoln Memorial Church "under the auspices of the Afro-American History-telling Association."[2] A comparison of this printed speech with Charles's handwritten manuscript held in the Walter O. Evans collection reveals that the *New York Age* chose not to reproduce the work in its entirety. Rather, the editor makes a powerful decision according to which she, or almost certainly he, perpetuates key and revealing omissions by excluding certain passages related to the collective activism of the Douglass family. Then, no less than now, it is the iconic, exceptional, and representative Frederick Douglass who is venerated above all others.

Among the sections edited out of the published version of Charles Remond's speech is his youngest son's emphasis on his father's newspaper, *The North Star*, as a collaborative effort. Nowhere to be found is his insistence that, "To maintain

1 Charles Remond Douglass, "Celebrate Douglass Centenary Memory Honored at Rochester Song Tells of Father's Career," *New York Age*, February 22, 1917.

2 Ibid.

this paper every effort was put forth by every member of the family to keep it alive." Equally, there is no inclusion of his discussion of the day-to-day running of the office of his newspaper. As Charles writes, "My brothers and sister were taken from school one day in each week to attend to the folding and mailing of the paper until they became old enough to be apprenticed at the trade of type-setting, being too young I was continued in School until at the age of ten I was taken from school one day in each week to deliver the paper to local subscribers." Equally off-limits for the *New York Age* was any mention of Charles's incisive assessment that, "These sacrifices of my father[']s family school advantages were made for the good of the cause in which he was engaged." No less damningly, the printed version of this speech makes no mention of the Douglass family's importance in running the Underground Railroad as a collaborative business. Charles's confirmation that, "my father[']s home in Rochester being the last station on that road before reaching Canada[,] the goal of the fleeing slaves['] ambition" is entirely cut, as is his statement that when fugitives arrived it was all hands on deck: "We have often had to get up at midnight to admit a sleighload, and start fires to thaw them out. Every member of the family had to lend a hand to this work and it was always cheerfully performed. We felt that we were doing a christian and humane duty."

As these and many more significant omissions related to Charles's, Lewis's, and Frederick Jr.'s military service, Anna Murray's exemplary financial acumen, and Rosetta's college education reveal, the focus of this published article is in diametric opposition to the vision undergirding Charles Remond's manuscript. For the editor of the *New York Age* commemorating Frederick Douglass's life story in the early twentieth century—no less than for the numerous scholars engaged in writing Frederick Douglass biographies in which his family members are given only a handful of pages in the twenty-first century—Charles's dramatization of the "sacrifices of my father's family" for the "good of the cause in which he was engaged" was never the focus. On these grounds, the onus was and remains on memorializing the life and works of Frederick Douglass as a representative, iconic, and exceptional leader. As if prophesying the extent to which he and his mother, sisters, and brothers were to be consigned to historical oblivion, Charles refuses to tell the Narrative of the Life of Frederick Douglass, An American Slave and Free Man in his speech. For Charles, as for Rosetta, Lewis, and Frederick Jr., the burden is on doing justice to the multiple and intertwined Narratives of the Lives of Frederick Douglass and His Family: Our Bondage and Our Freedom writ large.

63. Charles Remond Douglass, "Some Incidents of the
Home Life of Frederick Douglass" [c. February 1917]

Some Incidents of the Home Life
of Frederick Douglass

The first home of my father as
a freeman was at New Bedford
Mass. in 1839. His first employment
was as a Stevedore unloading ships
of Whale oil ~~that were~~ brought to
that port from their long whaling
voyages. My father earned nine
shillings ($1, 12½) a day for that labor, and
I have often heard him relate that
after a hard days toil, he would
come, and go to the Preachers house
home, eat his supper, in answer to his summons
a few doors away and saw a half
cord of Wood, before bed time without renumeration The ante-bellum
colored preacher never performed
manual labor, and very little
mental labor. His vocation during the week was
in visiting the homes of the good

651

63. Charles Remond Douglass, "Some Incidents of the Home Life of Frederick Douglass" [c. February 1917]

sisters and partaking of the well cooked
meals provided in his honor. He entered ~~came
into~~ the pulpit on Sundays with no
prepared sermon, and brought to his congre-
gation, no coherent ~~teaching~~ of religion,
 The next home of my father was in
Lynn Mass. His home a small frame
located
^on Union St. of that village was built
by him and became his first property.
It was in this home Oct. 21, 1844 that
I was born. One year after my birth,
1845, my father made his first trip to
England in the interest of the Anti-Slavery
cause. During his absence my mother
took up shoe-binding as a partial means
of support of the family which con-
sisted of my sister Rosetta, my bro-
thers Lewis, and Frederick and myself.
Shoebinding by the women of the
Town was quite a popular and ~~re~~
profitable
~~lucrative~~ ^employment at that time,
as there were no sewing machines in
those days, and Lynn then as now

63. Charles Remond Douglass, "Some Incidents of the Home Life of Frederick Douglass" [c. February 1917]

(3)

was a prosperous shoe-manufacturing town, After remaining abroad for about two years, lecturing in England Ireland, Scotland and Wales on Slavery and its evils, and in assisting in the organization of several Anti-Slavery Societies, he returned to his home in Lynn Mass. fully determined to establish a paper of his own through which to continue the agitation of abolition sentiment throughout the North. To carry out this latest determination a change of residence was decided upon. In 1847 he removed with his family to Rochester N.Y. where he at once set about the publication of "The North Star" a copy of the 4th number of which dated Jan. 23. 1848 I hold up before you To maintain this paper every effort was put forth by

(4)

every member of the family to keep it alive. Unlike the Negro press of to-day every column of this paper was original matter devoted to the cause of those in bondage, and the Underground R.R., my fathers home in Rochester being the last Station on that road before reaching Canada the goal of the fleeing slaves ambition. Canada was but 40 miles away, across Lake Ontario.

In the publication of "The North Star", the Office force consisted of the foreman Wm Oliver a scotchman, Horace McGuire an irishman, my brothers Lewis and Frederick, and my sister Rosetta. My brothers and sister were taken from school one day in each week to attend to the folding and mailing of the paper until they became old enough to be apprenticed at the

63. Charles Remond Douglass, "Some Incidents of the Home Life of Frederick Douglass" [c. February 1917]

(5)

trade of type-setting, being too young
I was continued in School until at the
age of ten I was taken from school
one day in each week to deliver the
paper to local subscribers. My sister
being the only one of the family to be
sent to a college, or higher institution
of learning than the common Schools
of Rochester. She was sent to Oberlin.
These sacrifices of my fathers family school advantages
were made for the good of the cause in
which he was engaged. Of the over 5000
subscribers in this Country and abroad to
The North Star, less than 500 were of our
own races, and they of course were
scattered throughout the North, and
Canada.
Several colored young men were
taken as apprentices into our family,
and under the foremanship of Mr.
Oliver learned the art, and branched
out into new fields. We were a happy

(6)

family in this work for the enslaved of
our race, but we were marked as con-
stant violators of the Fugitive Slave laws.
The white people of Rochester while in the
main were opposed to Slavery, they did
not encourage to any marked degree
Anti-Slavery agitation They would
aid an escaping slave in his flight
to Canada but they did not care to have
their names mentioned. They were
afraid of being held to account under
the infamous fugitive slave laws.

There was no break in the Douglass
homestead until 1859. The Winter of
that year brought to our home to be
secreted John Brown of Harpers Ferry fame.
He was being
hunted on account of his opperations
in Kansas and Missouri in behalf
of the enslaved, and a reward of
$2000 was placed upon his head dead
or alive. While at our home I became

63. Charles Remond Douglass, "Some Incidents of the Home Life of Frederick Douglass" [c. February 1917]

(7)

his errand boy. I went twice a day to the post office two miles away to receive his mail which was sent to my fathers box, addressed to N. Hawkins, the assumed name of John Brown. He spent nearly two months at one time at our home prior to his raid upon Harpers Ferry. Our hired man, Shields Green, himself an escaped slave from Charleston S.C. joined him, and was executed the week following Capt. Browns execution

Gov. Wise of Va, used every means in his power to obtain possession of the person of my father, ostensibly to that he might have him indicted and tried with John Brown as an accessory. He obtained from Prest, Buchanan the appointment of two men as Agents of the Post Office Dept. to be used in running Douglass down, being armed with a requisition upon the Gov. of New York, but my fathers friends and neighbors in Rochester kept

(8)

him advised of what was going on. The
United States Marshal in Rochester was
receiving many telegrams to watch
Douglass' movements, his home, his
sons and all others who came and
went forth from the home, but the
telegraph operater kept my father
advised so that he knew what moves
were being made to arrest him before
the Marshal did. My fathers friends
advised him to go to Canada and thence
to England which he did. The efforts
to get him becoming hotter and hotter.
The taunts of the school children whose
parents were pro-slavery made the further at-
tendance of my youngest sister Annie
and myself intolerable, so mother took
her out of school at the age of 11 and
sent her to a private teacher, I went
to work of my own choosing on the farm

63. Charles Remond Douglass, "Some Incidents of the Home Life of Frederick Douglass" [c. February 1917]

(9)

of Thomas Pierson 20 miles from Niagara Falls, and my brothers Lewis and Fred. continued at work on the paper under the Editorial control during my fathers absence in England, of Peter H. Clark of Ohio.

The execution of Capt. John Brown was a heavy blow to my youngest sister Annie, he had become very fond of her, and she of him, and to think of his being hung appalled her. She pined away and died a few months after his execution with congestion of the brain. We soon became a dis-membered family. Although it was considered insafe for him to return, upon learning of the death of my sister Annie my father hurried home having been absent over a year Thus at the age of 16 I left my fathers home never to return again only as a visitor, The following year the War of the rebellion

63. Charles Remond Douglass, "Some Incidents of the
Home Life of Frederick Douglass" [c. February 1917]

(10)

broke out ~~begun~~ and the following year I be-
came anxious to go to War. The colored
young men of Rochester and surround-
ing Country to the number of 35 organ-
ized and offered their ~~own~~ services to Gov,
John A. Dix, but were refused.
The next year however 1863, we found
the bars down, and I had the honor
of being the first to enroll at Rochester
for the 54. Mass. Infy. Feb. 9' 1863.
 With the abolition of Slavery Jan. 1. 1863
by proclamation of President Lincoln
my father discontinued the publication
of his paper. My brother Lewis began
teaching school at Salem N.J. but upon
learning of my enlistment in the 54
Mass. gave up his school and joined
me. He was at once made Sergeant
Major of the regiment while, I be—
came 1st. Sergeant of Co. F. My brother Fred.

660

63. Charles Remond Douglass, "Some Incidents of the Home Life of Frederick Douglass" [c. February 1917]

(11)

and Mr. Aaron Coleman of Boston were appointed Agents for the State of Massachusetts to go to Mississippi to recruit colored men for the 55th Mass. Inf.

My father devoted his time in public lecturing all over the Country encouraging colored men to enlist. He held that for the War to end with emancipation, without any assistance from the Negro himself, would work to his future disadvantage, no matter what the conditions imposed upon our services were.

After the War the Anti-Slavery agitation having ended with emancipation, a new field of activity opened up to my father, and he was in great demand as a Lyceum lecturer. He entered the field and was accepted in the most prominent lecture courses

(12)

in the Country, Courses which in-
cluded such orators as Phillips, Beecher,
Gough, Annie E. Dickenson, Theodore
Tilton and others of like note.

My fathers home life during my child-
hood days was not prolonged. My
mother was the head of the house.
She was the banker, the baker and
general manager of the home. My
father was in the field. The home-coming
was for a brief season of rest from
his labors.

In 1873 my fathers residence at
Rochester was destroyed by fire. He
was at the time visiting my
home here in Washington. I ac-
companied him back to Rochester
and found the ruins still smoking.

My mother came immediately to
this City while my father began plans

63. Charles Remond Douglass, "Some Incidents of the Home Life of Frederick Douglass" [c. February 1917]

(13)

for rebuilding of the house at Rochester. My mother objected saying that all of her children were residing here, and she preferred a home nearby. My father then purchased the house on A st. N.E. but was not satisfied with it. There was not ground enough about it to suit him.

In 1876 the spacious residence and grounds of Mr. Van Hook a land speculator, at Cedar Hill Anacostia was forced to a sale to satisfy a Trust of $7500. My father bid it in at $11000 It contained a 22 room house and 11 acres of land. He bought 4 acres more. It now contains the house and 15 acres of land.

In view the efforts that are being made to lift a mortgage of $4000 on this property, it is due to my

(14)

fathers memory to state that at the time of his death he was not indebted to anybody to the amount of one dollar. It was one of his strongest characteristics to keep out of debt by never getting into debt That is not always easy of accomplishment, but it was true in his case, This encumberance of a few thousand dollars on Cedar Hill, was placed there by his widow. For what purpose is not known for she had been sufficiently provided for in my fathers will, which was right and proper. There was no sacrifice made in willing this property to the Colored people of this Country as a memorial to my father. If any sacrifice was made it was made by my mother who toiled side by side with my father

63. Charles Remond Douglass, "Some Incidents of the Home Life of Frederick Douglass" [c. February 1917]

(15)

from the day he escaped from bondage
until the day of her death in 1882,
Let it be remembered then that the
appeals that are being made to lift
this debt, are for the purpose of clear-
ing an incumbrance placed upon
it by the donor. It is well that our
women have taken this matter in
hand. The home and Tomb of Wash-
ington at Mt. Vernon was rapidly
going to decay until the white
women of the Country stepped in
and saved it. There is less senti-
ment among our men than
among our women and if Cedar
Hill the home of my father and
mother, and the product of their
joint savings and economy,
is to be secured for all time to
the race, our women are the ones to

* Page 16 of this letter is missing from the collection.

(17)

aided in their flight by friendly white
farmers who took many risks, and suf-
fered many inconveniences in passing
their charges along from one point to
another, often traveling all night
through deep snow drifts, with the tem-
perature many degrees below zero.
We have often had to get up at midnight
to admit a sleigh load, and start fires
to thaw them out. Every member of
the family had to lend a hand to this
work and it was always cheerfully
performed. We felt that we were doing
a christian and humane duty.
I love to visit the old homestead, or
at least the site of the old homestead
which I do every year. The four acres
that surrounded the house, and upon
which we raised all our vegetables for

(18)

the family use, is now well into the city, and is occupied by a Florist. It is a beautiful spot, and where any of our family visit there we are made welcome, and plants and flowers are freely given us. The present owner of the premises is a son of the man to whom my father sold the land after the house had been destroyed by fire. He was an old friend of my father.

There is but little to add to this recital except to say that the incidents of our home life were similar in character to those of any well ordered home.

In Rochester all of our neighbors without a single exception were white people, and I can truthfully

(19)

add that they were all neighborly,
ready and willing at all times to do
a neighborly act, and they were not
all of the same political faith either.
My father was honored and respected
by the citizens of Rochester. On the
15' of the present month the 100th
Anniversary of my fathers birth
will be celebrated at Rochester. The
Mayor of the City will preside and
the Governor of the State, Mr. Whitman and
Hon. Charles W. Anderson of New York City
will deliver the principal addresses.

In behalf of the decendents of Frederick
Douglass, and as the last surviving mem-
ber of his immediate family, I return
to you and all others who cherish his
memory our deep appreciation and
heartfelt thanks.

63. Charles Remond Douglass, "Some Incidents of the Home Life of Frederick Douglass" [c. February 1917]

The first home of my father as a freeman was at New Bedford Mass. in 1839. His first employment was as a Stevedore unloading ships of Whale oil ~~that were~~ brought to that port from their long whaling voyages. My father earned nine shillings ($1.12 ½) a day for that labor, and I have often heard him relate that after a hard days toil, he would come home, eat his supper, and then go to the Preachers house a few doors away in answer to his summons and saw a half cord of wood before bed time without remuneration. The ante-bellum colored preacher never performed manual labor, and very little mental labor. His vocation during the week was in visiting the homes of the good sisters and partaking of the well cooked meals provided in his honor. He ~~came into~~ entered the pulpit on Sundays with no prepared sermon, and brought to his congregation no coherent teaching of religion.

The next home of my father was in Lynn, Mass. This home a small frame located on Union St. of that village was built by him and became his first property. It was in this home Oct. 21. 1844 that I was born. One year after my birth, 1845, my father made his first trip to England in the interest of the Anti-Slavery cause. During his absence my mother took up shoe-binding as a partial means of support of the family which consisted of my sister Rosetta, my brothers Lewis, and Frederick and myself. Shoebinding by the women of the town was quite a popular and ~~remunerative~~ profitable employment at that time, as there were no sewing machines in those days, and Lynn then as now was a prosperous shoe-manufacturing town. After remaining abroad for about two years, lecturing in England Ireland, Scotland and Wales on Slavery and its evils, and in assisting in the organization of several anti-Slavery societies, he returned to his home in Lynn Mass. fully determined to establish a paper of his own through which to continue the agitation of abolition sentiment throughout the North. To carry out this latest determination a change of residence was decided upon. In 1847 he removed with his family to Rochester N.Y. where he at once set about the publication of "The North Star" a copy of the 4 number of which dated Jan. 23 1848 I hold up before you. To maintain this paper every effort was put forth by every member of the family to keep it alive. Unlike the Negro press of to-day every column of this paper was original matter devoted to the cause of those in bondage, and the Underground R.R., my

fathers home in Rochester being the last Station on that road before reaching Canada the goal of the fleeing slaves ambition. Canada was but 40 miles away, across Lake Ontario.

In the publication of "The North Star," the Office force consisted of the foreman Wm Oliver a scotchman, Horace McGuire an irishman, my brothers Lewis and Frederick, and my sister Rosetta. My brothers and sister were taken from school one day in each week to attend to the folding and mailing of the paper until they became old enough to be apprenticed at the trade of type-setting, being too young I was continued in School until at the age of ten I was taken from school one day in each week to deliver the paper to local subscribers. My sister being the only one of the family to be sent to a college, or higher institution of learning than the common schools of Rochester. She was sent to Oberlin. These sacrifices of my fathers family school advantages were made for the good of the cause in which he was engaged. Of the over 5000 subscribers in this Country and abroad to The North Star, less than 500 were of our own race, and they of course were scattered throughout the North, and Canada.

Several colored young men were taken as apprentices into our family, and under the foremanship of Mr. Oliver learned the art, and branched out into new fields. We were a happy family in this work for the enslaved of our race, but we were marked as constant violators of the Fugitive Slave laws.[3] The white people of Rochester while in the main were opposed to Slavery, they did not encourage to any marked degree Anti-Slavery agitation. They would aid an escaping slave in his flight to Canada but they did not care to have their names mentioned. They were afraid of being held to account under the infamous fugitive slave laws.

There was no break in the Douglass homestead until 1859. The Winter of that year brought to our home to be secreted John Brown of Harpers Ferry fame. He was being hunted on account of his opperations [sic] in Kansas and Missouri in behalf of the enslaved, and a reward of $2000 was placed upon his head dead or alive. While at our home I became his errand boy. I went twice a day to the post office two miles away to receive his mail which was sent to my father's box addressed to N. Hawkins, the assumed name of John Brown. He spent nearly two months at one time at our home just prior to his raid upon Harpers Ferry. Our hired man, Shields Green, himself an escaped slave from Charleston S.C. joined him, and was executed the week following Capt Browns execution.

3 The 1850 Fugitive Slave Act required US federal officials in all states and territories (including those in which slavery had been prohibited) to enforce the return of escaped enslaved people to their masters in those states and territories which continued to permit slavery.

Gov. Wise of Va,[4] used every means in his power to obtain possession of the person of my father, ~~ostensibly to~~ that he might have him indicted and tried with John Brown as an accessory. He obtained from Prest. Buchanan[5] the appointment of two men as agents of the Post Office dept. to be used in running Douglass down, being armed with a requisition upon the Gov. of New York, but my fathers friends and neighbors in Rochester kept him advised of what was going on. The United States Marshal in Rochester was receiving many telegrams to watch Douglass's movements, his home, his sons and all others who came and went forth from the home, but the telegraph operator kept my father advised so that he knew what moves were being made to arrest him before the Marshal did. My fathers friends advised him to go to Canada and thence to England which he did. The efforts to get him becoming hotter and hotter.

The taunts of the school children whose parents were pro-slavery made the further attendance at No.13 school of my youngest sister Annie and myself intolerable, so mother took her out of school at the age of 11 and sent her to a private teacher. I went to work of my own choosing on the farm of Thomas Pierson 20 miles from Niagara Falls, and my brothers Lewis and Fred. continued at work on the paper under the editorial control during my fathers absence in England, of Peter H. Clark of Ohio.[6]

The execution of Capt. John Brown was a heavy blow to my youngest sister Annie, he had become very fond of her, and she of him, and to think of his being hung appalled her. She pined away and died a few months after his execution with congestion of the brain. We soon became a dismembered family. Although it was considered unsafe for him to return, upon learning of the death of my sister Annie my father hurried home ~~after~~ having been absent over a year ~~absence~~ Thus at the age of 16 I left my fathers home never to return again only as a visitor. The following year the War of the rebellion ~~began~~ broke out and the following year I became anxious to go to War. The colored young men of Rochester and surrounding Country to the number of 35 organized and offered ~~our~~ their services to Gov. John A. Dix,[7] but were refused. The next year however 1863, we found the bars down, and I had the honor of being the first to enroll at Rochester for the 54 Mass. Inf. Feb. 9' 1863.

4 Henry A. Wise (1806–76), governor of Virginia between 1856 and 1860 and later a general in the Confederate army. He signed the death warrant of John Brown in November 1859.
5 James Buchanan (1791–1868), US president between 1857 and 1861.
6 Peter Humphries Clark (1829–1925), Ohio-based abolitionist and teacher who also ran for Congress in 1878 as the first African American socialist.
7 John Adams Dix (1798–1879), US governor of New York in 1873–4, was a major general in the Union army during the Civil War.

With the abolition of Slavery Jan 1. 1863 by proclamation of President Lincoln my father discontinued the publication of his paper. My brother Lewis began teaching school at Salem N.J., but upon learning of my enlistment in the 54 Mass. gave up his school and joined me. He was at once made Sergeant Major of the regiment while I became 1st. Sergeant of Co. F. My brother Fred. and Mr. Aaron Coleman of Boston were appointed agents for the state of Massachusetts to go to Mississippi to recruit colored men for the 55 Mass. Inf.

My father devoted his time in public lecturing all over the Country encouraging colored men to enlist. He held that for the War to end with emancipation, without any assistance from the negro himself, would work to o͞ur his future disadvantage, no matter what the conditions imposed upon our services were.

After the War the Anti Slavery agitation having ended with emancipation, a new field of activity opened up to my father, and he was in great demand as a Lyceum Lecturer. He entered the field and was accepted in the most prominent lecture courses in the Country. Courses which included such orators as Phillips, Beecher, Gough, Annie E. Dickenson [sic], Theodore Tilton and others of like note.[8]

My fathers home life during my childhood days was not prolonged. My mother was the head of the house. She was the banker, the baker and general manager of the home. My father was in the field. The home-coming was for a brief season of rest from his labors.

In 1873 my fathers residence at Rochester was destroyed by fire. He was at the time visiting my home here in Washington. I accompanied him back to Rochester and found the ruins still smoking. My mother came immediately to this City while my father began plans for rebuilding of the home at Rochester. My mother objected saying that all of her children were residing here, and she preferred a home nearby. My father then purchased the home on A st. N.E. but was not satisfied with it. There was not ground enough about it to suit him.

In 1876 the spacious residence and grounds of Mr. Van Hook a land speculator, at Cedar Hill Anacostia was forced to a sale to satisfy a Trust of $7500. My father bid it in at $11000. It contained a 22 room house and 11 acres of land. He bought 4 acres more. It now contains the house and 15 acres of land.

8 Wendell Phillips (1811–84), US abolitionist and advocate for Native American rights and female suffrage; Henry Ward Beecher (1813–87), US clergyman and social reformer; John Bartholomew Gough (1817–86), white US temperance reformer; Anna Elizabeth Dickinson (1842–1932), US speaker on abolitionism, women's rights, and temperance; Theodore Tilton (1835–1907), US newspaper editor, social reformer, and abolitionist.

In view [of] the efforts that are being made to lift a mortgage of $4000 on this property, it is due to my fathers memory to state that at the time of his death he was not indebted to anybody to the amount of one dollar. It was one of his strongest characteristics to keep out of debt by never getting into debt. That is not always easy of accomplishment, but it was true in his case. This encumbrance of a few thousand dollars on Cedar Hill, was placed there by his widow. For what purpose is not known for she had been sufficiently provided for in my fathers will, which was right and proper. There was no sacrifice made in willing this property to the colored people of this Country as a memorial to my father. If any sacrifice was made it was made by my mother who toiled side by side with my father from the day he escaped from bondage until the day of her death in 1882. Let it be remembered then that the appeals that are being made to lift this debt are for the purpose of clearing an encumbrance placed upon it by the donor. It is well that our women have taken this matter in hand. The home and Tomb of Washington at Mt. Vernon was rapidly going to decay until the white women of the Country stepped in and saved it. There is less sentiment among our men than among our women and if Cedar Hill the home of my father and mother, and the product of their joint savings and economy, is to be secured for all time to the race, the our women are the ones to

[page 16 of this letter is missing from the collection]

aided in their flight by friendly white farmers who took many risks, and suffered many inconveniences in passing their charges along from one point to another, often traveling all night through deep snow drifts, with the temperature many degrees below zero.

We have often had to get up at midnight to admit a sleighload, and start fires to thaw them out. Every member of the family had to lend a hand to this work and it was always cheerfully performed. We felt that we were doing a christian and humane duty.

I love to visit the old homestead, or at least the site of the old homestead which I do every year. The four acres that surrounded the house, and upon which we raised all our vegetables for the family use, is now well into the city, and is occupied by a Florist. It is a beautiful spot, and when any of our family visit there we are made welcome, and plants and flowers are freely given us. The present owner of the premises is a son of the man to whom my father sold the land after the house was had been destroyed by fire. He was an old friend of my father.

There is but little to add to this recital except to say that the incidents of our home life were similar in character to those of any well ordered home. In Rochester all of our neighbors without a single exception were white people, and I can truthfully add that they were all neighborly, ready and willing at all

[63] times to do a neighborly act, and they were not all of the same political faith either. My father was honored and respected by the citizens of Rochester. On the 15' of the present month the 100th anniversary of my fathers birth will be celebrated at Rochester. The Mayor of the City will preside and the Governor of the State, Mr. Whitman[9] and Hon. Charles W. Anderson[10] of New York City will deliver the principal addresses.

In behalf of the decendents [sic] of Frederick Douglass, and as the last surviving member of his immediate family, I return to you and all others who cherish his memory our deep appreciation and heartfelt thanks.

9 Charles Seymour Whitman (1868–1947), US governor of New York from 1915 to 1918.

10 Charles W. Anderson (1866–1922), collector of internal revenue for the Second District of New York and a prominent Republican in the state.

Figure 67: Charles. F. Douglass, *Snow at Cedar Hill*, February 27, 1887. (National Park Service: Frederick Douglass National Historic Site, Washington, DC.)

Part VIII

Frederick Douglass and Family
in Photographs and Prints

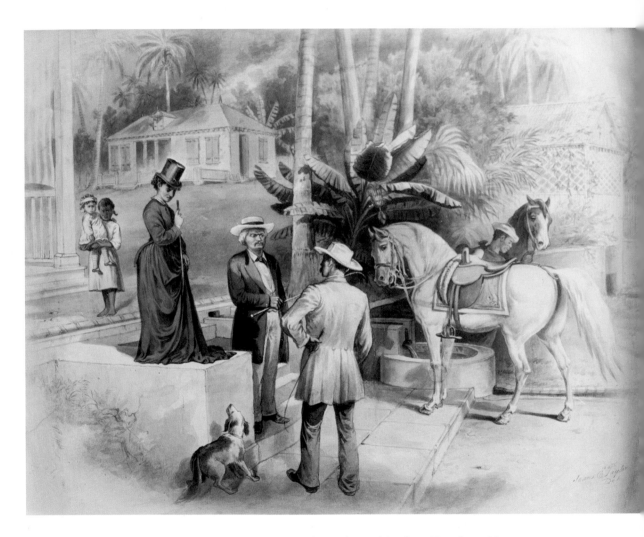

Figure 68: James E. Taylor, *Frederick Douglass with Madame Hyppolite in Haiti*.
(National Park Service: Frederick Douglass National Historic Site, n.d., Washington, DC.)

Walter O. Evans's Frederick Douglass and Family Album

The Walter O. Evans collection includes over twenty photographic prints consisting of daguerreotypes, cartes de visite, cabinet cards, and albumen prints of Frederick Douglass, his oldest and youngest sons, Lewis Henry and Charles Remond, and his grandsons, Joseph Henry and Haley George Douglass. As this visual archive is accompanied by no detailed provenance, there are currently extensive gaps in our knowledge. In many cases we have so far been unable to establish the exact date on which the image was taken, or even the name of the photographer. As well as the portraits of Douglass, his sons, and his grandsons, this collection also includes images of extended family members and friends who, despite our best efforts, we have yet to identify.[1] For some of the information included in the detailed captions below, we acknowledge our heartfelt debt of gratitude to the expert research undertaken by John Stauffer and Zoe Trodd.[2]

[1] These investigations are ongoing in support of Celeste-Marie Bernier's forthcoming *Struggles for Liberty: The Letters, Essays, Speeches and Photographs of Frederick Douglass and Family* and *For Your Eyes Only: The Private Letters of Frederick Douglass and Family*. This volume is part collective biography, consisting of new research on Douglass's family members' lives and works, and part scholarly anthology, comprising annotated transcriptions of over 800 essays, speeches, and letters they authored—many of which have recently come to light and will be published here for the first time.

[2] Stauffer, Trodd, and Bernier, *Picturing Frederick Douglass*.

64. John Chester Buttre, *Frederick Douglass* [c. 1853]

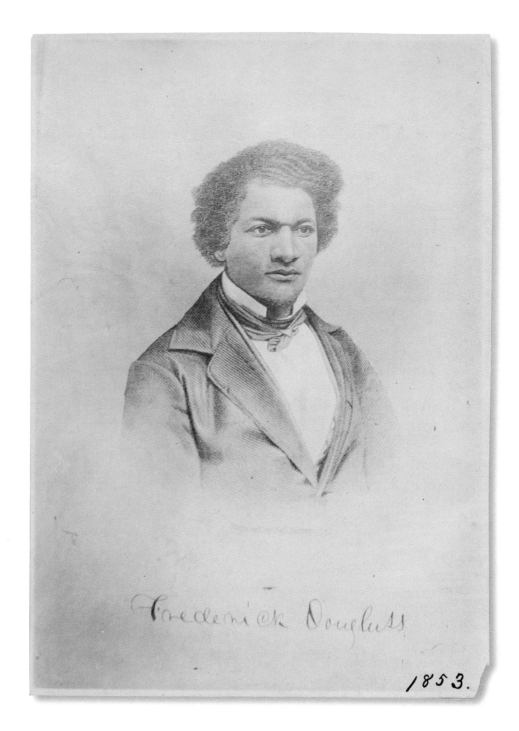

64. John Chester Buttre, *Frederick Douglass* [c. 1853]

Two copies of this print are held in the Walter O. Evans collection. While one of these Douglass portraits is in monochrome on paper, the other (shown here) is in sepia and pasted onto black cardboard. The following inscription is hand-written on the reverse: "Please return to H. G. Douglass 1732 15th Street, NW ~~318 A Street NE~~ Washington D.C." Another unknown writer inserts the phrase "copied by," underneath which the following information appears in typed lettering: "Hamilton S. Smith, Photographer, Washington, D.C." No details have yet come to light regarding Hamilton S. Smith or his studio. Given the instruction, "please return to H. G. Douglass," it is most likely that Douglass's grandson Haley George Douglass loaned this image for a private or public use that is yet to be established.

The original engraving for this print was first reproduced in *Autographs for Freedom*, an antislavery publication edited by white radical British abolitionist Julia Griffiths and published in Rochester and Auburn, New York, in 1854. As the brainchild of the Rochester Ladies' Anti-Slavery Society, this volume was key to their fundraising initiatives. In her editor's preface, Griffiths lays bare this organization's reformist vision by communicating their determination to usher in a new world according to which "the chains of the Slave shall be broken, and this country redeemed from the sin and the curse of Slavery."[3] Appearing in *Autographs for Freedom* for the first time, this engraving, which was created by renowned white US artist John Chester Buttre (1821–93), supplies the frontispiece to an "Extract" of a speech Douglass himself donated to this anthology. As Douglass writes Griffiths in the letter accompanying his submission, "If the enclosed paragraph from a speech of mine delivered in May last, at the anniversary meeting of the American and Foreign Anti-Slavery Society, shall be deemed suited to the pages of the forthcoming annual, please accept it as my contribution."[4] In this hardhitting sample of his firebrand oratory, Douglass cuts to the heart of the nefarious consequences of US racism. "Were I a white man, speaking for the right of white men, I should in this country have a smooth sea and a fair wind," he proclaims, only to admit to his sense of despair regarding the sufferings experienced by Black women, children, and men in their daily fight for survival in a racist US nation: "But for *my* poor people, (alas, how poor!)—enslaved, scourged, blasted, overwhelmed, and

3 Griffiths, *Autographs for Freedom*, v–vi.
4 Ibid.

ruined, it would appear that America has neither justice, mercy, nor religion."[5] Here Douglass relies on graphic imagery to denounce the inhumanity of "my white fellow-countrymen" who "have no other use for us whatever, than to coin dollars out of our blood."[6]

There can be no doubt that the engraving of Douglass that John Chester Buttre created is based on the full-plate daguerreotype held in the Onandaga Historical Association collections, Syracuse, New York, and dated circa 1843 (see Figure 10). Recognizing that daguerrean technology allowed only for a reversed mirror image of all portraits, Buttre chose to invert the daguerreotyped original's representation of Douglass in order to return his physiognomy to its likeness in life in his engraving. Very little is known about this early Douglass daguerreotype. Bereft of any detailed provenance, the daguerreotype's object file simply reads, "The Syracuse Public Library gave it to the historical association in 1954, but no one knows when or where it was made, or even when and how the photo came into the library's possession."[7] A source of yet further misinformation, according to curator Tom Hunter, is that the portrait was initially incorrectly identified as Jermain Wesley Loguen, Helen Amelia Loguen's father.[8]

Given Douglass's close working relationship with Julia Griffiths, as she excelled in the role of business manager on his newspaper *The North Star*, there can be little doubt that he himself exercised his free choice not only in selecting John Chester Buttre as his lithographer but in requesting that Buttre create his engraving from this sole surviving full-plate daguerreotype. An exceptionally gifted individual in his own right, Buttre was an outstanding lithographer and steel-plate engraver. He was renowned for having produced exemplary portraits of countless renowned political and historical figures. His masterpiece, *American Portrait Gallery with Biographical Sketches*, is a three-volume work that he published in 1877 with the assistance of his daughter, Lillian Buttre. "In this Gallery we propose to present the Portraits and Biographical Sketches of some of our most prominent Americans," he and his daughter write in their preface. Working to provide "an instructive lesson to mankind," they lay bare their selection criteria by solely creating portraits of exemplary individuals that they consider "worthy of being held up as examples for emulation."[9] Unfortunately, they immediately betray their racist biases by relying on an exclusively all-white line up of "prominent Americans."

5 Ibid. 252.
6 Ibid. 252–3.
7 Moriarty, "Frederick Douglass Mystery," n.p.
8 Ibid.
9 Buttre, *American Portrait Gallery*, n.p.

While Buttre failed to include African American women and men in his pantheon of American "greats," Douglass was undoubtedly impressed by his technical virtuosity. As an anonymous commentator proclaimed following his death, "John Chester Buttre was well known as a publisher and engraver, and especially as a pioneer in the very delicate operations of modern steel-plate work."[10] More especially, Douglass would have been drawn to Buttre for his prowess in having developed "a special process," according to which he had the unique ability to "impart to his pictures what has been well described as a 'special life-like tint,' which has, perhaps, never been excelled in the history of steel engraving."[11]

There can be little doubt that Buttre's ability to capture a "life-like tint" alone would have singled him out, according to Douglass's very particular criteria, as *the* portraitist most qualified to take his likeness. During his lifetime, Douglass persistently lamented a deadening state of affairs according to which, "Once fairly" reproduced "in the book" in a photographic likeness, "and the man may be considered a fixed fact, public property."[12] For Douglass, a man who had been born into slavery and whose lifelong war for freedom was to remain unfinished at his death, there was nothing more damaging than for human beings to be reduced to "fixed facts" or "public property." "To stand still is stagnation, and stagnation is death," he repeatedly insisted, urging, "Life itself, is a picture of progress."[13] Across his lifetime, Douglass remained immovable in his conviction that his pictures, like his lives in slavery and freedom, had to bear witness to social, political, and moral progress.

Buttre's success in capturing his likeness in a lifelike manner may well account for Douglass's later decision to commission this artist to create the beautifully executed portrait that appears as the frontispiece to his second autobiography, *My Bondage and My Freedom* (see Figure 29), published in New York in 1855.

10 Anon., "John Chester Buttre," 202.
11 Ibid.
12 Douglass, "Pictures and Progress," 453.
13 Douglass, "Life Pictures," n.d., 20–1.

65. Anon., [*Charles Remond Douglass*] [c. 1863]

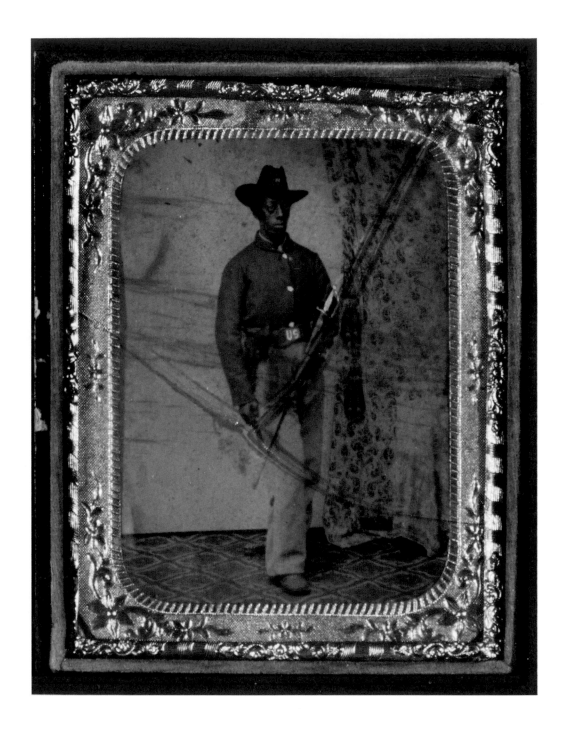

65. Anon., [*Charles Remond Douglass*] [c. 1863]

This half-plate daguerreotype is encased in a gilt frame with a partially fractured glass surface. No name of the photographer or address of the photographic studio can be found on either the case or the reverse of this likeness. A soldier portrait, it shows Charles Remond Douglass not only attired in his Civil War uniform but armed with a pistol and sword. An artist at the photographic studio chose to hand-tint the portrait; as a result, the buttons on his coat, the brass letters "US" on his belt, and his sword have all been painted gold, while his sash has been colored red. This portrait survives as a very powerful point of comparison with the photograph of Charles Remond Douglass held in the Moorland-Spingarn Research Center (Figure 35). Despite the differences in his stance and attire, in both portraits Charles Remond Douglass stands erect as he solemnly and thoughtfully contemplates the viewer.

66. Anon., [*Lewis Henry Douglass*] [c. 1863]

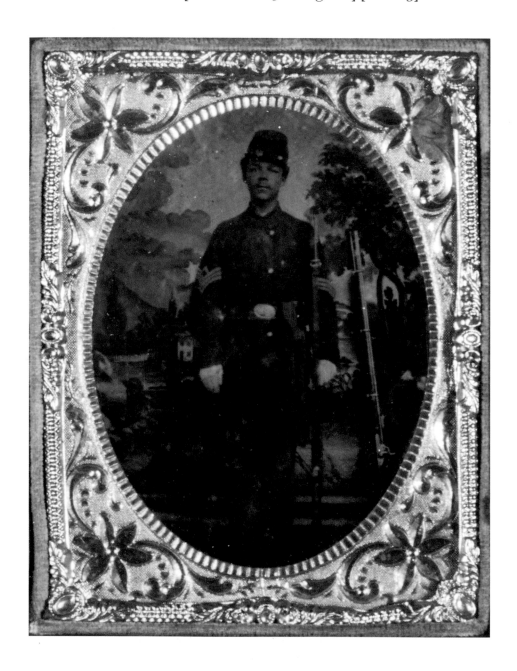

67. Anon., *Lewis Henry Douglass* [c. 1870]

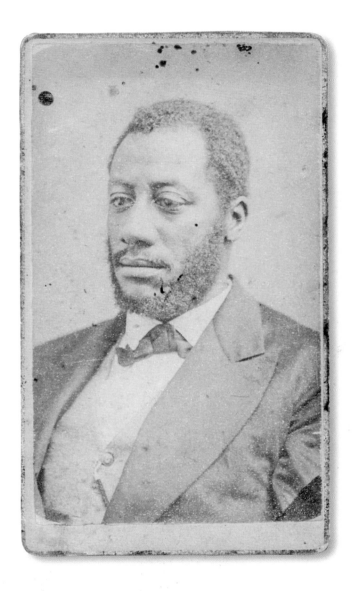

This portrait was very likely taken in the same sitting as the photograph in which Lewis Henry appears seated while Helen Amelia Loguen Douglass, his wife, stands beside him (Figure 24). Even a very cursory examination confirms that he is not only wearing the same clothing but that his facial hair is identical across both likenesses.

68. Anon., Mathew Brady, *Frederick Douglass* [c. 1877]

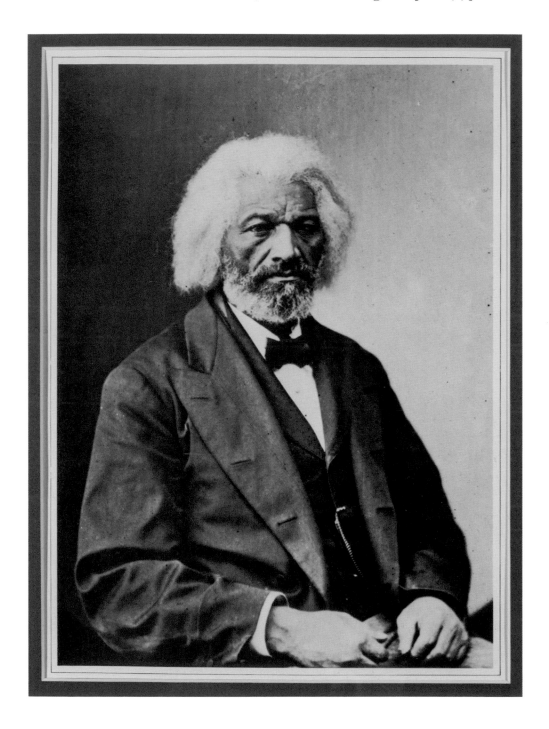

68. Anon., Mathew Brady, *Frederick Douglass* [c. 1877]

This photographic print is a copy of the stereoview of Frederick Douglass created by Mathew B. Brady (1822–96) circa 1877, and held in the Prints and Photographs Division, Library of Congress (Figure 17). As a renowned white US photographer, Brady is a household name not only due to his pioneering significance as a Civil War photographer but as a result of his celebrated National Portrait Gallery, located at 625 Pennsylvania Avenue, Washington, DC. While he created thousands of portraits of celebrated politicians, entertainers, military icons, and socialites, he earned fame for the daguerrean portraits he produced for his *Gallery of Illustrious Americans*, published in 1850. As per John Chester Buttre's pantheon of US greats, this gallery of "illustrious Americans" was for whites only. Brady's white-centric choice of portraits makes his decision to photograph Frederick Douglass—let alone Douglass's own determination to choose to have his likeness taken by Brady—all the more revealing.

69. Anon., *Frederick Douglass and Unidentified Family Members, Cedar Hill* [c. 1891]

While the figures standing on the porch of Frederick Douglass's home, Cedar Hill, in Anacostia, Washington, DC are difficult to identify, there can be little doubt that the figure standing on the far left and leaning against the pillar is Frederick Douglass himself. He is instantly recognizable, not only due to his height but because of the white hair that protrudes from underneath his hat. While it is currently impossible to prove or disprove with any certainty, it is very likely that the figure standing against the right pillar is his second wife, Helen Pitts Douglass. If this is the case, then the white woman seated in the rocking chair is almost certainly Jane Wells Pitts, Helen Pitts Douglass's mother. A long-term sufferer of a protracted illness, she was residing with the Douglasses under the care of her daughter before her death a year later, in 1892.

Figure 69: Anon., *Mr. Douglass' "Den,"* n.d. Reproduced James M. Gregory, *Frederick Douglass the Orator*. (Springfield, MA: Willey Company, 1893. Collection of the Rochester Public Library Local History Division, Central Library of Rochester and Monroe County, Rochester, NY.)

"Mr. Douglass's 'Den'"—so reads the caption accompanying this anonymously produced photograph, which James Gregory included in his 1893 biography *Frederick Douglass the Orator*, published just two years before Frederick Douglass's death. No more stark confirmation of Douglass's beginnings in slavery can be found than in his decision not only to buy Cedar Hill, the architectural equivalent of the "Great House" of the Wye Plantation owned by the Lloyd family, but to have built on its spectacular grounds a "Den" or, as he named it in honor of Charles Dickens, a "Growlery."[14] While the associations with Dickens are indisputable, the resemblance between Douglass's den and a slave cabin is incontestable. On these grounds, his decision not only to read but to write in this "den" constitutes a radical declaration of independence. For Frederick Douglass, the site of physical bondage and mental slavery endured by Frederick Augustus Washington Bailey is newly transformed into a space of intellectual and political liberation.

14 Further information on Douglass's "Den" is available at <https://www.nps.gov/frdo/learn/historyculture/the-growlery.htm> (accessed January 14, 2018).

70. Anon., Dennis (or Denys) Bourdon, Notman Photographic Company, *Joseph Henry Douglass and Frederick Douglass* (May 10, 1894)

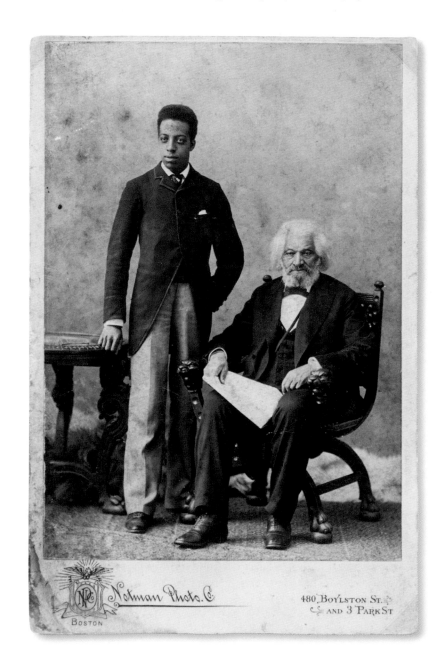

70. Anon., Dennis (or Denys) Bourdon, Notman Photographic Company, *Joseph Henry Douglass and Frederick Douglass* (May 10, 1894)

The Walter O. Evans collection includes two identical copies of this cabinet card. Additional copies are also held in the Massachusetts Historical Society, Boston; Beneicke Library, Yale University, New Haven; Library of Congress, Prints and Photographs Division; and the Moorland-Spingarn Research Center collection, Howard University, Washington, DC.

This photograph of Frederick Douglass with his grandson Joseph Henry Douglass, son of Charles Remond and a virtuoso violinist in his own right, was almost certainly taken by white photographer Dennis (or Denys) Bourdon. As "one of William Notman's most skilled associates" employed at the Notman Photographic Company, a studio housed in 280 Boylston Street in Boston, Bourdon "had been with the Notmans most of his life, beginning as an apprentice in Montreal in 1868, and advancing rapidly there until 1877, when he left Montreal to join the Notman & Campbell Studio in Boston."[15] "There he was the main photographer in 1880, and four years later became the principal mainstay of the Notman Photographic Company, as manager of the whole operation," confirm Gordon Dodds, Roger Hall, and Stanley Triggs.[16]

A letter dated a few weeks later, on May 29, 1894, survives in the General Correspondence File held in the Frederick Douglass Papers at the Library of Congress, and sheds light on this particular grandfather and grandson's visit to this photographic studio. While the signature and name of the sender are impossible to decipher, the letter is written on headed paper belonging to "D. Bourdon General Manager." As Bourdon himself, or possibly one of his assistants, writes in this letter, addressed to none other than Frederick Douglass himself, "We send you by Express today part of the order given by Mr Joseph Douglass. The Cabt size head & shoulder picture (of which 3 are sent) Mr. Bourdon will send you 1 doz Complimentary of the 8 x 10 size, there are 11 sent, Mr J D. has kept 1. There are 7 more of the Cabt grp to come to you." The author is at pains to emphasize the reasonableness of the studio's fees by informing Douglass that, "On the order given by Mr J. D. [Joseph Douglass] we have quoted you specially low prices; we trust the pictures will give you satisfaction."[17] Clearly, this letter establishes that the Notman Photography Company produced numerous copies of these grandfather-grandson portraits at a low rate following their receipt of an order submitted by Joseph Henry Douglass. The likelihood that these photographs did indeed give "satisfaction" is confirmed by the number of copies that have survived across multiple private and public US archives.

15 Dodds, Hall, and Triggs, *The World of William Notman*, 59.
16 Ibid.
17 [D. Bourdon General Manager] to Frederick Douglass, May 29, 1894. General Correspondence, Frederick Douglass Papers, Library of Congress.

71. Anon., *Charles Remond, Joseph Henry, and Lewis Henry Douglass* (February 1895)

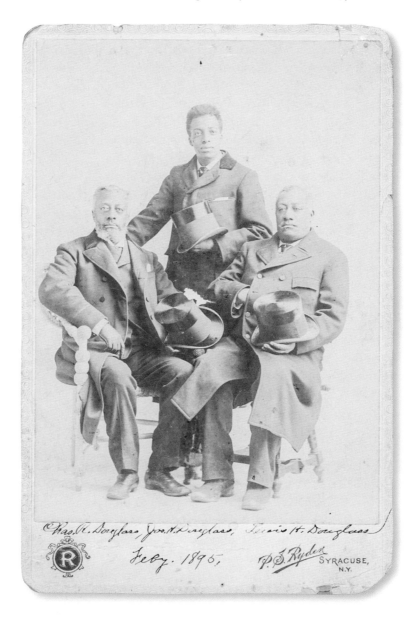

The names of the two Douglass brothers and one grandson are handwritten at the bottom of this cabinet card, along with the date "Feby. 1895" and the logo and name of the photographic studio, "P. S. Ryder Syracuse."

72. **Anon.,** *Charles Remond, Joseph Henry, and Lewis Henry Douglass* (February 1895)

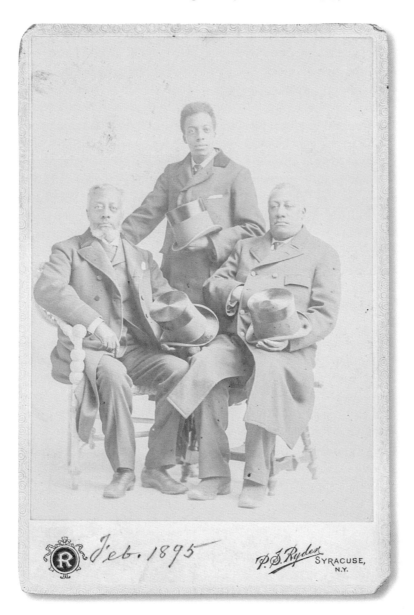

This copy includes the date "Feb. 1895," along with the logo and name of the photographic studio, "P. S. Ryder Syracuse."

The Walter O. Evans collection includes two copies of the same cabinet card showing a group portrait of Charles Remond, Joseph Henry, and Lewis Henry Douglass. Additional copies of this photograph are held in the Prints and Photographs Divisions at the Library of Congress and the Moorland-Spingarn Research Center, Howard University, Washington, DC.

An undated newspaper clipping, accompanied by Lewis Henry Douglass's handwritten signature and pasted into one of the scrapbooks held in the Walter O. Evans collection, provides vital information concerning when and where this group photograph was created. As the anonymous writer of this untitled article confirms: "friends in Syracuse had the honor of entertaining the two sons and a grandson of Frederick Douglass, who died in Washington and whose body was taken to Rochester for burial." "It was owing to that sad errand," the reporter summarizes, "that Louis [sic] H. Douglass and Charles R. Douglass, the sons, and Joseph Douglass, a son of Charles R. Douglass, paid a visit to this city." "They stopped here to visit Gerrit S. Loguen, who is a brother-in-law of Louis [sic] Douglass," the journalist further confides, stating that their visit did not go unnoticed: "Their appearance on the streets caused many to ask as to their identity and remarks were passed on the distinguished looks of the colored gentlemen." Not content with paying Helen Amelia Douglass's brother, Gerrit S. Loguen, a visit, the Douglass sons and grandson decided to have their photograph taken. "While seeing the sights of the city the three visitors went to the studio of Philip S. Ryder, the photographer, and sat for a group photograph," the reporter confirms. While this unnamed journalist expresses the opinion that "It is a very excellent likeness," she, or very likely he, intimates that Charles, Lewis, and Joseph gave their approval by confiding, "the gentlemen were not slow in complimenting the Syracuse artist on his ability."

On the very same page of this scrapbook held in the Walter O. Evans collection can be found another article in which an unnamed journalist commemorates the occasion of this photograph's being taken, only to declare, "The Douglass brothers are handsome and intelligent men." This writer singles out Lewis and Charles's combat service for special commendation: "Both wear G.A.R. buttons in their coat lapels, for both served through the war with credit." This anonymous reporter quotes Charles himself as saying: "'We always have felt that Syracuse was half home to us . . . for father was often here, and Bishop Loguen was one of the best friends the negro race in the North had during the war.'" "'Frederick Douglass often came here, for here he found ready sympathy in his work for the release of negroes from slavery,'" Charles further informs this journalist, at pains to declare, "'The underground railway had a station here, and a valuable one.'" Here Charles betrays his repeated determination to inform

audiences that Frederick Douglass's participation in the "underground railway" was no isolated endeavor but a family enterprise.

"Photo from copy negative of photo belonging to Mrs Fannie Douglass." So reads the reverse of the cabinet card (Plate 8) in a statement written in an unknown hand, confirming that the owner of this image was in fact Joseph Henry Douglass's wife. The following information also appears in typed lettering: "P.S. Ryder photographer 72 South Salina Street, Syracuse N.Y." While very little is to be gleaned from the official archives about Philip S. Ryder, it would appear that he was a US photographer who was active over a long period, beginning in the 1870s and ending in the 1920s. The scant information on offer in the archives confirms he served as the treasurer (with Frank E. Cady as secretary and Abraham Bogardus as president) of the Photographers' and Artists' Mutual Benefit Association based in Syracuse, New York. An anonymous author confirms the vital importance of this "Association," which was "calculated to embrace in its membership every respectable and worthy photographer and artist in the country." As this writer observes, "The Association was inspired by the general complaint which prevails throughout the land against the unreasonable and ruinous reduction in prices below the figure at which first-class work can be produced."[18] Yet more revealingly, this article provides researchers with access to Ryder's personal testimony by directly quoting his reasons for deciding to resign from his position as treasurer. "'I have never drawn one penny out of the Association, but, on the contrary, have put hundreds of dollars in it, until I am tired of it. I now resign the treasureship,'" he declares, only to defend himself against his detractors by insisting, "'I do not care at this late day to have my reputation ruined by being connected with an association which is virtually playing into the hands of such a lot of wolves.'"[19] It can be no surprise that Douglass's sons and grandson chose to have their portrait made by a photographer who was committed to preserving an honorable name and a respectable reputation regardless of the persecutory forces that surrounded him.

The death of Frederick Douglass on February 21, 1895, was a source of national sorrow, and his funeral ceremonies in Washington, DC and Rochester, New York were momentous occasions attracting record numbers of mourners. As John W. Thompson confirms, on February 24, just three days after Douglass's death, a private ceremony was held for the family at Cedar Hill in which there was "a prayer and the reading of the Scriptures."[20] Immediately afterwards, the "remains of Frederick Douglass were conveyed early in the morning of February

18 Anon., "Photographers' and Artists' Mutual Benefit Association," 360.
19 Ryder, "The P. and A.M.B.A.," 408.
20 Thompson, *An Authentic History*, 17.

25th to the Metropolitan Methodist Episcopal Church" in Washington, "there to lie in state."[21] Following an emotional service to packed crowds, Douglass's body was then "put aboard the 7.10 train for Rochester."[22] The members of the family that accompanied Douglass's remains on the train included his widow, Helen Pitts Douglass, his daughter, Rosetta Douglass Sprague, and his sons, Charles Remond and Lewis Henry Douglass, as well as Rosetta's daughters, Rosetta, Estelle, and Harriet Sprague, and Charles Remond's eldest son, Joseph Henry Douglass. As John W. Thompson recalls, on their arrival with Douglass's body on 26 February, "the State Assembly adjourned in respect to his memory."[23] A powerful testament to his national importance in death if not in life, Douglass's body was "received in Rochester in the honored presence of the Mayor and all Common Council of that city and thousands of citizens with uncovered heads."[24] As Thompson reports, "his remains laid in state in the City Hall," and "schools were closed" so "that teachers and scholars might view for the last time the picturesque form of Frederick Douglass."[25] Unprecedented numbers of women, children, and men came to do so, with the result that "the crowd in the street increased to such proportions that passage was almost impossible."[26]

As of 2018, on a peaceful spot on the hillside and shaded by beautiful trees in Mount Hope Cemetery, Rochester, Douglass's grave can still be visited. Entombed beneath a large gray slab distinguished solely by his name and the years of his birth and death, his body remains buried beside the loves of his life: his two wives, Anna Murray and Helen Pitts, and his youngest daughter, Annie Douglass.

21 Ibid.
22 Ibid. 20.
23 Ibid. 28.
24 Ibid.
25 Ibid.
26 Ibid. 27.

Figure 70: Anon, *Frederick Douglass*, February 21, 1895.
(National Park Service: Frederick Douglass National Historic Site, Washington, DC.)

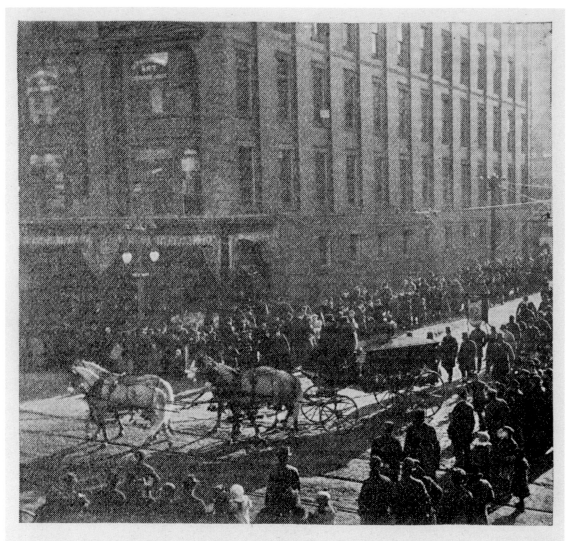

THE DOUGLASS FUNERAL.—The Funeral Procession.

Figure 71: Anon., *The Douglass Funeral: The Funeral Procession*, 1895.
Collection of the Rochester Public Library Local History Division, Central
Library of Rochester and Monroe County, Rochester, NY.)

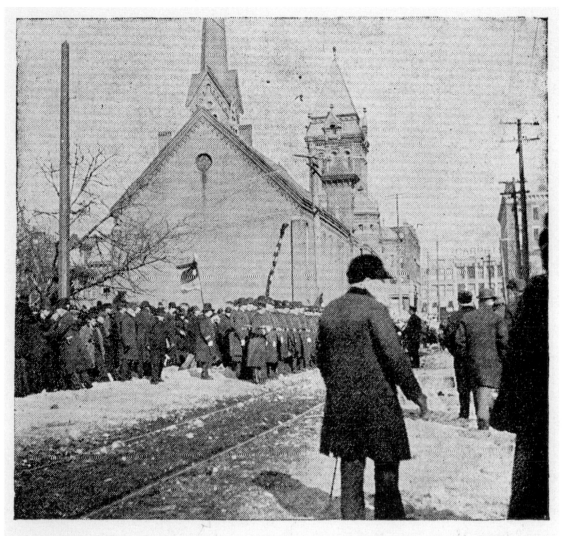

THE DOUGLASS FUNERAL.—On Church Street; the Line of March.

Figure 72: Anon., *The Douglass Funeral; On Church Street; The Line of March*, 1895.
Collection of the Rochester Public Library Local History Division, Central
Library of Rochester and Monroe County, Rochester, NY.)

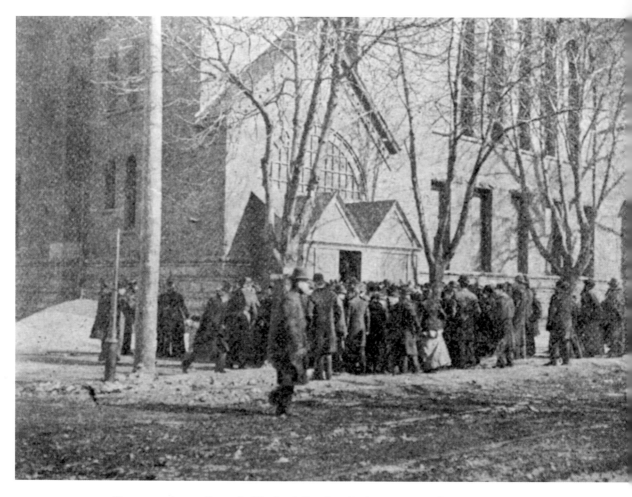

Figure 73: Anon., *Funeral of Frederick Douglass, Rochester, New York*, 1895. Reproduced *Rochester Union and Advertiser*, March 2, 1895. (Collection of the Rochester Public Library Local History Division, Central Library of Rochester and Monroe County, Rochester, NY.)

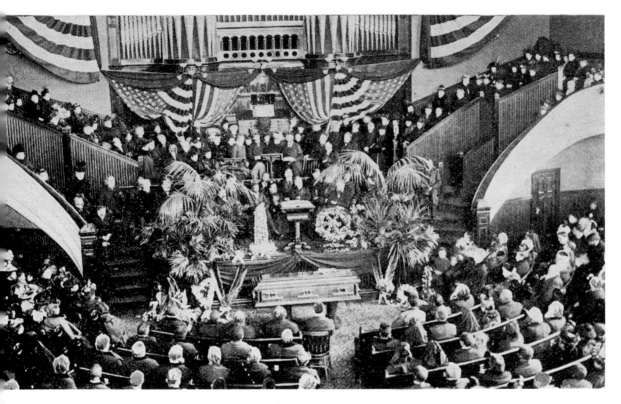

Figure 74: Anon., *The Douglass Funeral: Inside the Church*, 1895.
(Collection of the Rochester Public Library Local History Division,
Central Library of Rochester and Monroe County, Rochester, NY.)

73. John Howe Kent, *Charles Remond Douglass*, Rochester, NY [c. 1890s]

73. John Howe Kent, *Charles Remond Douglass*, Rochester, NY [c. 1890s]

This cabinet card of Charles Remond Douglass was created by renowned white US photographer John Howe Kent (1827–1910). He ran a very successful photographic studio in Rochester, New York during the same period in which the Douglass family lived there. As Joan Pedzich's research reveals, Kent had an exalted reputation as an "exemplary studio artist" and a "photographic inventor."[27] As she summarizes, "Kent's portraits are, for the most part, idealized views of the sitter in which he used lighting, props, and careful posing to soften the effects of age, emphasize and sculpt flattering features, or modify those which were not."[28] The fact that Kent not only photographed Charles, as shown here, but that he took repeated individual portraits and group photographs of Frederick Douglass that he himself commissioned, immediately establishes that both father and son were most likely drawn to Kent for his technical virtuosity in general and for his dedication to taking an "idealized" portrait more particularly.

No more categorical evidence of Kent's exceptional skill can be found than in this cabinet card of Douglass's youngest son. Wearing a double-breasted coat, a top hat, and a Grand Army of the Republic pin, Charles Remond carries an umbrella in one hand and his gloves in the other, appearing as the epitome of the beautifully dressed, elite gentleman. Bereft of any handwritten inscription or instructions, the reverse of this cabinet card carries Kent's advertisement of his studio in the following capitalized letters: "J. H. Kent DUPLICATES FROM THIS NEGATIVE FURNISHED AT ANY TIME FINE LARGE PICTURES A SPECIALTY COPIES OF A VERY SUPERIOR QUALITY." As this image, one of the most meticulously executed and beautifully rendered portraits of a Douglass family member, makes clear, Kent was not exaggerating his prowess: this cabinet card was indeed of "very superior quality."

27 Pedzich, "John Howe Kent," 1.
28 Ibid.

74. *Anon., Maj. Charles Remond Douglass:*
Commander Frederick Douglass Post No. 21,
Department of the Potomac, G.A.R. [n.d.]

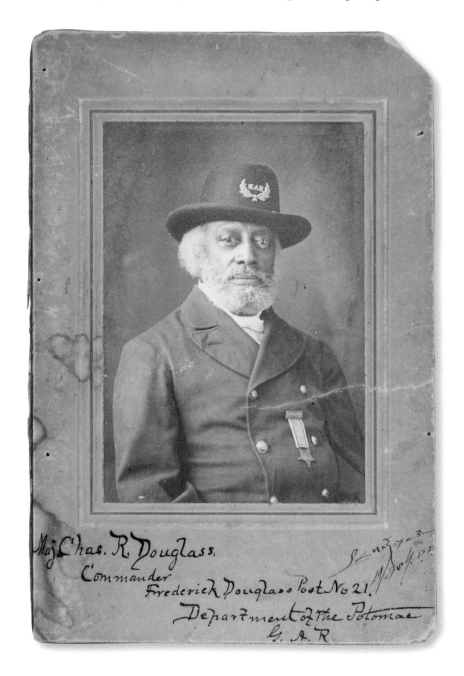

74. Anon., *Maj. Charles Remond Douglass: Commander Frederick Douglass Post No. 21, Department of the Potomac, G.A.R.* [n.d.]

The date of this portrait of Charles Remond Douglass, as well as the identity of the photographer, has yet to be established. The only information that survives appears on the reverse of this print and reads: "Charles R. Douglass, Commander Frederick Douglass Post No. 21 Return to Mrs. Chas. Douglass 318 A St N.E." At the bottom of the likeness an unknown author has also written Charles's full name, and repeated the information that he was Commander of the Frederick Douglass Post No. 21.

Writing in an article in the *Cleveland Gazette* on October 11, 1902, an unnamed reporter celebrates Charles Remond Douglass for his political and moral integrity on all issues, but especially when it came to acts of discrimination in the Grand Army of the Republic.[29] According to this journalist, "Mr. Douglass stands at all times for the manhood of our people and in recent weeks has led the fight against the Washington, D.C., G. A. R. 'Jim Crow' committee, with signal success." Charles Remond was to be especially applauded for his resistance to "Prejudiced whites and cheap Negroes at the nation's capital" and their attempts to institute segregated facilities at the "G.A.R. encampment." As this reporter confirms, "Mr. Douglass was among the staunchest supporters *The Gazette* had in its fight against the despicable thing at that time and we have done all in our power to assist him in his commendable effort." The writer concludes with a heartfelt plea: "The race needs more MEN like Charles Remond Douglass."[30] Clearly, Charles took his veteran status and post-war military position as a commander of a G.A.R. post named after his father very seriously.

As further evidence that the "race needs more MEN like Charles Remond," Douglass's youngest son writes a public letter "To the Editor of the Bee" in which he himself names and shames the injustices of the same "Jim Crow Committee."[31] Appearing in this newspaper on September 20, 1902, he voices his virulent opposition to "the insult offered to the colored Veterans, and other respectable colored people by the appointment of a 'Jim Crow' committee to look out after colored visitors coming to the G. A. R. Encampment." He replies on impassioned rhetoric to exclaim, "Lincoln once said 'You can fool some

29 Anon., n.t., *Cleveland Gazette*, October 11, 1902.
30 Ibid.
31 Charles Remond Douglass, "To the Editor of the Bee: The Jim Crow Committee," *Washington Bee*, September 20, 1902.

people all the time, you can fool all of the people some of the time, but you can't fool all the people of all the time,'" only to urge that, "this aptly applies to those negroes who have consented to remain on this 'Jim Crow' Committee, being fooled into the belief that they are members of the Committee on Public comfort." Charles concludes his public letter of protest not only by registering his own virulent opposition to any and all nefarious attempts at segregation but by celebrating the revolutionary actions of many more Black radicals. As Charles writes, "such men as Hon. Jno. F. Cook, L. C. Bailey, L. H. Douglass, Judge R. H. Terrell, D. B. McCary, Whitfield McKinley, Dr. Jno. Francis. Col. P. H. Carson, C. A. Fleetwood, J. H. Butcher, and a number of others of our foremost citizens, together with those of the Veterans of Chas. Sumner Post. No. 9, and the Frederick Douglass Post No. 21, have positively refused to accept assignment on this Jim Crow committee, notwithstanding the false pretense that they were members of the Com. on Pub. Comfort." He is categorical in his conviction: "The word black or white cannot be found in any law governing our order. That they are Posts composed entirely of black men, and Posts composed entirely of white men, and Posts that are mixed, is true, but it is not so by compulsion. A black man can enter any Post in the United States provided he is a member of the Grand Army of the Republic."[32]

While it is currently impossible to establish an exact date for this portrait, Joseph Douglass Jr., Charles's son, provides some vital information by remembering that, "Having been the first adjutant for the Frederick Douglass Post," his father "later served at least five terms (1902, 1905, 1911, 1912, and 1916) as commander."[33] On these grounds, it would seem very likely that this portrait was made during the final two decades of Charles Remond Douglass's life.

32 Ibid.
33 Joseph Douglass Jr., *Frederick Douglass*, 241.

75. Anon., *Charles Remond Douglass* [n.d.]

Beneath Charles Remond's portrait and handwritten on the paper frame are the name "Leon De Vaux" and the location "Washington."

76. Anon., *Charles Remond Douglass* [n.d.]

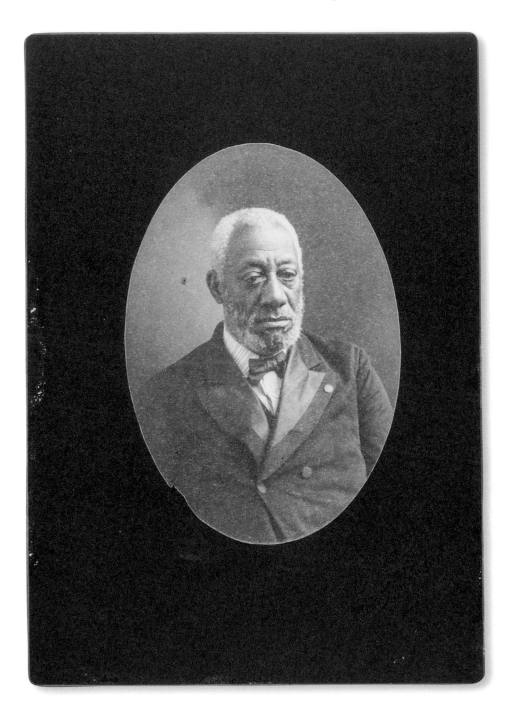

77. E. Paul Tilghman, *Lewis Henry Douglass*, New Bedford, MA [n.d.]

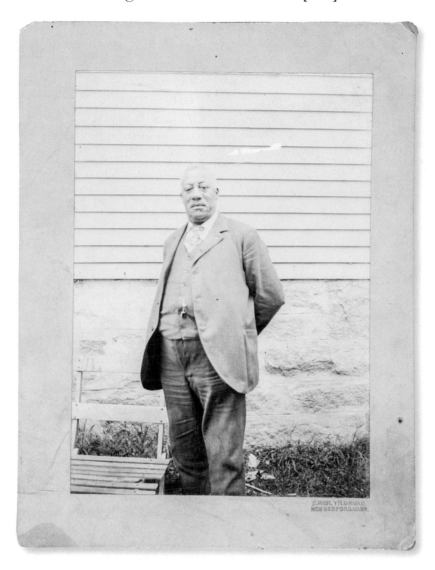

In the bottom right-hand corner, the following words are embossed in capital letters: "E. Paul Tilghman, New Bedford, Mass." E. Paul Tilghman was very likely Eugene Paul Tilghman (1858–1909), a photographer working out of New Bedford, Massachusetts. Lewis Henry Douglass probably had this photograph taken during a visit there.

78. Anon., *Lewis Henry Douglass* and unidentified children [n.d.]

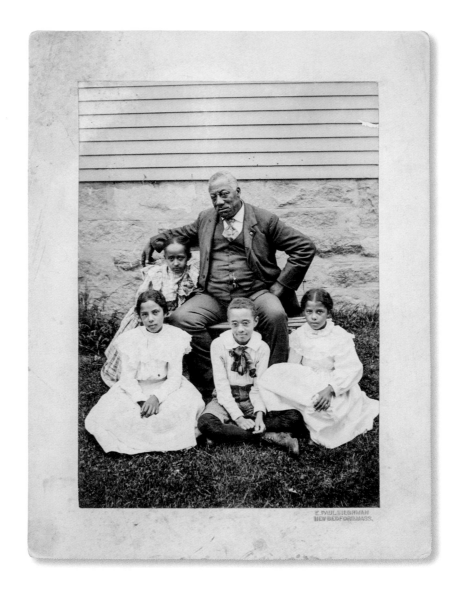

In the bottom right-hand corner, the following words are embossed in capital letters: "E. Paul Tilghman, New Bedford, Mass." This photograph was undoubtedly taken during the same sitting as No. 77. The three girls and one boy are as yet unidentified.

79. Anon., *Unveiling of Frederick Douglass Monument* [June 9, 1899]

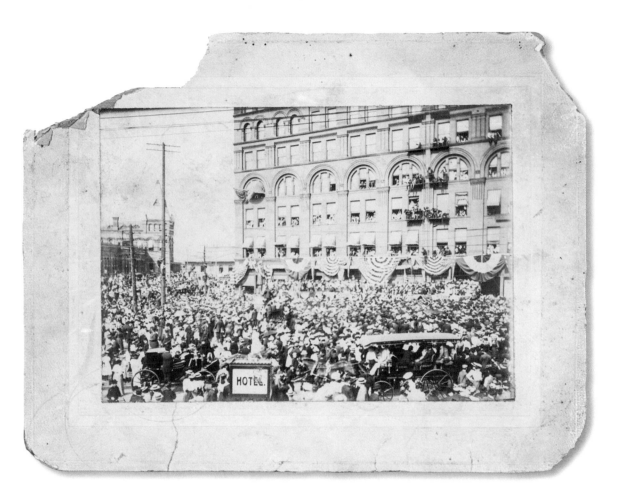

A handwritten summary on the reverse of this image erroneously reads: "Photo of Frederick Douglass funeral." This was not, in fact, Douglass's funeral, but a public occasion commemorating the unveiling of a monumental bronze statue of Douglass in Rochester, New York, on June 9, 1899. A photograph of the scene appears in John W. Thompson's *An Authentic History of the Douglass Monument* (Figure 75), with a key difference: while Douglass's statue is clearly on view in this photograph, in Thompson's illustration his monument is still covered with the US flag prior to its ceremonial unveiling.

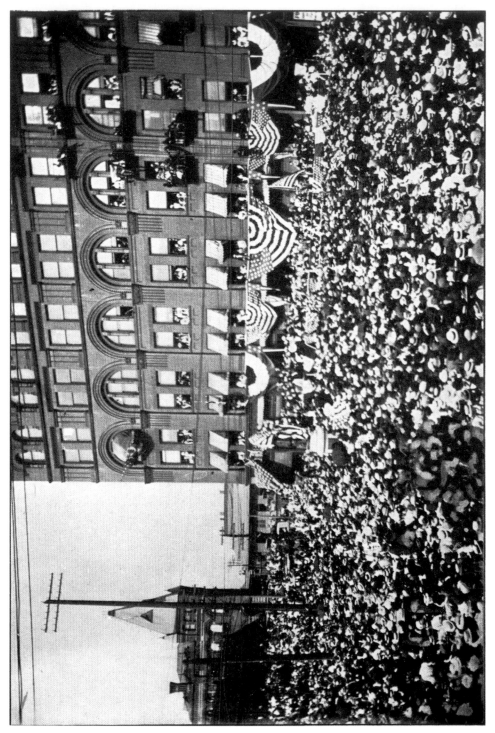

Figure 75: Anon, *Scene at the Unveiling, Rochester N.Y.* Reproduced John W. Thompson, *Authentic History of the Douglass Monument.* (Rochester: Rochester Herald Press, 1903; Collection of the Rochester Public Library Local History Division, Central Library of Rochester and Monroe County, Rochester, NY.)

The vision to design and secure funds for a monument in honor of Frederick Douglass was the brainchild of African American activist and reformer John W. Thompson. While Douglass was still alive, Thompson had initially conceived of a very different public memorial: a monument to African American Civil War combat heroism. As early as November 20, 1894, Thompson held a meeting in Rochester in which he was responsible for putting forward "a motion that a committee be appointed for the purpose of erecting a monument in memory of the Afro-American soldiers and sailors who had fallen in the Civil War."[34] Buoyed up by his success, he wrote an appeal for support on behalf of the committee to no less an individual than Frederick Douglass. On December 3, 1894, just two months before his death, Douglass wrote Thompson to express his wholehearted approval of his initiative, which he applauded because it would play a vital role in memorializing Black heroism for current and future generations. "I am more than pleased with the patriotic purpose to erect in Rochester a monument in honor of the colored soldiers who, under great discouragements, at the moment of the national peril volunteered to go to the front and fight for their country," Douglass writes. "The colored soldier fought with a halter about his neck, but he fought all the same." He seems delighted to proclaim, "I shall be proud if I shall live to see the proposed monument erected in the city of Rochester, where the best years of my life were spent in the service of our people."[35]

While Frederick Douglass sadly did not "live to see the proposed monument," passing away unexpectedly a few months later, his memory immediately became its source of inspiration instead. Just two years after Douglass's death, John W. Thompson delivered a speech "before the Finance Committee of the State Assembly at Albany, N.Y." on February 24, 1897. Working to galvanize support in his new role as Chairman of a Douglass (rather than a Black Civil War) Monument Committee, he asks members of the state assembly to "grant" his "appeal" for a statue immortalizing Douglass's life. He foregrounds Douglass's enduring power as a catalyst to Black liberation struggles over the generations: past, present, and future. Thompson insists that, "by the erection of such a memorial we may leave a witness which shall speak long after our tongues are hushed." He envisions his imagined Douglass monument as an "inspiration for generations to come, insighting to American manhood a love of country, to unconquerable devotions to a great cause, telling our boys and girls that the humbleness of birth is no insurmountable barrier to eminence."[36] He asks the

34 Thompson, *An Authentic History*, 38.
35 Frederick Douglass to John W. Thompson, December 3, 1894, General Correspondence, Frederick Douglass Papers, Library of Congress.
36 Thompson, "Douglass: Ex-slave and statesman," 106.

commitee for "an appropriation of $5,000," with the result that he is awarded "$3,000."[37]

In order to raise the full $10,000 that was necessary for making Thompson's dream a reality, Douglass's key supporters and friends, including Susan B. Anthony, Booker T. Washington, and the Douglass family, worked hard to raise the remaining funds. In a letter he writes in November 1898, Charles Remond Douglass was disheartened to realize that, "Less than $500 came from the pockets of the 10,000,000 negroes in the United States."[38] While he singles out "[t]he little republic of Hayti, numbering less than a million inhabitants," for praise because it "gave a thousand dollars," he observes that this sum was "more than was contributed by all the negroes in the United States together." He is saddened to realize, "The balance of the $10,000 came from white people."[39] His disappointments notwithstanding, Charles commends Thompson: "He has undertaken and accomplished more than has ever been accomplished before by any negro. He has erected a monument to one of his race."[40] Due to the difficulties Thompson experienced in raising the necessary funds and unexpected delays with its execution by the artist, there was a separate ceremony for the laying of the cornerstone, which took place on July 20, 1898, while the 54th Massachusetts Regiment band played (Figure 76.)

Just under a year later, on June 9, 1899, the monument was unveiled in Rochester by Thompson's daughter, Gertrude Aleath Thompson, in a public ceremony attended by Helen Pitts, Lewis Henry, Charles Remond, Rosetta Douglass Sprague, and her daughter Rosa.[41] The monument, depicting the erect figure of Douglass with a hand outstretched in a gesture of authority, was created by the Smith Granite Company of Westerly, Rhode Island, and executed by white US sculptor Sidney W. Edwards. Yet more fascinatingly, "Charles Remond Douglass posed for the handsome bronze statue that so gracefully portrays the illustrious father in life."[42] The then governor, Theodore Roosevelt, gave a speech as part of the day's activities, which also included numerous receptions and a parade. As Thompson recalls, "citizens had decorated their building in flags, buntings and rosettes of Stars and Stripes. Old Glory floated from all the public buildings, schools and many residences."[43]

37 Thompson, *An Authentic History*, 28.
38 Ibid. 114.
39 Ibid.
40 Ibid.
41 Ibid. 137.
42 Ibid. 157.
43 Ibid. 119–21.

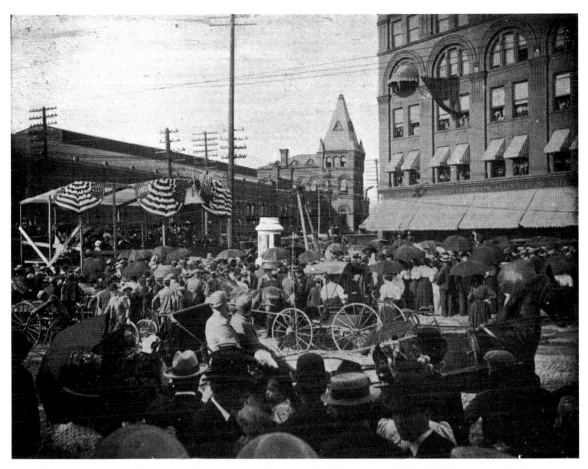

Figure 76: Anon., *Scene at the Corner Laying, Rochester N. Y.* Reproduced John W. Thompson, *Authentic History of the Douglass Monument.* (Rochester: Rochester Herald Press, 1903. Collection of the Rochester Public Library Local History Division, Central Library of Rochester and Monroe County, Rochester, NY.)

He further remembers, "The proclamation of the mayor caused many factories and business houses to close at noon and the laborers augmented the throng."[44] And yet, he is under no illusion that "[t]he most imposing scene of the day was around the spot where stood the bronze figure of Frederick Douglass, standing erect and portraying the colored statesman in his favorite and most effective pose."[45]

Thompson was jubilant regarding the event's monumental success: "Here, and occupying every inch of the street and every foot of the grounds of the

44 Ibid. 121.
45 Ibid. 125.

New York Central station, were gathered thousands upon thousands of citizens." As he remembers, "There was a crush and jam, a pulling and tugging to obtain best positions, and the police found their efforts useless to keep the crowd within the limits prescribed by the ropes."[46] He further speculates, "Probably 10,000 people saw the bronze statue of Frederick Douglass revealed as the folds of the Stars and Stripes were drawn aside."[47] Among the famed individuals who were unable to attend was P. B. S Pinchback. As a result, he wrote Thompson a letter thanking him for "'your kind invitation to be present at the unveiling of the Douglass monument,'" which he predicts, "'will be an historic occasion.'" While he admits, "'I deeply regret my inability to attend,'" he takes solace in his realization that, "'The citizens of Rochester are entitled to, and will have the thanks of the entire race, for the patriotic and creditable manner in which they have seen fit to honor and perpetuate the memory of the race's world wide champion.'"[48] In a detailed history of the monument that he published a few years later, Thompson is no less jubilant that this statue was "the first monument erected by popular contribution, to the memory of an Afro-American statesman," and that it was "carried on to completion by one of his own race," with the result that "Its history will be an inspiration for generations to come."[49]

"The pedestal is made of the best Westerly gray granite, is nine feet high, and the bronze statue eight feet high; total height, seventeen feet. There are also four bronze tablets containing these words, from some of his most famous speeches," Thompson summarizes regarding the construction of Douglass's monument.[50] Each of these tablets take inspiration from Douglass's life as an orator and author as well as an activist; Panel 1 reads: "THE BEST DEFENCE OF FREE AMERICAN INSTITUTIONS IS THE HEARTS OF THE AMERICAN PEOPLE THEMSELVES." "ONE WITH GOD IS A MAJORITY." "I KNOW OF NO RIGHTS OF RACE SUPERIOR TO THE RIGHTS OF HUMANITY." Panel 2 avows: "MEN DO NOT LIVE BY BREAD ALONE, SO WITH NATIONS, THEY ARE NOT SAVED BY ART, BUT BY HONESTY, NOT BY THE GILDED SPLENDORS OF WEALTH BUT BY THE HIDDEN TREASURE OF MANLY VIRTUE, NOT BY THE MULTITUDINOUS GRATIFICATION OF THE FLESH BUT BY THE CELESTIAL GUIDANCE OF THE SPIRIT." Finally, Panel 3 reads: "I KNOW OF NO SOIL BETTER ADAPTED TO THE GROWTH OF REFORM THAN AMERICAN SOIL. I KNOW OF NO COUNTRY WHERE THE CONDITIONS FOR EFFECTING GREAT CHANGES IN THE SETTLED

46 Ibid.
47 Ibid. 126.
48 Ibid. 162.
49 Ibid. n.p.
50 Ibid. 157.

ORDER OF THINGS, FOR THE DEVELOPMENT OF RIGHT IDEAS OF LIBERTY AND HUMANITY ARE MORE FAVORABLE THAN HERE IN THESE UNITED STATES."[51]

Against a backdrop of the escalation in acts of violence and violation enacted against Black people of all backgrounds and ages, Douglass's words as cast in bronze on this first public monument remain as a testament to hope and a vindication of the fight for preservation of the "right ideas of liberty and humanity" that is far from over on US soil in the twenty-first century.

51 Images of the panels can be viewed at <https://ordinaryphilosophy.files.wordpress.com/2016/06/ frederick-douglass-quotes-on-monument-in-highland-park-rochester-ny-2016-amy-cools1.jpg> (accessed January 14, 2018).

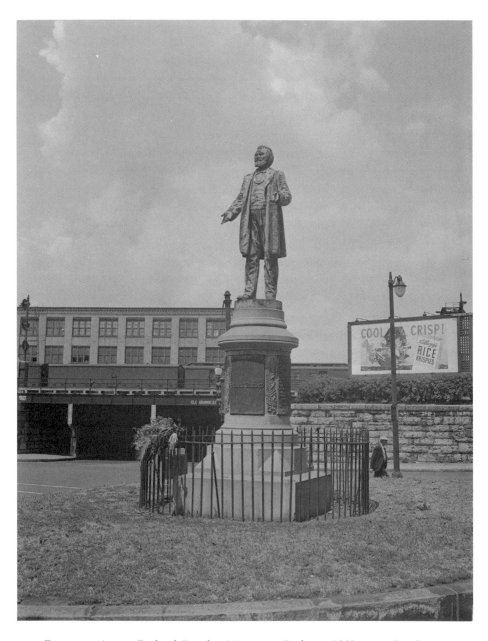

Figure 77: Anon., *Frederick Douglass Monument, Rochester, N.Y.*, 1941. (Rochester Municipal Archives Collection. Collection of the Rochester Public Library Local History Division, Central Library of Rochester and Monroe County, Rochester, NY.)

80. John Howe Kent, *Frederick Douglass Monument*, Rochester, NY [c. 1899]

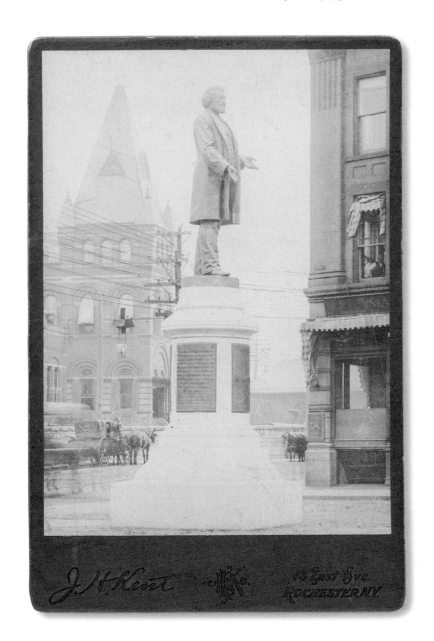

81. Anon., *Haley G. Douglass*, Highland Beach, MD (1895)

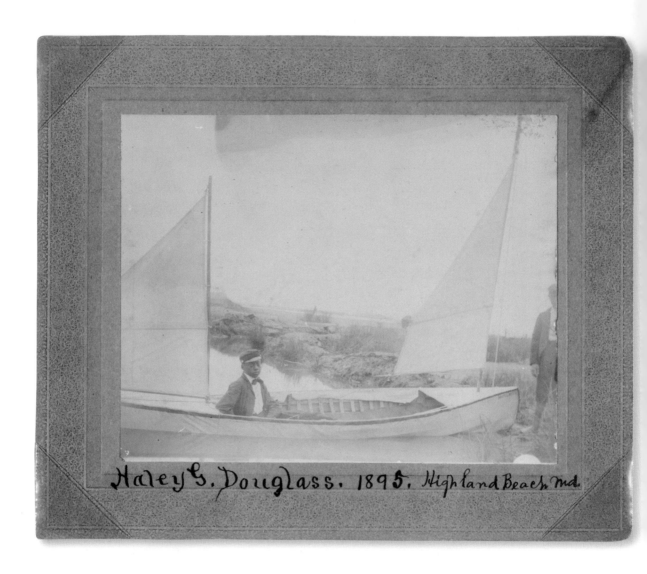

81. Anon., *Haley G. Douglass*, Highland Beach, MD (1895)

This photograph of Haley George Douglass (1881–1954), Charles Remond's youngest son and Frederick Douglass's grandson, is not labelled with the name of a photographer. However, the handwritten caption identifies the location as "Highland Beach Maryland." Located on the Chesapeake Bay, Highland Beach is of singular historical importance, not only as the "First African American Incorporated Town" but as a community founded by none other than Charles Remond Douglass himself.[52] As Jack E. Nelson, Raymond L. Langston, and Margo Dean Pinson confirm, "After being rebuffed because of their race following their arrival at the popular Bay Ridge Resort and Amusement Park," Frederick Douglass's youngest son, Charles, and his second wife, Laura Antoinette Haley Douglass, "took a stroll along the beach in the direction of Black Walnut Creek."[53] As Haley George Douglass further remembers, "My mother, Laura Douglass, liked the place so well that she tried to find a place where she could board for a few weeks, and so she walked around the beach to the South of Bay Ridge."[54] "My father then made inquiry and learned that the property could be bought, and through an attorney in Annapolis negotiated for the sale of the property," he recalls.[55]

In a letter Charles Remond writes his father as early as 1893, he informs him: "There are some lots bordering on 'Black Walnut Creek' that contain more or less square feet of ground." He explains, "In order to please everybody I have named the streets and avenues after prominent colored men so far as there were streets to go around."[56] Among these names of "prominent colored men" can of course be found Frederick Douglass, P. B. S. Pinchback, and Booker T. Washington. "I have named the place as you will see 'Highland Beach,'" Charles confides to his father, "because the land at this point is higher than either side of me on the Beach." He is jubilant: "I have no doubt of the success of the venture."[57] Frederick Douglass was clearly convinced of his son's success. As Carole Greene Jr. confirms, he "bought a lot from his son in 1893 and began to build his own cottage," which he named Twin Oaks. As he explains, this "cottage" was erected in just the right position, "so that I as a free man could look across the Bay to the Eastern Shore where I was born a slave." But

52 Nelson, Langston, and Pinson, *Highland Beach*, 10.
53 Ibid.
54 Ibid.
55 Ibid. 14.
56 Ibid.
57 Ibid.

Douglass's dream was not to be realized, as he died "before the cottage was completed."[58]

Despite his father's passing, Charles Remond's business venture in establishing Highland Beach was a resounding success. "Within twelve years, by 1905, he had sold quite a few of the newly subdivided lots for a gross income of $8,000—an annual return of 58.3 percent," Greene observes, with the result that "the foundation for a unique and vibrant community had been laid."[59] Yet more particularly, this "vibrant community" was not only a source of financial reward but a nurturing space for the exchange of oral stories. According to the testimony provided by one of the Highland Beach holiday-makers, Mrs Edna Bowen Newton, at various gatherings Lewis Henry Douglass "'used to tell us all about the Civil War' and how he had worked before the war as a printer."[60]

After his father passed away in 1920, Haley George Douglass became "the first mayor of Highland Beach and the first African American mayor in the state of Maryland."[61] As William M. Brewer writes, Haley also "personified the ideal of human dignity in Washington, D.C."[62] A Harvard graduate, he had a distinguished career as a teacher: he "taught in high schools in the city" in which he made sure "no student ever missed" learning "the inspiring tradition of Frederick Douglass."[63] According to Brewer, Haley possessed "a passion and concern about the fortune and hopes of colored people—an inheritance, no doubt, from his noble lineage."[64] "In public and community relations Mr. Douglass's life was full, as he was long a representative survivor of his grandfather," Brewer summarizes. He recalls, "On many occasions he represented the family at honors and tributes to Frederick Douglass and often spoke giving reminiscences and illustrating in his personal appearance a fitting symbol of considerable resemblance in long white hair."[65]

Nothing could be further from Haley George Douglass as a public icon, single-handedly responsible for perpetuating his grandfather's legacy, than his appearance in this photograph as a young child sailing at Highland Beach, or the surviving letters from his youthful correspondence with Frederick Douglass. In a letter dated August 17, 1893, held in the Frederick Douglass Papers General Correspondence Files at the Library of Congress, Haley writes jubilantly to his grandfather of activities which call to mind this image, which was taken two

58 Greene Jr., "Summertime," 1.
59 Ibid. 17.
60 Ibid. 48.
61 Nelson, Langston, and Pinson, *Highland Beach*, 16.
62 Brewer, "Haley George Douglass," 146.
63 Ibid.
64 Ibid.
65 Ibid. 162.

years later: "Dear Grand Pa: My father received a letter from Joe saying that you would like to hear from me. I am down on the Bay spending the summer I go out fishing and crabbing almost every day. I have learned how to swim real well and I can swim over a hundred yards without stopping to rest. Please remember me to Mrs. Douglass and Joe. From your Affectionate Grand Son. Haley Geo. Douglass."[66]

In the exchange that survives in the Walter O. Evans collection, Haley had written Douglass a few months earlier on March 3, 1893, to express his heartfelt gratitude: "I received the flute you kindly sent me last evening. I can play a little on it now, but I think after a while I will be able to play much better. I am more than thankful to you for it." The reply he receives a few days later, on March 7, lays bare Frederick Douglass's hopes and dreams for all his family members: "Go on, my dear boy, you are a Boy now, but you will be a man some day—and I hope a wise and good man."

66 Haley George Douglass to Frederick Douglass, August 17, 1893, General Correspondence Files, Frederick Douglass Papers, Library of Congress.

82. Anon., *Charles A. Fraser* [c. 1882]

82. Anon., *Charles A. Fraser* [c. 1882]

The reverse of this cabinet card includes the following handwritten inscription confirming the identity of the sitter: "For Mr. Chas. R. Douglass in remembrance of my visit to Washington in the September of 1882 from Chas. A. Fraser Puerto Plata S. Domingo." As we have seen in this volume, Charles A. Fraser was the husband of Helen Amelia Loguen's sister, Sarah Loguen Fraser (1850–1933), a renowned medical doctor. According to Eric V. D. Luft's research, Frederick Douglass himself had played a role in their marriage: "Douglass introduced Charles Fraser, a pharmacist from Puerto Plata, Santo Doming (now the Dominican Republic), to the entire Loguen family and actively encouraged the courtship of Charles and Sarah from 1877 until he proposed to her in June 1881."[67] According to his findings, "Shortly after they were married in Syracuse on September 19, 1882, Douglass wrote to her: 'Tell Mr. Fraser that while I would have been glad to have you here as long as I am in the land of the living, that I do not blame him a bit for taking you away.'"[68] During their marriage, Charles and Sarah Marinda Loguen Fraser had one child, Gregoria Alejandrina Fraser Goins (1883–1964).

67 Luft, "Sarah Loguen Fraser," 68.
68 Ibid.

83. Anon., [Unidentified Woman] [n.d.]

84. Anon., [Unidentified Woman in a Rural Landscape] [n.d.]

85. Anon., *Haley George Douglass and Evelyn Virginia Dulaney Douglass* [n.d.]

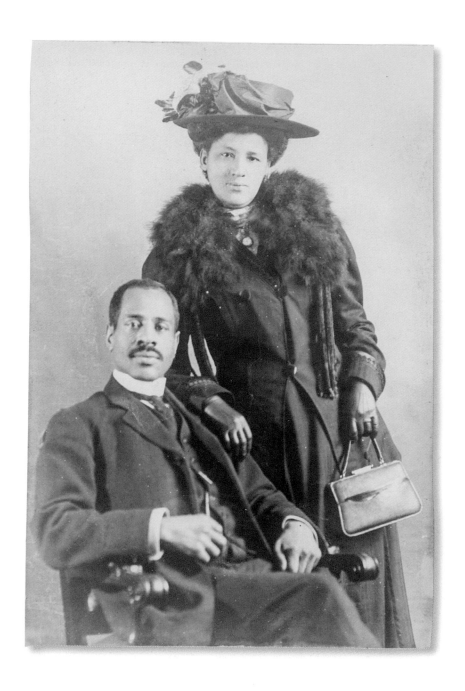

86. Anon., [Exterior Landscape,
Three Unidentified Male Children] [n.d.]

PORT ROYAL
JUL 7
S.C.

Miss H. A. Loguen
Box 685
Syracuse
New York

Part IX

Frederick Douglass
and Family Resources

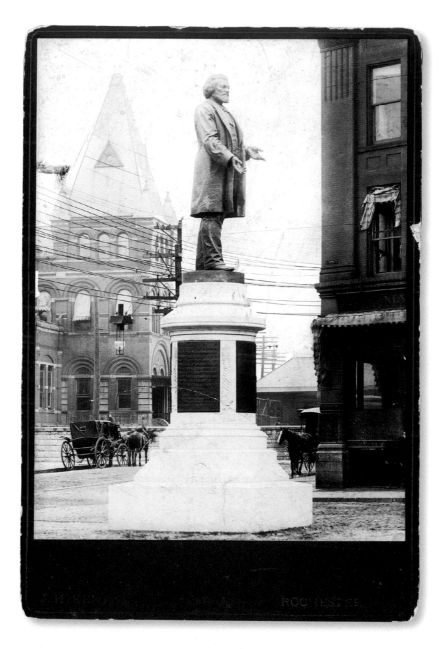

Figure 78: John Howe Kent, *Frederick Douglass Monument*, Rochester, NY [c. 1899]

Walter O. Evans Frederick Douglass and Family Collection Inventory

Printed Matter (Books)

Douglass, Frederick (1845), *Narrative of the Life of Frederick Douglass, An American Slave*, Boston: Antislavery Office. Inscribed: "this is the property of Lewis Douglass. At my death I desire this book to go to my nephew Haley G. Douglass Lewis H. Douglass August 17 1907. L. H. Douglass."

Douglass, Frederick (1856), *My Bondage and My Freedom*, New York: Miller Orton and Mulligan. Inscribed: "signed: Lewis H. Douglass Washington D.C. At my death I desire this book to go to my nephew Haley G. Douglass, Lewis H. Douglass, Aug. 17 1907."

Tyson, Martha E. (ed.) (1884), *Banneker: The Afric-American Astronomer from the posthumous papers of Martha E Tyson edited by her daughter*, Philadelphia: Friends' Book Association. Inscribed: "To Fredk. Douglass Jr. From Frederick Douglass 1884."

Printed Matter (Pamphlets)

Douglass, Frederick (1846), *Free Church Alliance with Manstealers. Send Back the Money. Great Anti-Slavery Meeting in the City Hall, Glasgow, containing Speeches delivered by Messrs. Wright, Douglass and Buffum from America, and by George Thompson Esq. of London; with a summary account of a series of meetings held in Edinburgh by the above named gentleman*. Glasgow: George Gallie, Buchanan Street; W. & R. Smeal, 161 Gallowgate; Quintin Dalrymple, Frederick Street, Edinburgh.

Douglass, Frederick (1847), *Report of Proceedings at the Soiree Given to Frederick Douglass, London Tavern, March 30, 1847*, London: R. Yorke Clarke and Co., 455 Grace Church Street.

Douglass, Frederick (1852), *Oration Delivered in Corinthian Hall, Rochester, by Frederick Douglass July 5th 1852*, published by request, Rochester: Lee, Mann & Co.

Douglass, Frederick (1859), *Eulogy of the Late Hon. WM. Jay by Frederick Douglass, Delivered on the Invitation of the Colored Citizens of New York City, in Shiloh Presbyterian Church, New York May 12 1859*, Rochester: Press of A. Strong & Co., Democrat and American Office.

Douglass, Frederick (1873), *Address Delivered by Hon. Frederick Douglass at the Third Annual Fair of the Tennessee Colored Agricultural and Mechanical Association, on Thursday September 18 1873*, at Nashville, Tennessee, Washington: New National Era and Citizen's Print. [Mr. Chas. R. Douglass signed in top left corner.]

Douglass, Frederick (1876), *Oration by Frederick Douglass Delivered on the Occasion of the Unveiling of the Freedmen's Monument In Memory of Abraham Lincoln, In Lincoln Park, Washington D.C. April 14th 1876, WITH AN APPENDIX*, Washington, DC: Gibson Brothers, Printers.

Douglass, Frederick (1877), *Self-Made Men Delivered before the Students of the Indiana Schools at Carlisle Penna. 1876–77*, n.p. No cover with info, but handwritten.

Douglass, Frederick (1878), *G.A.R. Decoration Day Hon Frederick Douglass*, G.A.R. Report of Proceedings, 30th Decoration Day, New York: n.p.

Douglass, Frederick (1881), *John Brown: An Address by Frederick Douglass at the Fourteenth Anniversary of Storer College*, Dover, NH: Morning Star Job Printing House. [Chas. R. Douglass signed in top corner.]

Douglass, Frederick (1883), *Address by Hon. Frederick Douglass, Delivered in the Congregational Church Washington D. C. April 16 1883 on the 21st Anniversary of Emancipation in the District of Columbia, Washington DC*, Washington, DC: n.p.

Douglass, Frederick (1883), *National Convention of Colored Men, At Louisville, KY., September 24, 1883*, Louisville: Courier-Journal Job Printing Company.

Douglass, Frederick (1883), *Proceedings on the Civil Rights Mass-Meeting Held on Lincoln Hall, October 22, 1883, Speeches of Hon. Frederick Douglass, and Robert G. Ingersoll*, Washington, DC: C. P. Farrell.

Douglass, Frederick (n.d.), *Frederick Douglass, on the Exodus*, n.p. [No cover.]

Unpublished Manuscripts (Scrapbooks)

Lewis Henry Douglass

Douglass, Lewis Henry [Original compiler probably Frederick Douglass Jr.] (n.d.), *Scrapbook*, n.p. [Inscribed: "This book is to be given to Haley G. Douglass at my death. There are several of these scraps that do not pertain to the above scrap Book, inclosed [sic] in these pages. Lewis H. Douglas August 2 1907."]

Douglass, Lewis Henry [Original compiler probably Frederick Douglass Jr.] (n.d.), *Scrapbook*. [Inscribed: "Lewis Douglass Scrapbook Notes August 2 1907."]

Douglass, Lewis Henry [Original compiler probably Frederick Douglass Jr.] (n.d.), *Scrapbook: Book No. 1*.

Douglass, Lewis Henry [Original compiler probably Frederick Douglass Jr.] (n.d.), *Scrapbook: Book No. 2*.

Douglass, Lewis Henry [Original compiler probably Frederick Douglass Jr.] (n.d.), *Scrapbook: Book No. 3*.

Douglass, Lewis Henry [Original compiler probably Frederick Douglass Jr.] (n.d.), *Scrapbook: Book No. 4.*

Douglass, Lewis Henry [Original compiler probably Frederick Douglass Jr.] (n.d.), *Scrapbook: Book No. 5.*

Douglass, Lewis Henry [Original compiler probably Frederick Douglass Jr.] (n.d.), *Scrapbook: Book No. 6.*

Frederick Douglass Jr.

Douglass, Frederick, Jr. (1880), *Frederick Douglass Jr. Account Book Sept. 20th 1880.*

Unpublished Typescripts

Douglass, Frederick (1842), "Speech of Mr. Douglass at a Mass Meeting Fanuel [sic] Hall. For abolition of slavery in the district of columbia Feb'y 4, 1842," 2pp.

Douglass, Frederick (December 12, 1845), "To the Public—Falsehood Refuted."

Douglass, Frederick (January 1, 1846), "Frederick Douglass, Victoria Hotel, Belfast," 6pp.

Douglass, Frederick (May 11, 1847), no title, New York, 6pp.

Douglass, Frederick (1852), "What to the Slave is the Fourth of July? Extract from an oration at Rochester July 5 1852," 6pp.

Douglass, Frederick (1871), "Speech by Frederick Douglass at Arlington, Va., May 30, 1871, in the presence of President Grant and his Cabinet at the 'Tomb of the Union,' where the bones of 1100 fallen heroes of the Bull Run battlefield lie buried," 3pp.

Douglass, Frederick (1872), "Political Speech in New York in 1872 by Frederick Douglass: Grant and Wilson," 8pp.

Douglass, Frederick (1874), "Speech of Frederick Douglass at the Sumner Memorial, March 17th 1874," 5pp.

Douglass, Frederick (1875), "His Speech on the Color Question: Past and Present Status of the Negro: The Great Change in His Condition: How Shall He Work Out His Destiny," 8pp.

Douglass, Frederick (1876), "Local Politics: Meeting of Colored Republicans: A great gathering at Douglass Institute: Speech of Hon. Frederick Douglass: The Issues of the Campaign ably discussed. From the Baltimore American," 6pp.

Douglass, Frederick (1880), "Fred. Douglass His Great Speech Yesterday: His Political Views Plainly Expressed: A Splendid Campaign Document: Hancock's 'Statesmanship' Portrayed: Why all votes should support Garfield: Read and Circulate," 18pp.

Douglass, Frederick (1882), "Decoration Day Address of Frederick Douglass at Franklin Square From the Rochester Union and Advertiser (Democratic) May 30 1882," 16pp.

Douglass, Frederick (1883), "Topeka Daily Capital December 11th 1883, Frederick Douglass. The Condition of the Freedmen by Frederick Douglass. The Grand Old Man Talks Eloquently to and for his people. From Harper's Weekly," 9pp.

Unpublished Manuscripts

Douglass, Frederick (1865), "Speech on the death of Abraham Lincoln delivered in 1865 in Rochester NY," 7pp.

Miscellaneous

Frederick Douglass

Anon. (1878), "Invitation to Frederick Douglass to attend the commemorative service for Victor Emanuel Italy Legation."

Adams, Charles Francis (1873), "Invitation to Frederick Douglass to attend the Memorial Discourse in Honor of William H. Seward, April, 18 1873."

Belknap, William Worth (1872), "Secretary of War. Dec 18 1872: To Frederick Douglass." [Refusing remission of the sentence of William Jones, a military prisoner at Baton Rouge.]

Fish, Hamilton (n.d.), "Invitation to Frederick Douglass To Call At His Home," n.d.

Hill, Charles, and William Hoyt et al. (1888), "Invitation to Frederick Douglass to Deliver a Speech, Stamford, CT, May 1 1888."

Paine, Thomas H. (1871), "Letter to Frederick Douglass, U.S. Consulate," March 16, Kingston, Jamaica.

Paine, Thomas H. (1871), "Letter to Frederick Douglass, U.S. Consulate," March 17, Kingston, Jamaica.

S. Nathan (n.d)., "Letter to Frederick Douglass."

Lewis Henry Douglass

Loguen Cromwell, Mary [Mate] (1882), "Letter of Condolence to Lewis H. Douglass on the death of his Mother," August 6, 2pp. Signed "your affection sister, Mate C."

Wilson, Henry (1872), "Letter to Lewis H. Douglass," March 6, Senate Chamber.

Frederick Douglass Jr.

Douglass, Frederick, Jr. (n.d.), "Index to Scrapbooks of Frederick Jr."

Molyneaux, Paul (1880), "Letter to Virginia L. Douglass Power of Attorney," November 17.

Molyneaux, Paul (1880), "Letter to Dear Sister," November 17.

Charles Remond Douglass

[name illegible] (1918), "Letter to Major Charles Remond Douglass, Grand Hotel Paris," December 19.

Public and Private Archives and Repositories

Alfred William Anthony Collection, New York Public Library.

Frederick Douglass National Historic Site, Washington, DC, <https://www.nps.gov/frdo/index.htm>.

Gilder Lehrman Institute of American History.

Indiana University-Purdue University, IN: The Frederick Douglass Papers Edition, <http://www.iupui.edu/~douglass/about%20fdp%20edition.html>.

Library of Congress, Washington, DC: Frederick Douglass Papers 1841–1964, <https://www.loc.gov/collection/frederick-douglass-papers/about-this-collection/>.

Maryland State Archives, Annapolis, MD, Frederick Douglass, <http://msa.maryland.gov/msa/speccol/sc3500/sc3520/013800/013800/html/msa13800.html>.

Massachusetts Historical Society, Boston, MA, 54th Massachusetts Regiment, <http://www.masshist.org/online/54thregiment/index.php>.

Moorland-Spingarn Research Center, Howard University, Washington, DC: Frederick Douglass Papers.

National Archives and Records Administration, Washington, DC: Civil War Records, <https://www.archives.gov/research/military/civil-war>.

Rubenstein Library, Duke University Frederick Douglass Papers, 1875–1880.

Syracuse University Libraries Special Collections Research Center, Syracuse, NY, Gerrit Smith Papers, <https://library.syr.edu/digital/guides/s/smith_g.htm#d2e59>.

The Central Library of Rochester and Monroe County Library <www3.libraryweb.org>

University of Rochester, NY: Frederick Douglass Project, <http://rbscp.lib.rochester.edu/2494>.

1863

Miss H. Amelia Loguen
Box 685
Syracuse
New York

Soldiers Lee
at S. Spottsburg
St. H. M.

Further Reading

Primary Sources

Adams, Amanda (ed.) (2016), *Performing Authorship in the Nineteenth-century Transatlantic Lecture Tour*, London: Routledge.

Allen, Walter R. (Feb. 1978), "The Search for Applicable Theories of Black Family Life," *Journal of Marriage and Family*, 40, no. 1: 117–29.

Andrews, William L. (1986), *To Tell a Free Story: The First Century of Afro-American Autobiography, 1760–1865*, Urbana: University of Illinois Press.

Andrews, William L. (ed.) (1991), *Critical Essays on Frederick Douglass*, Boston: G. K. Hall.

Anon. (1870), *Proceedings of the Colored National Labor Convention held in Washington D.C., on December 6th, 7th 8th, 9th and 10th 1869*, Washington, DC: Office of the New Era.

Anon. (December 1893–January 1894), "Early American Engravers: John Chester Buttre," *The National Magazine: A Monthly Journal of American History*, 19, no. 2–3: 202.

Anon. (1921), "Charles Remond Douglass: Men of the Month," *Crisis: A Record of the Darker Races*, 21, no. 5 (March 1921): 215.

Anon. (1947), "The Loguen Family," *Negro History Bulletin*, 10, no. 8 (May 1947): 171–4, 191.

Anon. (1954), "Haley George Douglass," *Journal of Negro History*, 39, no. 2: 160–2.

Ash, Stephen V. (2008), *Firebrand of Liberty: The Story of Two Black Regiments That Changed the Course of the Civil War*, New York: W. W. Norton & Co.

Blassingame, John W., and John R. McKivigan (eds.) (1979–92), *The Frederick Douglass Papers: Series One, Speeches, Debates, and Interviews*, 5 vols., New Haven: Yale University Press.

Borome, Joseph (April 1953), "Some Additional Light on Frederick Douglass," *Journal of Negro History*, 38: 216–24.

Brown, Norma (ed.) (1977), *A Black Diplomat in Haiti: The Diplomatic Correspondence of U.S. Minister Frederick Douglass from Haiti, 1889–1891*, vols. I–II, Salisbury, NC: Documentary Publications.

Brown, William Wells (1882), *The Rising Son; or, The Antecedents and Advancement of the Colored Race*, Boston: A. G. Brown & Co.

Douglass, Fannie H. (1953), "The David T. Howard Family," *Negro History Bulletin*, 17, no. 3: 51–5.

Douglass, Frederick (1845), *Narrative of the Life of Frederick Douglass, an American Slave*, Boston: Anti-Slavery Office.

Douglass, Frederick [1845] (2018), *Narrative of the Life of Frederick Douglass, an American Slave*, edited by Celeste-Marie Bernier, Ontario: Broadview Press.

Douglass, Frederick (1853), *The Heroic Slave*, in Julia Griffiths (ed.), *Autographs for Freedom*, Boston: John P. Jewett.

Douglass, Frederick [1855] (2003), *My Bondage and My Freedom*, edited by John W. Blassingame et al., New Haven: Yale University Press.

Douglass, Frederick [1855] (1987), *My Bondage and My Freedom*, edited by William L. Andrews, Urbana and Chicago: University of Illinois Press.

Douglass, Frederick (December 3, 1861), "Pictures and Progress," in John Blassingame, ed., *The Frederick Douglass Papers: Series One: Speeches, Debates, and Interviews*, vol. 3, New Haven: Yale University Press, 1985: 452–72.

Douglass, Frederick (1869), "William The Silent: An Address Delivered in Cincinnati Ohio on 8 February 1869," in in John W. Blassingame and John R. McKivigan (eds.), *The Frederick Douglass Papers: Series One, Speeches, Debates, and Interviews*, vol. 4, New Haven: Yale University Press.

Douglass, Frederick (1871), *Diary* (Santo Domingo), <https://www.nps.gov/frdo/learn/historyculture/upload/douglass-diary-1871.pdf> (accessed 14 January 2018).

Douglass, Frederick (1872), "Self-Made Men," <http://teachingamericanhistory.org/library/document/self-made-men/> (accessed 14 January 2018).

Douglass, Frederick (1873), "Santo Domingo: An Address Delivered in St. Louis, Missouri, on 13 Jan. 1873," in John W. Blassingame and John R. McKivigan (eds.), *The Frederick Douglass Papers: Series One, Speeches, Debates, and Interviews*, vol. 4, New Haven: Yale University Press.

Douglass, Frederick (1876), "The Country Has Not Heard the Last of P. B. S. Pinchback: An Address Delivered in Washington D.C. on 13 March 1876," in John W. Blassingame and John R. McKivigan (eds.), *The Frederick Douglass Papers: Series One, Speeches, Debates, and Interviews*, vol. 4, New Haven: Yale University Press.

Douglass, Frederick (1877), "Our National Capital An Address Delivered in Baltimore on 8 May 1877," in John W. Blassingame and John R. McKivigan (eds.), *The Frederick Douglass Papers: Series One, Speeches, Debates, and Interviews*, vol. 4, New Haven: Yale University Press.

Douglass, Frederick (1879), "The Negro Exodus from the Gulf States: A Paper Read in Saratoga, New York, on 12 September 1879," in John W. Blassingame and John R. McKivigan (eds.), *The Frederick Douglass Papers: Series One, Speeches, Debates, and Interviews*, vol. 4, New Haven: Yale University Press.

Douglass, Frederick (May 1880), "The Negro Exodus From The Gulf States," *Journal of Social Science*, 11: 1–21.

Douglass, Frederick (1881), "John Brown: An Address by Frederick Douglass At the Fourteenth Anniversary of Storer College, Harper's Ferry, West Virginia, May 30, 1881," <https://archive.org/details/johnbrownaddress00doug> (accessed 14 January 2018).

Douglass, Frederick (1891), "Haiti and the United States. Inside History of the Negotiations for the Mole St. Nicolas: Part I," *North American Review*, 153, no. 418: 337–45.

Douglass, Frederick (1891), "Haiti and the United States. Inside History of the Negotiations for the Mole St. Nicolas: Part II," *North American Review*, 153, no. 419: 450–9.

Douglass, Frederick [1892] (2012), *Life and Times of Frederick Douglass*, edited by John R. McKivigan et al., New Haven: Yale University Press.

Douglass, Frederick (1893), "Introduction," in Ida B. Wells, *The Reason Why the Colored American is Not in the World's Columbian Exposition*, <http://digital.library. upenn.edu/women/wells/exposition/exposition.html> (accessed 14 January 2018).

Douglass, Frederick (1894), "Lessons of the Hour," Frederick Douglass Papers: Library of Congress, Folder 5, 60 pp.

Douglass, Frederick (n.d.), "Life Pictures" (alternatively "Lecture on Pictures"), Frederick Douglass Papers, Library of Congress, Washington, DC, Series: Speech, Article, and Book File—A: Frederick Douglass, Dated.

Douglass, Frederick (n.d.), "The Louisiana Senator," Frederick Douglass Papers, Library of Congress, Washington, DC.

Douglass, Frederick (n.d.), "Santo Domingo," Frederick Douglass Papers: Library of Congress, Folder 1, 56 pp.

Douglass, Frederick (n.d.), "Santo Domingo," Frederick Douglass Papers: Library of Congress, Folder 2, 41 pp.

Douglass, Frederick (n.d.), "Santo Domingo," Frederick Douglass Papers: Library of Congress, Folder 3, 27 pp.

Douglass, Frederick (n.d.), "Santo Domingo," Frederick Douglass Papers: Library of Congress, Folder 4, 38 pp.

Douglass, Frederick (n.d.), "Santo Domingo," Frederick Douglass Papers: Library of Congress, Folder 5, 29 pp.

Douglass, Frederick (n.d.), "William the Silent," Frederick Douglass Papers: Library of Congress, Folder 1, 34 pp.

Douglass, Frederick (n.d.), "William the Silent," Frederick Douglass Papers: Library of Congress, Folder 2, 13 pp.

Douglass, Frederick (n.d.), "William the Silent," Frederick Douglass Papers: Library of Congress, Folder 3, 49 pp.

Douglass, Frederick (n.d.), "William the Silent," Frederick Douglass Papers: Library of Congress, Folder 4, 26 pp.

Douglass, Frederick (n.d.), "William the Silent," Frederick Douglass Papers: Library of Congress, Folder 5, 75 pp.

Douglass, Frederick (n.d.), "William the Silent," Frederick Douglass Papers: Library of Congress, Folder 6, 26 pp.

Douglass, Frederick (n.d.), "William the Silent," Frederick Douglass Papers: Library of Congress, Folder 7, 26 pp.

Douglass Sprague, Rosetta [1900] (1923), "Anna Murray Douglass: My Mother As I Recall Her," n.p.

Foner, Philip S. (ed.) (1950–75), *The Life and Writings of Frederick Douglass*, 5 vols, New York: International Publishers.

Foner, Philip S. (ed.) (1976), *Frederick Douglass on Women's Rights*, Westport, CT: Greenwood Press.

Foner, Philip S. (ed.) (2000), *Frederick Douglass: Selected Speeches and Writings*, Chicago: Chicago Review Press.

Garrison, William Lloyd (1973), *The Letters of William Lloyd Garrison. Vol. 3, No Union with Slave-holders, 1841–1849*, edited by Walter M. Merrill, London: Belknap Press.

Greener, Richard T. (May 1880), "The Emigration of Colored Citizens from the Southern States," *Journal of Social Science*, 11: 22–35.

Jimoh, A. Yẹmisi, and Françoise N. Hamlin (eds.) (2015), *These Truly Are the Brave: An Anthology of African American Writings On War and Citizenship*, Gainesville: University Press of Florida.

McKivigan, John R. (ed.) (2009), *The Frederick Douglass Papers: Series Three, Correspondence, Volume 1: 1842–1852*, New Haven: Yale University Press.

Stanton, Elizabeth Cady, Ann D. Gordon, and Susan B. Anthony (2006), *The Selected Papers of Elizabeth Cady Stanton And Susan B. Anthony, Volume IV*, New Brunswick, NJ: Rutgers University Press.

White, Charles (March 9, 1965), "Oral History Interview with Charles White by Betty Hoag," Washington, DC: Smithsonian Archives of American Art, <https://www.aaa.si.edu/collections/interviews/oral-history-interview-charles-w-white-11484> (accessed 14 January, 2018).

Woodson, Carter G. (1926), "Letters of Negroes, Largely Personal and Private: Part 2," *Journal of Negro History*, 11, no. 1: 87–112.

Woodson, Carter G. (1942), *The Works of Francis J. Grimké*, Washington, DC: Associated Publishers.

Yacovone, Donald (1997), *A Voice of Thunder: The Civil War Letters of George E. Stephens*, Urbana: University of Illinois Press.

Secondary Sources

Adams, Virginia (ed.) (1991), *On the Altar of Freedom: A Black Soldier's Civil War Letters from the Front: Corporal James Henry Gooding*, Amherst: University of Massachusetts Press.

Alexander, Eleanor (2001), *Lyrics of Sunshine and Shadow: The Tragic Courtship and Marriage of Paul Laurence Dunbar and Alice Ruth Moore*, New York: New York University Press.

Allen, Walter R. (1978), "The Search for Applicable Theories of Black family life," *Journal of Marriage and Family Life*, 40: 117–29.

Anon. (1893–4), "Early American Engravers: John Chester Buttre," *The National Magazine; A Monthly Journal of American History*, 19, no. 2: 202.

Anon. (1863), "Massachusetts to the Rescue!", *Anglo African*, May 16, 1863.

Anon. (1889), "Photographers' and Artists' Mutual Benefit Association by Bogardus, Abraham, Cady, Frank and Ryder P.S.", *Photographic Times and American Photographer*, July 19, 1889, p. 360.

Anon. (1898), *Massachusetts: Soldiers and Sailors of the Revolutionary War*, vol. IV, Boston: Wright and Potter Printing.

Anon. (1899), *Massachusetts: Soldiers and Sailors of the Revolutionary War*, vol. VI, Boston: Wright and Potter Printing.

Anon. (1947), "The Loguen Family," *Negro History Bulletin*, 10, no. 8 (May 1947): 173.

Bailey, William S. (1935), "The Underground Railroad in Southern Chautauqua County Bailey," *New York History*, 16, no. 1: 53–63.

Ball, Erica (2012), *To Live an Antislavery Life: Personal Politics and the Antebellum Black Middle Class*, Athens: University of Georgia Press.

Barnwell, Andrea D. (2002), *Charles White*, Portland, OR: Pomegranate.

Barnwell, Andrea D., and Tritobia Hayes Benjamin (eds.) (2000), *The Walter O. Evans Collection of African American Art*, Seattle: Walter O. Evans Foundation for Art and Literature.

Barrett-White, Frances, and Anne Scott (1994), *Reaches of the Heart*, New York: Barricade Books.

Battle, Thomas, and Donna Wells (2006), *Legacies: Treasures of Black History*, New York: National Graphic.

Berlin, Ira (1983), *Freedom's Soldiers: The Black Military Experience in the Civil War*, Cambridge: Cambridge University Press.

Bernier, Celeste-Marie (2004), "'Emblems of Barbarism': Black Masculinity and

Representations of Toussaint L'Ouverture in Frederick Douglass's Unpublished Manuscripts," *American Nineteenth Century History*, 43, no. 2: 97–120.

Bernier, Celeste-Marie (2006), "From Fugitive Slave to Fugitive Abolitionist: The Oratory of Frederick Douglass and the Emerging Heroic Slave Tradition," *Atlantic Studies: Literary, Cultural and Historical Perspectives*, 3, no. 2 (October 2006): 201–24.

Bernier, Celeste-Marie (2008), *African American Visual Arts: From Slavery to the Present*, Durham: University of North Carolina Press.

Bernier, Celeste-Marie (2012), *Characters of Blood: Black Heroism in the Transatlantic Imagination*, Charlottesville, VA: University of Virginia Press.

Bernier, Celeste-Marie (2012), "'The Face of a Fugitive Slave': Representing and Reimagining Frederick Douglass in Popular Illustrations, Fine Art Portraiture and Daguerreotypes," in Magnus Brechkten (ed.), *Political Memory*, Göttingen: Vandenhoeck & Ruprecht, 11–33.

Bernier, Celeste-Marie (2012), "'His Complete History?': Revisioning, Recreating and Reimagining Multiple Lives in Frederick Douglass's *Life and Times* (1881, 1892)," *Slavery and Abolition*, 33, no. 4: 595–610.

Bernier, Celeste-Marie (2012), "'Typical Negro' or a 'Work of Art'? The 'inner' via the 'outer man' in Frederick Douglass's Manuscripts and Daguerreotypes," in Fionnghuala Sweeney (ed.), *Slavery and Abolition*, 33, no. 2: 287–303.

Bernier, Celeste-Marie (2015), *Suffering and Sunset: World War I in the Art and Life of Horace Pippin*, Philadelphia: Temple University Press.

Bernier, Celeste-Marie (2015), "A Visual Call to Arms against the 'Caracature [sic] of My Own Face': From Fugitive Slave to Fugitive Image in Frederick Douglass's Theory of Portraiture," *Journal of American Studies* (Special Issue, co-eds. Fionnghuala Sweeney and Karen Salt), 49, no. 2: 323–57.

Bernier, Celeste-Marie (2016), "'Frederick Douglass, the freeman' versus 'Frederick Bailey, the slave': Private versus Public Acts and Arts of Letter-Writing in Frederick Douglass's Pre-Civil War Correspondence," in Celeste-Marie Bernier, Judie Newman, and Matthew Pethers (eds.), *The Edinburgh Companion to Nineteenth-Century American Letters and Letter-Writing*, Edinburgh: Edinburgh University Press.

Bernier, Celeste-Marie (2016), "'To preserve my features in marble': Post-Civil War Paintings, Drawings, Sculpture, and Sketches of Frederick Douglass: An Illustrated Essay," *Callaloo*, 39, no. 2: 372–99.

Bernier, Celeste-Marie (2017), "Interview with Walter O. Evans," Savannah, GA, April 12.

Bernier, Celeste-Marie (2017), "'Several Lives in One': Will the Real Frederick Douglass Please Stand Up?" *Slavery and Abolition*, 38, no. 1: 196–204.

Bernier, Celeste-Marie (forthcoming), *Living Parchments: Artistry and Authorship in the Life and Works of Frederick Douglass*, New Haven: Yale University Press.

Bernier, Celeste-Marie (forthcoming), *Struggle for Liberty: Frederick Douglass's Family Letters, Speeches, Essays and Photographs*, Philadelphia: Temple University Press.

Bernier, Celeste-Marie (forthcoming), *For Your Eyes Only: The Private Letters of Frederick Douglass and Family*.

Bernier, Celeste-Marie, and Bill E. Lawson (eds.) (2018), *Pictures and Power: Imaging and Imagining Frederick Douglass (1818–2018)*, Liverpool: Liverpool University Press.

Berwanger, Eugene H. (1975), "Reconstruction on the Frontier: The Equal Rights Struggle in Colorado, 1865–1867," *Pacific Historical Review*, 44, no. 3: 313–29.

Berwanger, Eugene H. (1979), "Hardin and Langston: Western Black Spokesmen of The Reconstruction Era," *Journal of Negro History*, 64, no. 2: 101–15.

Billingsley, Andrew (1993), *Climbing Jacob's Ladder: The Enduring Legacy of African-American Families*, London: Simon and Schuster.

Blatt, Martin Henry, Thomas J. Brown, and Donald Yacovone (eds.) (2001), *Hope & Glory: Essays on the Legacy of the Fifty-Fourth Massachusetts Regiment*, Amherst: University of Massachusetts Press.

Blight, David (1993), "The Private Worlds of Frederick Douglass," *Transition* 61: 161–8.

Blight, David (1995), "The Meaning of the Fight: Frederick Douglass and the Memory of the 54th Massachusetts," *The Massachusetts Review*, 36, no. 1: 141 53.

Blight, David (2002), *Beyond the Battlefield: Race, Memory and the American Civil War*, Amherst: University of Massachusetts Press.

Blight, David (2018), *Frederick Douglass: Prophet of Freedom*, New York: Simon & Schuster.

Bogardus, Abraham, Frank E. Cady, and P. S. Ryder (1889), "Article 1—No Title." *Photographic Times and American Photographer*, 19, no. 409 (July 19, 1889): 360.

Brady, Mathew (1850), *The Gallery of Illustrious Americans*, New York: M. B. Brady.

Brantley, Daniel (1984), "Black Diplomacy and Frederick Douglass's Caribbean Experiences 1871 and 1889–1891: The Untold History," *Phylon*, 45, no. 3: 197–209.

Brewer, William M. (1954), "Haley George Douglass," *The Negro History Bulletin*, XVII, no. 7: 256–7.

Brown, Ira V. (2000), "An Antislavery Journey: Garrison and Douglass in Pennsylvania, 1847," *Pennsylvania History*, 67, no. 4: 532–50.

Brown, William Wells (1882), *The Rising Son, or, The Antecedents and Advancement of the Colored Race*, Boston: A. G. Brown & Co.

Browne, Patrick T. J. (1997), "To Defend Mr. Garrison William Cooper Nell and the Personal Politics of Antislavery Authors," *The New England Quarterly*, 70, no. 3: 415–42.

Burchard, Peter (1965), *One Gallant Rush: Robert Gould Shaw and His Brave Black Regiment*, New York: St. Martin's Press.

Buttre, Lillian C. (1877), *The American Portrait Gallery: with Biographical Sketches of Presidents, Statesmen, Military and Naval Heroes, Clergymen, Authors, Poets, etc., etc.*, New York: J. C. Buttre.

Chaffin, Tom (2014), *Giant's Causeway: Frederick Douglass's Irish Odyssey and the Making of an American Visionary*, Charlottesville: University of Virginia Press.

Chase, Ted, Daniel Nelson, and Theodore Hudson (1993), *Highland Beach: the first 100 Years*, Highland Beach, MD: Highland Beach Historical Commission.

Chesnutt, Charles W. (1899), *Frederick Douglass*, Boston: Small, Maynard.

Coddington, Ronald S. (2012), *African American Faces of the Civil War: An Album*, Baltimore: Johns Hopkins University Press.

Cooper, Mark A., Jr. (ed.) (1990), *Dear Father: A Collection of Letters to Frederick Douglass from His Children 1859–1894*, Philadelphia: Fulmore Press.

Cornish, Dudley T. (1987), *The Sable Arm: Negro Troops in the Union Army 1861–1865*, Lawrence: University Press of Kansas.

Cromwell, John W. (1896), *History of the Bethel Literary and Historical Association*, Washington, DC: R. L. Pendleton.

Dinnella-Borrego, Luis-Alejandro (2009), "From the Ashes of the Old Dominion: Accommodation, Immediacy, and Progressive Pragmatism in John Mercer Langston's Virginia," *Virginia Magazine of History and Biography*, 117, no. 3: 214–49.

Dobak, William A. (2013), *Freedom by the Sword: The US Colored Troops 1862–1867*, New York: Skyhorse Pub.

Dobrzynski, Judith H. (October 2016), "An Eye for American Art," *Traditional Home*, 80–4.

Dodds, Gordon, Roger Hall, and Stanley Triggs (1993), *The World of William Notman: The Nineteenth Century Through A Master Lens*, Boston, MA: David R. Godine.

Douglass, Joseph L., Jr., "Harriet Bailey: Presumed Sister of Frederick Douglass," *Journal of the Afro-American Historical and Genealogical Society*, 21: 6–11.

Douglass, Joseph L., Jr. (2011), *Frederick Douglass: A Family Biography 1733–1936*, Shelbyville, KY: Winterlight Books.

Douglass Sprague, Rosetta (1923), "Anna Murray Douglass: My Mother as I Recall Her," *Journal of Negro History*, 8, no. 1: 93–101.

Egerton, Douglas R. (2016), *Thunder at the Gates: the Black Civil War Regiments That Redeemed America*, Boulder, CO: Basic Books.

Emilio, Luis F. (1894), *History of the Fifty-Fourth Regiment or Massachusetts Volunteer Infantry, 1863–1865*, Boston: Boston Book Company.

Ernest, John (ed.) (2014), *Douglass In His Own Time*, Iowa City: Iowa University Press.

Ernest, John (ed.) (2017), *The Oxford Handbook of the African American Slave Narrative*, Oxford: Oxford University Press.

Evans, Walter O. (2000), "Statement," in *The Walter O. Evans Collection of African-American Art: at North Carolina Agricultural and Technical State University and the H.C. Taylor Art Gallery, Greensboro, North Carolina, 18 April –30 June, 2000*, Greensborough, NC: North Carolina A. & T. State University.

Fordham, Monroe (1975), "Nineteenth-Century Black Thought in the United States: Some influences of the Santo Domingo Revolution," *Journal of Black Studies*, 6, no. 2: 115–26.

Fought, Leigh (2017), *Women in the World of Frederick Douglass*, Oxford: Oxford University Press.

Gannon, Barbara (2014), *The Won Cause: Black and White Comradeship in the Grand Army of the Republic*, Chapel Hill: University of North Carolina Press.

Garvey, Ellen Gruber (ed.) (2012), *Writing with Scissors: American Scrapbooks from the Civil War to the Harlem Renaissance*, Oxford: Oxford University Press.

Gatewood, Willard B. (2000), *Aristocrats of Color: The Black Elite, 1880–1920*, Fayetteville: University of Arkansas Press.

Gatewood, Willard B. (2000), "Aristocrats of Color: The Educated Black Elite of the Post-Reconstruction Era," *Journal of Blacks in Higher Education*, 29: 112–18.

Giddings, Paula (1993), "Foreword," in Andrew Billingsley, *Climbing Jacob's Ladder: The Enduring Legacy of African-American Families*, London: Simon and Schuster.

Gonzalez, Susan (2017), "Any Time is a Good Time for Illumination by Frederick Douglass, says Yale Historian," *YaleNews*, April 13, 2017, <http://news.yale.edu/2017/02/17/any-time-good-time-illumination-frederick-douglass-says-yale-historian> (accessed January 14, 2018).

Greene, Carroll, Jr. (1986), "Summertime: In the Highland Beach Tradition," *American Visions*, May 1, 1986, 1–3.

Greene, Robert Ewell (1990), *Swamp Angels: A Biographical Study of the 54th Massachusetts Regiment*, BoMark/Greene Publishing Group.

Greener, Richard T. (1880), "The Emigration," *Journal of Social Science*, no. 11: 22–35.

Greenough, Sarah, and Nancy K. Anderson (eds.) (2013), *Tell It With Pride: the 54th Massachusetts Regiment and Augustus Saint-Gaudens' Shaw Memorial*, Washington, DC: National Gallery of Art.

Gregory, James M. (1893), *Frederick Douglass: The Orator*, Springfield, MA: Willey & Co.

Griffiths, Julia (ed.) (1854), *Autographs for Freedom*, Auburn, NY: Alden, Beardsley and Co.

Grimké, Archibald H. (1905), "Cedar Hill or the Famous Home of Frederick Douglass," *Voice of the Negro*, December 1905.

Grimké, Francis J. (1934), "The Second Marriage of Frederick Douglass," *Journal of Negro History*, 19, no. 3: 324–9.

Grosz, Agnes Smith, "The Political Career of P. B. S. Pinchback," *Louisiana Historical Quarterly*, 27.2 (April 1944): 527–612.

Guyatt, Nicholas (2011), "America's Conservatory: Race, Reconstruction and the Santo Domingo Debate," *Journal of American History*, 97, no. 4: 974–1000.

Hallowell, Norwood P. (1897), *The Negro As a Soldier in the War of the Rebellion*, Boston: Little Brown and Co.

Hargrove, Hondon B. (2003), *Black Union Soldiers in the Civil War*, London: McFarland.

Haskins, James (1996), *The First Black Governor: Pinckney Benton Stewart Pinchback*, Trenton, NJ: Africa World Press.

Headley, P. C. (1866), *Massachusetts in the Rebellion*, Boston: Walker, Fuller, and Company.

Helfland, Jessica (2008), *Scrapbooks: An American History*, New Haven: Yale University Press.

Higginson, Thomas Wentworth [1869] (2014), *Army Life in a Black Regiment: and Other Writings*, edited by R. D. Madison, New York: Penguin Books.

Himelhoch, Myra (1971), "Frederick Douglass and Haiti's Mole St. Nicolas," *Journal of Negro History*, 56, no. 3: 161–80.

Holland, Frederic May (1895), *Frederick Douglass: The Colored Orator*, New York: Funk & Wagnalls.

Hooker, Juliette (2015), "'A Black Sister to Massachusetts': Latin America and the Fugitive Democratic Ethos of Frederick Douglass," *American Political Science Review*, 109, no. 4: 690–702.

Howard, Vicki (1996), "The Courtship Letters of an African American Couple," *The Southwestern Historical Quarterly*, 100 (July 1996), no. 1: 64–80.

Hudson, Gossie H. (1970), *A Biography of Paul Laurence Dunbar*, Ph.D. diss., Ohio: Ohio State University Press.

Huggins, Nathan Irving (1980), *Slave and Citizen: The Life of Frederick Douglass*, Boston: Little, Brown.

Humphreys, Margaret (2008), *Intensely Human: The Health of the Black Soldier in the American Civil War*, Baltimore: John Hopkins University Press.

Hunter, Carol (2013), *To Set the Captives Free: Reverend Jermain Wesley Loguen and the Struggle for Freedom in Central New York, 1835–1872*, New York: Hyrax Publishing Company.

Junger, Richard (2008), "'Thinking Men and Women, Who Desire to Improve our Condition': Henry O. Wagoner, Civil Rights, and Black Economic Opportunity in Frontier Chicago and Denver, 1846–1847," in William H. Alexander, Cassandra Newby-Alexander, and Charles Howard Ford (eds.), *Voices from with the Veil: African Americans and the Experience of Democracy*, Newcastle-upon-Tyne: Scholars Publishing Company.

Kahrl, Andrew W. (2017), *The Land Was Ours: How Black Beaches Became White Wealth in the Coastal South*, Chapel Hill: University of New Carolina.

LaBarre, Steven M. (2016), *The Fifth Massachusetts Colored Cavalry in the Civil War*, Jefferson, NC: McFarland Co.

Lampe, Gregory P. (1998), *Frederick Douglass: Freedom's Voice, 1818–45*, East Lansing: Michigan State University Press.

Larson, Kate (2004), *Bound for the Promised Land: Harriet Tubman: Portrait of an American Hero*, London: Oneworld.

Lawrence, Jacob (1968), "Oral History Interview with Jacob Lawrence by Carroll Greene," Washington, DC: Smithsonian Archives of American Art, <https://www.aaa.si.edu/collections/interviews/oral-history-interview-jacob-lawrence-11490> (accessed January 14, 2018).

Lawson, Bill E., and Frank Kirkland (eds.) (1999), *Frederick Douglass: A Critical Reader*, Malden: Blackwell Publishers.

Lee, Maurice S. (ed.) (2009), *The Cambridge Companion to Frederick Douglass*, Cambridge: Cambridge University Press.

Levine, Bruce C. (2013), *The Fall of the House of Dixie: The Civil War and the Social Revolution That Transformed the South*, New York: Random House.

Levine, Robert. S. (2008), *Dislocating Race and Nation: Episodes in Nineteenth-Century American Literary Realism*, Chapel Hill, NC: University of North Carolina Press.

Levine, Robert S. (2009), "Frederick Douglass, War, Haiti," *PMLA*, 124, no. 5: 1864–8.

Levine, Robert S. (2016), *The Lives of Frederick Douglass*, Cambridge, MA: Harvard University Press.

Loguen, Jermain Wesley (1863), "Call for Enlistments," *Anglo-African*, March 7, 1863.

Loguen, Jermain Wesley (2016), *The Reverend J. W. Loguen, as a Slave and as a Freeman*, edited by Jennifer A. Williamson, Syracuse: Syracuse University Press,.

Lovoos, Janice (n.d.), "The Remarkable Draughtmanship of Charles White," Unmicrofilmed Charles White Papers, Smithsonian Archives of American Art.

Luft, Eric V. D. (2000), "Sarah Loguen Fraser, MD (1850 to 1933): The Fourth African-American Woman Physician," *Journal of the National Medical Association*, 92, no. 3: 149–53.

Luft, Eric V. D. (2005), *SUNY Upstate Medical University: A Pictorial History*, New York: Urgensatz Press.

Marc, David (February 2000), "Sarah Loguen Fraser," *American National Bibliography Online*, <http://www.anb.org/articles/13/13-02676.html> (accessed January 14, 2018).

Martin, Henry Blatt, Thomas J. Brown, and Donald Yacovone (eds.) (2001), *Hope and Glory: Essays on the Legacy of the Fifty-Fourth Massachusetts Regiment*, Amherst: University of Massachusetts in association with Massachusetts Historical Society, Boston.

Martin, Waldo E. (1984), *The Mind of Frederick Douglass*, Chapel Hill: University of North Carolina Press.

Mcclish, Glen (2012), "Frederick Douglass and the Consequences of Rhetoric: The Interpretive Framing and Publication History of the 2 January 1893 Haiti Speeches," *Rhetorica: A Journal of the History of Rhetoric*, 30, no. 1: 37–73.

McFeely, William S. (1991), *Frederick Douglass*, New York: Norton.

McHenry, Elizabeth (2002), *Forgotten Readers: Recovering the Lost History of African American Literary Societies*, Durham, NC: Duke University Press.

McPherson, James M. (2008), *The Negro's Civil War*, New York: Vintage Books.

Moore, Jacqueline M (1999), *Leading the Race: The Transformation of the Black Elite in the Nation's Capitol 1880—1920*, Charlottesville, VA: University Press of Virginia.

Muller, John (2012), *Frederick Douglass in Washington, DC: The Lion of Anacostia*, Charleston, SC: The History Press.

Murphy, Angela F. (2014), *The Jerry Rescue: The Fugitive Slave Law, Northern Rights, and the American Sectional Crisis*, Oxford: Oxford University Press.

Murray, Hannah-Rose (n.d.), *Frederick Douglass in Britain and Ireland*, <http://www.frederickdouglassinbritain.com> (accessed January 14, 2018).

Murray, Hannah-Rose (2016), "'A Negro Hercules': The Legacy of Frederick Douglass's Celebrity in Britain," *Journal of Celebrity Studies*, 7, no. 2 (October 2016): 264–79.

Murray, Hannah-Rose (2017), *"It is Time for the Slaves to Speak": Transatlantic Abolitionism and African American Activism in Britain 1830–1895*, Ph.D. thesis, University of Nottingham.

Nelson, Jack E., Raymond L. Langston, and Margo Dean Pinson (2008), *Highland Beach on the Chesapeake Bay: Maryland's First African American Incorporated Town*, Virginia Beach, VA: Donning Company Publishers.

O'Keefe, Rose (2014), *Frederick and Anna Douglass in Rochester New York: Their Home Was Open to All*, Charleston, SC: The History Press.

Patenaude Roach, Monique (2001), "The Rescue of William 'Jerry' Henry: Antislavery and Racism in the Burned-over District," *New York History*, 82, no. 2: 135–54.

Payne, Les, Leslie King-Hammond, and Shirley Woodson (eds.) (1991), *Walter O. Evans Collection of African American Art*, Savannah, GA: Beach Institute King-Tisdell Museum.

Pease, William H., and Jane H. Pease (1967), "Boston Garrisonians and the Problem of Frederick Douglass," *Canadian Journal of History*, 2, no. 2: 29–48.

Pedzich, Joan (1984), "John Howe Kent," *Image*, 27, no. 1 (March 1984): 1–11.

Peterson, Carla L. (2012), *Black Gotham: A Family History of African Americans in Nineteenth-Century*, New Haven: Yale University Press.

Pickett, T. H. (1989), "The Friendship of Frederick Douglass with the German, Ottilie Assing," *The Georgia Historical Quarterly*, 73, no. 1: 88–105.

Pinkett, Harold T. (1941), "Efforts to Annex Santo Domingo to the United States, 1866–1871," *Journal of Negro History*, 26, no. 1: 12–45.

Pitre, Merline (1977), "Frederick Douglass and the Annexation of Santo Domingo," *The Journal of Negro History*, 62, no. 4: 390–400.

Pitre, Merline (1983), "Frederick Douglass and American Diplomacy in the Caribbean," *Journal of Black Studies*, 13, no. 4: 457–75.

Pitts Douglass, Helen (1897), *In Memoriam: Frederick Douglass*, Philadelphia: J. C. Yorston & Co.

Polyne, Millery (2006), "Expansion Now!: Haiti, 'Santo Domingo' and Frederick Douglass at the Intersection of U.S. and Caribbean Pan-Americanism," *Caribbean Studies*, 34, no. 2: 3–45.

Preston, Dickson J. (1980), *Young Frederick Douglass: The Maryland Years*, Baltimore: Johns Hopkins University Press.

Quarles, Benjamin (1938), "The Breach Between Douglass and Garrison," *Journal of Negro History*, 23, no. 2: 144–54.

Quarles, Benjamin (1955), "Frederick Douglass: Letters from the Haitian Legation," *Caribbean Quarterly*, 4, no. 1 (1955): 75–81.

Quarles, Benjamin (1968), *Frederick Douglass*, Englewood Cliffs, NJ: Prentice-Hall.

Quarles, Benjamin (1989), *The Negro in the Civil War*, New York: Da Capo Press.

Quarles, Benjamin (2001), *Allies for Freedom: Blacks and John Brown*, Cambridge, MA: Da Capo.

Ray, Angela G. (2002), "Frederick Douglass on the Lyceum Circuit: Social Assimilation, Social Transformation?" *Rhetoric and Public Affairs*, 5, no. 4: 625–47.

Ray, Angela G. (2012), "Making History by Analogy: Frederick Douglass Remembers William the Silent," in H. Van Emeren and Bart Garssen (eds.), *Exploring Argumentative Contexts*, Amsterdam: John Benjamins Pub. Co.

Redkey, Edwin S. (2009), *A Grand Army of Black Men: Letters from African American Soldiers in the Union Army, 1861–1865*, Cambridge: Cambridge University Press.

Reidy, Joseph, Leslie S. Rowland, and Ira Berlin (eds.) (2010), *Freedom: A Documentary History of Emancipation: The Black Military Experience*, vol. 1, Cambridge: Cambridge University Press.

Rice, Alan J., and Martin Crawford (eds.) (1999), *Liberating Sojourn: Frederick Douglass and Transatlantic Reform*, Athens: University of Georgia Press.

Ripley, C. Peter (ed.) (1991), *The Black Abolitionist Papers: Vol. III: The United States, 1847–1858*, Chapel Hill: University of North Carolina.

Rudwick, Elliott M. (1957), "The Niagara Movement," *Journal of Negro History*, 42, no. 3: 177–200.

Ryder, P. S. (July 5, 1890), "The P. and A. M. B. A. And MR. P. S. Ryder," *Wilson's Photographic Magazine*, 27, no. 373: 408.

Sears, Louis Martin (1941), "Frederick Douglass and the Mission to Haiti, 1889–1891," *Hispanic American Historical Review*, 21, no. 2: 228–38.

Seibold, George G. (1915), *Historical Sketch of Columbia Typographical Union Number One Hundred and One*, Washington, DC: National Capital Press.

Selby, Gary S. (2000), "The Limits of Accommodation: Frederick Douglass and the Garrisonian Abolitionists," *Southern Communication Journal*, 66, no. 1: 52–66.

Sernett, Milton C. (1987), "'A Citizen of No Mean City': Jermain W. Loguen and the Antislavery Reputation of Syracuse," *The Courier*, 22, no. 2: 33–55.

Sernett, Milton C. (2002), *North Star Country: Upstate New York and the Crusade for African American Freedom*, Syracuse, NY: Syracuse University Press.

Shaffer, Donald R. (2014), *After the Glory: The Struggles of Black Civil War Veterans*, Lawrence: University Press of Kansas.

Shearer, Jacqueline (2006), *The Massachusetts 54th Colored Infantry*, Boston: WGBH Boston Video.

Simmons, William J. (1887), *Men of Mark: Eminent, Progressive and Rising*, Cleveland: Geo. M. Rewell & Co.

Smith, John David (2004), *Black Soldiers in Blue: African American Troops in the Civil War Era*, Chapel Hill: University of North Carolina Press.

Stauffer, John, Zoe Trodd, and Celeste-Marie Bernier (eds.) (2015), *Picturing Frederick Douglass*, New York: W. W. Norton & Co.

Sterling, Dorothy (ed.) (1997), *We Are Your Sisters: Black Women in the Nineteenth Century*, New York: W. W. Norton.

Sweeney, Fionnghuala (2007), *Frederick Douglass and the Atlantic World*, Liverpool: Liverpool University Press.

Sundquist, Eric J. (ed.) (1990), *Frederick Douglass: New Literary and Historical Essays*, New York: Cambridge University Press.

Taney, Roger B (1857), "The Dred Scott Decision," <https://www.loc.gov/item/17001543/> (accessed January 14, 2018).

Taylor, Clare (1974), *British and American Abolitionists: An Episode in Transatlantic Understanding*, Edinburgh: Edinburgh University Press.

Taylor, Quintard (1999), *In Search of the Racial Frontier: African Americans in the American West, 1528–1990*, New York: W.W. Norton.

Thompson, John W. (1903), *An Authentic History of the Douglass Monument*, Rochester, NY: Rochester Herald Press.

Thompson, John W. (1999), "Douglass: Ex-slave and statesman reached the North Star," *The New Crisis* (January/February 1999), 106.

Trent, James W., Jr. (2012), *The Manliest Man: Samuel G. Howe and the Contours of Nineteenth-Century American Reform*, Amherst: University of Massachussetts Press.

Tucker, Susan, Katherine Ott, and Patricia P. Buckler (eds.) (2006), *The Scrapbook in American Life*, Philadelphia: Temple University Press.

Wallace, Maurice O., and Shawn Michelle Smith (eds.) (2012), *Pictures and Progress: Early Photography and the Making of African American Identity*, Durham, NC: Duke University Press.

Warner, John D., Jr. (1997), *Crossed Sabres: A History of the 5th Massachusetts Volunteer Cavalry An African American Regiment in the Civil War*, Ph.D. thesis, Boston: Boston College.

Washington, Booker T. (1906), *Frederick Douglass*, London: Hodder & Stoughton.

Wasserman, Adam (2010), *A People's History of Florida, 1513–1876*, Sarasota: A. Wasserman.

Welter, Barbara, "The Cult of True Womanhood: 1820–1860," *American Quarterly* 18.2.1 (1966): 151–74.

White, Charles (1968), "Charles White," unmicrofilmed Charles White papers, Washington, DC: Smithsonian Archives of American Art.

Whitfield, Stephen J. (1987), "'Sacred in History and in Art': the Shaw Memorial," *New England Quarterly*, 60, no. 1: 3–27.

Whittle, Gilberta S. (1901), "Negroes in Washington: What Douglass's Daughter Says of Them," *Los Angeles Times*, August 4, 1901, p. 9.

Willard, Frances E., and Mary A. Livermore (eds.) (1893), *A Woman of the Century*, New York: Charles Wells Moulton.

Williams, George Washington (1888), *A History of the Negro Troops in the War of the Rebellion, 1861–1865*, New York: Harper and Brothers.

Willis, Deborah (2017), "The Black Civil War Soldier: Conflict and Citizenship," *Journal of American Studies*, 51, no. 2: 285–323.

Wintle, Michael J., and Adriaan G. Jongkees (2007), "William I," <https:///www.britannica.com/biography/William-I-stadholder-of-United-Provinces-of-The-Netherlands> (accessed January 14, 2018).

Woodson, Carter G. (1926), "Letters of Negroes, Largely Personal and Private Part 2," *Journal of Negro History*, 11, no. 1 (January 1926): 87–112.

Yacovone, David (2005), "A Covenant With Death and An Agreement with Hell," <http://www.masshist.org/object--of-the-month/objects/a-covenant-with-death-and-an-agreement-with-hell-2005-07-01> (accessed January 14, 2018).

Yacovone, Donald, and Charles Fuller (eds.) (2004), *Freedom's Journey: African American Voices of the Civil War*, Chicago: Lawrence Hill Books.

RESIDENCE OF FREDERICK DOUGLASS, WASHINGTON, D. C.

Figure 79: Anon., *Residence of Frederick Douglass*, n.d. Reproduced James M. Gregory, *Frederick Douglass the Orator*. (Springfield, MA: Willey Company, 1893. Collection of the Rochester Public Library Local History Division, Central Library of Rochester and Monroe County, Rochester, NY.)

Part X

Helen Amelia Loguen
Correspondence

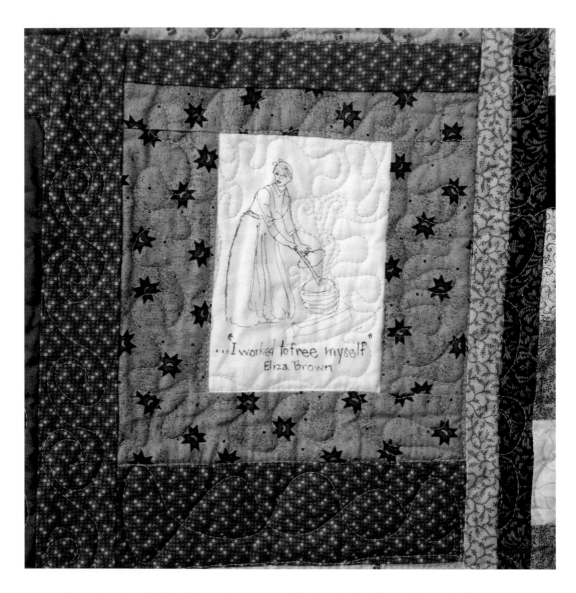

Figure 80: Vera P. Hall, *We too, Sing America: Blacks in the Civil War, 1860–1864*, Baltimore, Maryland 2006–2008. Detail. Machine pieced and quilted; embellished by hand. Vera began this quilt after winning the Civil War themed blocks in the border. She wanted to show that commemorating the Civil War has a different meaning for African Americans and started reading widely to create a quilt that refuted the too-common notion that blacks "were freed" by the Civil War. This block commemorates Eliza Brown, a black woman considered contraband who cooked for the troops and reportedly said, "I worked to free myself."

Helen Amelia Loguen Correspondence in the Walter O. Evans Collection Inventory

Anon. (n.d.), "To A Friend [a poem]"

[Douglass,] Helen Amelia Loguen, "Letter to Lewis Henry Douglass," January 15, n.p.

[Douglass,] Helen Amelia Loguen, "Letter to Lewis Henry Douglass," January 17, n.p.

[Douglass,] Helen Amelia Loguen, "Letter to Lewis Henry Douglass," February 16, n.p.

[Douglass,] [Haley] George (n.d.), "Letter to Aunt Amelia," Washington, DC.

Hawes, May C. (May 1, 1933), "Letter to Aunt Amelia," Atlanta, GA

Kendall, Kittie (August 24, 1861), "Letter to Amelia Loguen," Beloit, WI

Kendall, Kittie (March 18, 1862), "Letter to Amelia Loguen," Beloit, WI

Kendall, Kittie (October, 1911), "Letter to Amelia Loguen," Washington, DC

Kendall, Kittie (August 9, 1921) "Letter to Amelia Loguen," Washington, DC

Loguen, C. E. (April 10, 1864), "Letter to Cara," Syracuse, NY

Loguen, Gerrit (June 12, n.d.), "Letter to Helen Amelia Loguen," Rochester, NY

Loguen, Gerrit (February 11, 1878), "A musical programme," Lincoln Hall.

Loguen, Gerrit (May 11, 1885), "Letter to Miss Amelia Douglass," Syracuse, NY

Loguen, Gerrit (December 11), "Letter to Miss Amelia Douglass," Savannah, GA

[Loguen,] Jermain (November 3, 1921), "Letter to Aunt Amelia," n.p.

Mate [Mary Loguen Cromwell] (November 30, 1885), "Letter to Amelia Loguen," Syracuse, NY

Mate [Mary Loguen Cromwell] (December 16, 1894), "Letter to Amelia Loguen," Syracuse, NY

Mate [Mary Loguen Cromwell] (November 2, 1902), "Letter to Amelia Loguen," Syracuse, NY

Mate [Mary Loguen Cromwell] (March 8, 1903), "Letter to Amelia Loguen," Syracuse, NY

Mate [Mary Loguen Cromwell] (October 3, 1904), "Letter to Amelia Loguen," Syracuse, NY

Mate [Mary Loguen Cromwell] (October 18, 1906), "Letter to Meal [Helen Amelia Loguen], Kitty and all," Syracuse, NY

Mate [Mary Loguen Cromwell] (December 23, 1906), "Letter to Meal [Amelia Loguen] and Tin [Sarah Loguen]," Syracuse, NY

Mate [Mary Loguen Cromwell] (January 13, 1907), "Letter to Meal [Amelia Loguen] and Tin [Sarah Loguen]," Syracuse, NY

Mate [Mary Loguen Cromwell] (n.d.), "Letter to Amelia Loguen," n.p.

Mela (n.d.), "Letter to Aunt Amelia," Alabama.

Pierson, Mary Ann (October 2, 1903), "Letter to Dear Friend," Easingwold, Pasadena, CA

Sadie (December 11, 1952), "Letter to Amelia," Washington, DC

[Sprague,] Hattie (December 3, 1916), "Letter to Aunt Amelia," Monroe, TX

[Sprague,] Hattie (November 16, 1933), "Letter to Aunt Amelia," Kansas City

Tatterson, Henry J. (July 6, 1857), "Letter to Amelia Loguen," Niagara Falls

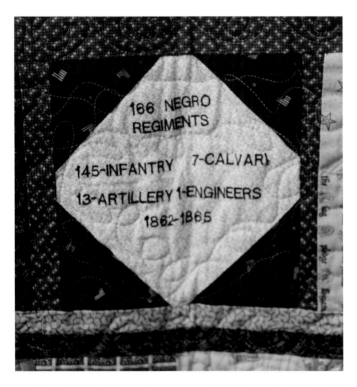

Figure 81: Vera P. Hall, *We too, Sing America: Blacks in the Civil War, 1860–1864* (Baltimore, Maryland 2006–2008). Detail. This block documents the multiple ways black soldiers served in the armed forces during the Civil War.

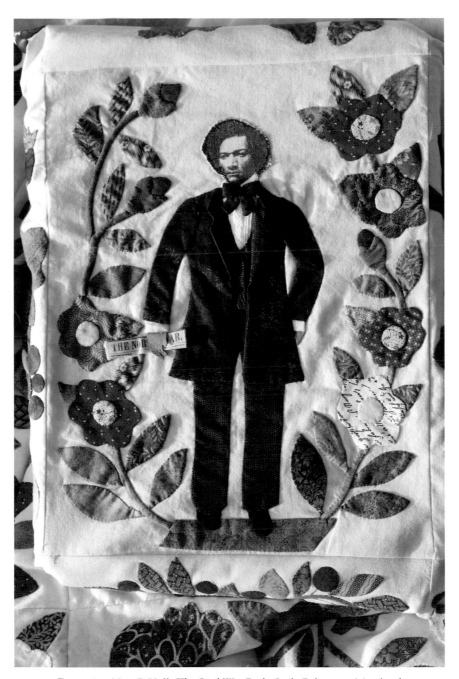

Figure 82: Vera P. Hall, *The Civil War Bride Quilt*, Baltimore, Maryland
2018. Hand appliqué. Original block in the style of the Corliss Searcey
pattern. When Vera P. Hall's appliqué group chose "The Civil War Bride
Quilt" as their project, Vera decided to do her own take it by creating blocks
about Frederick Douglass and Harriet Tubman for the center of the quilt.

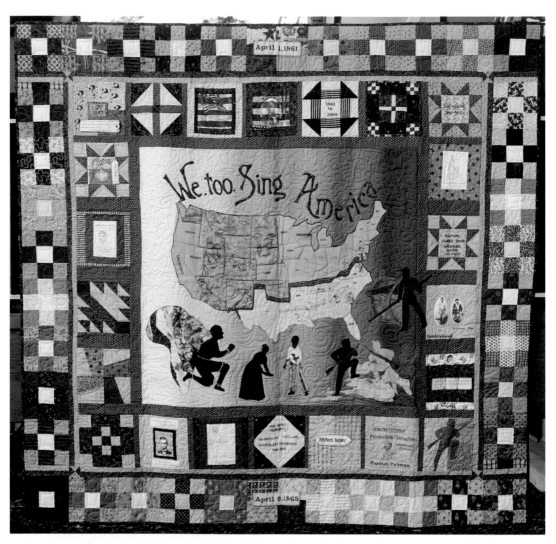

Figure 83: Vera P. Hall, *We too, Sing America: Blacks in the Civil War, 1860–1864*, Baltimore, Maryland 2006–2008. Detail. The map in the middle depicts the North/South divide and key battle sites of the war. Blocks around the map represent the different ways blacks fought for their own freedom from the Middle Passage through the Civil War. The title is from Langston Hughes' poem "I, too, sing America."

Afterword

Kim F. Hall

As I read *If I Survive: Frederick Douglass and Family in the Walter O. Evans Collection*, which offers a new, more intimate story of American icon Frederick Douglass, two contemporary images haunt me. In one, a grieving pregnant black woman, Myeshia Johnson, bends over embracing the flag-draped coffin of her husband, Army Sergeant La David T. Johnson. Her face is mostly hidden, but you can almost feel her shoulders shaking with tears, held up only by the coffin and her own dignity. A young black girl, his daughter, wearing carefully braided cornrows and a coordinating dress, perhaps bought in anticipation of a more cheerful homecoming, stands next to her mother with almost military erectness, her hands crossed behind her back. A uniformed officer looks on from across the tarmac.

Sergeant La David T. Johnson was surrounded by black women after the untimely death of his mother, especially Cowanda Jones-Johnson, the aunt who stepped in to raise him, and Congresswoman Frederica Wilson, who mentored him—othermothers who helped shape him into manhood.[1] The collective grief and activism of black women brought him to public consciousness. Mrs. Myeshia Johnson would soon be drafted from private mourning into a larger struggle over white supremacy and military accountability. In this moment of her unfolding story she merges with Mamie Till, demanding answers and justice; with the many "Mothers of the Movement" who turn grief into political action;[2] and with the

1 On othermothers, see Patricia Hill Collins, *Black Feminist Thought: Knowledge, Consciousness, and the Politics of Empowerment* (London: Taylor and Francis, 2002), pp. 178–83.
2 Keisha N. Blain, "Mothers of the Movement, Police Violence and Black Women's Activism," *The Huffington Post*, July 28, 2016, <https://www.huffingtonpost.com/keisha-n-blain/mothers-of-the-movement-p_b_11246410.html> (accessed November 15, 2017).

Douglass family, whose private moments—as small as a skating outing—must be read within their larger freedom struggle.

The image of the bereft Johnson family haunts another image, this one of patriarchal militarism. Standing in front of the White House seal, General John F. Kelly uses the authority of his national military service and personal grief over his own deceased son to attack Sergeant Johnson's othermothers, who have the temerity to demand answers and respect from the administration. The general's grief is palpable, "game-changing," according to political pundits. He turns the conversation from the murky fate of Sergeant Johnson in Niger to the supposedly indecorous behavior of the black women trying to protect his widow and legacy. Why, he wants to know, did an unrelated black woman listen in on a black family's personal moment? Insisting on a privatized notion of family, isolated from public life, his attack rhetorically takes the flag from La David Johnson's coffin and wraps it around the Trump presidency, along with a call for a return to the days of falsely sanctified white womanhood and patriarchal families that protect the interests of white supremacy. These images are a living example of black feminist theorist Hortense Spillers' assertion that one of the legacies of slavery is the placement of white family and black family "in a constant opposition of binary meanings."[3]

I am aghast, not only at this disrespect for black women and the blatant appeal to white supremacy, but also at this fundamental misunderstanding of black family. At any moment that called for a grace, my grandmother would end a prayer asking for blessings for our "family and family connections." Her expansive phrase reminded us that family was not just about connections through blood and marriage, but a world built from affinity, history, alliance, and love. This is the sense of family that sustained blacks in the diaspora while denial of legal marriage and bloodlines became a bedrock of the chattel slavery Douglass spent his freedom fighting. It lingers in the various states of unfreedom that continue to challenge black families. In describing the aftermath of John Brown's capture and execution—which resulted in his father's flight to England to save his own life and, he implies, the death of his youngest sister—Charles Remond Douglass offers the haunting phrase: "We soon became a dismembered family." His poignant evocation of grief and exile shows how the loss of a seemingly single heroic figure reverberates through their many family connections.

If I Survive transforms the common image of Douglass the icon: these letters, images, speeches, and manuscript writings gathered and transcribed for casual as well as scholarly reading for the first time make us alive to the Douglass family as a

3 Hortense J. Spillers, "Mama's Baby, Papa's Maybe: An American Grammar Book," *Diacritics* 17, no. 2 (1987): 66.

collective and vital component to his activism. In the first version of the *Narrative of the Life of Frederick Douglass, An American Slave*, family is watermarked in the descriptions of his childhood, coming to the forefront primarily to highlight chattel slavery's destruction of black family. In this volume we marvel at Douglass's singular gifts while at the same time finding inspiration in the familial comfort, encouragement, labor, advice, and sustenance that made possible their fullest expression. Between the more widely known individual portrait photos of Douglass (Figures 1, 2, and 10) and the photos of the thousands who gathered for his homecoming and commemoration (Figures 71–74 and 75–76) are the beautiful portraits of the Douglass descendants with Anna Murray Douglass's eyes and their parents' posture. When we see photos of Douglass, the great man alone in his study, we can now fill in Anna Murray Douglass, who kept home and family together during his absences; daughter Rosetta Douglass Sprague, his "amanuensis, editor, proof-reader";[4] sons Lewis Henry, Frederick Jr., and Charles Remond Douglass, offering insight and generational perspectives in person and correspondence; and his second wife Helen Pitts-Douglass, who, as his former secretary, carried on these duties.

In her essay, "homeplace: a site of resistance," black feminist theorist bell hooks insists that contemporary black struggle honor the many ways black women have historically struggled to create "homeplace":

> the construction of a safe place where black people could affirm one another and by so doing heal many of the wounds inflicted by racist domination. We could not learn to love or respect ourselves in the culture of white supremacy on the outside; it was there on the inside, in that "homeplace," most often created and kept by black women, that we had the opportunity to grow and develop, to nurture our spirits"[5]

Homeplace exists not solely for blood family and is not the byproduct of women's "natural" inclination towards service, hooks reminds us, but is a conscious, radically political practice that sustained black families through slavery and through various continuing states of unfreedom. All too often, the collaborative resistance of family and the efforts of black women to sustain a place of black care and humanity in the face of white supremacist oppression are lost in attention to more public and seemingly more glorious struggle.

The first *Narrative of the Life of Frederick Douglass* provides a powerful buried example of homeplace. Douglass recalls that his mother, Harriet Bailey, enslaved

4 *If I Survive*, Introduction.
5 bell hooks, "Homeplace: a site of resistance," in *Yearning: race, gender and cultural politics* (Boston, MA: South End Press, 1990), 42.

on the Lloyd plantation, would occasionally walk twelve miles to Holmes Hill plantation and back, risking whipping or worse, to "lie down with me and get me to sleep."[6] For Douglass, these are fleeting, barely remembered moments: "but long before I waked she was gone."[7] While acknowledging Douglass's need to impress upon white readers slavery's devastation of the black family, hooks nevertheless suggests that this moment devalues black womanhood. She offers another reading, "Now I cannot agree with Douglass that he never knew a mother's care. I want to suggest that this mother who dared to hold him in the night, gave him at birth a sense of value that provided a groundwork, however fragile, for the person he later became."[8]

Hooks' essay always provokes a lively conversation with my students, increasing numbers of whom have read the *Narrative of the Life of Frederick Douglass* in school or on their own. They have inherited this idea of Douglass's activist singularity reinforced by the scholarship and the numerous *cartes de visite* they access online. Many realize that they too have overlooked this story of a mother who defied confinement and the possibility of torturous brutality to give her son a literal touch of home. They wonder if making visible the unspeakable violence of slavery against the black family means making invisible black women's resistance, especially in seemingly small, yet radical creations of homeplace. In both the primary materials and the adroit analysis and context offered through the essays, *If I Survive* shows us other possible tellings: it gives readers new levers to pry open the hidden importance of homeplace, family, and black women in the lives of one of the US's most distinguished black families, and in histories of resistance more generally. The editors offer, not only abundant evidence that Douglass himself saw creation of homeplace as a radical act of liberation, but also a comprehensive view of homeplace in action in one remarkable family. Perhaps his exultation that his children are "all in comfortable beds, and are sound asleep, perfectly secured under my own roof"[9] both serves as "retributive justice for his own suffering"[10] and honors his mother's attempts at comfort, her reinforcement of her motherhood and their humanity in a bed that was, like them, someone else's property.

Part of Douglass's duty in his autobiographies was to show what Hortense Spillers calls "an American Grammar," the fractured relationship of blood, flesh, and property produced from settler colonialism and slavery. His children clearly saw illuminating the family's crucial role in fighting for freedom as their duty.

6 Frederick Douglass, *Narrative of the Life of Frederick Douglass* (Oxford: Oxford University Press, 1999), *eBook Collection (EBSCOhost)*, EBSCOhost (accessed January 18, 2018), p. 16.
7 Ibid.
8 hooks, "Homeplace," 44.
9 Frederick Douglass, "To My Old Master," September 3, 1848.
10 "Introduction," this volume.

Charles Remond Douglass's "Some Incidents of the Home Life of Frederick Douglass" heralds for future readers the importance of the Douglass family story, revealing Mrs. Douglass's labors as a shoemaker to sustain the family while Mr. Douglass supported the abolitionist cause abroad. Tellingly, Lewis Henry Douglass uses the phrase "I do not know where my home is" to convey to his beloved Amelia Loguen the depression brought by war-induced trauma and poor health: "I sometimes feel very gloomy and discouraged, and I have enough to make me feel so. I have an enemy that crosses me in nearly every undertaking, and that is poor health, however I do not intend to be discouraged."[11]

The Douglass children's careful preservation of Anna Murray Douglass's economic, physical, and psychological labors attests to her fundamental role as a freedom fighter, and the fact that homeplace was frequently her field of action. The Douglass house Anna Murray maintained was a space of black love and humanity, a refuge from the daily attacks of white supremacy. Moreover, as Rosetta Douglass Sprague points out, their house was often one of the first touches of homeplace for the fugitive slaves on the Underground Railroad: "It was no unusual occurrence for mother to be called up at all hours of the night, cold or hot as the case may be, to prepare supper for a hungry lot of fleeing humanity."[12] While Mr. Douglass was the visible face of the movement, Mrs. Douglass and the children cooked food, built fires, and carried messages that would lead these fugitives to recovering their humanity in freedom. This volume also shows the imprint of black mothers elsewhere. For example, Ethelene Gary, painter Charles White's mother and a domestic worker, surrounded him with books and art in his early years. Just as Anna Murray Douglass's inspiration to apprentice the very young Douglass boys to a printer gave them lifelong tools for surviving and contesting white supremacy, Ethelene Gary gave Charles White the foundation for an artistic/activist practice and the means to create a resistant artistic tradition.

If I Survive offers us a model of contemporary scholarship that values homeplace, that refuses the blinders of patriarchal and white supremacist notions of family, home, and activism. The book shows us how to read for resistance. Under the editors' tutelage, we become hyper-aware of the immense significance of even the smallest archival details, like Frederick Douglass, Jr. writing down the births and deaths of family members to the minute, placing them in a continuum of time and lineage in a way unimaginable to Harriet Bailey, stealing hours for brief contact with her son. The Douglass family didn't just value the printed word and their radical writings, they valued letters in a material way. In the exchange of advice and comfort, as well as in sending the small "uninteresting" details of

11 Lewis Henry Douglass to Amelia Loguen, September 28, 1864.
12 Rosetta Douglass Sprague, *Anna Murray Douglass*, 16.

community life,[13] father and children created homeplace across oceans and time while Douglass traveled in Europe and Haiti, the children taught in Maryland and New York, the sons served in the Civil War and then left to make their own ways as Lewis Henry Douglass does, dreaming of "Africa, Central America."[14] For sons of war separated from their beloved, the correspondence was not simply a means of communication. For Lewis Henry Douglass and Amelia Loguen, both children of formerly enslaved fathers anticipating marriage, the letters were a physical manifestation of black literacy and intimacy hard won by their fathers, as well as a source of emotional comfort. Lewis is particularly moving on the comfort of the physical letter: "With that dear box full of your own dear letters to me, close at hand," he writes Amelia. The box of papers is a companion, a talisman that "marks more pleasant the love with which I hold you at present."[15]

The intimacy of this archive has powerful connections to the present. In the twenty-first century, we have new vocabularies around activism. Although still occasionally co-opted and overlooked by the dominant media, activist writers keep the labors of women and queer activists like Alicia Garza, Patrisse Cullors, and Opal Tometi, the co-founders of #BlackLivesMatter, in the forefront of liberation struggle. The "fallible, mortal, and inclusive" Douglass depicted by Charles White and revealed throughout this volume also gives us a history for our now more overt attention to self-care as a necessary component to activism. For our current generation of activists and protestors who have "self-care" as part of the lexicon of resistance and survival despite media derision, this volume has preserved a history of activism and self-care: throughout we see the Douglass family struggle with the psychological burdens of depression, grief, and trauma descended through generations, as well as with physical injury and economic deprivation.

So too, the Douglass family story makes us consider more carefully the place of children and childhood in liberation struggle. Annie Douglass, who at the age of ten forged a close friendship with the fugitive John Brown and died at "10 years 11 months +13 days,"[16] appalled at the white supremacist violence visited upon him, is a poignant symbol of how early black children learn the bitter lessons of state violence. Lewis Henry Douglass's feeling "that we children have shared in a measure, your sacrifices for the good of the Cause" must too have been shared by the children who more visibly worked for freedom, resisting slaveholders, desegregating schools in the face of white rage, or protesting, as well as by those who, like the Douglass children, delivered messages, built fires, raised funds, served as sounding boards, and preserved individual and familial legacies.

13 Lewis Henry Douglass to Amelia Loguen, September 28, 1864.
14 Ibid.
15 Lewis Henry Douglass to Amelia Loguen, May 20, 1864.
16 Quoted in Frederick Douglass chronology, this volume.

Scholars and readers owe a great debt to the Douglass family's assiduous compiling of their family papers and to the Walter O. Evans and family's insistence on creating—and now sharing widely—an archive of black liberation. In place of the thingness and commodified flesh of the chattel ledger that Frederick Bailey escaped, the Douglass family scrapbooks and letters offer a living portrait of an incredible family, warm, connected, and vibrant in the endless pursuit of a freedom in more than name only. But I also want to make visible how carefully the editors have drawn from the Douglass family a methodology of liberation. Drawing their inspiration from Douglass's own evocation of "marks, traces, possibles, and probabilities" in his novella *The Heroic Slave*,[17] they endlessly seek out the invisibilized presences that make up the Douglass family story. *If I Survive* fills in significant lacunae in the record and points out numerous avenues for further inquiry, encouraging us to venture out on our own. For example, in examining Frederick Douglass, Jr.'s listing of his and his siblings' children in his family history, the editors see in the elegiac poetry written between the lines a man seeking reprieve from the burdens of remembering and recording the early sufferings and death brought by high infant mortality. Their analyses of what Lewis Henry Douglass called "the distresses, the anxieties, and the hardships that he and his family had to undergo in the struggle for the cause of liberty"[18] are models for understanding contemporary fights for freedom. The struggle for the cause of liberty needs such heroes and such families, but also such preservationists, scholars, and writers alive to falsely drawn divisions between public man and private life, homeplace, and liberation struggle. This is the first of many new stories being told about the Douglass family in this celebratory year. Others are waiting out there for you to tell.

17 Douglass, *The Heroic Slave*, 176.
18 Lewis Henry Douglass, "Undated and untitled handwritten statement."

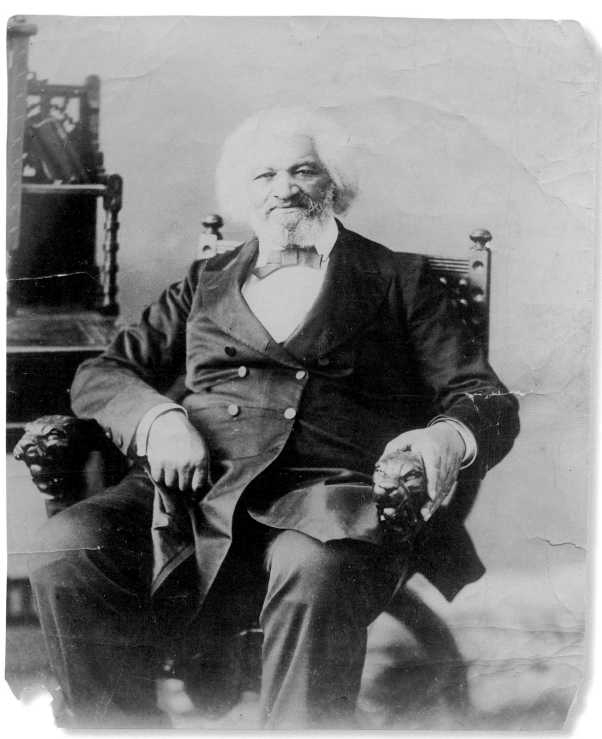

Figure 84: Anon., *Frederick Douglass*, 1895. (New York Public Library.)

Index

Numbers in **bold** refer to page numbers for Figures.